D0324031

REFERENCE NOT TO BE
TAKEN FROM THIS ROOM

THE COLOUR HANDBOOK

Ref.
QC
496.8
.D36
1987

The Colour Handbook
How to use colour in commerce and industry

E P Danger

Gower Technical Press

Muirhead Library
Michigan Christian College
Rochester, Michigan

© E P Danger, 1987

All rights reserved. No part of this publication may be reproduced, stored in a retrieval system, or transmitted in any form or by any means, electronic, mechanical, photo-copying, recording, or otherwise without the prior permission of Gower Technical Press Limited.

Published by
Gower Technical Press Ltd,
Gower House,
Croft Road,
Aldershot,
Hants GU11 3HR,
England

Gower Publishing Company,
Old Post Road,
Brookfield,
Vermont 05036,
U.S.A.

British Library Cataloguing in Publication Data

Danger, E.P.

The colour handbook : how to use colour
in commerce and industry.
1. Colour 2. Colour in industry
I. Title
535.6'02438 QC495

Library of Congress Cataloging-in-Publication Data

Danger, Eric P. (Eric paxton)
The colour handbook.

Bibliography: p.
Includes index.
1. Color–Handbooks, manuals, etc. 2. Color
in industry–Handbooks, manuals, etc. I. Title.
QC496.8.D36 1987 535.6 87-58

ISBN 0-291-39717-4

Printed and bound in Great Britain by
Billing and Sons Limited, Worcester.

Contents

36926

Preface

This book provides a guide to colour principles, colour selection techniques, colour usage and the characteristics of basic hues analysed under about a hundred different headings. It provides a convenient source of reference for all those who are concerned with the selection of hues, whether for the decoration of environments such as offices and factories; for the decoration of selling environments such as shops and catering establishments; for graphical applications such as packaging and print; for consumer products generally; for industrial products such as plant and paper; and for any other application which falls within these broad limits. It will be of help to all those who need to find a practical basis for the selection of colour, a basis which will stand up to argument, to the vagaries of committees and to the prejudices of individuals. In any commercial application colour should never be chosen without good reason, and personal preferences should be eschewed.

The book is concerned primarily with the use of colour in achieving maximum sales and optimum working conditions and therefore with the marketing, selling and productivity aspects of colour. It includes a summary of the principles of light and colour, including an explanation of trends; notes on colour usage and how to select colour; detailed lists of the characteristics of colour that are especially useful in marketing and environmental contexts; and an exhaustive colour catalogue which details the characteristics and uses of each basic hue and each type of colour. Terms commonly used when working with colour are defined, and there is an index to light and colour characteristics.

The overall aim has been to provide an answer to questions that arise in the course of everyday work, not about the technicalities of pigments or process colour, which are well served by other sources of information, but about the likes and dislikes of ordinary people. So far as is known, there is no other source of information which covers the same breadth of field or which contains so much information in a succinct form. A good deal of published information, supported by well-conducted research, is available, but it cannot easily be consulted or applied to everyday problems. This book tries to summarise available data in a form which facilitates easy reference. It is not anticipated that it will become out of date very quickly, and it will therefore constitute a permanent source of reference. However, no claim is made that it will provide the answer to any, and every, question. Many questions require individual investigation.

The material is intended for management generally and particularly for marketing management, but it will be of interest and help to all those who are concerned with choice of colour and with the likes and dislikes of customers, including advertising agents, architects, designers, interior decorators, decoration contractors and retailers; above all, it will be of maximum assistance to all those responsible for the use and selection of colour in selling applications.

Colour recommendations for individual products or situations are not provided, because each case needs to be studied in its own context, but it does provide a starting point by formulating guidelines and an explanation of the methods to be adopted together with an index to the various uses and characteristics of each individual hue.

Some duplication of material has been inevitable in the interests of more convenient reference but it is hoped that this has been kept to an acceptable minimum. The contents are based on my own studies, researches, files and practical experience and reflect knowledge acquired in my practice as a colour research consultant over nearly thirty years and in making colour recommendations to many well-known companies. They also include the results of an extensive study of published information dealing with colour and associated subjects and extending over many years. In addition, I have had the inestimable advantage of access to the files and experience of Faber Birren, the world's leading authority on colour, whom I have been privileged to call a friend and associate for many years. I owe a deep debt of gratitude to Mr Birren for permission to use his material in this work.

The plan of the book

The book falls naturally into three parts:

I The Principles of Light and Colour
II The Principles of Colour Selection
III Colour Catalogue.

The first part includes the basic information about light and colour which must be applied to a specific situation in order to achieve the objective of selecting colours which have practical benefit.

The second part explains the method of applying the basic information to five broad categories and how colour can be used to maximum effect in each category; it outlines the principles involved in finding the right hues and provides guidelines for the selection process. The five categories are:

- productive environments such as offices and factories
- selling environments such as shops and restaurants
- graphical applications such as packaging and print
- consumer products, particularly those used in the home
- industrial products such as equipment and semi raw materials.

The third part is a comprehensive guide to the use of colour, subdivided by hue. Each hue heading includes the uses of the hue in some twenty-five separate applications, the characteristics of the hue analysed under nearly sixty

headings and some general notes on the character of the hue also analysed under a number of headings.

E.P. Danger

Part I

PRINCIPLES OF LIGHT AND COLOUR

1 About vision

1.1 The eye

Any discussion of colour principles requires some knowledge of the way that the eye operates, because colour is essentially an interpretation of light by the eye and the brain, although visible light will also penetrate the skulls of some animals (including humans) and produce physiological effects that are quite independent of those received through the eye. Human beings have a radiation sense which is quite independent of vision, and this is most fully developed in blind people. It is not necessary to describe the eye in full technical detail, and it will suffice to mention its principal parts.

Iris

This is the muscular 'shutter' at the entrance to the eye and controls the amount of light that enters it. When the light is strong, the muscles automatically close the shutter so that the eye is not overwhelmed; under very bright light the eye may close to such an extent that vision is impaired. The iris opens to its fullest extent when light is very dim. The movement of the iris is co-ordinated with movements of the lens, and when the eye is subject to constant changes from light to dark and back again, the muscles concerned tend to become tired and contribute to the disability known as eyestrain.

Lens

This collects the rays of light and focuses them on the retina at the back of the eye. It operates by muscular control in co-ordination with the iris, and the movement is complex. The movement compensates for distance and also adjusts so that the images in both eyes merge together as one; the lens is also sensitive to different wavelengths of light and flattens out or becomes concave to deal with them. The actual point of focus is not the same in all cases; colours of shorter wavelength tend to focus at a point slightly in front of the retina, the longer wavelengths slightly behind it. The eye automatically tries to correct this imbalance and it is for this reason that hard colours seem larger and form a strong and clear image on the retina even through fog and haze; while soft colours seem further away and are often blurred. The difference between hard and soft colours is described in detail in a later Section.

3

Retina

This is the covering of the back of the eye and it is directly connected to the brain by nerves which transmit impulses in such a way that the retina is a light-sensitive expansion of the brain. The covering consists of a large number of cells which are sensitive to light; these photo-receptor cells (receptors) are of two kinds:

Rods These are sensitive to brightness of light and are distributed evenly over the entire surface. They react to brightness and motion even in subdued light and provide low-intensity vision.

Cones These are cells of three different kinds which respond to red, blue and green wavelengths of light, respectively, and it is through these that all colours are seen. Cones are mainly concentrated in the central area of the retina and the fovea and they produce high-intensity vision. When the three types of cone are all stimulated equally, the eye and the brain see white, but if one type of cone is stimulated more than the other two, the image appears to be tinted with the corresponding primary hue. The eye is not sensitive, however, to ultraviolet and infrared rays, although most sources emit these as well as the visible light.

The most central part of the retina is called the fovea and it has the largest concentration of cells, each of which is believed to have its own nerve connected directly to the brain. The process of seeing mostly takes place in the fovea and adjacent areas, and it is only here that the eye can distinguish fine detail, texture and colour. The foveal area will simultaneously resolve colour, form, brightness and detail; foveal vision is based, broadly speaking, on the cones and is most effective in daylight. In the outer parts, or periphery, of the retina the cells are not so closely crowded together and nerve connections are arranged in groups. This area cannot resolve fine detail, but it is better able to detect faint images and will respond better to brightness changes and motion on the outer boundaries of vision. Peripheral vision is mostly based on rods and is most effective at night.

Near the fovea is the 'blind spot', where the optic nerve connects the eye to the brain and which does not have any cells. It is located slightly inwards from the centre of the retina and at close distances covers a small area of the field of view. However, at 7 feet the blind area measures 8 inches across and looking into the sky it covers an area about eleven times the size of the moon. Under normal conditions the brain 'fills in' the gap in vision, but this 'blind spot' may be a cause of industrial accidents and of road accidents at night if the object to be seen is directly in line with the blind spot; in such cases the object may not be seen at all.

Because of the different types of receptor, the eye sees with equal facility under widely different light intensities, and seeing is efficiently performed in light or moderate shadow; human beings can see the world as normal under widely differing conditions of illumination. An object seen in a room illuminated by 100 lamps will alter very little in appearance if ninety of the lamps are switched off; the observer is conscious of the lower level of lighting, but the

eye allows for it and after a while the retina adjusts to the lower lighting level. Severe use of the eyes is no more harmful than severe use of any other muscle or organ, and the eye has a wide range of capabilities, although vision tends to deteriorate if it is not stimulated. Although the eye was originally developed to cope with sunlight or daylight, it has acquired adjustments which enable it to cope with a variety of other conditions. These adjustments are co-ordinated, and it is when they are separated that trouble ensues. For example, excessive brightness in the field of view will cause disruption, the eye will struggle to set things right and this causes strain. Lower levels of light also cause strain, and reactions to either will show up in higher rates of blinking, dilation of the pupil, increased muscular tension, irritability, fatigue and a collapse of sensitivity on the outer boundaries of vision. To the human eye there is no such thing as underexposure or overexposure as there is with a camera. A photograph of a white object would look grey if too little light reached the film, but to the eye the object will always be white. However, the same thing does not happen with colour (this effect is known as colour constancy and is described in a later section).

1.2 Sensitivity

The sensitivity of the retina changes under different light conditions; it may easily vary from hour to hour and be affected by disease, fatigue and other emotions. Loud sounds will decrease red sensitivity of the eye and increase sensitivity to green and the same thing can happen with strong tastes and odours. Sound increases the sensitivity of cones (daylight vision) and decreases the sensitivity of the rods (night vision); loud noises at night are more frightening than during the day.

Nerve endings within the eye respond to a range of wavelengths which varies slightly from individual to individual and covers broadly the band from 4000 to 7000A. The sensitivity is not constant over this range but rises gradually from zero to a maximum in the middle regions and then decreases to zero again at the other end. The eye cannot distinguish more than about 180 pure colours, but this total is increased when tints, tones and shades are taken into account.

The eye groups colours into relatively few bands. The sensitivity is highest in the middle region of the spectrum – the wavelength of yellow – and decreases towards the wavelengths of red and blue at the opposite ends of the spectrum, although the eye finds it easier to focus red than it does blue. The eye can focus yellow perfectly without aberration, and the brain finds it emotionally pleasing. The eye finds difficulty in focusing blue, causing objects to appear blurred and surrounded by haloes (see also Accommodation in 1.4 in this part).

The completely dark-adapted eye loses all sense of colour, and the cone endings become dormant. When the eye is partly dark-adapted, as at night, colour discrimination is lost because the rods then operate and they are only sensitive to light and dark. However, as long as the eye can see at all, a white surface will always appear white. Generally speaking, the eye sees very well in light equivalent to daylight, and acuity is reduced the more nearly the light approaches blue. However, the dark-adapted eye has best acuity under red light, and this is

often used for instrument panels and the like which have to be seen in the dark. Acuity is best in a light source which has a yellowish quality, because the sensitivity of the eye is at its maximum. Acuity is poorest in light having a blue quality, because sensitivity is low.

1.3 Mental processes

The brain is an essential part of vision, and the eye cannot see without it. Stimuli received by the eye have no meaning until the brain interprets them. The region of the brain responsible for sight has an area corresponding to the fovea and a much smaller area devoted to the periphery. Although the fovea is little more than a dot on the retina, it has a vital function and requires a relatively large area of brain.

The right hemisphere of the higher brain is proficient in processing information and deals with the perception of colour while the lower brain has an ability to recognise bright colour and to store up ancient memories and ancestral lore.

Example The lower brain associates red with blood, fighting and fire, which are ancient memories, and because of its ability to recognise bright colours reacts to impulse colours and is more at home in the 'bright lights'. The higher brain deals with art and architecture.

There is a need to link the two parts of the brain in most uses of vision, and the whole process is what we know as visual perception; perception is not quite a straightforward matter of seeing. The images on the retina are inverted and transferred left to right, the correction being made by the brain. If the brain is upset in any way, it can make interpretations which make nonsense of the data received. The eye records without understanding, the brain interprets the visual information fed to it by the eye and compares it with previous experience. Thus a child has to build up a store of experience before it can correctly estimate scale, distance, speed and so forth.

The brain finds it difficult to interpret a visual phenomenon of which it has no previous experience; good and reliable eyesight is acquired by training and experience. Man has to use his eyes to see, but with experience the retina requires only a very few hints of the existence of an object for the brain to piece it together. A camera would not be able to see such objects at all. On entering a room, people virtually form a montage of what is before them by using their brains to piece together, and remember, small bits of visual data. A man is not able to count his own teeth because critical vision is limited to very small areas, and it takes the brain, and the perception process, to build up whole pictures from small scraps of visual information.

Because individual experience varies, different conclusions may be drawn by different people from the same sensory data, and different conclusions may be drawn by the same person at different times. The make-up of individuals also plays some part; some people are better able than others to structure their visual experience because they have greater experience. Some people suffer from

glare but others do not; most people judge red as warm and blue as cool, but there are some who take a reverse review, although they are few in number. The process of interpretation is therefore irrational and these irrational feelings cannot be excluded from perception. The act of perception, however, demands the creation of visual order because only in this way can like be compared with like. The eye and the brain together try to simplify all stimuli and tend to see irregular shapes as regular ones. Beauty is a product of good order.

The eye does not scan in a continuous movement; it skips and hops, and consequently there is a certain amount of retinal lag. Stimulation of the retina at one moment holds over until the next, and it is this that makes motion pictures possible. Although the brain records a scene almost simultaneously with actual sight, when two lights are flashed together, the one seen by the fovea will appear to flash ahead of that seen by the periphery.

The brain is slightly slower in picking up blue light because the eye finds it difficult to focus; blue lights used on police cars require a slower flashing rate than lights of other colours if they are to be seen clearly. It is only the higher animals that can signal anything to the brain in the absence of movement.

Most of the phenomena which modify colour take place in the brain rather than in the eye itself. The way in which we see a surface is largely independent of the intensity and wavelengths of the light it reflects, although the nature of the light source may affect the appearance of colour. We do not have to look at a light source to know whether an environment is bright or dim; we can tell from the appearance of things within the field of view. By manipulating surface colours it is possible to indicate different levels of illumination; strong contrasts and saturated colours imply strong illumination, but large areas of subdued colours suggest dim illumination. Illusions of brightness, such as colours looking relatively brighter on a dark ground, also take place in the brain.

One of the best examples of the brain in action is in the phenomenon known as after-image. In seeing any colour the eye produces a strong response to the complementary colour, and the brain brings after-images to view when the first image is removed. This has great influence on colour effects; it gives intensity to strong contrasts and mellowness to blends. It is interesting that hypnotised subjects can see colour and after-images even though the seeing mechanism has been stimulated by suggestion.

1.4 Vision processes

Acuity

This is the ability of the eye to see detail. The more light there is, the better the acuity, but the law of diminishing returns applies and there is no point in increasing the level of light beyond a certain point. Acuity is a measure of the accuracy of vision, combined with the time taken to see accurately and it helps to determine the quantity of light required for a specific task, without taking into account eye fatigue and colour preferences. The eye has different acuity according to the state of its adaptation and according to the colour appearance of the light (see 1.2 above).

Accommodation

This is the ability of the eye to focus on an object and is a muscular function of both the lens of the eye and the iris, together with the convergence of the two eyes so that the two images merge in the brain. The lens of both eyes are adjusted so that the image on the retina is sharp, and this operation is performed automatically each time the gaze is shifted; where there are frequent shifts the muscles can become tired.

The movement of the lens is co-ordinated with the movements of the iris. At low levels of lighting the iris is fully open and the depth of field of view is shallow; at high light levels the iris is almost closed and the depth of vision is increased. This increased depth can take care of small differences in distance without changing the lens and there is, therefore, less muscular effort.

Adaptation

This is the ability of the eye to adjust itself to different levels of light and is a co-ordinated movement of the iris and a change in the sensitivity of the retina. The eye will function over a wide range of light levels and cope with brightness differences as great as 1000 : 1 by adjusting its sensitivity, but at very high brightness levels there may be some blindness due to glare, and at low levels there will be loss of detail. The eye always tends to adjust to the area of highest brightness within the field of view.

An adjustment from low brightness to high brightness is accomplished in seconds, but the reverse may take minutes. The opening and closing of the iris is quick but the change in sensitivity of the retina is slow, especially when it has to adapt to low brightness. When a person first walks into a dark room vision will be poor because the cones cannot see, but as the rods take over vision becomes clearer, although this may take as much as thirty minutes. However, acuity will be improved if the light is red.

Small changes can be taken care of by the movement of the iris, but larger changes require the help of the retina; both consume energy, and too frequent changes from light to dark are to be avoided.

Example Scanning a page of print will set the adaptation level of the eye; looking at an illustration may change the iris. Looking away from the page to a black topped desk will require a change in the sensitivity of the retina. Looking back at the page will reverse the process and adaptation will be slower.

It follows from this example that contrasts within the field of view should be avoided as far as possible if tiredness is to be kept within bounds.

2 About lighting

2.1 The need for light

This is not intended to be a treatise on lighting, the technicalities of which are the province of the lighting engineer, but it is necessary to have some idea of the broad principles of light and lighting before discussing colour and the relationship between colour and light. The reason is simple: without light there can be no colour.

The primary aim of the art, or science, of lighting is to provide sufficient light to see objects clearly and to carry out tasks efficiently, and to achieve these objectives in the most economical way. This axiom applies whether the light source is natural daylight or artificial light. Even daylight is not free; it costs money to use it to maximum advantage, although it does provide visual variety at no extra cost. Artificial light is easier to control but does not adapt so readily to changing conditions, and visual variety may have to be provided in some other way, for example by the use of colour. In addition to the primary task of providing sufficient light for seeing, a lighting installation must also contribute to the appearance of people and objects, the pleasure of the observer and the well-being of users of the environment.

Light is essential to life and to the growth and health of all living things, and a third function of the lighting installation (and an increasingly important one) is to create conditions which promote health. The principal tasks of lighting are summarised below, and the categories are described in more detail in the sections that follow.

- Good vision lighting, essential to both consumer and commercial environments and mainly a question of the quantity of light and the placing of fittings.
- Psychological lighting ensures the mental well-being of people and enables them to derive maximum pleasure from the environment. It depends mainly on the characteristics of the light source and there may be a contribution to good vision.
- Biological lighting, essential to growth and to the health of people and of increasing importance as man spends more time in controlled environments. Biological lighting is largely concerned with the physical responses of people.

2.2 Good vision lighting

Lighting which will provide good seeing conditions can only be specified in terms of actual environments and will depend on the nature of the environment and the tasks that are carried out within it. Ideal light levels can be specified but are largely academic because the eye can adapt itself to any light level, or almost any light level, and in any case, vision is regulated by the sources within the field of view. What may be more important in calculating light levels is the nature of the task and the amount of detail that has to be seen. The lighting engineer, primarily concerned with good vision, usually tries to duplicate the light which is encountered in average temperate zones during the day (i.e. light that is cold and bluish in tone), but this may not provide the most pleasing environment. The lighting engineer also aims for high levels of light, although these are not always necessary for efficient seeing. There are differences of opinion about the ideal level of light, but it seems to be generally agreed that levels above 1000 lux are unnecessary. Although there may be circumstances where higher levels are required, in general they will tend to cause glare. Too high brilliance may damage the retina itself, and intense light may cause real distress.

In general, light should be neither too directional or too diffuse; one causes shadows and the other causes loss of detail. Direct lighting is more efficient but tends to cause glare and a semi-indirect system is probably the best in most commercial situations. Some directional light is often necessary, either to provide variety or to illuminate a task, but planning needs care because the equilibrium of the body, and its orientation, will change if the light sources also change in either direction or hue.

When planning the lighting of a working environment, the age make-up of the workforce may be a significant factor. Once a worker attains the age of 40, the amount of light necessary to achieve a given standard of visual efficiency increases rapidly. Furthermore, a large proportion of the population suffers from eye defects of one kind or another, and these defects tend to be more common as age increases. Older people, generally speaking, require more light to see adequately, and if they are given the opportunity, they will ask for very high light levels indeed, although not usually in the home.

Lighting is a subject for the careful consideration of management responsible for any commercial environment, and the results are important in terms of efficiency and economics. Complaints about lighting cannot be shrugged off as being psychological in nature, because there is often a physiological element as well.

The advantages of well-thought-out lighting can be summed up as follows:

Physiological	*Psychological*
• less eyestrain	• better concentration
• better colour perception	• better housekeeping
• faster vision	• better morale
• improved visual acuity	• feeling of well-being
• better distance judgement	• improved productivity
• less tiring work	

The whole leads to better work, greater safety and higher morale. Ultimately, it leads to better profits.

2.3 Psychological lighting

This term describes lighting which improves the appearance of the environment, which improves the appearance of people within the environment and which is pleasing to people at large. It is of more significance in the home than good vision lighting because it reflects the likes and dislikes of the individual. It is equally important in the commercial environment, although less weight can be given to the likes and dislikes of individuals.

An adequate level of light is not enough to provide a pleasing environment; there must be change, variety and colour. The unvarying whiteness of white light is sterile and can even cause vision to black out; ideal conditions require that surfaces within the field of view are not of equal brightness. A preponderance of white is emotionally sterile and visually dangerous, and sensory deprivation must be eliminated by providing variety and using colour to maximum advantage. Variety is particularly important in controlled environments where the psychological conditions should receive just as much attention as the engineering of physical conditions. Uniformity of stimulus is always undesirable because the human organism is not adapted to it; people require varying stimuli in order to remain alert. Monotony may increase visual efficiency, but it can cause emotional rejection and even distress. Contrasts can reverse the process, although overstimulation may cause equal distress; a white environment is sterile in a psychological sense, but a black-and-white one would be sterile in a physiological sense.

People tend to prefer a warm light for recreation and a cool light for work, but in general the body will react to bright light; turn up the light and the colour, and people are emotionally transported, barriers are broken down and people lose shyness and timidity.

The general principles of lighting for environments are:

- Tints of light should be warm in quality at low levels of intensity and cool at high levels. Cool light at low levels will create an uninteresting and depressing atmosphere.
- Warm light flatters the human complexion. Consider candlelight and firelight; these have a warm, orange, colour and are far more mellow and friendly than moonlight, which has a cold quality.
- Use colour in a positive way, but colour values will only appear in their true identity at reasonably high levels of light intensity.

2.4 Biological lighting

In addition to its function of creating good vision and ensuring the mental well-being of people, light also has a biological effect, and this is increasingly important as man spends ever greater time in controlled environments which do

not include any natural daylight. Visible light, together with invisible infrared and invisible ultraviolet light, is essential to the growth of all living things. It is well established that light is essential to controlling plant growth and that it has an effect on the sexual activities of birds and affects their glands. In some plants red light causes maximum growth but other plants thrive better under blue light; red light produces a higher ratio of male offspring in some animals and blue light produces a higher ratio of females. Light has a similar effect on humans, although any effect on the sex of offspring has not been proven.

Man does not need a great deal of light; the life-span in the tropics is no longer than it is in temperate climates, but the human race does require a proportion of ultraviolet light if it is to survive and thrive. This requirement is provided by natural daylight, but it is lacking in some forms of artificial light, notably incandescent light, which has no ultraviolet component at all; fluorescent light has some. Even the ultraviolet component of daylight may be filtered out by glass, and consequently there is a strong case for providing sources of ultraviolet light where people are living and working wholly in artificial conditions. It is particularly valuable for those working underground or in polar regions, where there is little daylight for long periods.

Although undue exposure to ultraviolet light is harmful, a controlled amount is beneficial to the health, and ultraviolet light produced by quartz lamps has valuable bacteriological and sterilisation properties, although the lamps must be shrouded to obviate harmful effects. A proportion of ultraviolet light in working environments will help to reduce respiratory ailments, although it should be noted that exposure to ultraviolet light may damage some materials.

This subject is of particular interest in modern buildings with large areas of glass. Air-conditioning systems do not deal with heat rays generated by glass windows, and if steps are taken to eliminate heat rays by using specially treated glass, there is a risk of eliminating the health-giving ultraviolet rays as well.

2.5 The colour of light

Irrespective of the category of lighting, the nature of the light source and its physical characteristics have a significant effect on the appearance of colour and on the functions that colour can perform in relation to light. The physical characteristics and the spectral composition of the light source influence the appearance of colours and objects, the overall appearance of the environment, the appearance of people and the enjoyment, by people, of the surroundings.

The eye has different sensitivity and different acuity when the field of view is illuminated by light of different hues. The eye sees well in natural light equivalent to daylight, but acuity is reduced when the spectral quality of the light approaches blue and improves as it approaches yellow and orange. This assumes some importance when the light source is a fluorescent tube, because this type of light has a band spectrum instead of the continuous spectrum of sunlight, daylight or incandescent light, which transmits in all regions of the spectrum. Daylight fluorescent tubes, for example, transmit a high proportion of blue light, which tends to reduce visual acuity. Acuity is far better when there is a yellowish quality in the light because yellow is the region of maximum

spectral acuity and the brightest portion of the spectrum.

A discussion of the characteristics of light is a highly complex subject and is frequently the subject of misunderstanding, the most common mistake being to compare the colour *appearance* of a light source with its colour *rendering* qualities. These are quite different, and the intensity of the light source may be more important than either of them. The characteristics that are relevant in the present context are:

- colour appearance of light
- colour temperature of light
- colour-rendering qualities of light
- intensity of light
- coloured light
- daylight
- glare
- lamp characteristics.

The colour appearance of light is the way that it looks to an observer, while the colour-rendering qualities refer to the way that light reveals the colour of objects. The intensity of the light has an effect on the appearance of the colour of objects seen in that light, while coloured light refers to those cases where the light source is artificially coloured either by coloured lamps or the use of filters. Daylight has special characteristics of its own, and glare is excessive light in the wrong place. These characteristics are discussed in detail in the following chapter, which also includes a summary of the characteristics of the principal sources of light.

The characteristics of light have a number of practical effects; on human appearance, on the appearance of food, on the appearance of objects or surfaces and on merchandising displays. The effect of light on the appearance of colours is significant in any process of colour selection, and certain colours are best not used as an illuminant.

3 Light characteristics

3.1 Colour appearance

This term describes the colour that a light source, or a white surface seen in the light from that source, appears to be to the observer and is usually expressed as cool, intermediate or warm. These are descriptions of the tint of the light, cool sources having a blue tinge and warm sources a yellow or red tinge. The colour appearance of any light source is measured by its temperature, as described in the following section, and a distinction needs to be drawn between, on the one hand, the colour appearance, or tint, which is an inherent quality of the light source and, on the other, artificially coloured light sources.

Cool sources create a rather uninviting environment, but the lamps have good colour-rendering qualities and may be required for practical reasons. They suggest efficiency and cleanliness and are most satisfactory when the level of illumination is high. Intermediate sources are neither inviting nor unfriendly and are generally most efficient in economical terms. Warm sources are appealing and inviting and are recommended when it is desired to create an attractive atmosphere, but they are more expensive in terms of running costs. They are preferred for working areas and are recommended when the level of illumination is low. In appropriate cases they may suggest luxury.

The colour appearance of the light thus has an effect on the general appearance of an environment and on the appearance of people in the environment, and the remarks made below refer to the physical characteristics of the light source and not to artificially coloured lamps, which require different consideration.

The human eye sees white when all the receptors of the eye are stimulated equally because white light is made up of all the hues of the spectrum in roughly equal proportions. Most light sources, however, do not emit all the hues in equal proportions and the relative strength of each wavelength of the spectrum emitted by the source may vary quite considerably, with the result that when there is more energy in one waveband than in others, the light is tinted with the spectral colour of maximum energy. It is not always realised that different sources have different tints, nor is it realised that daylight varies in tint according to the time of day.

Artificial light does not vary with the time of day, but it is different from

daylight, and each type of lamp is different again. An incandescent lamp, for example, emits light with a high red content and a low blue content, and when an individual is in an environment lit by incandescent light, which is a warm source, the receptors of the eye adapt themselves, or change their sensitivity, to compensate for the extra red; thus the brain receives nearly equal nerve impulses and 'sees' the light as white. The same process occurs with other types of lamp.

So long as the eye is exposed to only one light source it will not be aware of any tinting, but when an additional light source, having a different spectral composition, is introduced the eye has difficulty in adapting because the new sources also causes nerve impulses. This results in a situation known as simultaneous colour contrast and the effect is to make the second source appear tinted; the first source will still look white. The situation will remain so long as the two stimuli remain in view.

Example 1 When an area lit by fluorescent light is viewed from an area lit by incandescent light, the fluorescent light will be seen as blue because the eye is adapted to the high red content of the incandescent light.

Example 2 When a display is lit by incandescent light in an environment which is lit by fluorescent light, the display will look brighter and more colourful, and some of the colours in the display will be enhanced. The total effect depends on the type of tube in the overall lighting.

When the stimulus is changed from one to which the eye is adapted to a completely different one, a perception of the tint of the original stimulus remains for a short while until the eye has had time to readapt itself. This is called successive contrast.

Example 3 When entering an environment lit by incandescent light from daylight, the incandescent light appears yellow for a short period because the eye is adapted to the blue content of the daylight. When the eye has had time to re-adapt itself the incandescent light will be seen as white.

The tints of some typical types of lamp are listed below, but the light from them will normally be seen as white except in the conditions described above.

Lamp	Tint	Category
Daylight fluorescent	Slightly blue	Cool
Cool white fluorescent	Slightly grey	Intermediate
White fluorescent	Slightly beige	Warm
Warm white fluorescent	Slightly pink	Warm
Soft white fluorescent	Pink	Warm
Incandescent	Slightly orange pink	Warm
Mercury	Green	Intermediate
White mercury	Pale yellow-green	Intermediate
Colour-improved mercury	Pale khaki	Intermediate

These are quoted as examples; there are other types of lamp and new types are constantly being developed, and these may have different characteristics.

Significance

The colour appearance of light has comparatively little significance in consumer applications except that warm sources are generally used in the home. Any coloured object intended for consumer markets should look its best in warm light. In environmental applications of a productive nature, the appearance of the light is important where colour matching takes place and in the case of some materials. Workers generally prefer a warm source. In selling environments, warm sources are recommended because they are inviting and friendly, and they are particularly recommended for food. The chief significance in graphical applications is that any piece may be seen under different sources and should be equally satisfactory in all of them although a piece may be designed to look its best in a specific light source.

3.2 Colour temperature

Colour temperature is used to describe the colour appearance of light and is expressed in Kelvin degrees (K). The colour temperature is what the eye sees when a black body, such as iron, is heated; at first the body gives off invisible radiation, but as the temperature rises it glows dull red, then a brighter red and through orange, yellow and white to blue. Any colour which matches those shown by the black body at a particular temperature can be described in this way, although the colours may not have the same spectral curve as those emanating from the black body. The following are some typical examples:

- Twilight Colour temperature 1715–2500 K
- Candle 2000 K
- Incandescent lamp 2900 K
- Afternoon sunlight 4000 K
- Noon sunlight 5000 K
- Cloudy sky 6500 K
- Blue sky 10 000 K

For every colour temperature there is a high level and a low level of illumination at which the light is considered pleasing. If surface colours are to appear natural, they require an orange-tinted illumination when seen under light of low intensity; this can be provided by an incandescent lamp, and optimum conditions will be created if the light level is between 100 and 300 lux. If higher light levels are used, surface colours will appear yellowish. If the light source has a colour temperature of 5000 K, the light level should be maintained at about 300 lux; anything below this causes objects to look unreal. A light source having a colour temperature of 6000 K would require a light level of about 400 lux, and below this objects would have a greyish appearance. A colour temperature of 7000 K requires at least 500 lux, and anything below this would cause everything to have a very greyish appearance.

Two sources of light with the same colour temperature do not necessarily have the same colour-rendering qualities. For example, a fluorescent lamp and an incandescent lamp might have the same colour temperature but they do not give the same results; the fluorescent lamp will have a shortage of long wave-

length (red) light, and this will make warm colours seem dull and the excess of short wavelength light will impart a violet tinge to blue. This is sometimes counteracted by adding more yellow-green phosphers to tubes, but this tends to impart a green tinge to yellow.

Significance

Colour temperatures have very little practical significance in most commercial applications, but they are, of course, important to the lighting engineer, and they provide a reason for recommendations made elsewhere in this text.

3.3 Colour-rendering qualities

The colour-rendering qualities of a light source refer to the accuracy with which it reveals the colour of objects or surfaces and is unrelated to its colour appearance. To achieve the best colour-rendering qualities, a lamp should emit energy at wavelengths to which the eye is not particularly sensitive, and thus the efficiency of a light source having good colour-rendering qualities is lower because the total light produced is less.

The appearance of any colour seen depends on the spectral distribution of the light source, on the colour-rendering qualities of the light source and on the state of adaptation of the eye of the viewer. The spectral distribution curve of a light source is the most complete description of its colour-rendering qualities, but different spectral curves can produce similar effects if the energy distribution is such that the different curves each produce the same response in the receptors of the eye. If spectral curves are similar, colour-rendering qualities are about equal, but if there are large spectral differences, there will be equally large differences in colour rendering.

Examples 1 De luxe warm white and warm white fluorescent tubes and incandescent lamps have different spectral curves, but they all produce roughly the same receptor response, the light from all of them looks very much the same, and they all have broadly the same colour-rendering qualities. Differences will only be noticeable if two or more different lamps are on view at the same time.

Although the lamps may look the same, and the eye sees the light as white, lamps having different spectral curves will have different colour-rendering qualities when the light from them is reflected from a coloured object. The colour of the object will look different because the eyes will be adapted to the light source.

Example 2 An object having a given colour will look slightly different in daylight, in incandescent light, in fluorescent light and in any other type of light. The difference will be most marked in fluorescent light, depending on the type of tube.

The rules apply so long as there is only one light source within the field of

view, but when a second light source is introduced, or an object of a different colour, the eyes have to adapt themselves afresh, and the appearance of the object will change again. The practical effect of this is that any given colour may look slightly different when seen under light sources of different spectral composition, and also when seen in close proximity to an object or surface of another hue.

Example 3 In display applications a colour chosen under fluorescent light in a shop may look completely different when seen under the incandescent light of the home. This can cause dissatisfaction.

Example 4 Packages, posters, point-of-sale displays and the like can look quite different when seen under different forms of illumination.

In certain cases, light sources that look different have similarities of spectral balance and colour-rendering qualities, and when they are used together and the eye is not completely adapted to either of them, differences in appearance of objects are emphasised by simultaneous contrast. Comparison may be made with the description of simultaneous contrast in 3.1 above. When either of the sources is removed, the eye becomes adapted to the one remaining, and any difference in colour appearance disappears.

The colour-rendering qualities of a light source are usually measured by comparing a colour, illuminated by the source, to a standard source, which might be incandescent light or daylight; the observer must be adapted to the source. The better the colour-rendering qualities of a light, the lower its efficiency, this is inherent in the physics of light sources. Yellow is the point of highest visibility in the spectrum, and if the spectral curve of the light peaks at yellow, it will have the highest possible luminous efficiency, but it will be deficient in red and blue and will therefore have poor colour-rendering qualities.

Where several colours are involved, visibility depends on colour contrasts, as well as on brightness contrasts, and this requires a light source that has good colour-rendering qualities. If only black and white are involved, visibility is dependent on brightness contrasts alone, and visibility only requires an efficient source of light – colour-rendering qualities are not important. A light source that is strong in one spectral region will always tend to emphasise object colours of the corresponding hue. A source that is weak in any spectral region will tend to 'grey' objects of corresponding hue.

Significance

The colour-rendering qualities of light are significant in consumer applications because colour matching is important to most customers, and light sources in a store usually have different characteristics to those used in the home. Colour-rendering qualities may be important in productive environments where colour matching has to be carried out or where painted or plated surfaces have to be examined. The qualities are vital in any selling environment but have to be balanced against the appearance of customers; the subject requires very careful thought in any selling situation.

Good colour-rendering costs money, often between 30 and 100 per cent more than standard lighting, but the extra cost may be justified, depending on

the type of merchandise and the type of market. Two sources of light may appear the same but will give noticeably different renderings of a colour sample. On the other hand, a light with good colour-rendering qualities may make the customer look ghastly, and some compromise may be desirable.

In graphical applications the main significance lies in the fact that any display material has to be seen under many different types of light, some of which may have poor colour-rendering qualities.

3.4 Intensity of light

The relationship between the colour temperature and light levels has been mentioned in previous sections, and the reason for this relationship is that colour is seen differently when the eye is adapted to bright light (i.e. when there is a high overall level of illumination) and when the eye is adapted to dim light (i.e. a low overall level of illumination). The retina of the eye has different sensitivity at different light levels, and it follows that colours selected in a bright light cannot be expected to look the same when seen in a dim light.

The Electricity Council has defined high and low light levels as follows:

- Very low 150 lux
- Low 150–300 lux
- Medium 300–500 lux
- Moderately high 500–750 lux
- High 750–1000 lux
- Very high 1000–1500 lux

For comparison purposes, note the following:

- Bright sunlight may be 50 000–100 000 lux
- An overcast sky may be 5000 lux
- Good street lighting 20 lux
- Bright moonlight, about 0.5 lux
- A modern office 500 lux
- 1 metre from 100w lamp 100 lux

When the eye is adapted to high levels of brightness, colours will seem much sharper and tend to become yellowish. Cool light is satisfactory when the light level is high, surfaces will have a normal appearance. Under bright light space is readily defined, distances are easily determined, focus appears sound and three dimensional, fine details and colour variations are easily seen. Space expands under bright light but contracts under dim light. Matt surfaces look their best, and texture is seen in full detail.

This is not the case with dim light; when the eye is adapted to low levels of light a number of consequences ensue:

- Dark tones will blend together and be impossible to distinguish.
- All colours tend to be achromatic and to look more violet; they may look grey.
- Colours reflecting less than 20 per cent of light (about half of all colours) will tend to have a uniform brightness.

- Dark walls will not show up unless they are showered with light, and a room may have a drab and hollow look.
- Certain colours, such as red, may not be seen at all.
- Some colours, such as blue, are, however, seen more clearly.

A corollary of the above is that most colour values will only appear in their true identity at reasonably high light levels and not at low levels. If a dark colour such as navy blue is to be seen at its best, plenty of light is needed. A scale of grey values from white to black will appear to have normal steps when the light level is above 300 lux, but below this there will be a pronounced contraction of the steps. If an environment is designed to be seen in a soft light (i.e. low light levels), there is little point in using dark colours because the eye will not be able to distinguish them. If low levels of illumination are necessary, warm light sources are recommended and should be slightly tinted with pink, orange or yellow. Incandescent light fulfils these conditions, but it looks strongly tinted at high light levels, whereas light having a high colour temperature looks quite natural.

Significance

In consumer applications, intensity is a significant factor in interior decoration; the colours in a room should be related to the intensity of the light planned for that room. No colour with a reflectance value of less than 10 to 15 per cent should be used in a home, because the eye will not be able to perceive it clearly in the dim light of the average home. The point is often not appreciated when an article is purchased in a brightly lit shop, and it can be a cause of dissatisfaction.

Intensity is only significant in productive environments when colour matching or colour coding is carried out, but it is significant in selling environments for the reasons described above. The chief significance in graphical applications is the conditions under which a piece will be seen.

3.5 Coloured light

Coloured light has nothing to do with the colour appearance or the colour-rendering qualities of light and should not be confused with the tinted light mentioned in previous sections. It may be derived from artificially coloured lamps or created by means of filters and, in some situations, by means of lampshades. Lamps are normally available in red, green, blue and yellow, and the colours are apt to fade rather quickly.

Coloured light is used primarily in merchandising situations and is often used as the backing to a display in order to emphasise, by contrast, the predominant colours in the display or to enliven a selection of goods which have no colour interest of their own. It is hardly ever a good idea to direct coloured light on to products themselves, and even contrasting backing is better established by coloured surfaces, although this method is not so flexible. Coloured light is often encountered in interior decoration situations in both consumer applications and selling applications because lampshades are employed in colours which

distort the appearance of the light; certain colours should be avoided for lamp-shades.

Nor is coloured light recommended in any situation where it falls on people or on food. Light that is artificially coloured yellow is particularly difficult to handle because it makes people look ill and distorts the appearance of food; pink- or red-coloured light is more flattering, although it also distorts the appearance of food and its effect on nearby walls can be unpleasant. The effect of yellow street lighting on the appearance of people will be familiar to almost everybody.

Coloured light is often used to attract attention; splodges of coloured light will generate impact, but they are best not used indoors, where they may distort the appearance of merchandise. The use of coloured light for outdoor signs is well established and is primarily a means of attracting attention and ensuring maximum visibility for the message.

Significance

Coloured light has little significance in consumer applications or in productive environments but may be used in selling environments for display purposes as noted above. Coloured light is sometimes used in shops – for example, red light is used by butchers to improve the appearance of meat and green light is used to improve the appearance of vegetables – but this is not recommended.

It has little significance in graphical applications except where used as a background to display. In that event, the colours of point-of-sale material should be selected with care so that they are enhanced by the background.

3.6 Daylight

Daylight is, of course, a source of light, and for psychological reasons it is often considered to be a part of good environmental lighting, but it needs special care because it is not constant. Brightness and colour appearance vary throughout the day, and throughout the year, and it is not emotionally appealing at low levels. Too much sunlight may also be bad, at least for the eyes; although it is supposed to be good for the body, it is noteworthy that animals do not sunbathe.

Daylight varies in quantity, direction and colour appearance with the time of day, the time of year and the weather, and its quality varies from direct sunlight to completely diffused light. It cannot be controlled in the same way as artificial light, and therefore the artificial light levels of any environment, and the colour-rendering qualities of the light, do not match those provided by daylight. In addition, the colour tint of daylight varies with the time of day, from blue at dawn, to yellow in the middle of the day, to pink at sunset. Pure white is seldom encountered, and even in arctic regions daylight is almost always pink or orange (reflections from white snow are another matter); the human eye is not aware of this. However, daylight does have good colour-rendering qualities.

Workers in a productive environment generally demand that lighting installations should include daylight, partly for psychological reasons and partly

because the human organism has developed in response to a full spectrum of natural sunlight. For this reason, unbalanced sources of light can lead to biological disturbances, and the nearer that the composition of the light source is to natural daylight, the better for worker morale. Sunlight includes a proportion of ultraviolet rays, which have the effect of increasing energy and output and health.

Where the natural light is limited, it is desirable that the artificial light source should include a proportion of ultraviolet light; all white light is best avoided. Man feels differently on a sunny day, compared with a rainy or overcast day, and the body reacts differently. In schools sunshine may be a nuisance, in offices it may be a pleasure, and in hospitals nurses find it a nuisance, although bedridden patients love it.

Daylight is not free, it costs money to provide, and although it provides visual variety without extra charge, it requires a great deal of careful planning. The amount of daylight that will be received at any given point in a room depends on a number of factors; in some cases it is sufficient to consider only the illumination that comes directly from the sky, but for a really accurate estimate it is necessary to take into account light reflected from internal surfaces and from outside sources visible from the windows.

It is possible to predict the amount of daylight that will be available inside a building, at the design stage of the building, and also to forecast whether it will provide sufficient light for the work performed and therefore whether supplementary lighting will be required. The amount of reflected light in a room can be fairly easily calculated, and in designing a daylighting system both the windows and the interior decoration have to be included.

In a specific room, a window of given size will give a certain level of daylighting with light-coloured walls; darker walls will require a larger window. The use of dark colours in small rooms with small windows need not be restrictive if the average reflectance value of all the surfaces in the room can be kept high. For example, a wall in a strong, dark colour can be safely introduced if the dark colour is compensated by other walls and surfaces in lighter colours.

To avoid glare and ensure comfortable seeing conditions, some thought must be given to the design of the windows and their surrounds; if the latter have too low a reflectance value, there is a risk that the high brightness of the sky, seen through the window, will contrast too sharply with the low brightness of the surround and thereby produce acute discomfort glare. A light floor might help to avoid this and so may neutral-tinted glass. Another alternative is to use artificial light to bring the window wall to a sufficiently high level of luminance to provide acceptable contrasts with the sky. There are sophisticated lighting systems that deal with this sort of problem and they may be cost-effective in appropriate cases, but the problem is one for the architect and lighting engineer.

Some other points to be considered are:

- Ensure that workers do not face windows directly so that their eyes do not have to adapt to bright light every time they look up from work.
- Ensure that the level of illumination allows for fluctuating amounts of daylight. The eye can readily adapt to changes in the lighting level if there are comparable changes in the surround.

- Special care is necessary when daylight comes from above, for example from roof lights.
- Remember that daylight also includes heat rays; air-conditioning will not automatically cancel heat rays.
- Where room lighting depends wholly or partly on daylight, additional lighting may be necessary at night to counteract the effect of black windows.
- Reflected light from the wall opposite windows prevents shadows.

Daylight is not particularly good for a selling environment because of its varying quality. Artificial daylight is often used in selling environments to create good colour-matching conditions, and although this is supposed to be equivalent to a patch of north sky in January, it is not well liked from a human appearance point of view.

Significance

Daylight is only significant in consumer applications of colour in the sense that many products chosen in artificial daylight in shops and stores will be viewed in natural daylight at home, and the product appearance may be quite different unless precautions are taken.

Daylight is very important in productive environments and justifies careful management. The extent and quality of daylight will have considerable significance in the selection of colours for walls and other surfaces. There is less significance in selling environments and it is often recommended that daylight should be excluded altogether because of its varying quality.

It is only significant in graphical applications in that a piece of material may be seen both in daylight and in different types of artificial light.

3.7 Glare

Glare can be defined as excessive light relative to the brightness of the surroundings and to the state of adaptation of the eye at the time. Glare is a problem that affects both staff and customers or visitors in working environments and great care must be taken to avoid it. It not only causes discomfort but may prevent seeing at all; it tends to cause a blinding effect through irradiation, and the source of light often seems to be surrounded by a halo, which confuses and blinds.

It is very difficult to achieve good seeing conditions and an efficient environment without taking positive steps to eliminate glare, which is very harmful to the human eye however it arises. It has the same adverse effects as excessive brightness in the environment, but to a much greater degree and may be more difficult to eliminate. Consider the following examples:

- Striking a match in the dark causes glare because the eyes are dark-adapted and slow to readapt to sudden brightness.
- A small area of outdoor brightness seen from the far side of a darkened room can be glaring and more blinding than looking at a wide area of

brightness, the reason being that that the eye has difficulty in adapting to the former.

There are different types of glare, such as:

- disability glare, which makes it difficult to carry out the task in hand
- discomfort glare, which merely makes it uncomfortable to do so
- veiling glare, which is the hazing that follows multiple reflections
- adaptive glare, where the brightness presented to the eye is too great to be acceptable to the state of adaptation of the eye.

Discomfort glare can cause a strong sense of visual discomfort, especially when it is experienced over a long period. Some parts of the visual scene, such as windows by day or light fittings by night, may be too bright compared with the surroundings against which they are seen. This type of glare is insidious and its effects grow with time; it is a particular problem with static staff, such as cashiers or bartenders. It may also cause discomfort to customers sitting at a table.

Glare arises in three main ways:

- directly from the light source – direct glare
- by reflection from shiny surfaces in the field of view (shiny counters can be exceptionally troublesome) – indirect glare
- by excessive contrast between the light source, or its reflected image, and the surroundings – indirect glare.

Direct glare can be relatively easily cured by screening or repositioning the light source. An individual worker often suffers from glare because of the position of a light fitting, unless the whole of the lighting is adequately screened. Discomfort may be caused by fittings which are too bright in relation to other things within the field of view; this type of glare tends to grow on people, thus creating strain, but it can often be avoided by moving the fittings.

Reflected glare from polished surfaces is much more difficult to eliminate. Where there are many glossy surfaces, bright areas in the surroundings, as well as the light source itself, may be reflected as images. These images become distorted when the surfaces are curved or irregular, and this can cause confusion, which is particularly annoying when it is caused by polished working surfaces. The problem can often be solved by recolouring surfaces so that there is not so much contrast between them, or by adopting matt surfaces instead of glossy ones. The trouble arises because the eye makes itself less sensitive, and thus there is greater difficulty in seeing.

Discomfort may be found where the surroundings of a task are illuminated too strongly, especially if the background to the task is too dark. There may also be a glare situation if the surroundings are too bright in relation to the task, and in such cases a worker will be under continual strain. A similar situation may arise by reflection from surfaces near the task.

Many buildings have too much glass, and this causes glare, but the most common cause is excessive contrast between areas of high brightness and adjacent areas of lower brightness. The second most common cause is trying to increase the level of illumination without considering all the consequences. Actual disability may arise from a bright area or a source of light near the line of

sight, because the adaptation level of the eye is altered and there is a veil of scattered light which causes objects or surfaces of low contrast to become almost invisible or much less clearly seen. The eye is more sensitive to contrast as the level of brightness rises.

Significance

Glare has little significance in consumer applications or in graphical applications, but it is very important in environmental applications and should be eliminated as far as possible. Colour is a vital factor in controlling glare, and the avoidance of glare is one of the most important considerations when selecting colour for working environments. Changing the decoration of an area will often help to remove glare.

3.8 Lamp characteristics

The principal factors affecting choice of lamp for any particular situation are efficiency, size, heat production, colour appearance and colour-rendering qualities. The lamp should be economical in use and it should create the best possible effect in the situation in which it is fitted, but in many circumstances the effect on human appearance may be more important than any of the factors mentioned. It is seldom possible to obtain all the desired attributes in the same lamp and some compromise may be necessary. It is not practicable to provide a complete list of lamp characteristics, because the lighting industry is a dynamic one and constant changes are being made in the qualities of lamps and new types of lamp are frequently introduced. Anyone concerned with the selection of lamps should take the advice of a competent lighting engineer.

The principal features of the more commonly used sources of artificial light are summarised in the notes that follow.

Incandescent lamps

Include	Tungsten filament and tungsten halogen lamps, which have a continuous spectrum.
Colour appearance	Warm, emphasising warmer hues.
Colour rendering	Rich in red emission, deficient in blue, tend to make colours appear yellower.
Efficiency	Low, relatively short life.
Human appearance	Flattering.
Use	The most common form of lighting in the home. Seldom used in productive environments except for decorative purposes. Useful in selling environments to create sparkle and essential where light has to be controlled (e.g. spotlights).
Remarks	When the eye is adapted to incandescent light, reds will appear redder and blues stronger because the sensitivity of the eye adjusts to the weak blue emission. Provide more shadow and contrast than fluorescent lamps.

Fluorescent lamps

Include	Many different types and a wide range of colours and sizes each having different features and spectral distribution; new types are frequently introduced. The quality of the light can be changed by lamp designers adjusting the mix of phosphers.
Colour appearance	May be cool, intermediate or warm, and in each category there are standard lamps designed for high efficiency and reasonable colour rendering; or a de luxe lamp designed for reasonable efficiency and good colour rendering.
Colour rendering	Cool appearance tubes tend to emphasise blues at the expense of red and orange. Intermediate tubes have varying colour-rendering qualities but in general tend to emphasise green and yellow at the expense of blues and reds. The less-efficient lamps usually have the best colour-rendering qualities. Warm-appearance lamps tend to emphasise red and yellow at the expense of blue. Some types have improved colour-rendering qualities without loss of efficiency but tend to be expensive.
Efficiency	In general, fluorescent lamps have high efficiency, long life and uniform brightness.
Human appearance	Most types, except daylight lamps, are flattering to the human complexion.
Use	Fluorescent lamps tend to give diffused light, which is featureless, and for that reason they are generally used for overall lighting in productive and selling environments. Types specially designed for colour matching are available but require a light level of at least 300 lux.
Remarks	Daylight types only assume true colour rendition when the light level is high; at least 200 lux is recommended. Warm types are recommended for any application involving food.

Sodium lamps

Include	Two types – high pressure and low pressure – and the light is concentrated in the yellow part of the spectrum.
Colour appearance	Warm, emphasising warmer hues.
Colour rendering	Poor. High-pressure lamps have better quality, but the colour of the light is golden white. Reds appear brown under most sodium lighting, and most colours look yellow.
Efficiency	High efficiency, but at the expense of colour-rendering qualities.
Human appearance	Not flattering.
Use	Generally used for road lighting and industrial areas.
Remarks	Fluorescent inks and pigments for display purposes look particularly drab under sodium lighting.

Mercury lamps

Colour appearance	Intermediate.
Colour rendering	Most of the light is emitted in narrow wavebands of blue, green and yellow, and because of these narrow bands and the lack of red emission, mercury light tends to give unnatural colour renderings. Colour-improved mercury lamps provide a more balanced distribution and are similar to daylight fluorescent.
Efficiency	Not very efficient but have a long life.
Human appearance	Not flattering.
Use	Road lighting and industrial applications.
Remarks	Suffer from the disadvantage that they take a considerable time to reignite after a supply interruption.

Metal halide lamps

Include	A wide range of efficiencies and colour-rendering qualities.
Colour appearance	Intermediate.
Colour rendering	Reasonable but a little weak in reds.
Human appearance	Not flattering.
Efficiency	More efficient than mercury.

3.9 The effect of coloured light

The following colour analysis shows the effect of the colour appearance of light in various situations and also the effect of artificially coloured light sources. This analysis should be compared with the effect of light on colour in 4.5 in this part.

Colour analysis

Violet	Not recommended as an illuminant or for lampshades.
Blue	Blue-tinted light reduces acuity, the sensitivity of the retina is low and it does not flatter humans and therefore does not provide the most pleasing environment. Blue-coloured light causes objects to become blurred and surrounded by haloes and is not recommended as an illuminant or for lampshades.
Blue-green	As for blue.
Green	Any green-tinted or green-coloured light shining on the human complexion should be avoided at all costs. Best not used as an illuminant except in certain industrial applications but might be used for lampshades.
Yellow	Acuity is best in light which has a yellow quality because then the sensitivity of the eye is at its maximum but it may have poor colour rendering qualities. Best at low levels of illumination. Yellow-tinted light is pleasing to

the brain. Yellow is at the top of the list of desirable illuminants, followed by orange-yellow. Yellow-green provides good acuity but is not flattering to human appearance. Light that is artificially coloured yellow is difficult to handle because it tends to make people look ill. Acceptable for lampshades.

Orange Acuity is good in orange-tinted light, and it is best at low levels of illumination. Recommended as an illuminant and for lampshades. Particularly recommended for food.

Brown No special comments. Acceptable for lampshades.

Red The dark-adapted eye has best acuity under red light. Red-tinted light helps to create a flattering environment but red-coloured light may distort the appearance of food. Good illuminant and suitable for lampshades.

Pink Very flattering to humans. Recommended as an illuminant and for lampshades. Artificially coloured lamps may distort the appearance of food. Best at low levels of illumination.

White A white surface will always appear white as long as the eye can see. Recommended for lampshades. A preponderance of white is emotionally sterile, and all-white light should be avoided.

Off-white No special connotations but recommended for lampshades.

Grey Not suitable as an illuminant or for lampshades.

Black No special connotations.

Grey tints Some may be used for lampshades.

4 Light effects

4.1 Human appearance

Different light sources have an effect on the appearance of people, and flattering illumination may be more important than visual acuity in many situations, particularly selling environments. The colour appearance of the light (see 3.1 above) will have an effect on human appearance:

- Cool sources are most unflattering to the appearance.
- Intermediate sources are more or less neutral.
- Warm sources are flattering to the appearance and give it a ruddy glow.

In terms of tints, blue light is unflattering while red or pink are flattering. Green light shining on the human complexion is not only unflattering but makes it look ghastly. Candlelight, incandescent light and warm white fluorescent light are all flattering to the human complexion because they have a pinkish tinge, but daylight fluorescent is distinctly unflattering. Although daylight fluorescent enhances the appearance of blue and green, no one would light a room with blue light simply to enhance the appearance of a blue carpet; the effect would be awful. People generally prefer warm illumination, which also, incidentally, enhances red, orange and yellow.

No one tint of light is best under all conditions, and the level of lighting plays a part. At low levels of light, as in the normal home, people have a normal appearance under warm sources, and the effect of cool sources is most unflattering. As the light level increases from dim light to bright light, the colour quality of the light should also change if human appearance is to remain the same. There should be a shift in the colour appearance of the light from pink, to yellow, to white, to blue. The orange-pink of a candle is the most pleasing to human appearance and a pale blue light of the same intensity would create an unreal look, but at high brightness levels the same blue will have a totally normal and natural effect; the high brightness might not be emotionally pleasing but may be required for practical reasons. This is an innate response of the human body and reflects the fact that natural daylight is warm (and pinkish)

when the sun is rising and setting but white or blue in tone when the sun is directly overhead.

This subject is of great importance in any environment where it is necessary to match colours, for example in a shop selling womens' fashions. The light that is most flattering to the customer contains an excess of red and makes colour matching (e.g. of fabrics) very difficult. Proper appreciation of colours such as blue and magenta requires a cold light, and this is very uninviting to the customer. Some compromise may be necessary, and it may be better to flatter the customer instead of the things that she is buying. Warm light is virtually mandatory in cosmetics and fashions because of the customers' appearance; cooler light may give the product a more realistic appearance but makes the customer look unnatural.

Cool white fluorescent light gives accurate colour values to dresses, but if the customer tries them on in the same light, she will look pallid and the dress may be rejected. A solution to this problem may be warm general light for the benefit of the appearance of customers, but to specify cooler sources of colour-matching quality over merchandise where accurate colour discrimination is required. Even in food applications too much cool light would not be liked. In impulse merchandising the appearance of the customer is of secondary importance, and bright, cool light may be acceptable. The appearance of customers in a catering environment is equally important; a customer whose complexion looked greenish because of the effects of light would never enter the place again; sodium light would be particularly unfavourable. It is no accident that expensive restaurants encourage their customers to eat by candlelight.

Daylight fluorescent tubes are often used in working areas where good colour rendering is desirable, but they tend to be unflattering to the workers and some compromise may be desirable. The colour appearance of the lighting in any productive environment should be carefully thought out in terms of both worker appearance and the appearance of the products or material being worked on. The unflattering effect of daylight tubes will be less marked when light levels are high.

In general terms, illumination that is close to natural daylight is best not used unless accurate colour discrimination is necessary, because human complexions will tend to look greyish and sallow under its influence. Human memory of true complexion colours is substantially on the pinkish side, and most people prefer complexions that look redder than they actually are.

The effect of different types of lighting on adjacent areas also requires some consideration in this context and can best be illustrated by an example.

Example If a person moves from an area lighted by a de luxe warm white fluorescent tube to an area lighted by a cool white tube, the complexion will appear to turn sallow, the lips will look darker, and blue or green clothes will look yellowish. This effect can be disconcerting and is often unintended; it may be due to faulty tubes being replaced by new ones with different characteristics.

Significance

Warm-type lamps are generally used in the home because of their flattering effect, and most consumer products will look their best under this type of light. Colour selection for consumer products should be adjusted accordingly.

Both colour and light should be selected to flatter the appearance of workers in a productive environment, but both must be related to the colour of the material being worked.

Colour and light are particularly significant in selling environments as described above; both should be selected to improve the appearance of the customer but care taken to ensure that the colour of the products sold is not distorted.

Human appearance is not significant in graphical applications.

4.2 Food

The nature of the light source is particularly important to the display of food. Most foods look their best under a warm light, and this is especially the case with bakery products such as bread, rolls and the like. The relative shortage of red wavelengths in high-efficiency tubes may do less than justice to appetising browns, and excess yellow in the light may give many bakery products a cheap, synthetic, appearance.

The appearance of meat is equally important. General lighting with good colour rendering should bring out the surface interest of the meat and make it look fresh and attractive. Most of the light should be provided by fluorescent tubes with a colour-rendering quality close to that of filament lamps. De luxe natural fluorescent or filament lamps are often recommended to heighten the contrast between fat and lean. The use of red lamps or red filters is not recommended, because they exaggerate the colour of the lean unnaturally and make the fat look pinkish, thus reducing the contrast between the two. Light beams should be arranged to emphasise the surface texture, and similar remarks apply to bacon and to cheese.

Pies, cooked meats and similar articles also benefit from attention to light, particularly as they are often displayed in glass cabinets; lighting must be arranged so that specular reflection is not distracting. If meat is sliced, a high level of light is indicated over the slicing machine. Delicatessen are often an impulse buy, and more light of good quality will encourage people to examine more closely. Daylight-type lamps will enhance the appearance of vegetables, but too much cold light is not well liked; green filters are sometimes used but are not recommended because of the risk of the green light falling on people.

Food ready for the table should be lit as it would appear on the table and daylight lighting is not usually appropriate. Tungsten lighting and de luxe warm white tubes provide rather lower levels of illumination and an intimate, relaxed atmosphere is desirable. In places where food is served, such as canteens, light

with good colour-rendering qualities is prescribed, and care is necessary to see that the planned lighting does not become altered over a period through replacing the original tubes with others having different colour values. In one canteen it was noticed that users tended to congregate on one side of the room, and investigation disclosed that the lighting on the less popular side had become altered, with the result that the food looked most uninteresting; tomato soup looked grey.

Significance

The effect of light on the appearance of food has very little significance in consumer applications of colour, except in the kitchen, and even there most consumers are likely to use tungsten lighting.

The quality of light is very important in food-processing plants, and there are well-authenticated cases where workers have been adversely affected by seeing food in unsuitable light. The nature of the light is equally important in catering applications and in food-selling applications. This subject is of little importance in graphical applications, although the effect of light on the appearance of packaging and display material is, of course, significant.

4.3 Object appearance

The appearance of any coloured object or surface largely depends on the spectral distribution curve of the source of the light in which they are seen, that is on the relative strength of each wavelength of the spectrum that makes up the light.

The human eye sees white when all the receptors of the eye are stimulated equally, and white light consists of all the hues of the spectrum in roughly equal proportions. When there is more energy in one of the wavebands than in the others, the light is tinted with the spectral colour of maximum energy and the receptors change their sensitivity to compensate for the extra energy, with the result that the brain receives nearly equal nerve impulses and the light is seen as white. It follows that the colour of any object or surface seen will be slightly modified because the eyes have adapted themselves to the light source. An object of a given colour will therefore look slightly different under natural daylight, under incandescent light and under any other type of light, the difference being most marked with fluorescent light.

Pure white light is very seldom seen in practice, and daylight varies in content according to the time of day. Artificial light does not vary, but it does have a different spectral curve; incandescent light, for example, has a high red content, and the receptors change their sensitivity to compensate for the extra red. The same process occurs with any other type of light, according to its spectral composition. The effect remains so long as there is only one light source within the field of view. When an additional source, having a different curve, is intro-

duced or if another coloured object comes into the field of view, the eye has to change its sensitivity again, and the appearance of the original object will be slightly altered.

The practical result of all this is that an object of a given colour may look different when seen in different types of light and also when seen in close proximity to another hue. In the latter case it is the reflected light from the object which strikes the eye and causes it to change its sensitivity.

Significance

The principles described above are of significance in most applications but particularly in the merchandising of consumer products. An object selected under the fluorescent light of a shop will look quite different in the incandescent light of the home. It is also significant in graphical applications; a piece will look different under different types of light.

4.4 Merchandising

When displaying any merchandise its appearance should make the greatest possible contribution to promoting its sale, and this involves paying attention to light characteristics. No single solution is ideal, and the appearance of a coloured object not only varies according to the tint of the light (see 4.3 above) but also according to the light intensity. Where colour is a measure of the merit of a product, the light source which most nearly simulates the colour of natural daylight is ideal, and a minimum light level of 350 lux is required for satisfactory colour appraisal.

The basic problem is whether the merchandise is to be seen as it really is or whether it is to be seen as it will usually appear in use. For example, fabrics that have brighteners in their dyes will be vivid in natural daylight but quite drab in filament light, and such fabrics will usually be seen in filament light in the home. On the other hand, there is also the situation where goods must look attractive but exact colour rendering is not critical; in such cases de luxe natural lamps can be recommended. If colour rendering is critical, suitable lamps are available, but they tend to be unflattering to the customers and are less efficient.

The most efficient types of lamp provide bright and cheerful light at the lowest overall cost, but they also only suit certain types of merchandise, and the light has little sparkle. Incandescent light has more sparkle but does not render colours accurately, failing particularly with browns, blues and violets. A colour like African violet looks very dull under incandescent light but looks quite beautiful in daylight; a warm yellow also looks different in daylight.

Daylight types of lamp enhance the purity of blues and greens, but proper appreciation of blue and variations such as magenta require a very white light, but this looks generally cold and uninviting. Navy blue needs a great deal of

light to be seen properly, and even black needs plenty of light if it is to look really black. High-efficiency lamps are deficient in red and strong in yellow but can be recommended for the sale of white goods or goods without colour of their own. Filament lamps or warm white fluorescent tubes will add richness to red, orange and yellow but are deficient in blue. With fluorescent lamps, the better the colour-rendering quality of the light, the lower the light output, and it may be necessary to sacrifice colour quality on grounds of cost.

Ultraviolet light should, as far as possible, be excluded from merchandise lighting because it tends to fade colours.

Significance

The significance of the above needs no special comment except that great care is necessary when lighting merchandise for sale; each situation needs careful thought.

4.5 The effect of light on colour

In any situation involving colour selection, the effect of light on the appearance of object, or surface, colours should always be borne in mind together with the colour-rendering qualities of the light in which they will usually be seen and its effect on human appearance.

The following points are relevant:

- Always compare colour samples in artificial light as well as in daylight; they may look quite different. Colours which contrast pleasantly in daylight may look identical under some light sources.
- Select colours in the type of light in which they will normally be seen.
- Colours that are selected in a bright light will look different when seen in a dim light.
- Bright colours seen as samples on a paint chip will look much more intense when seen on a wall.
- Dark colours require plenty of light to be seen clearly.

The colour analysis below indicates some of the effects of light on individual hues.

Colour analysis

Violet Strong violets look dull under incandescent light but not in daylight.

Blue Most blues look best in daylight and may turn grey or blue-black in artificial light. The eye finds difficulty in focusing blue; it can be seen more clearly at low light levels, but a dark blue requires plenty of light to be seen

clearly. Darker blues tend to look dead in artificial light and are best used in small doses. The true colour of darker blues shows up best in artificial light if relieved with white. Blue is enhanced by daylight fluorescent light; proper appreciation needs a cool light.

Blue-green
Surfaces reflect more light than pure blue and look brightest in dim light.

Green
Enhanced by daylight fluorescent lamps.

Yellow
Yellow may appear overpowering at first sight in daylight, but the eye soon tires of it and it may then appear greyish. It tends to lose its identity in artificial light. It often has a strong greenish tinge under fluorescent light, and this can cause trouble in some graphical applications, particularly when associated with food.

Yellow and yellow-green are brightest in strong light. The eye can focus yellow perfectly without aberration. Yellow is enhanced by warm illumination but tends to look quite different in natural daylight.

Orange
Enhanced by warm illumination.

Brown
No special comments necessary.

Red
Brilliant red surfaces under strong illumination may cause restlessness, and the green after-image may create a sickening effect. Red surfaces tend to 'disappear' or look black under dim light. Red is enhanced by warm illumination, but proper appreciation of variations such as magenta requires a cool light.

Pink
No special comments necessary.

White
A white surface will always appear white so long as the eye can see.

Off-white
No special comments necessary.

Grey
Under normal light a grey scale will be seen in all its gradations, but in dim light the grey scale shortens from the bottom up; the eye can only see white and deep grey. As illumination grows dimmer, white will always be seen but middle and deep variations tend to blend together, particularly in the middle greys.

Black
Darkness is a positive factor in human perception, not a negative one; total darkness is grey in visual experience. A black surface looks blacker as the illumination is increased.

Grey tints
No special comment necessary.

5　About colour

5.1　What is colour?

Colour means different things to different people:

- To an artist it means pigments.
- To the psychologist it means perception which exists within the mind.
- To the physiologist it is a response of the nervous system.
- To the physicist it is an attribute of radiant energy.
- To the man in the street it is a property of objects or light sources.

While colour is all these things at one and the same time, the most important point to make is that there can be no colour without light. Light is radiant energy and part of the electromagnetic spectrum which consists of energy of various wavelengths and includes radio waves, cosmic rays, X-rays and others. A few of these wavelengths are visible to the naked eye and it is these visible wavelengths that we know as light.

If the visible portion of the spectrum, which we recognise as white light, is broken down by a prism or a rainbow, it divides into violet, blue, green, yellow, orange and red. These are usually called the *primary* colours and each primary colour is light energy of a specific wavelength. Red, at one end of the waveband, has the longest wavelength, and beyond it are the invisible infrared rays; violet at the other end has the shortest wavelength, and beyond it are the invisible X-rays. The spectrum can, in fact, be divided into 180 hues, but the eye simplifies what it sees and groups the hues together into bunches of the primary colours listed above.

A sensation of colour is produced when radiant energy (i.e. light) enters the eye, either directly or modified by some object which reflects it. The light entering the eye stimulates the receptors, and these, in turn, generate nerve impulses, which are transmitted to the brain and there converted into mental impressions. The normal human eye has three types of receptor each of which is responsive to the wavelengths of either red, blue or green. These are the *primary light* colours, and the sensation of colour is produced by a mixture of them. If all three types of receptor are stimulated equally, the brain sees white, but if one receptor is stimulated more than another, then the image interpreted by the brain appears to be tinted with the corresponding basic hue, and the

whole process is subject to endless variations.

If, for example, the light entering the eye is deficient in blue, the eye and the brain will tend to mix the stronger reds and greens together and the brain will 'see' yellow. If the light is deficient in green, blue and red will be mixed together to produce violet, while a deficiency in red will produce blue-green (turquoise or cyan). The exact hue seen depends on the relative strength of the primary light colours which enter the eye.

White light is a mixture of the various wavelengths of the visible spectrum, but not necessarily in equal proportions. North sky light is very high in blue energy; direct sunlight has much less blue; tungsten light is high in red energy; daylight fluorescent light is high in blue but deficient in red energy. It follows from this that coloured objects or surfaces which reflect light back look different under different types of lighting.

The central portion of each wavelength produces a pure colour, described as a hue, and this is the quality by which we distinguish one colour from another. The six primary colours can be supplemented by the addition of white, black and grey. White is a combination of all hues and, strictly speaking, black is an absence of light, but as already mentioned, black is in fact a positive sensation, not a negative one. The spectrum of the rainbow contains no black, nor any colour containing black, and in practice many blacks are very dark versions of other hues, such as blue. One textile manufacturer lists ninety-two different blacks, and many of these are very dark blues. Grey is halfway between white and black, and as colours fade into the distance they melt together and become grey. Great distance is grey.

White, black and pure hues are primary sensations, and when white and black are introduced into primary colours, secondary forms are produced. These are:

- White and pure colours produce tints.
- Black and pure colours produce shades.
- Black and white (grey) and pure colours produce tones.
- Black and white produce grey.

The primary light colours are described as additive primaries, and when all are combined in equal proportions white is produced; red and green produce yellow as described above and so on. The hues produced by the additive primaries are described as subtractive primaries and are significant in process colour.

Red, yellow, green and blue when combined in vision produce grey and are known as psychological primaries, although this term is seldom used. Coloured lights, when mixed together, are additive and produce a bright overlap; when pigments are mixed together they are subtractive and produce a dark overlap. Under bright light, and in highlight, colours tend to shift upwards towards yellow, for example red becomes more orange. Under dim light, colours tend to shift downwards, for example red becomes more purple.

There are a number of different types of colour:

- surface colours the colour of objects (see 5.2)
- film colours seen in the sky, fill space and have no substance
- volume colours colour that has three-dimensional boundaries.

Fog might be described as a film colour, but when an object is seen through fog the latter becomes a volume colour. Surface colours can be made to look like film colours by viewing them through a hole in a screen; a flat colour will then appear filmy.

5.2 Reflected colours

The process described in 5.1 above applies to light entering the eye directly from a light source – from daylight or from an artificial light source such as a lamp. Another kind of colour, and perhaps the most important in practical terms, is reflected colour. In the great majority of cases light does not travel directly to the eye, it travels via, or is reflected by, some object which modifies it. It is modified because the object reflects certain wavelengths and absorbs others or converts them into heat. Objects seen in white light appear to be tinted with the hue corresponding to the wavelength at which the object reflects the most energy.

The process is subtractive in nature; an object appears red because it subtracts from the light striking it everything except the red component. The quality of perceived light depends in part on the position of the object in the field of view because true object colours are often altered by light reflected from nearby coloured surfaces; this is particularly the case where the object has a glossy surface. The true colour may be altered by specular reflection from other objects, or from the light source.

In the simplest case, light striking white paper will be reflected more or less in full and will be seen as white, but where the light strikes black type, practically all the energy is absorbed by the black – no light is reflected by the type, and the type is seen as black. When a yellow object or surface is seen the object absorbs the blue component of the light and reflects red and green, which are mixed together in the seeing process and interpreted by the brain as yellow. A purple object will absorb green and reflect red and blue, seen by the brain as purple. A turquoise object absorbs red and reflects blue and green in the same way.

Objects or surfaces are perceived as having shape, texture, size or colour because of the way they modify the light that strikes them, and it follows that the light from a given source reflected into the eye from an object or surface will have quite different qualities compared with the light from the same source that is transmitted directly to the eye. In other words, the spectral distribution of the light leaving an object is different from that of the source. It also follows that the same object may look quite different under light sources which have different spectral qualities.

In addition, the appearance of the coloured object will depend on the interpretation that the brain places on what the eye sees. Colour is something more than a physical phenomenon and may be a perception that exists entirely in the mind. Colour is an interaction of eye and brain and may be produced in a number of different ways. For example, by refraction, by dispersion, by diffraction, by interference, by reflection and by polarisation of light rays, as well as by pigments and dyes. The blue of a flower may look like the blue of a feather or the blue of a child's eye, but in each case the colour is produced in a different

way. The physics of colour and the physiology of colour are quite different things.

The concept of colour is really determined by the quality of light reflected from the objects seen. Colour is only partially concerned with the objects observed, although it is concerned with the capacity of the surface of the object to reflect or absorb light.

Colour is determined:

- by the physical characteristics of the light source
- by the reflection characteristics of the surface of the object on which the light falls
- by the nature of the human eye
- by the interpretation that the brain puts on the retinal stimulation of the observer.

Whatever the primary source of light in an environment, the illumination of any given object in the environment will be compounded from the primary source together with light reflected from all other sources of the area. The spectral composition of the light in the area will vary from object to object depending on the proximity of other coloured objects or surfaces which act as secondary sources. The brain is able to perceive the essential reality.

Colour is subjective; the sensation of colour is within the human being and it cannot exist without an observer to receive the sensation; it only exists when the information received is processed in the consciousness of the observer.

5.3 Pigment colours

The principles set out in the two previous sections do not apply to the mixing of paints, pigments and printing inks. It is not possible to mix red, blue and green pigments together to produce white. The point is particularly important in colour printing, which depends on the *primary pigment colours*.

The principles that dictate what the eye will see when light enters the eye are reversed in the case of colour printing. The primary pigment colours – or, as they are more generally known, the process colours – are those constituents of white light which the eye and the brain produce by mixing, that is the subtractive primaries. The colour-printing process depends on the violet, blue-green and yellow sections of the spectrum, and these are generally described by the printer as magenta, cyan and yellow. The significance of these colours, and their importance in the printing process and in colour mixing, derives from the fact that each of them absorbs one of the primary light colours (blue, green, red) and reflects two others. Thus:

- Magenta absorbs green and reflects red and blue.
- Cyan absorbs red and reflects blue and green.
- Yellow absorbs blue and reflects red and green.
- Red, yellow and blue mixed together produce black.

In making colour separations for process printing it is necessary to prepare three plates. The original is first photographed with a filter which cuts out the

red wavelengths, and this produces the cyan plate, which prints the blue and green components of the original illustration. Filtering out the green wavelengths produces the magenta plate, which prints the red and blue components; filtering out the blue wavelengths produces the yellow plate, which produces the green and red components. These remarks apply to all printing techniques whether the material to be printed is paper, textiles, plastics or some other material, and the same basic principles apply to the mixing of paints and pigments.

The difference between colour printing, pigment mixing, on the one hand, and colour produced from direct or reflected light, on the other hand, is not always appreciated. Coloured lights when mixed together are additive and produce a bright overlap; this phenomenon is used to produce television colour. Pigments, when mixed together, are subtractive and produce a dark overlap.

Note: This is a very brief description of a complex subject, and those concerned with printing or pigment mixing are advised to study the subject in more detail.

5.4 Modifying colour

The perceived colour of any object or surface depends on reflected light, and the nature of the reflected light will vary with the characteristics of the light source as described earlier. In other words, the coloured object will look different under different kinds of light. For example, the appearance of the object under filament light will be different from its appearance under fluorescent light, and changing the light source is often the only means of controlling the colour of things.

In addition to the effect of different kinds of light, the image that is actually seen will depend on the interpretation that the brain places on what the eye transmits, and this interpretation depends on a number of factors which modify the reflected light, including:

- the state of adaptation of the eye
- what the observer has seen immediately before
- whether the observer has normal colour vision
- what the observer expects to see
- other colours in the field of view
- the amount of light received
- a change in reality
- light reflected from nearby objects
- the composition of surfaces
- the interpretation of the viewer.

Light from any given source is first modified when it strikes the coloured object, but the reflected light is further modified by a number of phenomena which affect the interpretation made by the eye and the brain. These modifying factors are defined in Section 6 in this part.

The modifying factors are physiological and psychological in nature, and

they have a considerable significance when colour is used in a practical way for interior decoration, for display and for print and packaging. They have less significance when selecting colours for products because the product colour selection process involves identifying colours that have maximum appeal to purchasers; it is only when the product colour has been selected and it is known where and under what conditions the product will be displayed or seen, that the modifying factors come into play.

These modifying factors are important in a number of different ways. For example:

- to the designer or interior decorator
- to the artist or stylist
- when selecting colour combinations
- when planning a display
- when designing promotional material or packaging
- when planning interior decor
- when tendering advice to customers or retailers.

6 Colour modifiers

6.1 Adaptation

The interpretation of colour may be affected by the state of adaptation of the eye at the time that an object is seen. The mechanics of adaptation are described in 1.4 above, and the part of the process that has an effect on the appearance of colour is the change in the sensitivity of the retina.

The retina has different sensitivities under different levels of illumination, and therefore colour is seen differently when the eye is adapted to bright light and when it is adapted to dim light. There is some difference of opinion as to why this occurs, but when the eye is fully adapted to bright light the spectrum appears to be brightest at yellow and yellow-green, and these colours have maximum impact.

When the eye is adapted to dark, and the pupil is nearly closed, the spectrum is brightest at blue-green, and red may fade away altogether. On the other hand, when the eye is under extreme dark adaptation the eye has its best acuity under red light, which is widely used for illuminating instrument panels in aircraft and so on. This is because red has little influence on the dark-adapted eye and is in fact more easily seen on the outer boundaries of the retina; hence the suitability as a blackout illuminant.

The phenomenon has practical significance in that visibility of a particular object (e.g. in a display) will depend on the conditions under which it is seen. A simple example is a tag which has to be seen in a dimly lit basement; in such cases avoid red. When the eye is dark-adapted, deep colours tend to melt together and to resemble each other. All colours having a reflectance value of less than 20 per cent (about half of all colours) will tend to have a uniform brightness and will look grey. When the eye is adapted to high light levels, colours will appear much sharper.

Significance

In consumer applications the adaptation of the eye is only significant in interior decoration; it is also significant in the decoration of productive and selling environments and in achieving good seeing conditions. In both selling applications and graphical applications it may be very significant depending on the kind of light in which a display or piece of printed material will be seen.

6.2 After-image

Colour perception may be affected by what the eye has seen immediately be-forehand. The light from any coloured object enters the eye and stimulates the receptors, which transmit nerve impulses to the brain, which then interprets them as colour. The colour of the object may be such that it stimulates one type of receptor a great deal more than it stimulates the other two. If the object is viewed for an appreciable period, the receptor having maximum stimulation quickly becomes tired and fails to work properly, although the image of the colour remains on the brain; if the eye is then transferred to another object or to white paper, there may be a momentary vision of the complement of the original colour. The same effect may occur when two receptor types are stimulated more than the third but may even occur when all three types of receptor are stimulated equally.

Example 1 If the viewer stares at a blue and green object for an appreciable period, say 10 seconds, and then transfers the gaze to a white sheet, there will be a momentary impression of red and purple. This is because the blue and green receptors have become tired and consequently the red receptors pick up a stronger image than would otherwise be the case, white being a mixture of all colours.

Snow blindness is a primary example of after-image. The eye becomes fatigued by white and seeks the complementary colour, black, and this remains until the tired eye is relieved.

The time taken by the eye to correct itself varies with the individual and with the conditions of seeing; the after-image is always the complement of the original colour:

- After looking at red there will be a sensation of green
- After looking at green there will be a sensation of red
- After looking at yellow there will be a sensation of blue
- After looking at blue there will be a sensation of yellow
- After looking at orange there will be a sensation of blue-green
- After looking at blue-green there will be a sensation of orange.

The effect of after-image may be particularly important in packaging and other promotional applications and is important to the designer or stylist when planning colour combinations. An otherwise effective colour may be quite spoilt because the after-image of another part of the design alters the visual character of the whole. Avoidance of after-images is especially important in food packaging because an after-image caused by faulty design can make an otherwise good pack look most unappetising.

However, after-images can also be used to good advantage. If perfect opposites are located beside each other, the after-image of one hue will enhance the other hue, always provided that the areas are of reasonable size. On the other hand, if the colours are confused, or visually blended, the two colours may cancel each other out. If the two colours concerned are not exact opposites, both may be slightly modified in aspect.

Example 2 If red and yellow are used alongside each other, the green after-image of the red will tend to give the yellow a lemon tinge, and the after-image of the yellow may tend to make the red look purplish. The precise effect will depend on the areas of colour, the positioning of the colour and on whether the eye is likely to rest longer on the red or on the yellow.

After-image may also be important when a task involves looking at one colour for long periods; in such cases it is desirable that the surround to the task should be painted to complement the task colour. Failure to take any remedial action may result in nausea, and visual acuity will be impaired.

Significance

After-image is important in interior decoration and may be significant in productive environments in avoiding adverse seeing conditions. It is particularly important in graphical applications, both in a positive and in a negative sense.

6.3 Colour blindness

The colours seen may be different if the viewer does not have normal colour vision. Human beings can see colour, and so can monkeys, but no other mammals have the same ability. Birds and insects see colour because it is essential to their food-gathering activities, and humans need to see colour in order to make sense of the world that they live in; it influences them all their lives, but there are some humans whose sense of colour is deficient.

Colour blindness is congenital and genetically transmitted through normal mothers to their sons as a general rule. It has been estimated that one man in every twenty-six is colour blind to some extent but only one woman in 286, and the degree of colour blindness varies with individuals. There is usually no loss of ability to see clearly and there is often an excellent sense of brightness, form and detail; sometimes there is superior vision under dim light.

There are three basic types of colour blindness, people affected being called deutons, protons and tritons, respectively. The deuton is the most common and has the so-called green blindness; green is confused with grey or purplish red; fawns and browns may be confused; so may grass greens and warm reds, and bluish green and purple. There is no confusion between yellow and blue. Protons have red blindness, this colour being confused with grey or bluish green. Red, brown, dull green and bluish green would all be confused and so would red-orange and grass green; Yellow, brown, grey and purple can be distinguished clearly. The most rare types are the tritons, who do not confuse red with green but who may confuse yellow, purple, grass green and blue. There are other types, and sometimes colour blindness is caused by disease and may be difficult to classify.

Significance

This condition has little practical importance in interior decoration or in promotional applications of colour, but it is often important in commercial and

industrial applications where colour is used for coding, identification or safety purposes. It sometimes accounts for what, to normally sighted people, seem bizarre colour combinations.

6.4 Colour constancy

Colour interpretation may be affected by what the observer expects to see. The eye and the brain have an ability to 'remember' colour and to see the same colour qualities under widely different conditions of light. This ability is known as colour constancy and applies with most force to those colours that are familiar and which are seen most frequently under normal conditions of light, for example human complexions, foodstuffs and similar items. The colour rendering of familiar objects is accepted as natural when lit by daylight or incandescent light because humans have learnt to remember them. The colours may not be identical but they will look natural.

Many of the object colours in an environment (e.g. colours of walls) are noticed without particular regard to their perceived appearance and any aberration may not be noticed. Other object colours might be termed memory colours because they are related to the experience of the observer and often associated with physical well-being. Typical examples are human complexions, foodstuffs, natural materials, flowers and familiar trade-marks. Changes in this type of perceived colour may be disturbing because the changes are not what the observer wants to see. Neural processes require physical facts.

A white surface will always be identified by the brain as white whether it is seen in full daylight or in the dim recesses of a cellar. In the human eye there is no such thing as overexposure or underexposure. A photograph of a white barn would look grey if too little light reached the film but to the eye the barn would always be white. Similarly, if a white surface is showered with red light, the eye will still see the surface as white, but a camera would pick up the red light and see the surface as red.

The same principle applies to other colours but only at normal light levels. In a dim light darker colours appear black and the eye is unable to distinguish them, and when the eye is fully dark-adapted, colour disappears entirely. The dark colours – those of low reflectance value – do not reflect sufficient light to motivate the receptors of the eye; the lower the level of light, the higher the reflectance values have to be to give any impression of colour at all (see also 3.4 above, on light intensity).

Colour values will appear in their true identity only at fairly high levels of light intensity, and without bright light, dark colours are meaningless. A black surface needs plenty of light in order to appear black; the more light that shines on it, the blacker it will become. It follows that colours selected in a dim light will look different in a bright light. These rules apply whatever the spectral quality of the light source, provided that the object is seen under one light source and in a normal environment. If the same object is seen under another light source with a different spectral curve, the colour will look different, but the brain will tend to identify it as normally seen, at any rate in the case of familiar objects. If the object is unfamiliar, the brain will not be able to remem-

ber what it looked like previously, and this can lead to some confusion when colours are selected in one light for use in another. Colours used in interior decoration, for example, are unlikely to be 'remembered', and it is important, therefore, that selection should be made in light conditions which are as near as possible to those in which the object will be viewed.

Where there are two different light sources within the field of view, the eye and the brain will be confused because the object will look different according to whichever light source it is viewed under.

Significance

Colour constancy is significant in interior decoration, particularly if colours are selected in full daylight for an interior designed for evening conditions and having a dim light. All dark colours will tend to melt together, and dark walls will look drab.

Colour constancy is also significant in graphical applications. If a manufacturer can establish a corporate colour or a brand colour (e.g. for packaging) the colour will tend to become 'fixed' in the minds of the public; they will 'remember' it and see it as the brand colour whatever the quality of the lighting. For this reason it is very important to control colours of this nature within close limits.

6.5 Contrast

The appearance of colour may be modified by other colours within the field of view whether these are object or background colours. A perceived colour may be modified when it is put beside or on its opposite on the colour circle or, in more formal terms, when it is contrasted with its complement. Contrast may be achieved as part of a design or pattern, or it may be used to enhance the appearance of a colour by placing objects or surfaces in an appropriate position.

Contrasts are most noticeable when the two colours are similar in value; red on green, orange on green, blue on violet will dramatically influence each other, but the influence will be much less with yellow on violet because the values are different – yellow is bright and violet is dark. Yellow will, however, look lighter on black than it does on white.

Where perfect opposites are used next to each other, the after-image of one will enhance the appearance of the other and helps to attract attention and improve visibility and readability. If two opposites such as red and green are put next to each other, the result is naturally exciting and creates attention. In fact, when red and green are seen together they tend to dazzle because the eye cannot focus them clearly together; yellow and violet, on the other hand, do not dazzle. The perfect example of the use of contrast to achieve better visibility is black print on white paper; this has maximum readability.

Contrast does not necessarily only involve complements. If the observer views two stripes of different tones of the same colour, or two stripes of the same tones of different colours, placed side by side, the eye perceives certain modifications which influence the intensity of the colour and its optical composition. Where colours of different values are placed side by side, there may be a

fluted effect; where the different tones come together, edges will tend to be modified in contrary ways. If colours are confused through head movement and if the stripes are so close that they tend to merge into each other, any optical mixture or overlapping tends to heighten saturation and create a shimmer, but to obtain this colours must be analogous. If pure hues or rich pastels are shaded towards slightly deeper greys or neutrals, luminous effects follow. True highlights are not tints of the base colour but have increased saturation.

Apart from the contrast between hues, there can also be contrast between light and dark, and this is particularly useful in interior decoration. Light colour will tend to accentuate the depth of dark colours, and dark colours will tend to accentuate the brightness of light colours; a bright background will add depth to a deep colour. A grey area, for example, will appear relatively light on a deep ground and relatively dark on a light ground.

In general terms, a colour having a low reflectance value will be accentuated by a colour having a high reflectance value, although the reverse may also be true, depending on the proportions of colour. Where black and white tasks are involved, visibility is dependent on brightness contrasts, which can be enhanced by the use of a high-efficiency light source. The visibility of objects or tasks involving several colours is dependent not only on brightness contrasts but also on colour contrast. Contrast may also have a negative effect; contrasting colours may detract from the appearance desired. Brightness contrasts tend to inhibit hue contrasts.

Significance

Contrasts are particularly useful in interior decoration, especially when dealing with large areas; the effect may be lost in smaller areas, although the use of contrasts to provide accents is well established. They are also useful in productive environments as a means of improving the visibility of tasks.

Contrasts are particularly useful in graphical applications, especially packaging. A package should stand out from its environment and have maximum contrast with its surroundings, and contrasts may also be useful in improving the design on the package. The principal feature of a design should have maximum contrast with its surround, and in many cases the principal feature will have a low reflectance value which can be accentuated by a high reflectance value in the surround.

6.6 Glare

A colour may be partly obscured by glare, particularly that arising from specular reflections. Glare tends to modify colour because it affects the adaptation of the eye. The automatic reaction of the eye is to narrow the pupillary opening in bright light or glare, and consequently the eye is unable to see clearly. The nature and causes of glare are discussed in 3.7 above.

Significance

Glare is significant in all applications.

6.7 Illusion

The appearance of a colour or an object may be altered by changing reality to an extent that people see things that are not there. Although most people associate colour with visual reality, various effects can be used to change reality by optical illusion. That these are possible is often due to people having preconceived ideas; a tall container appears to hold more because height is associated with volume. However, the physiological responses of the eye also create illusion; hard colours make an object look larger by virtue of the effect that hard colours have on the process of vision.

In practical terms, an illusion means modifying the appearance of a colour by the way that other colours are placed in relation to it. While an illusion of this nature is partly due to the effect of colour vision, it also requires the skill of the artist or designer to give it full value. The following are some typical examples:

- A circle coloured black or grey will appear smaller than a circle of equal size in a bright colour. If the latter is placed against a dark background, it will seem even larger.
- Break the circumference of a circle and the line will become more important than the middle of the circle.
- A few curved lines will make a circle look oval.
- Put a design inside a circle and the latter loses its identity, it becomes a frame.
- Against different backgrounds an identical colour often appears to be quite different; the effect varies with the hues and values concerned.
- When complementary or near complementary colours are placed in close relationship to each other they produce visual vibrations which are effective in attracting attention, but such vibrations may be quite disturbing if caused accidentally.
- Vibrations caused by two complementary colours can be eliminated by mixing one colour with the other.
- Colour can be used to indicate the abstract by employing brilliant hues.
- A line of white type, placed against a pure colour, seems to advance and adds an illusion of depth which strengthens impact; the impact is greater if the line of white is contrasted with a line of black. The same principle can be used in many different ways.
- Overprinting one colour with another may produce a third which is related to both, but different from them.
- An ambiguous image assumes different meanings when different colours are applied to it. Change the colour, change the mood. This effect is primarily of interest in connection with printed material.
- Discords are exciting and can often be seen in nature.
- Some colours flicker when seen together, provided they are the same strength. This effect is used in industry but not in interior decoration. The most effective combinations are red and blue, cyan and orange, yellowish red and greyish blue, red and green.

There are, of course, many other illusions which will be familiar to the artist or skilled designer.

Significance

Illusion is significant in relation to the design of products and graphics and also in interior decoration.

6.8 Juxtaposition

Colour appearance may be affected by light reflected from a nearby coloured object or surface.

By definition, light reflected into the eye from a coloured object is modified by the colour of that object and thus the eye and the brain perceive the colour of the object. The perceived colour is, however, also modified by light reflected from other, adjacent objects within the same field of view. Light of a given spectral distribution, reflected from a coloured object will stimulate the receptors of the eye in a certain way, but if the receptors are simultaneously stimulated by light reflected from another (or more than one) coloured object, the state of adaptation of the eye will be altered and the perceived colour will be slightly different to that which would be seen if each object were viewed separately. This applies where both objects are coloured or one of them is black, white or grey.

The effect is exactly the same when light is reflected from surfaces rather than objects, as in print or packaging, and the reason is that each colour seen loses something of the other colours within the field of view and is modified accordingly. The appearance of each colour inclines towards its adjacent (on the colour circle), which is furthest away from the colour with which it is in combination. Thus, if orange and green are seen together, the orange would incline to red and the green would incline to blue. Red seems more intense when green dominates. These effects are optical in nature and do not apply to pigments, nor do they apply in the printing process where transparent inks are employed; these are subtractive in nature, and when red dots overlap yellow dots, orange results.

If the primary print colours – red, yellow and blue – are brought together, the results are as follows:

- If red and yellow are seen together, the red will incline towards violet and the yellow will incline to green. This is because the red loses something of its yellow and appears bluer, while the yellow loses something of its red and becomes greener.
- If yellow and blue are seen together, the yellow inclines towards orange because it has lost something of its blue and appears redder. The blue loses something of its yellow, appears redder and inclines to purple.
- If blue and red are seen together, the blue will lose red and incline to green, while the red will lose blue and incline to orange.

When intermediate hues are seen in close proximity to either of the primary hues of which they are composed, the intermediate hue will tend to incline away from the primary hue. Thus blue-green inclines to blue when seen in close proximity to green and inclines to green when seen in close proximity to blue.

Similar modifications take place when there is a difference in brightness between two objects or surfaces, or when one of them is black or white. This can be stated in the following rule:

- A colour looks lighter on a dark ground and darker on a light ground.

When grey is seen in close proximity to other colours, the following rule applies:

- A colour looks intense when seen against a greyed ground and greyer when seen against an intense ground.

The following effects typically appear when grey is used with

- violet grey appears yellowish, the violet more intense
- blue grey inclines to orange, the blue is more intense and often greener
- green grey inclines to red, the green becomes more intense and usually yellower
- yellow grey inclines to violet, the yellow becomes more intense and less green
- orange grey appears blue, the orange purer and more yellow
- red grey appears greenish, the red purer.

In a similar way, if red is put near

- blue red seems yellower
- green red seems purer and brighter
- yellow red seems bluer
- white red becomes lighter and brighter
- grey red seems brighter
- black red seems darker and duller.

These effects are worth bearing in mind in any interior decoration application. In practice, few colours are seen in complete isolation, and the effect of other colours should be studied and used to advantage in appropriate cases. The effects are particularly important in commercial and industrial applications, and especially where good colour rendering or accurate colour definition is required. The effect of juxtaposition is most important in display and packaging applications. The colour of the surround or background should be carefully chosen so that there is no undue emphasis on any part of the spectrum; the background should be carefully related to the feature colour.

Significance

Juxtaposition is significant in product design, in interior decoration and in most graphical applications. It is also significant in display and merchandising but has comparatively little significance in productive environments, except where colour rendering is important.

6.9 Metamerism

The appearance of colour is affected by the chemical composition of the surface.

The simple meaning of metamerism is that it is impossible to colour match two objects or surfaces which have a different chemical composition, and this applies whether it is the objects themselves that are dissimilar or whether the pigments or dyes used on similar objects have a different composition. The light reflected by the object or surface is modified because different chemical structures react differently to light. In some cases objects which appear to match each other in one light will not match in another light having a different spectral composition.

Metamerism causes a number of difficulties in practice. In the first place it can lead to frustration on the part of the consumer who is unable to match dissimilar materials such as plastics and textiles; or the consumer might match two fabrics in the shop and find that they do not match in the different light of the home. Many consumers are very keen about having everything matching, and it is often difficult to try to convince them that matching is a scientific impossibility. There is no real answer to this problem except to point out the difficulty and to suggest that harmony often gives more pleasing results than matching.

In the second place, the manufacturer has a practical production problem in matching output to a standard sample. For example, printing inks will look different if they are printed on to different types of paper; it may be necessary to change the formulation of the ink if the paper is changed during a run. In the same way, if the composition of the ink is changed during a run, the resulting output will not match the sample. Similar problems arise with fabrics, plastics formulations and in other directions.

Matching is a particularly difficult problem to solve because no two people see in exactly the same way and will seldom agree on a colour match. Even to the same eye, colours that match in one light will not match in another. Under normal production conditions it is usual to match output to a standard sample, but correct matching requires a standard light, a standard eye and a standard method of observation; these conditions are not easy to achieve except by using instruments. Subjective matchings, which may be sufficient for most practical purposes, can be achieved by using a colorimeter which measures the transmitted or reflected light as it appears to the viewer and approximates to an individual's own response to colour. Comparison with a standard sample depends on the intensity of the illumination, the angle of illumination, the size and shape of the colour area, the texture of the surface and the physical condition of the viewer because the eyes become tired after long exposure to one colour; the process may also be very time-consuming.

Where colour matching is particularly important it is advisable to use a spectrophotometer, which measures the light as a function of the dye or pigment which accounts for the colour of the object. The instrument fingerprints the sample by pinpointing its colouration in terms of the light energy that it absorbs. The theory is that any colour that the eye can see can be defined in terms of a combination of the three primary light colours.

The proportions of these primaries that need to be mixed to match a given colour are called the x, y and z values of the colour, or the tri-stimulus values. To measure the values correctly is to measure the colour itself, but it is not sufficient to measure the colour of the dye, pigment or paint, it must be measured in relation to the base material. Thus, if pigments having the same tri-stimulus values are applied to materials having different compositions (e.g. coated or uncoated paper), the completed articles will not look identical and will not have identical readings.

Spectrophotometric measurement is based on the principle that chemicals vary in their ability to absorb light and, in fact, the instrument may be used to identify the structure of the material in appropriate cases. If two materials can be made to give the same reading, perhaps by adjusting the pigments, the finished article will look the same under all conditions of light. Objects having the same spectrophotometric curve will match perfectly under all conditions. Thus it is possible to measure samples or swatches and compare them with a permanent numerical standard. This provides an absolute reference against which all subsequent measurements can be checked.

Significance

Metamerism is significant in consumer applications in situations where matching is important. It is also significant in similar situations in productive applications and in selling applications. It is particularly significant in graphical applications where printing is involved.

6.10 Perception

The image may be affected by the interpretation that the viewer places on it. Colour is more than a purely physical phenomenon, it is also an interpretation of the eye and the brain that has little to do with physics or chemistry. In other words, colour may be a perception that exists entirely in the mind because colour may be produced in a number of different ways, including refraction, dispersion, diffraction, interference or polarisation of light waves rather than by pigments or dyes which absorb and reflect light waves in a different way.

This may be illustrated by observing a rainbow, the lustre of an opal, a drop of oil on water, iridescence in a peacock's feathers or the wing of a butterfly. In each case colour is produced in a different way; many colours found in birds, such as the blue jay, are formed by small air bubbles in the horny mass of feathers. While the blue of a flower or the blue of a child's eye may look the same, the colour of the feather is produced in a different way. Rays of sunlight may be scattered by suspended particles or split apart from their component hues as they pass through screens like a crystalline surface or thin film. Lustre is largely psychological in nature; silk is lustrous even in shadow, but cotton is not, even in full sunlight.

The physics of colour and the psychology of colour are quite independent, and human beings experience many interpretations of colour. A given colour, say red, may be filmy and atmospheric like a red sky at sunset, it may have volume like a glass of red wine, it may be transparent like a sheet of cellophane,

it may be luminous like the stop light on a car or a lantern, it may be dull like a piece of suede, it may be lustrous like a piece of silk, it may be metallic like a Christmas tree ornament, it may be iridescent like the gleam of an opal. In each case the red will have a different appearance, but it is quite conceivable that all the reds can be made to match each other and would be identical so far as instrument measurements and physics are concerned. Highlights appear to be opaque; shadows appear transparent; conjoined shadows seem to melt into an object; cast shadows seem to cover a surface like a transparent membrane.

The importance of interpretation can be tested by placing a square of smooth coloured paper on a table or desk. The colour will appear flat and definitely localised, but if a black card with a small opening in its centre is held several inches from the eye, and the paper is viewed through the hole, the colour lying on the desk will appear more filmy and will be seen to fill the space between the card and the desk.

Perception is particularly important when working out colour harmonies; for example, when trying to decide what harmonises with the reds described above, it is all important to consider what types of red are involved. Will a red surface colour have the same appeal as a red film colour, a red volume colour, a transparent red, a luminous red, a dull red, a lustrous red, a metallic red or an iridescent red? There is no real answer to this problem: it is the realm of the artist and conventional rules are quite academic; the artist can reproduce all these effects but may break formal rules in doing so.

As explained under the heading of colour constancy (see 6.4 above), the way in which human beings see the colour of an object or surface may be quite independent of the intensity or wavelength of the light that falls on the surface. It is possible to shower a black surface with intense light so that it is actually brighter than some white surfaces, but the black will still appear to be black to the viewer. Thus it will be seen that reflected light is modified in a physical way, but it is also necessary to take into account what the mind will make of what the eye sees.

The difference between white, grey and black is not one that concerns light intensity alone; it also concerns visual interpretation. Identical colours, reflecting an identical intensity of light, may have a different appearance, and different material may match from a physical standpoint but will appear different. Black in physical terms is negative, but in human situations it is positive.

Significance

Perception is significant in interior decoration, in decoration generally and in graphical applications.

7 Reactions to colour

7.1 Overall reaction

It will be noted from previous Sections that when light enters the eye, either directly or reflected from some object, it generates nerve impulses which are transmitted to the brain and there converted into mental impressions by a process in which the brain interprets the impulses by comparing them with previous experience, heredity, tradition and other factors which are stored up in the mind. What the brain does with the message received results in the impression ultimately made on the mind.

Colour, being light, is interpreted by the brain in exactly the same way, the mental impression registered by the brain depending on the conditions under which the eye receives the image, and this impression has a significant effect on the mind and on the senses. The singularity of colour is that it imposes itself on the eye and the brain and the senses, and triggers off reactions which are both physiological and psychological in nature. Colour is both physically and psychologically a vital part of the life of human beings, but it motivates people in a way that is largely subconscious and it is difficult to say where physical, visual processes end and mental processes begin.

The physiological reactions include sensitivity to brightness and dimness, to lightness and darkness, and to warmth and coolness of colour; these may be described as the physical, visual reactions, although the interpretation made by the brain may be psychological in nature. Psychological reactions may be described as the way in which colour affects the mind and the emotions and are partly the result of the physical reactions already described. However, there are also a number of other reactions of a psychological nature which are less a matter of physical reaction than of interpretation, experience, association and perception. Colour does not only involve the retina, it involves the body as a totality. Many reactions to colour depend on the interpretation of a sensation by the brain.

Example 1 Red may appear filmy and atmospheric like a sky at sunset or it may have volume like a glass of wine. In each case the colours match each other in a physical sense but the mind of the observer interprets the message differently.

7.2 Brightness and dimness

Before there can be colour there must be light, and the human organism shows a marked reaction to the presence or absence of light, which affects the eye, the brain and the whole body. While the eye is largely indifferent to light intensity, brightness of light stimulates the nervous system of the body, and dimness of light has the reverse effect. Plant life thrives on visible light; it thrives best under strong light and dies away if light is removed. Growth is also inhibited by invisible infrared and ultraviolet light.

The process of photosynthesis is directly related to visible light, and animal life which feeds on plants (including humans) is responsive to visible light in the same way. Some authorities believe that the visible light of the sun acts directly on the superficial layers of the skin and has a definite metabolic effect, but visible light certainly has effects through the eye, and man feels differently on a sunny day when there is maximum light, compared with a rainy day when there may be little light; the reaction is both physical and mental.

Almost all living things orientate themselves towards light and particularly towards bright light; as the energy of stimulation goes up, the response tendency of the organism goes with it. The reverse of this process is illustrated by the simple daisy on the lawn, which closes up when the sun goes in. In human terms, strong light, or high brightness of light, conditions the organism for vigorous muscular activity but may hinder mental tasks. Under certain conditions an attempt to increase light levels so that fine detail can be seen can disturb the human organism to such an extent that concentration becomes impossible. A high degree of brightness demands attention, consumes bodily energy and stimulates the nervous system to such an extent that energy is directed away from the task to the environment itself, and if this happens, seeing and concentration become difficult.

Light creates a centrifugal action away from the organism towards the environment, and the stronger the light, the more the body tends to direct its attention outwards. With lower levels of brightness there is a centripetal action away from the environment and towards the organism, there is less distraction and the individual is better able to concentrate on difficult visual and mental tasks.

Example 2 When the light is too bright people tend to close their eyes when trying to solve a difficult problem; they try to shut out the environment completely.

7.3 Lightness and darkness

Lightness and darkness of colour affects the human organism in the same way as brightness and dimness of light. 'Brightness' is a term usually applied to the quantity or intensity of light, while 'lightness', or 'value', are the terms applied to colour, although all mean roughly the same thing. Value is the quality by which a light colour is distinguished from a dark colour; pink is a high-value (or light) red, maroon is a low-value (or dark) red. The amount of brightness pro-

duced by light colours depends partly on the amount, or intensity, of light falling on a coloured surface or object but mainly on the percentage of that light that is reflected back by the coloured object or surface; this depends on the value of the colour.

In addition to the effect of lightness and darkness on the total human organism, light and dark colours also affect the mechanism of the eye. The lighter the colour, the greater the effect because the brightness produced by the colour of high value (light colour) tends to spread out on the retina like water on blotting paper; this has the effect of making light colours look nearer and larger; consequently they attract more attention and have more impact.

Colours that have maximum brightness command attention whether a person likes them or not; the brightness of colour, like brightness of light, tends to increase muscular tension and excitement. Dimness of colour, or dark colours, have the reverse effect.

Example 3 Anyone who has experienced sudden brightness, for example a bright light on a dark night, will be aware that the effect is to increase tension.

In general terms:

- Light colours stimulate to a greater extent than dark ones.
- Light colours increase size, dark colours decrease it.
- Light colours make an object look lighter in weight; dark colours make the object look heavier.
- Light colours (and especially pastels) are generally preferred to dark colours because of their greater brightness.
- Light colours on objects or surfaces reflect heat; dark objects or surfaces absorb heat.
- Pure colours stimulate the eye and the brain to a greater extent than greyish ones, which are subduing.
- Pure colours have more impact than mixtures of primary hues.

7.4 Warmth and coolness

The reaction to brightness and darkness is a physiological reaction, but it is a reaction to light and not to the wavelength of light; in other words, the reaction takes place as the result of brightness and irrespective of hue. However, further reactions are caused by hues of different wavelengths, and to understand this it is convenient to divide the primary hues into two categories which have considerable significance in the whole area of colour usage. These are:

Warm colours Red, orange, yellow. The pure versions of these are generally of high value. They are also called hard colours.

Cool colours Blue, green, violet. The pure versions of these are generally of low value. They are also called soft colours.

The significance of warm and cool colours is that they are focused differently by the eye because of their wavelengths. The warm colours focus at a point behind the retina of the eye, and to see them more clearly the lens of the eye grows convex, pulling the image forward and making it look nearer and larger. Although this is a reaction to wavelengths rather than to light and dark, the two go together. Thus a bright red will have an effect on the focus of the eye as well as spreading out on the retina as described in the previous section.

Cool colours have the reverse effect and focus at a point in front of the retina causing the lens to flatten out, push the image back and decrease the size. Cool colours are more difficult to focus and often appear blurred.

Warm and cool colours have a further significance in that human beings also have a radiation sense and the human organism is sensitive to the different wavelengths in addition to the physical reaction already noted. Some researchers claim that warm and cool colours accentuate or retard the release of chemicals from nerve endings, and this may have an exhilarating or sedative action. Thus the response to colour is not solely in the eyes, and this explains why blind people are often more sensitive to colour than sighted people; the blind are able to feel the vibrations. Workers with the blind report that people who have been blind from birth have an extraordinary gift of being able to 'feel' colour. Blind girls have a very good colour sense and they are able to identify the colour of a face powder by rubbing it between their fingers. Men blinded in the war developed a gift of 'seeing' colour with their finger tips and could tell the colour of a girl's hair by feeling it. There are reports that blind people feel yellow to be warm and soft like sunshine; blue to be like cold water; brown to be hard like the bark of a tree; green to be like grass or leaves; and red to be warm like fire.

The effects of this sensitivity to radiation tend to be towards red on the one hand and towards blue on the other; red has an exciting effect and blue has a subduing effect. These reactions are automatic whether a person is conscious of them or not, and the two colours induce different levels of activation both in the autonomic nervous system and in the brain. Exposure to red and the other warm colours increases bodily temperature and, when combined with brightness, bring the human body 'to attention' and directs activity outwards; there will be an increase in blood pressure and other physical responses. Exposure to blue and other cool colours decreases bodily temperature and causes the autonomic processes of the body to slow down.

Because of these reactions the human race can experience warmth and coolness independently of skin temperature. The effect is most marked with red and blue, yellow and green tending to be more neutral. The equilibrium of the body is better maintained under the influence of blue than under the influence of red, which is more exciting. Red has a stimulating effect on sexual activity and it has even been suggested that humans who desire a male heir would be well advised to have a pink bedroom! (Bright light may also stimulate sexual activity.) It has been found that a lecture appears to last longer and to be more boring in a blue room than in a red room.

7.5 Hardness and softness

Warm colours are also called hard colours because they are much more easily focused by the eye and are hard and angular in perception. Cool colours are described as soft because they are not easily focused by the eye and often appear blurred and soft in outline. The terms 'hard' and 'soft' are more often used in practical colour work.

The validity of the reactions outlined in the previous sections can be established by exposing the human body to coloured light. There is a general light tonus in the muscular reactions of the body, and these are most active with hard colours. When light is directed at one eye a tonus condition is produced in the corresponding half of the body, and this acts on the whole body and not only on the muscles; the arm on the side of the light will deviate towards the source of illumination. If the face and neck are exposed to red light from the front, the arms will tend to spread away from the side and from each other, but when the face and neck are illuminated from the side the arms will deviate towards the light if it is red, and away from the light if it is blue. The same reactions occur if the subject is blindfolded and also when the light is reflected rather than direct.

Coloured light affects functions of the autonomic nervous system as well as causing emotional and aesthetic reactions. For example:

- Blood pressure is increased under red light and decreased under blue.
- Palmar inductance is increased by both colours, but it is higher with red.
- Respiratory movements increase with red and decrease with blue.
- Heart rate shows no appreciable difference.
- Eye blink increases with red and decreases with blue.
- Cortical activation is consistently greater with red light after about 10 minutes.

It has been found that red light consistently shows a more pronounced pattern than blue light, both on the introduction of stimuli and after a period; arousal with red is more aggressive. White light, because it is bright, is physiologically stimulating, but it may be boring to the senses and may cause irritability. White and red are related to excitation in general, but blue and other soft colours are more specific in their effect.

The following is a summary of the responses to hard and soft colours, which are also, by definition, warm and cool colours.

Hard (warm) colours – red, orange, yellow:

- have maximum brightness in pure form
- focus at a point behind the retina of the eye, thus making objects look nearer
- always dominate soft colours because of their effect on the retina of the eye (e.g. red letters on a blue ground are better than the reverse)
- are easier to focus; red is only slightly refracted by the eye
- are more visible because they are brighter; visibility is dependent on brightness differences between two colours
- are impulse colours, inviting to the viewer
- tend to make objects look larger

- associate with warmth
- signify contact with the environment
- create excitation
- cause people to overestimate time
- tend to make objects look heavier
- hold most attention in the early years of life.

Soft (cool) colours – blue, green, violet:

- are more retiring colours
- focus at a point in front of the retina of the eye, thus making objects look further away
- are dominated by hard colours
- recede into the background
- are less visible than hard colours
- are retarding, not inviting to the viewer
- are difficult to focus and often appear blurred
- tend to make objects look smaller
- are associated with coolness
- signify withdrawal from the environment
- have a calming effect on the organism
- cause people to underestimate time
- increase mental concentration
- are preferred by those of mature age.

7.6 Psychological reactions

These are reactions which affect the mind mainly as a result of interpretation, experience, association and perception. Many of these reactions derive from tradition and long-forgotten experiences which have become buried deep in human nature. Colour not only affects the minds of people, it affects their appetite and behaviour, and the reactions vary with age, race, nationality, sex, seasons, location, economic conditions and personal characteristics.

Women tend to like brighter colours than men of the same age, children generally like different colours from those liked by older people, and young men tend to buy more colourful ties than older men, who are generally more conservative. A liking for colour is often due to personality; colour helps to make people gloomy or happy, it helps to make them warmer or cooler, depending on how it is used. Many colours suggest different ideas: red suggests danger, heat, war; blue suggests cold, truth, happiness.

Many of the traditional interpretations derive from the increase or decrease in muscular tension, which is a function of the physical reaction to warm and cool colours. Red is the colour of war because it is stimulating and tends to put up blood pressure and increase tension. Blue is associated with peace because it reduces tension and perhaps because it causes people to think of the sea and the sky.

Historically, colour has been concerned with symbolism, as in heraldry, but in the modern world red traffic lights inspire caution or even cause conster-

nation. On the other hand, the red lights on a Christmas tree inspire pleasure; a child finds pleasure in a red ball and when the child grows up it will find excitement and activation in a red sports car.

Experience of colour is more basic than experience of form, and many associations and symbols derive from physical reactions to light energy. Man tends to give precise and compassionate meaning to that which is stimulating, but tends to give more profound properties to that which is tranquil. However, there is a subjective attitude and an objective attitude to colour. For example, in objective terms green is cool, clean, fresh and pleasing, but in subjective terms green light on pink flesh is repulsive. While physical reactions to colour can be scientifically defined, few of the responses, reactions and associations which are embraced within the term 'psychological reactions' can be discovered from formal rules; they have to be discovered by research or study or learnt from experience.

7.7 Colour characteristics

The various properties of colour described so far may be divided into two broad categories: colour functions and colour attributes (see below). The distinction is somewhat arbitrary, but in general terms, colour functions are physical and colour attributes are emotional in nature.

Colour functions The purely physical and optical properties of colour may be applied in many practical ways, the most important of these being the control of light in industrial and commercial environments, thus ensuring efficient working conditions by eliminating glare and reducing strong contrasts. Colour can also be used to control heat in environmental and packaging applications, to ensure readability of print and in many other practical ways (see Section 9 in this part).

Colour attributes The responses, reactions and associations which have been discovered by research and experience are conveniently known as the attributes of colour. Each individual hue has a number of attributes, properties and qualities which are partly emotional in nature and partly derived from the other responses triggered off by colour. Anyone who needs to make use of colour in a practical way should be aware of these attributes (see Section 10 in this part). The attributes of colour are particularly valuable when using colour in a positive way to sell, and the first step in any process of selecting colour for selling applications is to identify those attributes of hue which would be most useful in the marketing situation under consideration.

Both the categories have a part in the various applications of colour described in Section 8 in this part. In all applications of colour, whether environmental, marketing or graphical, it is important to analyse the various functions that colour has to perform in each situation, such as attracting attention, creating impulse, ensuring maximum visibility or any of the many other tasks. Once the various functions have been isolated it is relatively simple to select colours which have appropriate attributes or qualities.

7.8 Trends

There is a third aspect which plays a part in all applications of colour and particularly with those concerned with ordinary people, with consumers. This third aspect is the reaction of people to colour trends; these cannot strictly be described as colour characteristics, but they are just as important as colour attributes in almost all applications of colour. There are a number of different types of trend and they are described in detail in Section 17 in this part.

The use and importance of trends in general does not need to be discussed at this point, but in any application of colour it is important to remember the reaction of people to trends; they must be taken into account in any selection of colour. There is usually some relationship between all trends because the same people are involved. There are general trends of preference for colour and there are preferences which apply to specific products or situations, and all of them change periodically. In any colour application it is desirable to follow trends whenever it is practicable to do so, and especially where the general public is involved.

Where a colour is selected for visual or functional reasons, it is sound practice to choose a variation which is popular by the standards set by consumer preferences. A variation – of whatever hue – chosen from a standard colour range may be obsolete and might do more harm than good. A variation which is currently fashionable or popular will have more emotional appeal than one that is not.

8 Colour uses

8.1 The importance of colour

Colour is necessary to the total human being and is more important than form because responses to form arouse intellectual processes whereas responses to colour are more emotional in nature. Form perception is usually accompanied by a detached, objective attitude to the subject, while colour perception is more immediate and personal and very largely subconscious. Human reactions to colour are influenced by conscious thought but not wholly dependent on it.

Colour has evolved to ensure that man is better adapted to his environment; people are able to distinguish colour because it gives meaning to the world in which they live. Both light and colour have biological significance, but colour has the additional task of aiding perception; the ability to distinguish colour improves the acuity of the eye, but the eye is primarily a lens and it is the brain that makes sense of what the eye sees. In other words, colour helps the brain to make a more perceptive interpretation of everyday things. Birds and insects have the same ability because they need it in order to find food but most mammals, except man, depend on other senses such as hearing and smell.

Man has a soul as well as a body and needs agreeable visual light to lead a normal life. There is far more colour within man than there is in the world outside and this exists irrespective of light energy; it can be released by certain drugs such as LSD or mescaline, both of which 'turn on' colour from the inside so to speak, although this is not in the best interests of the participant. The colour of everyday things provides an attraction towards the outer world and away from self, which is far better for the individual.

Variety is psychologically beneficial in itself, although an attempt to cheer up people by means of uninhibited colour may have the reverse effect. Colour stimulation should be specific and will then be accompanied by a specific response pattern of the entire organism. This has been noted, even in blindfolded subjects, because human beings have a radiation sense which is sensitive to colour, quite apart from what is seen. Blind people who have never seen colour can visualise the blue of the sky or the green of the trees, probably because colour is buried deep in their heredity. It is also probable that they are sensitive to the wavelengths of light, and some researchers believe that blind people are more sensitive to colour than sighted people.

8.2 Liking for colour

An innate liking for colour is part of the human psyche. People, and particularly children, react to colour before they react to shape or form, and a sense of colour is as old as man himself. Primitive man needed colour in order to compete with birds for available food supplies and, in the course of time, learnt to apply colour for decorative purposes; he decorated his caves with colour and decorated his skin to keep away enemies. He knew, from the colour of the sunset, when it was time to hurry home.

In the beginning, colours that were not part of the general scheme of things were probably used mainly for signalling purposes. Ceremonial dress, for example, was usually highly coloured and identified the leader. Even today colour is still used as a signal and for many other purposes which derive from man's inheritance. This may be demonstrated by the universal liking for red. Red is by far the most common signal colour in nature; it is an alert. The signal can be both pleasing and the reverse; monkeys react to red light with fear. The colour of most living things is there for a particular purpose; an insect is attracted to flowers by their colour, and human beings learn to keep away from poisonous toadstools because they are exotically coloured. Colour may have sexual connotations, such as the peacock's tail. Colours of natural objects are designed to attract attention and transmit information, and the colours of an inanimate object may be selected for the same reason.

The innate liking of human beings for colour has a number of marketing implications; the higher standards of living of the present day mean that people have the opportunity and the money to indulge their liking for colour. This liking, being natural to all human beings, provides excitement and pleasure, and people will take a lot of trouble to fill their homes and adorn their persons with colours that appeal to their emotions. More important from a marketing point of view, this liking for colour motivates that desire for change which is inherent in all humans and which is a vital part of the selling process.

A liking for colour, and a desire for frequent change, is especially marked amongst the young, and for this reason colour is vitally important when selling to the young, and today the young have money to spend. However, the young will only buy colours that appeal to them, and their likes and dislikes change quite frequently. Young people are more adventurous in their use of colour than older people, and they change their ideas more often; appearance, and colour, are more important than long-lasting qualities. This point is of immense significance in marketing. There are a number of ways in which the reactions of human beings to colour can be exploited in a commercial sense, and they may be divided into a number of broad categories:

- environmental applications
- marketing applications
- graphical applications.

8.3 Use in the environment

The use of colour in the environment includes the practical employment of the

physical and optical properties of colour in such functions as controlling the amount of light, heat control and similar functions. However, it is also valuable to use the emotional aspects of colour to create an acceptable environment. The emotional qualities of colour will help to make the home look more attractive, although this is concerned with individual likes and dislikes and not with broad principles. The emotional aspect is equally important in commercial and industrial environments; people will always work better in an environment which appeals to their emotions as well as being efficient. In this case broad principles are more important than the likes and dislikes of individuals. Industrial and commercial environments may be divided broadly into productive environments and selling environments, and these are discussed in later sections.

The human organism responds in a positive way to brightness and warmth of colour; and in a negative way to dimness and coolness of colour. Cheerful and colourful backgrounds produce a creative atmosphere and improve the efficiency of workers. The combination of practical properties and emotional properties in creating efficient working environments is termed the functional use of colour and is described in Section 16 in this part.

Because it is normal for human beings to like colour, no one should be expected to live without it. The human organism is not adapted to unvarying stimuli; uniform brightness and uniform illumination are not consistent with the make-up of human beings. The human organism is in a constant state of flux and if this is not stimulated, its ability to respond will deteriorate. People require varying stimuli if they are to remain sensitive and alert to their environments. Comfort is identified with moderate, if not radical, change; this change covers all the elements in an environment, including colour. Severe monotony may cause distress, and so, of course, may overstimulation. The colouring of walls, furniture and so on is an escape from monotony, and this is just as true in the home as it is in the industrial environment.

Colour helps to take a man's mind off what ails him. Balanced light helps to keep an individual in good physical shape, and colour helps to keep the individual in good emotional shape. Blandness and bleakness are psychologically intolerable, and the resourceful use of colour will ensure emotional and mental balance.

Ill, desperate and disturbed people are often expected to spend long hours in confined and drab quarters and this can cause disorganisation of brain functions. The same thing can happen to urban dwellers in some instances; the possibility of vast neurotic populations cooped up in massive housing projects, plagued by blank walls, is disturbing. Monotony can lead animals and humans to destroy themselves. If sight is not stimulated by colour, the reactions that colour causes may take place in the mind (see 8.1 above). Prisoners and others who are deprived of normal variety in their environment often have colourful hallucinations for no apparent reason and in some cases these become an occupational hazard, for example for workers engaged in monotonous tasks like tending automatic machines, or in space craft. Colour and vision inside the mind, caused by lack of stimuli, may even block vision of the actual environment. Studies of sensory deprivation have shown that after indulging in excessive sleep, an isolated person begins to have visual and auditory hallucinations, perception becomes blurred and objects become unstable. Intelligence deter-

iorates and there may be outright panic.

Blank surfaces tend to fade out when viewed continuously, and even coloured surfaces may fade into grey if the vision is not stimulated; it is for this reason that astronauts need mental and visual stimulation during a lengthy flight. Normal consciousness, perception and thought can only be maintained in a constantly changing environment, and this applies with special force to children.

Colour can perform a number of practical and valuable functions in the environment; colour is a storehouse of hidden power that can be harnessed to carry out many useful tasks. Paint costs comparatively little, and if there has to be colour, it might just as well be colour that creates practical benefits; good colour is no more expensive than poor colour. Colours that do not show any practical advantages in terms of worker attitudes or increased sales, are wasted.

8.4 Marketing uses

Both the physical and optical properties of colour and its emotional aspects can be employed to increase the sales of products, both consumer and industrial, by attracting attention and by making the products more pleasing. The emotional aspects are particularly important in the marketing of consumer products because the colour must have maximum appeal to the potential purchaser. Sales figures prove that the right colour sells, and with some products, such as carpets, colour is the most important single factor in achieving maximum sales. The right colour increases sales and the wrong colour kills them. In addition, colour is used to attract attention to the product, to set it off to best advantage and to create impulse sales where practicable.

In all age groups it is good business to offer a product for sale in those colours that people want, and these wants will vary from time to time as preferences change. Colour may be selected to trigger off a specific response, or to attract attention, but it is always good business to respect current preferences. Selecting the right colour, or colours, for products is a complex process in which marketing and other factors have to be taken into account; these include the nature of the product and the response that it is desired to trigger off. Even in those cases where a product is bought for its function rather than for its decorative effect, colour will add to sales attraction.

The ability of colour to create a more attractive background, or a more pleasing background, has implications in the marketing of industrial products; if the colour of the product contributes to the efficiency of the environment, a good selling point has been created.

8.5 Uses in communications

The third major field in which the characteristics of colour have a part to play is that concerned with facilitating communication and creating sales in display, packaging and promotional applications.

The physical and optical properties of colour have a practical application in display, packaging and promotion generally. For example, a hard colour will attract more attention than a soft colour, and a hard colour will show up best against a soft background. A dark object is displayed to best advantage against a light background, and this light background can reflect light on to an object and provide attractive contrast; the reverse also holds true except that more care is necessary lest the light object reflects light on to the dark background and reduces the contrast.

The emotional properties of colour facilitate communication and improve display and promotion, and they are a further development of the marketing process. The physical properties of colour can be applied to making print and packaging more visible and therefore emotionally attractive.

8.6 Other uses

Many applications of colour are concerned with the interior decoration of the home and should reflect the ideas and wishes of individuals rather than follow broad principles, but principles can be formulated for the headings indicated in 8.2 above, and these principles are to be found in the sections which make up Part II of this book. However, there are a number of less important applications of colour which tend to cut across the main headings. These minor applications do not justify discussion at length, but they are summarised in Section 11 in this part.

9 Colour functions

9.1 Camouflage

One of the functions of colour is to provide camouflage, and there are positive and negative aspects to this as well as the much larger aspect of camouflage against, say, attack or to prevent an unsightly structure becoming a blot on the landscape. This larger aspect is beyond the scope of this book and requires the skilled services of the expert.

The practical aspect is the use of darker colours to protect surfaces that are subject to soiling and abuse. Such areas as corridors, staircases, finger panels and the like, are best finished in darker colours in order to hide finger marks and other marks. The walls of a corridor, for example, may be painted in light colours above the dado in order to create maximum light, while the lower half may be painted in a darker shade of the same hue so that scuffs do not show to the same extent.

One of the primary aims of management is to ensure good housekeeping, for example to ensure that workers take care of their equipment, keep it clean and do not abuse it. The average worker is much more likely to take pride in a well-finished and attractively coloured piece of equipment than equipment in dull, depressing hues, but if everything is finished in white, there will be so many finger marks that the worker will soon get tired of trying to keep it clean. This argument in favour of good housekeeping is also an argument against using colours that are too light or too bright for areas that may be subject to handling or soiling. A medium tone will hide minor blemishes and scratches without hiding gross neglect, but very dark colours may handicap workers and destroy incentive. There is no point in emphasising areas which show dirt unless they are cleaned every few minutes. There are exceptions to this general rule; for example, in food processing, where a high degree of hygiene is essential, light colours and high illumination will ensure that dirt is not overlooked.

The negative aspect has safety connotations. A man may easily step from a grey scaffolding on a grey day when working on a grey building. The scaffolding should be painted in colours which are not found in the immediate environment. This is a problem of optical camouflage, the camouflage of deception, which delays receipt of visual information. The use of grey for machinery and industrial structures can be particularly dangerous and is very common in the

67

engineering industry – engineers are wedded to the idea of grey which is supposed to save money. Dark green can have the same effect, but on the other hand, the meaningless use of bright colours can also cause accidents because the light areas are distracting.

Colour analysis

It is difficult to say that one colour is better than another for camouflage purposes; it all depends on the circumstances. Hues of medium or dark tones are best when it is desired to hide soiling, but safety considerations may dictate avoidance of colours that have little visual impact.

Hard colours	not generally recommended where camouflage is involved
Soft colours	tend to hide soiling, especially darker tones
Bright colours	not significant in this context
Muted colours	can be recommended to hide soiling
Light colours	not significant in this context
Medium colours	may be used for camouflage
Dark colours	can be recommended to hide soiling but not where safety is involved
Neutrals	not recommended
Violet	helps to camouflage soiling
Blue	darker shades of blue can be recommended
Blue-green	not recommended
Green	darker shades can be used to hide soiling, but safety considerations should be watched
Yellow	not recommended
Orange	not recommended
Brown	medium and darker tones may be used
Red	not recommended
Pink	not recommended
White	not recommended
Off-white	not recommended
Grey	medium and dark tones will hide soiling, but be careful of safety connotations
Black	will hide soiling
Grey tints	not recommended.

9.2 Coding

Colour is frequently used for coding and identification purposes, and the colours need to be carefully selected to ensure maximum contrast between each one. It is difficult to say that any one hue is better for this purpose than another. The principal requirement is that all the colours in a range which is to be used for coding purposes should be sufficiently far apart on the colour circle to avoid any risk of confusion. A good deal depends on the extent of the range and the purpose for which it is intended. Where the colours required are few in

number, it would be good strategy to select those colours that have maximum visibility and recognition qualities and to mix these with their exact opposites on the colour circle, although some compromise may be necessary in order to avoid using colours that are too close to each other. Where appropriate, a colour of low reflectance value can be paired with a colour of high reflectance value. Tests carried out in connection with postage stamps indicated that a symmetrically structured range of seven light hues, each used at two levels of saturation, provided the best results.

In packaging applications, colour is often used to distinguish between different flavours, scents and so on, for example, to distinguish different types of cake mix. In each case the colours used should have some association with the product or with the flavour or scent involved. Architects often see colour as a factor in the coding of individual environments; it has been used in homes for the elderly, machine rooms of office buildings and primary schools; in the latter case the idea is that the child comes to know its environment through its colour. There are British standard colours for the identification of pipes and pipelines, electric cables, gas cylinders and various other usages. These standards should always be used where applicable.

Significance

The use of colour for identification purposes is chiefly significant in commercial and industrial applications, for example in filing systems, but it also has applications in packaging, as noted above. The important point is that the colours should be selected in such a way that there is no confusion between them.

Colour analysis

Hard colours	Generally preferred for identification purposes because they have greater impact.
Soft colours	May be used in some cases because they provide contrast with hard colours or because it is essential that legend should be visible, as in filing systems.
Bright colours	Generally preferred.
Muted colours	Not recommended.
Light colours	May be used if there is adequate contrast.
Medium colours	Recommended.
Dark colours	May be used where appropriate.
Modified colours	Not recommended.
Neutrals	Use only if there is adequate contrast.
Violet	Not recommended because it is difficult to distinguish from blue. It should only be used where a large range of colours is required.
Blue	A strong medium blue would be recommended in most ranges, although it does not have good visibility or recognition qualities; however, it does provide good contrast with other colours. Clear blues and muted blues could be used in the same range without difficulty.
Blue-green	Turquoise would have better qualities than blue, and in

	appropriate cases a clear turquoise could be contrasted with a muted blue.
Green	Excellent recognition qualities and yellow-greens have good visibility. Can be recommended for identification purposes; strong greens are better than pale greens.
Yellow	Excellent visibility but only third best in terms of recognition qualities. Strong yellow should be included in most ranges, but pale yellows may be difficult to distinguish from white.
Orange	Excellent visibility and recognition qualities and high impact. Better than yellow but red-orange could be used in the same way as yellow.
Brown	A neutral colour and has few qualities to recommend it for identification purposes. However, lighter browns such as fawn, buff or beige could be used and would contrast well with darker colours.
Red	Easiest of all colours to identify and has excellent visibility. However, it tends to 'disappear' in dim lighting conditions and may then be difficult to identify.
Pink	Not generally recommended except as a contrast to darker colours. A strong pink is indicated if used at all.
White	Only to be used if contrast is necessary. Has little interest because of its lack of chromaticity and not generally recommended.
Off-white	Not recommended in this context.
Grey	Little to recommend it in this context, although it is commonly used in office systems.
Black	Provides maximum contrast with light colours but not otherwise recommended.
Grey tints	Not recommended.

9.3 Heat control

The technique of using colour in the control of temperature is one of the most practical examples of the functional use of colour. The principle is quite simple and is that white and all light colours with a high reflectance value repel heat through reflection; black and dark colours with a low reflectance value absorb it. The ability of colour with a high reflectance value to reflect away light and heat has many useful applications. In tropical countries, buildings are commonly white on the outside in order to reflect the heat and sun, and cool the interior. The same principle can be used for ships, tanks and other structures, including the exterior walls of sheds and warehouses. Motor car tops, airplane exteriors and many other structures can take advantage of these heat reflecting qualities.

An official United States government report indicated that a petrol tank used for bulk storage and painted white had a loss of only 1.4 per cent by evaporation over a period of four and a half months, compared with a 2.4 per cent

loss where the tank was coated with aluminium paint and 3.5 per cent when coated in red. A white ship in the tropics will be at least 10 degrees centigrade cooler inside than a black one and light colours also restrict the growth of barnacles. In comparisons between black helmets and white helmets in sunny weather in hazardous conditions, the temperature inside the white helmet was as much as 22 per cent below the temperature inside the black helmet.

In packaging applications, bright colours on the outside of a container or package will tend to reflect heat and light and keep the contents cooler. A dark coloured container, on the other hand, will absorb heat; black absorbs 17 per cent more heat than white. Aluminium foil, being bright and having good reflectance qualities, is often used to keep products cooler, but the effect would be lost if the foil were printed in dark colours.

This aspect of colour also has significance in retail applications because of the build-up of heat in shop windows which are exposed to sunlight. The blue-green band of the spectrum – ultraviolet light – causes objects in the window to fade, and the infrared component can do more damage than visible light because of heat build-up. Solar gain due to radiant energy impinging on the glass causes the whole window to heat up. Radiant heat and light cannot pass through an opaque object but the heat impinging on the face of the object causes a heat shadow to be formed behind it; the area of the shadow will remain cool, but the area surrounding it will build up heat. In addition, if the object is dark, the object itself will absorb radiant heat and become hot. Radiant heat will be reflected away from an object with a bright surface and may cause the surround to heat up. Anodised aluminium reflects 80 per cent of the light falling upon it, bright red may reflect 40 per cent, while black reflects 6 per cent.

In addition to the subconscious effect of warm and cool colours, light colours of high reflectance value used on interior surfaces reflect light (by definition) and also reflect heat, and if the illumination is very high, heat can be created in physical terms. Colours of low reflectance value absorb heat and therefore cool down an interior as well as creating coolness by association.

Significance

The heat control functions of colour have little significance in consumer applications, except in so far as the colouring of house exteriors is concerned, but they do have significance in many commercial applications, as indicated above; they are also significant in packaging applications.

Colour analysis

Heat control qualities are a function of reflectance values rather than of actual hue. Any colour with a high reflectance value will reflect heat away, and any colour with a low reflectance value will absorb it.

Hard colours	Not significant in this context.
Soft colours	Not significant.
Bright colours	Will reflect away heat.
Muted colours	Effect depends on reflectance value.
Light colours	Generally recommended.

Medium colours	Recommended if reflectance value is high enough.
Dark colours	Absorb heat.
Modified colours	Not significant.
Neutrals	Generally recommended but depends on reflectance value.

Analysis of hues is not required in this context.

9.4 Insect control

Colour is sometimes used to repel insects, but this is a difficult subject which requires a great deal of study because colours repel some insects but attract others. Blue generally attracts mosquitoes, but pink and yellow repel them; blue also attracts some kinds of beetle. The mosquito-repelling qualities of colour are reputed to be responsible for the present colour of US Army uniforms, because the colour previously used was found to attract mosquitoes when the Panama Canal was being built during the early years of this century.

Significance

This function of colour has few practical applications but may have some significance in kitchens and in food-processing plants.

Colour analysis

Hard	Generally not attractive to insects.
Soft	Generally attractive to insects.
Violet	Peach moths are responsive to violet, and bees are very sensitive to it. Some beetles react to it.
Blue	Dark blues attract mosquitoes; bees are sensitive to it, and it attracts some beetles. Peach moths are responsive. Blue light is often used to attract insects to destruction.
Blue-green	As for blue.
Green	Mosquitoes are neutral to green, and bees are insensitive to green and yellow-green; however, about a third of beetles react to yellow-green.
Yellow	Attracts horseflies but repels mosquitoes. Many beetles like yellow, including Japanese beetles.
Orange	Orange light will keep insects away.
Brown	Attracts mosquitoes.
Red	Red light will keep insects away and inhibits the growth of cockroaches. Bees are confused by red, but ants like visible red light.
Pink	Repels mosquitoes.
White	No significant effect.
Off-white	No effect.
Grey	No effect.

Black No effect.
Grey tints Effect depends on base colour.

9.5 Light control

One of the principal functions of colour is to control light in the environment in a broad way and, more specifically, to help deal with those lighting conditions that would be inimical to good seeing if left uncorrected. These include:

- eliminating excessive brightness within the field of view
- eliminating glare
- correcting contrast ratios between task and background
- avoiding uniformity of brightness in the environment as a whole.

Control of light is a function of the reflectance value of colour rather than a function of the hue itself. The reflectance value of a surface measures the extent to which the colour of that surface modifies the ambient light. Colours with a low reflectance value absorb a good deal of light, and thus an area full of colours of low value may require additional lighting. Colours of high value, on the other hand, reflect more light and may make it possible to reduce the total illumination. By selecting colours with an appropriate value it is possible to exercise control of the total light in the environment.

The reflectance value of any surface depends partly on the colour of the surface but also on the nature of the surface; a textured surface, for example, will show a lower reflectance value than a high-gloss surface in the same colour. Reflectance values are of particular importance when making lighting calculations for an environment, because they influence visual comfort, utilisation of light, and the feeling of an area. Where light levels must be high, the reflectance value of the surfaces in the area should also be reasonably high if comfortable seeing conditions are to be maintained. An area with dark walls and ceilings is a drab and cheerless place, and surfaces having a higher reflectance value impart cheerfulness and efficiency.

In fact, the efficiency of the lighting system depends on the reflectance value of the surfaces in the area; in all interiors part of the useful light is reflected from the walls, ceilings and other surfaces, and if indirect lighting is employed, all the light is reflected from these surfaces. It is for this reason that it is recommended that ceilings should be white in order to reflect as much light as possible and thus make savings, both in the installation of a lighting system and in the annual cost. Walls should generally have a reasonably high reflectance value, especially walls opposite the daylight source, and a figure of between 50 and 60 per cent is recommended for most industrial environments. Floors should have as high a reflectance value as possible to reflect light upwards, a figure of between 20 and 25 per cent is recommended.

Quite apart from the overall lighting, colour is useful in controlling excessive brightness within the field of view. Brightness may be defined as the amount of light falling on or reflected by a given surface; its technical name is luminance. A white wall reflects about 85 per cent of the light falling on it; given an illumination of 100 lux, the wall would reflect back 85 lux. A black wall, on the other

hand, reflects only about 5 per cent of light, and in similar conditions of illumination would reflect only about 5 lux. It is relatively easy to fix the correct level of light for any task, and the eye can cope quite easily with light levels ranging from 50 to 3000 lux, but the eye does suffer from fatigue caused by factors which are common to all forms of illumination, and the most frequent cause of trouble is too much brightness within the field of view.

The human organism reacts automatically to too strong light or excessive brightness and seeks equilibrium and balance. Emphasis on brightness often leads to the conclusion that eye fatigue is retinal, but this is not strictly the case; it is muscular in character, and trouble occurs when high and low brightness are present concurrently. The presence of excessive brightness tends to cause a blinding effect, and the source seems to be surrounded by a halo of light. This seems to confuse and blur seeing in direct relation to the intensity of the light source and in inverse relation to the distance from the line of sight. The effect is caused by a scattering of the light by the reflecting media of the eye, and this tends to throw an overlay of light on the image being received. There may also be disturbance of the control mechanism of the eye, with consequent fatiguing of the muscles of adjustment. Too high brilliance may cause actual damage to the retina of the eye itself, but most trouble arises from efforts to accommodate. The eye always strives to see clearly; the action is involuntary and can set up a long chain of events from ocular fatigue to general debility.

Excessive brightness usually arises from surfaces having too high a reflectance value and can be adjusted by changing the colours of the surface to those with lower values. Glare is very similar to excessive brightness and is described in more detail in 3.7 above and is most often caused by badly placed light sources, although a change in the colour of surfaces will cause some conditions. The eye can see with equal facility under widely different conditions of light and can see brightness differences of an order of 1 000 000 : 1 under intensities of light of an order of 10 000 : 1; it sees detail better under bright light than it does under dim light, but where the light is subject to sudden or frequent changes in intensity, the repeated demand for rapid adjustment may result in temporary blindness. This kind of trouble is particularly marked in areas where there is a superabundance of light and where white or other light colours are used to excess; such conditions have an effect on the individual which is akin to snow blindness.

If comfortable seeing conditions are required, brightness ratios are critical. If an environment was decorated only in black and white, the brightness ratio between the two would be about 85 : 5, that is 17 : 1. This is far too high and causes difficult seeing conditions. Trouble will frequently arise when a working surface is not separately illuminated or is illuminated at a lower level than the surroundings. The working surface will be at the centre of the field of view and the eye will be adapted to its light; if the eye is then caught by high brightness in the surround, there will be a sharp contraction of the pupil. A reduction in pupil breadth by half cuts the amount of light entering the eye by 75 per cent, and where the light is from the working surface, there is a consequent reduction in the ability to sustain clear seeing of the details of the working surface. This reaction is compounded if the working surface is already badly lit. Pupil reaction should be controlled by the working surface and not by any other source of

light. Abnormal contractions of the pupil, caused in this way, are irritating to the iris, may lead to congestion of the blood vessels at the front and back surfaces of the ciliary body and may put a strain on the muscles of accommodation. In most productive environments adverse conditions of this nature can be cured by altering the reflectance value of surfaces; the ratio between the reflectance value of the task and its background should not usually exceed 3 : 1.

Lighting engineers often claim that seeing is at its best when all areas or surfaces within the field of view have an approximately equal brightness, but this is a fallacy because the process of vision is neural as well as ocular and involves complex physiological, psychological and psychophysical elements. Uniform brightness in the environment is uninteresting and monotonous and provides no variety. Uniformity of brightness is a subject about which there is much dispute, and varied views. Some authorities tend to prefer an approach in which light intensity is the only criterion of good seeing, and they consider that any approach in which the human organism is involved to be an unnecessary confusion of issues. In fact, psychological factors play a very important part in the comfort of a lighting installation and purely scientific facts may be at variance with experience. Apart from the light necessary to see detail, there are other things that should be taken into account, and colour plays an important part in creating comfortable conditions.

The following are some broad rules:

- Plan sufficient light to convey all the information that is needed to work efficiently and to make people fully alert to their surroundings.
- Keep illumination and colour simple to avoid confusion and emotional rejection.
- Do not forget the human appearance factor.
- Give all the elements in the field of view a realistic appearance without flattening them out with too much light or distracting from them with too much colour.
- Use colour to provide variety instead of monotony.
- Hold colour contrasts and light levels within the limits of reasonable adaptation of the eye.

Significance

Control of light and elimination of excessive brightness is of most significance in productive environments where adverse seeing conditions can lead to considerable loss of production. Colours should be selected, and used, to produce ideal seeing conditions, not forgetting the need for adequate contrast between task and background.

Colour analysis

Control of light is a function of the reflectance value of colour rather than a function of hue. Actual hues may be selected for many good reasons, such as emotional pleasure, but the tone should be adjusted so that the reflectance value performs the right function.

9.6 Pipeline identification

Colour is used to identify the contents of pipelines in industrial and commercial environments in order to prevent errors and ensure that the contents of pipes are easily identified. British Standard 1710:1971 specifies colours for the marking of pipelines in accordance with international usage, and this should always be followed where possible.

It is recommended that the basic colours should be applied along the whole length of a pipe as far as possible, but colour may also be applied in bands at junctions and other suitable points, or coloured panels may be used if banding is impossible. In some environments full colouring of pipes may cause distraction, and bands or panels would be preferable.

In certain cases, additional coding colours are imposed on the basic colours by means of bands at strategic points but where the colour is already applied in the form of bands or panels, the superimposed colours should be applied between the bands of basic colours. Lettering or symbols should be applied in any case where supplementary information is desirable or where there is risk of confusion; it would be particularly important to do this in the case of dangerous fluids because some workers may be colour blind. It is also useful to indicate the direction of flow.

Significance

Pipeline identification is primarily of significance in productive environments, although it may be used in some other commercial environments (e.g. public buildings).

Colour analysis

Colour categories are not significant in this context.

Violet	Acids and alkalis.
Blue	Light blue for air; dark blue for fresh water, drinking water; dark blue with red for central heating; dark blue with white for cold water.
Green	Light green for water; dark green with red for condensate; dark green with white for chilled water; dark green with bamboo for town gas; dark green with dark brown for lubricating oil.
Yellow	With black stripe for dangerous contents; with trefoil symbol for warning of radiation.
Orange	Electrical services.
Brown	Light brown for natural gas; dark brown for oils.
Red	Fire fighting, fire extinguishing; with white for boiler feed; with green for condensate; with dark blue for central heating; with white for hot water; with dark brown for transformer oil.
Pink	With dark brown for hydraulic oils.
White	Cooling water; with red for boiler feed; with green for

chilled water; with dark blue for cold water for storage tanks; with red for hot water supply; with light blue for vacuum; with dark brown for diesel.

Grey Steam.

Black Drainage and other fluids.

For the actual hues to be used, reference should be made to the British Standard mentioned above.

9.7 Protection from light

Colour can often be used as a protection against the effects of sunlight and excessive ultraviolet light. Tinted glass, for example, is used in buildings to filter out the worst effects of the sun, brown bottles are used to ensure that beer is not spoilt by exposure to light, and amber coloured containers are used for medicinal products for the same reason. The most important function is in the protection of food from rancidity.

Ultraviolet radiation causes havoc with many foodstuffs, besides tanning the skin, creating Vitamin D and fading coloured merchandise. Certain glass is manufactured to screen out ultraviolet light and is particularly appropriate for use in hot climates. Although ultraviolet rays have little penetrating power, they will be transmitted through clear glass and also through some forms of plastics sheet; amber-coloured sheet is specifically designed to ensure visibility of a product while denying access to harmful rays, and it provides an alternative to total opacity.

A study carried out by the Food Research Division of the US Department of Agriculture into the effects of light on spoilage of oil-bearing foods showed that certain wavelengths of light promoted more rancidity than others. The ultraviolet portion of the spectrum caused most rancidity, while the violet, indigo and blue regions came next. After blue, came red, orange and yellow, but almost twice as much exposure to these colours was necessary to cause the same rancidity as blue. The green regions of the spectrum and the infrared region of the invisible spectrum caused virtually no rancidity at all. Oil-bearing foods are best protected from all light but where this is impossible a green filter transmitting light between 4900 and 5800 A (a yellowish green) has the best protective properties. Green will only exclude light up to a wavelength of 350 millimicrons. Amber glass will provide protection up to a wavelength of 450 millimicrons.

Although yellow-green has good light protection qualities, it is not very popular with the public, especially in association with food, and amber may be more pleasing. It should be noted that although infrared rays do not cause rancidity, they do cause heat build-up, and this may be even more damaging.

The qualities of colour discussed above also have significance where transmission of light is under consideration, for example in the supply of translucent corrugated sheets (usually of plastics) for awnings and the like. These are usually used for decorative purposes, but in some instances they may be required to cut out ultraviolet or infrared rays. Yellow and yellow-green would

transmit light in the high-visibility region of the spectrum but would also cut out ultraviolet and infrared. This might be important where such sheets are used as covers for foodstalls and so on. Brown would also eliminate ultraviolet and infrared but would not have the same vision qualities.

Significance

Protection from light is particularly significant in packaging applications, especially of foodstuffs, and may also be significant in some display applications. In environmental applications, colour may sometimes be used to screen out the more harmful effects of light, but it should be remembered that total exclusion of ultraviolet light may be harmful to health.

Colour analysis

Colour categories are not significant in this context.

Violet	Does not exclude harmful effects of light and promotes rancidity in food.
Blue	Does not exclude harmful effects and promotes rancidity.
Blue-green	As for blue.
Green	A yellowish green transmitting light between 4900 and 5800 A has the best protection qualities and minimises rancidity, but green will only exclude light up to a wavelength of 350 millimicrons.
Yellow	Excludes more harmful effects than blue or violet.
Orange	Excludes more harmful effects than blue or violet.
Brown	Brown or amber glass will protect against light up to a wavelength of 450 millimicrons and is recommended for beer bottles, medicinal containers and most packaging applications. It is more pleasing than yellow-green and is also recommended for windows where it is necessary to exclude the harmful effects of light.
Red	Excludes more harmful effects than blue or violet. Infrared light does not cause rancidity but may cause heat build-up.
Pink	Not significant in this context.
White	Not significant in this context.
Grey	Darker greys may exclude light altogether, otherwise not significant.
Black	Excludes light altogether.

9.8 Readability

Some combinations of colours have better visibility than others where reading qualities are required but they are not necessarily psychologically more appealing. This aspect of colour is particularly important in print and packaging appli-

cations and in display, but the combination having the greatest visibility is not necessarily the most appealing, nor may it have the most impact on the viewer. Blue on white has better reading qualities than red on white, but the latter is more likely to catch the eye because red commands the eye to an extent that blue does not.

There is some divergence of opinion when experts try to rank colour combinations by readability but all authorities agree that the combination that has the highest readability is black on yellow; this is because yellow is the colour having maximum visibility and black has the maximum contrast with it. However, this is not the most pleasing of combinations.

Combinations that are the most visible by test are not necessarily the most suitable for promotional applications because the combinations do not necessarily take account of the emotional aspects of colour, nor do they take account of recognition qualities. White, for example, is difficult to find and to remember, and therefore black on white, or white on black, may not be the best combinations for packaging and point-of-sale applications, although both have excellent readability because of the contrast between white and black. Black on white is highly readable because it has a contrast ratio of about 15 : 1, the maximum that can be provided in print, but if it is desired to attract attention, colour would have twice as much impact. Material may be just as easy to read, and more pleasant to look at, if a combination of colours is used (e.g. coloured inks on tinted paper), always provided that the contrast ratio does not fall below about 8 : 1.

The contrast between colours is, of course, a function of their reflectance values, and the contrast ratio is the higher reflectance value divided by the lower. An average paper has a reflectance value of 75 per cent and black print has a reflectance value of 5 per cent, hence the ratio of 15 : 1 mentioned above. The greater the difference in reflectance values, the greater the contrast and the better the readability. However, it should be remembered that a high gloss may make any combination difficult to read, especially in artificial light, and much advertising material fails in its purpose for this reason.

In most print applications, combinations of colour are pleasing when light tones of colour that are bright in normal printing are combined with deep tones that are dark in normal printing. Tints of pure colours which are naturally light in value (orange, yellow, green) look best when combined with shades of pure colours which are naturally dark in value (purple, violet, blue).

Significance

When selecting colours for promotional applications where it is important that a message should be read, select a combination that has good visibility but which is also pleasing to the eye. It would be useful to relate the colour to the subject-matter and to take note of colour associations or colours for products. In packaging applications the readability of labels may be particularly important, often because of legal requirements.

Colour analysis

Types of colour are not significant in this context. The combinations listed

below are considered to be satisfactory in most applications.

Violet	White on purple, purple on white, purple on yellow.
Blue	Blue on white, white on blue, orange on navy blue, navy blue on yellow, yellow on navy blue. Navy blue is recommended but a deep blue on a very pale yellow tends to be disturbing.
Blue-green	As for blue.
Green	White on green, green on white, red on green, green on red.
Yellow	Black on yellow, yellow on black, blue on yellow, scarlet on yellow, yellow on blue, yellow on purple.
Orange	Black on orange, orange on navy blue, orange on black.
Brown	Not recommended where readability is required.
Red	Red on white, white on red, red on green, green on red, red on yellow (scarlet is recommended).
Pink	Not recommended if readability is required.
White	Black on white, white on black, blue on white, white on blue, white on green, green on white, red on white, white on red, white on purple, purple on white.
Off-white	Not recommended if readability is required.
Grey	Not recommended if readability is required.
Black	Black on yellow, black on white, yellow on black, white on black, black on orange, orange on black.
Grey tints	Not recommended if readability is required.

9.9 Signalling

Colour is important as a factor in signalling, and this may be significant in a number of commercial applications as well as in such obvious applications as railway signals and traffic lights.

Signalling is a function of the visibility of colour, and it is no accident that red, green and amber are used for traffic signals: these are the most visible colours. Red is, perhaps, the best of all signalling colours because it is easily produced, easily recognised and plainly visible at low intensities of light. Green is second, followed by yellow and white. When all colours are seen in the same light, yellow is the colour of highest visibility, it is intensely bright and visible. Red is aggressive and has good recognition qualities, and therefore yellow and red are best for all signalling purposes.

Blue and purple are much more difficult to see and to distinguish, although when the eye is dark-adapted, blue can be seen over a wider range of vision than red; the rods of the eye which are most active in dim light may not see red at all, although this is unlikely to happen with light signals. Blue light, however, does require a slower blinking rate than red light if it is to be seen clearly; blue flashing lights on, say, police cars should have a slower flashing rate than red or yellow lights.

Significance

This function of colour is of minor significance in commercial terms because the use of red, yellow and green for signals is well established.

Colour analysis

Types of colour are not significant in this context.

Violet	Not suitable for signalling purposes, because it is not easily recognised and focused.
Blue	Difficult to see and distinguish but can be seen over a wide range of vision when the eye is dark-adapted. When used for flashing lights a slower flashing rate is required.
Blue-green	As for blue.
Green	Recommended for signalling. Good recognition qualities.
Yellow	The most visible of all colours but lower in recognition qualities than red.
Orange	Has some of the qualities of both yellow and red.
Brown	Not for signalling purposes.
Red	The best of all colours for signalling: it is aggressive, has good visibility and good recognition qualities, although it is less visible when the eye is dark-adapted.
Pink	Not suitable for signalling.
White	Good visibility but does not have good recognition qualities.
Off-white	Not significant in this context.
Grey	Not suitable for signalling.
Black	Not suitable for signalling.
Grey tints	Not suitable for signalling.

9.10 Visibility of controls

Colour has a function in making controls and instruments more visible. The visibility of dials and scales depends, in the main, on contrast between two colours, and the combination of maximum readability is black on white, or white on black, but other combinations having good readability are equally suitable.

Red, yellow, orange or green would be the most suitable colours for controls because they have maximum recognition and visibility qualities, but it should be remembered that red is associated with 'stop' or 'caution' more or less world-wide, and red controls should be reserved exclusively for emergency use.

A light-coloured door knob is easier to find in the dark than a black or brown one, and similar remarks apply to controls, but it must be remembered that the eye has different sensitivity under different conditions of illumination. In the

light-adapted eye the spectrum is brightest at yellow and yellow-green, but in the dark-adapted eye the spectrum is brightest at blue-green, and red may be almost invisible. On the other hand, when instruments are illuminated by red light the dark-adapted eye sees very well, but it does not see instruments illuminated by blue-tinted light.

Thus a control which has to be seen in the dark would be best coloured blue-green, but an instrument panel which also has to be seen in the dark would be best illuminated by red light. A control which has to be seen in daylight would be most visible if it was coloured orange red, while a control panel, also to be seen in daylight, would be best illuminated by yellow or yellow-green. This rather confusing situation is of particular importance on vehicles and aircraft – less so in industrial applications, where it is unlikely that controls or panels will have to be seen with dark-adapted eyes. Where instrumentation is concerned, it is important that the background to controls, dials, gauges and so on should be either neutral in character or should fade into the background so that controls and dials have maximum visibility.

Significance

This function of colour is chiefly of significance in industrial environments where controls have to be readily visible and easy to recognise. This applies particularly to controls for emergency operation.

Colour analysis

Hard colours	Recommended for marking controls and providing maximum visibility.
Soft colours	Can be used as background to dials and so on, and to controls.
Bright colours	Recommended for controls and dials.
Muted colours	Not recommended for controls.
Light colours	Recommended for controls and dials.
Medium colours	Recommended for controls and dials.
Dark colours	Not recommended for controls but may be used as contrast for dials and gauges.
Modified colours	Not recommended.
Neutrals	Not recommended.
Violet	Use is not recommended in this context because the colour is difficult to focus and has poor recognition qualities.
Blue	Not recommended in this context.
Blue-green	Recommended for dials and controls which have to be seen by a dark-adapted eye.
Green	Can be recommended for controls; it has good recognition qualities.
Yellow	The best of all colours for controls or dials which have to be seen in normal lighting conditions. Yellow or yellow green would be excellent for illuminating panels.
Orange	Excellent for controls which have to be seen in an emerg-

	ency; red-orange is preferable.
Brown	Not recommended in this context.
Red	Excellent recognition and visibility qualities and recommended for controls associated with 'stop' but tends to disappear when the eye is dark-adapted. Red illumination, however, is excellent for controls which have to be seen by the dark-adapted eye.
Pink	Not recommended.
White	Good visibility but poor recognition qualities. Best used as background to dials and the like.
Off-white	Not recommended.
Grey	Not recommended.
Black	Best used for contrast.
Grey tints	Not recommended.

9.11　Other functions

There are one or two other functions of colour which justify a brief mention but which do not require detailed explanation.

Travel

Colour has an important part to play in eliminating travel sickness in aircraft, road vehicles and rail vehicles. Aircraft operators have found that some colours, such as yellow-green, are conducive to air sickness, and purple shades are generally disliked by travellers. In general terms, neutral colours are best for the interior of any moving vehicle, and if pattern is used it should be discreet. Patterns which form into 'lines' or 'shapes' are disturbing to people and may cause irritation as well as sickness. This is not a subject on which it is practicable to formulate hard-and-fast guidelines; it requires expert advice and careful study of all the circumstances.

Wires and cables

Colour is used to identify wires and cables, particularly for automobile wiring; colour codes are also used to identify manufacturers of cables. This is a complex subject which is of interest only to a limited number of specialists and does not justify space here. Reference should be made to British Standards covering the subject. The internationally accepted colour code for electric cables used for household appliances will be well known to most people, and the more elaborate codes are only of interest to those intimately involved.

10 Colour attributes

10.1 Age

Certain colours appeal particularly to the young and less so to older people, who generally prefer less bright and more conservative colours. It is difficult to draw a positive line between age groups, but a rough division can be made on the following lines:

- Children, up to about 5 or 6, or sometimes later, prefer bright reds, yellows and whites.
- The young, up to about 30 (although in marketing terms there are many subdivisions), prefer bright and fashion colours.
- Older people, over about 30, prefer more restrained colours.

The colour preferences of children differ from those of adults, the first preference of children being yellow, which is far down the list of adult preferences. The first choice of adults is usually blue; this is due principally to the ageing of the eye. The lens of a child's eye absorbs only 10 per cent of blue light while that of an older person absorbs 85 per cent or more; consequently as people get older they become 'thirsty' for blue. In addition, the fluids of the eye become yellowish with age and there is less demand for yellow.

In practical terms, younger people generally prefer brighter and stronger colours than their elders, who often prefer greyish colours. Younger people are usually more adventurous in their choice of colour, they are willing to experiment and they take a less conservative attitude than older people, who are apt to be more cautious and take a longer-term view. The young often choose colour on the assumption that they will be able to change it after a comparatively short period whereas older people usually want colours that will 'last'. Older people generally have greater interest in form. On the other hand, younger people tend to be more conformist than their elders and are more influenced by trends of fashion. Young people generally react favourably to the enterprising use of strong colours and to unusual colour combinations, although there are periods when all young people seem to be attracted by earthy, depressing colours. These periods are usually short-lived.

People about retiring age, say about 60, often select the brightest and most fashionable colours, especially when they furnish a home for retirement, and

women tend to like brighter colours than men of the same age. Older people generally like blue and green but often find some difficulty in distinguishing between them because age has a greying effect on the perception of colour.

Significance

In consumer applications, use colours that appeal to the young for products aimed at teenagers and young marrieds. Products for children require special consideration. Research by a paint manufacturer showed that over-55s bought twice as much cream and beige as the under-35s, who bought three times as much orange and tangerine.

In productive applications, use colours appropriate to the make-up of the workforce. Older people, generally speaking, require more light to see adequately and if given the opportunity will choose very high light levels indeed, although not usually for the home. Once a worker attains the age of 40, the amount of light necessary to achieve a given standard of visual efficiency increases rapidly. Furthermore, a large proportion of the population suffers from eye defects of one kind or another, and these defects tend to be more common as age increases. With an older workforce, colour may have to be toned down as the level of light increases, to avoid adverse seeing conditions.

In selling applications, consider the type of customer aimed at. In graphical applications, consider the age group aimed at; promotions aimed at, say, young marrieds, should employ strong, bright colours reflecting current fashions. Tests have shown that in packaging, young people like large areas of white and bright colours, pastels taking second place. Red, yellow and stronger blues are particularly recommended, but older people generally prefer something more dignified.

Colour analysis

Hard colours	Usually appeal to the young more than to older people.
Soft colours	Often preferred by older people.
Bright colours	Appeal to the young.
Muted colours	Appeal to older people.
Light colours	Preferred by the young so long as they are bright; the young are less interested in pastels.
Medium colours	Appeal to both young and old.
Dark colours	Generally preferred by older people, although they are sometimes a fashion influence on the young.
Modified colour	No special significance.
Neutrals	No special significance.
Violet	Appeals to the young only in a fashion sense; they will go for strong purples when in vogue but usually only for short periods. Older people will seldom buy purple but are attracted by lilacs and mauves.
Blue	Mainly preferred by older people, but strong blues often appeal to the young, especially for packaging.
Blue-green	More appeal to the young than blue.
Green	Mainly appeals to older people, but there is often a

	strong demand from the young, especially for brighter greens but usually for short periods.
Yellow	Appeals to the young, especially the very young.
Orange	Appeals to the young, less so to older people.
Brown	Mainly for older people, except when a fashion colour.
Red	Appeals to both young and old; children particularly like bright reds.
Pink	Appeals to both young and old but more to the former than to the latter. Generally appeals only to women.
White	Particularly appeals to the very young.
Off-white	Mainly for older people.
Grey	Not recommended for either young or old; they find it depressing. Sometimes a fashion colour. Not recommended for packaging.
Black	Fashion colour only.
Grey tints	Mainly for older people.

Note: Attention is also drawn to the notes of colour for children in 11.2 in this part.

10.2 Appearance

Certain colours tend to flatter human appearance and others have the opposite effect. This attribute of colour is chiefly of significance in interior decoration, particularly in commercial and industrial environments and in the home; appearance is relatively more important to older age groups. Some colours, such as pink, flatter by reflection from objects and surfaces, others, such as blue-green, flatter by contrast. Pink and blue are often recommended for bathrooms because of their flattering effect, and pink is recommended for bedrooms for the same reason. Yellow-greens, on the other hand, are most unflattering and give people a sallow look.

After-image may also cause deterioration in the appearance of people in an environment. If things are so arranged that there are large areas of brilliant red in the field of vision, the eyes will become adapted to red, and when they are moved to other areas people seen will look yellow and sick for a short period because of the effect of after-image. The after-image of yellow-green is purplish, and purple has a yellow-green after-image; both should be avoided.

Lighting is also an important factor in achieving satisfactory human appearance and is described in 4.1 above. The colour of the lighting in any area needs to be carefully considered for its effect on the occupants. In any environment, colours used for background should not have a reflectance value exceeding 55 per cent lest the skin of occupants is given an apparent dark pallor by direct visual comparison.

Significance

In consumer applications, colours that flatter the appearance are very suitable

for products used in the bathroom or bedroom, and this attribute can be used in promotion; for example, a pink bathroom is flattering. Unflattering colours should be avoided for products that are likely to be used by individuals for the toilet.

In productive environments, appearance is considered more important where women are employed, and special care is necessary with the colours of bench tops and material being worked, both of which can cause unflattering reflections.

In selling applications, consider the effects of after-image; unflattering colours may deter customers from buying. In all environments flattering colours help to ensure pleasing working conditions.

Appearance has little significance in graphical applications.

Colour analysis

Types of colour are not significant in this context.

Violet	All variations are generally unflattering to human appearance and should be avoided in any situation where colour may be reflected on to humans, especially darker variations.
Blue	Not very flattering when reflected on to the human face, but the medium blues provide good contrast. Blues are a little cool for working environments unless used for a specific purpose, but they are very suitable for bathrooms and the like. Too large areas of blue are, however, likely to be unsatisfactory.
Blue-green	The complement of the human complexion and flatters by contrast. Can be highly recommended from an appearance point of view; less cooling than pure blue.
Green	Perfectly suitable as a contrast but too much green reflected on the human skin has a sickly effect. Green light shining on the human face is to be avoided at all costs. Avocado and chartreuse tend to give people a bilious and sallow look.
Yellow	A flattering colour which provides a warm, sunny effect but too much yellow reflected on the skin may make it look sickly; especially the harsher yellows.
Orange	Not a very flattering colour; it is too strong and may cause the complexion to look unnatural.
Brown	The lighter shades of brown are flattering but not dark browns, although these may provide acceptable contrast. A complexion seen against dark oak, for example, is flattered.
Red	Generally flattering, although too much may look unnatural. Red walls, or even red light, help to create a flattering environment and are used in restaurants for this purpose. Too much red would be a little overpowering in the home. Full-blooded reds, such as crimson,

	make a flattering background for blonds and grey-haired people.
Pink	The most flattering of all colours and is often considered to be particularly suitable for situations, with 'feminine' associations, for example bathrooms, bedrooms and women's rest rooms. Reflections of pink on the face create a flattering, healthy glow. Peachbloom and warm coral are particularly flattering.
White	Neutral in character and while not unflattering, tends to be sterile and uninteresting.
Off-whites	As for white, but the warmer off-whites have more interest.
Grey	Provides a good background but is a little depressing.
Black	Provides maximum contrast with human skin and may account for preferences for black underwear. Black sheets for bedwear are sometimes popular because they are supposed to make the skin look more attractive.

10.3 Associations

Many colours have traditional associations and use of them will often increase appeal; they can also be used in promotion. These associations are with specific products, with ideas or with various aspects of marketing; they have grown up by virtue of tradition, custom or because of long usage. Purple has been associated with royalty from very early times; it has also become associated with chocolate because it has been used by Cadburys for many years and well promoted. The association of blue with the law dates back to Roman times.

Other associations have grown up by chance or have been deliberately established. Red is used for pillar boxes because it is highly visible, but it is peculiar to the UK; other colours are used in other countries. Blue pillar boxes were introduced many years ago for airmail letters because blue is associated with the sky, and although the pillar boxes have disappeared, blue airmail labels are still used.

It is virtually impossible to list all associations but when selecting colour it is useful to consider whether there is an association that could be used with advantage. Many are a matter of common sense; green for agricultural products is an example, and in some cases there is a well-established trade usage. Always use traditional colours where possible because people are familiar with them.

Many colours have associations with religion (e.g. cardinal red) or with politics (e.g. the red flag), but these have little practical applications for commercial purposes. In the UK, however, some care is necessary with the use of orange and green because of religious and political associations; this is particularly the case in Scotland and Northern Ireland. Blue for a boy and pink for a girl were commonly used for products for babies, but this custom is falling into disuse, and recent research suggests that yellow is more popular for female babies. Some colours are associated with parts of the home, such as pink with bedrooms.

The nine colours used in heraldry are very ancient. Gold (or) stands for honour and loyalty; silver (argent) represents faith and purity; red (gules) betokens courage and zeal. There are old-established symbols to represent these colours. There is also an association between colour and music. Many people experience colour responses when music is heard. Slow music is associated with blue; fast music with red; high notes with light colours and deep notes with dark colours.

Some colours have a negative association. Old people protested that a red-and-white colour scheme introduced into their old folks home reminded them of hospitals and death.

Significance

Colour has more appeal when people recognise it as having associations with familiar objects; it also helps to identify traditional things. In many cases it is possible to use a well-established association to create a mood or a desire or to suggest pleasant things. People associate green with the country, and therefore it is entirely appropriate to use it to convey a suggestion of the open air, trees and so forth. People are likely to be attracted to an object if it appears in a colour that they know, and in other cases the traditional colours help to identify an object and bring it to the attention of the viewer. In environmental applications, use colour associations that are appropriate, for example to encourage cleanliness. The remarks made above which apply to consumer applications also apply to graphical applications; colours should be selected to associate with the specific theme that is to be communicated.

Colour analysis

Hard colours	Inviting to the viewer.
Soft colours	Not inviting to the viewer.
Bright colours	Strong, saturated colours create excitement and appeal; associated with high musical notes.
Muted colours	No special associations.
Light colours	Cheerful associations.
Medium colours	No special associations.
Dark colours	Subduing; associated with deep musical notes.
Modified colours	No special associations.
Neutrals	No special associations.
Violet	Not inviting to the viewer. Purple is associated with royalty and chocolates and is frequently used for overall winners in a contest. Lilac is particularly associated with high fashion, florists, cosmetics.
Blue	Not inviting to the viewer. Associated with the law, coolness, the sky, the navy, the sea, summer, engineering, airlines, steel, dairy products, baby products, male cosmetics, electricity. 'Blue for a boy' is still associated with male babies. Blue is traditionally the symbol of first prize and only purple ranks above it as a symbol of excellence. The passive connotation of blue derives from

primitive man, who associated it with dusk. It is also linked with slow music, with depression, with pornography and with cold. In antiseptics a blue/green/silver combination suggests a clinical look.

Blue-green

Associated with cleanliness and freshness. It is the complement of, and flatters, the human complexion.

Green

Neither inviting nor unfriendly to the viewer. Associated with the country, the open air, movement, spring, summer, freshness, trees, agriculture, cosmetics, motor racing (British racing green), safety (growing crops suggest safety). Also associated with jealousy and inexperience and has strong religious associations which tend to cause prejudice against it; it is a sacred colour to Moslems.

Yellow

Associated with energy, spring, summer, sunlight, newness and also with quarantine, defeat and cowardice. Inviting to the viewer. It stands for honour and loyalty in heraldry and is third prize at a cattle show but first prize in athletics. Favoured for female babies, and Kodak yellow is associated with photography world-wide. The energetic connotation derives from primitive man, who associated yellow with dawn.

Orange

Associated with autumn and winter.

Brown

Associated with autumn, winter, warmth, firelight, refinement, quality, the earth. Most of these refer to fawn, beige and tan rather than darker variations. Also has some unpleasant associations (e.g. with laundry soap, manure, etc.).

Red

Inviting to the viewer. In heraldry red betokens courage and zeal, and a red ribbon is usually second prize at a cattle show. Associated with excitement, urgency, warmth, winter, passion, fashion, fertility, fire, the Post Office (although only in the UK), the army, prohibition, danger; it means 'stop' world-wide. It also has political associations (e.g. with the left wing) and is traditionally the colour of fire, although some fire brigades now use orange for their appliances because it has better visibility under modern street lighting. Also associated with anger.

Pink

Associated with fashion, women, flowers, sweetness, confectionery, the bedroom. The old association 'pink for a girl' is now falling out of use.

White

Associated with purity, weddings, cleanliness, but means mourning in some countries.

Grey

Associated with dignity, common sense, good taste, high fashion, conservative; also with depression and old age and, in some circumstances, dirt. In heraldry, silver stands for faith and purity.

| Black | Associated with mourning and high fashion. |
| Grey tints | No special associations. |

10.4 Fashion

Some colours have a high fashion connotation quite apart from trends, and such colours are a potent sales aid in appropriate cases because they have wide appeal. The fashion angle can be promoted and will help to create prestige. It is necessary to draw a distinction between fashion in the sense of trends, and fashions for clothing (of either sex). In the present context it is the latter that is meant, and the term embraces not only clothing but also the accessories and fabrics that go along with them.

The relationship between fashion and colour is a strange one which reflects emotional feelings, tradition, convention, wish fulfilment and other subconscious motivations. Fashion really falls into two parts where colour is concerned; at one end of the scale is high fashion (haute couture), where people do not think alike. They have a wish (either conscious or subconscious) to be different and to set themselves apart, and in this area colour needs to be new, original and creative.

At the other end of the scale is the mass market, where products and colours sell in volume and where people tend to follow broad trends of popularity and do what everyone else is doing. People in the mass market are influenced by the mass media and by what is going on around them, but they will nevertheless take an interest in what is being promoted in high-fashion markets.

Fashions change much more quickly in the clothing area than they do in other product groups, and the poor colour of yesterday may be the best seller of today. But because a colour is popular for clothing it does not follow that it is popular for products used in the home. The principle of high fashion and low fashion does spill over into products for the home but changes are slower.

In general, high-fashion promotions should always employ high-fashion colours, and mass-market promotions should employ mass-market colours, but it is often worthwhile using those colours that are particularly associated with fashion. A high-fashion colour may create 'snob appeal'. In the colour analysis below, those colours that are described as high-fashion colours will generally have little appeal in mass markets.

Significance

In consumer applications, the use of colours that indicate high fashion may be a potent selling point even though the colours do not accord with current trends. It would be particularly useful to include high-fashion, sophisticated colours in a range of colours (e.g. of fabrics) even though the great bulk of the range consists of current-trend colours.

In selling environments, high fashion colours may be important in putting over a high-class image. In graphical applications, use fashion colours where it is desired to put over a specific image. Care is necessary in planning promotion;

the colours must be popular at the time the promotion appears.

Colour analysis

Types of colour are not significant in this context.

Violet	A high-fashion colour, purple often has a short-lived popularity.
Blue	Always popular with the British public. Clear blues are generally mass market and muted blues are high fashion, but this rule does not always hold good.
Blue-green	Turquoise is a high-fashion colour.
Green	Neutral, but strong yellow-greens such as lime green are high fashion. Darker greens often appeal to men.
Yellow	Generally high fashion except in more subtle shades. Golden rod and canary yellow are high fashion.
Orange	Sells in all markets when popular.
Brown	Fawn, beige, tan have a high fashion note and appeal to upper-income groups.
Red	Universally liked and mass market. Blue-type reds have a high-fashion note.
Pink	Subtle pinks are exclusive and high fashion; also considered very feminine.
White	Generally for traditional use, such as weddings.
Grey	High fashion and appeals to upper-income groups.
Black	Usually high fashion, seldom a mass-market trend.
Grey tints	High fashion and appeal to upper-income groups.

10.5 Impulse

Certain colours have high attraction value and may be used primarily to attract attention especially at point of sale, thus creating impulse sales. The best attention getters, in order of rank, are red-orange, red, yellow, green (luminous tones), pink.

Colours having maximum attraction value do not necessarily rank first in visibility and recognition qualities. Red-orange ranks first in attracting attention because it is a colour of great vividness and impact and is impossible to disregard; these colours attract people for visual and optical reasons and attract whether people like them or not. The fact that some colours attract and others do not is tied up with the way the eye sees and the brain perceives. Because the eye is primarily a lens, the brain is the organ that makes sense of what the eye sees, and the image registered on the brain is affected by the conditions under which the eye records the image. Long before colour becomes associated with coolness or warmth or other emotions, it imposes itself on the eye in a primitive way.

When the eye views the spectrum the brain will immediately sort out the elemental hues – red, yellow, green – and the simplest form of these colours will attract attention most easily, irrespective of likes and dislikes; the brighter the

colour, the greater the attraction, because the brightness stimulates the eye to a greater extent. For the same reason, pure hues are preferred to greyish ones. When two or more colours are involved, the brighter colour will have the most attraction because it stimulates the eye to a greater extent; thus better visibility is almost solely dependent on brightness differences rather than on differences between hues.

The first three colours in the ranked list above are hard colours which attract the eye because they are brighter. Green has excellent recognition qualities and is well liked, and it must be included in the list but it is important to use luminous tones of green and not dark or muted greens.

Red-orange is very compulsive, although it does not rank high in average preferences; it is better than brilliant orange because the red in its make-up increases the value. Red has an effect on the autonomic nervous system, and when this is combined with the high visibility of yellow the effect is hard to withstand. Vermilion red also has very high visibility and has a strong visual and emotional impact; it appeals to both men and women in all parts of the world and no other hue has so many advantages. Yellow is the point of highest visibility in the spectrum and is most easy to see, although red has better recognition qualities and will be picked out first. Yellow makes things look larger.

Pure, strong, colours are advised when it is desired to attract attention; greyed and modified colours should be avoided because they are neither one thing nor the other. This point is particularly important in graphical applications, and colour will always dominate neutrality. It is usually advisable to use variations that coincide with current trends of consumer preference for colour and to use combinations that are emotionally acceptable. Impulse colours bring people to merchandise and, in appropriate cases, they will create sales. Impulse colours are also useful for accent purposes and help to create a friendly look, but they should be used with discretion; too much impulse colour is self-defeating.

Significance

In consumer applications, impulse colours are vital when it is desired to attract impulse sales; they may be included in a range of colours purely to attract attention to the range. Impulse colours have little significance in environmental applications, but they are certainly important in graphical applications, particularly for packaging.

Colour analysis

Hard colours	Recommended in all cases where it is desired to attract attention. They are more visible than, and dominate, soft colours and command attention whether or not a person likes them, because they create a physiological stimulus. Hard colours on a soft background will have maximum impact, although some combinations may not be emotionally acceptable.
Soft colours	Best used for background.
Bright colours	Recommended for impulse attraction.

Muted colours	Little impact.
Light colours	Good impulse attraction, depending on hue.
Medium colours	Good impulse attraction, depending on hue.
Dark colours	Little attraction value.
Modified colours	Not recommended.
Neutrals	Some neutrals have impulse attraction.
Violet	Little value from an attraction standpoint.
Blue	Essentially a background colour; passive; little impact.
Blue-green	Has more impact than pure blue, particularly turquoise, which has good impulse value.
Green	Luminous shades of green have good attraction value especially those having a good proportion of yellow. Other variations are best used for background.
Yellow	Excellent attention getter but avoid very pale yellows and harsh, acid variations.
Orange	Red-orange has by far the strongest impulse value; it is impossible to disregard. Preferred to brilliant orange.
Brown	Not recommended. Fawn does have some attraction value but is not as good as orange.
Red	Excellent attention getter but use reds on the yellow side. Vermilion is particularly recommended and appeals universally. Flame red is also good but avoid blue-type reds. Do not use red for background except in special circumstances.
Pink	Luminous tones of pink have excellent attraction value but avoid pale pinks. Coral pink is recommended.
White	Background only.
Off-white	Not recommended for impulse applications.
Grey	Background only; not recommended for impulse applications.
Black	May be useful in special circumstances.
Grey tints	Not recommended.

10.6 Markets

Colour can be related to markets, and the selection of colour for many applications depends very largely on the market that one wishes to attract. The broad principle is that the mass market likes bright and simple colours, while the top end of the market requires something more sophisticated, while specialised markets have specialised needs. Commercial, as distinct from consumer, markets require colours that have a utilitarian purpose; business people tend to react to subdued hues, which reflect tradition and respectability. The more educated individual generally prefers subdued colours, but this is not an invariable rule.

Price is seldom a major consideration when selecting colours; the class of trade is much more important. In mass markets, where bright and simple colours are prescribed, current trends and preferences will usually be a signifi-

cant factor in selection. Bright colours, allied with a high level of illumination, encourage a fast trade, but a quiet family trade indicates more restrained colours.

Broadly speaking, the top end of the market consists of the top 10 per cent, and although trends and preferences are still important, they have less impact than in mass markets. Top customers are looking for something sophisticated and wish to be different from everybody else. The teenage sector is an increasingly important sector; bolder and brighter colours are indicated, and colours must be changed more frequently.

The business market requires separate consideration; the term includes financial services and insurance as well as promotion to business people generally. Trends and preferences play some part in business and commercial markets, and up-to-date variations are most certainly required. Reds, blues and greys are recommended where it is desired to indicate safety, security and restraint.

Significance

When selecting colours for consumer products they should be related to the market at which the product is aimed, and similar remarks apply to products aimed at business markets. There is little significance in environmental applications, except in selling and catering environments, where decor should be related to the type of customer desired.

In graphical applications, colour should always be related to the type of market at which the promotion is aimed, always provided that it is practicable to do so. In many cases, of course, packaging or promotion is aimed at a universal market.

Colour analysis

Hard colours	No particular virtues from a market standpoint.
Soft colours	Generally have more appeal in higher-grade markets, but this is not an invariable rule.
Bright colours	Generally preferred in mass markets.
Muted colours	Generally preferred in sophisticated markets.
Light colours	Preferred in mass markets.
Medium colours	Suitable for all markets.
Dark colours	Mainly for higher-grade markets.
Modified colours	For sophisticated and fashion markets.
Neutrals	No special significance.
Violet	No particular virtue for any market except certain high-fashion markets.
Blue	Good for almost any market. Sky blue often appeals to business markets.
Blue-green	Appeals to most markets; turquoise is recommended for fashion and higher-grade markets and for businessmen.
Green	Appeals to most markets but watch prejudices. Lime and other yellow-type greens can be recommended for higher-grade markets; pastel green is generally well

	liked by businessmen.
Yellow	A mass-market colour. Gold and similar variations are suitable for higher-grade markets, and golden rod can be recommended for business use, especially where it is desired to create impact.
Orange	A mass-market colour. Secures attention in almost any market, but it is a little brash for business applications.
Brown	Not usually for mass markets, although lighter shades, such as fawn, beige and tan, appeal to higher-grade markets. Buff and other yellow-browns are suitable for business markets.
Red	Suitable for all markets, but bluish reds generally have more appeal to higher-grade markets. Scarlet is well liked by businessmen.
Pink	Suitable for most markets but essentially for fashion applications, or for women.
White	Universal market.
Off-white	For higher-grade markets; creates a subtle difference from white and may be used for this purpose in business markets.
Grey	Not recommended for products for the home as a general rule. Charcoal has an appeal in higher-grade markets but is not recommended for mass markets because it tends to suggest futility, particularly at the lower end of the market. It is dignified, and for this reason is often used for business applications. Do not use for promotions directed at the very young or the very old.
Black	Often useful in fashion markets.
Grey tints	Generally for higher-grade markets.

10.7 Moods

Colour appeals to the emotions and different colours convey different moods; appropriate colours may be used to set a mood or convey an image, perhaps of luxury. The effect of colour can be compelling and forceful, and there is strong evidence of its effect on our daily lives. It may be:

- dreamy
- arrogant
- comforting
- luxurious
- fresh

- bold
- exciting
- tender
- restless
- subduing

- seductive
- restful
- like sunshine
- a sign of good breeding
- influential

Bright colours and strong illumination create a centrifugal action; warm, luminous colours help to direct attention outwards while softer colours have the reverse effect. In environmental applications the first encourages a fast trade and a rapid turnover of customers; the combination of bright colour and light tends to excite people and promote a cheerful atmosphere. Softness of colour

invites greater relaxation and encourages people to stay awhile. A dark environment with low light levels is depressing, and a pale environment with low light levels may be too passive. These general reactions are common to most people.

Sophisticated colours are usually required to achieve emotional appeal, but pure hues are indicated where direct impact is desirable. Restrained colours, for example, will help to create a mood of luxury, while neutrals, such as grey or off-white, help to create a mood of dignity or safety. Specific colours can create warmth or coolness, indicate the seasons, flatter the individual, increase the desire for food and perform other useful functions; some create excitement and vitality.

Significance

In consumer applications this attribute of colour is primarily a selling point in interior decoration, but in environmental applications it is an important factor in creating the right decor, particularly in selling environments.

Mood is very significant in graphical applications where colour may be used to create and illustrate a mood or a sales theme. Colour should be selected to support the effect that it is desired to create. An example is the packaging of menthol cigarettes, where green is used to create an image of coolness.

Colour analysis

Hard colours	Generally create an exciting mood and express vitality. They are inviting to the viewer.
Soft colours	Subduing, generally create a quiet mood but can also suggest the sea and waves.
Bright colours	Pale green and yellow will suggest the spring and turn peoples' thoughts to new clothes and furnishings.
Muted colours	Subduing, can suggest luxury and sophistication.
Light colours	Help to direct attention outwards.
Medium colours	No special significance.
Dark colours	Tend to create a sombre, serious, mood.
Modified colours	Often have a strong emotional appeal.
Neutrals	Create a mood of dignity and safety.
Violet	Purple is enigmatic and dramatic; royal purple creates an influential atmosphere. Evokes conflicting emotions; people either like it or hate it; indicates depth of feeling, sensuality and richness but mishandled it can cause confusion and be unsettling.
Blue	The perfect colour to release highly strung, overworked people because it calms their emotions. The peacemaker. Denotes quietness because it retards autonomic responses, and also softness, coolness, freshness, cleanliness, the outdoors generally. Blue is fresh and translucent but may also be subduing and depressing if not used with care; large areas of blue are cold. Smoky blue is particularly depressing and creates a restrained

Muirhead Library
Michigan Christian College
Rochester, Michigan

	mood, although it may also infer influence.
Blue-green	Less subduing than blue. Infers coolness, freshness, cleanliness. Also flattering to the complexion.
Green	Represents stability and security, soothing, refreshing, abates excitement, non-aggressive and tranquil. Denotes freshness, restfulness, the outdoors. Although classed as a cool colour, green is neither inviting nor un-inviting to the viewer and in this context is neutral. It creates a feel of spring and of the country. Fresh and translucent, but pastel greens can be a little subduing; dark greens tend to be rather depressing; greyish green creates an influential image.
Yellow	Friendly and cheerful; it provides inspiration and prompts a sunny disposition. The happiest of colours and 'brings you out of the cold'. Energising and conducive to vitality; incandescent, suggests the spring, sunshine, holidays. Pale yellow produces a quieter note.
Orange	Gives a feeling of solidity and warmth, serenity and assurance; cheerful and stimulating but can also be tiring and slightly irritating in large areas. Compels interest and indicates excitement. It makes a 'loud sound', and although incandescent, tends to be hard, dry and opaque.
Brown	Evokes deep, restful feelings and peace and tranquillity. Peaty browns are intimate; yellow-browns create an intense mood, but tan is soft and warm. Indicates warmth and mellowness. Shades such as tan and sandtone are influential, while fawns and beiges are sophisticated.
Red	Makes for passion, warmth and excitement because it increases autonomic response. Can be welcoming and cosy but also an irritant, especially in large areas; many people quarrel when they are in a bright red room. People react more quickly to red than to any other colour. Rich reds and terracotta are intimate. Creates a 'loud sound' and is hard, dry and opaque.
Pink	Creates a gentler mood than red and is essentially feminine in character. Peach is a warm colour associated with happiness.
White	Neutral in character. Creates a stark atmosphere but is associated with weddings and joyous occasions.
Off-white	Gives a distinctive tone to an otherwise white world. Creates a mood of dignity and safety.
Grey	Creates a mood of dignity and safety and denotes common sense and influence, but in the wrong context may be depressing and suggest old age. A conservative colour which reduces emotional response and is non-committal.
Black	Creates a 'deep tone'. Can be dramatic but may also

	suggest mourning and in the wrong context can be depressing.
Grey tints	Tend to be subduing, but effect depends on the base colour.

10.8 Personality

Colour can be related to personality and the relationship can often be used as a theme for promotion, although it should not be taken too seriously. Experience suggests that people who like specific colours have fairly well-marked personal characteristics and that people who dislike specific colours can be typecast. This is quite a fascinating study and the idea has promotional possibilities (e.g. for personal stationery or for tableware). It is unlikely that there are many other practical applications.

Significance

A suitable product can have a range of colours based on the appeal of colour to the personality of the purchaser, and this can be promoted as a selling aid. The idea needs to be carefully worked out.

Colour analysis

Hard colours	Generally preferred by people with an extrovert personality and younger, less conservative people. Appeal to dynamic people who are outwardly integrated; such people often like modern abstract and radical designs.
Soft colours	Appeal to conservative people who have a natural predilection for tradition and sentiment. They are generally inwardly integrated and usually older.
Bright colours	Outwardly integrated people prefer sharp contrasts.
Muted colours	Inwardly integrated people and conservatives.
Light colours	Generally for outwardly integrated people.
Medium colours	No special connotations.
Dark colours	No special connotations.
Modified colours	No special connotations.
Neutrals	No special connotations.
Violet	People who like purple tend to be artistic, temperamental, introspective, aloof, aristocratic, creative. People who like lavender are generally quick witted, individualistic, vain, refined. People who dislike purple are generally critical, lacking in self-confidence.
Blue	Like: deliberate, introspective, conservative, cautious; they have reflective minds and are likely to be conscientious workers. Dislike: irritable, neurotic, resentful.
Blue-green	Like: discriminating, exacting, sensitive. Dislike: disap-

	pointed, confused, weary.
Green	Like: good citizens, loyal friends, frank, moral; they have balanced personalities and are good workers. Dislike: frustrated, undeveloped.
Yellow	Like: intellectual, idealistic, aloof; they have imagination, nervous drive and they like novelty. Dislike: seeking reality, critical.
Orange	Like: social by nature, gregarious, good natured. Dislike: serious, cold.
Brown	Like: conscientious, shrewd, obstinate, conservative; they are solid and dependable types. Dislike: generous, gregarious, impatient.
Red	Like: aggressive, vivacious, passionate, optimistic, dramatic, may be abrupt in manner. People who like maroon are generally passionate but disciplined. People who dislike red tend to be fearful, apprehensive, unsettled.
Pink	Like: gentle, loving, affectionate. Dislike: resentful, peevish.
Grey	Like: calm, self-contained, sober, dedicated. Dislike: unemotional, mediocre.
Black	Like: regal, dignified, passive, sophisticated. Dislike: fatalistic, naïve.

10.9 Preferences

If people are asked which colours they like, the results of the poll will be consistent and more or less true world-wide, although preferences vary with age. These preferences are, however, overriden by trends of consumer preference for colour, which vary with fashion, with markets and with type of customer. The remarks that follow apply to people in the mass and not to individual preferences, which have little place in commercial applications. Individual preferences are related to personality as described in the previous section. The rankings are:

Children	*Adults*
yellow	blue
white	red
pink	green
red	white
orange	pink
blue	violet
green	orange
violet	yellow

The fact that people *like* these colours in the order set out does not necessarily mean that they will *buy* them or be influenced by them in promotional applications. Colour preferences change with age but also vary according to

education, income group and mentality. Natural preferences are superseded by trends of consumer preference, particularly when buying colours for the home.

These natural preferences do not help very much in selection of colour for specific applications, because there are situations where the best-liked colours, such as blue, would be quite unsuitable. Furthermore, at any given time the preferred shade of blue would vary according to current trends and according to the market and product concerned. Preferences for type of colour also change from time to time; at some periods pastels will be preferred to muted colours, and so forth.

Even though yellow is at the bottom of the list of preferences of adults, it cannot be left out of any calculations, because it is the most visible and recognisable of all colours and has many practical uses whether people like it or not. It has less appeal to older people because the eye tends to yellow with age. Blue comes first in any poll and is particularly popular with the British, probably for climatic reasons. Red is universally popular, irrespective of nationality.

Climate plays some part in preferences. In sunny regions the most wanted colours are likely to be warm and vivid, but in cloudy regions people generally prefer cooler and more subdued hues. This is because in sunny regions the colours have to compete with the strength of the sun; pastels would be 'lost'. Economic conditions also play some part in preferences. During depression years people tend to prefer subdued colours because they buy for the long term and subdued colours are thought to last longer. When buying conditions are good, people tend to look for bright, vivid hues.

It will be noted that preferences vary with age, but it is difficult to draw a hard-and-fast line between children and adults. Blue is quite well down the list of preferences of young children, but liking increases with age and reaches the top position with the mature adult. Children tend to prefer brighter colours than older people, and this becomes significant when selling to teenagers and young adults – they will generally purchase brighter colours than their elders and do not usually like pastels.

In broad terms, simple colours are preferred to complex ones and pure colours are preferred to greyish ones.

Significance

Broad preferences are significant when all other factors are equal. When selecting colours for most consumer applications consider fashion and trends first because these are the most important in sales terms, but in a range of colours include a proportion of colours that are likely to appeal to the type of customer at whom the range is aimed. Individuals may well dislike trend colours, and a range should be designed to meet their needs as well as those of the majority. Similar remarks apply to environmental and graphical applications.

Colour analysis

Hard colours Generally preferred by young people and those living in sunny climates.

Soft colours	Preferred by older people and those living in temperate climates.
Bright colours	Pure colours are preferred to greyish ones. Pure colours should be as brilliant and saturated as possible.
Muted colours	No special preferences.
Light colours	Preferred to dark ones.
Medium colours	No special preferences.
Dark colours	Less well liked than light colours.
Modified colours	Not generally well liked.
Neutrals	No special connotations.
Violet	Choice 8 (out of eight) in children, 6 in adults.
Blue	Choice 6 in children, 1 in adults. Comes first in any poll and is very popular with the British. Liking increases with age.
Blue-green	As for blue.
Green	Choice 7 for children, 3 for adults.
Yellow	Choice 1 for children, 8 for adults. Yellow is bottom of the list of preferences for adults because the eye yellows with age, but it cannot be left out of consideration because it is the most recognisable and visible of all colours and has many practical uses whether people like it or not. Particularly appeals to babies and very young children.
Orange	Choice 5 for children, 7 for adults. Low in both categories but has many practical uses.
Brown	Not well liked except when fashionable.
Red	Choice 4 for children, 2 for adults. Universally popular irrespective of nationality. A red which is less than pure may appear shoddy, weak or faded.
Pink	Choice 3 for children, 5 for adults. Does not usually appeal to teenagers, and is found to appeal to women more than men.
White	Choice 2 for children 4 for adults. Should be unquestionably white; if this cannot be achieved, try some other colour.
Off-white	No particular preferences.
Grey	Not well liked by either young or old. If used, should be unquestionably grey.
Black	No particular preferences.
Grey tints	As for basic hue.

10.10 Presentation

The selection of appropriate colours for point of sale use, for presentation themes, requires special consideration. In practical terms there is little difference between colours for display and colours for presentation, the main distinc-

tion being one of usage. The term is intended to cover the use of colour to enhance reports, sales literature and other items of a similar nature when presented by salesmen or intended to enhance a company image.

The colour used will depend on the exact usage. In some cases bright colours with a high degree of impulse attraction will be most suitable; in other cases something more restrained and dignified is indicated, especially where it is intended to enhance corporate image. Some organisations may use house colours for this purpose or they may have a standard company colour for sales presentation purposes, and this should have an association with the product or service concerned.

In most cases a distinctive colour will be useful: one which attracts attention, can be easily remembered and which is recognisable as belonging to the company concerned. Pure, basic hues are generally recommended, except in those cases where it is desired to put over a positive image, perhaps of high fashion or financial solidity. Generally speaking, colours should be up to date and lively, and fairly frequent alterations may be required because specifiers will be looking for something new. Use colours that:

- attract attention
- are easy to identify and remember
- have an association with the product or service
- have good visibility
- reflect current trends
- have dignity and solidity
- have unusual qualities, in some cases.

Significance

In consumer applications, presentation colours are chiefly required in connection with promotional material, or products intended to convey an image. In environmental applications they only have significance in connection with house colours and the like. They are important in graphical applications, particularly for printed material like brochures and so on.

Colour analysis

Hard colours	Generally preferred for presentation purposes.
Soft colours	Use only where a subdued image is required or as background.
Bright colours	Have more impact than dark colours but the latter may be preferred as having more dignity.
Muted colours	May be used where dignity and restraint are required.
Light colours	Recommended where impact is required.
Medium colours	For general use.
Dark colours	Where dignity and restraint are required.
Modified colours	Not recommended.
Neutrals	Lack impact in this context.
Violet	Not generally recommended except for high-fashion presentations.

Blue	Medium clear blues have dignity, and although they do not have a great deal of impact, they convey a feeling of efficiency. Muted shades of blue would be suitable where it is desired to convey restraint.
Blue-green	Turquoise has more impact than blue and has dignity and fashion associations.
Green	Clear greens on the yellow side are suitable for many applications; medium shades have good attraction qualities, good visibility and good recall value.
Yellow	High visibility and excellent attraction value but may be a little overpowering for most applications. Muted shades such as gold are dignified and convey an impression of luxury.
Orange	Maximum visibility and impulse attraction but a little too brash for most business applications.
Brown	Lighter shades such as beige have a high-quality image and reasonable visibility. Darker shades are a little too retiring, although they convey solidity.
Red	Excellent recognition and impulse qualities, and one of the best of all colours for presentation. Yellow variations are preferred, but darker reds and blue-type reds often have fashion connotations and convey restraint.
Pink	Good visibility and considered suited to certain presentations aimed at women. Rose pink has fashion implications.
White	No special virtues in this context.
Off-white	No special virtues.
Grey	Not recommended except where it is desired to convey a particularly restrained image.
Black	Not recommended except in very special cases.
Grey tints	Not recommended.

10.11 Products

Colours often have an association with specific products or services, and these associations should be respected. The right colour to use for any product or service is the colour that will sell that product or service, and a colour which is associated with the product in the minds of purchasers will generally be more effective than a colour that is not. This will apply to the selection of colours for the products themselves as well as to the promotion of the product. Most of these associations have grown up over the years and have been discovered by trial and error or by research. There are some broad rules that apply in most cases:

- Products used in the home should be associated with colours that are popular for interior decorating.
- Expensive colours should be used for expensive products.

- Food colours should be used for food products, especially those that are appropriate, for example red for meat, yellow for butter, green for vegetables.
- Pale, delicate colours are best associated with flowers.
- Light colours suggest lightness and are good for textiles, underwear and so on.
- Grey should not be used for most home products; it may suggest dirt.

The following list of specific applications is primarily of interest in connection with packaging, print and other promotional applications; the selection of colours *for* products is a much wider subject discussed in later sections.

Some associations with specific products

Aspirin	Orange and blue are recommended for children.
Baby products	Blue and pink are traditional but lack compulsion; red, yellow and strong blue would be better.
Beverages	Cola is brown, lime is green, lemon is yellow.
Coffee	The colour of the can is significant; mauve has been found to be quite wrong.
Cigarettes	Red tends to suggest a harsh taste, pink is too feminine, brown tends to suggest manure, black is too funereal; white suggests cleanliness and purity; green is associated with menthol cigarettes and conveys a theme of coolness.
Chemicals	Neutral colours are normal except for household products.
Child's wear	Yellow can be recommended, but avoid green.
Cosmetics	Colour is often used to identify different scents or uses. Sophisticated colours are recommended and should follow fashion trends; pastel colours are preferred but avoid pasty colours. Recommended colours include pink, yellow, aqua, peach, flesh, rose and orchid, all of which are considered feminine. Sea blue, lime green, strong greens and reds are considered masculine.
Dairy products	Blue and white are recommended (see also milk).
Electricity	Blue is associated with electricity.
Farmers	Green is a poor colour for products bought by farmers because the farmer is in a green atmosphere all day. It may be suitable for winter, but red is better for summer.
Fish	Blue or pink can be recommended; pink is the colour of shellfish.
Household products	Colours should be associated with the usage of the product (e.g. in the kitchen, bathroom, etc.). Purple is unsuitable for kitchen products.
Milk	Blue is particularly suitable because it is 'clean', but very pale blue may suggest that the milk is watery.
Machinery	Red is a traditional colour, particularly for exhibition purposes, but is not recommended for normal use.

Peas	Special care is necessary in choosing colours for packaging; the wrong shade of green may suggest staleness.
Soap	Red and brown are traditional for carbolic soap, but brown also denotes laundry soap.
Pharmaceuticals	White, black or neutral are recommended for ethicals; for other pharmaceuticals use restrained colours suggesting coolness and cleanliness.
Photography	Kodak yellow is known world-wide.
Sanitary towels	White, light blue, dark blue, pale mauve, pink, green have been found suitable.
Steel	Blue is traditional.
Toothpaste	Yellow-green is not liked for things put in the mouth.

Significance

In consumer applications always consider whether there are any associations that can be used with advantage (whether listed here or not), but do not neglect other factors when selecting colours for products. Product colour may be useful in selling environments but not elsewhere. In graphical applications make use of product associations where practicable; a familiar colour may help to arouse a train of thought in the minds of prospective purchasers.

Colour analysis

Hard colours	No special associations with products.
Soft colours	No special associations.
Bright colours	Generally preferred for products where brightness is a virtue.
Muted colours	No special associations.
Light colours	Light, delicate, colours; for example, pastels are best with flowers.
Medium colours	No special associations.
Dark colours	In many cases dark colours infer heaviness or strength.
Modified colours	No special associations.
Neutrals	No special associations.
Violet	Cosmetics, fashion, florists. Mauve is particularly good for florists. Avoid purple for coffee and kitchen products.
Blue	Travel, food, fish, steel, engineering, electricity. Blue is particularly associated with baby products and with kitchen products because of its cleanliness; also good for dairy products and milk. Recommended for masculine cosmetics. Sapphire blue is good for caps and closures.
Blue-green	Travel, food, cosmetics. Aqua is recommended for cosmetics; turquoise is good with meat products.
Green	Farm produce, florists, trees, cosmetics. Clear greens are best for farm produce but not recommended for products sold to farmers. Associated with lime juice. Lime

	green for cosmetics and strong greens for masculine toiletries. Avoid green for childrens' wear and for anything put in the mouth (e.g. toothpaste).
Yellow	Travel, food, photography, cosmetics. Associated with lemon drinks; recommended for childrens' wear. Primrose yellow is good for caps and closures.
Orange	Food.
Brown	Associated with cola drinks and coffee. Avoid use of brown for cigarettes and use with care for soap.
Red	Travel, food, meat products, machinery, soap. Use for masculine toiletries but with care for cigarettes.
Pink	Cosmetics, food, confectionery, fish, fashion. Flesh, peach, rose are good for feminine cosmetics; traditionally for baby products; use for shellfish. Peach is particularly good with food and, along with soft rose, can be used for fashion promotions. Pink is for 'feminine' cigarettes.
White	Pharmaceuticals. Right for most products but lacks impact.
Off-white	No special associations.
Grey	Should not be used for products for the home.
Black	Associated with pharmaceuticals, particularly ethicals.
Grey tints	No special associations.

10.12 Recognition

Some colours have better recognition qualities than others, although not necessarily better visibility.

There is a difference between recognition and visibility. Although yellow is the point of highest visibility in the spectrum, red would be far better than yellow on a supermarket shelf because red has better recognition qualities. White has little visual interest, and although it has good visibility it has less good recognition qualities and is difficult to identify. Studies have shown that red is first in recognition value and easiest to identify; next is green and then yellow and white.

Significance

This attribute may be significant in consumer applications when it is desired to create a corporate or brand image, and it is valuable in environmental applications for marking hazards or, say, drawing attention to directions. Recognition is also important in graphical applications when it is desired to create an image and attract attention, and it may have to have priority over all other considerations.

Colour analysis

Hard colours	Better recognition qualities than soft colours.
Soft colours	Poor recognition qualities.
Bright colours	Generally good recognition qualities.
Muted colours	Poor qualities.
Light colours	Recognition qualities depend on hue.
Medium colours	Qualities depend on hue.
Dark colours	Not easy to recognise and remember.
Modified colours	No special connotations.
Neutrals	Poor recognition qualities.
Violet	Poor recognition qualities.
Blue	Poor recognition qualities.
Blue-green	Easier to recognise than blue.
Green	Excellent recognition qualities.
Yellow	Good recognition qualities; although highly visible it is not so easy to recognise as red.
Orange	Red-orange has excellent recognition qualities.
Brown	Poor recognition qualities.
Red	The easiest colour of all to identify and recognise.
Pink	Poor recognition qualities.
White	Has little visual interest because of its lack of chromaticity. Good visibility but difficult to find and identify.
Off-white	Not significant.
Grey	Difficult to identify.
Black	Not easy to identify.

10.13 Reflectance

Every colour that is applied to a surface reflects back a proportion of the light that falls upon it and absorbs the remainder. The proportion reflected is the reflectance, or reflectance value, of the colour, and this is significant in many applications. Thus a surface which reflects back three-quarters of the light falling upon it has a reflectance value of 75 per cent.

The reflectance value is a measure of the brightness of a colour and is an expression of the value of a colour, value being the quality which distinguishes a light colour from a dark one. The higher the value of a hue applied to a surface, the more light is reflected back and the higher the reflectance value. White reflects back as much as 80 per cent of the light that falls upon it, but black only reflects back about 5 per cent. The exact reflectance value of any colour depends on the precise tint, shade or tone; on the degree of gloss of the finish; on the conditions of viewing; and on the nature of the light source.

A coloured surface may not have exactly the same reflectance value under light from different sources having different spectral composition. A red surface, for example, has a somewhat higher reflectance value under incandescent light, which has a high red content; a blue surface has a higher reflectance value under white fluorescent light. In practice the differences are small and can be ignored.

For most practical purposes an approximate figures is sufficient, and if the Munsell notation of the colour is known, it is quite easy to calculate the reflectance value by using the formula $V(V-1)$, where V is the value figure in the Munsell notation. Most paint and printing-ink manufacturers provide reflectance values for the colours in their ranges.

Pink is a high-value red and maroon is a low-value red; it follows that pink will reflect more light than maroon. Because high-value colours reflect more light, they have greater impact on the eye and attract more attention, and when applied to surfaces they may have more effect on the appearance of adjacent objects. Thus the effect exercised by a particular hue will depend on the reflectance value of that hue, and this is of particular importance in controlling light in the environment.

Reflectance values provide a useful means of classifying colour and provide a guide to contrasts between colours; the greater the difference between values, the greater the contrast. A colour having a low value will be accentuated by colours having a high value. Reflectance values provide a useful guide to colours used for identification purposes and to colours used for heat control purposes; colours of high value reflect heat as well as light. They may also be significant when considering colours to be used on television; a contrast ratio of about 5 : 1 is desirable.

Significance

Reflectance values have limited significance in consumer applications, except when planning interior decor, but they have a vital role in environmental applications for control of the total lighting environment. This is discussed in 16.2 in this part.

Reflectance values are also significant in graphical applications. For example, in packaging, a feature colour having a comparatively low value will be enhanced by a background of high value. A dark red feature would be enhanced by a light blue background.

In print, readability is ensured by the contrast between colours; maximum readability is provided by black and white, which has a contrast ratio of 15 : 1, but other colours can be used provided that the ratio between them does not fall below 8 : 1. The contrast ratio is the higher reflectance value divided by the lower. Colours with a high reflectance value are generally good for display purposes.

The reflectance values quoted in the colour analysis below are typical figures but are approximate. They are based on calculations using a photometer and light reflected at 45 degrees.

Colour analysis

Hard colours	Not significant.
Soft colours	Not significant.
Bright colours	High reflectance value by definition.
Muted colours	Usually have a low reflectance value.
Light colours	High reflectance value by definition.
Medium colours	Low reflectance value by definition, but depends on hue.

Dark colours	Low reflectance value by definition.
Modified colours	Depends on hue.
Neutrals	Most have a high reflectance value.
Violet	Typical purple, 20 per cent.
Blue	Light blue, 36 per cent; dark blue, 8 per cent.
Blue-green	Typical variation, 42 per cent.
Green	Sage green, 36 per cent; dark green, 9 per cent.
Yellow	Typical variation, 51 per cent.
Brown	Buff, 51 per cent; medium brown, 27 per cent.
Red	Dark red, 13 per cent.
Pink	Light pink 66 per cent; flesh, 51 per cent.
White	Typical white, 84 per cent.
Off-white	Cream, 68 per cent; ivory, 66 per cent.
Grey	Light grey, 45 per cent, aluminium grey, 41 per cent.
Black	Typical black, 5 per cent. No black surface absorbs all light; the more light that shines upon it the blacker it appears to be.
Grey tints	Reflectance value depends on base hue.

10.14 Regional

Certain colours are more appropriate to some parts of the country than to others, but this is often a local problem which requires a local solution; there may be traditional colours in some parts of the country.

One regional factor is the incidence of coloured people, both black and brown, in the population. Generally speaking, such people prefer brighter colours for both cultural and practical reasons. Those areas of our cities where there is a substantial coloured population show records of sales in brighter and stronger colours than normal. The coloured population is increasing, has relatively high spending power and strong brand loyalty, and therefore is worth cultivating from a marketing point of view. For obvious reasons cosmetics are the strongest market.

Climate may also have some significance in environmental applications. Brighter colours tend to sell better in seaside locations of the UK than they do in urban areas because the light is stronger in the former. Cool tones should be used for interiors where there is plenty of sunlight, but warmer tones would be better in cloudy regions.

One regional aspect that should always be borne in mind is that of religion. The use of orange and green in countries and towns that have an Irish element needs particular care.

The remarks made above apply primarily to UK markets. Other countries require special consideration, each country having its own individual characteristics. This is a subject which does not lend itself to specific analysis, but it should be borne in mind whenever colours are being selected.

10.15 Seasons

There are colours that are appropriate to each season of the year and these can be used in promotion of seasonal products or in promotions undertaken at appropriate seasons. Every colour belongs to some season of the year because of the close association of colour with nature; yellow and green are the colours of the country in spring and summer; browns and reds are the colours of autumn leaves.

- Spring Use bright, pale, colours; yellow, pink, green; remember green for St Patrick's Day in March.
- Summer Darker shades than for spring; blue, yellow, green.
- Autumn Brown, yellow brown; orange particularly for the late autumn; fawn and beige for late autumn.
- Winter Orange can also be used for early winter; red, especially for Christmas; fawn and beige can also be used.

Colour has more impact in the spring, probably because increasing sunshine affects bodily functions and causes something of an inner compulsion to use delicate hues. It is no accident that the thoughts of people turn to new clothes and new furnishings in the spring, it is a natural process, and for the same reason it is also a good time to introduce new colours, although new colours are often introduced in autumn as well where the marketing picture so dictates.

Significance

When planning a promotion for any season of the year (e.g. spring promotion) use those colours that are appropriate to the time of year. Colours for products that have their maximum sales in, say, winter can also be chosen with the season in mind. Typical examples are space heaters, which have their maximum sales in the winter; on the other hand, leisure products which sell best in the summer should be featured in the yellows and greens of that season. This attribute is not significant in environmental applications.

Colour analysis

Hard colours Essentially for autumn and winter because they are warm.

Soft colours Essentially for spring and summer because they are cool colours and associated with the outdoors.

Bright colours Suggest sunshine and are particularly welcome in spring, but bright, warm colours are also warming in winter.

Muted colours Tend to be subduing and cooling, spring and summer.

Light colours Essentially for the spring.

Medium colours Spring and summer.

Dark colours Autumn and winter, but too dark colours may be rather sombre.

Modified colours No special connotation.

Neutrals No special connotation.

Violet Summer, paler versions such as lilac may be used for spring.

Blue	Acceptable for all seasons because it is the colour of the sky but is especially associated with summer.
Blue-green	As for blue.
Green	The colour of the country; particularly associated with spring and, to a lesser extent, summer. In appropriate cases use green for St Patrick's Day in March, and dark green also has associations with Christmas.
Yellow	The colour of sunshine, especially associated with summer but equally good for spring; think of daffodils.
Orange	A warm colour but bright and particularly suitable for early winter; think of the leaves in autumn.
Brown	Essentially the colour of autumn and winter. Warm and the colour of the leaves, the trees and the earth in winter. Fawn, beige and lighter shades of brown are best for the early part of the winter.
Red	The warmth and the cosiness of red makes it specially suitable for winter, and it is particularly associated with Christmas.
Pink	The pale, delicate tone of pink is suitable for spring; stronger shades for summer.
White	Late winter and early spring; think of snow and crocuses.
Off-white	As for white.
Grey	Only suitable for winter but can be a little depressing. Light shades, such as silver, might do for spring.
Black	No seasonal implications.
Grey tints	Depends on base shade.

10.16 Sex

In general, some colours appeal more to women than to men, while other hues appeal most to men. This fact can be used in many different ways.

Colour tends to appeal more to women than it does to men, and women often take a greater interest in colour and fashion. There does not seem to be any reason for this other than the traditional association of women with the home and gentler pursuits. It has been said that British men fight shy of fashion and are suspicious of colour; their sexual insecurity makes them take refuge in neutrality. This is almost certainly less true today than it may have been at one time. For the most part men are more individualistic in their interpretation of colour. Here are some broad rules:

- Women tend to prefer lighter colours than men of the same age.
- Trends and fashions tend to be relatively more important to women than to men.
- Men are usually particularly interested in the colour of cars and of mens' clothing.
- Younger men often have more subtle tastes in colour than older men, particularly for clothing.

- Women tend to be susceptible to colour advertising, especially for products that appeal to women.

Significance

In consumer applications, use feminine colours for products bought by women. Sex has little significance in environmental applications except for facilities designed specifically for males or females; for example, a washroom for men is best in blue but a similar facility for women is best in pink. 'Feminine' colours may be used for working areas where women predominate; colours that flatter appearance are particularly important. Sex has most significance in graphical applications; 'feminine' colours can be used with advantage for promotion aimed at women and 'male' colours for promotions aimed at men. This is particularly important in packaging, where appropriate colours will suggest feminine (or male) appeal. For example, cosmetics are commonly packed in pink, or pastel, containers whereas mens' toiletries are packed in strong blues and dark greens.

Colour analysis

Hard colours	Most appeal to men but also appeal to women with dark hair.
Soft colours	Generally, but not always, appeal to women, especially with fair hair.
Bright colours	No special connotations.
Muted colours	No special connotations.
Light colours	Pale and pastel hues are often considered feminine.
Medium colours	Appeal to both sexes.
Dark colours	Generally appeal to men.
Modified colours	No special connotations.
Neutrals	Tend to be more feminine than male in appeal.
Violet	Most variations have feminine appeal.
Blue	Considered a male colour, but women will of course buy blue for themselves because they think that men like it. Blue for a boy is well established.
Blue-green	Tends to appeal to women more than blue, especially aqua.
Green	Appeals to both sexes, but dark green tends to appeal more to men.
Yellow	Considered feminine, but stronger shades appeal to men. Commonly used for female babies.
Orange	Probably appeals to women more than to men.
Brown	Generally appeals to women, especially lighter variations such as fawn and beige. Yellow-browns, including tan, tobacco and saddle brown, tend to appeal to men because of their association with outdoor pursuits.
Red	Appeals to both sexes equally.
Pink	Often appeals to women but not generally to men. Rose pink is considered to be particularly feminine; peach and

flesh also appeal. Pink was, at one time, particularly associated with female babies, but yellow is now taking its place.

White	Neutral.
Off-white	Cooler off-whites tend to appeal more to men; women generally like warmer variations.
Grey	Appeals to both sexes but essentially a fashion shade for women; a status symbol for men.
Black	May be bought by men for women because of its contrast with pink skin.
Grey tints	Considered feminine in character.

10.17 Shape

In psychological terms, colour tends to suggest certain shapes, and this may be useful in some design applications, or in packaging, to create greater emotional appeal.

Significance

This point has little significance in choice of colour for products but it is often useful to the designer.

Colour analysis

Hard colours	Form a sharp and clear image on the retina and suggest angularity.
Soft colours	Tend to appear blurred and suggest roundness and softness; will convey a rounded or gentle image.
Bright colours	No special connotation.
Muted colours	Same effect as soft colours.
Other colour types	No special connotations.
Violet	Suggests the form of an oval. Soft, filmy, never angular. Tends to 'cling to the earth'.
Blue	Suggests the form of a circle or sphere. Does not lend itself to sharpness of detail.
Green	Suggests the form of a hexagon. Not sharply focused and does not lend itself to much angularity. A 'big' colour which can dominate the eye without distressing it. Cool, fresh, soft.
Yellow	Suggests the form of a pyramid or triangle with its apex or point down. Sharp, angular and crisp in quality but without solidity. The point of highest visibility.
Orange	Suggests the form of a rectangle. It produces a sharp image and therefore lends itself to angles. Hard, dry and impelling.
Brown	No special connotations.

Red	Suggests the form of a square or cube. Sharply focused and lends itself to structural planes and sharp angles; has a feeling of durability, solid and substantial; hard, dry and opaque in quality.
Pink	No special connotations.
White	No special connotations.
Off-white	No special connotations.
Grey	No special connotations.
Black	Signifies solidity.

10.18 Size

Colour can make objects look larger or smaller, heavier or lighter and can make objects or surfaces look nearer or further away. These effects are due to a combination of optical and physical phenomena. Apparent size is a function of brightness because when it strikes the eye, the image tends to spread out like water on blotting paper and thus something bright will form a larger image than something dark. Yellow will be seen as largest followed by white, red, green, blue and black. Pastels or light tints will seem larger than shades.

However, in addition, the hard colours are only slightly refracted by the lens of the eye and focus at a point behind the retina, and in order to see them clearly the lens grows more convex, pulling the colour forward and making the image larger. The image will also seem to be nearer. The cool colours tend to retire because they focus at a point in front of the retina thus causing the lens to flatten out and pushing the image back, making it seem smaller and further away. Because of these qualities, hard colours will also tend to make surfaces, such as walls, look nearer than they actually are, whereas cool colours will tend to cause them to recede.

Apparent weight is also a function of brightness, the lighter and brighter the colour, the lighter in weight it seems to be, while darker colours give a sense of weight. The effect of colour on weight depends more on the depth of hue than on the hue itself. A shipping crate painted dark grey will appear dense and heavy, but the same crate painted yellow or light green will be apparently easier to lift. The colour of the light also has some effect; experiments have shown that red light tends to make weights appear to be heavier, and judgement of length is also much less accurate in red light than in green light. In general terms, dimension in colour increases from coolness to warmth, from darkness to brightness and from greyness to purity, while apparent weight decreases in the same way.

Significance

These effects are particularly important in display, packaging and print applications and explain why it is universally recommended that cool colours should be used for background and hard colours for the features of a design; the back-

ground tends to retire and the feature comes forward and impresses itself on the viewer. The apparent weight effect of dark colours is often used to give stability to an object. A base in dark colours will often be used so that a package or object does not look as if it would blow away in every wind.

These effects also have significance in interior decoration. Cool colours are often used to make a room look larger, while warm colours make a room seem more cosy.

Colour analysis

Hard colours	Make an object look nearer and larger; surfaces appear nearer to the eye.
Soft colours	Make an object look further away and smaller; surfaces appear to recede.
Bright colours	Make an object look larger and lighter; surfaces are nearer.
Muted colours	Make an object smaller and heavier; surfaces recede.
Light colours	Make an object look larger and lighter; effect on surfaces depends on contrast.
Medium colours	Effect depends on hue.
Dark colours	Make an object look smaller and heavier. Effect on surfaces depends on hue.
Modified colours	No special connotations.
Neutrals	Make an object larger and lighter in some cases, but grey is a far element.
Violet	Make an image smaller and surfaces look further away.
Blue	Makes an image smaller and surfaces look further away.
Blue-green	Makes an image smaller but not as much as pure blue.
Green	More or less neutral. Lighter greens will make the image larger but darker shades will make it seem smaller with an equivalent effect on surfaces.
Yellow	The largest of all colours and surfaces seem nearer to the viewer. Also gives the lightest sense of weight.
Orange	Makes the image larger and surfaces look nearer.
Brown	Effect depends on the variation used. Lighter shades will make the image look larger; darker shades will make it look smaller with an equivalent effect on surfaces.
Red	Makes the image larger and surfaces look nearer to the eye.
Pink	As for red; stronger pinks will make an image look even larger than dark reds.
White	Makes the image larger but has little effect on the distance of surfaces.
Grey	Makes an image smaller and surfaces seem further away.
Black	Smallest of all colours but gives a good sense of weight. Effect on surfaces tends to be claustrophobic.

10.19 Smell

There is an association between colour and smell which can be used in appropriate cases. There is also a physical link; strong smells raise the sensitivity of the eye to green and decrease sensitivity to red, although this has little practical application. This association is primarily one of nature: various plants and foods have distinctive scents and colours, and use of the appropriate colour conveys an impression of the scent. Thus pale green would be appropriate to a pine-scented soap. Pink has an association with flowers in general and with the scent of crushed flowers in particular; pale colours generally are associated with flower scents. Green has an association with many odours, including trees, herbs and shrubs generally; it has been successfully used for a scent combining floral and woodland elements. Other examples of green include pine, sage, olive and apple. Blue is associated with antiseptic qualities because of its connotations of cleanliness. Purple conjures up rich, exotic odours, but brown is more earthy in nature.

Significance

This attribute is chiefly significant in connection with the colour of packaging; it would be very appropriate to use green for a pine-scented soap as suggested above, and this applies to the packaging as well as to the soap itself. Colours having the right association can, of course, be used for any product where it is appropriate to do so, particularly if the scent is an important selling point. The taste may also be significant.

Colour analysis

Types of colour have little significance in this context, except that pastels and pale colours are associated with flowers.

Violet	Typical colours with an associated distinctive scent are lilac, violet, lavender. Purple conjures up rich, exotic odours and lavender has pleasing associations.
Blue	Blue is particularly associated with antiseptics and cleaning products having an antiseptic smell.
Blue-green	As for blue.
Green	Typical colours: pine, wintergreen, sage, olive, apple, lime. Green is also associated with trees, herbs and shrubs generally, and also with scents conveying a country atmosphere. It has pleasant associations.
Yellow	Typical colours: vanilla, lemon, honeysuckle, saffron.
Orange	Typical colours: orange, apricot, tangerine.
Brown	Coffee, balsam, cedar, chestnut, ginger, cinnamon, nutmeg, chocolate. Also associated with carbolic soap and laundry soap.
Red	Rose, plum, geranium.
Pink	Rose, carnation, peach; pink has an association with flowers in general and crushed flowers in particular.

White	No associations, except, perhaps, lilies.
Off-white	Lily of the valley, almond.
Grey	Charcoal.
Black	No associations.

10.20 Stability

Colour is often used to suggest stability, dignity and restraint as distinct from impulse and excitement. This use will often be associated with corporate image. A bank, for example, would want to create an image of stability quite opposite to the excitement generated by a supermarket and to that end would use dignified and restrained colours. In print applications it will often be desirable to convey dignity and even some interiors may be planned to enhance the dignified status of the occupant.

Significance

Colour conveying stability can often be used with advantage for higher-grade products and as part of a company image. In environmental applications, colour may be used to create an atmosphere of dignity as in a bank. In graphical applications, colours expressing stability may be used to convey an appropriate image, either corporate or brand.

Colour analysis

Hard colours	Generally suggest excitement.
Soft colours	Recommended where dignity and restraint are required.
Bright colours	Suggest brightness and awareness.
Muted colours	For dignity and restraint.
Light colours	More associated with excitement.
Medium colours	Effect depends on hue.
Dark colours	Suggest stability and weight.
Modified colours	No special connotations.
Neutrals	Effect depends on hue.
Violet	Restrained colour; purple suggests influence.
Blue	Restrained colour; fresh but not particularly dignified.
Blue-green	Suggests a higher-grade image than blue.
Green	Suggests stability and has safety associations. Greyish greens suggest an influential atmosphere. Restrained colour; darker greens may be a little depressing.
Yellow	Suggests vitality, but muted shades such as gold create dignity and stability.
Orange	Brash colour, not suitable to convey stability.
Brown	Denotes refinement and quality. Tan is recommended for good taste and has an influential quality.
Red	Cool reds are dignified; bright reds are exciting.
Pink	Creates a gentler mood than red, and a 'feminine' atmosphere, but does not suggest stability.

White	Dignified but a little stark and sterile.
Off-white	Creates a more dignified atmosphere than white and gives a distinctive tone.
Grey	Puts over a refined and dignified message and creates a distinctive tone. Charcoal is particularly dignified.
Black	Suggests weight and stability but is a little sombre for most applications.
Grey tints	Most create a dignified atmosphere.

10.21 Taste

There is an association between colour and taste which varies with the product, and needs to be investigated in each case. There is also a physical link in so far as strong tastes tend to raise the sensitivity of the eye to green and to decrease sensitivity to red, although this has little practical application.

Tests indicate that different colours seem to have different flavours even though no actual difference exists. In the United States, pale oranges are commonly dyed because the darker, dyed skin makes the inside of the orange seem sweeter. It has also been found that cake mixes of different flavours will have more appeal if the colours are also different; the colour should be related to the flavour in question (e.g. green for apple pie, etc.). Other tests have indicated the following:

- When a colourless syrup is used for a product, people are often unable to judge the flavour.
- People thought that coffee out of a brown can was too strong; out of a red can, very rich; out of a blue can, very mild; out of a yellow can, too weak.
- Mothers considered that a baby food in a blue pack was watery.
- Cigarettes in a red package were thought to be too harsh; in a brown package to have an unpleasant taste. On the other hand, a green package suggested a cool taste.
- Children prefer a blackcurrant flavour to a lemon flavour, and packets should be coloured accordingly.

In most cases common sense will dictate the appropriate colour; the association is primarily a natural one, foods having a distinctive taste and flavour being associated with a colour which conveys an impression of the flavour. In some cases it may be useful to undertake research, particularly where taste is an important factor in the sale of a product; choice of the wrong colour for packaging may create a wrong impression.

In general terms, pink or lilac suggest sweet things. In beverages, yellow suggests a lemon flavour, green suggests a lime flavour and brown suggests a cola flavour, but there are exceptions. Most bottled lemonade is white, although in some parts of the country it is brown. Only lemonade made from pure lemons is yellow.

Significance

The association between taste and colour may be very important to the sale of some products, such as flour confectionery or beverages, but it is of most importance in relation to packaging. In broad terms, the stronger the flavour of the product, the stronger the colour of the package should be, and where flavour is an important part of the sales story, it will be useful to test the reactions of customers.

Colour analysis

Hard colours	No special connotations.
Soft colours	No special connotations.
Bright colours	Effect depends on hue.
Muted colours	No special connotations.
Light colours	Generally suggest a milder and more delicate taste.
Medium colours	Effect depends on hue.
Dark colours	Suggest a stronger, or even harsh, taste.
Modified colours	No special connotations.
Neutrals	No special connotations.
Violet	Associated with confectionery and other sweet things but not sugar confectionery.
Blue	May suggest that a product is weak or watery.
Blue-green	No special connotations. Turquoise has pleasant associations.
Green	Suggests a lime flavour for beverages and coolness in cigarettes. The shade of green may be significant in some vegetable products. Light green is pleasing.
Yellow	In some cases it may suggest a weak product, but a dark yellow would suggest a stronger-tasting butter or cheese. Suggests a lemon flavour for beverages.
Orange	Appropriate to any product having an orange flavour and also to cereal products.
Brown	Appropriate to any product having a coffee or chocolate flavour, but shade is important: a dark brown might suggest a strong coffee.
Red	May suggest richness, or even harshness in some cases. Vermilion and flamingo have pleasing associations.
Pink	Associated with sweet things, including bakery products and sugar confectionery. A 'candy' colour. Coral and peach have pleasing associations.
White	No special associations, but white lemonade is expected in some areas.
Off-white	No special associations.
Grey	No special associations.
Black	No special associations.

10.22 Tradition

Traditional colours and decorative ideas appeal to many people particularly in higher-grade markets. There are two types of traditional colours. The first type includes those colours that have become associated with a particular product or practice by long-established custom. Some typical examples include:

- red and white stripes for peppermint sticks
- white for major domestic appliances
- red for fire appliances.

There are many other traditions which will be well known in the trade concerned, although they may be less well known to people at large, and there may be some that would benefit from research because it is not clear how acceptable they are to consumers generally. There may be a ready sale for traditional colours, and there is no reason why they should not be used; in some cases a sale may be lost if any attempt is made to change traditional colours, and before doing so it would be wise to test the strength of the tradition. On the other hand, there is no reason why alternative colours should not be used; consumers may be sick to death of the old traditional colours.

The second type of traditional colour is associated with historical periods of interior decoration, such as Adam, Regency, Georgian and so on. These decorative periods, and the colours that are associated with them, appeal to many people and particularly to older people and those in higher-grade markets. This type of tradition can often be promoted and has been used by paint manufacturers as a sales theme; it can also be applied to the sale of furnishings generally. One of the particular features of interior decoration of the eighteenth and nineteenth centuries was the extensive use of green in both pale and medium shades, while purple and dark red were associated with the Victorian era. In general, variations of basic hues are associated with historical periods rather than pure hues.

Significance

The use of traditional colours should generally be followed unless it is felt that the tradition has become outdated. In most cases the benefits will outweigh any disadvantages. The other aspect of traditional colours is primarily a theme for promotion, and the subject needs a good deal of study if the colours are to be used in a systematic way for promotion purposes.

Colour analysis

Hard colours	No special connotations.
Soft colours	No special connotations.
Bright colours	Associated with Georgian periods and earlier.
Muted colours	Associated with later Georgian and early Victorian periods.
Light colours	No special connotations.

Medium colours	No special connotations.
Dark colours	Associated with the Victorian era.
Modified colours	No special connotations.
Neutrals	No special connotations.
Violet	Particularly associated with the Victorian era; also, of course, with royalty.
Blue	Widely used in Georgian times; Wedgwood blue belongs to the later Georgian period. Traditionally the symbol of first prize, of the sea and of the law. A blue/black combination traditionally means trouble.
Blue-green	No special traditions.
Green	Light and medium greens distinguish the Adam and Regency periods, and moss green is Georgian. It was common to use a rich, dark green for wainscots in the Queen Anne period, and green has been used throughout the ages in interior decoration. Adam recommended pale green for ceilings to reduce glare, and pale green was favoured by William Morris; Adam was a great user of delicate pastel greens. There is a tradition of dark green for executive office furniture, and British racing green is traditional for cars. A white/green combination is associated with the young. Green is also associated with Ireland and with the Catholic faith, and there are often traditional prejudices against it.
Yellow	Gold was used extensively in Georgian times and has always typified richness. Traditionally associated with children.
Orange	Associated with the Protestant faith.
Brown	Darker browns, such as tobacco, belong to the Regency period and to the Victorian era. Buff belongs to the latter.
Red	Deep red belongs to the Victorian era. Traditionally used for fire appliances and for the Post Office in the UK.
Pink	Widely used in most decorative periods; Adam recommended pink for ceilings.
White	One of the most popular colours for interior decoration. Traditionally for weddings and domestic appliances. White/green combination is associated with the young.
Grey	Associated with the Victorian era and with dignity.
Black	Chiefly used as a foil to other colours. Traditionally associated with mourning and with funerals (although only in Western countries). Blue/black combination is reputed to mean trouble.
Grey tints	Associations depend on basic hues.

10.23　Visibility

There is a difference between visibility and recognition, but visibility may vary according to lighting conditions and the characteristics of the colour concerned.

It is generally recognised that in full daylight the point of highest visibility in the spectrum is yellow because it is seen without aberration and the eye can focus it perfectly. It is also reasonably easy to find and to recognise, although it does not have the highest recognition value. White is also very highly visible and can be seen at long distances, but because it has little visual interest the eye has great difficulty in seizing upon it; it is a difficult colour to find and to remember. The most visible colours, in order, are:

- yellow
- orange
- red-orange
- yellow-green.

In general terms, visibility depends on brightness differences and not on hue, but where several colours are involved, visibility depends on colour contrasts as well and requires a light source with good colour-rendering qualities. If only black and white are involved, visibility is dependent on brightness differences, which only require an efficient light source.

The point of highest visibility in the spectrum is where there is the greatest brightness and where acuity is sharpest, and this is the reason why objects coloured yellow, or surfaces painted or printed in yellow, can be seen further than those in any other colour. However, it is not always practicable to use yellow, and orange may be better; red-orange is used for air/sea rescue because yellow would be almost invisible against water and wave caps. Red is, in fact, easier to identify and recognise and will attract more attention.

Colours of highest visibility, and particularly yellow and orange, should be used sparingly for printed items which are read at short range, because they have a tendency to pull the eye from the text and to cause difficulty in reading. A combination of yellow and white would be very difficult to read.

Where it is desired to attract attention by using colours of maximum visibility the best plan is to use colours of high visibility against a neutral background; too much colour may frighten people away. Hard colours always dominate soft colours and this domination should be followed in most circumstances; red letters on a grey background, for example, are far more visible and compelling than grey letters on a red background, but red letters on a blue background need great care because they can easily merge into each other. The eye will always tend to focus on the brightest colour in any combination and the less bright of the two will seem to be slightly blurred and out of focus; this is why soft colours are recommended for background: they enhance the image of the brighter colours.

Most of these remarks refer to colours seen in normal daylight. In dim light, when the eye is dark-adapted, blue can be seen over a wider range of vision than red, and in certain conditions the red may not be seen at all. The reason for this is that the rods in the retina of the eye are most active in dim light, and these

rods do not see red. The factor is of especial significance in twilight; as daylight decreases, blues are seen more clearly. It also follows that yellow will tend to look greenish.

Significance

The visibility of colours is chiefly significant in packaging and print applications, and also in display, where it is desirable that features should be highly visible and so attract attention. Visibility is also significant in safety and other functional applications and in connection with vehicles. The visibility of road signs is equally important because they must be easy to pick out and identify.

Colour analysis

Hard colours	Only slightly refracted by the lens of the eye and focus at a point behind the retina; this pulls the image forward and makes it larger. Hard colours are also brighter and therefore attract the eye to a greater extent. They offer a sharp, clear image and suggest regularity.
Soft colours	Are more sharply refracted by the lens of the eye and focus at a point in front of the retina; the lens flattens out, and the image is pushed back and decreases in size. Soft colours also tend to be less bright than hard colours, and when seen in combination with them the soft colours will tend to look blurred and less visible. Suggest softness.
Bright colours	Generally more visible than dark colours because the eye tends to focus on brightness.
Muted colours	As for softer colours.
Light colours	As for bright colours.
Medium colours	Effect depends on hue.
Dark colours	Least visibility and in dim lighting will tend to merge into greyness.
Modified colours	Effect depends on hue.
Neutrals	Effect depends on hue.
Violet	Difficult for the eye to focus and to recognise. Makes objects look smaller than they actually are and may be blurred when seen in combination with other colours.
Blue	A retiring colour, difficult to recognise and to focus. Sharply refracted by the eye and often makes objects appear blurred or surrounded by haloes, especially when seen in combination with other colours. Blue tends to merge into a grey background. Makes objects look smaller than they actually are, and this may lead to mistakes in judgement in some instances. Can be seen over a wide range of vision at night because the rods of the retina do not see red. Best used as background but take care when used as a background to red: the two may merge. Does not lend itself to sharpness of detail.

Blue-green	As for blue but has rather more impact. Turquoise has some of the properties of green.
Green	Has many of the same properties as blue; it is a restful colour and kind to the eye, but it does not provide good contrast and tends to retire. Particularly difficult to distinguish in country conditions. It is not sharply focused and does not have angularity. Can dominate the eye without disturbing it. Yellow-greens have good visibility and many of the properties of yellow.
Yellow	The most visible of colours and stands out sharply in the dark. The eye focuses it clearly without aberration and it is only slightly refracted by the lens of the eye. Sharp, angular and crisp but without solidity. Shade may be important. A pastel yellow would look little different from white. Strong yellows, approaching yellow-orange or orange-red, would have maximum visibility and recognition value.
Orange	The best of all colours from a visibility and attention getting point of view and has excellent recognition qualities. Has many of the attributes of yellow allied with the recognition qualities of red. Provides a sharp image and lends itself to angles.
Brown	Colours such as brown and beige, which are mixtures of primary colours, acquire the attributes of the dominant primary colour, but they generally lack brightness and recognition qualities. Beige has reasonably good visibility but lacks punch.
Red	The most easily recognised and identified colour and the easiest to see in daylight conditions. Slightly refracted by the lens of the eye and therefore tends to advance and make objects look larger. A bright red attracts attention to itself and will take a lot of dirt without losing its appearance. Yellowish reds have better visibility than blue-type reds. Red tends to 'disappear' in dim light because the cones of the retina which 'see' red do not operate in dim light (i.e. when the eye is dark-adapted). Can be difficult to see in the twilight period and loses its value under some lighting conditions. Sharply focused by the eye and angular.
Pink	Stronger pinks such as coral have excellent visibility and have reasonable recognition qualities.
White	Can be seen at considerable distances, but because it has little visual interest, it is difficult to remember and to find; the eye has difficulty in seizing upon it. It stands out sharply in the dark but tends to reflect sunshine and can be trying for the eyes. It is particularly difficult to pick up quickly when dirty.
Off-white	As for white.

Grey	Has little brightness and in full daylight tends to look further away than it actually is. Tends to merge into shadows, particularly at twilight, and is virtually invisible in the dark.
Black	The least visible of all colours and makes objects look smaller than they actually are. Particularly difficult to see at night because it merges into shadows, but it stands out well against greyness.

10.24 Warmth

Warm colours are more appealing than cool colours and help to warm up a cold environment, but cool colours are often more suitable for practical reasons.

In interior decoration, warm colours are recommended for most north facing rooms and, generally speaking, are energetic, vital, cheerful and sociable. They help to reduce the visual size of a room and are particularly suitable for rooms used by children or the young.

Cool colours are best for sunny or south-facing rooms; their general effect is relaxing and restful, but they can be a little cooling; a Norwegian study indicated that people would set a thermostat 4 degrees higher in a blue room. They are recommended for areas where study or intense mental effort takes place. Green, although classified as a cool colour, is neutral in character and is neither inviting nor unfriendly. Intermediate hues, such as blue-green, can be combined with either a warm or a cool colour.

Significance

Because warm colours are more appealing than cool colours they will usually be chosen when it is desired to create customer appeal, but they will also be used in a cool environment when it is desired to create a somewhat warmer atmosphere. The reverse applies to cool colours.

Colour analysis

Types of colour are not significant in this context.

Violet	Soft colour, cool, not inviting to the viewer.
Blue	Soft colour, cool, not inviting to the viewer.
Blue-green	Soft colour, cool, more inviting than pure blue.
Green	Soft colour, neutral, neither inviting nor unfriendly.
Yellow	Hard colour, warm, inviting to the viewer.
Orange	Hard colour, warm, inviting to the viewer.
Brown	Hard colour, warm, inviting to the viewer, although this may not apply to some 'earthy' browns.
Red	Hard colour, warm, inviting to the viewer.
Pink	As for red but may be a little less inviting.
White	Neutral but may be a little cool.
Off-white	Neutral, less cool than pure white.

Grey	Cool colour, not inviting to the viewer.
Black	Cool colour, not inviting to the viewer.
Grey tints	Effect depends on basic hue.

11 Colour applications

11.1 Biological aspects

The biological aspects of colour have comparatively limited applications in commercial and industrial terms, except in the following areas:

- It is well established that colour, and variety of colour, has a beneficial effect on the environment, particularly those environments where people are confined for long periods under artificial conditions.
- Strong colour has a marked reaction on the activities of certain categories of people, and particularly on the activities of children. This is of course significant when selecting colours for environments which are occupied by children.
- Warm colours create an outwardly integrated environment which is particularly useful when it is desired to create an active atmosphere.
- Cool colours are preferred when it is desired to create a more subdued atmosphere.

Colour analysis

Hard colours Psychological effects: warm colour dominated subjects are receptive and open to outside influences; have warm feelings, suggestibility and strong effort. Mental functions are rapid and highly integrated. With warm colours go the primitive responses of children and the extrovert.
Medical effects: pleasing to depressed patients; cause an increase in blood pressure, pulse rate, respiration rate and muscular tension, speed up digestive processes and more marked cortical activation; muscular reactions are more marked; recommended for schizophrenia.

Soft colours Psychological effects: cool colour dominated subjects have a detached attitude, find it difficult to adapt and to express themselves freely; they are cold and reserved. With coolness goes the more mature response and tranquillity of the introverted type.
Medical effects: pleasing to people with hysterical reac-

	tions; decreases blood pressure and, in general, have the reverse effect to warm colours; recommended for manic depressives.
Bright colours	Psychological effects: Stimulate the nervous system and direct attention outwards.
	Medical effects: generally stimulating.
Dark colours	Psychological effects: little significance.
	Medical effects: little significance.
Violet	Psychological effects: very little significance.
	Medical effects: no significance.
Blue	Psychological effects: most people judge blue as cool, but not all; calms anxious subjects; allied with a conscious control of emotions; the colour of circumspection; under stress, people who like blue try to run away; reduces crying and activity in infants; introverts prefer blue; blond people generally prefer blue because they are descended from Nordic stock; blue skies cause the pigmentation of the retina.
	Medical effects: associated with schizophrenia and can cause urticaria solare; relieves headaches and high blood pressure; may retard muscular activity of nervous origin and tranquillises in cases of tension and anxiety; alleviates muscle spasms and helps in cases of irritation of the eye; contributes to the subjective relief of pain; reduces activity in torticollis; dim blue light is conducive to sleep in insomnia and visible blue light helps to counteract jaundice in new born babies.
Blue-green	Psychological effects: tends to increase narcissism, fastidiousness, sensitivity and discrimination; such people need to be loved. Otherwise as for blue.
Green	Psychological effects: a predilection for green symbolises the escape mechanism; the colour of people who are superficially intelligent and who have an inherent appetite for food; liking grass may suggest an escape from anxiety, a sanctuary in nature, and such people will crave company when under stress; likely to be preferred by the mentally ill and is a great favourite of psychoneurotics and psychotics.
	Medical effects: liked by hysterical people; decreases restlessness in torticollis; causes the least increase in autonomic arousal; anxiety state is improved by tablets coloured green, and green glasses which screen out red rays help psychiatric patients; protects against red and yellow in Parkinson's disease.
Yellow	Psychological effects: colour of the morbid and feeble-minded and also those of great intelligence; intellectual reformers may like it.
	Medical effects: preferred by schizophrenics; dangerous

	in Parkinson's disease. Tablets coloured yellow improve depression.
Orange	Psychological effects: attractive to convivial persons; very friendly people like orange.
	Medical effects: none significant.
Brown	Psychological effects: none significant.
	Medical effects: related to paranoia.
Red	Psychological effects: associated with outwardly integrated personalities, highly prized by people of vital temperament; such people are often ruled by impulse rather than deliberation, and desire to be well adjusted to the world; most people judge red to be warm, but not all; debilitating to more anxious subjects and the chosen colour of many manics and hypomanics; causes the greatest increase in autonomic arousal.
	Medical effects: red flashing lights will excite some forms of epilepsy; dangerous in Parkinson's disease; helps relieve skin diseases, scarlet fever, measles; may cause distress in cerebellar disease; accentuates nervous diseases such as torticollis and tic; red light may increase restlessness in the former. Disturbing to anxious subjects and related to excitation in general; may help to increase blood pressure in muscular tonus; stimulating effect on sexual activity; induces a decrease in blood sugar; red inert tablets help to reduce pain in arthritis. May help to arouse people with reactive depression and neurasthenia; red light helps active eczema; prevents scar formation in smallpox; mentally disturbed patients are excited by red.
Pink	Psychological effects: aggressive people may be drawn to pink, a symbol of an unconscious wish for gentility.
	Medical effects: none significant.
White	Psychological effects: preferred by schizophrenics.
	Medical effects: none significant.

11.2 Children

The colour preferences of children are quite different from those of adults, and if both are asked, the results of a poll are quite consistent. This has an effect both on the colour of products sold to, and for, children and also on the colours that should be used in environments in which children live.

Very young children are seldom customers in their own right, but they are attracted by bright colours, and this attraction remains when teenage children are able to exercise their own preferences. Present-day parents are very conscious of the effect on colour on the environment in which their children are brought up, and they will tend to exercise the same influence on purchase as the children themselves.

Colour analysis

Hard colours	For children and for the young generally.
Soft colours	Preferred by older people.
Light colours	Preferred by children and the young generally, so long as they are bright. Children tend to be less interested in pastels.
Dark colours	Generally preferred by older people, although darker colours are sometimes a fashion influence on the young.
Violet	Appeals to children and the young only in a fashion sense.
Blue	Strong blue often appeals to the young but generally preferred by older people. Light blue is sometimes recommended for children.
Blue-green	Has more appeal to children and the young than pure blue.
Green	Lighter greens often appeal to children, and there is frequently a strong demand from teenagers and the young generally. Spring green is said to have a particular appeal when teamed with pink or peach.
Yellow	Highly recommended for children and appeals to the young generally. Light yellow is recommended for childrens' bedrooms and dark yellow is suggested for a child's playroom.
Orange	Well recommended for children and also appeals to teenagers and the young generally. Recommended for childrens' carpets.
Brown	Mainly for older people, except when a fashion colour.
Red	Children generally love bright red, and it appeals to all age groups.
Pink	Appeals to all age groups, but to grown ups more than to children. Recommended for a child's bedroom, particularly peach or rose pink.
White	Appeals to all age groups but is not recommended for furnishings for the very young, for practical reasons. Too clinical for a child's bedroom.
Off-white	Not for children but appeals to other age groups.
Grey	Does not appeal to the young; nor is it recommended for the very old.
Black	Fashion colour only.

11.3 The country

The selection of colours for the interiors of buildings which are located in rural areas, and in which work is performed, is not as complex as the selection of colours for buildings in towns or industrial areas. The buildings concerned include farm buildings, such as dairies, and food-processing plants, such as creameries, meat-processing plants and vegetable-processing plants.

Colour analysis

Hard colours	Of little significance in this context except as accents.
Soft colours	Generally preferred for interiors concerned with the processing of food.
Light colours	Best for most applications in this category. Pastels are particularly recommended.
Dark colours	No application.
Bright colours	Only required for accent purposes.
Medium colours	May be used for walls instead of light colours.
Violet	No applications in this context.
Blue	Blue is frequently used because it is cool and clean, but in fact it has little virtue compared with white, except to provide change. Colder blues should be avoided; they tend to appear bleak. Blue is quite a good background for food and is sometimes used for creameries. Deeper blues might be used as accents where required.
Blue-green	Generally better than pure blue where a change from white is desirable; it is more lively and less sterile. Particularly recommended for meat-processing plants because it is the complement of the red of meat; it prevents unsavoury after-images and enhances the appearance of the meat. Also recommended for dairies. Tends to accentuate coldness.
Green	Cool and restful but tends to cause unpleasant reflections on food. In any case there is plenty of green in the country, and some change from it may be desirable. A light green might be used in meat-processing plants.
Yellow	Light yellow is suitable for dairies and dairy plants.
Orange	No applications in this context.
Brown	There are few applications for brown in this context, but tan might be used as a background for meat processing and for vegetable processing. It could also be used for farm shops.
Red	There are no applications for the stronger reds.
Pink	May be used in cases where a warmer tone is required. Peach is well recommended in association with any food. Coral may be used in a food factory to compensate for very low temperatures, also for vegetable processing and in farm shops.
White	Widely used but tends to be cold and sterile and accentuates the natural coldness of food-handling installations. For dairies, cow houses, slaughter houses; only recommended for food plants if maximum cleanliness is imperative and cost is a major consideration.
Off-white	Cream or ivory are generally better than white for dairies, farm buildings generally, food plants, dairy plants, piggeries. Cream is less cold than white when used for

	large wall areas.
Grey	Pearl grey can be used for corridors and so on in food plants since it hides smudges and the like, but generally speaking grey should not be used where the appearance of food is important.
Black	No applications.
Grey tints	Mushroom can be used for large wall areas and is less cold than white.

11.4 Export

Colours for products, packaging and promotion that are suitable for British markets are not necessarily suitable for overseas markets, but each country has different needs, requirements and preferences, and each country should be investigated individually before finalising colour choice or design.

The following notes on colour usage include items that have come to hand during the course of research, or as a result of experience, but the list is by no means exhaustive or definitive. In case of doubt, the local situation should be examined in detail and the views of local agents, distributors and retailers taken into account.

In any application which includes an illustration, it would be a good idea if people illustrated had the same skin colour as the inhabitants of the country concerned.

Colour analysis

Hard colours	Generally preferred by people living in warm climates. For interiors in temperate climates. Preferred in seaside areas.
Soft colours	Generally preferred by people living in temperate climates. For interiors in warm climates, including wall-coverings.
Bright colours	Usually preferred by people with very dark skins; pastels are acceptable to Europeans. For exteriors in hot climates, interiors in cool climates. Recommended for unsophisticated markets and for decoration and accents in temperate climates. Usually preferred for kitchens in sunny climates.
Dark colours	For exteriors in cool climates, interiors in hot climates. If used for packaging, will not be seen in a dark shop in a bazaar.
Violet	Pale shades (e.g. lilac) may be used to cool interiors in sunny climates. Japan: people never wear purple, it is a royal colour.
Blue	Essentially for temperate climates; the bright blue of the sky overpowers it in warm climates but it can be used to cool down interiors. Always popular in British and Scan-

dinavian markets; less popular in other parts of the world.

China: blue and white mean money.

Sweden: do not use blue and white for packages (national flag).

Switzerland: conveys textiles.

Other countries, except Switzerland: conveys detergents.

Holland: liked for bathrooms.

France: liked for bathrooms.

Ireland: preferred by the young.

Arab countries: do not use blue and white (Israeli flag).

Blue-green Has more impact than blue but similar remarks apply.

Green Recommended for interiors in sunny areas and for exteriors in temperate zones, but certain shades can be used for sunny exteriors, especially where natural green is lacking. Has a general cooling effect and is widely liked; vivid greens are often used in sunny areas for both exteriors and interiors. Has religious connotations and needs to be used with care in Moslem countries and where there is an Irish element; there are often local prejudices against green.

France: associated with cosmetics.

United States: associated with confectionery.

China: green hats are a joke.

Czechoslovakia: green means poison.

Turkey: a green triangle indicates a free sample.

Ireland: use needs care.

Arab countries: use needs care.

Yellow For exteriors in sunny areas and interiors in temperate zones but may be overshadowed by natural sunlight. The high-visibility qualities of yellow make it suitable for exteriors in any climate. Conveys food in most countries except Switzerland.

Israel: avoid yellow.

Eastern countries: yellow means plenty but can also mean pornography.

Switzerland: conveys cosmetics.

Sweden: gold is not recommended for packages.

Pakistan: saffron and black are the colours of hell.

Buddhist countries: saffron is the colour of priests.

Orange Suitable for exteriors anywhere because of its impulse qualities but not likely to be used for interiors in sunny regions. Use with care in markets with an Irish element.

Brown Generally a colour for temperate regions; in most sunny regions there will be enough brown already, and it is a little warm for interior use, although lighter shades can be used to simulate wood. Tan could be used for in-

	teriors in sunny regions.
Red	Essentially for sunny areas, especially for exteriors, but can also be used in temperate zones. Unlikely to be used for interiors in sunny regions except to create a feeling of richness. Universally popular. Vermilion appeals to both men and women in all parts of the world. Conveys Post Office in the UK but not in other countries. Conveys caution in most countries. Brazil: not allowed for cars. Ecuador: not allowed for cars. Zambia: use with care, particularly for illustration. China: a happy, propitious, colour. Taiwan: as for China. Czechoslovakia: a red triangle means poison.
Pink	Essentially a colour for temperate regions; it is lost in strong sunlight, but rose and peach might be used for exteriors in sunny regions. Arab countries: pink bathrooms are liked. Eastern countries: may convey pornography in some cases.
White	Suitable for any country or climate and is often used for its heat-reflective qualities, but it is not a very practical colour for undeveloped countries because it gets too dirty. Restricted to ambulances in some countries. Means purity in most Western countries. China: the colour of mourning: use with care for illustration; blue and white together mean money. Hong Kong: not recommended for packaging. Columbia: not allowed for cars. Arab countries: avoid blue and white (Israeli flag). Sweden: avoid blue and white for packages (national flag).
Off-white	As for white but more often used in temperate climates; tends to look dirty in sunny climates.
Grey	Not suitable for sunny climates except for its cooling qualities. Can be used for exteriors in cloudy areas. Columbia: not allowed for private cars.
Black	To be avoided in sunny regions; it absorbs heat. The colour of mourning in many countries. Pakistan: saffron and black are the colours of hell. Egypt: associated with evil.

11.5 Exteriors

It is as great an art to choose colours for building exteriors as it is to choose colours for an interior. First considerations should be the neighbours and their colour schemes; a lemon yellow might clash hideously with the building next

door, whether home or factory.

Different colours for domestic houses signal different messages to the passer by; strong, primary colours, for example, signify a definite personality with the courage of its convictions. The front door is one of the most important features of a home and it should say 'welcome' and create a good impression.

The following colour palette for exteriors is intended primarily for the climatic conditions of the UK, although it would also be suitable for other temperate climates. Warmer climates and those where the sun is very strong, require different treatment.

Colour analysis

Hard colours	Appropriate for prominent forms and details seen at short distances; warm colours are recommended for north-facing houses.
Soft colours	Lend themselves to large areas and simple mass; soft pastels best match the colours of the landscape.
Light colours	Best suited to the upper regions of high buildings. Recommended for doors with a dark porch.
Bright colours	Strong colours look best in sunnier regions; vivid colours are strong and demanding and have more attraction than dark colours. Recommended for the seaside and very suitable where awnings are fitted.
Dark colours	Grey tones are preferable in metropolitan areas and show less dirt in town conditions; a dark colour scheme with white woodwork can be recommended where traffic fumes are bad; dark colours appear heavier than pale colours and weather better than lighter colours; dark colour with white plaster work is dignified; dark colours are specially recommended for doors of red-brick houses and for weatherboarding and shingles.
Neutrals	Suitable for a well-proportioned house and may be used if the house next door is brightly coloured.
Violet	For the charmer; weathers very quickly. Doors: purple may be used in some instances. Walls: not generally recommended but lilac might be used for a period house. Windows: not generally recommended.
Blue	Cool, calm, collected; tends to make a building look smaller and to be forbidding in bulk. Recommended: blue moon (pale blue), federal blue (rich, cool). Doors: navy blue for doors of red brick houses and for yellowish brick; smoky blue is also recommended. Windows: smoky blue for outer frames of white windows. Walls: navy blue looks good set off by white; dark blue for walls in towns; hyacinth blue for walls in a garden

setting; all shades of blue are good in towns especially with a black-and-white surround to the door; Trafalgar blue for terrace houses; pale blue for a cottage in the country; dark blue is not right for the country but quite suitable for the seaside; bright blue recommended for colour washed walls; Pekin blue goes well with lichen green; alpine blue for an Edwardian house; pigeon blue for a semi-detached cottage; blue is recommended for bungalows.

Industry: generally for accent only; good association with food and food packaging.

Farms: dark muted blue is recommended for roofs.

Blue green
As for blue, but it has more impact than pure blue; harmonises well with other colours; acceptable in a civic colour scheme.
Recommended: Gulf blue (turquoise), aquatone.

Green
For those who are self-confident, assured and always content.
Recommended: evergreen.

Doors: grey green is recommended for front doors; dark green for doors of brick houses. All shades of green are suitable for front doors in the country, especially if sparked off by white; Thames green doors with pink walls look good; sage green is sophisticated for doors in town; dark olive is also suitable.

Windows: grey green for outer frames of white windows.

Walls: dark green with white windows and doors; Looks best in town when linked with white or cream; sage green or olive green look best when set off by white woodwork; dark green for walls in towns. Dark green does not look right in the country but is suitable for the seaside; willow green helps a house to blend with its setting; lichen green looks well with Pekin blue; apple green for a period house.

Industry: spruce green is recommended for factory exteriors and may also be used for structures and accent.

Farms: for walls – medium muted green or pale muted green.

Yellow
A little ray of sunshine; for lighthearted, cheerful and friendly people. Pale yellow lacks impact in urban conditions; very deep yellow can be unpleasing; avoid strong, harsh, yellows. Recommended: sun yellow.

Doors: mustard can be used for doors of a pinkish-brick house. A yellow-green door is suggested with blue walls.

Windows: no special comment

Walls: mustard walls create a sunny effect; golden yellow looks fresh as a daffodil even on the greyest day (team with white); yellow is too dazzling for a south-

facing house. Pale yellow can be used in towns with woodwork in white, pale grey or off-white; a good strong yellow can also be used; lemon is a possibility for a cottage in the country; deep mustard is practicable in the country; pale yellow for colour-washed walls; jonquil for plaster walls; lemon and white for a terrace cottage.

Industry: right associations with food.

Farms: medium muted yellow or dark muted yellow may be used for farm roofs.

Orange

Should generally be avoided for exteriors, especially in towns because, it is too compelling, but it can be used in limited quantities where the light is strong.

Brown

For outgoing people.

Doors: beige is suitable; tan and pale chocolate are sophisticated in towns.

Windows: beige for outer frames of white windows.

Walls: brown/pink decreases height and narrowness; dark brown for walls in towns and also practicable in the country; rich ochres are successful where light is strong.

Industry: tan is useful for exteriors, particularly food manufacturers.

Farms: dark brown for walls and farm roofs.

Red

Recommended: imperial red (rich tone).

Doors: explosive, dramatic, fiery but also generous, kind and helpful; it gives a cheerful welcome; bismarck reds are recommended; salamanca red goes with a cameo façade; bright red for doors of yellowish-brick houses; avoid maroon and bluish reds.

Windows: brownish reds for outer frames of white windows; terracotta goes well with white walls.

Walls: true reds are a possibility in the country with black-and-white woodwork; terracotta is practicable in the country; brownish reds with blue or yellow doors are a possibility for the seaside; cinnabar, russet for a Victorian house.

Industry: for factory exteriors and structures, particularly as accent.

Farms: dark warm red for farm walls.

Pink

Anything for peace and quiet; for gentle, dreamy characters. Some forms of pink weather very quickly; avoid too strong pinks in towns. Recommended: apricot (clean, fresh, warm).

Doors: no special comment.

Windows: no special comment.

Walls: Suffolk pink for suitable houses; soft pink for a semi-detached bungalow; suits a garden setting; dawn pink for a cottage in the country; for colour-washed walls. Strong pinks are successful if the light is strong;

coral and slate go well together; pink/brown decreases height and narrowness; peach for a cottage; damask pink for a semi-detached cottage.

Industry: no special comment.

Farms: no special comment.

White Always light, pure, clean, simple; excellent in sunny regions and for town houses, although it tends to look dirty after a while and lacks impact. Pick out details in white.

Doors: a white frame to a black door is good; very suitable for doors of town houses.

Windows: white window frames reflect light and are welcoming. Use white if the paintwork next door is bright. White woodwork goes well with sage green, olive green, navy blue, battleship grey; looks well with a house painted golden yellow.

Walls: white plasterwork with dark panels is dignified. Use white for details of brick houses, it cools down the brick; use for colour-washed and roughcast walls. Balconies should usually be white; white walls go well with terracotta wood work; black and white is good for plain houses. Recommended for mouldings in town houses; use with green or pale yellow for town houses. White walls provide an attractive background for foliage in the country; looks good linked with green and goes well with natural woods; brilliant white for a Victorian house.

Industry: recommended for industrial exteriors; useful for heat control purposes.

Off-white Similar to white.

Doors: cream for doors of town houses and pinkish-brick houses.

Windows: no special comment.

Walls: cream looks good linked with dark green, particularly in towns. A cameo façade goes well with doors in salamanca red. For town houses try off white with pale yellow, mid stone. Magnolia is recommended for terraced houses; buttermilk looks well on a country cottage. Cream goes well with natural woods.

Industry: no special comment.

Farms: no special comment.

Grey Middle of the road, looks forlorn in bright sunlight; cold, austere, does not lend itself to a cheerful mood.

Doors: for front doors of brick houses and sparked off by white in the country.

Windows: fine for outer frames of white windows.

Walls: battleship grey can be recommended if set off by white wood work; pale grey for pebble-dashed walls; subtle grey for concrete walls. Grey walls are best in the country but are practical in towns; pale grey looks well

with pale yellow for town houses; slate and coral go well together; pale grey goes well with natural wood.
Industry: for factory exteriors.
Farms: medium grey for farm walls or farm roofs and also dark grey.

Black Always right, particularly for town houses; traditional for drainpipes.
Doors: sophisticated, up to the minute, creates an aura of mystery. Black doors look well with white woodwork; good for doors of red-brick houses.
Windows: can be used for outer frames of white windows; recommended for windows in town.
Walls: black and white for plain houses; black and brownish red walls with blue/yellow doors are suitable for the seaside; goes well with natural woods.
Industry: no special comment.
Farms: no special comment.

Grey tints Doors: mushroom is sophisticated for doors of town houses.
Windows: no special comment.
Walls: no special comment.
Industry: no special comment.
Farms: sandtone is recommended for farm walls.

11.6 Food

There is a definite art of colour in relation to food which is important to those who manufacture, merchandise or consume food. There is a good deal of common sense involved in selecting the right colour for foodstuffs, but there is also a fair volume of research findings and these have been summarised in the notes that follow. It would be a mistake to generalise too extensively about food colours, and each food needs to be considered individually in the light of tradition and accepted practice, as well as in the light of the market in which it is sold, the way in which it is served and the way in which it is tasted or eaten.

As a general rule, natural colours are best for raw foods. The colour of good food itself is always acceptable – the rich red of meat, the red orange of freshly baked bread, the green of lettuces and the yellow of fresh butter. When a foodstuff does not have an established, or accepted, colour of its own (e.g. sugar confectionery) the best colours to use are those that attract attention and give most pleasure to the individual, whether young or old, male or female. Colour may also be selected to accord with or emphasise the flavour or smell. Generally speaking this is established by tradition or custom as with coffee, cinnamon, chocolate and so on.

Colour analysis

Hard colours Generally preferred for most foods because they stimulate the appetite.

Soft colours	Tend to retard the appetite and are generally used for background.
Light colours	Pastels suggest 'sweetness', and 'candy colours' are commonly used for sugar confectionery.
Bright colours	Unless they are the natural colours of a food, bright colours tend to suggest something artificial.
Medium colours	Generally best for most foodstuffs.
Dark colours	For any foodstuffs having a naturally dark colour, and darker colours may also be used to suggest strong flavour.
Violet	Soft colour, retards digestion; the natural colour of grapes and grape juice; purple, violet and lilac should generally be avoided in association with food, although mauve and lilac may be used for certain sweet things where they are traditional (e.g. crystallised violets).
Blue	Not a colour of any natural foodstuff but is an excellent foil for most foods. Cool, clean, well liked; soft colour, retards digestion. Clear blue is a good foil, but violet blues should be avoided. Blue is not suitable for any food but is an excellent background especially to meat and dairy products. Not recommended in association with baby products or bread; tends to suggest a mild taste but may also suggest a product is watery.
Blue-green	Not a colour of any natural foodstuff but an excellent foil; soft colour; retards digestion; otherwise as for blue.
Green	The natural colour of vegetables, fruit and other good things to eat; country products generally; soft colour but neutral in digestion terms. Light, clear greens are best with food, and yellow-greens or greenish yellow should be avoided. Select the shade of green carefully to match the natural colour of the product. In association with meat, green suggests spoilage and in association with bread it suggests mould. Yellow-greens should generally be avoided because they suggest sickness, but lime is the natural colour of many products. Olive greens are best avoided except where they are the natural colour of the product. Green has a purplish effect if used on iced cakes because of after-image.
Yellow	The natural colour of butter, cheese and other foods; hard colour, stimulates digestion. Butter yellow is a good variation and gold has a high-class image; yellow-greens, greenish yellow, mustard tones, orange yellow and cold or harsh yellows are best avoided. Excellent for food, especially the paler variations; appeals to children and has good attraction value. May convey a mild flavour; well liked for wine.
Orange	The colour of fresh bread, oranges and other eatables; hard colour, stimulates digestion. Red-orange and pure

	orange are the best variations; yellow-orange is best avoided. One of the best of all colours for food; red-orange has high impulse value and associates well with many products, particularly bakery products, meat and so on; good attraction value.
Brown	The natural colour of many foods such as coffee, choco-late, cocoa, many bakery products, nuts; stimulates di-gestion. Light and medium browns and tan are best; avoid earthy browns, which may suggest dirt. Warmer shades, including tan, are recommended for many foods such as bakery products, baked beans, nuts and so on. Brown bread is acceptable and brown shelled eggs are well liked in the UK. Warmer variations are acceptable for baby foods.
Red	The natural colour of raw meat and many fruits. One of the best of all colours for food; hard colour, stimulates digestion. Warm reds are best; avoid purplish reds. An excellent colour for food, and variations like flame, coral, scarlet and vermilion can be recommended. The best forms of red are warm (i.e. with a yellow bias) and are friendly, but purplish reds tends to be repelling (suggesting bad meat).
Pink	Peach is the colour of many fruits, including the peach itself, and is well recommended for many foodstuffs; hard colour, promotes digestion; peach is an especially good appetite colour. All pinks are recommended for confectionery and other sweet things, especially sugar confectionery and iced cakes.
White	The natural colour of salt and sugar and always correct in relation to food; goes with any other colour; no particu-lar effect on digestion. Good foil and is best used as a background for food, except for iced confectionery. Salt and sugar should always be pure white (although colou-red sugar crystals are acceptable); white and blue together should be avoided for bakery products.
Off-white	Cream is a natural food colour and acceptable in any cir-cumstances, but otherwise off-whites are best avoided in association with food – they may suggest dirt; warmer variations can be used instead of white.
Grey	To be avoided in relation to food; grey bread or grey meat would be rejected, and bacon on a grey plate looks revolting.
Black	No association with food, except black puddings, black sausages and black bread, most of which are not really black. Best avoided in relation to food.

Note: Attention is also drawn to 10.19 and 10.21 above, dealing with the associ-ations between colour and smell and taste, respectively.

11.7 Food packaging

In most food-packaging applications strong and vivid colours will be required because of the need to achieve impulse attraction at point of sale, but pastels may be used to suggest a more sophisticated or expensive product and where it is desired to convey softness and gentleness. The best colours to use are those that have a relationship with food and preferably a direct association with the product contained within the package, although colour may also be used to emphasise or modify flavour, smell and other attributes of the product.

It would be desirable to pay some attention to fashion and to select those variations of basic hues which accord with current trends of consumer preference for colour so long as this does not conflict with the functional application of the hue. For example, if red was being used, it would not be wise to choose a blue-type red for a food application, however fashionable it might be. On the other hand, almost any shade of blue is suitable, irrespective of fashion.

Colour analysis

Hard colours	Generally preferred for most food packaging. Inviting to the viewer.
Soft colours	Pastels suggest sweetness, and soft colours may be used to suggest sophistication.
Bright colours	Preferred for most food-packaging applications because of the display element; have more emotional appeal.
Deep colours	Not recommended except to suggest strong flavour; also suggest stability and weight.
Violet	Food generally: avoid violet shades in association with food, although mauve and lilac may be used for sweet things; it is particularly unsuitable for coffee, but is the natural colour of grapes or grape juice. Purple might be used for grape juice but not for mashed potatoes. Food packaging: purple and violet are not recommended but lilac and paler shades might be used for some bakery products. Cadbury purple is an exception to most rules.
Blue	Food generally: does not have any direct association with foodstuffs but is an excellent foil. Cool, clean and well liked; suitable for use with sea foods, milk, dairy products but not recommended for bakery products or for bread; tends to suggest a mild taste, and pale blue may suggest that a product is watery. Food packaging: essentially a background or foil colour but denotes coolness or cleanliness. Cambridge blue has been used for baby foods and for white vegetables. Suggests sea and water and is suitable for seafoods; suitable for products such as seafoods, milk, dairy products, baby foods, tomatoes, white vegetables, frozen chicken.
Blue-green	Food generally: does not have any direct associations with food but is a good foil, especially for meat because it

is the direct complement of the red of meat and helps to make it look more appetising.

Food packaging: as for blue but is especially good for meat.

Green

Food generally: the natural colour of vegetables, fruits and other good things to eat; select the shade of green carefully to reflect the natural colour of the product. Avoid in association with meat because it tends to suggest spoilage and also in association with bread because it tends to suggest mould. Olive should be avoided in most applications except where it is the natural colour of the product; marked yellow-greens and greenish yellows are also best avoided because they suggest sickness, but lime is the natural colour of many products and has good attraction value.

Food packaging: for vegetables and for country products generally but avoid in association with bread, meat and iced cakes. Lime green and similar shades have good attraction value but otherwise greens tend to be neutral. Suitable for products such as vegetables, country products, baby food, peas; suitable for Easter packaging.

Yellow

Food generally: the natural colour of butter, cheese and other eatables; excellent for food, especially the paler shades and gold has a high class image; stimulates the appetite and has good attraction value. Mustard tones and harsh variations are best avoided.

Food packaging: highly visible and recommended to attract attention, but use 'butter' yellows and not harsh variations. Excellent for appeal to children; suitable for butter, cheese, baby foods, split peas, corn; Suitable for Easter packaging.

Orange

Food generally: the colour of fresh bread, oranges and other appetite-provoking foods. Red orange is one of the best of all colours for food; it attracts attention and creates appetite appeal. Particularly suitable for bakery products.

Food packaging: Red-orange is well recommended for many foodstuffs, particularly those with an orange flavour; paler variations are equally suitable but less powerful. May be a little overpowering in large areas. Suitable for bakery products, bread, flour, cereal products, meat.

Brown

The natural colour of many foodstuffs (e.g. chocolate). Warmer shades such as tan can be recommended for baby products but avoid earthy browns.

Food packaging: relate the shade to the actual colour of the product but avoid earthy shades, which might suggest dirt. Suitable for baked beans, nuts, coffee, bakery products, chocolate, corn; Tan or warmer variations are suggested.

Red

Food generally: the natural colour of meat and one of the best of all colours with food; stimulates the appetite and has good attraction value; warmer shades are recommended. A friendly colour, although some variations are repelling.

Food packaging: warm shades are preferred and have high attraction value, although red-orange may be better. Flame, scarlet and coral can be recommended. May be a little overpowering in large areas. Suitable for meat, meat products, cherries, beetroot, bread, baby foods (coral), frozen chicken.

Pink

Food generally: peach is the colour of many fruits and is well recommended for many foods, especially confectionery and other sweet things; appeals to children. Pink is appropriate for an iced cake but not for coffee.

Food packaging: peach is suitable for many fruits and is a good background for many foodstuffs. Pinks are recommended for many sweet things but lack impact at point of sale; suitable for confectionery, fruit, seafoods.

White

Food generally: white is always correct in association with food and conveys cleanliness but is best used for background. Lacks impact but goes with any other colour.

Food packaging: always correct but lacks impact. Excellent as background, the universal alternative; conveys purity and has been used for health foods to emphasise the health aspect; suitable for almost any product.

Off-white

Food generally: best avoided in association with food because it may suggest dirt; warmer off whites might be used in suitable circumstances and cream is always correct.

Food packaging: warmer off whites might be used as background to suggest softness and quality.

Grey

Food generally: avoid in association with food.

Food packaging: not recommended.

Black

Food generally: generally avoid in association with food, although there are some black foods.

Food packaging: few uses except to create contrast; black tops may be used to make a package stand out; suitable for tea but not recommended for cake mixes.

11.8 Food colour in the home

When selecting colours for products used in the kitchen or dining area of the average home, particular emphasis should be placed on those colours that associate well with food and which create the most favourable reaction in the minds of consumers. These are the colours of good food itself, and they are frequently termed 'appetite' colours because they enhance appetite. The subconscious effect of these colours applies equally to the environment in which the food is prepared and eaten and to the products used in those areas.

Good food colours are red, red-orange, orange, peach, pink, tan, brown, yellow, green, blue-green, blue and white. Poor colours are purplish red, purple, violet, lilac, yellow-green, greenish yellow, olive, grey, mustard tones. Appetite colours are significant in all selling situations where food is involved.

Colour analysis

Hard colours	Stimulate the appetite.
Soft colours	Retard the appetite.
Bright colours	Decorative value.
Dark colours	Best avoided.
Violet	Avoid in association with food, particularly the darker variations. Might have a decorative function for food containers but not recommended for tableware applications.
Blue	Clean, cool and well liked and an excellent background for anything to do with food, especially meat. Well recommended for food containers, especially those used in freezers; clear blues are indicated. Blue can be recommended for tableware applications and either clear or muted variations may be used. Wedgwood blue is well established for tableware. Light and medium variations are best, although strong blue can be used for ovenware.
Blue-green	As for blue. An excellent background for any food. Perfectly suitable for food containers; medium variations have good attraction value; aqua is recommended for tableware; stronger blue-greens are suitable for table linen.
Green	Excellent in association with most foods but avoid in association with meat or bread. Light and medium greens are better than dark greens; olive greens are not liked in association with food, although avocado has been a strong seller in kitchen units. Avoid yellow-greens in all applications – they suggest nausea. Clear greens are suitable for food containers, and muted greens might be included in an up-market range. Pastel and pale greens can be recommended for tableware in either clear or muted variations; deep green is best not used; light or medium greens provide a cheerful table covering.

Yellow	Excellent in association with most foods but avoid greenish yellows and mustard tones; muted variations may be used to suggest richness. An essential for any food container range; deeper and muted yellows can be used and have decorative value. Excellent attraction value. Light and medium yellows are preferred for tableware but muted versions may be used, and gold adds refinement; a butter yellow would be particularly good. Antique gold and similar greenish shades are best avoided for tableware.
Orange	Red orange is one of the best of all colours in association with food and has excellent attraction value. Particularly suitable in association with bakery product, bread and meat. Should be included in most food container ranges; excellent for display. A little strong for tableware, although it is used for some forms of pottery. Pale or medium variations are preferred, especially for table linen.
Brown	Recommended in association with food; light and medium shades are best in most applications but warmer variations of dark brown may be used. Care is necessary in using brown for food containers; it is not suitable for, say, freezer use but excellent for coffee and for containers which are kept on a shelf; brown lids for clear-bodied containers are acceptable. Warmer variations such as beige or tan are preferred. Not recommended for tableware except for casseroles and the like. Pale variations would be acceptable for table coverings and beige might be used for plates and plastics ware. Brown mugs can be used for coffee but not for tea. Avoid earthy shades in all applications.
Red	One of the best of all colours in association with food and has excellent attraction value. Warm variations like flame, scarlet, coral and vermilion can be recommended; cool variations have less attraction; avoid purplish reds, which suggest bad meat. Warm reds are well recommended for food containers, but most reds are a little strong for tableware applications, although warm reds may be used for table linen. Strong reds may be a little overpowering, but bright reds are acceptable for plastics ware. Cool reds and muted reds are best avoided in tableware applications.
Pink	The colour of cooked meats and seafood and also the colour of many fruits. Peach is particularly suitable in association with food and has been found to promote appetite; other pinks can be used, but not dusty pinks or cool pinks. Peach could be used for food containers but other pinks lack impact. Acceptable for tableware and

	has refinement.
White	Always correct in association with food and is the universal alternative. It conveys purity and cleanliness. Excellent as a background to food and for trays and the like. Recommended for the interiors of food containers; can also be used for exteriors but lacks interest; right in all tableware applications.
Off-white	Cream is the colour of many foodstuffs and can be used in association with food in almost all circumstances; it is an alternative to white. Other off-whites need care – they may suggest something not quite clean. Cream would be acceptable for food containers and so would warm off-whites; cream and warmer off-whites are acceptable for tableware applications, but some off-whites need care because they can look grubby.
Grey	Should be avoided in association with food – it may suggest dirt. Not recommended for food containers nor for tableware.
Grey tints	These may be used in association with food where the base hue is suitable, but they require care. Not recommended for food containers, clear colours are better; could be used with care for tableware.

11.9 Food processing

When selecting colours for use in food plants, place the emphasis on simplicity. Elaborate colour schemes are not justified except, perhaps, where the plant is open to the public for inspection; in such cases something a little more decorative may be thought desirable. Clear colours are generally best associated with food; greyed shades may suggest dirt, and any mixed colours are generally best avoided. The following points should be considered:

- Because cleanliness is vital, light colours are prescribed.
- The colours used should have an appropriate association with the colours of the food; this applies whether the colour is reflected on to the food or is seen in association with it.
- The colour-rendering qualities of the light should not affect the appearance of the food.
- Both the colour of the light and the colour of the surround should flatter the appearance of workers.
- Light colours should be adjusted so that they do not cause glare.
- Walls facing the worker should usually be finished in colours which are the complement of the colour of the food being processed.
- Where there is manual labour, brighter colours and plenty of light will be conducive to better working conditions.
- Where the working area is cool, consider warmer colours; refrigerated areas, in particular, will benefit from warm tints. Ivory, peach, light yel-

low, beige, buff, coral pink promote a cheerful atmosphere without losing the benefit of light colours to promote cleanliness.

Colour analysis

Hard colours	Not generally recommended in this context; pale yellow is acceptable where appropriate.
Soft colours	Generally preferred in food-processing applications.
Bright colours	Colours of high reflectance value are recommended to promote cleanliness.
Dark colours	Few applications.
Violet	All variations should be avoided in food plants.
Blue	Particularly suitable for food plants because it is cool and clean and a good background for any food; has a flattering effect on appearance but tends to accentuate coolness. Recommended for dairies, although it may be a little cool; for meat-processing plants, light blue is suggested.
Blue-green	Similar remarks as for blue but is more decorative; turquoise is particularly useful where an attractive appearance is desired; excellent effect on human appearance. Recommended for meat processing because it is the complement of the red of meat.
Green	Recommended for food plants, especially where a cool atmosphere is desired; Lighter greens are flattering. Recommended for meat processing and vegetable processing but avoid darker greens, which may create an unpleasant reflection on the food; also avoid yellowish greens and olive greens. Use green with care in the country; the green is provided by nature and something warmer may be better.
Yellow	Soft yellow or primrose can be recommended as an alternative to white, and they are warmer than white. Can be used as an accent with white to provide variety. Recommended for refrigerated areas, it warms them up; dairies, it is the natural colour of butter. Avoid harsh or greenish yellows.
Orange	An excellent colour in association with food but too strong to be used in food plants.
Brown	Lighter variations, such as buff or beige, can be used to create a warmer atmosphere, but dark browns should not be used. Lighter variations are reasonably flattering. Recommended for dairies, refrigerated areas, vegetable processing (tan provides a good background), bakery products.
Red	No applications in the food-processing plant except as a safety colour – it is too strong. Avoid purplish reds, which suggest bad meat.

Pink	Some variations are a little too warm for food plants, but peach is a good background to food and is an alternative to white. All pinks are flattering to the human complexion. Peach or coral is recommended for refrigerated areas; coral is suitable for cool areas generally and for vegetable processing.
White	The ideal colour for food plants because it is cool and clean and promotes hygiene; it is widely used but tends to be cold and sterile unless relieved, large areas tend to be trying and to create glare; they also accentuate coolness. Reasonably flattering to human appearance. Recommended for dairies.
Off-white	A warmer alternative to white and suitable for large wall areas where pure white would be bleak. Use with care – some off-whites suggest dirt. Cream, ivory, shell white are suitable. Recommended for refrigerated areas and vegetable processing.
Grey	Should not be used where appearance of food is important, but can be used in corridors and staircases to conceal soiling. Recommended for bottling plants; to camouflage soiling.
Black	No applications in the food plant.
Grey tints	Mushroom can be recommended for large wall areas where white would be bleak.

11.10 Food service

When selecting colour for the decoration of places where food is served and eaten, place particular emphasis on enhancing the appearance of the food and making it more attractive to eat. The immediate background to the food, including plates, serving dishes, napery and so on should be in colours that are complementary to the colours of the food and thus present it to best advantage. The colours of the immediate surround should complement, or associate with, the food. The colours of the overall surroundings may be more decorative in nature and should be welcoming, but they should associate well with the food and inspire a desire to eat it.

 Cleanliness is vital in all food operations and colours used for background to food; the immediate surround of food should be light, clear and clean. More latitude may be allowed in the overall surroundings, but the colours should never suggest dirt. Reflected colours from walls and fittings must not spoil the appearance of the food and should flatter the appearance of the customers. The colour-rendering qualities of the light are important to the appearance of the food and to that of the customers. Avoid:

- too much colour
- modified colours which cause unpleasant associations
- any light or colour which may distract from the appearance of food.

Colour analysis

Hard colours	Stimulate the appetite. Recommended for overall surroundings, fascias and signs and to provide welcome and decorative effect. May be used with care in the immediate surround.
Soft colours	Retard the appetite. Recommended for the immediate background to food and in the immediate surround. Most food is warm in colour and cooler shades provide good contrast.
Bright colours	Recommended for display and for areas with a fast trade. Plenty of light and colour is welcoming and promotes traffic.
Deep colours	May be used for accent purposes and for the overall surround in more intimate establishments.
Violet	Not recommended for food service; not well liked and does not associate well with food.
Blue	Well liked in association with food; popular, non-distracting, cool. Use: best used as a background for food, especially meat and sea food; background to display and presentation of food, one of the safest colours for display and can be used adjacent to salads. Can be used in immediate surround to food but is too cool for large wall areas. Light: plates, serving dishes, table tops. Medium: immediate surround, background to servery. Dark: accent only, small areas in luxury establishments.
Blue-green	Well liked in association with food and more lively than pure blue. Use: best used as an immediate background, especially to meat, also walls; background to food presentation; especially allied to white. Light: plates, serving dishes, table tops, etc. Medium: immediate surround, overall surround. Dark: accent and decorative purposes.
Green	Stimulates a desire for food. Excellent in association with most foods but not as background to meat or bakery products. Clear greens are best. Use: overall surroundings, immediate surround, presentation of salads and green foods. Light: plates, serving dishes, table tops and so on; interiors generally (combines well with peach); presentation of salads, food display fixtures. Medium: immediate surround, overall surroundings, immediate surround to display. Dark: accent or decorative purposes in small areas only.
Yellow	Associates well with all foods; paler yellows are preferred, although not lemon yellow.

Use: walls generally, immediate surround; warm versions are a good general accent colour; may be used for presentation.

Light: plates, serving dishes, table tops and so on; walls in general run of restaurants; immediate surround.

Medium: walls generally, and for accent.

Dark: accent and decorative purposes only.

Orange Excellent in association with food.

Use: mainly for accent purposes; too overpowering for any large areas or for walls.

Light: peach is to be preferred (see under Pink below).

Medium: accent only.

Dark: accent only.

Brown Good in association with food but light shades are best.

Use: overall surroundings, immediate surround; darker shades for accent.

Light: a good general sequence colour in all catering environments.

Medium: for fixtures, fittings and furniture; for accent.

Dark: not recommended except in small areas.

Red The best of all colours with food and one of the most useful colours in the catering environment.

Use: overall surroundings, immediate surround, presentation.

Light: see Pink.

Medium: immediate surround to cooked meats and display; generally, for accent purposes, fixtures and so on.

Dark: mainly for decorative purposes.

Pink Peach is probably the most useful catering hue and conducive to good appetite.

Use: good for walls in any eating area; overall surroundings, walls adjacent to display, canteens.

Light: for walls in any catering environment, including walls adjacent to display. Plates, serving dishes, table tops, etc. Immediate surround, particularly with fish.

Medium: accent in fast-trade outlets; coral is a good alternative to peach but for a faster trade.

Dark: as for medium.

White Clean and effective for food applications.

Use: Ideal background for presentation. For fittings, fixtures and refrigerated displays. Accent in immediate surround, table tops, serving dishes, meat trays, etc. Back of shelves and racks.

Off-white As for white.

Use: May be used for overall surroundings in catering applications provided the variation is carefully chosen; it must not look grubby. Off-whites are best not used as an immediate background to food.

| Grey | Best not used in association with food but can be used for decorative purposes. |
| Black | No applications. |

11.11 Food stores

When selecting colours for the decoration of food stores, place particular emphasis on the colour of the food that is being sold. The immediate background to the food displayed should be in colours that are complementary to the colour of the food and thus show it off to best advantage. The colours of the immediate surround should also complement or associate with the colour of the food. The colours of the overall surroundings may be more decorative in nature and should be welcoming, but they must not attract attention away from the display, and they should associate with the food and inspire a desire for food.

Cleanliness is vital and therefore light, clear, clean, colours are indicated. It is important that no reflected colour from walls or fittings should affect the colour of the food. The colour-rendering qualities of the light are particularly important. Also:

- Avoid too many colours.
- Avoid too deep colours.
- Avoid modified colours and those which may cause an unpleasant effect such as yellow green.
- Avoid distracting colours. Let the merchandise sell itself.

Colour analysis

Hard colours	Recommended for overall surround, fascias and signs and to provide decorative effect.
Soft colours	Generally recommended for the immediate background to food display and in the immediate surround. Most food colours are warm, and cooler shades provide a contrast.
Bright colours	Recommended for most food stores. Plenty of light and bright colour promotes cleanliness and is welcoming.
Dark colours	Few applications in the food store except for small areas for accent purposes.
Violet	Not recommended for any food applications, but it has an association with sweetness and may be used for the interiors of confectionery stores of the highest class.
Blue	Excellent for most food stores, especially in relation to meat or provisions. Popular, non-distracting, cool. Use: walls, fixtures, trim for shelves, immediate surrounds, a bit cool for large areas. Associates well with meat and may be used for trim with milk and seafood. Light: walls for grocery. Medium: food shop exteriors, although it may make the shop look smaller.

	Dark: reputed to make the fat and tissue of meat look whiter and more tender.
Blue-green	Excellent for the food store, especially for meat. Use: walls, immediate surrounds, display generally, especially allied with white. Makes meat look more appealing. Light: for walls and immediate surrounds in the provision section of grocers and for display generally. Medium: immediate surround to meat service. Dark: accent only.
Green	Excellent with many foods but not with meat or bakery products. Clear greens are best. Use: walls, immediate surrounds. Light: for interiors generally and especially for vegetables; combines well with peach; for cooking areas. Medium: immediate suround to display, particularly of vegetables. May be used for accent. Dark: not recommended. Green is not recommended for the exteriors of grocery shops.
Yellow	Excellent in association with food, but paler yellows are preferred. Use: walls generally, immediate surround, for rear walls of a long narrow shop. Warm yellow is a good general accent colour. Light: good immediate surround for vegetables. Walls in grocers' shops and when lighting is less than brilliant. For refrigerated areas and end walls. Medium: display accents. Dark: accent only.
Orange	Excellent for most food stores. Use: mainly for accent purposes; a little overpowering for walls or larger areas. Particularly suitable for bakery products. Light: peach is to be preferred (see Pink). Medium: for accent purposes. Dark: accent only.
Brown	Lighter shades are suitable for food stores. Use: some walls, fittings, accents. Good for tea and coffee. Light: for refrigerated areas; suggests warmth. Medium: for fixtures and fittings; also accents. Dark: not recommended.
Red	Excellent for food stores; red-orange is good for accents and display. Use: walls, immediate surrounds, accents. Light: see Pink below. Medium: generally for accent purposes, fixtures and so on. Strong coral might be used for exteriors. Immediate

Pink surround to cooked meats.
Dark: mainly for accent purposes.

Pink Peach and coral are the most useful hues in the food store, particularly in supermarkets, because they suggest activity and promote appetite.
Use: walls, immediate surrounds, accents.
Light: for walls in groceries, immediate surrounds to vegetables, walls for bakers, refrigerated areas, walls in delicatessen. Immediate surround to shell fish, immediate surround for confectionery, accent for fixtures, walls in car salerooms.
Medium: as for Light above.
Dark: as for Red above.

White Clean and effective for food applications and psychologically pleasing to the housewife who feels white is clean.
Use: Walls, although too much white can be sterile and may cause glare; a neutral might be better in some cases. Ideal background for display of foodstuffs, particularly meat and provisions. Interiors and backs of shelves; fittings in grocers' shops; refrigerated fittings; walls in off-licences, dairies.

Off-white Much the same as white; off-whites are less glaring but need care in use, they may suggest something is less than clean.
Use: magnolia is a warm off-white very suitable for food stores, where something a little warmer than pure white is required. Cream may be used for walls where lighting is dim and for refrigerated areas. Ivory and shell white can also be used.

Grey To be avoided in food stores because it suggests dirt and bad housekeeping.

Black No application in the food store.

11.12 Industrial plant and equipment

When selecting colours for any piece of equipment remember that the principal functions of colour in this context are:

- to provide the best possible seeing conditions
- to eliminate glare and specular reflection
- to provide variety and eye appeal
- to mark hazards and provide identification.

To achieve these objectives it is necessary to decide which part of each machine should be finished in light, medium or dark colours. Light variations are intended for highlighting those portions of machines which are handled by the operative or which are in the direct line of vision of the operative. They are

intended to reflect light at important points and to provide better contrast with the materials being worked. Suitable hues are buff, light stone or light green.

Medium variations are intended for the main body of equipment. The average overall reflectance value should be within the limits 35 to 50 per cent. The main body of most equipment should be in the 35 to 40 per cent range, but the upper limit can be used for the superstructure of machines or where work is carried out to close tolerances. The lower limits should be used in very large machines to avoid overwhelming brightness and can also be used for the base or plinths of all machines; the latter could be in darker colours still. Here is a rough guide.

- Where working to close tolerances 40–45 per cent
- Average 35–40 per cent
- Large machines 30–35 per cent

Cool colours are generally best and recommended shades are grey, greyed blue, greyed blue-green, greyed green. Warmer colours may be used where material colour so dictates or for machines used for semi-automatic assembly work. Dark variations are used only for bases or plinths which are subject to a great deal of soiling, kick marks and so on. Safety yellow, safety blue, and safety red fall within the dark category and should be used for marking hazards and giving warnings in accordance with established practice.

A semi-gloss finish is recommended for most industrial equipment because it is less distracting and less likely to cause glare. If full-gloss finish is used, care is necessary to eliminate specular reflections. Metallic finishes are generally best avoided because they are difficult to apply, impractical to touch up, do not conceal small imperfections and tend to accentuate specular reflections, which may cause glare and be troublesome to operatives.

The hues suggested above should be satisfactory in average lighting conditions, but special considerations may be required where lighting conditions are exceptionally difficult. Other hues can be used, and reference should be made to the colour analysis that follows. All equipment should be finished in colours that are functionally suitable in terms of reflectance value and hue.

Colour analysis

Hard colours	Only for marking hazards, control boxes and so on.
Soft colours	Recommended for most surfaces of industrial plant and equipment.
Bright colours	Not recommended, except for highlighting; medium tones are preferred.
Dark colours	For bases and plinths only; also for safety purposes where appropriate.
Violet	Colours in this group are not recommended in this context.
	Uses: purple is sometimes used to indicate radiation hazards, but the practice is not universally accepted.
Blue	Blue is perfectly suitable for most industrial equipment. It is cool and relaxing in character, and although less

neutral than grey, may be more attractive to operatives. It is a little too cool for large machines but could be recommended to cool down a warm environment. Muted blue (i.e. slightly greyed) is preferred to clear blues.

Uses: a light blue might be recommended for food-processing machinery but not for most workshops; very dark blue might be recommended for bases and plinths. Safety blue is used to indicate mandatory action and impart information (contrast with white); medium tones are recommended for machine bodies. Often used for control boxes.

Blue-green Well recommended for most industrial uses. It has more character than blue and has restful qualities; it is passive in character and does not impose itself unduly. Medium tones will conceal marks and stains and withstand considerable wear without showing worn areas.

Uses: can be recommended when appearance is important; has a normal appearance under most types of lighting, including sodium lighting. It photographs well and can be recommended for display purposes. Recommended for instrument housings where the instruments have to be viewed under dark conditions, but it is also restful and non-distracting under normal lighting conditions; this also applies to VDUs. Particularly suitable in difficult lighting conditions and where a distinctive colour is required.

Green Restful in nature, not as cooling as blue; has more character than grey and is suitable for machinery and all industrial equipment.

Uses: light greens are suitable for highlighting working areas; medium greens are suitable for machine bodies, preferably greyish tones; dark greens have few uses. Safety green is used to indicate first-aid points and safety exits.

Yellow Few uses in industrial applications because it reflects too much light.

Uses: safety yellow is used to mark hazards, including the edge of shears, guards, exposed gears and the like.

Orange No applications in this context.

Brown Perfectly suitable for industrial equipment but has not been widely used. Warmer than blue or green and may not be suitable for a warm environment; would be conducive to good morale in semi-automatic assembly plants.

Uses: light browns are excellent for highlighting purposes and can be applied to prominent parts of a machine (e.g. heads, background to working plane, etc.) but should not be used for the main body of the machine.

	A tone having a reflectance of about 60 per cent is particularly suitable where the material being worked is copper, brass, aluminium or wood. Medium browns may be used for a main body, whether or not brown is used to highlight. Darker browns are only suitable for bases.
Red	Not a suitable colour for workshops, although machines are often finished in red for exhibition purposes.
	Uses: safety red is used to indicate stop or prohibition and can also be used for firefighting equipment.
Grey	A neutral colour ideally suited for most industrial equipment, including machine tools. Non-distracting and strikes a balance between black and white, each of which has equal visibility on it; a good background for most visual tasks because it acts as a cushion to visual shock, and even if there are lighter and darker colours in the environment, it promotes a steady and uniform adjustment of the eye.
	Uses: medium tones are recommended for the body of most machines, including VDUs, but are not recommended for working surfaces; it does not provide sufficient contrast with the task nor reflect light where it is required.
White	Not recommended in the industrial context because it tends to cause glare and distraction. Can be used for the bodies of food-processing machinery to promote cleanliness.
Off-white	Not recommended for industrial plant, although it is sometimes used for the housing of VDUs.
Black	No applications for industrial plant.
Grey tints	Light stone is recommended as a highlight colour and similar remarks apply as for brown.

Note: VDUs are visual display units, now commonly used in workshops, for example where computer-controlled machine tools are in use. VDUs are discussed in more detail in 11.19 in this part.

11.13 Merchandising

The use of colour for merchandising is primarily the use of colour to make displays more effective, and some colours are better than others for this purpose. A display is defined as something to attract attention and usually to draw attention to and enhance some specific merchandise or service offered for sale. The term includes shop window displays and the more elaborate displays such as showcases used on the shop floor. Graphic point-of-sale displays are not included in these notes.

The starting point in the process of attracting attention is the colour of the

merchandise itself, but the colour of the background and of the immediate surround is equally important. There are four aspects to the process of selecting colours for displays:

- The colour of the merchandise itself when a coloured object or a group of similar objects is displayed. The colour of the merchandise may be chosen to attract attention and create impulse sales, as well as for other reasons.
- The colour of the target. This applies when the merchandise itself lacks colour or when a group of different coloured objects, such as a dress collection, is displayed; or when packages are displayed on shelves, creating their own colour. In such cases it is the colour of the 'framework' and the arrangement of the display which attracts attention.
- The colour of the background to the products displayed. This is of most significance in the first instance but also of importance in the second. It should usually be the complement of the product colour.
- The colour of the immediate surround to the display. This must enhance the overall appearance without distracting attention from the merchandise.

The following points are important:

- Primary hues are best for the target area of any display, but softer and more subdued hues can be used for background; hues may be subtle.
- Use brightness against darkness. Merchandise should be bright.
- A dark object is best displayed against a light background.
- Use warm colours against cool ones.
- Use cool colours against neutrals.
- Use detail and texture against filminess i.e. let the background be indeterminate.
- Use form against or surrounded by space.

Colour analysis

Hard colours	Best for display purposes whenever possible; have good impact and greater visibility.
Soft colours	Mainly for background purposes in display applications.
Bright colours	Best for display purposes, but not for background.
Dark colours	May be used for background in some cases, but otherwise mainly for contrast.
Violet	Seldom used for display purposes because it has little impact, poor recognition qualities and is difficult for the eye to focus and see.
	Use: purple is sometimes used as a background colour for high quality products because of its associations (e.g. with royalty).
Blue	Retiring, passive, colour; not very easy to recognise or to find, and it is difficult for the eye to focus.
	Use: ideal background because it does not attract attention away from the merchandise; especially good where

it is desired to place maximum emphasis on the product; for food; and for impulse-sold merchandise. Not suitable for use in large areas. Navy blue is particularly recommended as a background to light-coloured merchandise and for fashion merchandise.

Blue-green
Has more impact than pure blue and better recognition and visibility qualities.

Use: generally used as background. Turquoise is recommended as a background to womens' fashions but also has some impact when used as a feature colour.

Green
Basically neutral, but luminous shades have good impact; excellent recognition and visibility qualities; well liked.

Use: best used for background purposes and to create a pleasing immediate surround. Darker greens should generally be used for accent purposes but forest green can be recommended to provide dramatic emphasis; as a background for light-coloured merchandise; and as a background for fashion merchandise, especially in alcoves.

Yellow
Excellent impact value, good recognition qualities and the most visible of all colours.

Use: paler yellows are suitable for background and immediate surround; deeper yellows are best where impact is required. Avoid harsh yellows.

Orange
Best of all colours for impact, excellent recognition qualities and excellent visibility.

Use: a little overpowering if used in large areas and a little strong for most background purposes.

Brown
Little impact and poor recognition qualities. Light browns, such as beige, have reasonable visibility.

Use: essentially a background colour. Warm wood tones are a good background for clothing.

Red
Excellent impact value, good recognition qualities and good visibility. Yellowish reds are generally preferred to bluish reds and have better visibility.

Use: strong reds are best used as attention getters or for accent; pink can be used as a background colour. Red loses value in some lighting conditions and is at its best in daylight.

White
Lacks impact, difficult to find and to remember, but has good visibility; stands out sharply in the dark.

Use: best used as background, especially for food.

Off-white
Not generally recommended for display purposes.

Use: may be used as immediate surround. Not recommended as a background to merchandise.

Grey
Little impact, difficult to identify and poor visibility.

Use: may be used as a background for hardware, par-

	ticularly metal articles.
Black	Little impact, poor recognition and poor visibility.
	Use: sometimes used to create contrast with lighter colours. Can be used as a background for hardware and recommended as a background to china and glass.

11.14 Pattern

However many colours there are in a design and however the colours are put together, it is the overall colour impression which is the vital point. What counts in marketing terms is the base colour or ground colour, although in some designs there may be no real base colour, just an overall impression.

There is an association between colour trends and pattern trends in consumer markets. When there is a trend towards pastel colours there will also be a trend towards gentler and traditional patterns. A trend to strong, brilliant colours will signal a demand for bolder patterns; a trend towards muted colours indicates restrained patterns. Some colours are just not suitable for some designs, but it is difficult to formulate hard-and-fast rules; the choice is one that depends on the skill of the designer. There are two broad rules:

- Advanced designs require advanced colours.
- Assymetrical shapes go best with bold colours and attract attention at point of sale.

The association between colour and pattern is really only significant when considering the selection of colour for products, and the situation will vary with the nature of the product. It is also important, of course, in interior decoration.

Colour analysis

Hard colours	No special comment.
Soft colours	Not generally suitable for modernistic or geometric designs. Preferred by professional specifiers.
Bright colours	Not suitable for traditional 'pretty' patterns; recommended for large flowing patterns; suited to regimented designs.
Dark colours	Suited to regimented designs.

Individual colours have little significance, with the exception of the following:

Red	The nature of red is such that it ought to command a design.
White	Often used as a base colour for patterns because it will go with anything. In such cases the secondary colour has added importance.
Off-white	As for white.

11.15 Safety

Certain colours have accepted safety connotations and are used to mark hazards and to assist in the visual presentation of information about safety. The virtue of colour in this context is that it is immediately seen and recognised by people with normal vision, and the recognised safety colours can be used to draw attention to safety points and hazards. However, it should be remembered that some people are colour blind and therefore colour cannot entirely replace suitable wording and/or signs.

There is a British Standard relating to safety colours, BS 5378:1976, and this specifies the following preferred colours. References are to BS 5252:1976:

- Safety red Stop, prohibition, firefighting equipment 04E53
- Safety yellow Caution, risk of danger 08E51
- Safety green Safe condition, emergency 14E53
- Safety blue Mandatory action, including an obligation
 to wear safety equipment, information 18E53

Safety colours have little significance so far as marketing is concerned, but they are of considerable significance in industrial and commercial applications – for machinery and for vehicles. They are seldom used in the home except, perhaps, for red emergency switches, but the reasons why the colours are recommended may be significant in many applications.

Colour analysis

Hard colours Generally best for safety purposes because they have more impact.

Soft colours Best used for background.

Bright colours Pure hues are desirable but avoid mixtures of primaries.

Dark colours Best avoided in safety applications.

Violet Purple is frequently used overseas to indicate radiation hazards on doors, door frames leading to hazardous areas, controls, charts, labels and so on.

Blue Blue is recommended with white contrast for signs designed to indicate mandatory action and to give information. Used in some countries to indicate electrical hazards or to mark equipment that is out of order and control boxes that might otherwise be difficult to find. It is also used to mark cars or equipment that is being loaded or unloaded. It is painted on electrical control panels, switchboxes, welding generator boxes, electrical control panels. Also whenever caution is necessary.

Green Recommended with white contrasts for exits, escape points, first-aid points, safety equipment. Overseas uses are similar. Large green crosses are painted on walls or columns to aid location.

Yellow Yellow is recommended with black contrasts to mark hazards which may cause accidents. Most vivid and high

in attention value. Useful for any hazards likely to cut, burn or shock. Overseas, it is recommended that yellow should be painted on or near gear wheels, pulleys, along cutting edges, rollers, presses and the hazardous parts of saws. It is also used inside guarding plates and lids and exposed rollers or gears so that attention is drawn to them. Also for guards and railings over hot pipes; exposed wires and overhead electric rails; inside areas of switchbox doors. Yellow is used for stumbling, falling and tripping hazards; it is applied to guard rails, transportation equipment, platform edges and so on; suggested for containers of flammable liquids, with black letters to indicate contents. Yellow and black stripes can be used on the steps of buses to prevent accidents; one company in the United States reported a reduction of 90 per cent in boarding accidents. Yellow is valuable because it is the colour of highest visibility in the spectrum and because its great brightness makes it distinguishable under dim light. It is widely used for vehicles that perform a service, such as breakdown vehicles and the like, and also for works trucks and similar vehicles.

Orange	An alternative to yellow in most safety applications and has rather more impact. Red-orange has better visibility than weak yellow and is strongly recommended for use at sea (e.g. life rafts).
Brown	Few safety applications. Orange-brown is used to indicate the presence of hazardous chemicals and explosives (HAZCHEM).
Red	Recommended with white contrast to locate firefighting equipment and alarms; also for prohibitions and instructions to stop. Overseas it is used for stop buttons and positive prohibitions, although its use as a danger signal requires care because so many males are colour blind. In certain countries it is recommended that red should not be used for anything flammable.
Pink	No safety connotations.
White	In safety applications it is used as a contrast to other colours. Overseas it is used for aisle markings, storage-area bins, waste receptacles.
Off-white	As for white.
Grey	No safety connotations but has camouflage implications; grey objects are difficult to see and tend to merge into the background.
Black	Used as a contrast to yellow in safety applications.

Note: Some notes on the relationship between vehicle colour and safety on the road will be found under the appropriate colour headings in Part III.

11.16 Signs

When selecting colour for any sign, the principal functions of colour are:

- to ensure recognition of the sign and make it easy to pick out and identify in the environment in which the sign is used
- to ensure that the sign is visible, particularly at long distances and in difficult lighting conditions
- to ensure that the sign is legible; this means good contrast between legend and ground
- to avoid the risk of glare and bright sunlight making the sign unreadable
- to differentiate between signs, particularly in urban clutter
- to provide a method of coding or to establish a corporate image; the colour may have an association with the object of the sign.

The following points should be considered:

- the purpose of the sign and the emphasis necessary
- the background against which the sign will be seen
- the distance from which it must be seen
- whether the sign is intended to convey information or to trigger action
- whether the colour of the ground, or the colour combination, can be used to convey any useful information (e.g. a brand image) or in the case of direction signs, whether it can be used to direct people to a specified goal
- whether colour is to be applied to the ground or to the legend or to both
- the general appearance – except for warning or prohibition signs, all signs should be pleasing in appearance and appropriate to the environment in which they are used.

In the analysis that follows, the most legible combinations have been listed against each principal hue. These are based on tests carried out by various authorities, but the combinations are not necessarily pleasing to viewers. A black on yellow combination, for example, would be excellent for drawing attention to a hazard, but it would not be at all appropriate in, say, a hotel lobby. The most pleasing combination is a matter for the exercise of common sense in the circumstances of the case.

Colour analysis

Hard colours	Generally best for signs of all kinds because they have better recognition value and more impact.
Soft colours	Generally best for ground use, especially for advertising signs, because they tend to recede and thus emphasise the legend.
Bright colours	Pure hues having a good reflectance value are recommended for most signs and should be strong enough to provide good contrast with legend.
Dark colours	Not generally recommended for signs, except for legend against a light ground; dark colours used for ground tend

	to merge into black or grey.
Violet	Purple is sometimes used as a ground colour for signs where variety is required or because of some association; not widely used because it lacks impact.
	Recognition: poor qualities.
	Visibility: difficult for the eye to focus and may be blurred when seen in combination with other colours.
	Uses: radiation hazards in some countries; used in hospitals to signpost mortuaries.
Blue	Has some disadvantages as a colour for signs because it tends to recede and is difficult for the eye to focus. Best used as a ground colour for large signs as on direction signs on motorways. Blue is very apt to fade.
	Recognition: not very easy to recognise or to find, especially against an outdoor background.
	Visibility: a retiring colour which is difficult for the eye to focus; it tends to make objects look blurred, particularly when seen in combination with other colours, but for this reason it is excellent for advertising signs because it emphasises the legend; tends to merge into a grey background. Has better visibility than other colours at night or in dim lighting conditions; does not lend itself to sharpness of detail.
	Uses: cleanliness (toilets, baths, etc.); the sea and the sky (outdoor activities).
Blue-green	As for blue but has rather more impact than pure blue.
	Recognition: better qualities than pure blue.
	Visibility: better qualities than blue; turquoise has some of the qualities of green.
Green	Excellent qualities for signs; a luminous medium green is recommended; very dark green may be difficult to distinguish from black, especially in dim light.
	Recognition: excellent qualities but is difficult to identify against a green background.
	Visibility: good visibility and is kind to the eye but tends to be a little retiring and may not provide good contrast. It is not sharply focused by the eye and is usually best as ground. Yellow-greens have better visibility than greens with a blue bias.
	Uses: movement generally, safety (escape routes, first aid).
Yellow	Yellow, or preferably yellow orange, is suitable for signs and is particularly associated with caution and hazards. Less likely to cause glare than white. A pale yellow would look too much like white. Yellow can be confused with green.
	Recognition: good recognition qualities; black on yellow can be highly recommended where maximum im-

pulse is required but is best restricted to cautionary notices.

Visibility: excellent visibility, the most visible of all colours; it reflects in the high visibility region of the spectrum where visual acuity is keen and where images are most easily focused. Although highly visible, it may not be easy to identify or to find. Stands out sharply in the dark. The eye focuses it clearly and without aberration, and it provides a sharp, crisp, image.

Uses: mainly for caution and marking hazards.

Orange
An alternative to yellow when maximum impact is required, but a little brash and overpowering for most uses.

Recognition: excellent qualities; red-orange has all the virtues of red.

Visibility: excellent qualities; red-orange is better than yellow and is the best of all colours in this respect; provides a sharp image.

Uses: is used for hazard warnings.

Brown
Not widely used for signs and has little impact. Light browns, such as beige, might be used for ground but not for legend. Brown is a mixture of colours and acquires the characteristics of the dominant hue, but it lacks brightness.

Recognition: poor recognition qualities.

Visibility: beige has reasonable visibility but lacks punch.

Red
Excellent for signs because of its recognition and visibility qualities. It has excellent impulse attraction but suffers from the disadvantage that many people are colour blind to red, therefore the form of the sign may be as important as the hue. Red is used world-wide to indicate prohibition, and its use is best limited to this application. Red tends to 'disappear' in dim lighting conditions, but a bright red will take a lot of dirt without losing appearance.

Recognition: the colour of highest recognition value.

Visibility: an easy colour to see in daylight conditions. Slightly refracted by the lens of the eye and therefore tends to advance and make objects look larger. Yellowish reds have better visibility than bluish reds. Can be difficult to see in the twilight period and loses value under some lighting conditions. Sharply focused by the eye.

Uses: red on white is associated with prohibition, and its use is best limited to that purpose. Also fire and 'stop'.

Pink
Quite suitable for signs, but its use should be limited to ground; not recommended for legend. Less impact than red but may be used for signs where it is desired to

	convey something unusual.
	Recognition: poor recognition qualities, although stronger pinks, such as coral, have reasonable qualities.
	Visibility: strong pinks have reasonable visibility.
	Uses: suggested for powder rooms and other feminine facilities.
White	Good ground colour for signs, but is difficult to recognise and to find, although it has good visibility. Best used for regulatory signs and in the UK is used for minor road signs. It is particularly subject to glare and can cause blurring. It may cause a blind spot in bright sunlight but is good in darkness because it is always seen as white and does not lose its identity.
	Recognition: poor qualities; it has little visual interest because of its lack of chromaticity; this is particularly the case against a background of sky.
	Visibility: good; it can be seen at considerable distances but is difficult to find; it stands out sharply in the dark but tends to reflect sunshine in daylight; it is particularly difficult to pick up quickly when dirty.
Off-white	Not recommended for signs.
Grey	Not recommended for signs.
	Recognition: difficult to identify.
	Visibility: little brightness and in full daylight tends to look further away than it actually is; tends to merge into the shadows at twilight and invisible in the dark.
Black	Used mainly for contrast with other colours but is a poor target. Black is almost wholly passive in this context and affords no stimulation to the nerves of the retina of the eye; it is also emotionally negative and holds little visual interest. It is difficult to focus and to judge as to distance and is not recommended for ground use.
	Recognition: not easy to identify.
	Visibility: least visible of all colours; particularly difficult to see at night but stands out well against greyness.

Note: Attention is drawn to 9.8 above for information about the comparative readability of variour colour combinations.

11.17 Television

Colours react to the television camera in a different way to their reactions to the human eye, and special care is necessary when selecting colours for products or packages that will appear on the television screen. Reflectance values may be significant when considering contrast between colours; a ratio of at least 5 : 1 is desirable.

The colour analysis that follows sets out the main effects of television on the basic hues and the points that should be watched when selecting colours; but where television advertising is a vital part of the marketing plan, it is recommended that advice should be sought from a television expert and camera tests made where necessary.

Colour analysis

Hard colours	Most variations of red and orange reproduce satisfactorily, although intermixtures are often present. Yellow is more difficult (see below).
Soft colours	Blue and green reproduce satisfactorily, but violet shades are difficult to fix.
Pure hues	Most pure hues, except yellow, reproduce well. Variations of red, blue and green which are the television phosphers reproduce very well, although reds tend to have an orange cast and greens tend to go yellowish, although some greens take on a turquoise tinge. Sharp distinctions of shade or tone may be difficult to obtain. Combinations of red and green, or blue and green ,are likely to prove difficult.
Muted hues	Greyish tones and muted hues generally should be used for background; background colours are unlikely to appear visually vivid.
Light colours	Colour differences will be fairly well maintained, although tints are likely to appear filmy in quality. Very pale tints may appear indistinct. Pale colours should be emphasised by surrounding them with medium or deep colours.
Medium colours	Middle tones reproduce satisfactorily, whether pure or muted, and they show up best of all after pure hues. Medium and grey tones are, perhaps, the safest of all for use of television and are preferred in most circumstances because they help to avoid flare.
Dark colours	Deep shades such as maroon, dark brown, olive and navy blue are difficult to use satisfactorily, and objects in these colours will not appear structural. All very dark surfaces will tend to appear the same, and it is difficult to register subtle differences. It is difficult to make dark colours appear darker by surrounding them with brightness. Highly saturated colours tend to look black.
Violet	Purple and most variations in this group are difficult to fix.
Blue	Most variations reproduce satisfactorily but navy blue is difficult to use and will fail to register small differences. Dark blues tend to look black; ultramarine tends to look turquoise and combinations of blue and green present some difficulty.

Blue-green	Most blue-greens tend to look too blue on the screen.
Green	Most variations reproduce acceptably, but some will pick up a yellowish or lime green cast in one direction and a blue cast in the other direction. Dark greens tend to look black, and olive is best avoided; forest green will fail to register small differences; combinations of green with red or with blue tend to be difficult.
Yellow	It is not easy to create a satisfactory yellow on the screen because to see yellow the eye must 'confuse' dots of red and green. At the slightest excuse, pure yellow becomes tan, orange, mustard, buff or green. The balance between red and green is very critical.
Orange	Reproduces well.
Brown	Darker browns are difficult to use, and the screen fails to register small differences. Tan often looks like pale orange because the slight grey influence in the original shade is lost.
Red	Most variations reproduce acceptably, although they often tend to have an orange cast. Small variations do not show up; vermilion with an orange cast or scarlet with a purplish cast, simply appear as red. Maroon is difficult to reproduce and combinations of red with green often present difficulty.
Pink	The pinkish tones of the human complexion are picked up exceptionally well. A dusty pink against a dark field will look like washed-out pure pink. When using pinks aim for a contrast ratio of about 5 : 1.
White	Large areas of white may cause 'flare'. White is often indistinct on the screen and may be emphasised by surrounding it with medium or deep colours.
Off-white	No special connotations.
Grey	Greys will normally be indistinct, and darker greys will show up as black.
Black	May look like darkness seen in space and may not be definite. The theory of television presupposes that black is absence of light but, in fact, it is a psychological effect. There is a vast difference between a piece of coal and an empty tomb and, in practice, black surfaces look more black as increasing light is thrown on them. Dark shades containing black are difficult to fix satisfactorily.

11.18 Texture

The appearance of any colour is affected by the texture of the surface on which it is used, and this may require testing and modify the selection of colours. It will be obvious that a shiny lacquer has a very different effect to a coarse-textured wallpaper. The same colour looks quite different on a rough wool

carpet, on glazed ceramics, on woven satin or on plastics. The impact of almost any colour depends on the surface on which it is used, and the sense of touch complements the eye.

Matt and soft materials tend to appear warm and welcoming; shiny and smooth materials are cooler and can be uninviting. An appropriate colour can increase or reduce the effect of a colour. Delicate pastels are out of place on a rough brick wall.

If the colour remains the same but the texture is changed, then appearance changes, and this applies particularly to interior decoration. A hard, shiny, surface gives a brisker look and more light, while wood panelling gives a room a homely, informal, look. A textile wallcovering has the same effect.

Colour analysis

Hard colours	Generally look best on rich materials with a marked texture. Can be overwhelming on a shiny surface.
Soft colours	Look best on shiny surfaces or on materials with a comparatively smooth texture. Out of place on a brick wall.
Bright colours	Happiest on less-textured surfaces.
Dark colours	Go well with strong textures.
Neutrals	Texture is specifically recommended with neutrals.
Violet	Looks best on comparatively untextured materials; mauve is not recommended for velvets.
Blue	Dark blue looks best on a pile fabric or soft velvet.
Blue-green	Best on a hard, glazed, surface, and this applies particularly to turquoise.
Green	Suitable for most textures.
Yellow	A light yellow is best on comparatively untextured materials; it looks good on shiny silks and loses much of its radiance on felt or wool. Not recommended for velvets.
Orange	Suitable for most textures but may be overpowering on shiny surfaces.
Brown	Darker browns are best on shiny surfaces; a matt dark brown is very dreary. A matt untextured surface in brown or beige is neutral. Good on thick pile rugs.
Red	Strong reds demand rich materials. A surface lacquered in red is impressive and looks better than a rough wood painted in the same colour.
Pink	Not suitable for heavily textured surfaces.
White	Suitable for most textures.
Off-white	Suitable for most surfaces; cream goes well with texture.
Grey	Suitable for most surfaces.
Black	Looks best on shiny surfaces; matt black looks dreary.

11.19 Visual display units (VDUs)

In solving the problems created by VDUs, colour has a number of parts to play. For example:

- The use of suitable colours will help to make the screen easier to read. The recommended colour combination for the screen is yellow-green characters on a dark green background, but orange characters could also be used on a dark green or amber background. These combinations have the advantage that the eye is most sensitive to them; other combinations could be used provided they are acceptable to users.
- The use of colours of moderate tone for furniture and equipment helps to eliminate distractions and unnecessary contrasts in the immediate surroundings of the worker. Colours having a moderate reflectance value, say between 30 and 35 per cent, are recommended, and all equipment should have surfaces that are not shiny, particularly desk tops. Strong colours should be eliminated, and the recommended colours are warm neutrals such as beige or light brown. Blue or grey could be used, but warmer tones help to make for a more pleasing atmosphere. Two-tone arrangements are acceptable and lighter shades, such as off-white, could be used for one of the tones, provided that they do not create large areas which might be a source of glare.
- The use of appropriate colours for the walls and other major surfaces in the overall surroundings, controls unwanted light and contributes to a more pleasing working environment. Reflectance values of the major surfaces in the overall surroundings should be in the lower ranges of the recommended limits. Cool and retiring colours, such as blue or blue-green, are generally recommended for areas where intense mental effort is required, but these colours may be too cool when the work is largely routine in nature; warmer neutrals such as beige can be recommended. Green and grey would also be acceptable, although grey tends to be a little depressing. Green needs care to ensure that workers have an acceptable appearance; all colours used should be flattering to workers. Strong colours should not be used, and surfaces generally should have a matt or eggshell finish.

Colour analysis

Hard colours	Not recommended for use in association with VDUs.
Soft colours	Recommended for most surfaces in VDU applications.
Bright colours	Colours of medium tone are preferred.
Dark colours	Small areas for accent only.
Violet	No application in relation to VDUs.
Blue	Screen: blue on grey can be used.
	Equipment: medium blue is acceptable.
	Surround: acceptable if mental effort is required.
Blue-green	Screen: no applications.
	Equipment: medium shades are acceptable.
	Surround: acceptable, more flattering than blue.
Green	Screen: yellow-green on dark green is recommended. Orange on dark green is acceptable. Green characters can be used on a neutral dark grey or black background.
	Equipment: medium green is acceptable.
	Surround: green is acceptable and pleasing but avoid

Yellow	yellowish or harsh greens. Screen: yellow-green is the most visible of colours and recommended with green background. Equipment: not recommended. Surround: not recommended.
Orange	Screen: orange characters on dark green recommended; orange on amber acceptable. Equipment: not recommended. Surround: not recommended.
Brown	Screen: not recommended. Equipment: lighter browns and beige are highly recommended. Surround: lighter variations are recommended, especially where tasks are routine and a warm effect is desired. Flattering to appearance.
Red	No applications in relation to VDUs.
Pink	No applications.
White	Screen: white characters on grey or black background can be used. Equipment: no application. Surround: ceilings only.
Off-white	Screen: no application. Equipment: deeper off-whites can be used as part of a two-tone arrangement but should not create glare. Surround: not recommended.
Grey	Screen: background only, with blue or green characters. Equipment: acceptable. Surround: acceptable but may be a little depressing.
Black	Background to screen only.

11.20 Woods

Most woods have a distinctive colour of their own and need the right colour as a background if they are to look their best. The following list suggests the colours that will show up the woods named to best advantage. The colour analysis below shows the type or tone of woodgrain that would be most suitable for use when the colours in question are strong trend colours.

Wood	Tone	Suitable colours
Mahogany Rosewood	Reddish	Light blue, medium blue-green, medium clear green, medium yellow.
Teak, Tola Dark oak Afrormosia	Brown	Medium violet (purple), medium blue, light orange (apricot), medium warm red, cream; neutrals generally.
Light oak Pine	Yellowish	Medium violet (mauve or purple), medium blue, medium blue-green, medium clear green, brick red, dark brown; dark walls are a good back-

		ground.
Beech	Creamy	Medium blue, medium yellow, medium clear green, light clear green (lime), dark brown, deep pink; clear, strong, colour.
Strongly marked woods		Plain, smooth, fabrics and subtle stripes.
Straight or faintly marked woods		Bold, patterned, fabrics and rough texture.
Antique furniture		Light violet (pale mauve), deep violet (purple), medium green, medium brown, medium and deep red.
Built in furniture		Match to the background; matt paint to a matt wall; high-gloss finish to a shiny wall.
Teak furniture		goes well with chrome, leather, glass and plastics.
Most wood furniture		Peachbloom looks neutral.

Colour analysis

Hard colours	No special comment.
Soft colours	No special comment.
Bright colours	Clear, strong, colours go well with beech.
Neutrals	Go well with teak, dark oak, afrormosia, tola.
Violet	Medium violet goes with teak, dark oak, afrormosia, tola. Mauve goes with light oak and pine. Pale mauve and purple go well with antique furniture. Purple goes well with polished brown.
Blue	Light blue with mahogany and rosewood. Medium blue with most other woods.
Blue-green	Medium blue-green with mahogany, rosewood, light oak, pine.
Green	Medium clear green with mahogany, rosewood, light oak, pine, beech, antique furniture. Light clear green (lime) with beech. All greens go best with pine and paler woods. Emphasises old furniture.
Yellow	Medium yellow with mahogany, rosewood, beech.
Orange	Light orange (apricot) with teak, dark oak, afrormosia, tola. Medium orange will also go with these woods. Orange creates a feeling of sophistication and warmth with wood.
Brown	Dark brown with beech. Browns and beiges create a feeling of warmth with wood; they are the complement

of good furniture. Brown is at home with pine, and fawn goes well with most wood tones.

Red Medium warm red with teak, dark oak, afrormosia, tola and with antique furniture. Brick red with light oak, pine. Deep red goes well with antique furniture and is an excellent background for all furniture.

Pink Deep pink goes well with beech; peachbloom is neutral with wood tones.

White Goes reasonably well with pine; less so with rosewood or mahogany.

Off-white Cream goes well with teak, dark oak, afrormosia, tola; silver grey and lilac grey are elegant and well suited to darker woods; darker greys look well with antique furniture.

Black No special comment.

12 Colour identification

12.1 The problem

Defining colour in a way that permits accurate specification presents considerable difficulties because there are no positive standards to which everyone can refer and various systems of identification are in use, some of them very scientific and academic. There are many colour charts, systems, atlases and collections that may be used, but the appearance of any hue may vary quite considerably according to the chart or system being used and also, of course, according to the material which is being reproduced and the light in which it is seen. Two well-known systems in common use are the Munsell and Ostwald systems, both of which are valuable to those who are professionally concerned with colour but both of which have limitations in practice.

The best-known system is the Munsell system which defines colour by hue, value and chroma, and this system may be found most practical by those who have to make day-to-day specifications of colour. The constituent parts are defined as follows:

- Hue The quality of colour which distinguishes red from yellow, green, blue and so on.
- Value (or brightness) That quality which expresses a relationship to a series of greys ranging from white to black in ten steps.
- Chroma (saturation, purity) That quality which expresses the strength or amount of hue in a colour.

The appearance of values is dependent on background and the amount of illumination. Those values that are carefully balanced in the strong light of a studio may look completely different on the counter of a shop. Munsell value 5 is halfway between black and white and would appear quite different when seen against a black background or against a white background. Values also look different under varying conditions of illumination.

The weakness of the Munsell system, from a practical point of view, is that ordinary people do not understand value or chroma, and there would be little point in using these terms when dealing with the public. It is the quality of the predominant hue (or white or grey or black) which distinguises popular taste,

175

and most people think of colour in such terms as:

- pastels, usually tints and mainly hue and white
- shades, or pastel shades, mainly hue and black
- muted colours, mainly hue and grey
- autumn colours, mainly hue and black
- spring colours, usually hue and white
- peasant colours, mainly pure hues.

The British Standard for building paints (BS4800:1981) is widely used and classifies colour by hue, greyness and weight, a classification which can be readily translated into the Munsell notation. However, the standard is primarily designed for architectural use and has limited uses in marketing and graphical applications. There is also a British Standard for process colour, but this is primarily of interest to the printer; in most graphical applications it will be usual to employ one of the standard ranges of printing inks and to specify in terms of those inks, but it is important to make sure that the ink ranges includes up-to-date colours. In many commercial applications it has been found necessary to devise a suitable method of identification which will take account of fashion and colour trends, and many industries have their own standard ranges of colours.

Another way of describing colour is to use the colour triangle explained below, but those who are concerned with everyday problems of colour selection, and who need to record movement of trends, require a simple method of identifying hues, and such a method is described in 17.7 in this part. This method was designed specifically for colour research purposes.

12.2 Colour measurement

Colour measurement is an extremely complex subject, and while it is of great interest to the scientist and the colour technician, the subject does not require more than a brief mention here, because the text is primarily concerned with the everyday commercial use of colour.

Colour can be physically identified by using a spectrophotometer; and colours having the same spectrophotometric curve will match perfectly under all conditions. The theory is that any colour that the eye can see can be specified in a hypothetical combination of the three primary light colours, red, green and blue. The proportions of these primaries that have to be mixed to obtain a given colour are known as the x, y and z values, respectively, or tri-stimulus values, and to measure these values correctly is to measure the colour itself. As no two substances of different chemical structure exhibit the same response to light energy, measuring the response also identifies the structure. If two materials read out the same way on the spectrophotometer, their colours will look alike under all lighting conditions.

Colour measurement is of particular significance where it is desired to fix colour standards for a specific purpose and to ensure that subsequent production matches the standard. A colour standard must be based on three elements:

- the characteristics of the light source
- the spectral reflectance curve of the object
- a standard observer.

It is unnecessary to go into a detailed explanation of standard observers, but once a standard, or absolute, reference has been fixed, all subsequent production can be checked against it to minimise 'drift', and this can most easily be done by spectrophotometric measurement. The same principle enables a pigment or dyestuff manufacturer to provide an exact match, but it is of little practical use to management, which has to select colours in a marketing situation.

It is only possible to compare standards by having two objects of exactly similar composition in the same light source and against the same, preferably muted, background. Even if the two objects are then an exact match, they may not be seen as such by two different observers with different eye sensitivity. The human eye is unable to judge, or appraise, colour except by making comparisons with other colours, or by contrast with other colours. The eye cannot remember colours except in relation to a fixed standard. Most people can judge accurately that two colours match, but they are unable to make accurate appraisals of colour differences.

In any case, comparisons can only be made under the same light conditions, and this can be illustrated by considering a red star on a grey background. This would appear white under red tinted light because there is no contrast which would enable the appraisal to be made. If blue light is added to the red, the star will then be seen as red because the blue provides the necessary contrast. If the same red star is placed on a black background, it will appear much brighter than it does on a white ground. By using different coloured backgrounds it is possible to obtain many different effects from the same red star.

12.3 Colour triangles

An easy way of describing colour in practical terms is to refer to variations of pure hues as tints, shades and tones, which are, respectively, the pure hue mixed with white, black or grey. This principle can be illustrated by means of a colour triangle (see figure 12.1). A separate triangle can be produced for any pure hue, for any intermediate (e.g. blue-green) or for any mixture of pure hues, and this method has the advantage that all the variations in each triangle relate to each other; all the colours seen by the human eye classify into one of these variations.

By following the lines on the triangle it is possible to balance variations of pure hues with white, black or grey. Thus:

- Pure colours, tints and white harmonise.
- Pure colours, shades and black harmonise.
- Shades and tones harmonise with white.
- Tints and tones harmonise with black.

There are innumerable variations between the pure hue and either black, white or grey, and an extension of the basic triangle will provide a convenient

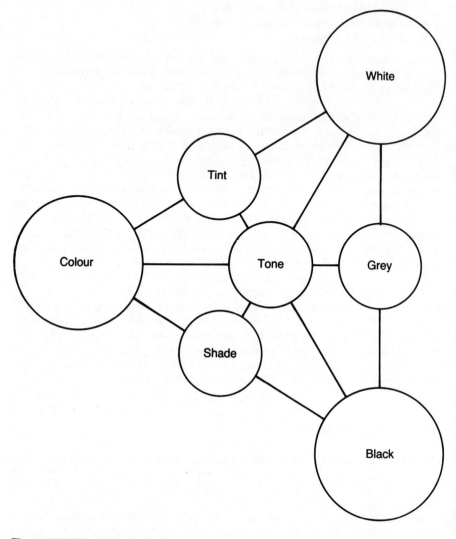

Figure 12.1 The colour triangle

key to colour description as shown in figure 12.2. From this extended triangle it
will be readily apparent that when the pure hue is red, a faint tint would be a
very delicate pink; when the full hue is orange, a dusky shade would be a deep,
rich brown. What is usually described as a pastel is, in fact, a tint with a large
proportion of white, and what is usually described as a muted colour is a shade
or tone with a fairly large proportion of black.

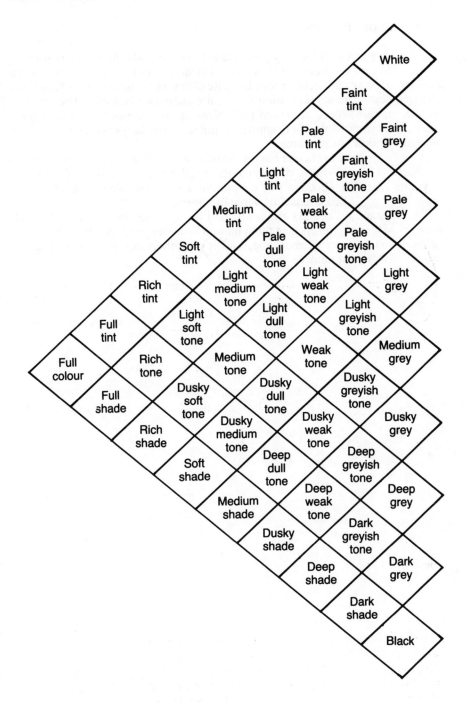

Figure 12.2 Key to colour description

12.4 Colour names

The names given to colours by paint manufacturers and others is no real guide to the nature of the hue. There is no standardisation of colour names and the sky blue of one manufacturer may be quite different to the sky blue of another. Nevertheless, the names of colours are quite important and should be selected with great care; there are often prejudices against names for no very good reason. English people, for example, do not seem to like 'peach', but the hue is acceptable under other names.

It is always best to choose names that are descriptive of the colour and not abstracts; it is also wise to choose names that are unlikely to be confused with anything else. The *Dictionary of Colour Names* published by the US Government Printing Office is a useful source of names.

British Standard colours are not named but specified by number, although most paint manufacturers give them names; however, each manufacturer has a different name for the same hue, and it may therefore be available under dozens of different names.

13 Colour harmony

13.1 The colour circle

'Colour harmony' is a much misunderstood term which is often surrounded by jargon and academic theories and principles which have little to do with the practical world. All it means in the present context is ensuring pleasing results from a combination of two or more colours. The principles of colour harmony ensure an answer to the question of what goes with what, and therefore they are of interest to the manufacturer seeking a suitable colour combination for a product, or to the interior decorator, the package designer and many others.

Colour harmony is also of primary interest to the public at large, which attaches a great deal of importance to having everything matching but which often forgets that it is impossible to match two dissimilar objects. The public often overlook the possibility of creating attractive results by harmonising colours instead of trying to match them. It follows that in most commercial applications a harmonious combination of colours should reflect the emotions and feelings of individuals rather than adhering to strict rules. There is certainly no need to be too academic, nor is there any need to accept an unpleasing combination of colours simply because it is in the rules.

Most formal rules of colour harmony are based on the colour circle in which each of the primary hues is allotted a segment of a circle. The segments usually appear in the order red, violet, blue, green, yellow, orange, although other colours may also be included. A simple colour circle is illustrated in Figure 13.1, and from this it will be noted that blue and green are next to each other and are therefore termed *adjacents*. Red and green are opposite to each and are termed *contrast* colours or *complements*; in other words, green is the complement of red and similar remarks apply to the other hues. There are numerous variations of the colour circle, each using the same basic principles, but whichever circle is used, there can be no guarantee that the resulting combinations of colour will be equally popular.

The majority of people find pleasure in colour combinations based on adjacent hues or opposites, but opposites like red and green will always be better liked than opposites like yellow and violet, which have little popular appeal. Combinations of intermediate hues, that is those between the primary hues and exemplified by blue-green, are usually less attractive, although they have a

181

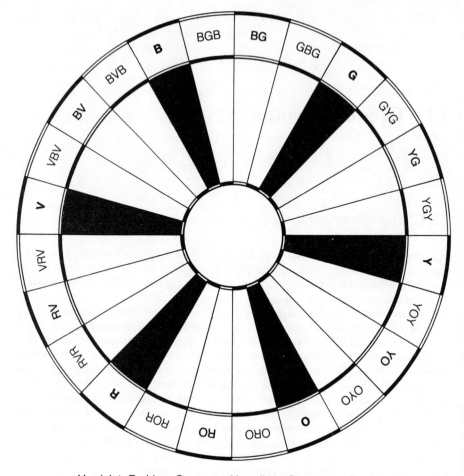

V=violet, B=blue, G=green, Y=yellow, O=orange, R=red.

Figure 13.1 Colour circle

certain refinement. Balanced harmonies involving three or more colours are often popular.

Any combination in which one of the primary light colours (i.e. red, blue and green) dominate will satisfy the great majority of people, although these colours may not be the best for a specific purpose. These colours are well liked because the eye and the brain are geared to see them clearly and they have a simple, basic quality which appeals. Orange, yellow and violet are admixtures of the primary light colours and are often more acceptable in sophisticated markets even if they do not have the same individuality as red, blue and green.

Warm colours, like red, orange and yellow, are best for the feature parts of a design while the cooler colours are excellent for background; they are always dominated by the warmer hues.

13.2 Using the colour triangle

When a number of colours are used in any design it is useful to draw a distinction between the primary forms of colour and the secondary forms. The primary forms are the pure colours plus black, white and grey, and the secondary forms are tints, tones and shades. The two forms can often be combined with advantage; a pure colour will often harmonise very well with the tint of the complement.

Some useful principles of colour harmony involving secondary forms can be derived from the colour triangles described in 12.3 above. This produces the following rules:

- All pure colours will usually harmonise with black or white.
- Tints of all kinds will harmonise with white.
- Shades of all kinds will harmonise with black.
- Tones of all kinds will harmonise with grey.

Pure colours go well with tints on a white background, with shades on a black background and with tones on a grey background. In tint scales the common harmonising element is white, and in shade scales it is black. These are natural arrangements that can be identified with the elements of colour vision.

The principles outlined above are broad generalisations, and there will always be circumstances where they can be, and should be, overridden. The chief need is to assemble combinations of colour which suggest harmonious order, and it is a good general rule to start with a dominant colour which accords with current trends of consumer preference for colour, especially if the combination is to be used for promotional purposes. However, there may be good reasons for starting with a dominant colour chosen for some other reason, particularly in functional applications.

Many systems have been developed in attempts to provide a logical basis for selection of colour combinations, but they usually overlook the emotional appeal of colour and are apt to become far too technical. When average people are shown colour schemes that vary from light to dark, they usually prefer the lighter variations and they also prefer richer hues to neutral ones. The basic rule is to keep the colours simple and to consult the preferences of ordinary people; no one gains anything from academic theories alone. It is often a good idea to follow the example set by nature, which seldom produces an unpleasing combination of colour, and this idea is followed in the paragraphs that follow.

13.3 Adjacent hues

Tints of pure colours which are naturally light in value (orange, yellow, green) look best when combined with shades of pure colours which are normally dark

in value. Thus:

- An orange-pink would look better with violet or navy blue than lavender or pale blue would look with maroon.
- Peach and ivory will look better with deep reds, blues and violets than pale tints of the latter would look with brown, olive or dark green.
- Deep blue on pale green is better than deep green on pale blue.
- Orange buff with deep violet is better than lavender with brown.
- Pale yellow, with brown or blue or violet is better than pale green, blue or lavender with olive green.

If samples of colours are arranged on this basis, it will be found that nature follows a similar order. In nature the highlights of a colour usually show glints of its adjacent on the upper side of the colour circle. Shadows usually drop towards the adjacents on the lower side of the circle. Thus a pure red rose will have vermilion and orange highlights and blue-green shadows.

Adjacents are those hues which are next to each other on the colour circle, and in considering them the analogy with nature can be carried further. Combinations of adjacents are commonly found in nature: water may appear greenish, bluish and violet at different depths, and autumn colours run through green, yellow-green, yellow, orange, red and purple. These combinations are always attractive and have an emotional quality; they either give preference to the warm regions of the spectrum or to the cool regions, and this inspires a precise mood – active when the arrangement is warm, passive when the arrangement is cool.

Nevertheless, it must be remembered that the preferred colours of the majority of people are blue, red and green, and the appeal of adjacents in one part of the circle may not equal the appeal of adjacents in another part of the circle; in other words, the rule does not hold good for the whole circle. In basic attraction, adjacent combinations based on red, blue and green will usually be best, but where sophistication is required, combinations based on their intermediates such as orange, violet and yellow-green will hold good. Adjacent schemes may include tints, tones and shades as well as pure hues.

13.4 Complementary harmonies

The use of complements or opposites (on the colour circle) can create startling results which have a compelling quality, but the selection does not have to be too strict. The complement of scarlet (or red-orange) is blue-green, but it can also be complemented by blue or green. One pair has no particular advantage over another so long as the hues are far removed from each other in visual terms. In choosing contrasts the selection may be a simple one, such as scarlet with blue-green, or it may be based on the so-called split complements, where the key hue is combined with the two adjacents of its opposite (e.g. scarlet with blue and green). Nature makes frequent use of opposites: blue and violet wild flowers frequently have orange or yellow centres, and blue on a bird or butterfly is often combined with spots of orange; red and purple flowers have green foliage and a clear blue sky is often combined with golden rock formations.

The use of visual contrasts tends to produce a visual quality rather than an emotional quality. The mood associated with warm colours tends to be cancelled out by the conflicting emotional qualities of the cool colours. In working out colour combinations it is safe to say that strong, pure hues look best when they are confined to small areas and when they are seen surrounded by larger areas in shades, tints and tones, but this rule may not apply to packages, particularly when red is used as an impulse colour. The nature of red is such that it ought to command a design and be emphasised through the use of small touches of blue and green.

Warm hues such as reds and orange will tend to look aggressive and advancing, and they make good feature hues. The cool hues make ideal backgrounds because they are passive. Tints, shades and tones tend to retire, but lightness will usually hold ascendancy over darkness. The most subdued, or passive, form of colour is the tone, and a bluish or violet tone will appear more distant and atmospheric than anything else. Although it is suggested that strong colours look best when confined to relatively small areas, this suggestion should not be interpreted too strictly, particularly in packaging and promotional applications.

13.5 Balanced harmonies

A third principle of harmony is to take three or four pure colours which are evenly removed from each other on the circle (or at least more or less equally). A triad is a combination of three colours, and a tetrad is a combination of four colours. A triad based on the colour circle illustrated would be, typically, red, blue and yellow, although this would be rather gaudy. A tetrad based on purple, yellow, orange and blue would be very subtle and refined.

Balanced colour schemes are commonly found in nature; the sunset and the rainbow are complete spectrums in themselves. Lichens and mosses often show glints of intermediate hues; the colours of spring show balanced harmonies of tints; summer presents balanced harmonies of pure hues; autumn shows balanced harmonies of shade; winter shows balanced harmonies of greys.

13.6 Colour combinations

Formal rules of colour harmony do not always reflect the feelings and emotions of ordinary people; if it is desired to achieve a harmonious arrangement of colours, it is better to follow principles that are acceptable to people rather than to follow strict rules. There is certainly no need to be academic, nor is there any need to accept an emotionally unpleasing combination of colour simply because it follows the rule. Some colour combinations are more psychologically pleasing than others, although they may not have good visibility or reading qualities. In the home, in particular, colour choice is a matter of individual choice and taste, and most people will prefer to follow their own inclinations whatever the rules may be.

It is useful to compile a list of harmonious colour combinations by drawing

on the ideas of interior decorators and other experts and by collecting suggestions from such sources of information as may be available. Such a list will be found helpful, even though some of the suggestions liked or recommended by individuals may conflict with established principles. The list could, with advantage, include suggestions for colour schemes for home interiors and other uses and would have the virtue of drawing on wide experience and providing a source of ideas for those who need them.

Suggestions might be grouped under hue and subdivided into:

- good harmonies
- harmonies to be avoided
- good contrasts
- accentuating colours
- diminishing colours
- colours which the hue accentuates
- colours that the hue diminishes
- suggested combinations.

Colour schemes made by combining harmonious colours are much easier to live with, and colour combinations should be selected, as far as possible, because experience has shown them to be effective and to have appeal. A list of combinations, combined in this way, would not necessarily include the best combinations for graphical applications or for functional or safety applications, in all of which other factors have to be taken into account. A list of suggestions and combinations has been included in the Colour Catalogue which forms Part III of this book.

Note: Many of the comments made in this Section refer primarily to visual applications of colour such as packaging and promotional print. Some modification may be required when using colour for interior decoration.

14 Colour planning for domestic interiors

14.1 About planning

This Section attempts to formulate some basis that can be applied when selecting or planning colours for interiors. The main emphasis is on colour for individual rooms in the home, but many of the rules can be applied to any interior, although with modifications for commercial interiors, which are discussed in a later section. Even in the home the various types of room such as bathroom, bedroom, living room, kitchen and so on require individual consideration.

The suggestions made are based on established principles of colour psychology, and they reflect and summarise the work of many experts in this field; they are essentially the results of research and are not intended to be creative. Therefore they do not pre-empt the creative skill of the interior decorator or stylist, but they may be found helpful by the latter as a check on the many items that have to be considered when planning an interior. The ideas will be particularly useful to those who have to advise the public and who need ideas for promotional literature and the like.

Some of the guesswork has been taken out of colour scheming since co-ordination came on the scene. The key word is now said to be *integration*, including total-look ranges that develop pattern and colour harmony to a degree never achieved before. Paint is planned to go with paper, fabrics and carpets, and using co-ordinated ranges of this nature ensures that colours will match and that patterns will tone in with each other.

Whatever rules or principles are suggested, it does not follow that people will adopt these rules, and the best that can be done is to provide some guidelines. A room in which an individual spends a great deal of time must contain colours that that person can live with, and it is seldom that a room can be planned from the floor upwards; in most cases there are existing decorations, furniture and furnishings which have to remain and which have to be incorporated into any new scheme.

14.2 The character of the room

Before any plan can be adopted, the room or area has to be considered indi-

187

vidually, and the first step is to decide what character of room is required; whether it is to be bright, cool, restful or stimulating and so on. This will depend in part on personal preferences but also on the use to which the room will be put and on the users of the room. There will be a distinct difference between the character of a room used by children and growing teenagers, and a room which is the study of a scholar.

Warm, luminous colours and a high level of illumination create a sense of excitement; softer colours have the reverse effect. A dark environment with low light levels is depressing and a pale environment with low light levels can be too passive. The colours selected for the room will help to make it elegant, full of fun, cold, aloof or gently still. The mood of a room can be changed by using a colour which conveys an appropriate emotion whether that is extrovert, tranquil, enigmatic, warm or cosy. The colour can give the room a personality of its own. Consider the following:

- Warm hues create a mood that is energetic, vital and cheerful and suggest sociability.
- Cool hues create a quieting and relaxing effect, although they can be a trifle cold if not relieved in some way. They are recommended for a room in which study or mental effort is undertaken.
- Bright colours produce a stimulating effect and offer lively contrasts. They will also brighten a large dark room.
- Light colours, such as pastels, may look insipid and uninviting.
- Dark, rich, deep colours make a room look more intimate; they will bring the walls forward and give an illusion of warmth.
- Colours that are close together on the colour circle produce a calming effect; they are harmonious.
- A background that is in sharp contrast to the rest of the room will make it look exciting.
- Plenty of colour, within reason, creates a warm and easy feeling in a large room; the more colours, the cosier the room.
- Take furniture away from the walls to create a friendly look.
- Strong, contrasting colours will make a room feel more comfortable.
- A lively effect is created if carpets and draperies contrast with the walls.
- A restful scheme needs restful colour.
- The character of a room can be changed by shine (e.g. enamel).
- Too many colours chasing too little space are restless.
- Natural colours create a calm background.

14.3 The aspect of the room

The direction of the compass in which a room faces is particularly important in colour scheming because dark rooms need plenty of light colours while rooms that have plenty of sun can take any colours. A room facing north tends to lack sun and have a cold look; warm colours will cheer it up. A room facing south will have much more sun and may need cooling down. Rooms that face east or west vary in warmth at different times of the day, and this may affect the appearance of colour.

Consider the following:

- North-facing rooms seem cold all the time but the light remains constant. Lack of sunshine may be countered by using, bright, warm colours; avoid white, it looks grey. Deep, warm colours create an exciting look.
- South-facing rooms receive the whitest light and colours remain constant. Almost any colour is suitable. Cool colours will help to cool it down.
- East-facing rooms suffer from changing light and only seem warm in the morning. It is a good idea to combine warm and cool colours but avoid cool colours if the aspect is north-east.
- West-facing rooms suffer from changing light and are warmer in the afternoon. Warm and cool colours can be combined.

Generally speaking, a north-facing room will receive less natural light than a south-facing room, but this may not always hold true because of the house plan. Rooms that receive a lot of natural light, particularly at the time that the room is most used, can be decorated in cool colours, but be careful of white, which looks creamy during sunny periods and grey when there is little sun.

When there is little natural light for any reason, use:

- light colours, particularly yellow
- neutrals with brilliant accents
- 'firework' colours in small doses to brighten it up
- warm colours, such as pink and beige, to add a flattering glow to a chilly room.

Rooms, adjoining or overlooking a garden, or with a rural outlook, need colours that blend with the view.

Note: The comments made above refer to British geographical conditions and modification would be required in, say, the southern hemisphere.

14.4 The size of the room

The size of the room is an important consideration in colour planning because colour can help to make a narrow room look wider, a large room look cosier, it can make the most of a small room, make the ceiling look higher or reduce room height.

The qualities of hard colours tend to make surfaces, such as walls, look nearer than they actually are, while cool colours will tend to cause them to recede. However, contrasts also play a part in establishing distance. The more the colour of an object approximates to its background, the more the object appears to recede towards the background. The more the colour of an object (such as furniture) differs from its background, the nearer the colour seems to be. It follows that in a large area colour can be used to establish a space relationship; weak contrasts are a far element. There is a natural sequence of hues running from white to black, and from light to dark, and from pure to

deep, and this natural sequence tends to merge into medium light grey in the distance. If strong colours are used for near elements, together with strong contrasts and greyish or weak colours for far elements, this will add to distance. Lines in the field of view should converge to concentrate on a single point (i.e. the focus). Colours at the focal point should be warm and more intense than elsewhere, and colours should become cooler and less saturated as they recede towards the periphery. Consider the points below.

Large rooms

- These will take strong colours and large-scale patterns; this will warm up a large forbidding area.
- It is a good idea to highlight major features.

Small rooms

- They can often be improved by using warm, dark colours enhanced by very light touches.
- Small rooms are much more difficult to decorate than large areas; because the area is smaller, more costly materials can be used and the room can easily be made relaxing and cosy.
- They can be given an illusion of spaciousness by a neat, uncluttered look.
- Small rooms need light or pastel colours and small patterns.
- Big colours in a small room can create all the decorating drama of a large room.
- Pale colours on the ceiling and walls will make it look larger.

Increasing room size

- Use cool colours or use pastels, which are warmer.
- Reduce the amount of furniture.
- Use neutrals to create a spacious effect.
- Unity helps to create space.
- Limit the number of colours; one is best of all.
- The fewer the number of colours, the larger the room will look.
- Use light colours, which lend distance.
- Paint a small room white, but paint the ceiling a cool colour that pulls the eye upwards.
- A ceiling painted to match the floor will visually lengthen the walls and make a room seem longer and wider.
- Reflective materials on the walls enlarge a room.
- A diagonally patterned paper will make a room larger and longer.
- Painting the walls and ceiling the same colour will create a spacious look.

Reducing room size

- Add more furniture; the more there is the smaller the room looks.
- Use warm colours which appear to be nearer than they actually are.

- Paint one wall in bright colours, it will seem to advance.
- Light walls and a dark ceiling will make a room look more intimate.
- Strong, warm colours will bring forward short end walls in a long, narrow room; a long side should be neutral.
- Strong colour on one wall, contrasting with the other, will bring the strong coloured wall closer.
- Darker side walls with lighter ceilings and other walls will narrow a room.
- Warm colours and a paper with a fussy pattern make a room seem smaller.

High ceilings

- Deep colours will bring down a high ceiling.
- Painting the ceiling a dark colour down to picture rail height will lower a lofty ceiling.
- Adding a dado rail lowers a high ceiling and gives definition to a plain room.
- A strong contrast with the wall colour has a dramatic effect.

Low ceilings

- White or pale colours will make a ceiling seem higher.

Increasing room height

- Strong colours on the lower part of the wall, lighter colours on the upper part and right across the ceiling will increase the height of the room.
- Low ceilings will appear higher if they are painted the same colour as the walls.
- Colour right up to the ceiling and vertical stripes make a room look higher.
- A dark floor will increase visual height.
- Painting the skirting board the same colour as the walls will make a room seem higher.
- Strong vertical light will help to counteract lowness.
- Striped wallpapers will help to increase room height.
- Painting the walls the same light colour as the ceiling will raise it.

Lowering room height

- Horizontal stripes and plenty of picture rail lower the height.
- Paint the ceiling a strong colour.
- Borders at picture rail height make a ceiling look lower.
- Keep the weight of the furniture low.
- Set the main decorative details at or below eye level.
- Painting the walls the same strong colour as the ceiling will bring down the latter.
- Dark colours on the walls and ceiling down to dado height, with lighter colours below, matching the floor, will reduce the emphasis of the upper part and make a lofty room seem lower.

14.5 Features of the room

Colour can help to hide defects or make the most of features such as doors, windows, walls and so on. Consider the points below.

General points

- If you are using a lot of colour in adjoining rooms, the colours ought to complement each other.
- To unify the space in a long, narrow room, keep the furniture all in one colour.
- An open-plan room with large windows can take drapes and more un-usual colours.
- Monochromatic colour will help to wash out the irregularities in a room with irregular beams and spaces.
- Attractive mouldings can be highlighted.
- Ugly pipes, wires and so on can be disguised by painting them the same colour as the background.
- Highlight the major features in a large room by using strong contrasting colours to make them stand out. The room will feel more comfortable.
- Avoid painting the cornice the same colour as the woodwork except in a high room.
- To highlight details, tone down the background.
- Features can be lost by matching them to surroundings; if things are painted the same colour, the eye will smooth out differences of shape.

Room proportions

- Dark, warm colours on the short end walls with a lighter shade on the longer walls will make a room seem better proportioned.
- The proportions of an oddly shaped room can be changed by using dif-ferent colours on adjacent walls.
- Dark colours on floor and ceiling, with neutral walls, make a room seem longer and wider.
- Horizontally striped carpets make a room seem wider.
- Vertically striped carpets make a room seem longer.
- Colour can do things to a poorly proportioned room.
- Large rooms can be divided up by taking tones of one colour and using them in various areas of the room.
- A mixture of light and dark colours can improve proportions.
- A warm colour on an end wall will bring it forward; a light colour will make it recede.
- Pattern across two ends of a room will make it look wider.

Ceilings

- Be cautious about dark or brilliant colours; some people feel un-comfortable with dark ceilings, especially black.
- Pay as much attention to ceilings as to any other element in the room; interesting architectural features should be emphasised.

- Ceilings can be tented, vaulted or stencilled; a tented ceiling will hide almost anything, including pipes.
- A really dark ceiling will disappear optically.
- Bright colours will reflect more light.

Doors

- Panels can be painted in two or three colours for an interesting effect.
- Attractive door panels can be highlighted by painting them a lighter or darker shade than the walls.

Floors

- Close-fitting carpets will given an impression of spaciousness if the colour is related to the rest of the room.
- A carpet with several colours can last through a number of decorative changes.
- Neutral colours on the floor create a calm background.
- Plain colours make a room appear larger.
- Pale shades on the floor show soiling more easily.
- Choose colours that are lighter than planned; they tone down rapidly in use.
- Use deeper tones on the floor to add weight to a light, pale room.
- A dark floor will increase visual height.
- Horizontally striped floors make a room seem wider.
- Vertically striped floors make a room seem longer.
- Colour the floor the same colour as the walls in a large room.
- Rugs reduce the visual area of the floor.
- Fabrics should either match or tone with the ground colour of the floor covering, or with one of the larger areas of the pattern.
- Use a large patterned fabric with a small-patterned floor covering, or the reverse.
- Avoid busy pattern changes from room to room.
- Use the same designs, but in different qualities, for halls, living rooms and so on.
- Do not use jazzy patterns for stairs: they cause accidents.
- Soiling is less apparent with patterned carpets; mottles also hide soiling.
- Large designs are best suited to large rooms.
- Choose patterns for floor coverings with some thought to what else is in the room.
- A patterned floor covering will provide quite a different effect from a plain one in the same colour.
- A dense piled carpet produces a warm feeling.
- A shaggy carpet will provide warm texture to counter the coolness of marble, laminates and so on.

Mirrors

Although mirrors are not strictly part of colour planning, they do merit a mention because of their function in improving room proportions. They reflect light

and space and can double the size of a room and give it twice the amount of light. This obviously affects colour.

- A complete wall of mirrors is an effective way of giving a small room extra depth and light.
- Doors adjoining two rooms can be brightened up by replacing panels with mirrors.
- A large expanse of mirror tiles can add space and light to a bathroom.
- An entire wall covered with mirrors can double the size of a room, but it is important to create a restful room in the first place with gentle colour tones, otherwise the colour will jump out and prove difficult to live with.
- Mirrors can transform a small dark room with many different images and reflect back what natural light there is.

Picture rails

- Paint in a matching colour just a shade darker than the walls.

Radiators

- Paint radiators the same colour as the walls, preferably with matt vinyl.
- Shelves on the radiator will attract attention away from it.
- Radiators painted to match the walls should ideally be a shade darker.
- An eggshell finish will make radiators even less obtrusive.

Skirtings

- Can be painted in a positive colour; this adds variety and makes the dimensions of the room look different.
- Skirtings to match the floor will make a room look wider.
- Skirtings to match the walls will make the walls look taller.

Walls

- Matching walls and fabrics can be effective in a small room.
- Chintz fabrics stretched over walls can hide anything.
- Never use a strongly directional paper on both walls and ceilings, because it will be impossible to match them.
- A dado provides an opportunity for two complementary wallpapers.
- Striped wallpapers will raise room height.
- In dim light walls will not show up unless they have light showered on them; consequently the room may have a dull and hollow appearance.
- Patterned walls and bright colours are good for morale.
- Large, intricate designs are recommended for lumpy walls.
- A small-design wallpaper will be enhanced by larger-design furnishings.
- Bold-design wallpapers fit in well with simple furniture.
- Curtains having the same patterns as the walls are recommended.
- A patterned wallpaper will pull together an awkwardly shaped room and introduce enough visual detail to make a half-empty room seem furnished.

- Wallpapers can hide defects in the walls.
- Borders can be used at dado height to break up a co-ordinated paper.
- Light-reflecting walls make a small room expand.
- Paper provides texture.
- Fabric covered walls provide interest in a bedroom.
- Match walls to built-in furniture; matt surfaces to matt walls, high-gloss surfaces to shiny walls.
- A warm end wall will bring the wall forward.
- A light end wall will make it recede.
- The light will bring a light-coloured wall by the window to life.
- Strong, light colours on a feature wall will attract the eye; neutrals on the other walls will act as a foil to it.
- Dark walls are a good background for pictures or for framing pine or light-wood furniture.

Windows

- Where there are dormer windows continue the wall colours up to the ceiling and have the reveal of the window in the same colour. A different colour will create a dramatic effect.

14.6 The function of the room

Whereas colour plays an active part in determining the character, aspect or size of the room, it plays a passive part so far as the function of the room is concerned. In other words, the activity performed in the room determines the colours used. In colour planning terms, the function of the room will decide the colours used in it.

Function is particularly important in the home where the living room requires quite different treatment from the bedroom, bathroom or kitchen. Even within the living room there may be a dining area as well as a living area, and the kitchen may also be part of the living room. A living room may be an area for lively family gatherings or it may be a room for study or mental effort, thus there is a link between the functions of the room and its character.

An even more important factor when considering room function is trends of consumer preference for colour, which vary according to the nature of the room and which will influence the colour decisions of most people. Trends dictate the dominant colour of each individual area, but there is no need to discuss this important aspect here; it is discussed in more detail in later sections. Suffice to mention a few points of a general nature. Consider the points below.

Living rooms

- If for recreation, a lively character may be desirable, but a calm atmosphere may also be preferred.
- Colour may be used to set a mood, with the trend colour of the moment introduced by cushions and other accents.
- Most light should come from warm-tinted shades.

- A large living room can be cold; use contrasting colours.
- Where television viewing is consistent, bright colours are required to provide relief when the set is switched off.
- Living rooms should generally be warm, friendly and relaxing; use harmonious colours.
- A television room needs to be relaxing.
- Multi-purpose rooms need original thinking.

Dining areas

- The decor of a dining room which leads on to the living room should harmonise with the living room scheme.
- Dining rooms are used for such a short period that they can make a strong statement. Rich, dark colours are inviting; bright primaries can be recommended for family eating; subtle pastels will provide soothing charm.
- Blue will provide a good background because it contrasts with most foods and improves their appearance.
- A pinkish colour quality to the light will enhance a meal.
- Strong contrasting colours will separate dining and living areas.
- Place-settings that match the carpet are effective.
- Colour prevents any overcrowded feeling in a dual-purpose room; pale colours help.

Halls

- A hall need never be neutral. A bold approach can bring it to life while matching the mood of the house.
- The hall is the most public part of the home and should lead visually into all the other parts.
- Pick out colours used elsewhere in the house and repeat in the hall.
- Halls should have a warm and friendly quality.
- Lively colours will create a welcome in the hall.
- The hall should be a foil to the rooms that lead off it.
- Halls, and any other rooms used for short periods, will take a lively and aggressive colour scheme.
- The hall is a vitally important first impression in any house.
- Pastels or pale colours are not recommended for halls or staircases except where plenty of light is required.

Studies

- Use lighter colours against a neutral background for a cheerful setting.
- Use cool colours in areas where mental tasks are performed.
- A library needs some stimulation as well as relaxation.

Bedrooms

- Avoid stimulating colours and aggressive colours.
- A bedroom needs to be relaxing.

- Bright colours are recommended for newly weds.
- Pastels and pale colours are recommended.

14.7 Users of the room

Quite apart from the function of a room, the people who are going to use it may have some influence on colour scheming. This applies particularly to a room that is used mainly by children, whose colour needs are quite different to those of grown-ups. On the other hand, a room may be used as a refuge from the children.

- To get away from the children and provide a refuge for precious objects, use light colours and delicate fabrics.
- Where there are young children, avoid plain or very pale colours; they reveal finger marks, stains and so on.
- To help release the energy of children, provide a room full of bright colours such as yellow and red.
- Children are responsive to lively colours. The first colour preference of the child is yellow, and this changes to red by the age of 5.
- Children find primary colours most attractive but because they are strong; they can be intimidating. They can often be combined in a neutral setting with advantage.

14.8 Pattern and texture

Pattern and texture are just as important in interior decoration as colour and cannot be disregarded in any discussion of colour planning.

It is less easy to generalise about pattern than it is about texture, and there is a greater degree of individual taste involved, but there is a relationship with colour (see 11.14 above), and pattern is an important part of interior decoration. Colour itself may be used to provide pattern. The ability to use pattern with skill escapes all but the most experienced interior decorators, especially when dealing with small, close patterns. Patterns which feature a portion of the spectrum are much easier to deal with than those that incorporate a wide range of colours, and there must be a common bond to draw pattern and colour together. Each individual pattern should be considered in terms of colour, scale and design, and then in the context of the room as a whole. The dominant colour of the pattern may be used elsewhere in the room or as a starting point for a colour scheme.

Established wisdom has it that one strong pattern in a room is enough, and this may be on either the floor covering or on the walls. Too many different patterns in the same room are apt to create a 'bitty' effect. Many people worry about this and solve the problem by making the rest of the room neutral, but with care a lot of designs can work well together. The strategy is to select one design as the starting point and to choose others which use the same colour range. Different colour will blend so long as there is a link between them, and once started, more patterns can be added without destroying the scheme. How-

ever, it is good advice to put large patterns below smaller ones. Consider the following points.

Types of pattern

- Pictorial designs are not a good idea, even children tire of them.
- Do not mix geometrics, floral and stripes.
- People grow tired of geometrics quite quickly because the eye prefers symmetry. Asymmetrical shapes attract more attention but they worry people and are changed sooner.
- Do not mix bold designs with soft florals.
- Do not mix florals from different sources; they may clash.
- Monotonous regularity of pattern may affect the nerves of sensitive people.
- Do not use bold, jazzy patterns on a small area of wall or at a small window.
- Diagonal stripes give a dramatic effect to plain surfaces while maintaining the airy feel of an unpatterned area.
- Nondescript patterns make a nondescript room.
- A bold design will dominate a dull room.
- Regimented designs require strong, bright colours.
- Delicate prints and precise geometric designs decorate a room without dominating it.
- Bold patterns work best in a room with few pictures.
- Small patterns depend on the blend of colours and if used to excess merely lend textural quality to a room.
- Small designs and miniprints tend to fade into insignificance when seen on a large expanse of surface.
- Plain smooth fabrics and subtle stripes go with strongly marked woods.
- Bold-patterned fabrics and rough textiles go with straight grained or faintly marked woods.
- High-fashion designs that are compelling are best used where they can be easily changed.

Pattern and room character

- Pattern is particularly important when trying to create a romantic look.
- Large patterns give an illusion of warmth; also strong patterns.
- More pattern achieves a less formal effect.
- A scheme with large patterns calls for attention and is a pace-setter.
- A finely patterned print in light colours is relaxing.
- Floral designs will change the character of a room.
- A bold design will dramatise a dull room.
- Patterned walls and bright colours are good for morale.

Pattern and room size

- A large pattern looks dramatic in a spacious room.
- Large rooms will take large-scale designs and strong colours.

- Small rooms look best with small patterns and pastel colours, but very small patterns can make the room look claustrophobic.
- Patterns on a light ground make a room larger.
- A diagonally patterned paper will make a room look larger and longer.
- Patterns across two ends of a room will make it look wider.
- Too much pattern will make a room smaller.
- Colour and pattern combined can make a room look smaller or larger.
- A paper with a fussy pattern and warm colours makes a room look smaller.
- Vertical stripes make a room look higher.
- Horizontal stripes lower the height.
- Discreet all-over patterns suit small rooms.
- Bold designs can make an area look smaller when used on major surfaces.

Pattern and room features

- Pattern can help to eliminate flaws in the walls, but geometric designs can show up major faults.
- Pattern on a ceiling is decorative; it will lower the ceiling.
- A change of pattern size is useful when one room leads into another.
- Large intricate designs are good on lumpy walls.
- A small design on the walls will be enhanced by larger-design furnishings.
- Bold designs fit in with simple furniture.
- A patterned wallpaper will pull together an awkwardly shaped room.
- Use a large-patterned fabric with a small-pattern floor covering, or the reverse.
- Avoid busy pattern changes from room to room, particularly on the floor.

Pattern and room function

- Subtle designs are best in rooms that are used continuously.
- Bright and exciting designs are best in a high traffic area and can be discomforting in a relaxed living room.
- Have plain-patterned rooms around a plain hall, or vice versa.

Texture

The appearance of any colour is influenced by the surface on which it is used; matt and soft materials create a welcoming effect, while shiny, smooth surfaces are cooler and less welcoming. Thus, although the colours may remain the same, the appearance of a room changes as the textures change. Natural materials such as sisal, straw, parchment, stone, brick, provide their own colours, and the colour is enhanced by the texture. Consider the following points:

- Rough fabrics, like densely piled carpets, hessian, velvet, wool, tweeds and so on, are warm in nature and need harsh contrasts to emphasise them.

- The colder textures of marble, laminate and so on need the softening influence of warmer textures.
- Different types of finish, ranging from matt to high gloss, will give different effects to the same surface.
- Use a matt finish on an uneven surface; sheen finishes will tend to highlight lumps.
- A hard, shiny surface creates a brisker look and gives more light.
- A textured wallcovering makes a room warmer and softens its tone.
- Wood panelling gives a homely, informal look.
- Stone and brick walls are suitable for the country, not for the town.
- Paper produces texture.
- Texture goes well with neutrals; it adds interest to white and cream.
- Texture and pattern can add interest to a one-colour room.
- Thoughtful contrasts of texture and pattern can add to the overall visual effect.
- Texture can help to build up comfort or crispness or both.
- Coarse textures look best in a room with rough brick walls.
- Matt surfaces look flatter than gloss.
- Textured papers are good for walls in poor surface condition.
- Contrasting textures add interest.
- Glossy walls show off rough and tweedy fabrics well.
- Matt surfaced walls enhance the richness and sheen of satin and velvet.
- The way that the light bounces off or is absorbed by a surface makes an object look more interesting or more subtle; it emphasises the roughness or smoothness.

14.9 Room lighting

The notes that follow are primarily concerned with lighting for the home; the lighting of industrial and commercial environments is discussed in later sections. It is entirely appropriate to include lighting in a chapter dealing with colour in interior decoration because of the close relationship between light and colour; lighting can make all the difference to a colour scheme. Colour can look just right in bright sunlight, but light from the sun changes constantly and the colour scheme may be completely out of character when the weather is dull. It may also look quite different under artificial light; fluorescent lighting, in particular, can severely distort colour.

Lighting can add warmth, drama and atmosphere, as well as colour, to an interior; by introducing areas of brightness and shadow, colour and texture can be intensified. Direct illumination of a heavily textured wall immediately banishes the texture. Most lighting in the home is decorative in nature, the objective being to ensure that the objects, surfaces and colours which comprise the decorative scheme are satisfactorily conveyed to the eye, but to achieve this aim requires a great deal of practice and experience.

Lighting experts recommend that lighting should take account of the practical aspects of vision as well as being decorative. They point out that poor lighting is a common cause of accidents in the home and that the approach should be

functional rather than purely technical or decorative. A functional approach takes account of needs like the following:

- ease of performance of the tasks that have to be carried out, such as reading, sewing, washing up and so on
- safety, for example illumination of danger spots and avoidance of accidents
- economy, that is light should not be wasted
- delineating architectural features, for example changes in ceiling heights, outlining spaces, and so on.

The recommended minimum lighting standards are 25 watts for each square metre of floor space, or 10 watts if the lighting is fluorescent; but a better guide is the recommended illumination level. For example:

- Kitchens 200 lux
- Stairs 100 lux
- Workshops 200 lux
- Garage 70 lux
- Sewing and darning 700 lux
- Casual reading 150 lux

A number of low-wattage sources are recommended rather than one large one, and some experts recommend avoiding long-life lamps.

Different rooms in the home require different treatment. For example:

- A living room requires background lighting; it requires some general light to soften shadows, but most working light should come from warm-tinted shades.
- A dining area requires a soft glow to dispel shadows, but localised light on the table is desirable; a pinkish quality light will enhance the appearance of food.
- Halls also need background lighting and should be well lit.
- Staircases and landings should be well lit so that shadows are dispersed; shadows may cause accidents.
- Bedrooms need soft overall light.
- Bathrooms need special care; pull-cords are obligatory, and spot lights should be avoided. Mirror illumination is useful.
- Kitchens require good overall lighting; appliances, in particular, should be well lit.

Accent lighting is frequently used to enhance the atmosphere of a dull room and objects can be emphasised by lighting them from the front. However, lighting from the side will bring out shade and texture to better effect.

Planned lighting requires knowledge of light sources and their characteristics and the effect of these characteristics on surfaces to be lit. Any recommendations of a general nature can only be a guide, and it is most unlikely that the average home will follow the recommendations of experts to the letter. However, the colour characteristics of the light are important in interior decoration and should be related to the colour scheme planned; the final choice of colour should certainly be made in the light in which the colours will be seen.

Two colours which contrast pleasantly in daylight will appear almost identical under some artificial light sources, and this can destroy the whole decorative idea; the results are often surprising and disappointing. Most lighting in the home is incandescent but most shops use fluorescent light and the product that looks quite satisfactory in the shop may look markedly different in daylight or in the incandescent lighting of the home; this often leads to confusion and dissatisfaction. A colour scheme planned in the lighting of the home may be very difficult to match in shop conditions.

Planned lighting also requires attention to light levels. Low levels of light tend to make colours appear grey, while high levels make them appear sharper. Deep colours absorb a good deal of light, and it may be necessary to increase light levels to compensate; on the other hand, very light colours reflect a great deal of light, and reduced light levels may be desirable. It is also very necessary to avoid harsh contrasts of brightness in the field of view because this may cause glare and eyestrain.

It is rarely necessary, or desirable, to have uniform levels of light in the home (except, perhaps, in the kitchen), and although high levels of light are recommended for some tasks, such as sewing and darning, it would not be usual to have the same level of light throughout the room. However, there must be adequate balance between high illumination on the task and the average light level.

If the brightness of the background is higher than the brightness of the task, then there will be discomfort, particularly if the task itself is dark and reflects little light. Ideally the background to any task should be one-third as bright as the task itself, and the overall surroundings should not fall below one-tenth of the brightness of the task. The higher the level of illumination used, the more care is necessary to avoid glare, which is largely caused by excessive contrasts. Glare is described in more detail in 3.7 above, and it is discomfort glare which is most usual in the home. A typical example is trying to read by means of a single light directed on to a white book; the brightness of the paper is extremely high and creates an unacceptable contrast with the immediate surround. This can be cured by a well lit overall environment.

14.10 Practical colours

The use of colour to improve working conditions in commercial establishments is well established, and it can equally well be used to practical advantage in the home. The importance of avoiding glare has been just mentioned, and colour can be used as a means of eliminating glare and preventing eyestrain. Every time that the eye moves from something light to something dark, or vice versa, the eye has to accommodate itself to the change in brightness; the pupil of the eye contracts or widens as the case may be, and the more often that this happens, the more tired the muscles of the eye become. This is eyestrain and it can be obviated by using colour to control contrasts in the line of vision.

Avoiding sharp contrasts as far as possible is particularly important when concentrating; when sewing on a white fabric, for example, it is best to do so against a light background which does not provide too much contrast with the

white of the fabric. At the same time, there must be some contrast between task and background or the task becomes impossible. A sewing machine provides a good example; most modern machines are finished in light colours, which provide adequate contrast with most materials, but older machines are often dark coloured and sometimes have a localised light source which provides trying contrasts and specular reflections from the machine itself. A sewing machine should always be used in a room with good overall lighting.

Many people hanker for an all-white kitchen, but this can cause intolerable glare, which will affect the eyes, particularly when doing fiddling tasks like seeding grapes. All-white environments need to be relieved with areas of colour, which will give the eyes rest, provide variety and avoid monotony. In the kitchen, relief can be provided by appliances and housewares and in the living room by accents such as rugs and cushions.

There are many other practical uses of colour. For example:

- A light coloured pram would reflect light and heat and keep the baby cool. For the same reason, children wear white hats in the summer.
- Coloured transparent food containers help to prevent food going rancid. Yellowish green is best.
- Brown bottles help to protect beer and other liquids from the effects of ultraviolet light.
- A dim red or orange light will help to keep flies away from the patio at night.
- Blue tends to attract mosquitoes; pink or yellow are better.
- A light coloured switch knob is easier to find in the dark.
- Cellar stairs edged with orange or yellow help to prevent accidents.

14.11 Basic plans

When all the room characteristics have been analysed, it is time to think about formulating actual plans. If the room is being decorated for the first time, there are three basic plans that can be adopted:

The complementary scheme This can also be called a contrasting scheme. The main colour is chosen first and then areas of its complementary colour are added for contrast. Complementary colours are those directly opposite on the colour circle. All possible variations can be considered: warm colours with cool colours; light variations with dark variations; clear variations with muted variations; and so on. Primaries may be used, or lighter tones if the primaries are too dark. A complementary scheme is often useful to people who cannot make up their minds which colours to choose.

The related scheme Based on two main colours which are quite close to each other on the colour circle, related schemes are also called toning schemes. Toning colours are usually those that are adjacent to each other on the colour circle, and because they have a common element, they are pleasing together. They give a room a definite character or mood.

The monochromatic scheme This is based on one colour only and uses many of its variations. In this case, texture and pattern are particularly important. A totally monochromatic scheme is sophisticated and need not be dull because the variety of tones is so vast. Variations of the basic colour can supply all the necessary drama, and small quantities of contrasting colours, as accents, are permissible. A monochromatic scheme permits greater flexibility. Colour changes can be made easily without having to change the whole scheme. It is recommended for those whose tastes change quickly.

Whichever scheme is adopted (and of course individuals have their own ideas), the most difficult problem may be to select the main, or dominant, colour. Many people start with the current popular trend colour, but there are other possibilities and the individual may have a favourite shade which will provide a starting point. One useful ploy is to pick out a hue from a curtain or other item of furnishing and to use that as the dominating colour; a scheme can then be built around the other colours in the pattern. A suitable floor covering is a particularly good starting point; many experts suggest choosing a carpet first and using it as the basis for the decorative scheme. One very important point to consider is the amount of light in the room; there may not be enough for very deep colours which absorb a great deal of light.

In many cases, of course, the reason for colour planning will be to change an existing room rather than starting from the beginning. In that event there will be existing carpets, furnishings and so forth which have to remain and which will modify any plans. Changes can be made in a number of different ways. For example:

- The colour scheme can be changed by keying it to a different colour in a carpet pattern.
- The room can be updated by introducing new colours and patterns without destroying the original plan.
- New colours can be introduced in a small way as a first stage; the walls and the curtains can be changed as a second stage, and the upholstery can be re-covered as a third stage.
- The room can be updated by removing everything surplus and then redoing it in one colour.
- A living room can be updated by making the walls darker; this gives the room more guts.
- One of the easiest ways to change the look of a room is to change the wallcovering; wallpaper is still the cheapest way of making a change, although wallpapers are seldom emphasised as fashion products and do not always appeal to younger people.

Changing a carpet provides an opportunity for a completely new colour scheme if the new carpet is a radical change from the old one. The carpet will last through a number of changes in other features in the future, and therefore the new design can be a basis for a complete rethinking which will provide a foundation for future change.

Actual hues will usually be chosen because they are fashionable or conform with current trends but special care is necessary in selecting colours in a shop or from a paint chip. Many rooms in the home are basically lighted for evening

conditions, and if the colours are selected in the light of the shop, or in daylight conditions, they may not produce the results desired. Colours are particularly deceptive when chosen from a paint chip; light colours will appear a good deal more intense on the wall than they do on the chip and are apt to cause a highly reflective surface, which may bounce light back and forth with disturbing results. Pale colours, like yellow, are particularly deceptive; a colour which looks right on the colour card will probably need 50 per cent admixture with white to create the right effect on the wall.

Attention is drawn to the hints on colour schemes in the next section and to the colour pointers listed in Section 18 in this part.

14.12 Hints on colour scheming

- It is inadvisable to use more than two primary colours in any room, except for accent purposes.
- One dominant colour is generally best, and the room should be built around it. The dominant colour does not have to cover a large area; small areas of warm colour will create more impact than small areas of weak colour.
- The most foolproof scheme is one colour plus white.
- Neutral colours, with small areas of brighter hues, are often attractive. A neutral main colour can be contrasted or accented with one contrasting colour. Variations of one neutral colour throughout a room will create an architectural effect.
- Contrasting colours between two rooms can be useful; it will separate the rooms. On the other hand, two rooms can be turned into one by using the same colours throughout.
- A room with strong colours used boldly is less distracting than one glaring wall and a few odd accents here and there.
- Colours do not have to be strong to be effective; lots of pale, clear colours look good against a neutral background.
- Colour schemes for ground floor rooms should be closely related so that there is continuity from one room to another.
- The larger the area, the stronger the colours should be.
- Dark rooms need plenty of light and colour.
- Sunny rooms can take any colour.
- Use intense colours as accents against a neutral background.
- Choose colour schemes that harmonise from room to room.
- The colours of natural materials (e.g. cork) are restful.
- Warm pastels are restful without being cold.
- Colour intensifies itself as it spreads over a large wall area.
- To highlight details, tone down the background.
- Changes in colour can alter the shape of a room.
- Rooms used mainly at night need colours that look their best in artificial light.
- The same colours on walls and woodwork create an uncluttered look.
- Too many colours in a room will camouflage it, make it look a muddle and tend to be 'jumpy'.

- Accents will provide lift in a room.
- In a period house, respect the period in question.
- Strong colour will provide a focal point where there is no fireplace; put the colour where it will attract most attention.
- The colours of nature are the easiest to live with.
- Use intense colours as accent against a neutral background.
- A touch of neutral will unify a colour scheme.
- With a cool scheme, have warm accents.
- Use paler tones to contrast with rich, dark colour.
- Avoid strong contrasts in light and dark; they are bad for the eye.
- Great differences in brightness can be trying.
- Shock colours can be used in areas which are passed through quickly.
- Concentrate universal colours in one grand punch rather than saturate a room.
- Do not hesitate to have fun with colour.
- When a colour seems right, use it.
- Take attention away from mistakes by placing strong colour elsewhere.
- To appear lustrous, colours need plenty of hue and strong contrast, preferably against black.
- The true highlight of a vivid colour is never a tint of it.
- Irridescence needs grey contrast; rich pastels are recommended rather than pure hues.
- To make pigments resemble lights, the colours should be soft and filmy; colours meant to look like light must be clean in hue.
- To appear luminous, colours must be brighter than white surfaces under the same conditions, and the surround must be scaled down.
- Colours picked from an existing carpet or wallpaper can be used for curtains.
- Fabrics should generally be matched to carpets and curtains should be matched to the wall.
- A change of just one pattern can give the appearance of a complete colour change.
- The environment can be changed to suit the season by using neutral tones for walls and floors and having furnishings in either warm or cool tones according to the time of year. This can be achieved by loose covers for upholstery or by rugs and curtains. Deeper, richer colours can be added for winter, and bright, clear colours for small items like cushions in summer.
- Seasonal changes can be effected by repositioning the furniture. During the summer the windows can be the centre of attention, but in winter the furniture can be turned inwards.
- A room for all seasons could have an overall scheme based on off-white with shades of blue and grey. Bright blues and turquoise can be highlighted during the summer and the muted greys emphasised in winter.

15　Colour for domestic interiors

15.1　About colour in interiors

Colour is the simplest and most effective way of giving an interior a certain style, and it is a vital ingredient in interior decoration, without which nothing else works. Colour does not only mean choice of hue but also depth of tone and how one hue is combined with others to influence the end result. Colour is a never-ending source of pleasure, a ready means of changing the way that an interior looks and can even be an expression of the personality of an individual.

Colour is the cheapest and most effective way of making maximum change. Change the colour, change the room, change the mood. Colour can transform a room more easily than any other device, disguising faults and altering the whole feeling of a room. Adding an extra colour creates instant pep.

No room can make an impact without colour; it can make or break the proportions or the aspect of a room and set off the contents to best advantage. Colour gives a room drama at little extra expense, and it is screen which disguises or emphasises. Colour has an astonishing power to change the size, shape, temperature and feeling of a room.

The art of interior decoration is to create an area which fulfils both aesthetic and functional needs, and which at the same time is comfortable. Nothing is more rewarding than a well-decorated room, and the ultimate aim of interior decoration is to make sure that the occupant is happy with the result. The individual who decorates with colour communicates something that no one else has.

The wrong colour will make the individual feel edgy and restless; uninspired choice can make any furniture look dull and hide good proportions. There is no such thing as a right or a wrong colour for the decoration of a home interior because colour should be geared to the personality of the individual. Everyone has a favourite colour and logic plays little part where human likes and dislikes are concerned. People should select hues which do not grate on their susceptibilities, and they are recommended to choose that part of the spectrum with which they feel most comfortable. Any use of colour in an interior ought to ensure the comfort of the occupant and encourage maximum relaxation. The true test of good interior decoration is whether it provides a sense of physical relaxation. Interiors by Robert Adam are particularly good examples, which

prove that colour and quiet interiors can live together. Hence the importance of individual choice.

Many people disguise their true feelings by following the dictates of fashion and good taste; they choose colours to conform, but colour ought to come from the heart, and there is no reason why people should not have their own way. Many people do not realise how colour affects them, but on the other hand, research suggests that most people have a fairly definite colour theme in mind when they start decorating, and they are much more flexible in their ideas about pattern. Some people seek advice from neighbours, but this is never a good idea because everybody visualises colour in a different way.

Choice of colour depends, to some extent, on climate. In the UK brilliant use of colour is indicated to compensate for lack of light, and the further south you travel, the less colour is required. However, the British tend to be afraid of vibrant colour and to prefer toning and delicate shades. Conservative people (i.e. those who are inwardly integrated) have a natural predilection for tradition and sentiment in decoration and for soft, subduing hues, preferably those that are cool. More dynamic people (i.e. those who are outwardly integrated) will prefer modern, abstract and more radical designs and a bold array of sharp colour contrasts. To some extent, conservative people tend to be older, and it is the young who prefer to experiment, but this is by no means a universal rule.

Whatever their personal feelings, however, the great majority of people will be influenced by broad trends of consumer preference for colour when they make a selection, and there is a positive tendency to do what everyone else is doing. Many people are fearful of using their own judgement in case they do the wrong thing, but they should be encouraged to keep their nerve. It is, after all, their own rooms that they are dealing with.

Every colour has properties which make it particularly suitable for a specific use in interiors, but the following notes refer specifically to home interiors; commercial and industrial interiors are discussed in later sections. The properties of each hue in the decoration of the home have been listed, and references to likes and dislikes are based on normal usage and not on fashion. At any given time certain colours may be 'in fashion' and may be used in ways that conflict with normal usage.

In any selection of colour due weight should be given to current preferences, but remember also that colour in the home is a matter of individual taste and many people prefer to follow their own inclinations whatever the experts may say.

Advice on decoration, decorative ideas and help in using colour for decorative purposes is a useful sales aid in appropriate cases. Although most people have fairly firm ideas about what they dislike or like, they are often afraid to trust their own judgement and therefore seek the help of experts. It follows that any manufacturer or supplier of products which are, or maybe, used for decorative purposes can offer help in using colour, with advantage to sales.

Such a sales aid might include advice or specimen colour schemes in appropriate cases, but care should be taken to ensure that they are geared to the type of customer at whom the promotion is aimed and that they are appropriate to the type of product. Although many housewives are delighted to look at exotic

and sophisticated colour schemes, they are unlikely to buy them, and it should always be remembered that the purpose of any exercise of this kind is to promote sales.

The average customer is always on the look out for ideas about the use of colour for decoration. A large proportion of the mail of any womans' magazine is from readers requesting advice about how to use colour.

15.2 Colour categories for interiors

The following notes summarise the properties of the various categories of colour which are useful in interior decoration.

Warm (hard) colours

Usage	No special comment.
Room character	Warm colours create a mood that is energetic, vital and cheerful and suggests sociability.
Room aspect	Warm colours will cheer up a north-facing room and create an exciting look; they add a flattering glow to a chilly room.
Room size	Warm colours and a wallpaper with a fussy pattern make a room seem smaller. Warm, dark colours can improve a small room. Warm colours reduce room size; they appear to be nearer than they actually are.
Room features	Warm colours on an end wall will bring it forward and on a short end wall make a room seem better proportioned.

Cool (soft) colours

Usage	Cool colours tend to make things recede and fade into the background.
Room character	Have a quieting and relaxing effect, although they can be cold if not relieved in some way.
Room aspect	Help to cool down a south-facing room but should be avoided in a room with a northerly or north-easterly aspect. They can be used in a room which receives a lot of light.
Room size	Increase room size.
Room features	Tend to make walls recede.
Room function	Recommended for much-used rooms because they are soothing and relaxing. Recommended for a room in which study takes place or where mental tasks are performed.

Bright colours

Usage	Brightness stimulates darkness but the meaningless use of areas of bright colour may cause accidents because they are distracting.

Room character	Bright colours set against a neutral background create a cheerful setting; they produce a stimulating effect and will brighten up a large dark room. They are good for morale, on the walls.
Room aspect	Recommended for north facing rooms and will look even brighter in a south facing room. Cheer up a N facing room.
Room size	No special comment.
Room features	On a feature wall they will attract the eye; the wall will seem to advance.
Room function	Bright primaries are recommended for a family dining room, and bright colours are suggested in bedrooms for newly weds.

Muted colours

No special comment is called for in this context.

Light (pale) colours

Usage	A light colour placed next to a dark colour seems lighter. Light colours may look insipid without accents. Pale colours help to avoid an overcrowded feeling in dual-purpose room. They reflect a good deal of light, and reduced levels of illumination may be desirable. They need special care when chosen from a paint chip, and they show soiling more easily, especially on floors.
Room character	No special comment.
Room aspect	Recommended for dark rooms, which need plenty of light colour; should be used in rooms which have little natural light.
Room size	Light, cool, colours on the walls and ceiling of a small room will make it appear larger; they tend to recede and to diffuse light. They increase room size and lend distance.
Room features	Reflect more light from ceilings and will make a ceiling seem higher. Light colours below the dado will reduce emphasis on the upper part. Light tones on longer walls will make a room better proportioned. Light colours for overall decoration make angles less noticeable and create a more unified appearance. Pale colours on the floor show soiling more easily and on end walls will make them recede.
Room function	Not recommended for halls or staircases unless plenty of light is required. Recommended for bedrooms.
Room users	Very pale colours are not suitable for children.

Medium colours

No special comment is called for in this context.

Dark colours (see also Deep colours)

Usage	Dark colours placed next to light colours appear deeper. Dark colours in a matt finish tend to absorb light.
Room character	Make a room more intimate, bring the walls forward.
Room aspect	No special comment.
Room size	Dark colours on floors and ceilings, with neutral walls, make a room seem longer and wider; on the walls down to dado height they will make a lofty room seem cosier. Dark colours will make a room seem smaller and absorb light, but they can improve a small room.
Room features	Dark wall colours will have little significance. Dark ceilings make some people feel uncomfortable; a really dark ceiling will 'disappear' optically. On a short end wall they will make a room seem better proportioned. Dark side walls will make a room seem narrower; dark floors will increase visual height; dark colours on the ceiling will lower it. Dark walls are a good background for pictures or for framing pine or light-coloured furniture.
Room function	Dark, rich colours are inviting in a dining room.

Pure hues

Usage	Primaries should be used boldly but are best used as accents.
Room character	Primary colours, angular shapes and abstract designs combine to make the most practical situation cheerful.
Room users	Primaries are recommended for children; they find them most attractive and they are most responsive to them.

Modified colours

No special comments are called for. Some designers favour 'muddy' colours because they think that they are easier to work with.

Neutrals

Usage	Neutrals without sharp contrasts, but with texture and pattern, will make a room less claustrophobic; they go with texture and will unify a colour scheme. Recommended for a narrow house.
Room character	Neutrals are enigmatic; with rounded shapes they create a quiet, gentle decor and a relaxed atmosphere that is easy to live with.

Room aspect	Neutrals can be used with brilliant accents, in a room which has little natural light.
Room size	Neutrals create a spacious effect.
Room features	Can be used to disguise a badly shaped room; will act as a foil to a bright feature wall.

Strong colours

No special comments are called for except in relation to room size.

Room size	Strong colours are suitable for large rooms and on the ceiling they will raise it. They are recommended for end walls in a long narrow room.

Pastels

Usage	Pastels intensify over a large area; select tints half as bright as the effect wanted. They can create a distinctive modern setting which is easy to live with; think of them as blocks of colour that can be blended with each other or mixed with small amounts of primaries. They work well with neutral tones such as grey or cream but show soiling easily.
Room character	Pastels and rounded shapes create a quiet, gentle decor and a relaxed atmosphere that is easy to live with. Too many pastels in an interior tend to cause people to become silent and withdrawn. Warm pastels are restful without being cold, but they can look insipid and uninviting.
Room aspect	No special comment.
Room size	Recommended for small rooms, they increase room size and are warm. Increase ceiling height.
Room features	Pastels on the floor show soiling easily.
Room functions	Pastels should generally be avoided in places where people work and concentrate, because they are apt to lead to emotional monotony. Candy colours are recommended for bedrooms and provide soothing charm in a dining room; they are not recommended for halls and staircases unless plenty of light is required.

Deep colours

Usage	Deep colours should be used in small areas; too much may be overpowering.
Room character	Deep colours make a room more intimate, they bring the walls forward and give an illusion of warmth.
Room aspect	Deep colours create a warming and exciting look in a north-facing room.
Room size	Deep colours will bring down a high ceiling.

Natural colours

No special comment is needed except that natural colours are the easiest to live with and create a calm background, especially on the floor.

15.3 Colour analysis

Violet group

Character	This group of colours includes purple, mauve, lilac and similar shades. Cool, soft, restful, not inviting to the viewer. A high-fashion colour, but as a trend colour usually has a short-lived reign. Modifies other colours, mixes well with blue. Not abundant in nature and arouses conflicting emotions because it is a mixture (of red and blue) and is visually either positively liked or disliked.
Light variants	Pale mauve is elegant and goes well with painted furniture and polished dark wood. Paler versions will create a fragile effect, but added accent is desirable.
Medium	Purplish pinks and lilacs will create a pretty room suitable for traditional floral fabrics and dark woods. Can be used as an accent at the back of an alcove when the walls are pale.
Dark	Deep mauve can be exciting; deeper mauves and purples create luxurious interiors but make a small room even smaller. They go with pine, polished brasses and velvet upholstery, for example the Victorian look. Deeper shades have a calming and atmospheric effect. Purple is powerful and dramatic and can provide some unusual colour combinations.
Usage in interiors	Creates a restful background, although deeper shades can be exciting. Better used as a background colour than as an accent, although purple and lilac can be used for cushions. Gives a rich effect but can be difficult to use. This is a colour for an original and unique decor. Apt to be distorted by fluorescent light; can be soft and subtle when used with blues and greys or strong and vibrant when used with greens and crimson.
Room character	Indicates a depth of feeling, sensuality and richness. Mishandled it can cause confusion and be unsettling.
Room aspect	Generally for south-facing and east-facing rooms.
Room size	Makes rooms look larger, although deeper shades tend to be claustrophobic.
Room features	–
Room functions	Not recommended for dining rooms.
Room users	–

Blue group

Character	This group includes darker blues, like midnight; medium blues, like summer blue; pastel blues; muted blues, like wedgwood. Cool, soft colour, tranquil and quieting and has the power to relax and soothe; man-made blues, as in textiles, harmonise with nature. Essentially a background colour, it tends to recede. Mixes well with violet and green but avoid mixing with bluish reds. Muted blues infer high fashion. Blue is the second favourite colour with most of the world's people; always popular with the British, less so overseas.
Light variants	Pale blue greys will make a room seem larger and raise a low ceiling, but they are cold to the eye and best kept for sunny rooms; brighten up with accents.
Medium	Powder blue can create an ethereal background.
Dark	Deeper blues will create a less chilly effect and may remind people of holidays. Very deep blues make a room seem smaller, although most blues have the opposite effect. The darker versions tend to be claustrophobic.
Usage	Blue will flatter the home and creat tranquillity, elegance and spaciousness; a refined colour. Can be used almost anywhere if it is clean and pure, but avoid purplish blues in most cases. Flexible in use, especially in the dining room. Avoid large areas of blue – they may make the eyes near-sighted and cause headaches. Has a quieting effect if not relieved with accents; lends emphasis to more vivid colours. Most blues look darker in electric light; apt to be distorted by fluorescent light.
Room character	The colour of the sky, creating a cool, fresh, restful feeling which can make a room appear larger. Tranquil.
Room aspect	Blue is recommended for sunny rooms with a south or south-west aspect but not for rooms facing north and north-east, although a deep, rich blue could be used in a north-facing room; not for rooms having little natural light. Looks grey in a cold room and tends to look dirty in setting sunlight.
Room size	Blue increases the size of a room.
Room features	–
Room function	A good background for dining areas and recommended for narrow halls and small cramped rooms, especially the cooler blues. Recommended for a library or a study; it provides stimulation as well as relaxation but use accents. Refreshing in a kitchen. Blue fabrics make for a peaceful bedroom.
Room users	Blue is attractive to children but can be intimidating; it is the ideal colour to relax highly strung, overworked people because it calms the emotions. A peace maker.

Blue-green group

Character	This group includes mixtures of blue and green such as aqua and turquoise, which have rather more blue than green in their composition. The group has many of the attributes of blue but has rather more impact and is more inviting than blue. Cool, soft colour, very flattering to humans by contrast.
Light variants	Aqua has many of the properties of pale blue but has a higher fashion connotation.
Medium	These have a calming effect and are relaxing but a little cold if not relieved. Turquoise will provide accent against a neutral background and has a fashion connotation.
Dark	Deep blue-greens are for the adventurous; they create a jewel-like effect.
Usage	Very similar to blue but is less chilly and more flattering to the human complexion; any chilly tendencies can be offset by using accents. Blue-green reflects a good deal of light and creates spaciousness and elegance. Are generally best for background; they tend to recede but not as much as blue.
Room character	Blue-green is elegant and brings a touch of fashion.
Room aspect	Blue-greens are recommended for sunny rooms with a south or south-west aspect.
Room size	Blue-green has the effect of making a room look larger but also decreases the height of a ceiling.
Room features	–
Room function	Blue-green is a good background for food and is very suitable for a dining area.

Green group

Character	The green group is one of the most complex groups and includes a wide variety of colour ranging from greens with a blue bias to the more widely used yellow-greens, including grass green, lime green and deeper variants such as olive. It also includes greyish greens, like sage, and greens with a touch of black, like the popular avocado. Most greens are named by association with nature, for example pea green and grass green. Green is the colour of nature and has all the manifold variations of nature; it signifies plant rebirth and life and represents stability and security. Many people set great store by green; one of England's oldest and best-known tunes is *Greensleeves*, but there are also prejudices against it, and some people will not have it in the house. Cool, soft colour, restful and easy to use; neutral in appeal. Man-made shades of green, as in textiles, seldom harmonise

with nature. A modifying colour, also described as a no-nonsense colour. Mixes well with yellow and blue, goes well with brown; contrasts with pink; the after-image of yellow-green is purple and this can be disturbing.

Light variants

Pale grey greens are restful but rather limpid. The lighter greens are refreshing without being over cool and are lively without being aggressive.

Medium

Lime green is a high-fashion colour and can be used as accent against a neutral background; it looks good in the tin but not so good on the wall. Avocado tends to appear bilious and may give people a sallow look; the same applies to chartreuse.

Dark variants

Olive green can be just plain gloomy; it is a masculine colour.

Usage

Green transforms the gloomiest room and brings a breath of fresh air into the city. Greens are best used as a background, but luminous shades can be used for accents such as cushions and lampshades. Green can be the most pallid and doleful of foreground colours or the most deep and enriching of background colours, but out-of-place use can depress the temperature of a room. Green has considerable furnishing appeal. Sickly yellow-greens are best avoided, but most greens are refreshment pure and simple; it is wonderful with white and friendly to the whole spectrum. Apple green is nature's own colour, easy to live with, easy on the eye, fresh as spring, a breath of the country. Green creates spaciousness and elegance.

Room character

Greens have a quieting effect, but some variations may be rather cool; well used they can make a room look sunny. Green is the most restful colour to the eye, being cool, fresh, elegant and dignified.

Room aspect

Should be avoided in a north-facing room.

Room size

Helps to make a room look longer and airier. Pale greens make a room look larger but are cold.

Room features

Green will go with pine or paler woods.

Room function

Green is excellent for a study and any area where concentration may be required. Dark greens are an ideal background for books. Lighter greens are good for dining rooms and make for a restful bedroom; they are recommended for television rooms. Green is very refreshing in the kitchen.

Yellow group

Character

This group includes pure yellows ranging from the palest shades to very deep yellows and also a range of muted shades such as gold, antique gold, mustard and similar

colours which have many uses in decoration. At the green end of the spectrum, yellow tends to be dominated by green and in the other direction by red, although yellow itself dominates soft colours. Warm, hard colour, incandescent; reflects more light than any other colour; inviting to the viewer; excellent for accent but loses much of its radiance when used on felt or wool. It is generally a mass-market colour, except in some subtle shades. Yellow blends well with orange and brown and also with green to create a 'country effect'. Harsh, acid yellows are best avoided, and so is yellow-green in relation to food – it may cause nausea. Pale yellows need special care when chosen from a paint chip, and so in fact do all yellows.

Light variants

Pale yellows are generally unsuitable for carpets. Lemon yellow, used in excess, is liable to cause a kind of psychological jaundice, and it can look sickly, although it can be recommended to offset neutrals, for north-facing rooms and for dining areas.

Medium

Sunny yellow will cheer up a bleak room; it is a very cheerful colour to greet you in the morning and suitable for a breakfast room, dining room or kitchen. Golds create richness and warmth.

Dark

Deep yellow is very suitable for a playroom and will provide the most cheerless room with light.

Usage

Yellow is particularly suitable where there is little natural light; it is for peace lovers but can be cheap and cheerful for those who love excitement; the British tend to be cautious with yellow; people find it too invigorating. Some yellow is recommended for decoration because so many other colours can be used with it; it is best used with other colours. Yellows are wonderful to live with but are tricky and should not be overdone. The warmer the yellow, the more it seems to need a little light relief or bright contrast. Yellows are excellent for accents such as cushions or lampshades and other accessories in a dark room. Yellow has high reflective qualities and can be used to lighten up a room. Yellow looks twice as bright on the wall as it does in the tin.

Room character

Yellow is the colour of flowers and sunshine and evokes a feeling of warmth and inspiration; when used for furnishings it is soft and vibrant and is versatile; it mixes with almost any other colour, creating a bright and uplifting environment. In its purest form it radiates warmth, provides inspiration and prompts a sunny disposition. The happiest of colours and it 'brings you in out of the cold'.

Room aspect

Golden yellow can be used for a north-facing room,

although light variations can also be used. It cheers up dark rooms and brings light and colour to dark corners; it is particularly useful in a room which has little natural light.

Room size Yellow is the largest of all colours, but because it advances it tends to make a room look smaller.

Room features Yellow is not recommended for floors except in darker variations.

Room function Yellow is ideal for basements – it brings light. Yellow, but not yellow-green, can be used for dark dining rooms.

Room users Particularly suitable for rooms used by children; sunshine yellow is the first preference of young children, but it can be intimidating if overdone.

Orange group

Character This group is almost always used in pure form and includes such variations as tangerine and apricot; the darker tones, such as burnt orange, merge with brown. Warm, hard colour; exciting, stimulating, energising; has very high intensity; excellent for accents, compels interest. Blends well with yellow and brown.

Light variants Pale orange is easy to live with and warms up a cold room. Apricot is clean, fresh, warm and brings a touch of sunshine; a warm shade for a cosy atmosphere, complemented by blue.

Medium Brighter shades are useful in a darkish small hall.

Dark Burnt orange is easy to live with and warming.

Usage Orange is trying in large areas but creates a feeling of sophisticated warmth with wood. It is an earthy colour which represents nature (e.g. autumn leaves). It creates a feeling of solidity, warmth, serenity and assurance; it can be cheerful and stimulating like red, but can also be trying and slightly irritating if overdone. It looks better in the tin than it does on the wall and should be used sparingly.

Room character Orange may be useful for a warm, friendly, living room.

Room aspect Orange is good for a north facing room; apricot is recommended for a cool room.

Room size Orange reduces the size of a room.

Room features Orange is recommended for receding end walls; used for walls at the end of a long room, it will make the room seem wider.

Room function Apricot is suitable for a relaxing bedroom and can also be used for a television room. Orange can be recommended for halls.

Room users Orange is particularly suitable for rooms used by children and teenagers.

Brown group

Character	The browns have a very wide range, from the palest beige to the deepest chocolate browns, and therefore the whole group has many uses in interior decoration. A country colour which will go with anything. Warm, hard colour; flexible, inviting, restful. Blends well with orange and yellow, looks well with green.
Light variants	Beige creates an impression of spacious calm; with a matt surface it is neutral, but it is not a true neutral and often has a deadening effect on other colours. Beiges are warm without being overbearing, they look smart, are easy to use and will blend with any colour scheme. Fawn and beige have a high-fashion connotation; they are warm and flattering to any furnishings. Fawn goes well with wood tones. Pale browns are restful without being cold.
Medium	Tan and copper make a beautiful background for living rooms; they are warm and flattering to furnishings. Khaki shades provide a long-lasting background for lighter colours; Berber shades look well in almost any setting; caramel is recommended for a luxury home.
Dark	A matt chocolate surface would be very dreary; gloss livens it up.
Usage	Browns are easily harmonised and blend with any colour; they have the invaluable decorative faculty of changing their character in proximity to other colours. Brown is a perfect background for good furniture, for pictures, for ceramics and for works of art. It has a tonal kinship with many natural materials, but it needs to be lit with the sparkle of white or the sheen of black. Browns are easy to live with and warm up a cold room; they add a flattering glow to a chilly room. Beiges are frequently used for formal interiors which are traditional in style.
Room character	Brown is a country colour which is soothing and restful, it creates a feeling of sophisticated warmth.
Room aspect	Browns are recommended for north-facing rooms.
Room size	Lighter browns make a room larger. Beige reflects light well and is particularly suitable for small rooms, but is too dazzling for a south-facing room or a large area.
Room features	Brown walls have a relaxing effect.
Room functions	Brown is particularly good for the 'public areas' of the home.
Room users	Brown is not recommended for children or teenagers.

Red group

Character	The red group includes reds with a bluish cast, such as magenta, and yellow-type reds, like vermilion, which

usually have more impact. Muted reds include maroon and terracotta. The lighter reds are discussed below (see Pink group). Warm, hard colour; easy to identify and creates most attention; universally liked. Red is a colour for all seasons and all temperaments, which signifies richness and warmth. Red mixes well with pink and blue, but avoid mixing bluish reds with blue. Yellow reds are generally better than bluish reds.

Light variants See Pink group.

Medium Vermilion is recommended for a dining area. Rust is good for receding end walls, it makes a room warm, welcoming and smart and it will warm up a north-facing room. Terracotta adds an atmosphere of warmth and cosiness and enhances the rich colours of mahogany furniture. Flame is recommended for halls and corridors.

Dark Dark reds are recommended for a dingy dining room. Pillar-box red makes floor space contract.

Usage Reds with a touch of white or black in them will not be liked; it is better to be definite. Reds with blue in them can be comforting and purposeful, but the deeper tones can be sombre. Reds will give a warm and friendly look to a large room and can be used in rooms that seem cold. They are a splendid background for antique furniture. Red will consistently assert itself against all other colours and is inclined to be aggressive and demanding. Venetian reds are demanding because of their high yellow content; brownish reds are much easier to live with. Too much red can be overpowering. Full blooded reds, such as ruby or crimson are appealing and make a flattering background for blond or grey-haired people. Deep reds are apt to be distorted by fluorescent light. Red can cause restlessness if used in large areas, and its green after-image can be disturbing. Many people only quarrel when they are in a bright red room.

Room character Reds can create an extremely restful background and a cosy quality, but red can also be an irritant because its physical effects prompt a release of adrenalin into the bloodstream. People react more quickly to red than to any other colour; it is fiery, dramatic, eye-catching and exciting.

Room aspect Reds are ideal for rooms that seem cold, including north-facing rooms but are not recommended for south-facing rooms.

Room size Reds tend to make a room look smaller; they tend to draw walls closer together and will reduce the size of an already small room.

Room features Red walls at the end of a long room will make the room look wider.

Room function	Red is very comforting for a study or writing room and is suitable for some dining areas. Red floors in a hall create a welcoming effect.
Room users	Red is a warming colour for the escapist or a dramatic colour for the extrovert; it leaps on the beholder and refuses to be taken for granted; it never recedes or takes second place. Reds are the preference of children between about 2 and 5 years old and are therefore recommended for rooms used by young children. Strong reds are good for all children.

Pink group

Character	The pink group includes light reds mixed with white; those with a blue bias are akin to lilac or orchid; those with a yellow bias include tints like peach which are akin to orange. Warm, hard colour; cosy, flattering. Subtle pinks are exclusive and considered essentially feminine. Mixes well with red.
Light variants	Pale pinks are delicate, unobtrusive and flattering; they are restful without being cold. Pastel pinks with primaries create a demure and lively look.
Medium	Peach is recommended for a sophisticated living room or bedroom but requires the addition of accents; it is neutral with wood tones and has a sunny aspect in winter; it is an appetising colour, very suitable for use in eating areas and in the kitchen.
Dark	Flame pinks are more dominating and aggressive.
Usage	Pinks make a room seem warmer but not overbearing; as background they warm even the cool light of northern exposure and certain fluorescent lamps. Pink is the colour most flattering to complexions. Bold pinks can be bright and striking. Contrasting pinks add impact to neutrals, while pure pinks create a fashionable look. Soft pinks are warm and subtle; fuschia pinks have a more lively effect than candy pinks; warm coral pink is particularly flattering to the appearance. Pink is adaptable to a variety of styles; think of it as a neutral with an extra block of colour. Different tones of pink create a positive look.
Room character	Pink is one of the most versatile and imaginative of colours; it can be subtle, sophisticated, bright, clean, vibrant and stylish.
Room aspect	Pink is recommended for north-facing rooms and rooms without direct sunlight or for east-facing rooms that only get sun in the morning. It is ideal for rooms that seem cold and adds a flattering glow.
Room size	Pink has little effect on room size.

| Room features | Pink ceilings give a glow to a room. |
| Room function | Pink is excellent for bedrooms; peach and coral are good for dining areas; darker pinks may be used for halls. |

White

Character	The universal alternative, something unaltered. Good background but has little interest because of lack of chromaticity.
Usage	White is a good background colour but may cause headaches if not broken up; it cannot add warmth or depth. White should be unquestionably white, and if this is impossible, it is better to use some other colour. White can have more effect in a room than most other colours; it is the greatest reflector of light and can often be used to lighten a colour; it can be used as a foil to enhance or add impact to other colours. Touches of white enhance a room and soften other colours. White is the space-maker and bringer of light, but large areas of white are generally best avoided if they fall within the normal field of view; the eye cannot help focusing on the brightest object within the field of view, and because this constricts the pupil of the eye it tends to blur vision. White goes well with pine but not so well with mahogany or rosewood. Texture adds interest to a white surface.
Room character	No special comment.
Room aspect	White is suitable for dark rooms but not for north-facing rooms, because it tends to look grey. Care is necessary in a room which receives a lot of light – white looks creamy during sunny periods and blue-grey when the sun goes in.
Room size	White tends to make a room look larger.
Room features	White ceilings make a room seem higher; it is not recommended for floors, off-white is better; white walls may be used when in doubt; all fabrics look good against white. White tops the poll of preferences for ceiling colour; tinted whites can add a touch of colour to ceilings without affecting light. A preponderance of white walls is emotionally sterile and visually dangerous, especially where people work and concentrate, because of glare and eye abuse.
Room function	No special comment.
Room users	White is not recommended for rooms used by children, mainly on practical grounds.

Off-white group

| Character | Off-whites can be warm, like magnolia, or cool, as ivory, and there are many variations such as cream and the so- |

called tinted whites, which have a hint of colour. Off-whites are similar to white but less stark and have a luxury image. Some off-whites have a high-fashion connotation.

Variations	Cream is a good background to many different colours; it is easier on the eye than white and easier to live with; it can be recommended for a narrow house. A warm cream will make everybody healthy looking.
Usage	Off-whites are a good background to other colours and texture goes well with them.
Room character	No special comment.
Room aspect	Warm off-white or pale cream are better than white in a north-facing room, otherwise as for white.
Room size	Off-whites have little effect on room size.
Room features	Off-white floors have a luxury image and are better than white, although not very practical.
Room function	No special comment.
Room users	Off-whites are not recommended for children.

Grey group

Character	True greys are mixtures of white and black and range from silver grey to darkest charcoal. A conservative colour which reduces emotional response and is non-committal. High fashion and suited to people of 'expensive' taste.
Light variants	Silver grey and lilac grey are elegant and well suited to polished, darker woods or for the display of silver. Light greys create a spacious effect in small areas.
Medium	Pewter is for a modern home.
Dark	Darker greys are dramatic and look well with silver-coloured metals, including chromium. Good background for antique furniture. Charcoal has a sophisticated image.
Usage	Greys are useful for toning-down purposes. Schemes based on grey have a long-lasting appeal because they do not date. They create a spacious and sophisticated setting. Greys blend well and are refined and pleasing to the eye. All greys should be unmistakably grey. Grey is the most versatile of colours; an unusual scheme uses nine shades of grey from charcoal on the floor to light grey on the ceiling.
Room character	No special comment.
Room aspect	Grey is not recommended for a dark room.
Room size	Greys make a room look larger.
Room features	Grey walls and floor can be offset by yellow.
Room function	No special comment.
Room users	Grey is not for children or old people – both find it depressing.

Black

Character	There are many kinds of black, ranging from jet black to blue-black and green-black, and there is nothing negative about any of them. There are blacks that reflect, blacks that absorb and blacks that act as a stimulant to other colours. Blacks can create serenity and has maximum contrast with white. Black often has a high-fashion image.
Usage	Black is normally used in small doses; it creates a stark appearance; it is frequently used in high-fashion applications. Black should be unquestionably black and needs more cleaning than white.
Room character	Black represents style and sophistication.
Room aspect	No special virtues.
Room size	Black can change shape, sizes and so on but can be deceptive.
Room features	Black ceilings make some people feel uncomfortable. Black is frequently used for rugs in high-fashion applications.
Room users	Black is not recommended for children.

Grey tints

Character	Grey tints are very pale colours with a hint of grey; they might be classified with the muted versions of the basic hues, but experience has shown that a separate heading is useful. The attributes will be the same as for the basic hues, but the special points below are worth recording.
Brown versions	Stone is recommended for modern living rooms, it is always smart.
Yellow versions	No special comment.
Green versions	Grey-green is recommended for really small areas.
Blue versions	Grey-blue is suitable for sunny rooms.

16 Colour for working interiors

16.1 About environmental colour

Colour has an important part to play in creating a satisfactory ambience which will ensure that commercial, industrial and institutional environments perform the functions for which they are intended and provide the best possible seeing and working conditions. Colour has a practical part to play in controlling light, improving safety, enhancing productivity and increasing profits. In addition, of course, colour has a decorative aspect, particularly in selling environments where it must appeal to men and women in the street. The way that colour performs these functions is described in the pages that follow, but there are also a number of subsidiary and practical functions which are significant in both environmental and other applications; these are listed in Section 9 earlier in this part.

This Section is primarily concerned with the interior decoration of industrial, commercial and institutional premises, as distinct from domestic interiors, and although colour for exteriors is briefly mentioned, the chapter is not concerned with the place of buildings within the wider environment; the latter is a much more complex subject which is properly the province of the architect or town planner.

The basic areas in which colour has a significant part to play in achieving a satisfactory working environment are:

- catering, including restaurants, hotels and canteens
- factories and industrial plants generally
- hospitals, including doctors' and dentists' surgeries
- offices, including banks, government offices and the like
- schools, including teaching establishments of all kinds
- shops and retail establishments other than catering.

These areas may be divided into three broad categories:

The productive environment, designed to achieve efficient and profitable working conditions and applicable to factories, offices and the like.

The selling environment, designed to attract the public and to ensure sales of merchandise and services, applicable to catering establishments and shops.

The institutional environment, designed to perform a specific function, depending on the nature of the institution and applicable to schools, hospitals and the like.

Some areas may span more than one category, but all must be pleasing to those who work in them or use them; they must be safe in the sense that hazards should be adequately marked; they must be economical in the sense that proper use is made of light; and they must contribute to the image of the company or organisation concerned.

16.2 Functional colour

In all the areas listed in the previous section, colours must be selected for sound reasons that have a practical and functional background; personal preferences should be eschewed. The sound reasons are embraced within the term *functional colour*, which may be described as the art or science of increasing efficiency, profitability and safety through the use of colour in industrial, commercial and institutional environments. It should be noted that there are also functional uses of colour in both consumer and graphical applications.

Functional colour is so called because it is a system or method of colour application in which definite objectives are set up for each situation and colour is specified to meet these objectives. The guiding factor is the function that the colour has to perform. Personal prejudices and artistic considerations have no part to play except in a few instances where trends and decorative conceptions can be taken into account with advantage.

Functional colour is primarily concerned with tangible and factual data based on research by colour specialists, lighting engineers, ophthalmologists and others. There is a great deal of published information available on the subject, supplemented by well-documented research, but it is not easily consulted without a great deal of effort, and this book seeks to summarise the more important points. The aim is to put colour to work in a practical way and, where possible, to prove a case by results, taking advantage of the fact that colour has effects which are largely autonomic in nature and which influence people whether they are aware of them or not.

The functional use of colour as part of the environment had its beginnings in the 1920s and 1930s, when the lighting industry succeeded in achieving high levels of illumination in hospital surgeries and operating theatres. These advances in lighting technology obviated dependence on daylight but caused problems of glare and brightness which reduced the visual acuity of the surgeons. This problem was solved by the skilful use of colour, by developing coloured wall material which controlled the excessive brightness. The use of blue-green not only helped to control the glare but, because the colour complemented the red of human blood and tissue, it enabled the surgeons to have a much clearer view and made their task easier.

The same principles were developed for, and tried out in, schools and then

applied to factories, especially during the Second World War, when maximum production was essential. Colour helped to achieve the best possible seeing conditions by eliminating glare and unnecessary eye adjustments within the field of view. Many industrial tasks require critical use of the eye, and control of the environment helps to eliminate factors which cause eyestrain and fatigue and which lower manual dexterity.

The functional use of colour in the environment is profitable because it helps to increase efficiency and improve productivity in the working environment and helps to attract customers and promote sales in the selling environment. It is not easy to measure benefits exactly in financial terms, but colour does help to achieve better results.

16.3 Management responsibility

Industry is, or ought to be, interested in the subject of functional colour, and particularly in the efficiency aspects. All grades of management have something to gain, including office managers, works managers, production managers, store management, hotel management and, in fact, everyone who is responsible for places where people work or play. Management should not only be concerned with the functional application of colour to buildings and structures but also to the tools, equipment, furniture and other objects within the environment, because these are parts of the whole. Those responsible for environments need knowledge of the psychic make-up of people; controlled environments are comparatively easy to engineer, but the right psychological conditions are much more difficult to achieve.

The office manager wants to increase productivity; the factory operator wants to lower accident rates and increase output; the store must appeal to customers; the hotel must attract guests and keep them; the hospital is concerned with aiding recovery; and the school is concerned with child response – in all these areas colour will pay dividends if it is chosen according to sound principles and with definite purpose.

An improvement in productivity of the order of 5 per cent is not to be sneezed at, and if this can be obtained by the functional use of colour, it is worthwhile for management to pay attention to the subject. A number of economies can be achieved, such as:

- colour standardisation which will reduce paint requirements and stores
- reduced lighting costs and improved illumination
- lowered accident frequencies with substantial savings.

The industrial or commercial buyer is also an interested party because he will have to choose colours and needs to be assured that the choice is the best possible one for the purpose, whatever the purchase may be; the choice must have some definite reason behind it. The considerations which should affect the buyer's judgement include good seeing conditions, safety, morale and a pleasing appearance; the buyer must take a long-term view because the purchase will probably have to last for some years, and it may be necessary to have to justify the choice of colour to higher management. These remarks apply par-

ticularly to office managers who are likely to be involved with both decoration of the offices and with the purchase of quantities of comparatively small equipment.

Because the industrial buyer cannot be expected to be an expert on colour, the manufacturer or supplier of products for industrial or commercial use has a duty to see that the products offered are finished in colours which are appropriate to the various environments in which the products are to be used and will therefore contribute something useful to those environments. The manufacturer may also have to produce proof that the colours offered do help to achieve suitable objectives. Average management is most unlikely to be fully informed about the functional use of colour and therefore needs, and welcomes, advice provided by their suppliers. Whether the product supplied is paint or machine tools, colour should not only play a part in the attraction of the product but the colours should be useful to the ultimate user.

When the general public is involved, as in shops and restaurants, the colours must be attractive to the public as well as utilitarian, and they should set off the merchandise to best advantage. The architect is also interested in functional colour; he has to ensure that his building is a good place to work in, that it will not date too quickly and that the colours will enhance the design.

Consistent and inspired direction of the use of colour is a valid responsibility of management.

16.4 Design responsibility

At one time the selection of colours for any architectural entity of a commercial or industrial nature was largely 'good taste', but nowadays the emphasis should be on purpose rather than on appearance, and the architect or interior designer will, or should, seek advice on illumination and colour. Colour is integral with, and cannot be separated from, design and form.

The use of colour in architecture was once symbolic and before the Renaissance was ritualistic; spiritual and emotional qualities came in with the fourteenth and fifteenth centuries. Functionalism in colour came to the fore in comparatively recent years mainly due to advances in lighting engineering. It is concerned with broader and more social values than with individual feelings, whether or not these feelings reflect the ideas of designer or client; a home owner may still indulge his fancy, but a store owner is more concerned to sell merchandise, the office manager to improve efficiency and the factory owner to increase productivity.

There is no reason why beauty should become subservient to utility, nor should colour be treated in an impersonal way. Selection should take account of the physiological make-up of human beings, and the universal qualities of human taste should be respected. It is a mistaken notion that simple colours are vulgar colours, and history shows that pretension is emphemeral. In home decoration the form of beauty that tends to be revived generation after generation is based on folk art and peasant art.

Creative people, by nature, resist advice and counsel and, not unnaturally, desire to put 'their mark' on the environments for which they are responsible.

There is plenty of scope for individual design in homes, in places like hotel lounges and in shops. In working areas, however, decorative colour should give way to form and design; the creative viewpoint should give way to the functional aspect, and the emphasis should be on purpose rather than on appearance. In all places where the public gathers, as distinct from the individuality of the home, colour will attract far more attention than form and design. People tend to look on design as a kind of intellectual reserve; they will like or dislike shape as their mind dictates, but the appeal of colour is to the emotions and is much more deep and compelling. This appeal is also part of the atmosphere that a building creates and the lighting may be a principal part of the atmosphere; colour and light together can modify or destroy any structure. Environmental colour is one of the visual elements which link together all aspects of a structure and act as a common denominator on all levels and in each discipline.

16.5 The ideal environment

The most important function of colour is to help create an ideal environment in which colours give of their best and from which the public derives maximum pleasure, and this is achieved by controlling light, eliminating glare and modifying surfaces in such a way that excessive contrasts are avoided and good seeing conditions are created. In addition, the decorative and psychological aspects of colour contribute to an environment which is pleasing to both workers and to the public. Colour is an essential part of the ideal environment and without it the most elaborate lighting installation is a waste of money. Colour has two principal tasks in creating the ideal environment:

- to control light
- to provide a pleasing environment.

The first of these tasks is achieved by using colour to modify surfaces in such a way that brightness is controlled within the field of view, excessive contrasts are avoided and glare is eliminated as far as possible. Colour helps to strike a balance between the high light levels recommended by lighting engineers and the desire of the designer to achieve variety and beauty; it modifies the light in such a way that the best possible conditions are created. The control of light is related to the reflectance value of the colour rather than to the hue itself and is described in 10.13 above.

The second task is to provide a more attractive and pleasing environment which promotes visual relaxation and release from tension. This aspect was particularly useful in the war years, when long hours of work at monotonous tasks tended to cause a falling-off in efficiency; good morale is just as important as good seeing in terms of productivity. However, functional colour is not interior decoration in the accepted sense of that term because it is not solely concerned with appearance; the latter must be linked with more objective factors.

Lack of colour, or badly planned colour, can handicap vision and reduce efficiency and also lead to a dull and depressing appearance, but good visibility is generally more important than appearance and too much colour may be self-defeating if it is distracting. In most working environments the trend is towards designs with lower ceilings and less individuality, and this makes the use of

well-planned colour particularly important; staff are unwilling to spend their time in dull working conditions.

Colour has a psychological function of providing variety and interest in an environment in which a high level of lighting might otherwise cause a sterile atmosphere and an uninviting prospect. This is primarily a function of hue and not of reflectance values and it is discussed in later chapters.

16.6 Colour analysis

It is difficult to provide a colour analysis suitable for environmental use because the primary function of colour in the environment is to control light and this is related to reflectance value rather than to hue. To overcome this difficulty, reference had been made to British Standard colours, which are designed primarily for use in the architectural and building field and whose reflectance values are easily obtainable.

Table 16.1 is an index to those British Standard colours which are considered to be suitable for the environments indicated in terms of both reflectance value and hue. The references are taken from BS 4800:1981 and from BS 5252:1976, and these references provide a convenient means of illustrating colour without the need for actual colour samples. The standards will be familiar to most specifiers, and surface finishes in BS colours are available from all major paint manufacturers who also supply appropriate colour cards or sample swatches.

However, BS colours are not the only colours that can be used, and in some areas the standards lack attractive colour suitable for decorative purposes; the trade ranges of paint manufacturers often fill these gaps with unclassified colours. Any variations of hue that fall within the recommended limits of reflectance value would be suitable, and something a little different from standard colours may provide variety and, perhaps, competitive advantage.

An explanation of the divisions of the spectrum into the principal hues will be found in 17.7 in this part.

Table 16.1 Colour analysis chart

The column headings to this table are:
1 Subdivision of hue.
2 References to BS 4800:1981
3 Approximate reflectance value for 2
4 References to BS 5252:1976
5 Approximate reflectance values for 4
6 Recognised safety colours
7 Recommended for identification of pipelines
8 Recommended for office use
9 Recommended for factory use
10 Recommended for industrial plant and equipment
11 Recommended for retail use
12 Recommended for catering use
13 Recommended for hospital use
14 Recommended for school use
15 Recommended for signs in hospitals.

1	2	3	4	5	6	7	8	9	10	11	12	13	14	15	
Violet group															
Light	24C33	56								*	*				
			24E50	56						*					
Medium	22C37	30				*									
			22D41	42						*	*				
Dark	22D45	6												*	
			24E56	20						*	*				
Clear blue subgroup															
Light	18E49	70					*	*		*	*	*			
	18C31	72					*	*		*	*				
	18E50	56								*	*				
Medium	18E51	30					*	*	*	*	*	*			
	20E51	30				*	*			*	*				
			18D41	42						*	*				
Dark	18D43	20							*	*	*				
	18E53	12			*	*				*	*	*		*	
			18D45	6						*					
Muted blue subgroup															
Light	18B17	56					*	*		*	*	*			
	20C33	56						*	*	*	*	*			
Medium	18C35	42					*	*	*	*	*	*			
			20C35	42			*	*	*						
Dark	18C39	12							*		*				
	20C37	21						*	*		*		*		
	16C37	20											*		

(Table 16.1 continued)

1	2	3	4	5	6	7	8	9	10	11	12	13	14	15
Blue-green group														
	16C33	56					*	*	*	*	*	*	*	
			16E50	56			*	*		*	*			
			16C35	42			*	*	*	*	*	*	*	
			16D41	42				*	*	*	*			
Dark	16D45	6							*	*	*			
	16E53	20									*		*	*
	16C37	20					*	*	*			*		
			18C37	20								*	*	
Clear green subgroup														
Light	14C31	72					*	*	*	*	*	*		
			14E49	72			*			*	*			
			14E50	56			*	*		*	*	*	*	
			12D41	56						*				
Medium	14E51	30								*				
	12E53	42					*	*		*	*	*		
			12E55	30						*	*			
	12D43	20						*	*					
Dark	14E53	20			*	*				*	*	*		
	12D45	12				*		*	*	*	*			
Muted green subgroup														
Light	12C33	56					*	*			*		*	
	12B17	56					*	*	*		*	*	*	
Medium	12B21	30					*	*	*		*	*	*	
	14C35	44					*	*	*	*	*	*	*	
			12B19	42			*	*						
			12C35	42									*	
Dark	14C39	6									*			
			14C37	20								*	*	
Clear yellow subgroup														
Light	10E50	56					*	*		*	*	*		
	10E49	72						*		*	*			
			10D41	56			*	*		*		*	*	
	10C31	72										*		
	10C33	56					*				*	*	*	
Medium	08E51	42			*	*	*	*		*				*
			10E56				*			*		*	*	

(Table 16.1 continued)

1	2	3	4	5	6	7	8	9	10	11	12	13	14	15	
Muted yellow subgroup															
Medium	10C35	42									*	*	*		
Orange group															
Light	06E50	56									*	*		*	
	06C33	56					*	*	*		*	*	*		
			08E49	72							*	*			
Medium	06E51	42				*	*				*	*	*	*	
Dark			06E55	20							*	*			
Brown group															
Light	08B17	56								*		*	*	*	
			08C33	56			*	*			*	*			
			06D41	56									*	*	
			08D41	56							*	*			
Medium	08C35	42				*	*	*	*	*	*	*	*	*	
	06D43	30					*	*	*	*	*				
Dark	06C39	6						*	*		*				
	06D45	12										*	*		*
	06E56	20							*						
	08C39	6										*			
			08D45	12							*	*			
Warm red subgroup															
Light	04C33	56				*	*	*			*	*	*	*	
	04E49	72							*		*	*			
	06C33	56										*			
			06D41	56							*	*			
			04E50	56			*	*			*	*			
	04B15	72					*	*							
Medium	04E51	30							*		*	*	*	*	
			04D41	42				*			*				
			04C35	42									*		
			04D43	19							*	*			
			02D41	42							*				
Dark	04E53	15			*	*				*	*	*			*
	04D45	7				*					*	*			
	04C37	20											*	*	

(Table 16.1 continued)

1	2	3	4	5	6	7	8	9	10	11	12	13	14	15
Cool red subgroup														
Light	02C33	56					*	*		*	*			
	04B17	51						*				*	*	
	04B15	72										*		
Medium			02C35	42			*	*						
			02D41	42			*	*						
Dark	02C37	20									*			
	02C39	6									*			
White	00E55	84				*	*	*		*	*	*	*	
Cool off-white subgroup														
	22B15	72					*	*				*		
	10B17	56								*	*		*	
Warm off-white subgroup														
	08B15	72						*		*	*	*		
	10C31	72						*		*	*	*		
Cream subgroup														
	08C31	72					*	*		*	*			
	04B15	76								*	*			
Grey group														
Light	10A03	56				*	*	*		*	*	*	*	
			02A03	56						*	*			
			00A03	56						*	*		*	
			00A01	67			*	*	*	*	*	*	*	
			06A03	56			*	*						
Medium	10A07	30					*	*	*	*	*		*	
			00A05	42			*	*	*	*			*	
			10A05	42						*	*	*	*	
			06A07	30								*	*	
Dark	10A11	12							*	*	*		*	*
	00A13	6									*			
	00A09	20					*	*						

(Table 16.1 concluded)

1	2	3	4	5	6	7	8	9	10	11	12	13	14	15
Grey tints group														
Green	10B17	56					*	*		*	*			
Brown			08B27	30			*	*						
	04B21	30						*						
Blue	22B17	56									*			
Yellow														
	10B21	30								*	*			

17 Colour trends

17.1 About trends

There is overwhelming evidence from research and from sales returns that the average purchaser of any product is influenced by those broad trends of consumer preference for colour which are current at the time the purchase is made. Any manufacturer who wishes to achieve maximum sales must ensure that these trends are reflected in the colour or colours offered, and this maxim applies whatever the nature of the product and whether it is a considered purchase or an impulse buy. It also applies to the promotion of the product, and the influence of trends extends in unexpected directions, even to roses; one store reported that a customer brought in a yellow toilet roll in the latest trend colour and asked for a dress in the same shade.

The reason for the importance of trends may simply be summed up in the one world *people*. No matter what the product is, it is sold to the same people, and it is their likes and dislikes which decide which colours are chosen and which colours will attract attention in promotion; in other words, their likes and dislikes decide whether the product will sell or not.

Although every individual has his or her own personal preferences, the same individuals are influenced by what is going on around them; by what is recommended in the press, particularly the womens' press, and other organs of communication; and by what other people are doing. At any given time there are certain basic trends that affect all consumer purchases, and there is often one basic hue which will be seen everywhere in products of all kinds bought by everybody. These trends are particularly important in products bought for use in the home, although the popular hue may not be bought for every part of the home at one and the same time.

The reason why there are trends and why people conform and buy the same colours as everyone else is really quite simple. It is because a desire for change is a basic human motivation and a desire for change forces a natural progression. Another reason for conformity is that people distrust their own judgement and therefore tend to do what everyone else is doing. Some designers and stylists believe that it is their function to provide leadership and dictate what the consumer should buy, but this is seldom very successful in

commercial terms because people as a whole cannot be pushed too far. They prefer to conform – within reason.

It is almost impossible to force a trend, and people will only take up a new colour when it fits into the natural progression from one hue to another. It is very difficult to influence a trend by, say, press promotion, and there are certainly no journals in the UK with sufficient circulation and influence to do so. Even the large-circulation journals in the United States, which have a great deal of influence on consumer trends and tastes, would find it very difficult to force consumers to accept colours when they were not ready to do so. However, people are undoubtedly influenced by what the press recommends, provided that the recommendation is not too far out of the mainstream.

A liking for change can be traced back to prehistoric times when early man painted and decorated his caves and no doubt changed the decoration periodically. However, his ability to make change was limited, and the mass market of today is able to exercise choice in a way that would have been unthinkable in an earlier generation. The higher standards of living of today permit a large proportion of the population to make changes; they can afford change and they can afford to make changes more often.

The reasons given in the previous paragraph indicate why colour has become so much more important as a factor in sales in modern times. There are other reasons for its importance, including the discovery of better and cheaper dyes and pigments and therefore better and cheaper colour; also the fact that mass methods of communication are able to influence the thoughts and feelings of more people.

The desire for change shows up most strongly in the home. People get tired of the decor of their homes and feel that they are in a rut; by changing the colour of the walls, of the furnishings, of the carpet, they seek uplift and a fresh start. Many women feel a certain restlessness in spring which drives them to clean their homes, buy new curtains and decorate everything in sight. When people feel the need for change, they consult their friends, notice what the neighbours are doing, seek help and guidance from any source that is open to them, and read press recommendations. Consequently the great majority go in the same direction and tend to choose the same colours.

All this boils down to a colour trend and it spills over into all areas where colour is used. People want to see something fresh, and they are not impressed by last year's colours, even though they may try to match what they already have. The pace of change is slow and progressive, and it is not necessary to change colours every few months, but any colours for sale must be updated periodically. Colour trends move quite definitely, but they move slowly and the reason for this is largely economic. When people buy new furnishings and the like they seldom buy the same colour a second time.

The first purchase of any product is based on need and the colour will probably be chosen simply because it is available or because it is what everyone else is buying. When second or subsequent purchases are made much more care is taken over choice; careful consideration will be given to the choice, and while the purchasers will not buy the same colour again – because they want change – they will choose colours to tone with or match what they already have. They will seldom be able to afford to change everything at once, and consequently

there is very rarely a radical change.

The result of all this is that there is a slow shift from one colour to another, and the shift moves in a progressive way from, say, orange to brown, to red, to violet, to blue, to green, to yellow and then back again to orange. In practice, colour trends move in cycles of about ten years. The movement, or shift, is seldom quite as simple as this sequence suggests, and there are often twists and turns, and sometimes extraneous factors introduce complications into a natural progression. There might, for example, be a shift from brown to green because these two colours go particularly well together – they are the colours of nature.

The beginning of a shift, or a change in emphasis, will often first show up in the sales of a few market leaders of which decorative paints are the most important. Trends tend to move more quickly in higher-grade markets, where thre is greater pressure for something new.

Although it is difficult to say that trends start at any one point, some trends start with the introduction of a new pigment which makes possible hues that have not hitherto been available, but this is rare. A more common influence on trends is high fashion, a market in which colour is promoted by clothing manufacturers. Some of the colours promoted 'catch on' and eventually reach the mass market, but they will only do so if the market is ready for them. Out of a dozen shades promoted by clothing manufacturers, only one or two will find their way into mass markets and to acceptance in the home.

17.2 The nature of trends

There are a number of different types of trend. For example:

- trends of consumer preference for colour in the home
- trends of consumer preference for colour generally
- trends of consumer preference for colour in womens' and mens' clothing
- trends in interior decoration
- trends in pattern
- trends in colour usage in the office
- trends of colour in architectural usage.

There are other trends as well, but it is the first two that are important in the present context because they reflect the wants and desires of ordinary people and influence everything that they do. There is usually some relationship between all trends because the same people are concerned; trends in clothing, interior decoration and pattern tend to influence the trends relating to the home, but it is the latter that are dominant for the reasons discussed in 17.1 above, and they influence colour choice generally.

Trends in interior decoration and trends in pattern may also be influenced by colour trends in the home, but there are sometimes trends in interior decoration, such as a liking for natural materials, which have an effect on colour usage generally. It is difficult to generalise about this, but the situation needs to be watched and assessed.

As already mentioned, trends of colour in womens' clothing sometimes affect trends in the home, and those concerned with forecasting colour are ad-

vised to watch colour trends in high-fashion markets and to screen out those colours that seem likely to 'catch on' and influence trends in the home. It is very desirable to draw a distinction between fashion in the clothing sense and '-fashion' in the colour sense. A fashionable colour for products used in the home is not necessarily the same as a fashionable clothing colour.

At any given time there is usually one dominant trend colour which is not only popular in the home in its many variations but which is also popular for products used outside the home and which is safe for use with almost any product, particularly those sold in one colour only. However, there is seldom any overall trend relating to the home as a whole, because trends tend to move differently in different parts of the home. At one time there were two distinct avenues of approach to colour, the one covering hard goods such as paint, wall-coverings and housewares, the other covering soft goods such as textiles, carpets and furnishings generally. In recent times this distinction has become blurred, and it is where the product is used in the home that is significant in colour selection.

A colour variation that might be popular in the living room might not be acceptable for the kitchen, but the difference is often one of timing. For example, colours chosen for products used in the kitchen are dominated by the colour of the kitchen unit, which is unlikely to be changed so frequently as the furnishings in the living room. However, there is usually some relationship between all the strand in the web, although the differences complicate the process of colour selection.

These differences are illustrated by the following examples:

Example 1 A few years ago green was fatal to the sale of kitchen utensils, although extremely popular for carpets and textiles. Later, avocado became popular for kitchens, and for kitchen utensils, and eventually gained acceptance in every part of the home, but it was popular for kitchen use some years before it became acceptable in the bathroom.

Example 2 Blue is particularly popular for the kitchen, but less so in other parts of the home, despite the fact that blue, as a colour, is better liked in the home in the UK than in most other parts of the world. Over the years blue will sell in almost any product, but it is seldom popular in the whole house at one and the same time.

Most people talking about colour trends are thinking in terms of the living room and may have to make a positive shift in thinking when considering other areas. In recent years trends have become much more important in the bedroom and bathroom, and where the product is used is therefore a significant factor. There are sometimes traditions and prejudices relating to specific parts of the home, and while these need to be identified, if they exist, they tend to be less important than they used to be because of the influence of mass methods of communication. Regional colour trends are also sometimes noted, but they are becoming less important for the same reasons.

The difference between trends in various parts of the home applies particularly to UK markets, where practices and preferences differ from those in other parts of the world. This is partly due to geographical location and climatic con-

ditions and partly to the fact that the British, as a nation, are less conformist than some other nationalities. The British are apt to seek stability rather than status, although status cannot be ruled out altogether. In the United States, on the other hand, status is all-important, and everyone tends to choose the same colours for everything in the home at one and the same time. The popular trend colour of the day will be equally in demand for refrigerators, bath mats, bedroom carpets, kitchen sinks and upholstered furniture. Colour is often used in the United States to force obsolescence to a degree which would not be acceptable to British customers.

17.3 Outside the home

Trends of consumer preference for colour represent what people like in their homes, and it follows that the same people will look for trend colours in the other things that they buy, and they will be influenced by trends when colour is used for visual or functional purposes.

Whatever it is that is being bought or promoted, the people who have to be attracted are the same, and their wishes have to be gratified if maximum sales are to be achieved. When selecting hues for any application of colour it is sound practice to select a variation which is popular by the standards set by consumer preferences in the home. A hue which is popular or fashionable will have more emotional appeal than one that is not, and the fashionable hue will attract more attention. A variation chosen at random from one standard colour range may be obsolete and do more harm than good. Consumers are hardly likely to get excited over a colour which was selected ten years ago, whatever the application.

Similar remarks apply to colours used for advertising and promotion. If people like a colour sufficiently well to purchase it for use in their own homes, they will also like it when they see it in print, on a poster or in a display. The same people are involved at all stages. A package, a tag, a business form or a mailing shot should have emotional appeal as well as being correct in terms of vision and colour associations. The ideal exists where colour does its job efficiently in a visual way and pleasantly in an emotional way at one and the same time. No matter what the product, it is sold to the same people, and if people like the colour of the product, it is more likely to be noticed, and the message is more likely to be read, where the colour is used in the press, or on television, or in a mailing shot.

17.4 Overseas influences

Broadly speaking, trends are peculiar to the country in which they originate, and the trends applicable to each country should be considered separately because each country has its own usages and practices, although the broad principles of colour choice are similar in most countries.

Attempts are often made to select a colour, or a range of colours, suitable for all European countries, and in practice it is sometimes possible to combine all

the various influences, especially since Britain joined the Common Market, but there is no such thing as a European trend colour which applies to all parts of the home. Nowadays, continental ideas influence the British consumer to a much greater extent than in the past, and at various times the British have been influenced by the Scandinavian look, by the Italian look and by the French look, although these are more differences in style or design than differences in colour.

The use of wallpaper and fabrics and the shape and design of furniture distinguishes a national style much more than colour. Continental manufacturers are active in the British market and have introduced continental ideas and colours with some success. So far there has been little evidence of any move in the reverse direction, except, perhaps, in furnishing fabrics, where the 'English look' has had some success.

Generally speaking, Europeans prefer brighter and stronger colours than the British, especially in southern European countries, and there are also differences in practice in various parts of the home. Germans tend to like solid wood kitchens, for example, often in dark colours, while Scandinavians prefer lighter colours. These differences need to be taken into account when selecting a European colour range.

When selecting colours for the British market it is desirable to review practice and usage applicable to the product in major European countries and also to study colour trends in those countries because of their possible influence on the British consumer.

In the past, manufacturers have often followed American colour trends, but such a course needs caution. Although British and American trends often coincide, at other times they follow quite different paths. In the United States there is normally a marked trend colour which will be found in every part of the home from the kitchen sink to the bedroom carpet, but this does not happen in Europe. Europeans are much less conformist, and the British are now influenced more strongly by Europe than by America. It is worth noting that American style and design is quite cosmopolitan and reflects British, French and Oriental influences, together with a strong craft flavour.

17.5 Variations of hue

Trends do not only apply to primary colours. There are also related trends which dictate whether people want bright, muted or pastel variations of the primary colours. These related trends move quite independently so that if, say, a muted green is popular now, a pastel green may be wanted when green picks up again in the future. Given that colour trends move in cycles of about ten years, a colour which is at peak demand now will begin to lose favour over the next few years and then begin to pick up strength again – but it is most unlikely that the same variation will be wanted in ten years time.

It follows that the shade, tint or tone of a hue may be just as important as the hue itself. Thus, if the chosen hue is red, selected perhaps because of its optimum visibility, select that variation of red which best reflects current preferences; at any given time a bright red may be preferred to a dull red, or a red

with a yellow bias may be preferred to a red with a blue bias.

Red is a particularly good example because it has so many attributes in promotional applications, and it is also a colour where preferences for shade change quite frequently. Use of an up-to-date variation ensures competitive advantage. People are always attracted to red because of its psychological and physiological attributes, but they will be even more attracted by the variation that they prefer to use in their own homes. Although these remarks apply with special emphasis to red, they apply equally to all other colours. Red is a particularly good colour to use for selling applications, but it cannot be used for ever; this applies to any colour whether used in the home, outside the home or for promotional purposes.

Overall colour trends in the home have an effect on the variation of basic hue that is preferred; thus, although customers may choose red because it is the most suitable colour for their purpose, they will choose that variation of red which is popular by current trends.

17.6 Identifying trends

It is little use asking people what colours they would like, because the opinions expressed will be pretty valueless from a sales point of view. An opinion expressed in a poll taken today will not be reflected in action taken at point of sale in, say, six months time, because by that time opinions may have changed, and in any case, opinions expressed in a poll reflect what people *like* and not necessarily what they will *buy*. At point of purchase the average person is motivated by many considerations, such as economy, matching the curtains, what is practical with children in the home and so on.

Moreover, people are influenced, often unconsciously, by the trends that are current at the time that they make the purchase. Even when making an impulse purchase they will be influenced by the dominant trend colour, and when making a considered purchase for the home, the influence will be even more specific. Remember also that variations of hue may be just as important as primary hues; it is difficult to include all possible variations in a poll.

It follows that a manufacturer who wishes to achieve maximum sales must find a method of identifying those hues, and variations of hue, that the average customer is likely to prefer at the time that the product will be on sale and for as long as it remains on sale without colour change. This period may be as long as two years, and therefore the manufacturer not only has to identify current trends but also to forecast the future. The manufacturer must also, incidentally, endeavour to identify factors other than colour trends which are likely to influence the choice of the consumer. For example, the nature and usage of the product may be such that people prefer colours that do not show dirt.

The process of colour research which will solve this difficulty is complex, and it involves market analysis as well as collection of data about the movement of colour; it also requires plain common sense. The fact that the product may have a lead time of up to a year, quite apart from the time that it remains on sale, adds to the difficulty, and there is no easy answer.

Forecasting colour trends is an art and not a science; trends cannot be accurately assessed by analysis of past sales, nor by mathematical projection. In theory it should be possible to use a computer to forecast colour trends, but in practice it would be necessary to program the computer with factors which are not readily available and which cannot be calculated in advance. The art of forecasting is to collect together as much information about colour as possible; to watch what is happening in the world of womens' fashions; to analyse the recommendations made by the press; to watch what advertisers are doing; and to make studies of specific situations. The more information that is available, the more accurate predictions can be.

The forecaster has to watch overall colour movement, including the movement of demand for:

- primary hues
- variations of hue, for example bright, muted, pastel
- colour in various parts of the home.

Other movements to be watched include:

- the movement of trends in markets; for example, trends tend to move faster in higher-grade markets than in mass markets
- any overseas influences there may be
- the broad direction of trends.

All the data has to be collected together, interpreted and then applied to a specific product and its market conditions. The forecaster is required to make an assessment of future consumer requirements for a period, which depends on the lead time of the product and on the length of time that the colour or range of colours will remain on the market. It is usually possible to forecast colour trends with reasonable accuracy up to about two years ahead.

17.7 Subdivisions of the spectrum

In order to record the movement of trends and forecast the future, some suitable method of defining colour is essential. Defining colour always presents considerable difficulty, as explained in section 12 earlier, and the name of the colour is no guide. The subdivisions of the spectrum that follow have been devised to solve the problem of identifying hues and variations for colour research purposes. The colour names are descriptive only and in no sense standards, they are simply intended to help in identifying and explaining the various subdivisions. No special virtue is claimed for this method of classification other than one of convenience, and it derives from experience in the recording of trends. It will be noted, for example, that hues have been divided into light, medium and dark versions because it is important to record movements from light to dark. Clear variations have been separated from muted variations in some instances; in other cases warm variations have been separated from cool variations; and variations with a blue bias have been separated from variations with a yellow bias; pink has been treated as a separate hue. These subdivisions have been found to be important in the recording and forecasting of trends.

The subdivisions of each hue into light, medium and dark variations are arbitrary, but a convenient way of making the division is to base it on reflectance values:

- Light Reflectance value 50–70 per cent
- Medium 25–50 per cent
- Dark 5–25 per cent

The groups have been divided into two parts:

- A Basic hues
- B Other groups

A word of explanation about the other groups may be useful. Grey tints are very pale colours with a hint of grey; they might be classified with the muted versions of the basic hues, but experience has shown that a separate heading is useful. Tinted whites are a category that has come to the fore in the 1980s, and they have proved extremely popular as an alternative to white or off-white; they are basically white with a hint of other hues.

Miscellaneous groups have been chosen arbitrarily and can be added to as desired. They reflect the need to record broad movements. At any given time there may be a trend in favour of, say, natural materials; at other times Berber shades have been very popular in textiles. Such movements are worth recording.

Categories This group makes provision for recording the movements of categories of colour. Irrespective of hue, there is often a trend to pastels or to neutrals or to bright colours, and these movements are important because they reflect the preferred colours of all products.

Woodgrains The trend to light or dark woodgrains need only be recorded in appropriate cases, for example in connection with furniture.

Pattern There is a relationship between pattern trends and colour trends, and when machinery is set to collect information about colour, it will often be useful to record pattern trends at the same time where the nature of the product justifies it.

Part A *Basic hues*

Violet group	Light	Blue type	Lilac
		Red type	Heather
	Medium	Blue type	Mauve
		Red type	
	Dark	Blue type	Purple
		Red type	
Clear blue group	Light		Pastel, kingfisher
	Medium		Summer, mallard
	Dark		Midnight, navy
Muted blue group	Light		Steel
	Medium		Saxe, wedgwood
	Dark		Slate

Blue-green group	Light		Aqua
	Medium		Turquoise
	Dark		Petrol, ming blue
Clear green group	Light	Blue type	Porcelain
		Yellow type	Pastel
	Medium	Blue type	Apple
		Yellow type	Lime, emerald
	Dark	Blue type	Bottle
		Yellow type	Grass
Muted green group	Light	Blue type	Opaline
		Yellow type	Sage
	Medium	Blue type	Quartz
		Yellow type	Olive, jade
	Dark	Blue type	Forest, fir
		Yellow type	Georgian
Clear yellow group	Light		Lemon, primrose
	Medium		Sunshine, gold, amber
	Dark		Maize, saffron
Muted yellow group	Light		Topaz, sand
	Medium		Gold, mustard
	Dark		Antique gold
Orange group	Light		Orange
	Medium		Tangerine
	Dark		Burnt orange
Brown group	Light		Beige, fawn, buff
	Medium		Copper, tan
	Dark		Saddle, chocolate, coffee
Red group	Light	Warm type	Pink (see also below)
		Cool type	Rose pink
	Medium	Warm type	Coral, flame, terracotta
		Cool type	Rose, claret
	Dark	Warm type	Scarlet, tango, cherry
		Cool type	Magenta, aubergine
Pink group	Light	Orange type	Pastel pink, peach
		Mauve type	
	Medium	Orange type	Coral pink
		Mauve type	Orchid
	Dark	Orange type	Flame pink
		Mauve type	
White			
Off-white group	Generally		All off whites
		Cool type	Ivory, parchment
		Warm type	Magnolia
		Cream type	Regency cream
Grey group	Light		Pearl, dawn, oyster
	Medium		Silver
	Dark		Charcoal
Black			

Part B Other groups

Grey tints group	Brown type	Mushroom, stone
	Yellow type	Champagne
	Green type	Mistletoe
	Blue type	Dove
Tinted whites group	Blue type	
	Green type	
	Yellow type	
	Brown type	
	Pink type	
Miscellaneous group	Brownish reds	
	Berber shades	
	Natural materials	
	Sophisticated colours	
	Other	
Categories	Hard colours	
	Soft colours	
	Bright colours	
	Muted colours	
	Light (pale) colours	
	Medium colours	
	Dark colours	
	Pure hues	
	Modified hues	
	Neutrals	
	Strong colours	
	Pastels	
	Deep colours	
	Comments	
Woodgrains	Light	
	Medium	
	Dark	
	Yellow	
	Silver	
	Other	
Patterns	Abstract	
	Geometric	
	Close	
	Florals	
	Chintz	
	Large scale	
	Stripes	
Texture	Comments	

17.8 Assessing trends

An assessment of trends of consumer preference for colour is an essential part of the colour selection process for any product, but where trends are a vital factor in sales, as they are with most products for the home, a more elaborate and reliable method of finding, recording and forecasting trends is necessary, and the construction of a suitable chart is recommended.

The chart must embrace the whole spectrum of colour as defined in 17.7 above, and it must record the relative strengths of each subdivision of the spectrum and any other useful movements. A chart should be constructed for each product at the time that colour selection is made, although, once constructed, it is relatively easy to keep up to date. It should record the demand for colour in all those areas of colour usage which have an influence on the colour choice of the consumer for the product concerned. Identification of these areas and their relative importance is a vital part of the colour research process and before constructing a chart, it is necessary to establish, in respect of each product:

- how, and where, the product is used; this should be clearly identified
- those parts of the home in which the product is used; trends of preference in the appropriate parts must be recorded
- the related products which may influence the purchaser; sales by colour of these products must be recorded
- market influences; as far as possible, movements of colour in the market in which the product sells should be recorded
- any other influences that may affect colour choice; for example, trends in interior decoration may be usefully recorded (these influences have to be established in each case)
- overseas influences; record these if significant.

The recording should cover a reasonable past period, say five years, because past sales are, or may be, an important influence on demand for colour and will help to show up the colours that are declining. It may be desirable to cover an even longer period when the product is a lead product which sets a trend, as distinct from a subsidiary product which follows a trend set by something else.

The aim of the chart is to identify, in each area of colour usage:

- the important trend colours
- current best sellers
- declining colours that are likely to be poor sellers in the future
- up-and-coming colours, likely to be wanted in the future.

It will be appreciated that steps must be taken to obtain the required information, and suitable sources of data must be set up; the more data that is available, the more valuable the chart will be. Where sales figures by colour are available they will be most valuable, but in other cases assessments must be made on the basis of the best available data. Collection of data is a matter for the individual responsible and the success of the process depends on his or her skill and application. It would be ideal to record demand in each subdivision of hue, but this may not always be practicable; there may be no data available.

Example 1 A chart constructed for a product used in the living room would record information in the following areas of colour usage which research has shown to be influential:

- general tendencies in decorative paints
- tendencies in interiors generally
- trends in furnishing fabrics
- trends in carpets
- trends in upholstered furniture.

Completion of the chart should make it possible to grade each colour group, and each subdivision of the colour groups, for each year covered by the chart and for each of the areas of colour usage included. As far as possible each subdivision should be graded:

- strong trend colour
- strong trend colour, but for the future
- strong seller
- strong seller but declining
- reasonable seller and recommended
- some demand
- declining
- poor seller.

Similar charts can be constructed for any part of the home and for any type of product.

When the grading is complete it is possible to make an analysis and assessment of the whole and to interpret all the information available. This requires experience, and the value of the results largely depends on the skill of the individual operator. The main objective is a forecast of the future direction of trends, and this is almost entirely dependent on skill and experience.

The analysis should include an assessment of those colours that are declining and a reading of the way that trends seem to be moving at the time that the chart is constructed. The result should be a rating for each colour group, and preferably for each subdivision, as follows:

- trend colour – most desirable
- strongly recommended
- less important colours
- colours that can be eliminated.

The fact that a colour is rated as a strong trend colour, or the reverse, does not necessarily mean that that colour must be included in, or excluded from, a range. There may be other good reasons for selecting a colour, for example for good marketing reasons or to provide a balanced choice.

Example 2 A typical chart for upholstered furniture indicated that purple was recommended for interiors in 1969, and also for carpets and furnishing fabrics. It was a trend colour for decorative paints in 1970 and recommended for interiors generally. In 1971 it was still a trend colour in paints and for interiors; it was strongly recommended for furnishing fabrics and featured at ex-

hibitions. By 1973 there were signs that it was less strong, although lilacs were a strong trend in paints. The conclusion reached in 1973, from an assessment of all the information available, was that purple was not a good colour to recommend for the future, especially as experience has shown that purple is a colour that reaches a peak very quickly and then drops off again just as quickly. This conclusion was proved correct by events.

It will be appreciated that a good deal of work is involved in this operation, but there is no short cut if trends are to be given the importance that they warrant. The most difficult part is locating and setting up sources of information; once this has been done, the rest is relatively routine.

The actual form that the chart takes is a matter for the individual responsible; it need not be elaborate so long as it sets out all the available data in a form from which an assessment can be made.

18 Colour pointers

18.1 General rules

In any situation involving the selection of colours for a specific purpose there are a number of points of a general nature that are worth bearing in mind. These rules apply to all applications of colour and cannot be classified under any individual heading.

- Simplicity of colour is always best.
- Any colour should be easy to identify and not indefinite.
- Differences in brightness may be more important than differences in hue.
- The eye can become tired of a dominating hue.
- Colours show up better when represented by a shape or a figure.
- Always consider the possible effects of optical illusion.
- Gloss livens up a dull colour.
- Tints, shades and tones tend to retire.
- Many colours tend to appear greyish when light levels are low.
- Colours will appear sharper and brighter at high light levels.
- People prefer lighter variations to darker ones.
- People prefer richer variations to neutrals.
- A lot of strong colours used together can be dazzling.
- When in doubt choose colours from the same family.
- The lavish use of colour requires a measure of restraint.
- The eye prefers simplicity in shape, as well as in colour.
- Contrasting colours raise eye interest; contrast produces a lively effect.
- If basic colours are modified towards white, or black, it is best to use precise steps rather than slight variations. This produces better contrast.
- Use a colour of high visibility on a neutral background.
- The right proportions of colour create a balanced design.
- Any colour looks lighter on a dark ground.
- Any colour looks darker on a light ground.
- Any colour looks greyer on an intense ground.
- Colour appearance changes according to the colour placed next to it.
- People as a whole prefer combinations based on red, blue and green.

- Colour dominates neutrality.
- Adjacent combinations based on cool colours are passive.
- Adjacent combinations based on intermediates are sophisticated.
- Adjacent combinations may include shades, tints or tones.
- Harmonies have a calming effect.
- Avoid sharp contrasts that are too marked.
- Outwardly integrated people prefer sharp contrasts.
- Contrasts have a visual quality rather than an emotional one.
- Complementary colours placed together will intensify both.
- Contrasts at full strength will create a bold, striking effect.
- Tints:
 - should be bright and clear
 - of all kinds harmonise with white
 - harmonise with black
 - of pure colours which are light in value (such as yellow), will harmonise with shades of pure colours which are dark in nature.
- Tones:
 - should be mellow and greyish
 - harmonise with black
 - harmonise with white
 - of all kinds, harmonise with grey.
- Shades:
 - should be rich and deep
 - harmonise with white
 - of all kinds harmonise with black.
- Hard colours:
 - make objects look nearer
 - have better visibility than soft colours because visibility depends on brightness differences between two colours irrespective of hue.
 - make an image look nearer to the eye
 - focus at a point behind the retina of the eye and thus bring colours forward
 - on a soft background are better than the reverse
 - dominate soft colours
 - tend to cancel out soft colours.
- Soft colours:
 - fade away into the background
 - focus at a point in front of the retina of the eye and make a colour look further away
 - are best as background because they are passive.
- Bright colours:
 - make objects look larger; brightness spreads out on the retina like water on blotting paper.
 - are preferred to deep colours because they afford greater stimulation to the retina of the eye.
 - are more visible against a neutral background than the reverse.
 - make an image look nearer to the eye, but avoid one dominant colour.

- will accentuate darkness because there is good contrast; the reverse also holds true.
- Muted colours:
 - make objects look smaller
 - can be depressing if they are too greyish.
- Dark colours:
 - tend to resemble each other at low light levels
 - are stimulated by light colours
 - look heavy
 - are accentuated by brightness; the reverse also holds true.
- Pure hues:
 - should be vivid and intense, not indefinite
 - with a touch of black or white they are not liked; better to turn them into positive shades or tints
 - have more appeal than muted hues; they stimulate the retina to a greater extent
 - look light in weight
 - tints and white harmonise
 - tones and greys harmonise
 - harmonise with black and white
 - harmonise with the tint of their complement
 - harmonise with tints on a grey background
 - harmonise with tints on a white background.
- Modified hues are not as well liked as pure colours; they may be depressing.
- Neutrals are best as background.
- Strong colours:
 - should usually be confined to small areas
 - look best when surrounded by large areas or shades, tints or tones.
- Pastels look larger than shades because they are brighter.
- Deep colours should be used in small doses, too much may be overpowering.

18.2 Picking out colours

There are certain axioms to remember when making a selection of colours:

- Choose colours in the light in which they will be seen in use.
- Always compare colour samples in both daylight and artificial light.
- The colour of a chip (e.g. of paint) is not usually a good illustration of how the colour will appear in bulk, as on a wall.
- Choose colours in a sequence from pale to dark; that is, choose the light colours first.
- Consider the lightfast qualities of hues. This is particularly important in any application where colours are exposed to daylight.
- Samples should be viewed in the plane in which they will be used; this applies particularly to carpets.

- A colour which looks right on a colour card will probably need a 50 per cent admixture with white to create the right effect on a wall.
- Bright colours seen on a paint chip will look much more intense when seen on a wall.
- Colours that are selected in a bright light will look different when seen in a dim light.

19 Colour definitions

Accommodation	The ability of the eye to focus on a particular object. The muscular adjustment of the lens of the eye so that the image on the retina is sharp and the eyes converge so that the two images are merged on the brain. It also includes the opening and closing of the iris according to the level of lighting.
Acuity	A measure of the accuracy of vision combined with the time taken to see accurately.
Adaptation	The change in the sensitivity of the eye caused by greater or lesser brightness. The eye adapts to the brightest object within the field of view.
Additive primaries	Blue, green and red. See Primary light colours, below.
Adjacents	Colours that are next to each other on the colour circle.
After-image	When an object of a specific colour is viewed for a period and the gaze is then shifted to another object there will be a momentary vision of the complement of the original colour because the receptors have become tired. For example, after looking at red there will be a sensation of green.
Autumn colours	Usually hue and black; browns and oranges are particularly associated with autumn.
Brightness	This is a term usually applied to the quantity or intensity of light. Colour is usually described in terms of lightness or value.
Bright colours	In effect, those that reflect most light. White, which reflects about 84 per cent of the light falling on it, is brighter than black, which reflects only about 5 per cent. Brightness is also governed by the nature of the surface. See also Value, below.
Brightness ratio	The ratio of task brightness to the brightness of the overall surround.

Candy colours	A mixture of pastels including, particularly, warm pastels such as pink, yellow and green.
Colour	The Optical Society of America defines colour as consisting of the characteristics of light other than spatial and temporal inhomogenities; light being that aspect of radiant energy of which a human observer is aware through the visual sensations which arise from the stimulation of the retina of the eye.
Chroma	That quality which expresses the strength or amount of hue in any colour; also called saturation or purity. A vivid red would be more saturated than a dark greyish red; a strong, bright, yellow would be more saturated than a tan.
Colour appearance	The colour that a light source, or a white surface seen by a light from that source, appears to be, and is usually expressed as cool, intermediate or warm.
Colour blindness	The inability of some individuals to distinguish colours; may be partial or total.
Colour constancy	The ability of the eye and the brain to 'remember' colours and to see the same colour qualities under widely different light conditions.
Colour rendering	The accuracy with which a given light source reveals colour; it is different from colour appearance.
Complement	Colours that are opposite to each other on the colour circle. Also called contrasts or opposites.
Contrasts	The same as complements.
Contrast ratio	The same as brightness ratio.
Cool colours	Violet, blue, green. Focus at a point in front of the retina of the eye; retiring, not inviting to the viewer.
Dark colours	Generally those having a reflectance of below 25 per cent.
Deep colours	Generally those having maximum saturation.
Direct glare	See Glare, below.
Disability glare	See Glare, below.
Discomfort glare	See Glare, below.
Film colours	Colours like those seen in the sky.
Foot candles or foot lamberts	See Lumens, below.
Glare	Excessive light striking the eye and making it difficult to see. Direct glare arises directly from light fittings; disability glare is excessive light entering the eye from objects within the field of view and including specular reflections; discomfort glare arises from excessive contrast between the light source, or its reflected image, and the surroundings.

Greyed colours	Any pure colour with an admixture of grey; the same as tones, used to limit brightness.
Greyness	The measure of difference between black and white; usually divided into ten steps.
Hard colours	See Warm colours, below.
Hue	The quality which distinguishes one colour from another, for example red from yellow, green from orange, and so on.
Illuminance	The amount of light falling on a surface, measured in lux.
Illusion	Modifying the appearance of a colour by the way that other colours are placed in relation to it; for example, the same colour will appear quite different when seen against different backgrounds.
Immediate surround	The immediate background to a work task as distinct from the overall surroundings.
Intermediates	Mixtures of pure colours lying next to each other on the colour circle, for example purple, blue-green, yellow-green.
Juxtaposition of colour	Altering colour appearance by light reflected from nearby coloured surfaces or objects.
Light	That aspect of radiant energy of which the human observer is aware through the visual sensations which arise from the stimulation of the retina of the eye.
Light colours	Generally those having a reflectance value of over 50 per cent.
Lumen	The measure of light, defined as the light given by one candle placed 12 inches away from the task.
Luminance	What the eye actually sees. In colour terms it is the amount of light reflected from a surface, that is its brightness or reflectance value.
Lux	Lumens per square metre; 10.764 lux equals one lumen. The usual European measure of light intensity.
Medium colours	Generally those having a reflectance value of between 25 and 50 per cent.
Metamerism	The impossibility of matching two objects or surfaces which have a different chemical composition.
Mixtures	Any mixture of pure colours, especially with black, white or grey.
Modified colours	Mixtures of primary colours not lying next to each other on the colour circle, for example mixtures of hard and soft colours and those having an element of grey such as mustard, orchid, wedgwood blue. Less impact than pure colours.
Muted colours	Those with a substantial proportion of black or grey.

Natural colours	The colours of natural objects such as bricks, straw and so on.
Neutrals	Imprecise term but generally means paler shades such as grey, off-white and beige which will harmonise with all other colours and which will not modify stronger colours except by contrast.
Opposites	Same as complements.
Pale colours	Difficult to define exactly. In theory it means colours having a low chroma or value, but in practice it is often used to describe tints with a large proportion of white. Not necessarily the same as light colours, although most pale colours will have a high reflectance value.
Pastels	Tints with a large proportion of white. See also candy colours.
Peasant colours	Mainly pure hues.
Perception	The interpretation that the viewer places on any colour; colour may be a perception that exists only in the mind.
Primary colours	Violet, blue, green, yellow, orange, red. These are the constituent parts of light when it is broken down by a prism. In practice the term also includes black, white and grey.
Primary light colours	Blue, green, red. These are the colours identified by the receptors of the eye. To perceive all other colours the brain mixes these three. Also known as additive primaries.
Primary pigment colours	Yellow, magenta, cyan (turquoise) and black. The so-called process colours used in printing and obtained by filtering out the primary light colours.
Process colours	See primary pigment colours.
Psychological primaries	Red, yellow, green, blue. When mixed they produce grey.
Pure colours	Strictly speaking the central portion of each waveback of the primary colours (see above), but in practice the term also includes mixtures of primary colours without the admixture of any white, black or grey.
Purity	See Chroma, above.
Receptors	The cells on the retina of the eye which are sensitive to blue, green and red and which 'see' colour.
Reflectance	See Luminance, above.
Reflectance value	The percentage of the light falling on any object or surface which is reflected back by that object or surface. In formal terms it is reflected light divided by incident light but varies according to light source and the nature of the reflecting surfaces.
Reflected colours	Colours which derive from light reflected from a

	coloured object or surface, as distinct from light which enters the eye directly from the light source.
Saturation	See Chroma, above.
Secondary colours	Primary colours mixed with white, grey or black, that is tints, shades and tones.
Shades	Pure colours mixed with black; often used to describe all variations of pure hues.
Simultaneous colour contrast	A situation that occurs when there are two different light sources within the field of view, each having a different spectral composition. The second source appears to be tinted.
Soft colours	See Cool colours, above.
Spectrum	The whole band of visible light, that is all colours.
Spectral distribution	The spectral distribution curve of any light source is the most complete description of its colour appearance and colour-rendering qualities. Lamps with different curves will have different colour-rendering qualities when the light is reflected from a coloured object.
Specular reflection	Reflection of light from shiny objects within the field of view, for example from a mirror or polished surface.
Spring colours	Usually hue and white but particularly greens and yellows.
Strong colours	An imprecise term which usually means colours of good chroma and value which have good impact. The opposite of neutrals.
Subtractive primaries	Violet, yellow, orange. Produced by mixing. See also Primary light colours, above.
Successive colour contrast	Occurs when the viewer moves from an environment lit by one light source to an environment lit by a light source of a different type. The second source appears momentarily tinted until the eye re-adapts itself.
Surface colours	The colour of objects.
Tints	Pure hues mixed with white.
Tones	Pure hues mixed with grey.
Tri-stimulus values	The proportions of primary light colours that need to be mixed to obtain a given colour. Measured by means of a spectrophotometer and expressed in terms of x, y and z values.
Value	The brightness of a colour measured in relation to a series of greys ranging from white to black in ten steps.
Volume colours	Colours that have three-dimensional boundaries.
Warm colours	Yellow, orange, red. Focus at a point behind the retina of the eye. Impulse colours, inviting.
Weight	Generally means the strength of hue in any colour.

20 Colour and light characteristics: Index

In the preceding Sections reference has been made to a number of light characteristics, colour modifiers, colour attributes, colour applications, colour usage and colour functions, and these are described more fully in separate subsections. To facilitate reference to these details, the following is a list of all the references in alphabetical order, showing the section in which the details will be found. Cross-references are also provided.

Part II

PRINCIPLES OF COLOUR SELECTION

1 Introduction to Part II

This part of the book provides a guide to the principles governing selection of colour for the major commercial and industrial uses of colour, which divide up into broad categories as follows:

- productive environments
- selling environments
- promotional material
- consumer products
- industrial products.

A sixth category, institutional environments, has been mentioned in earlier sections, but this category does not lend itself to a summary of principles in the same way as the other types of environment. Institutional environments need individual attention, but a reference to suitable colours has been included in Section 16 of Part I.

The plan is to show how the data about light and colour set out in Part I can be applied to practical use in each of the categories listed above. Colour should never be used solely for the sake of colour; it should be used for good reasons, and the guidelines formulated provide a starting point for doing just that.

It should be made clear that the broad categories can be subdivided as indicated below. Further study of these subdivisions will be required when selecting colours for an individual situation (e.g. for an office, for a shop, for packaging, for the kitchen or for a machine) and the pages that follow set out the basic principles to be applied to the individual subdivision.

Sections 2 to 16 in this part are concerned with choice of colour for environments and the application of the principles of functional colour (see Section 16 of Part I). The sections dealing with productive environments apply to those situations where colour is used to achieve efficient and profitable working conditions. This category may be further subdivided into:

- Factories and industrial plants generally
- Offices, including banks, government offices and the like.

The sections dealing with selling environments apply to those situations which are designed to attract the public and ensure the sale of merchandise, and the category may be subdivided into:

- catering, including restaurants, hotels and canteens
- shops, and retail establishments other than catering.

Sections 17 to 25 in this part suggest ways in which colour can be used to maximum effect for promotional material, and they outline the broad principles involved in finding the right hues. This category can be subdivided into:

- packaging
- print generally
- images (corporate image and brand image)
- vehicle liveries.

Sections 26 to 33 in this part provide guidelines for the selection of colour for products which are sold to the ordinary man or woman in the street, particularly for use in the home. This is arguably the most important category of all because colour plays such a vital part in the sale of consumer products. This category may be subdivided into:

- Bathroom products
- Bedroom products
- Domestic appliances
- Housewares
- Kitchen products
- Living room products

- Window decoration products
- Floor coverings
- Wall coverings
- Surface coverings
- Personal products (e.g. shavers)
- Leisure products

The final sections in this part provide information about the selection of colours for industrial products generally, and the category may be subdivided into:

- contract furniture
- surface coverings for contract use
- wall coverings for contract use
- floor coverings for contract use
- office supplies
- paper and board
- plastic sheet.

2 About productive environments

By definition a productive environment is designed to achieve efficient and profitable working conditions and is applicable to factories, offices and the like; the principal function of colour is to help create the ideal environment. Before discussing how colour can help to perform this function it is necessary to define the ideal environment which must be efficient, pleasing, safe, profitable and practical at one and the same time.

Colour is not the only factor in achieving the ideal environment; other factors include light, heat, ventilation, control of noise, suitable equipment, the building itself, and many others. However, this book is concerned with the two principal factors, the first of which is light; this is of primary importance and without it there can be no colour. The second is colour itself, which helps to control the light and ensure that it is used to maximum advantage.

No ideal environment can be achieved without good lighting, and the success of a lighting installation in a productive environment is measured by the degree to which the lighting enhances the performance of the task. Lighting must encourage work to be carried out efficiently and without strain and must be combined with a high standard of visual efficiency so that the task can be seen clearly and comfortably; this requires more than just adequate illumination. In broad terms, human vision is indifferent to degrees of light intensity, and overall fatigue is no worse under dim lighting than it is under brilliant light. What does cause trouble is difficulty in eye accommodation and unnecessary contrasts within the field of view.

In recent years workers have demanded more light, and better quality light, as part of an enhanced standard of living, and in many cases levels of light that were once considered adequate have trebled. Because of this, more attention must be paid to visual efficiency, including the use of colour in the overall surroundings, more pleasing surroundings, and other factors. In addition, workers demand more daylight, despite it being expensive in building terms, because they prefer to be in contact with natural forces. Attempts to persuade workers to accept working areas totally devoid of daylight have been unsuccessful. This feeling for visible contact with the world outside has little to do with the composition of daylight but is concerned with its availability. At the same time, people are not prepared to work in inadequate daylight.

Good lighting, and the level of light required, depends on what has to be seen, and it must be cost-effective. Light for the sake of light has little justification, and there is no point in having a higher light level than is necessary. At the same time, it is false economy to try to reduce energy costs by lowering lighting standards or by such measures as removing shades; this will create glare and reduce efficiency.

In seeking to achieve satisfactory visual conditions it is particularly important to note that light only has meaning in terms of materials, surfaces and objects which are visible; the colour of these surfaces or objects will control or modify the light. The lighting of any one area must be related to the overall design and decoration; the lighting of the overall surround is just as important as the lighting of a specific area or task.

Colour is an essential part of the ideal environment, and without it the most elaborate lighting installation is so much waste of money. The use of colour to achieve a satisfactory productive environment is the functional use of colour (defined in Section 16 in Part I), and it is profitable because it helps to increase efficiency and improve productivity; therefore it is of vital interest to management of all kinds. Consistent and inspired direction of the use of colour is a valid responsibility of management.

There are a number of objectives to be achieved if a satisfactory productive environment is to be produced, and the proper use of colour helps to achieve these objectives in four main ways:

- by ensuring that seeing conditions are satisfactory
- by ensuring that the surroundings are acceptable
- by ensuring that the surroundings contribute to well-being and morale
- by ensuring optimum economic benefits.

Colour is a specialised study involving knowledge of optics, physiology, psychology, medical science and other disciplines, and an average management cannot be expected to have knowledge of, or to study, these things for themselves. The advice of experts is desirable, and these will include lighting engineers and colour specialists, but it is hoped that these chapters may go a long way to solving the problems by providing suitable guidelines. A colour scheme is an expression of the total physical equation of light, space and surfaces; it is part and parcel of design and must relate to both structure and equipment.

3 The ideal productive environment

3.1 Good working conditions

The environment and its effect on the human beings who work in it, is one of the most important subjects of the day, and almost all authorities are agreed that a satisfactory working environment is conducive to better worker morale and better productivity, and therefore to increased efficiency and profitability. There is nothing new about improving the conditions of work people; one of the pioneers was Robert Owen of Lanark, who endeavoured to create the best possible working conditions for his employees in the 1820s. Today the establishment of good working conditions is accepted as part of the function of good management, and there is extensive legislation on the subject, such as the Health and Safety Act of 1974.

A good working environment makes work tasks easier, cuts down accidents and makes for economical operations. Good surroundings are profitable and not just purely decorative or part of the visual scene; the nature of the physical environment affects the mental attitude of people to their jobs. Bright, well-lit and well-planned surroundings make for brighter and happier staff and enhance efficiency; discomfort and poor working conditions make for restlessness and waste of time and lead to poor morale, excessive absenteeism and undue staff turnover, particularly on the part of female staff.

To achieve the lowest possible staff turnover, lower rates of absenteeism and higher quality of work, it is necessary to provide pleasant surroundings, convenient equipment and a well-designed environment which will encourage people to come to work for an organisation, encourage them to remain and encourage them to give of their best. In addition, the environment should be pleasing to outsiders, such as customers or visitors, and should enhance the image of the organisation.

The first essential in the productive environment is plenty of light and good seeing conditions that will avoid eyestrain and tiredness. Adequate light makes it possible for the worker to see the task and to carry it out with the minimum of fatigue and the maximum of efficiency; adverse seeing conditions, such as glare, must be eliminated. However, the efficient environment must also be pleasing and emotionally acceptable. Each feature of the environment should support the others; the whole involves careful planning of light and colour.

3.2 Good seeing

Good seeing conditions simply mean comfortable vision all day long and the avoidance of eyestrain, which is one of the commonest causes of ailments and of poor productivity. If it can be reduced to a minimum, there is an immediate benefit in happier, healthier workers and in increased output. Eyestrain is often caused by insufficient light, but it can also derive from a number of other conditions of which the following are typical:

- constant adjustments of the eye from light to dark
- disturbing brightness on the outer boundaries of vision
- excessive contrasts within the field of view
- continual shifts in adjustment from near to far
- glare
- prolonged convergence of the eye due to lack of areas for visual relaxation.

In order to understand this it is useful to know something about the mechanism of the eye. Eyestrain, or ocular fatigue, is muscular in nature; the muscles controlling the movements of the eye become overstrained usually because of efforts to accommodate the eye to adverse conditions. The automatic reaction of the eye is to widen the pupillary opening in dim light and to narrow it in brilliant light; this is a purely muscular reaction which may be most easily observed in the eyes of a cat. If there are excessive movements of this nature, the muscles become tired, with effects on the well-being of the individual.

In addition, the eye is quick to adjust itself to brightness but much slower in adjusting itself to dimness. Thus the eye will very quickly adapt itself to a bright wall, but the reverse action of adapting to darker machines or furniture is a much slower process. Until the eye is properly adjusted, the task cannot be focused clearly, and work and productivity suffer.

When there is excessive brightness, or glare, within the field of vision, the pupillary opening will contract, and the eye is deprived of sufficient light to see clearly, and this causes muscular and nervous tension. When there are excessive contrasts within the field of view (e.g. where the task is dark and the surroundings are too bright), there will be too many pupillary movements and efficiency will inevitably fall off. The reverse conditions, when the task is too bright in relation to the surround, is equally harmful. The ideal is where the brightness of the surround is very nearly equal to that of the task.

The process of vision is both neural and ocular in nature, and severe and prolonged use of the eye is no more harmful than severe and prolonged use of any other organ. The retina of the eye and the brain seem to be more or less immune to fatigue, but this does not apply to the muscles of the eye. It follows that excessive activity of the eye muscles tires them and affects other responses of the body; this excessive activity may be due to the conditions mentioned above or it may be due to continual shifts in adjustment from near to far, and this latter should be avoided as far as possible. When the eye is abused in the ways described, a number of adverse reactions can be noted and measured – for example, severe dilation of the pupil, higher rates of blinking, collapse of the nerves on the outer boundaries of the retina, increased muscular tension, ner-

vousness, fatigue, nausea and irritability.

The visual process is clearly connected with the responses of the body as a whole, and while the eye, as an organ, can stand a good deal of abuse, good seeing requires that the conditions that cause ocular fatigue should be avoided as far as it is possible to do so. Failure to remove these adverse conditions inevitably has an effect on morale and productivity.

Because the eye and the brain need time to see and to adjust to different levels of light, these latter must be held within the limits of reasonable eye adjustments or adaptation. Although good seeing depends on adequate light of the right quality, the light must be controlled, and this control is provided by the skilful use of colour. Good seeing conditions may be summarised as follows:

- adequate and well-planned light
- good brightness levels, but not in the wrong place
- good contrasts between work and background
- elimination of distraction and unnecessary contrasts
- elimination of glare
- areas to provide relief for the eye.

3.3 Controlling brightness

A major cause of trouble which makes for a less efficient environment is too much brightness, and this does not necessarily mean too much light. Brightness is explained in more detail in 9.5 of Part I, dealing with the use of colour for light control. Pronounced differences of brightness within the field of view cause some of the conditions outlined in the previous subsection and contribute to ocular inefficiency and fatigue. Brightness is a relative term and what constitutes too much brightness in a given environment depends on the nature of the task performed and on the objects within the field of view.

Where the light level overall is raised to the maximum necessary to ensure adequate illumination of the task, and if there is a good deal of white or light colour in the surround, the pupils of the eye will be restricted and may fog vision. In such cases it would be necessary to suppress the tone of the surround or to lower the overall light level and direct localised light on the task. If the task requires a high light level, the immediate surround to the task must also be suppressed in tone.

High brightness outside the immediate field of vision is always undesirable because the eye tends to focus automatically on the brightest object in the field of view; in other words, it adapts to the point of maximum brightness instead of to the task in hand. This tends to cause strain and nervous tension.

There is no such thing as too much light but there should be an even level of light to avoid unnecessary adjustments of the eye, and it is desirable that the levels should be the same in daylight and at night. Pools of darkness should be avoided. However, uniform brightness is almost impossible to achieve, nor would it be emotionally desirable. Theoretically, uniform levels of illumination and uniform brightness are ideal, but in practice, uniformity of stimulation is

inconsistent with the functioning of the human organism, which requires variety. People working in a monotonous environment for long periods lose their ability to respond. Some tasks are so monotonous that they require very little light, and in such cases workers would be stimulated by some brightness. Human sensations ebb and flow, and the eye is in a constant state of flux. While too much stimulation may be troublesome, unrelieved monotony is hardly any better.

The answer to the problem is to compromise, to use colour to control the brightness and to provide variety, taking care that the overall surroundings do not compete with the task and attract attention away from it. Brightness can be controlled by combining good lighting with colour of the right value, but there is no one answer to every problem and each situation must be considered individually. It is equally important to eliminate glare, which may be described as brightness in the wrong place.

3.4 Glare

It is very difficult to achieve good seeing conditions and an efficient environment without taking positive steps to eliminate glare; glare is very harmful to the human eye however it arises. It has the same adverse effects as the excessive brightness mentioned in the previous subsection but to a greater degree, and it may be more difficult to eliminate. Glare may be defined as excessive light relative to the brightness of the surround and to the state of adaptation of the eye at the time, and is more fully described in 3.7 in Part I, which also includes some suggestions for removing it.

3.5 The individual task

An efficient environment depends on the human eye and work must be properly seen if it is to be properly performed; comfortable vision involves the ability to see objects and distinguish detail at a distance of not less than 14 inches, and this requires adequate illumination together with contrast between work and background. A black object against a white background would be an ideal contrast but not comfortable for vision.

Every task requires a certain brightness so that the details can be seen clearly, and the level of illumination which will provide this is determined by:

- the speed, accuracy and direction of critical vision demanded by the nature of the work
- the characteristics of the task itself
- the level of brightness in the surround as a whole.

In the first case a high level of brightness is required when the task is visually exacting, but efficiency can be achieved at much lower levels when the task is visually simple. In general, high levels of light are required for critical seeing tasks because they promote rapid perception and reduce visual error, but such tasks may not always be improved by more light if it causes excessive eye movement.

In the second case the characteristics of the task (i.e. what the worker has to see) will dictate the amount of light required, and this, in turn, will depend on three factors:

- the size of detail
- the contrast of that detail
- the reflectivity of the workpiece.

The simple way to ensure adequate light is to set up the task and then to increase the light level until the task can be performed efficiently. If the object to be seen is very small, the level of illumination required will be quite high if the viewing distance is to be kept above 14 inches; if the light level is too low, the focusing of the eye will be affected and eyestrain and tiredness may result. In any case, the success of this strategy depends on the brightness of the surrounding surfaces.

Discomfort and glare may be caused if the immediate background to the task has a higher reflectance value (i.e. high brightness) than the task itself; it should preferably be lower than that of the task so that the eye has no difficulty in focusing on the brightest object in the field of view. This makes it easier to concentrate on detail, and even where a localised light source is used, as in the case of a critical seeing task, the background should be kept one or two steps below the actual work, and there should not be so much difference between the two that unnecessary eye adjustments become inevitable. The immediate background to the task should provide some contrast, but not too much.

Example 1 A typical case where there is too much contrast is working on white paper at a dark desk; the constant shifting of the eye from paper to desk, and vice versa, tires the muscles that control the pupillary opening. White paper reflects a great deal of light thus causing the iris to contract, but each time the eye moves back to the darker desk the iris widens, and it is this constant adjustment which tires the muscles.

Similar considerations apply to machine operations and the like, and the trouble can usually be avoided by adjusting the brightness of the immediate surround so that the visual task is slightly brighter than it. If the background is too dark, there may be a mild type of glare from the task itself, while if the background is too light, the worker will be under continual strain to maintain concentration on the task in face of distraction.

Trouble may also arise from reflections from surfaces near the task; this reflected glare may cause particular difficulty if the images are fairly sharp and not in the same plane as the task. As far as possible there should be no fixed demarcation line between the task and its immediate background; a gradual merging of colour and light is desirable, although it is not always practicable.

Special care is necessary where the material being worked upon is glossy; the gloss may cause highlights which have to be eliminated by special lighting arrangements, as everyone who has tried to read proofs printed on glossy paper will readily understand. Pencil lines may be very difficult to see if light is reflected from them; meter dials are often unreadable because of light reflected from the glass cover. Very dark machinery can be just as difficult as machinery which

is too light and where the brightness attracts attention away from the actual working area. Much depends on the nature of the material being worked upon.

In broad terms, the brightness ratio between the task and its immediate surround should not exceed 3 : 1. There may be occasions when it is necessary to create stronger contrasts which will show up a work surface to better advantage, for example where the work surface is indented. There is a difference between focusing the outline of an object and the detail *on* an object, and contrasts may have to be arranged to suit circumstances.

Example 2 Consider the ability to see dark surface faults on a piece of black cloth and picking up white threads from a black cloth. The former would require directional lighting; the latter is much easier to see.

Sensitivity to glare and to adverse lighting conditions varies with individuals, and an operator may be unconscious of any difficulty, although it may be discovered by a check on errors or a search of productivity records. The extent of the trouble may be insufficient to cause actual disability, but it may cause discomfort, which has an effect on productivity.

The third consideration mentioned above is the level of brightness in the surround as a whole. The visual task is, in fact, inseparable from its environment, and the two must be considered together. This is discussed in 3.6 following. Human efficiency is at its best when the environment does not draw attention away from the work in hand; this is accomplished by subdued tones, avoidance of severe contrasts and walls that are not too bright or too dim. Special consideration is necessary when the individual task includes use of Visual Display Units (VDUs) such as word processors or computer terminals. These are a special source of strain and an increasing problem in many environmental applications.

3.6 The overall surroundings

To achieve good seeing conditions in any working area it is necessary to consider three elements:

- the task itself
- the immediate background to the task, which may be a desk, worktable or machine
- the overall surroundings, which includes ceilings, floors, walls, together with equipment and furnishings.

The light level necessary to carry out the task efficiently is the first consideration, and the other elements have to be related to it; in doing so it is important to distinguish between the immediate surround – the background against which the work is carried out – and the overall surroundings, in the sense of the walls and other features of the area.

The immediate background has been discussed in the previous subsection and it should provide reasonable contrast with the task itself, particularly where critical seeing tasks are performed. If the contrast ratio is poor, higher

levels of lighting in the immediate surround may be required.

In a typical working area, an operative may work with a comparatively dark material against a dark background, and to provide higher light readings the walls are painted white or in light colours. While the higher light levels will solve one problem, walls that are too light will cause another. When walls are showered with light, the ratio of brightness between the task and its immediate background can jump to high figures and thus create adverse effects. In extreme cases the pupil of the eye may be constricted to such an extent that the darker task cannot be seen properly, vision may be blurred and real distress noted. The reason for this is that pupillary adjustments to the brightness of the walls are accomplished easily and quickly, but the darker task, and its background, will not be so easily focused. The action of adjusting from light to dark is slow and time consuming, and body reflexes of individuals may thereby be retarded and production capacity reduced, despite the extra light.

On the other hand, trouble can also be caused if the walls, and other contents of the area, are too dark in relation to the task and absorb much of the ambient light. The same tiring eye adjustments will occur but in a reverse direction. In such cases the level of illumination will often be increased in an attempt to counter the dark surround. Increasing the light level is not always the answer because the light fittings may appear too bright and cause glare; the higher the level of lighting, the more care must be taken to avoid direct glare from fittings and from glossy surfaces. In any case, there is no point in increasing the light levels if all the light is absorbed by dark surfaces – it is simply a waste of money. The overall surroundings must be kept reasonably bright so that there is no excessive contrast between it and the task. In other words, some brightness must encompass the whole field of view but not enough to cause excessive glare or contrasts.

It is difficult to formulate precise guidelines for calculating the brightness of the overall surround without knowing the exact nature of the task carried out. In general terms, the brightness of the walls should not be greater than that of the task and its immediate background in case the brightness of the walls attracts attention away from the task. Nor should there be too much difference in brightness between the light source and the major surfaces. It is desirable to strike a balance between the light source and the three elements listed above, but it is not a good idea to aim for uniform brightness, because this destroys contrasts and produces monotony. Some contrast must be retained to give depth and variety and to ensure a pleasing environment.

There are a number of ways of achieving the ideal, and some authorities suggest fixed ratios; the difficulty with these is that they are often used with ludicrously high light levels and will not achieve the desired result; a certain amount of discretion and experimentation is almost always necessary. Most difficulty will be experienced with the overall surroundings when a number of different tasks are performed in the same area, as they might be in a machine shop. The ideal requires that the level of brightness in the overall surroundings is sufficiently high to bring the eyes to an appropriate state of adaptation and to create a pleasing atmosphere without unnecessary discomfort and distraction.

It may happen that the nature of the work dictates a high level of brightness overall, or there may be features in a room, such as windows, that produce high

levels of brightness. In such cases the level of brightness may have an effect on the adaptation of the eye without throwing sufficient light on the task, and therefore the visibility of the task will not be sufficient for good work. In such a case it may be necessary to prescribe a high level of illumination overall and localised light on the task.

It is recommended that the overall brightness in any working area should be adjusted in such a way that the *average* reflectance values of all the major surfaces in the area do not exceed 50 per cent, which is the reflectance value of an average human complexion. If the brightness is raised above the average, haloes will tend to appear around the faces of workers and skins will look muddy. Furthermore, the very bright surroundings will be distracting because the extreme contrasts will tend to draw attention away from the work and make it difficult to concentrate.

Where floors and equipment are dark there is often a tendency to compensate by increasing the light levels and painting the walls in pale colours, but this should be resisted because it may aggravate the situation by increasing the contrasts within the field of view. The high reflectance of the walls will cause too much glare and performance will fall off; there will also be a problem if the walls are too dark. A medium tone will achieve the best results. If extreme contrasts within the field of view are unavoidable, the light level must be kept down, as the eye will find difficulty in accommodating itself properly, but if the illumination of the task must be kept constant, raising the surrounding brightness to some extent will improve acuity.

High light levels are only tolerable when the whole of the surround is relatively bright and uniform, but there is then a risk that the effect will be sterile and too bright. The overall level of brightness may exceed the light on the task with consequent loss of efficiency. A sterile environment is to be avoided on psychological grounds, and it is desirable to provide some life and interest by means of small patches of brightness or colour, which will act as visual rest centres, but they should be carefully placed so that they do not cause distraction. Attention cannot be concentrated on the task all the time, and when the eyes look up they should not have to accommodate themselves to areas of very high brightness or strong colour, at variance with the brightness level of the task. A view through a window will often provide a suitable rest area, provided that it is not too bright in relation to the task; it may be necessary to shade direct sunlight or to ensure that the interior light level is not significantly lower than the daylight. Sitting at the end of a dark room and looking out of a window on a sunny day may result in marked discomfort.

3.7 Psychological aspects

Previous sections have discussed the physical characteristics of the productive environment and the physiological effects of light and colour, but any working environment must also be psychologically and emotionally pleasing to the people who work in it if they are to give of their best; this introduces factors which affect the subconscious. A poll of office workers indicated that lighting was the most important factor in achieving a pleasant working environment, followed by ventilation, warmth, space, colourful surroundings, visual privacy

and a view of the outside. The results of this poll underline the point that good seeing conditions are the first consideration, and although tolerable working conditions may be made intolerable by too much noise or lack of ventilation, or other physical conditions, these are capable of measurement, and faults are reasonably easy to put right.

What the poll did not mention was the emotional impact of the environment. Productivity and good worker morale depend just as much on mental outlook as on physical well-being, and the factors that affect mental outlook are much more difficult to measure, or even identify, because they are hidden in the subconscious mind. People need reassurance from their surroundings, and they want to feel safe with machinery and equipment; in other words, they must feel at ease in an environment that appeals to them. In the context of light and colour such an environment can be achieved by attention to a number of points:

- the appearance of the worker
- avoidance of monotony
- acceptable decoration
- the relationship of overall surroundings to task
- ambient conditions
- the aspect of the area.

The first of these points is, perhaps, the most important, and it is very often forgotten. The light source should be of a type which allows the human complexion to look natural, and the background colours should, as far as possible, flatter the appearance of the workers. Where possible the light source should be warm in character; some types of lighting are particularly unflattering and tend to make workers look like sick ghosts. Experience has proved that unflattering lighting and unfavourable colours have a subconscious effect; morale suffers and absenteeism rises. In extreme cases actual illness results. The relationship between the colours of the material being worked on and the colour of the surround may be particularly important.

As already explained, uniform illumination and uniform brightness levels are both undesirable because the human organism is not adapted to unvarying stimuli – the human psyche needs action. A monotonous environment may even cause intelligence to deteriorate, and its effect is even more marked when the task is also monotonous. If the sense of sight is not stimulated, hallucinations may become a hazard; where people sit at automatic machines or in a projectile, colour and vision from inside may block off the actual environment.

Codes of lighting practice often suggest uniform illumination because it is said to promote visual efficiency, but in fact it leads to emotional rejection. Much better to provide an escape from monotony with a variety of colours and with illumination closely related to the task. The use of end-wall treatments will often provide variety and visual relaxation.

Acceptable decoration does not necessarily mean a high art form, but fashion-conscious girls tend not to like working in drab surroundings, and some attention to fashion, and fashion colours, seems to be indicated. There have been suggestions that offices that wish to retain their staff should be as like home as possible, and there is no reason why people should not have the conditions that they like, provided always that good seeing is ensured. People obviously work better in an environment that appeals to them, although it is equally

obvious that it is impractical to allow personal preferences to govern the appearance of a working area. More latitude can be allowed in rest and recreation areas than in areas where precise work is performed. Decoration is particularly important in reception areas and the like, which are accessible to customers and the general public.

Care is, of course, necessary with decoration. Although patches of colour may be introduced to provide variety and visual relief, the slap-dash use of bright colours is not only vulgar but may contribute to adverse seeing conditions. Contrasts also need care; although contrasts are desirable, they should not be overdone. Contrasts may be emotionally acceptable, but too much contrast may impair visual conditions. Moderation in all things is the key word. If workers can be allowed a certain amount of personal initiative, so much the better; allowing them to grow their own plants may be much better than impersonal rubber plants.

The relationship of the surround to the task refers to the difference between those areas where there is physical activity (e.g. where manual tasks are carried out) and those areas where most of the work is mental and where more concentration is necessary. In the first case, high levels of illumination and brightness in the surround will condition the human organism to activity and direct attention outwards. In the second case, more subdued brightness and softer illuminations are prescribed; supplementary local lighting on the task may be indicated, and bright colours are not really suitable.

Ambient conditions refer to the 'feel' of an area. Careful adjustment of light and colour will often make a warm environment seem cooler than it actually is and such a strategy can be recommended where the work processes generate a great deal of heat. The reverse also applies, and appropriate colours can make a cool area feel warmer. The effect is purely psychological, and many cases are reported where complaints about heating have been solved by changing the colour of the overall surround.

Colour and light can be used to change the aspect of an area; to reduce the visual size of a room; to make the walls and other surfaces look nearer than they actually are; and to make a spacy area look less bleak. The reverse effect can be used when conditions are crowded and in very small rooms where there may be a feeling of oppression.

3.8 Safety aspects

If an efficient environment is established in the ways outlined in the previous sections, it should have a beneficial effect on accident rates because the workers will be able to see better and will be more alert.

Colour can be used in a positive way to improve working conditions, but the use of colour does not mean that the safety aspects of better lighting can be neglected. For example, special attention should be paid to the adequate lighting of those areas where movement takes place, for example corridors, entrances and exits. It is most advisable to avoid sudden differences in brightness between well-lit work places and dimly lit corridors – the eye takes time to adjust to dimness, and this can be a fruitful cause of accidents. Similar remarks apply to exits, especially at night, and exterior lighting may have to be in-

creased when there is night work.

A great majority of disabling injuries relate to vision and the ability, or inability, to see, and therefore they concern illumination and colour. The principal causes of work injuries are:

- handling objects 22 per cent
- falls 17 per cent
- machinery accidents 16 per cent
- falling objects 13 per cent
- injuries from hand tools 7 per cent

Other causes of work injuries include vehicles (7 per cent) and miscellanous (18 per cent).

3.9 Practical aspects

There are a number of practical ways in which light and colour can be used to achieve an efficient environment. For example, good colour and a bright environment will help to promote cleanliness and good housekeeping by creating a pride in appearance. This does not necessarily mean painting everything in white or very light colours; white shows so many finger marks that workers soon get tired of trying to keep everything clean, but there are various strategies that can be used to make soiling less noticeable or, in appropriate cases, to show up dirt where extreme cleanliness is essential.

This does not mean to say that dirt should be hidden, but there is little point in emphasising areas which will show dirt unless they are cleaned every five minutes. Where a high degree of hygiene is essential, as in places where food is handled, light colours and high illumination will ensure that dirt is not overlooked. The need for good appearance must be balanced against the need for the best possible seeing conditions.

Colour can also be used with advantage for coding and identification purposes, both in production and in the environment itself. It may be used, for example, to identify departments, to identify prohibited or special areas, and most usefully to identify recognised movement channels. In the factory it can aid efficiency by simplifying the accumulation of pipes, conduits and tubes which proliferate in the average plant; this is not only helpful in a production sense but also adds variety to the decoration if carried out with care.

A well-decorated and well-designed environment is good business and part of the image of any company or organisation, and a clean, efficient and presentable environment is good business in any sense of the words and contributes to good public relations. In the United States a good deal of emphasis is placed on the status acquired by good interior decoration, especially of offices; companies believe that their staff will live up to their surroundings, and encourage them to do so. The design policy of an organisation, carried through in a rational way, down to the smallest detail, is a visible expression of the ability of a firm to control its affairs in larger matters of business. The use of colour as part of a corporate image is beyond the scope of these notes, but there is no reason why it should not be used to welcome the public and put over an expression of efficiency.

4 Ideal lighting for the productive environment

4.1 How much light?

The quantity of light required for efficient working depends very largely on the nature of the work, the sharpness of vision and the nature of the surrounding environment, and there is no precise point at which visual acuity can be said to be at its optimum. The minimum amount of light required for reading and writing, and for many domestic tasks, is about 1 foot candle, that is the amount of light given by a candle placed 1 foot away from the work. The unit of measurement is the lumen per square foot, which means roughly the same thing, but it is now usual to measure in lumens per square metre, or lux; 10.764 lux is the same as 1 foot candle.

The human eye can see remarkably well over a wide range of light levels and can adapt itself to conditions beginning with starlight and ending with full sunlight on snow-covered ground, one being millions of times brighter than the other. Seeing efficiency increases as the level of light increases from total darkness to a light equivalent to an overcast daylight sky or, in other words, as light levels are increased from darkness to about 500 lux. Beyond this point, higher light levels usually have little justification and are expensive to achieve because the quantity of light has to be doubled or trebled. A level of 500 lux is fairly easy to achieve but to increase the level to 1000 or 1500 lux will be very expensive indeed. Below are suggested light levels, at the working plane, to provide adequate visual performance for various tasks:

- casual reading 70 lux
- ordinary bench or machine work 150 lux
- carpentry 150 lux
- sustained reading 150 lux
- sewing 200 lux
- typing 200 lux
- draughting 300 lux
- critical colour work 450 lux
- fine assembly work 500 lux

The effect of different levels of light on ocular fatigue is relatively unimport-

ant at normal light levels, although continued use of the eyes at very low light levels may result in eyestrain, fatigue or possible organic damage. In addition, the eye is slow to react to dim light, and there may be a falling off in the alertness of the worker. There will also be eyestrain and fatigue when the eye is used at very high light levels, unless careful adjustments are made in the quality and distribution of the light. There are usually more complaints from workers about strong light than about dim light or weak light, and such complaints ought not to be shrugged off. The reason for this state of affairs is that nature intended man to see efficiently from dawn to dusk, in cloudy weather and in sunny weather. In the course of a day, man is quite unconscious of the fact that daylight illumination varies tremendously, and man sees just as well in winter as in summer. The human eye will see white as white and grey as grey, whatever the level of illumination.

Satisfactory light levels can be illustrated fairly easily by taking the gap in the letter 'e' of pica type. This has a size of 0.015 inches. If the type reflects 25 per cent of the light falling on it and the paper reflects 50 per cent, there is a reflectance difference of 25 per cent. Under such conditions it will be found that an illumination level of 60 lux will provide 90 per cent visual efficiency, and that 180 lux will raise the visual efficiency to 95 per cent. However, as much as 500 lux would be required to raise the visual efficiency to 98 per cent. It seems unnecessary to try to reach 98 per cent efficiency, bearing in mind that eight times as much light is required. One authority believes that 90 per cent efficiency can be accepted as standard and that there is little justification for seeking even an additional 5 per cent, which requires double the amount of light.

Generally speaking the eye is comfortable with a light level of 200 lux for average tasks in average environments, but higher levels may be necessary for some tasks in some occupational conditions. The optimum level would appear to be about 1000 lux, and above this there is a drop in efficiency. At the other end of the scale there is no action that can be taken to achieve good vision if the illumination is inadequate. Minimum illumination should be raised by 50 per cent if goggles or face guards are worn.

The light levels discussed up to this point are those applicable to specific tasks and not necessarily the values recommended for the overall surroundings, that is the interior in which the task is carried out. There are some differences of opinion about the minimum level of illumination suitable for all areas within a building, but a generally acceptable figure is 150 lux.

Whatever may be said about the theoretical intensity of illumination, it is only one factor to be considered. The visual task is inseparable from its environment, and there will be poor seeing conditions under any level of illumination if the control of surfaces is poor. The function of a lighting installation is to provide more than just an adequate level of light; it should enable the activities within an area to be carried out with maximum efficiency, it should ensure the safety of people using the area and it should help to create a pleasing environment.

The primary objective is to achieve good seeing conditions in the most economical way, and this involves adequate light and the interaction of light and colour. There are many established rules and recommendations for the lighting of working areas and a great deal of literature on the subject, some of it very

academic, but the aim should be to provide a moderate and comfortable level of light over the whole field of vision, supplemented by additional directional lighting on the work task when this is necessary. Most lighting standards are based on maximum visibility for the most difficult seeing task in the area, and this is often set too high with the result that there is overlighting in the area as a whole. Too much light may cause more trouble than too little light and may aggravate eyestrain rather than reduce it. Many experts recommend, and many other people have the conviction, that good seeing is directly related to more light, but this is not always the case.

Example 1 Assume two tasks in the same area with an equal level of ambient light, one task having a white immediate background and the other having a background of a softer colour. Because of the difference in the immediate backgrounds, the eye will reach a different adjustment in each case and the white background may well constrict the eye and fog vision. Dropping the level of ambient light will make it more difficult to see the task with the softer background. The answer to the problem would be to replace the white background with one of lower value.

Seeing efficiency is not ensured by raising or lowering light levels; there must be an accompanying adjustment of the brightness of the whole environment, and this may include both the immediate background of the task and the overall surroundings if optimum conditions are to be achieved.

The right level of light is a matter for careful planning and calculation in each situation. These remarks are not intended to pre-empt the work of the lighting engineer, and it is always desirable to make use of the skills of the expert when planning an installation. However, it should be pointed out that there are some differences of opinion about adequate levels of light, and the need to adjust the brightness of the environment as a whole is sometimes forgotten. There does seem to be general agreement that about thirty times as much light is required for easy performance of a difficult seeing task compared with the level at which performance of the task is just possible. As the table above shows, 300 lux is recommended for draughting; it would be extremely difficult to carry out such work at a level of 10 lux.

People adapt to their environmental conditions; they accept less than optimum conditions when any constant negative factor is not too extreme. But this can be costly in terms of efficiency and there may be a high cost in energy.

4.2 What kind of light?

In the productive environment the source of light may be daylight or artificial lighting or a combination of the two, and where the source is artificial it may be direct lighting, indirect lighting, supplementary lighting and, in some cases, localised lighting on the task, although general illumination must always cover the whole field of view. As pointed out in the introduction, workers generally demand that a lighting installation should include daylight, partly for psychological reasons but mainly for biological reasons.

The human organism has developed in response to a full spectrum of natural sunlight, and imbalanced sources can lead to biological disturbances which may affect output and worker morale. Sunlight includes a proportion of ultraviolet light which increases energy and improves health, and it would be desirable that artificial light should include a proportion of ultraviolet in those cases where natural light is limited; but remember that ultraviolet light can damage dyestuffs, pigments and textiles. Artificial light should not be white, nor should it be of consistent monotonous intensity; colour tone and brightness should provide variety. A proportion of ultraviolet light will increase work output and reduce respiratory ailments.

In most working environments some natural light is better than none at all, and it is almost always better to co-ordinate natural and artificial light. In those situations where natural light is scarce, it is often suggested that a windowless working space would be suitable, and attempts are often made to set off the advantages of daylight against solar gain and heat loss. It should always be remembered that a good environment for machines may not be conducive to good worker morale.

Once it is accepted that daylight is an essential part of good lighting in the productive environment, there are a number of points that have to be considered because daylight is not constant; the level of artificial light, and its colour-rendering qualities, have to be balanced with varying amounts of daylight. In addition, the amount of daylight that will be received at any given point in a room depends on a number of factors. In some cases it is sufficient to consider only the light received directly from the sky, but in other cases account must be taken of daylight reflected from internal surfaces and from exterior surfaces visible from the windows.

There are sophisticated lighting installations that deal with this kind of problem, and some adjustments to interior decoration may be required to ensure the best possible results. Glare must also be avoided; if the surrounds to the windows have a low brightness level, there is a risk that the high brightness of the sky, seen through the windows, will contrast sharply with the window surround and produce acute discomfort glare. It may be necessary to use artificial lighting to bring the window wall to a sufficiently high level of luminance in order to ensure adequate contrast with the sky. Workers should not face windows directly so that they do not have to adapt their eyes to bright daylight each time that they look up from their work.

When considering artificial lighting, whether in conjunction with daylight or not, there is often a difference of opinion about the relative merits of direct and indirect lighting. In many cases, and particularly in industrial applications, a direct system is preferred because it throws more light on the task and provides more contrast, but when a direct system is used it is essential that the eye should not be exposed to naked bulbs or tubes which form a sharp contrast with the surroundings, nor must the light source cause glare.

Indirect lighting is appropriate in some circumstances and is often psychologically pleasing because it reduces shadows and specular reflections, although the ceiling above an indirect system can sometimes cause glare; this can be compensated by reducing the brightness of the walls. An indirect system may not cater for the fact that the eye can concentrate more easily, and for

longer periods, when the task is somewhat brighter than its surround.

A mixed system where the direct light falls on the task and indirect light deals with the overall surroundings may solve the problem, especially when the seeing task is critical. It is desirable to strike a balance between the extreme contrasts which may derive from a direct system and the sterile and often soporific effect of a completely indirect system. The value of an indirect system depends very largely on the brightness of the surfaces in an environment, and it may be less economical than a direct system.

In order that the maximum amount of light should fall on the task, supplementary or localised lighting is often recommended. Such lighting may be directional in nature, and this gives form and depth to space and can provide a psychologically pleasing effect provided that it is positioned in such a way that shadows are controlled and glare prevented. In addition, care is necessary to ensure that the appearance of workers remains acceptable.

The position of light sources in relation to the task and to the worker is very important. Diffused overhead lighting tends to flatten and shadow and may cause difficulties, but equal difficulty may derive from direct lighting when reflectors are mounted low over the task, although this method gives most light at lowest cost. However, cost must not be the only consideration, and it may be more practical to obtain the full value of the light by using lighter colours in the environment.

The lighting installation should be planned in such a way that it provides sufficient light to convey all the necessary information that workers need to carry out their tasks efficiently. It follows that lighting must be related to the job in hand and to the environment in which the job is carried out. Even when light levels are based on recommended standards, there are still many variables that need to be considered.

4.3 The colour of light

This subsection considers the various types of lighting, such as incandescent, fluorescent and sodium, and their respective colour-rendering properties. The colour characteristics of the light source are particularly important where the material being worked upon is coloured, where colour matching is necessary or where workers are likely to be conscious of their appearance.

This last point is particularly important because of the effect of various types of light on the appearance of workers. This subject is discussed in more detail elsewhere (see Section 10 of Part I), but in general most workers prefer a warm type of illumination, and the most pleasing effect is obtained from incandescent lamps or from warm-white fluorescent tubes, although these are not the most economical form of lighting. The better the colour-rendering qualities of a lamp, the lower the efficiency, but on the other hand, lamps of high efficiency play havoc with the appearance of workers.

Surfaces, including human complexions, appear to change colour under different types of light. Under incandescent light, warm colours will appear stronger, cool colours will appear weaker and greys and whites will have a yellowish tinge. Under fluorescent light the subject is more complex and the ap-

pearance of colours depends on the type of tube. Lighting manufacturers make continual improvements in the colour-rendering qualities of their lamps, and reference should be made to the most up-to-date data on the subject.

It is always necessary to consider the colour-rendering properties of the light source when planning a lighting installation and the colour rendering should be related to the situation in which the light will be used. Once the correct colour has been chosen it should not be altered unless the conditions of work change. There are many cases where an otherwise satisfactory installation has been rendered useless by replacing specified tubes with a different type, and in some conditions this may cause nausea and real distress, particularly in the processing of food.

The ideal light should contain all the colours in fairly equal strength, but this is very difficult to achieve. Incandescent light is strong in yellow, and while it is pleasing, it is relatively inefficient and expensive. Visual acuity is best under light having a yellowish orange and yellowish green tinge, but such light is usually deficient in red. A light having an excess of blue, a cool light, is least desirable, but it may be necessary when colour matching is important.

The appearance of surfaces and materials also depends on the light intensity. If light levels are low, surface colours will appear normal even if the light source is slightly tinted. When light levels are high, a normal appearance will be found in a light that is near to sunlight at noon; this is cooler and more blue than incandescent light. There is an assumption that colour discrimination demands daylight type illumination, but this only holds good at high light levels, and if this is acceptable from an appearance point of view. If light levels are low, appearance is better under a warm light. In broad terms, the tint of the light source should be warm at low light levels, yellowish at medium levels and white or bluish at high levels. This will give the most satisfactory all-round effect.

It is most undesirable that light sources should be of mixed type, and this is particularly the case where coloured materials are being worked or where food is processed or served. Care should be taken to avoid flicker and other adverse factors.

The subject is quite complex, and when planning the type of light it is necessary to consider:

- the economic efficiency of the lighting
- the colour-rendering qualities required
- the appearance of the workers
- the effect of light on the surrounding colours.

4.4 Controlling light

A good lighting installation should be planned to eliminate glare and unnecessary contrasts within the field of view, but this is not always easy, because the problem may not be apparent until the occupants of the room are seated and the normal field of vision is in a fixed direction. Furthermore, sensitivity to glare tends to vary between individuals, and this often makes it difficult to establish an acceptable level.

The light source itself may cause glare, either directly or reflected from

glossy surfaces, and this may require repositioning of the fittings. Another common source of glare is bright sky seen from the interior, and the outside light may be reflected from surfaces within the room itself. Outside glare may make it difficult to see objects below the level of the sill and reflections of outside light may make it difficult to see detail. The solution may be to raise the level of interior light or to eliminate the reflective surfaces, depending on the way that the glare arises. Glare is a relative thing which can be reduced by elimination of the cause or by building up balancing intensity and brightness. This does not necessarily mean pale walls, because these may introduce high reflectance in their turn and make the situation even worse.

Glare Index tables are available and provide indices for various types of installation and for areas having difficult dimensions or surfaces of different reflective finishes. If the Glare Index proves to be higher than recommended, action to reduce it can be taken by reducing the brightness of the light source or by increasing the background brightness of the walls and ceiling; or by reflecting more light from the upper part of the light fittings.

More lighting, or increased levels of light, may provide better acuity but can also cause too much brightness in the surroundings, particularly on the walls. The eye cannot help focusing on, and accommodating itself to, the brightest area in the field of vision, and because this response is automatic, the eye may be drawn away from the task or be subject to constant adjustments in accommodation with consequent eyestrain. One answer to the problem may be to provide localised lighting for the task; another may be to reduce the brightness of the walls by judicious use of colour. If this latter proves necessary, it suggests that more light is being used than is strictly required and is therefore being used wastefully.

Brightness and colour should be planned in such a way that attention is drawn naturally to the most important areas, including the task itself, so that detail is seen clearly, quickly and accurately while the area as a whole is free from gloom and shadow. Special care is necessary in those cases where the time interval for seeing is fixed and brief. The lighting installation should also be planned to avoid unnecessary contrasts within the field of vision; the ratio between the brightness of the light source and that of the main surfaces needs to be carefully considered.

The light sources should be limited in brightness and area and should merge into the environment as a whole. The higher the level of illumination, the more care is necessary with this ratio. The eye can actually see better, and more clearly, under relatively dim light provided that there is adequate control of brightness and tiring eye adjustments are avoided. Where the lighting system exposes the eye to great extremes of light and constant pupillary adjustments, the eye will have to 'fight' its way through the extremes, and this is tiring; it may also require unnecessarily high light levels on the task itself.

It is worth noting that the human organism does more than just use light on visual tasks; it tends to orientate itself to the brightest area in the field of view. Thus in an environment which is too bright, intellectual activity may be difficult and an individual may rebel at sedentary tasks. In other words, the mind wanders. Severe mental and visual concentration is best performed against a softer and less aggressive background.

4.5 Lighting the task

It will be appreciated that the primary object of a lighting installation in a working environment is to ensure that the work is carried out properly and efficiently, and this means adequate lighting of the task. In theory, fixing the amount of light required is quite simple: set up the task and then increase the amount of light until the job is visible and can be performed comfortably. In practice, this is an oversimplification, and there are many other factors to be taken into account, particularly where more than one task is carried out in the same area.

A light level of 500 lux is adequate for most tasks, but 1500 lux may be required for some particularly difficult tasks – proofreading is a case in point – but more light on the task without increasing the ambient light may cause glare and distraction. It is not a good idea to fix a light level based on the most difficult seeing task performed in the area, and when particularly high light levels are necessary a localised light source is recommended. When high light levels are necessary, both the immediate background to the task and the overall surround should be light in tone; this should not cause any ocular fatigue provided that the light is well distributed and the eyesight of the workers is satisfactory. If the eyes of the workers are not up to the task, an oculist is required rather than a lighting engineer.

If the contents of, and the equipment in, the working area is dark and cannot be altered, a rather lower level of light, say 350 lux, would be more satisfactory because reflectance differences between the task and the overall surround may cause trouble.

The first step in fixing an ideal lighting level for the task is to decide what has to be seen; the task may be concerned purely with outlines or it may be concerned with the small detail on a surface, and this will affect both background and contrasts. The level of illumination will depend on a number of factors. For example:

The size of detail The smaller the detail, the more light will be required, up to a point. There is no virtue in increasing the overall light beyond a certain point, and it may be better to provide supplementary lighting. Directional lighting may be useful to assist perception of task details and to assist modelling. It may be useful to consider special seeing aids; doubling the size of detail by optical or other means can multiply the light by ten times.

The lightness or darkness of the task Light-coloured materials appear brighter under the same level of illumination than darker materials. Generally speaking, the task should be brighter than its immediate background because the eye is attracted to the brightest and most colourful object in the field of view. The immediate background should be neither too light nor too dark, and distraction should be avoided. If the background is too dark, there will be undue concentration on the task and unnecessary contrast. If the background is too light, it must be toned down. Where the task involves actual colour work, a higher light level will probably be required.

The contrast between task and background The success or otherwise of the

task lighting will depend on the reflectance factor of the workpiece in relation to the immediate background, but there must always be a satisfactory relationship between the task, its immediate background and the overall surroundings. It may be necessary to adjust the immediate background so that its brightness is slightly lower than that of the task itself. For example, an increase in visual comfort can be obtained by changing a dark desk top to one of moderate brightness, about halfway between white paper (the workpiece) and the surrounding walls. Where the eye is exposed to extremes of light and dark, the constant pupillary adjustment thereby engendered will tire the eye. More light will only compound the problem.

The speed of perception Rapidly moving tasks require more light. What is familiar and easily recognised will require less light than something strange. A monotonous task will require little light, but the worker may be stimulated by more brightness. High levels of light are required for rapid perception and will help to reduce visual errors; they are even more essential where fine work is performed.

The type of worker Lighting should be fixed at a level that is suitable for workers of average age and eyesight. Older people require more light than younger people in order to see adequately, and most older people will choose very high light levels indeed if given the opportunity. Once a worker attains 40, the amount of light necessary to achieve a given standard increases rapidly.

The reflectivity of the equipment Good lighting may be invalidated by careless placing of machines and equipment. If the workpiece has a low reflectance factor, local lighting is essential.

The work and its surround Where the task requires intense illumination, as in complicated assembly work, seeing conditions can be improved by suppressing the tone of the overall surroundings, but with monotonous tasks the worker needs to be stimulated by some brightness in the field of vision. If there is localised light, suppress the tone of the immediate background.

4.6 Lighting the surround

The lighting of the overall surroundings is just as important as the lighting of the task itself, and it is useful to draw attention to the difference between the immediate surround – the background to the workpiece, discussed above – and the overall surroundings.

The overall surroundings include ceiling, walls, floors, furniture and equipment not directly concerned with the task. Light is not, of course, the only factor concerned in achieving an efficient environment; a good interior is not too dark, not too light, not too hot, not too cold, not too noisy and not too dreary. With the exception of noise, light and colour can play a part in all these conditions.

Lighting intensities are frequently recommended without taking into account the nature of the environment and without considering reflectance dif-

ferences, or contrasts, that are acceptable to the human eye. Dark goods, materials and fittings stored within an area may absorb a great deal of light. The reflectance value of all surfaces within an area should be reviewed in order to avoid excessive brightness, particularly within the field of view of the worker, but it is equally important to avoid sterile uniformity; small, brilliant points of light can create sparkle without causing glare or other adverse reactions.

Birren has attempted to establish optimum light levels for an interior, based on reflectances that already exist. The following table shows recommended light levels for ratios which are the difference between the highest and lowest reflectance values within an area, taking into account walls, furniture, equipment and floors, but not ceilings.

Light level	*Aggregate of reflectance differences*
100 lux	More than 80
100–200 lux	60–80
200–300 lux	40–60
300–400 lux	20–40
400 or more lux	1–20

Thus, if the task requires 400 lux for adequate performance, reflectance differences in the overall surround should be reduced to a ratio of about 30; for example, assuming the floor to reflect 10 per cent of the light falling on it, the walls should have a reflectance value of about 40 per cent to provide the appropriate ratio. A light level of 500 lux in an area with reflectance differences of between 60 and 80 would be intolerable.

One deduction that could be made from the table is that an all-black or an all-white area would have no reflectance differences and could, therefore, in theory, have a very high light level, but in practice an all-white environment would be blinding and an all-black environment would be most depressing. In any case, high light levels and a uniform environment are not desirable, because of their effect on human appearance, a factor in achieving good morale. For morale reasons, the reflectance ratio within any area should not exceed the reflectance value of the average human complexion, which is about 50 per cent.

The ideal is therefore a reflectance ratio of between 40 and 60 per cent and a light level, taken from the table above, of between 200 and 300 lux, and this should be adequate for most ordinary tasks. If a higher light level is necessary because of the nature of the task, it would be better to use local lighting on the task and not to raise the overall level. One way to achieve the ideal is to raise the reflectance value of the floors and equipment towards 40 per cent and to reduce the reflectance value of the walls towards 60 per cent. The intelligent use of colour will facilitate this.

The quality of light, as well as the quantity, must also be considered and particularly its effect on the appearance of workers; the colour of the light should be considered in relation to the work, the worker, co-ordination with natural light and avoidance of mixed light sources.

Whatever may be decided about the lighting of an area, safety requires that excessive differences in light between an area and adjacent areas should be avoided, to reduce the risk of accidents. The lighting of passages, corridors and so on is particularly important and must be carefully correlated to ensure safe

movement within a building. Accidents may result if workers leave a lighted working area and pass into a dark corridor, because the time taken by the eye to adapt itself to the lower level of light may be too long for obstructions to be seen quickly enough. Correct grading of lighting within a building, to allow adequate time for adaptation, is particularly important at the entrance to buildings; at night, adjust the lighting of entrance halls and lobbies so that the illumination level reduces towards the exit. There should be no lighting fittings within the line of sight of people leaving the building; although steps at the entrance should be well lit, the fittings should be screened. For exactly the same reasons, emergency lighting should be installed. A sudden failure of the main lighting can be very dangerous.

5 Ideal colour for productive environments

5.1 Objectives

The objectives to be achieved in a productive environment include:

- improved productivity
- improved profitability
- better workmanship
- fewer rejects
- relief from eyestrain and fatigue
- fewer accident hazards
- shorter periods of worker training
- better morale
- lower absenteeism and labour turnover
- relief from distraction
- a cheerful and stimulating atmosphere
- higher standards of housekeeping
- better public and staff relations.

The functional use of colour can help to achieve all these objectives, as explained in the pages that follow, and the results will pay dividends in increased efficiency and conservation of effort. It is difficult to measure the benefits in statistical terms, and there is very little statistical evidence available, at least from British sources, but evidence from the United States proves that when colour is applied in a careful and methodical manner there is a marked improvement in productivity. Even if the improvement is only of the order of 5 per cent, it is worth having, and some sources report as high as 37 per cent improvement.

One of the first industries to apply the benefits of the functional use of colour was the pharmaceutical industry, where difficult problems of filling phials and threading surgical needles were overcome by the proper use of light and background. It has been found, by actual measurement, that provided brightness contrasts within an environment are held to a ratio of about 3 : 1, colour can create good order by concentrating attention and identifying hazards. Other things have also been discovered, such as the fact that colour properly used can

greatly improve working conditions and that adverse conditions are created when too much white contrasts with black machinery.

In order to achieve the best possible conditions, it is necessary to consider colour in relation to the whole environment, including:

- the various parts that colour can play in relation to the task, the environment and the worker
- the surfaces in an individual room or area, including walls, floors and equipment
- the requirements of different areas such as offices and machine shops.

5.2 What colour can do

The principal functions of colour in the productive environment are fourfold, as pointed out in Section 2, this part. They are:

Ensuring that seeing conditions are satisfactory Adequate seeing conditions depend on the relationship between colour and brightness in the field of view. Too much brightness handicaps vision; severe contrasts of light and dark cause fatigue and reduced efficiency. Too little light will, of course, make machines and materials difficult to see, but too much light is just as bad. The right colour will:
- eliminate conditions conducive to eyestrain
- help control brightness
- help eliminate glare
- help to spread light effectively
- remove distractions
- provide visual relief
- act as a reflector of light
- concentrate visual attention by contrast.

Ensuring that the surroundings are acceptable The environment must be psychologically pleasing, and elements of light and colour should be familiar. Variety, and not monotony, is required, and human appearance must be considered. All the elements in the environment should have a realistic appearance and not be flattened or distorted. Light levels and contrasts should be within the limits of reasonable adaptation of the eye, and the human organism should not be forced beyond its normal capacity. The right colours will:
- modify the surround to the task
- help to modify the overall environment
- make large spaces less bare looking
- make areas with low ceilings more spacious
- provide variety in a monotonous environment
- introduce sensory stimulation and relaxation
- help to achieve a psychologically pleasing atmosphere
- help to strike a balance between efficient operation, a pleasing environment and cost

- contribute to the appearance of the environment
- provide individuality
- help to provide emotional and mental balance
- provide decoration
- ensure the realistic appearance of the worker
- help to ensure harmony.

Ensure that the surroundings contribute to well-being and morale There must be sufficient light to convey all the information that people need to carry out their tasks in the easiest possible way, and the light must be controlled to ensure this and to obviate hazards. The right colours will:

- help to improve morale
- help to reduce light levels
- assist identification and coding in a practical way
- influence moods and behaviour
- direct attention outwards and encourage activity
- direct attention inwards and encourage mental concentration
- help to enhance the company image
- help to control heat
- help to ensure safe working conditions
- identify hazards
- identify escape routes, fire exits and so on.

Provide optimum economic benefits Management will find that careful attention to the use of colour will provide monetary benefits in the shape of increased productivity, lower absenteeism, fewer accidents and so on, and, in addition, a number of other advantages, such as:

- colour standardisation will reduce maintenance costs; one company reported that it cut stocks of different paints held for maintenance purposes from 350 to 24
- a reduction in lighting costs due to better use of light
- reduction in heating costs by a more psychologically acceptable environment
- reduced accident frequencies
- better machine maintenance.

5.3 The task

One of the most important functions of colour in the productive environment is to act as a secondary source, or reflector, of light, thus maximising the amount of light available from a given source, improving the illumination of the workpiece and pinpointing critical features. The total light on any work surface is partly that derived from the light source and partly that reflected from the surrounding surfaces. Theoretically the maximum amount of light would be available if all the surfaces were white, and this would permit a reduction of light levels with a consequent saving of money.

In actual conditions this is not practicable, because there would be far too much brightness and glare in the overall environment, and this would cause

adverse seeing conditions. There has to be a compromise, and colour has to be adjusted in such a way that excessive brightness is eliminated. In practice this means varying the colour of the surroundings because the colour of the work plane is dictated by the colour of the material being worked on. An example is a black desk top in a white environment; this would create a particularly difficult and harmful seeing condition, which would very soon overtax the eye muscles. Although the white environment would make the most of the available light, the dark desk ought to be raised in brightness to avoid eye strain. Failing this, the surroundings must be lowered in tone. Similar considerations apply to dark machines.

Where the surroundings are too bright, the eye will be quick in adjusting to the dark walls but slow in adapting back to the darker task, and this causes loss of efficiency because the emphasis is precisely wrong. There can be more brightness on the walls when the task is not critical and, in such cases, more brightness helps to relieve monotony.

White or very bright working surfaces should be avoided because they cause glare and impair visual acuity; grey, green or beige are better because they create a visual cushion, help to keep the pupillary adjustment of the eye steady and lessen visual shock in glancing from light to dark and back again. In one factory making shirts the operatives complained of dots before the eyes, and doctors diagnosed a condition akin to snow blindness. The whole factory had been painted white in the interests of cleanliness, and when this decor was combined with the white of the shirts being worked upon, it produced eye irritation and strain. The constant glare affected the eyes of the operatives and caused excessive tiredness. The operatives were advised to wear tinted glasses, but it would have been better to have reduced the brightness of the decor.

Generally speaking, excessive contrasts within the field of view are to be avoided, but there is often a case for more contrast between the task and its immediate surround. The illumination of the two will usually be very much the same, and to make it possible to see the task more clearly, the colour of the immediate background should be reduced in value slightly. Concentration on the task is easier if the brightness of the task moderately exceeds the brightness of the overall surround and slightly exceeds that of the immediate background. Where the workpiece is suspended, as in a lathe, a background screen of a suitable colour behind the workpiece will make seeing easier.

The colour of the material being worked upon is obviously important, and where colour matching is involved the immediate background should be neutral in character. Some difficulties may arise where materials are strongly coloured because of after-image effects; if the eye concentrates for long periods on a particular colour, the receptors of the eye become tired, and when vision is moved to an adjoining surface the eye will see a momentary image of the complement of the original colour. This can cause confusion and may need adjustment of the colour of the surround. Here are some other points:

- If a worker is staring down at a bench, the colour of the floor may be important.
- Patches of strong, bright colour may be used to direct attention to hazards and controls.

- Colour should seldom be brilliant when concentration is necessary.
- Heavy machinery should not be camouflaged with neutral colours; the machines should be made a focal point.
- When the task is repetitive, colour should be used to provide variety in the surroundings.

5.4 The overall surroundings

Another of the primary tasks of colour in the productive environment is to help control light and, more particularly, the level of brightness. Brightness is quite simply defined as the amount of light reflected by a given surface and obviously depends on the strength of the light source and the colour of the surfaces; dark colours reflect less light, light colours reflect more light. Control can be achieved by varying the colours and thereby the amount of light reflected. Although adverse seeing conditions exist where there is too little light, they also exist where there is too much light, because this causes glare and distraction as a result of excessive brightness in the field of vision.

The basic principle is that visual acuity is at its best when the brightness of the surround is slightly lower than or equal to that of the task, and in theory this can be achieved by selecting colours with an appropriate reflectance value for the walls, ceilings, floors and so on so that they are brought to a level where the eyes are in a state of adaptation appropriate to the task. This would be quite simple to achieve if there were only one task or if all the tasks in a given area were exactly the same, but this is rare, and two problems immediately present themselves.

If the task is dark in nature, application of the principle would suggest that the colour of the surroundings should be suppressed, but this would have the effect of making the total environment too dark. On the other hand, if the total environment is too light, attention will be attracted away from the task. A uniform brightness is equally unsatisfactory, and therefore it is necessary to consider the overall environment and the immediate background to the individual task separately and to seek a compromise between the two. Careful analysis of what people do in an area is an essential preliminary to colour planning.

When considering the overall environment, a common error is to use too much whiteness, or colours with too high reflectance values, in order to obtain more light and thus reduce the cost of lighting by relying on reflected light. Not only does this tend to cause glare but it may also be monotonous and depressing. A purely artistic approach may lead to needless and objectionable distraction. Both uniformity and excessive differences of colour values causing constant changes in the pupillary opening of the eye are adverse conditions which should be eliminated.

Glare must also be eliminated and, if caused by wall surfaces, a slightly darker colour would solve the problem and have the advantage that it concentrates attention on the task; the latter must always be the brightest object in the field of view. Glare often arises from a wall opposite a line of windows, and it may be necessary to reduce the reflectance value of this wall; special treatment is often required when the sun is very strong. It may even be necessary to

raise light levels slightly to compensate for a darker wall. Where the Glare Index proves to be too high for the task, action might be taken to reduce it by cutting down the brightness of the light source or by lightening the floor.

The aim should be to create a brightness ratio between task and overall surroundings of less than 5 : 1 if at all possible, and certainly not more than 10 : 1. This compares with the recommended brightness ratio of 3 : 1 between task and *immediate* background mentioned earlier.

Ceilings should generally be white in order to reflect the maximum amount of light, and if walls are finished in colours having a reflectance of about 50 to 60 per cent, equipment 25 to 45 per cent, machines 25 to 35 per cent and floors 20 to 25 per cent, this will reduce the brightness ratio to reasonable proportions. The maximum contrast between ceiling and floor will be countered by the lower ratio between the other features and the floor. Areas of convenient colour for relaxation purposes are also required, particularly where there is long concentration on near objects or fine detail. A common strategy is to use a contrasting colour for an end wall, especially if it can be arranged that all workers face the end wall. In such cases the reflectance value of the end wall could be 30 per cent, and the other walls could be raised slightly, although not normally to more than about 60 per cent.

Treating an end wall in this way provides relief for the eyes of the worker, helps to reduce glare and does not pull attention away from the task; the arrangement is unlikely to cause eye accommodation difficulties. An end-wall treatment is particularly useful where the work is very concentrated; if workers do not all face the same way, the same effect may be obtained by shields applied to the back of work tables or benches.

The lines or features of a work space may be emphasised by contrasting colours, and this provides variety; the changes in colour to increase contrasts may be equivalent to an increase in illumination.

5.5 Psychological aspects

Up to this point this section has been concerned with the physical characteristics of colour and the way that the ability of colour to reflect varying quantities of light can be used to control light and thus improve seeing conditions. These conditions can be achieved by using any hue that has the right reflectance value, subject to any limitations that may be imposed by the colour of the material being worked on. However, colour also has psychological and physiological characteristics which can be applied to secure a better environment, but to discover these it is necessary to examine specific hues; two hues having the same reflectance value may have entirely different psychological, physiological and emotional characteristics.

One of the most important effects of different hues is on the appearance of workers. It was suggested in the previous section that the colours of walls should reflect about 50 to 60 per cent of the light falling upon them, but it is important that the hues selected should be flattering to the appearance of workers. Other things being equal, warm lighting tends to flatter the complexion while cool lighting does not, but colour also has an effect. One reason

why pink is so popular is that it flatters the complexion and makes people look well and cheerful. Blue-green also has a flattering effect because it is the exact complement of the human complexion and flatters by comparison.

In most productive environments fairly pale colours will usually be employed, and reflections from walls and other surfaces on to the workers will not be a major problem; but where bench tops or equipment are coloured, or where coloured surfaces are in close proximity to workers, the possible effects on appearance should be examined. The colour of the material being worked on is also quite significant, especially if the materials are strongly coloured. They may have an effect on appearance, and this can be countered by altering the lighting or changing the colour of the walls or other surfaces.

Many managements may consider the appearance of the workers to be quite unimportant, but experience suggests that it is far more important than generally realised. The reaction to unfavourable colour is subconscious, and it has been found that when poor use of light or colour results in an unfavourable or unflattering appearance, morale suffers and absenteeism rises. In some cases actual illness may result; workers *look* sick and finally believe themselves *to be* sick.

Allied to the importance of appearance is the need for variety and avoidance of monotony. The use of end-wall treatments to provide visual relaxation has already been mentioned, and the need for variety is well established. Efficiency does not mean monotony, and small patches of colour to provide variety are acceptable provided that the effect is harmonious and that the colours are not too strong. Nor should they conflict with the visual task; strong and intense colour can be used with advantage in small areas to provide this variety, but these small areas should be kept out of the direct view of the workers. Deeper colours can be used for drawer fronts and the like; they provide variety in the overall surroundings while remaining out of direct view. Particular care should be taken that any patches of strong colour do not interfere with the colour marking of hazards.

Productivity does not depend entirely on physical conditions; it also depends on mental outlook as well. If the outlook is dull and depressing, workers are hardly likely to be enthusiastic. Subject to the overriding condition of good seeing conditions, there is no reason why the hues used should not be those that people like; they will work better in an environment that appeals to them, and if that environment is dominated by colours that are generally disliked, there will tend to be dissatisfaction. An individual plant or office does not need a high art form, but there is no reason why decoration should not be as attractive as possible. Two-tone arrangements are often practicable, and architectural features can be picked out in harmonising colours.

There is no place for trends or fashion colours in a productive environment because such colours seldom have the right qualities, but they might be used in rest and recreation areas which are redecorated fairly frequently. In any situation where female labour is employed on an extensive scale, it is profitable to pay extra attention to the decorative scheme because women, as a general rule, react more positively to colour than men; poor decoration may cause high rates of staff turnover and more absenteeism. Some colours are more acceptable to women than others, but feminine colours would be unsuitable for an area

where most of the workers were male.

Some attempt may be made to ask workers what they would like, but the result is seldom conclusive and tends to cause arguments; it is better to ask them to choose between two or more preselected colours. It is sometimes a good idea to colour a small area and to watch reactions before pushing ahead with a major scheme of redecoration, but in general, personal preferences should be avoided because the object of the exercise is to improve efficiency, and that includes reducing the number of colours in use.

Pleasing colours will help to inspire better housekeeping, neatness and care of equipment and should have a pleasurable effect on mood, improve morale, create better public relations and relieve tension. Decoration can, of course, be overdone; an example is quoted of radiators being painted with metallic paint to improve their appearance, with the result that the efficiency of the radiators was reduced by 20 per cent.

There are wider implications to the use of different colours in the productive environment and the most important of these depends on the type of work being carried out. Plenty of light and colour produces a centrifugal action, away from the organism and towards the environment. Warm, luminous colours in the surroundings allied with a high level of illumination tend to cause the body to direct its attention outwards; there is increased activation in general, more alertness and outward orientation. Such an environment is conducive to muscular effort and to a cheerful spirit. It is suitable for areas where manual tasks are performed, areas where there is much activity, such as general offices, and for automated assembly areas, where the task itself has little inherent interest. However, cooler colours are indicated in areas where the process itself generates heat (e.g. foundries); warm colours would not be suitable in such cases.

By using cooler colours and a lower light level it is possible to create a centripetal action, away from the environment and towards the organism. With this type of environment there is greater ability to concentrate on mental tasks and on difficult visual tasks such as fine assembly work, although in the latter case some additional light on the task may be required.

Brightness of light is stimulating, warm colours are exciting, and the two together tend to stimulate the human system with the result that rates of blood pressure, pulse and respiration tend to rise. Softness of light is subduing, cool colours are passive, and these two have the reverse effect. The human body has a natural tendency to orientate itself to light and as the stimulus is increased, the response of the body follows.

These reactions are involuntary, as may be seen when the muscles grow taut as the result of exposure to sudden brightness. Extreme room brightness tends to draw attention to the room at large and to invite a wandering interest; the individual may rebel at confining and sedentary tasks. Warm colours and plenty of light should be used in spaces where it is beneficial to encourage feelings of extroversion, for example where social contact is important. A stimulating atmosphere may be desirable in canteens and recreation areas, but a more suppressed atmosphere is better where mental tasks are carried out and in rest rooms and the like. Red has a particularly stimulating effect; tests have proved that a lecture given in a red environment aroused more enthusiasm than one given in a blue environment.

While warm and cool colours have an effect on the nature of the work carried out, colour also has a strong psychological effect on the apparent temperature of an environment and can often be used to compensate for extremes of temperature. Cool colours will make the environment seem cooler than it actually is, and warm colours have the reverse effect. For example, blue grey would intensify the chilly effect of a north-facing room while a warm yellow would counteract the chill. Generally speaking, warm colours are preferred unless the process generates heat. In one reported case cool colours were introduced into a weaving shed and the workers refused to work until the temperature had been raised by three degrees; this was a purely psychological reaction because there had been no change in conditions apart from a change of colour.

Warm colours help to reduce the visual size of a room by making the walls seem nearer than they actually are; the walls seem to advance, and this makes the room seem more cosy and a large area looks less bleak. Cool colours, on the other hand, appear to be more distant and make the room look larger; they can be prescribed when the conditions are crowded, for the more that a colour is greyed, the further away it seems to be.

Light colours also lend distance and help to make a room look larger, while deep shades make it look smaller. In small rooms it is best to have all walls in one colour. To summarise, warm colours should be used:

- if the room is cool
- if the noise element is low
- if the room is too large
- where texture is smooth
- where physical effort does not generate heat
- where time exposure is short
- where a stimulating atmosphere is desirable
- where light sources are cool.

Cool colours should be used:

- if the room is warm
- if the noise element is high
- if the room is too small
- where texture is rough
- where physical exertion generates heat
- where time exposure is long
- where a restful atmosphere is desirable
- where light sources are warm.

5.6 Practical aspects

Safety An essential step is to review the whole area and to pinpoint the various hazards that are likely to arise; it may be possible to eliminate some of them by improvements in layout or by installing additional lighting at danger points. Special attention should be paid to those areas where movement takes place, such as corridors, exits, entrances and yards. In appropriate cases the safety aspect should be given priority and background colours

adjusted as necessary. The camouflage effect of colour needs careful consideration; a man may easily slip from a grey scaffolding on a grey day. Engineers are particularly liable to forget this point because they have a predilection for grey finishes to machinery; it is considered to be economical.

Cleanliness Good colour and a bright environment will help to promote cleanliness and good housekeeping by creating a pride in appearance. Plenty of light in non-working areas prevents dust being 'brushed under the carpet'. Greyed surfaces that do not show marks are a good idea, but avoid very dark greys because they are depressing. In working out colour schemes it is worth while to give some thought to soiling and to use colour in a way which makes the place look reasonably clean. For example, a corridor will almost certainly acquire soil marks along the lower walls, and these can be made less noticeable by painting the bottom half of the wall in grey, greyed colours or darker tones. A dado is useful where trucks and trollies are likely to mark the wall, and the dado can be in darker colours.

The outer angles of internal walls are usually well marked by fingers and this can be made less obvious by suitable treatment such as darker colours, finger plates and so on. None of this means that dirt should be hidden, and in areas where a high degree of hygiene is essential (e.g. in food-processing or food-handling areas) there should be plenty of light and light colours so that dirt is not overlooked.

Image Colour is often used to establish a company image, but normally to exteriors. In the United States, however, interior colours are often part of the company image and even ash trays may be finished in house colours. This subject is rather beyond the scope of this book, but it is worth mentioning that the decoration of a reception area can establish the character of a company. Bright colours and plenty of light suggest a brash image, while more subdued colours can suggest something more sophisticated. Colour can also be used in the reception area to direct the attention of visitors in the right quarter, even to showcases when prospective customers have to wait.

Identification Colour can often be used with advantage for identification purposes, for example to identify departments, prohibited areas and recognised movement channels (particularly escape routes). It can also be used to simplify the accumulation of pipes, conduits and other equipment which proliferate in most working areas. There is a recognised standard colour coding for the identification of pipelines, and if this is used properly it promotes safety, saves time and can have a decorative effect. Direction signs and notices need to be easily recognisable and to have maximum readability; this can be achieved by the skilful use of colour. Different coloured doors will often assist identification and add variety to the environment. One office building is colour coded by means of plastics plates on doors:

- dark blue for toilets
- grey for stores
- red for fire doors, stairs, exits
- white for others.

The chief point to remember is that when colour is used for identification

purposes the colours must be easily recognisable and should be sufficiently different from other colours used in the immediate vicinity to prevent confusion.

Temperature control The use of colour to create warmer and cooler interiors has been mentioned above, but colour can also be used on exteriors to reflect heat away and thus cool down interiors. Tanks or storage hoppers can be painted in white, or light colours, which reflect the maximum light and heat, and this will cool down the interior of the tank or hopper to a substantial extent; similar treatment can be applied to roofs and the exterior walls of sheds and the like.

6 The individual productive area

6.1 Applying the principles

Previous Sections have defined the ideal environment and discussed the principles by which light and colour are able to help to achieve the ideal, and these principles can be applied to the selection of finishes for the surfaces of an individual room or any working area which can be considered as an entity. The broad principles suggested below can be modified by the function of the room and the work carried out in it, and this is discussed in the next chapter. Choice of actual hue will depend on the function of the room, or area.

The key factor in producing a satisfactory environment in any working area is the amount of light which is reflected from the various surfaces in the room, and the amount varies according to the reflectance value of the colours of the surfaces. It follows that by changing the colour it is possible to change the amount of light reflected from a given surface, and this control of light is the primary function of colour in the productive environment, although it is not the only function. Changing the colour does not necessarily mean changing the hue, but it does mean changing the reflectance value. A light, or pale, variation of a given hue may have a high reflectance value while a deep, or dark, variation of the same hue may have a low reflectance value; a medium variation will probably have a value about halfway between black and white.

If all the component parts of the environment are finished in colours which have a too high reflectance value, the resulting conditions may be blinding, especially if light levels are high. If all the colours have a low reflectance value much of the available light will be lost, and if light levels are increased to compensate, the result may be glare. If the difference between the values of the different surfaces in an area are too great, the resulting contrast will cause difficulty. It is necessary to strike a happy medium.

As far as possible, dark colours of low reflectance value should be avoided in working environments because they absorb too much light, make for a psychologically depressing atmosphere and are apt to cause details to become sources of glare; if used at all, they should be restricted to small areas for accent purposes. Colours of medium or relatively high reflectance value are almost always preferable because they improve the lighting and are psychologically more pleasing.

It may not always be possible to achieve the ideal; adverse features in an environment often cannot be altered. For example, it may not be possible to avoid a dark floor, and in that event the other surfaces must be adjusted to compensate; it would be reasonable to reduce the reflectance value of the walls and raise that of the machinery and equipment so that the contrast is maintained at an equable level – about 5 : 1.

The first step in the colour selection process is to fix suitable reflectance values for each major surface in the area so that the brightness ratio is fixed at a reasonable level, taking into account any adverse features, such as the dark floor. The values appropriate to the principal features of a room are discussed below.

6.2 The ceiling

As a general rule ceilings should be white in order to make the maximum use of available light, indeed, a white ceiling is essential with an indirect lighting system because it ensures maximum reflection of light. Even with a direct lighting system, white prevents the ceiling from causing distraction and ensures even distribution of the light. Coloured ceilings are not recommended in working environments, because they tend to distract attention away from the task. Ceilings should be unbroken as far as possible, again to prevent unnecessary distraction, and they should have a matt surface finish to prevent glare and excessive reflections.

6.3 Walls

In general the reflectance value of the walls should be about halfway between those of the floor and those of the ceiling, but depending on the reflectance value of the average task. A figure of between 40 and 60 per cent is satisfactory in most circumstances, but the walls should reflect slightly less light than the task to avoid eye accommodation problems.

In appropriate cases the lower part of the wall, where most soiling takes place, could be in a somewhat darker colour, with a lower reflectance value, and the upper part of the walls could have a somewhat higher value. Where the lighting is particularly good, values as high as 70 per cent would be acceptable for upper walls, but such a high value is best limited to areas where there is a degree of physical activity, and it should be avoided in areas where critical seeing tasks are performed. In broad terms, the average brightness of the walls should not exceed the brightness of the human skin (i.e. 50 per cent) lest the appearance of workers should suffer. A higher average would have to be compensated by special attention to lighting and colour.

Summary

Dado or lower part of walls:

- Down to 40 per cent. The reflectance values of lower parts of walls may be lowered if soiling is very rife and other values adjusted accordingly.

Upper walls:

- If floors and equipment are dark 50–60 per cent
- If floors and equipment are light 60–70 per cent

Walls containing windows should be light coloured, and the walls opposite windows should also have a fairly high reflectance value to make the most of the available light. The window frames will usually be white, and if the window wall and the opposite wall are both of relatively high value, it will help to reduce the contrast between the walls and the brightness of the windows. Apart from window frames, white should be avoided; it is sterile and uninteresting and tends to blur vision.

If deep colours are used for accent purposes, they should be restricted to those walls that are not faced by workers. Drab colours show dirt as readily as any other colours.

6.4 End walls

To provide variety it is recommended that at least one wall should be in a different colour to the others; this should not be the window wall nor the wall opposite the windows. The colour can contrast with the other walls, but the general effect should be harmonious. A different colour on an end wall helps to avoid a depressing environment, but it should not create a garish atmosphere.

Recommended reflectance values are between 25 and 40 per cent depending on the value of the main walls. If workers are engaged in assembly and inspection operations where concentration is necessary, a soft (cool) shade having a reflectance of between 25 and 30 per cent will prevent glare and will not pull attention away from the work. If the task is not particularly intensive, the end wall colours could be raised to between 30 and 40 per cent, provided that all the workers face the same way.

An end wall treatment is particularly useful at the end of a room with a low ceiling, it can create an illusion of height. If the room is long and narrow, warm colours on the end wall, combined with cooler colours on the side walls, will help to make the room appear less confining. If a room has an unusually high ceiling it would be better to reduce height by mechanical means rather than by end wall treatment.

If the reflectivity of the side walls is fairly high, an end wall in a soft hue of fairly low reflectance value will provide relaxation for the eye and relieve the monotony of high brightness.

6.5 Floors

A floor of very high reflectivity would not be very practical in most working environments, and figures of between 20 and 40 per cent would seem to be about right in most cases. This would cover an average red carpet at the lower end of the scale and a light wood block flooring at the upper end. The reflectivity to be specified and the actual colours to be used will depend on:

- the nature of the floor surface and the material used to cover it
- the nature and direction of the light source, small windows would dictate a floor of higher reflectance value to make the most of the available light; if there is strong overhead lighting, a darker floor would be advantageous; windowless working areas require special consideration
- the nature of the outside environment, an industrial landscape would suggest warmer colours to counteract the coolness of the landscape; a very busy street scene would suggest a more soothing colour
- the nature of the room: lighter colours will make the room look larger, darker colours will make it look smaller and less bare
- the overall colour scheme: a darker floor might be desirable for the sake of the overall effect, but 15 per cent reflectance would seem to be the practical minimum; even this is too dark for most areas, and the ideal is about 25 per cent
- the nature of the work: in a room full of people doing semi-routine jobs, a muted overall colour scheme may require some relief
- the atmosphere required: colour can be either stimulating or restful
- the size of the area: in large areas, such as open-plan offices, the overall colour effect can be very significant
- the type of soiling: spillages and ease of maintenance should be considered; appropriate colours can help to disguise initial soiling

There is a trend towards the use of carpets, particularly in offices, and where they are fitted consideration must be given to the pattern. A patterned floor helps to break up large areas and to hide soilage; an area having heavy traffic should be particularly strongly patterned. An unobtrusive pattern can help to discipline an area generally, and a strongly directional pattern can help to improve room proportions and may help to direct traffic; but watch the colours of the pattern – if the colours contrast too much they become distracting.

In some cases it may not be possible to avoid very dark floors (e.g. a floor covered with asphalt), and in such cases it may be necessary to drop the brightness of the walls and to raise the brightness of the machinery and equipment.

6.6 Furniture and equipment

Assuming an average reflectance of 60 per cent for walls and an average of 25 per cent for the floor, the ideal for the furniture and equipment would be halfway between the two (i.e. about 35 per cent), but between 25 and 45 per cent would be acceptable. Within these limits, colours can be chosen according to function and in shades which are pleasing to the worker.

The reflectance of furniture and equipment should be adjusted to avoid sharp contrasts between the task and the background; the reflectance of the walls should not be very much higher than that of the equipment because walls that are too bright may cause distraction. There is a strong argument for lighter tones for equipment because they help to avoid strong contrasts and convey an air of spaciousness; dark tones absorb light. On the other hand, surfaces that are too light cause glare.

Equipment should generally contrast with the walls but not in an excessive way. Colours should be:

- not too bright to avoid glare
- not too dark to avoid wasting light
- not too vivid to avoid distraction.

In most cases the colours of furniture, fittings and equipment should contribute to complete interior design in a positive way. They should be:

- psychologically pleasing to staff
- both decorative and functional
- practical in the sense of retaining good looks over a period
- adjusted so that all areas within the field of view are of uniform brightness.

These remarks apply particularly to office furniture, and trends have a minor part to play but can be considered where functionally appropriate. It is also worth noting that colour enhances the appearance of the equipment and provides a sales point.

Stronger and brighter colours may be used for equipment where it is not within the direct view of the workers; this provides accent and variety and has a decorative function in the environment as a whole. For example, accents colours can be used for drawer fronts and the like to provide variety, and for identification purposes, but they should be refined in tone, and strong colours adjacent to workers are best avoided. Colour is sometimes used to identify working groups, but some experts take the view that equipment should be neutral so that there is no pandering to status seekers.

The inside of doors will often be in white or other light colours to distinguish them from walls, and this may also provide variety. Exits should always be easy to distinguish for safety reasons.

6.7 Machinery

Plant and machinery, including machine tools and the like, as distinct from office equipment, requires special consideration which depends on the nature of the machines, and it is difficult to formulate guidelines of a general nature. The subject is one that requires more detailed study.

The body of any machine should be finished in a non-distracting colour of medium tone. If the machinery is too dark, it may contrast too strongly with light-coloured walls. If, for some reason, the colour of machinery cannot be lightened, it may be necessary to drop the reflectance value of the walls. Colour should not be used on machines for decorative purposes, but lighter colours may be applied to working planes to provide more light at the point of work, thereby improving visibility and contrast. In some cases small shields may be applied to the back of the work piece to reflect more light.

7 Specific productive areas

7.1 Reception

The first step in the colour selection process being to determine suitable reflectance values for each of the major surfaces in an area, the second step is to consider how these values may be modified by the functions of the room and the work carried out within it. It is only after this process has been completed that it is possible to select hues, having the appropriate reflectance value, which will fulfil the other functions of colour, such as appearance, decoration, safety and so forth.

The first area encountered when entering any establishment is the reception area, which often incorporates, or is adjacent to, a showroom, although the reception area itself frequently contains showcases. The reception area is the interface between any organisation and its public and should usually create an image of the organisation; it is primarily for visitors and is a visual extension of the organisation itself. The colours used may well mirror the company standard colours or those used on the exterior of the building, but they must not be too 'busy' or inappropriate. Fashion trends can be allowed some play provided that they do not create an unbusinesslike image.

Warm, welcoming colours are very desirable, and medium reflectance values are recommended. Dark ceilings and floors are sometimes used because they are thought to be fashionable and to concentrate attention on the reception desk, but they are unlikely to create a favourable impression on visitors. Light ceilings are much better, although they need not be white. Walls are sometimes finished in different colours to create individuality, but the colours should harmonise and make up a pleasing whole.

Showrooms or showcases should be coloured in such a way that they display the products contained in them to best advantage. Neutral walls may be desirable, but the colours should always have the right association with the products of the company. The colours in public areas should be simple and dramatic, but the possible effect on visitors, and on the appearance of visitors, should be considered. In appropriate cases colour may be used to direct visitors' attention where required.

7.2 General offices

The broad principles relating to rooms, set out in the previous sections, apply to offices. A matt texture is recommended for ceilings, and it is suggested that especial care should be taken to see that window walls are light in colour, to lessen contrast with the brightness outside.

Although colours with a reflectance value of up to 70 per cent are permissible for walls, the maximum figure should only be used if the floors are light and the lighting installation is perfect. Most offices include tasks which require mental concentration, and therefore a reflectance of 50 to 60 per cent is preferred. Lower walls may go down to 40 per cent to hide soiling. An end wall treatment in deeper shades can be recommended because it provides variety in what is often a monotonous environment; a semi-gloss finish is recommended to avoid unnecessary reflections. A recommended reflectance value for floors is about 25 per cent, but colours reflecting between 20 and 40 per cent are acceptable. Brighter colours on the floor will make the room seem larger; darker colours will help to make it look smaller and less bare.

There is a tendency to use a domestic approach to the decoration of offices because of the number of women employed. Office environments should now be colourful, they should look like home and, as far as possible, one office should differ from the next one. Human appearance is important; the light source should be warm, and background colours should be flattering to the human complexion.

Colour and tone should be related to light entering the room and to the environment outside it. A warm colour would be appropriate in a grey or urban environment; cooler colours are more appropriate in an exciting environment. Colours used can be either stimulating or restful, depending on the proportion of routine work and work requiring intense concentration. In the former case buff or beige would be satisfactory; in the latter case aqua or jade green is suggested. Peach is warmer still and suitable for typing pools, inner walls and rooms having little sun. Grey and parchment can also be used but are a little cool in nature. It may be useful to consider the views of workers; offices are used by a considerable number of people and therefore need to be finished in colours that are universally acceptable. Bright colours are not suitable for offices where mental effort is required because they tend to cause distraction; on the other hand, some bright colour does provide variety.

There has been a trend away from the cellular office towards a more open-plan form of layout, and this latter generally calls for brighter colours to provide variety and warmth but avoid excessive brightness.

7.3 Executive offices

More individuality can be permitted in executive offices, and trends can be allowed some play. An executive works best in surroundings which suit him, and individual ideas can be given full play. However, executive offices are frequently seen by visitors, and the decor should reflect the character of the company. Too much grandeur breeds distrust but too little may create a poor

impression. Variety is acceptable, and accent colours on the walls are permissible.

A garish decor would not be conducive to good work, but it might be good public relations in some circumstances; in other cases, however, it might do more harm than good. The efficiency of an executive is affected by the colour of the environment that he or she works in; dull and drab backgrounds accentuate feelings of boredom, while cheerful and colourful backgrounds produce a creative atmosphere and a sense of achievement. It has been suggested that an advertising executive needs an exciting environment.

7.4 Board and conference rooms

Boardrooms should be finished in colours which reflect the image of the organisation and its business, but colours should be restful and conducive to thinking. On the whole, light and cheerful colours are preferable because deep and depressing colours may affect decisions.

Conference rooms require colours that are conducive to concentration and intense mental effort. Light and medium tones together will provide variety. Light green, aqua or light blue would be very suitable, unless the main purpose of the conference room is the reception of visitors; in that event, warmer shades, such as beige or buff, would be acceptable.

7.5 Miscellaneous areas

Libraries Plenty of light and colours that are conducive to mental effort are required; the walls should have a relatively high reflectance value, and book shelves should be in light woods or light grey. Local lighting on reading desks can be recommended.

Drawing offices Plenty of light and colours that will not distract from the task in hand are required. Walls are best in neutral colours of high reflectance value.

Stockrooms, storerooms Use light colours to brighten up a confined area and make the maximum use of available light. Lower walls may be in darker colours to hide soiling.

Machine shops These require special consideration according to the nature of the work performed. Strong colours are quite permissible if tasks are routine or mechanical, but in most cases upper walls should be finished in colours reflecting about 60 per cent, although if the tasks performed are very exacting, this might be reduced to 50 per cent. End wall treatments can be recommended in assembly shops; colours reflecting about 20 to 30 per cent are relaxing and do not reflect distracting light. Oil seepage on to floors in machine shops may have the effect of making the whole area very dark; lighter walls will help to compensate.

7.6 Recreational areas

This heading includes washrooms, rest rooms and other similar areas, as well as recreational areas, canteens and the like.

Wash rooms Some managements object to dressing up wash rooms because they think that it encourages workers to stay in them and waste time. The reverse is true; light colours and ample illumination help to clear workers out and encourage them to keep the area clean. Blue is quite suitable, but it is found that pink is still preferred by women.

Rest rooms and recreation areas Should be different from working areas in both colour and design in order to provide a change of environment and a source of relaxation. Lively tones are recommended, and rest rooms should not be made so restful that production suffers. Warm colours are recommended.

Canteens A cheerful atmosphere is desirable; it should provide a change from the working environment and create a feeling of relaxation. Colour harmony should prevail; plain or patterned material for furnishings should harmonise with cheerful walls. Murals can also be recommended. Care is necessary in the selection of colours because of possible adverse effects on the appearance of food. Aqua and blue-greens are well recommended in association with food, and peach is also well liked. Lighter shades of yellow are often used because they produce a lively effect, but greenish yellows should be avoided; they affect the appearance of the food and make the workers look sick.

7.7 Staircases and corridors

Visual stimulation is desirable in corridors to provide a change from working areas; they are often dark, and pale colours will help to make the most of the available light. To prevent a long corridor looking too bare and endless, use a pale colour on one wall and a more luminous, deeper colour on the other. If soiling is likely, dados can be finished in deeper colours; light grey would be very suitable if upper walls are in a brighter colour of high reflectance value. Ivory is recommended.

 Similar remarks apply to staircases, and they should be well lit. If the undersides of stairs are painted in light colours, it will improve the reflection of light. White is recommended. A light colour is well recommended for doors, but stronger colours can be used to provide variety or for identification purposes. Exit doors need to be identified with particular care. Movement areas generally should be well lit so that there are no strong contrasts when passing out of a brightly lit room into a dimly lit corridor. The eye takes time to accommodate itself to different conditions of light.

8 Productive tasks

8.1 Work performed

The third stage in the colour selection process is to consider the characteristics of the task, how the task is performed, and who performs it. The results will almost certainly require further modification of the values provisionally selected in accordance with the previous chapters.

The colour of any working area is largely dictated by the nature of the task – for example, whether the task is a manual one which requires physical energy; whether the task is a sedentary one of a repetitive, monotonous, nature; whether the task is a sedentary one but requires close visual attention; or whether the task is one that requires mental concentration. Consider the following:

- Manual tasks. Where the task requires an output of physical energy and there is much activity, use bright, warm colours and strong lighting.
- Sedentary tasks. These include average tasks where a high degree of concentration is not required. Quieter, cooler colours are prescribed, but there should be plenty of visual interest.
- Sedentary tasks of a monotonous nature benefit from bright colours and plenty of visual variety.
- Critical seeing tasks (e.g. fine assembly) require carefully balanced lighting – either high levels of overall illumination or normal illumination enhanced by supplementary lighting on the task. In the first case the reflectance value of the walls should be kept down to between 30 and 40 per cent; in the second case the immediate surround to the task should be suppressed. Areas of visual interest for relaxation are recommended but should not cause distraction; retiring colours are indicated, for example greyish colours of medium tone.
- Tasks requiring mental concentration require cooler colours and as little distraction as possible.
- Processes that generate heat indicate cool colours in the overall surroundings.
- Processes that produce heat, dust or chemical fumes may require special lighting or special finishes which impose limitations on colour. Dust may clog light sources and require stronger lighting to allow for deteriorating

conditions. In some cases oil seepage on the floor may darken the whole environment.

- Shift work. Conditions that are tolerable in daylight hours may alter radically at night.

In general terms, the colour of the walls should not be too cool in any working area or there may be complaints from the workers that they are cold. Large spaces with work locations far removed from the walls can take light colours with little danger of glare.

8.2 Materials used

If the work itself, and the materials used, are coloured and provide variety, keep the surroundings simple. Soft colours will suppress the environment, will not require visual attention, and workers can concentrate better. Cool colours are desirable in the surround if materials are highly coloured, and especially if the materials are warm coloured. Consider also:

- The colour of the light; this is very important.
- The effect of after-image where materials of a distinctive colour have to be examined critically.
- That dark materials stored in a room may absorb a great deal of light.
- A high light level is required for actual colour appraisal, especially where colour-matching light is required; but avoid a cold atmosphere.
- Unpleasant associations between the colour of the materials used and the colour of the surroundings; this is particularly important where food is handled (avoid yellow-greens in such cases).
- If the work is neutral or white, colour introduced into the environment will provide interest; an all-white environment should be avoided since it may cause actual illness.
- Specific materials: food requires particularly careful consideration; the colour of the lighting as well as the colour of the background may be significant.
- Where the materials being worked upon include a good deal of colour, it may be useful to adopt overalls of a neutral hue to prevent too much distracting colour in the environment.

8.3 Machinery and equipment

In any area it is important to consider the machinery used and whether the colour of the machinery might be altered with advantage. Dark machines will absorb a great deal of light; office machines and VDUs require special consideration. Consider:

- The number and location of machines: these will certainly affect the lighting; the direction of rotation and possible effects on the vision of the worker are significant.
- The colour of the machines. Ideally the colour of machine tools and the

like should reflect between 25 and 35 per cent of light, but working planes should have a higher reflectance value in order to concentrate the attention of the worker, reflect light on vital parts, build up greater contrast and visibility, and encourage better machine care; office machinery requires different treatment.

- Vivid colours should only be used to draw attention to hazards or control panels and should not be applied to meaningless objects.
- Equipment. Lockers, storage racks and so on should generally be neutral in colour; grey is recommended but more decorative colours should be considered in offices.

8.4 What the worker has to see

The task can be measured in terms of three characteristics of visibility:

- the size of detail
- the contrast of the detail
- the lightness or reflectivity of the task.

These characteristics affect the amount of light required; the smaller the detail, the more light will usually be required, but too much light may cause too much brightness or glare within the field of vision, and in such cases it may be better to lower the colours of the background and to increase contrast. Consider:

- Detail. If the worker has to see detail on an object, rather than the object itself, supplementary lighting casting a degree of shadow may be the most satisfactory solution.
- Fine detail. The work itself should be the brightest point within the field of view and there must be no distracting glare in the background or in the environment generally; the brightness of the immediate surround should be lower than that of the task.
- Controlling the background. Where the nature of the machinery makes it difficult to control the background, a suitable screen behind the workpoint may be of help.

Colour and light cannot be separated, and the nature and positioning of the light must be carefully studied in relation to the task, with the aim of ensuring that the work can be seen comfortably and clearly. In addition to the amount of light, the amount of brightness and the amount of contrast must be controlled. If there are large areas of dark colour (e.g. because of dark machinery), supplementary lighting may be required. Raising the overall light level to compensate for the darkness can cause glare.

- If mixed artificial and natural lighting is employed, avoid obvious differences between one source and another.
- A balanced light is desirable, but if there is marked tinting of the light, make sure that lights of a different tint do not fall on the same surface. Light of mixed spectral quality falling on the same area will cause all sorts of difficulties. Illumination sources should not be changed without

reference to the colours of the environment, including the colour of the material being worked, and replacement lamps should be of the correct colour.

8.5 The nature of the worker

The make-up of the workforce is also important. If it includes a large number of older people, higher levels of light are recommended; older people require more light to see clearly.

If the workforce is all female, or includes a large proportion of females, warm and bright colours can be recommended, especially if the female workers are engaged in relatively monotonous assembly tasks. In any case, greater attention should be paid to decoration, women react favourably to decorative colour schemes. It is important that both light and colour flatter the appearance of workers, and this is especially the case where the majority are women.

8.6 Safety

Every working area should be critically reviewed for accident hazards and appropriate steps, such as increase in lighting, taken to obviate possible risks.

Standard safety colours should be applied where appropriate, but do not use colour without good reason. Red, for example, is used to distinguish fire appliances, but if the whole area is painted red, no one will be able to find the fire extinguisher. It would be advisable to identify and colour any possible hazards before completing any plans for decoration; the immediate background may have to be altered. Directions and instructions, in particular, should be clearly seen and easily read.

Where there is moving machinery, good contrast between the machinery and the background will help to avoid accidents. Good lighting, lighting at the right place and elimination of glare and excessive brightness are equally important.

8.7 Eliminating glare

Every working space should be critically reviewed to make sure that there is no glare disability in relation to the individual task. It can arise directly from a light source which needs repositioning, from glossy and shiny surfaces in close proximity to the work plane, and from surfaces that are too bright in relation to the light source. Screening the light source may solve the problem, and glossy surfaces can be reduced in value.

Actual observation is usually necessary to ensure that there is no glare within the field of vision of the individual worker, and too much brightness, even without actual glare, will also cause trouble because it will be a source of distraction. It may not be a good idea to have workers facing a light source because this tends to encourage glare; if it is impossible for all workers to face the same way, shielding at the back of desks or work tables will often prevent glare. End wall treatments will also help where there are assembly or inspection operations. End walls should have a reflectance of between 20 and 40 per cent.

9 Physical characteristics

9.1 The nature of the establishment

In addition to the nature of the surfaces, it is also necessary to consider the physical characteristics that may have an effect on those surfaces. These include the nature of the establishment as a whole as well as the features of the individual room or working area. First consider the establishment as a whole:

- Is it offices, an industrial plant, a laboratory and so on, or does it combine a number of functions? An industrial plant will usually include offices, machine shops and other facilities, and although each will require separate treatment, it may be necessary to provide a link between the various facilities or, on the other hand, to distinguish between them. The layout of the various areas may be significant because of the need to adjust light and colour to provide safe conditions when passing from one area to the other.
- What is the nature of the work carried out? It may be purely clerical work, it may be purely manual work, or there may be a combination of different types of work. The dividing line between one function and another needs to be clearly defined. It is difficult to formulate precise rules on this point, but it should be kept in mind.
- What is the location of the establishment; for example, is it in a town, in the country or by the sea? In some areas natural lighting will be adequate during most of the day but in others it may be subject to consistent interruption. In country areas green is provided by nature and to use too much green for working areas might be a mistake. In town, more light and a cheerful environment is indicated. In seaside areas it may be necessary to tone down the walls to counter brightness from outside.
- What are the climatic conditions? This is closely related to the last item. If the location is subject to foggy or cloudy weather conditions, higher levels of light are indicated and higher reflectance values for interiors to provide brighter conditions.

9.2 The aspect of the area

The position of the windows, roof lights and other openings in the individual working area will determine the amount of natural light available, and the location of the establishment may determine the quality of the light, for example whether it is obstructed by smoke, trees, other buildings and so on. These factors affect the extent of lighting and whether colours having maximum reflectance value are required or whether darker colours can be used. Consider:

- Rooms facing south will receive the warmest light and the greatest amount of sunshine. Cool colours are indicated.
- Rooms facing north will be cooler and will need warmer colours.
- Rooms lit naturally from one side require reflected light from the opposite wall, and the colours of the opposite wall should be light.
- Rooms lit naturally from both sides may require modification to equalise light.
- The height of the windows from the floor may dictate modifications.
- Light reflection from exterior objects or surfaces may need to be countered.
- Window walls should generally be in light colours to reduce contrast with the natural daylight, but at night the light wall contrasts strongly with the darkness outside. Some adjustment in lighting may be necessary, and the twilight period can cause difficulty.
- The age of the building may require clearances of dirt, replacing faulty windows or installing new ones before redecoration. Such improvements can have a considerable effect.
- Relationships with other areas are important. The room in question may be closely related to other areas, and if there is frequent movement from one to the other, an abrupt change of colour may cause confusion and even unnecessary eye adjustments.
- Overhead clutter may be a problem in old buildings. See if it can be eliminated.
- Lack of daylight indicates warm colours, especially in windowless areas.

9.3 Architectural features

Each room or working area needs to be considered individually; its shape and size must be related to the work carried out and to the machinery, fittings, equipment and furniture contained within it. Consider:

- Architectural lines. Colour should emphasise the lines, and breaking up surfaces should be avoided if it upsets balance. This may be significant when considering end wall treatment or the provision of visual relief.
- The size of the room. Very lofty areas can be reduced in height by colour changes worked horizontally and the use of greyed colours, although warm colours are better when the area is vaultlike or barren. Large spaces where work is located far from the walls can take light colours with very little danger of glare, but warm tints are desirable. The smaller

room can be enlarged by lighter colours and greater uniformity.

- The nature of the floor. A cement floor which cannot be coloured will look grey, and the reflectance value of the walls may have to be increased to compensate. A generally grey appearance requires particularly warm colours for the walls.
- The origin and nature of the natural light. White is generally preferred around window areas with light colours on the walls opposite the windows. Conditions are reversed at night and additional lighting may be required to counteract the effect of black windows at night. Special care is necessary if there are roof lights.
- Pipes and conduits. It may be desirable to hide these as far as possible and to emphasise the natural lines of the architecture. Indiscriminate colouring for identification purposes may cause unnecessary disturbance and coloured patches may be better.
- The relative area and position of the furniture and equipment. Storage and shelves around the walls may have to be coloured appropriately to adjust the overall effect. Dark machinery and fittings absorb a great deal of light and may benefit from repainting. The colours of furniture should be selected to fit in with the overall scheme; the position of VDUs requires careful thought in offices. These points are especially important in new buildings.
- The type of lighting, its direction and effects. This needs to be related to the shape and layout of the area and to the nature of the work performed.
- Overhead features should not be coloured since they are distracting.
- Contrasts between walls and equipment should be suppressed; they cause restlessness.
- Dados may be finished in darker colours than the upper walls, but this treatment should only be used in high rooms.

10　Specifying colour for productive environments

10.1　The specification

Up to this point certain broad principles for the application of colour have been formulated, based on the reflectance value of colours that are most appropriate in achieving the ideal productive environment in an individual room or working area, modified by the differing requirements of specific areas and by the nature of the task and certain other factors.

To apply these principles to the selection of actual hues requires a great deal of careful study and research, not only in general terms but also in relation to specific environmental applications. It is necessary to study what colour has to do, what it can usefully do and how it can be used to best advantage. It will be self-evident that before planning the decoration of any interior it is necessary to study the nature of the environment, the nature of the lighting, the colour and nature of the plant, tools, equipment and furniture used, all of which have a relationship with the environment; together with the nature of the operations performed and the materials used.

In most productive situations there are comparatively few colours which will have the right characteristics for the environment in question. These characteristics, and the practical limits permissible, have to be discovered before attention can be directed to other factors, such as appearance and the likes and dislikes of people.

There should be a simple co-ordinated plan, or specification, for each situation, partly to avoid the use of too many colours and partly to obviate arguments and second thoughts. Colour can quite easily be overdone and this is worse than no colour at all. Individual choice should be replaced by a study of the needs and desires of the worker. It is far better if colour is planned well in advance before decoration takes place. The purpose of the specification is to establish a basis for the application of colour on the lines set out in previous chapters. It is not possible to write a specification which is applicable to any and every productive environment; each area has to be considered individually.

The colour needs of an environment, or of any end use within the environment, derive from physiological, psychological and optical factors and may usually be specified fairly exactly in terms of reflectance values, but choice of the actual hues depends on other considerations.

318

10.2 Preparing the specification

Before preparing a colour specification for a specific area it is necessary to consider the establishment as a whole because this may have an effect on the colours to be employed in a specific area. The sequence of steps is as follows:

1. Consider the establishment as a whole and what effect this may have on the area under consideration.
2. Consider the various aspects of the area and the effects that these may have on choice of colour.
3. Consider the architectural features of the area.
4. Fix reflectance values for each main surface.
5. Consider the brightness ratio of the area as a whole and keep within 5 : 1 if possible.
6. Consider the desirability of end wall treatment.
7. Consider any adverse factors that may require special consideration.
8. Modify the selected reflectance values according to the function of the room.
9. Modify according to the task carried out.
10. Decide which colours can be warm and which cool.
11. Select actual hues.

The reflectance values suitable for each of the main surfaces can be summarised as follows:

Ceilings	Almost always white, but if colour is used it should have a reflectance value in excess of 75 per cent.
Upper walls	To a line level with the roof beams or truss; 50 to 60 per cent if floors and equipment are dark; 60 to 70 per cent if floors and equipment are light; higher values are only practicable with good lighting.
Lower walls	If the dado is used to camouflage stains, it would be preferable to use darker tones of the upper wall colour. Reflectance value about 40 per cent, but this figure could go down to 25 per cent if staining is severe.
End walls	Treatment in medium tones to provide variety and relaxation. Reflectance value 25 to 40 per cent. Ideal figure is about 35 per cent.
Equipment	Between 25 and 45 per cent, but 35 per cent is ideal.
Floors	Ideal figure is about 25 per cent.
Machinery	According to type but usually between 25 and 35 per cent.
Critical seeing tasks	Wall tones should be suppressed; 40 to 50 per cent, but even down to 30 per cent if extreme concentration is necessary; 20 to 30 per cent for end walls.

In deciding whether upper or lower limits of reflectance value would be most appropriate, consider the following points.
Use lower reflectance values (darker colours):

- in lofty areas which would otherwise look bare
- to make an area look smaller
- for dados and lower walls
- in laboratories
- in light-assembly shops
- where critical seeing tasks are performed
- for end walls in light offices
- for areas where mental concentration is necessary.

Note: Where dark colours are used, some additional lighting may be necessary, and supplementary lighting will be required for critical seeing tasks.

Use higher reflectance values (lighter colours):

- opposite windows and for window walls
- where the natural light is obstructed
- where manual work is performed
- in areas where there is much movement
- for corridors and staircases
- for walls and partitions where cleanliness is important
- in large areas, provided there is no danger of glare
- to make areas look larger and lend distance
- to eliminate shadows in dark areas
- for entrance halls
- in areas where monotonous work is performed
- in storerooms, libraries, drawing offices, restrooms and canteens.

The next step is to decide whether warm or cool colours are required. A list of those situations where warm colours may be used with advantage will be found under the subheading of Working interiors in subsection 2.2 of Part III, and a similar list relating to cool colours will be found in 2.3 following it. In general, colours in working areas should not be too cool and retiring; warm colours are better because they have a strong psychological effect in creating an acceptable atmosphere and temperature.

10.3 Selecting the hue

The result of the operation to date should have been that the colour for each surface of the area under consideration has been specified in terms of reflectance values, and it should have been decided whether a warm or a cool colour should be chosen. It is now possible to select actual hues.

Colour trends in the sense of consumer preferences are not important; hues should be chosen because they contribute to better working conditions. A degree of fashion or personal preference is permissible in executive suites and reception areas, and there are also broad trends in the usage of colour, particularly in the office, which should be considered. For example, there is a broad trend towards brighter colours and more variety in the office, encouraged by higher lighting standards and a realisation that dark colours absorb expensive

light. Failure to give weight to such trends may create an unfavourable impression.

The first step is to consider the various characteristics of colour and how they may help to improve conditions in the environment.

Example 1 The appearance of workers is an important factor in achieving a comfortable environment. Choose hues, having the right reflectance value, which flatter appearance.

Example 2 Certain materials have an association with certain colours – blue associates well with food – and the colour of the material being worked upon may be a significant factor in choice.

Next consider the various colour modifiers and whether they may be significant in a particular case.

Example 3 When the material being worked is highly coloured, trouble may arise from after-image, and it may be necessary to adjust the hue of adjacent surfaces to prevent discomfort.

Example 4 No colour choice should be finalised until it has been seen with the colours that will be adjacent to it; colours change in appearance when seen in juxtaposition.

Once these operations have been completed, it is possible to make sure that the environment is pleasing to the workers, as well as providing good seeing conditions. No productive environment requires expensive interior decoration, but the specification should allow for some variety and colour appeal, although the colour should be used for important, rather than unimportant, things as far as possible. Colour is always more compelling than neutrality.

The functional use of colour does not necessarily mean that the likes and dislikes of workers should be overriden; there is plenty of room for creative effort within the broad lines dictated by the specification.

The nature of the decoration will depend on the function of the area and what people do within it – for example, whether they stay a long time or a short time; whether the decor should be dramatic or restful. It will depend on the shape and proportions of the area, the mood desired and the feelings to be encouraged. Here there is room for creative effort. Make sure that people who have to live with any decorative scheme are made happier by it; staff work better when their surroundings keep them relaxed but aware, and care taken with decoration brings a bonus in better staff relations, better output and better atmosphere. The decor of any environment affects people in many ways, and adverse factors should be eliminated as far as possible.

Example 5 Peeling walls make people feel uncared for; unimaginative colours produce uninspired work; harsh, shiny surfaces create an impression of prison.

Pay attention to colour harmony, and the following points are also worth

considering:

- Aim at variety in walls and furnishings, but do not overdo it.
- Plan for variety and not monotony.
- Avoid overstyling.
- Avoid intense colours, particularly in small rooms.
- Remember that surface finishes affect colour properties; matt finishes are recommended to avoid glare.
- Consider the appearance of surfaces in both daylight and artificial light.
- Keep the number of colours to a minimum to reduce costs, but there is no need to have every room exactly the same.
- One overall colour throughout an environment is sterile; this applies particularly to white.
- An element of pattern or texture can provide variety.
- Strong, pure colours are best avoided except as points of emphasis.
- Strong colours can be used in moderation for accent purposes, so long as they do not distract workers.
- Avoid a 'busy' effect.
- Subtle shades provide a more comfortable environment.
- Greyish tones are less aggressive and distracting.

Once a specification has been drawn up for each area and suitable hues have been selected, it will be useful to review all specifications and, by a process of compromise and elimination, to reduce the number of variations as far as possible. One of the objectives of a systematic approach to colour is economy; that is, to cut down the number of different colours used and the number that have to be stocked for maintenance purposes.

The reflectance values that have been suggested are approximate, and it is seldom necessary to apply critical standards to choice; thus, if the required reflectance is 55 per cent, a hue having a value within, say, 5 per cent either way would be perfectly acceptable.

10.4 Checklist

The following checklist is intended to help in the preparation of a colour specification for an individual room or productive working area and lists the points that should be reviewed. The list does not claim to be exhaustive, and the whole subject should be approached from a commonsense standpoint.

- The nature of the establishment
 Type Office, factory and so on.
 Nature of work Clerical, manual, differences.
 Location Town, country, seaside.
 Climatic conditions If applicable.
- Aspects of the area
 How facing South, use cool colours; north, use warm colours.

How lit	From side, both sides, roof.
Windows	Extent, height.
Exterior objects or surfaces	Possible reflections.
Window walls	Nature, light colours.
Daylight	Extent; warm colours if little daylight.
Cleaning	Need for cleaning.
Adjacent areas	Relationship, effect on light and colour.

- Architectural features

Lines of room	Possible effects on decoration.
Size of room	Need for warm or cool colours.
Origin of natural light	Effect on lighting generally.
Pipes and conduits	Whether and how to be coloured.
Overhead features	Whether to be hidden.
Position of furniture and plant	Effect on lighting.
Contrasts	Need to suppress.
Dado	Darker colours for lower part of wall.
Floor	Existing colour and whether it can be altered.

- The nature of the space

Ceilings	Generally white.
Walls	Average reflectance 50 per cent, activity in area, walls opposite windows.
End walls	Whether treatment required, function.
Floors	Type of floor covering, use of pattern, effect on light.
Furniture and fittings	Average reflectance 35 per cent, relate to walls, pleasing, practical accents.
Machinery	Special consideration.
Contrast	Plan for ratio of 5 : 1.

- The function of the space

Reception	Image of the organisation, display.
General offices	Outside environment, appearance of workers, nature of work.
Executive offices	Fashion, individuality.
Boardroom, etc.	Conducive to decision-making.
Libraries	Cool, good light.
Drawing offices	Neutral, good light.
Storerooms	Light colours.
Machine shops	According to plant and work task.
Washrooms	Good light.
Rest rooms	Relaxing.
Canteens	Cheerful.
Staircases, corridors	Good light; soiling; safety.
Doors	Identification.

- The task

Work performed	Manual, sedentary, monotonous, critical seeing, mental concentration, heat

	generation, fumes, shift work.
Materials used	Colours, colour matching.
Machinery and plant	Detailed requirements.
What the worker has to see	Size of detail, contrast of detail, reflectance of task.
Working plane	Colour of the working plane and of its immediate background.

- Other factors

The worker	Age composition, proportion of females/males, appearance.
Safety	Hazards, safety colours, machinery.
Glare	Sources, means to eliminate.

- Relationships
 Overall surround to task
 Immediate background to
 the task
- Lighting

Daylight	How much daylight, effect.
Direct lighting	Intensity, effect.
Indirect lighting	Intensity, effect.
Localised lighting	Intensity, effect on task.
Colour of light	Colour-rendering qualities, effect on appearance, effect on materials, effect on surrounding colours.
The task	Size of detail, speed of perception.
The worker	Age composition, appearance.
The surround	Optimum light level.
Cost	Optimum economic benefits.
Glare	Eliminating and controlling glare.
Food	Possible effects of light on appearance.

- Specification
 Reflectance values for each
 main surface
 Warm or cool colours
- Selection of hues: colour modifiers

Adaptation	The key to good seeing.
After-image	Coloured materials may cause problems.
Colour blindness	Consider possible risks.
Contrast	Avoid sharp contrasts.
Juxtaposition	Adjacent colours may have to be modified.

- Selection of hues: colour attributes

Appearance	Use colours that enhance human appearance.
Associations	Colours should not have any adverse associations with materials.
Mood	Consider where appropriate.
Recognition	Use colours most suitable for marking hazards, signs and controls.

Regional	Use hues appropriate to location.
Sex	Appropriate consideration in some circumstances.
Size	Use colours appropriate to task size or room size.
Visibility	Consider where appropriate.
Warmth	Consider warm and cool colours.

- Selection of hues: colour functions

Camouflage	Avoid colours that camouflage hazards; use colour to camouflage soiling.
Coding	Use colour where appropriate.
Pipeline identification	Use appropriate colours where applicable.
Readability	Where legibility of instructions is important.
Temperature control	Use colour to achieve equable conditions.
Visibility of controls	Consider carefully.

- Selection of hues: colour applications

Biological	Consider where appropriate.
Food	Consider all aspects of colour in relation to food.
Safety	Consider all safety implications.
Signs	Make sure identification is clear.
VDUs	Consider implications.

- Decoration

General rules	Use colour to encourage good housekeeping, to avoid monotony.
Harmony	Study the rules of harmony.
Identification	Use colour to identify departments, and so on.
Atmosphere	Aim for atmosphere pleasing to the workers.

- Finally

Revise, refine and compromise where necessary.
Aim for minimum number of colours.
Enforce standards.

11 About selling environments

This Section is concerned with the use of light and colour to attract the general public and ensure their goodwill, thus achieving better merchandising and increased sales. The welfare of those who work in a selling environment is a secondary consideration, although still important.

A selling environment may be defined as one that is designed to attract the public and ensure the sale of merchandise at a profit; it includes shops, stores, catering establishments and other places whose primary function is to make a sale, whether of goods or services. Banks and other establishments which sell a service have a productive function as well but must still be pleasing to those who use them.

The function of colour is to help create an ideal environment which will ensure maximum sales and profitability, which will create the best possible conditions for customers and staff, and which will also be safe in the sense that hazards are properly marked. The environment should also contribute to the image of the company or organisation concerned. Colour is not the only factor in achieving the ideal selling environment; suitable equipment is also necessary, and it may be wise to point out that however much trouble is taken with the appearance of any establishment, that trouble is wasted if the goods or services do not appeal to the customer. These pages are concerned with three important factors:

- Design The overall design of the establishment.
- Lighting The vital factor that enhances the design and ensures that merchandise is seen; without it there can be no colour.
- Colour This helps to control the light and make it more effective, makes the design more attractive and helps to display the merchandise to best advantage.

None of these basic factors can be considered in isolation; they are all interdependent and together they constitute the stage on which display and merchandise experts plan their production of sales and profits. Design is a wide subject and can only be mentioned briefly in this book, which is primarily concerned with light and colour. However, it cannot be left out altogether.

12 Ideal design for the selling environment

12.1 The importance of design

The first of the factors which contribute to an efficient selling environment is the design of the establishment, and although this book is primarily concerned with lighting and colour, it is necessary to say a few words about design in order to identify the factors that affect choice of colour.

To make any profit at all, any establishment concerned with selling must attract customers. To make reasonable profits it must achieve the greatest possible customer satisfaction thus ensuring that the customer comes again and recommends others. To ensure maximum profits the establishment must create optimum sales by all the means open to it, including display of the merchandise to best advantage. Even in those establishments where the profit motive is less vital, such as canteens or institutions, there is still the same need to achieve customer satisfaction in order to justify their existence. Similar remarks apply to such establishments as banks, which sell a service rather than merchandise. The design of any selling establishment has four basic aims:

- to attract the attention of potential customers
- to ensure that potential customers enter the establishment
- to ensure that customers are happy while they are there
- to ensure that customers see the merchandise on offer to best advantage (or are made aware of the service), and buy it.

If these four aims are satisfactorily achieved, there is a reasonable supposition that the customer will leave with a feeling of satisfaction and will come again. Obviously, the quality of the merchandise, the price, the service and the degree of comfort will be contributory factors, but for the moment we are only concerned with lighting and colour. The way that the target is achieved will, of course, depend on the nature of the establishment, its location and class of trade, but certain basic requirements will be the same in all cases.

There is comparatively little published information about the use of light and colour in the selling environment because this has usually been considered the province of the interior decorator or specialist designer, and thus for the creation of individual creative ideas. However, there is a good deal to be said for basic principles which reflect the likes and dislikes of people at large. High-

style ventures which ignore sound principles of colour usage do not always achieve what their creators expect.

12.2 Design principles

The design of a selling establishment may be likened to a stage design, and while colour is one of the most effective tools of the designer, it is not the only one. Lighting, texture, fittings and so on are equally important. The major problem is deciding how the stage is to be set. The organisation of space, lighting, texture and colour requires the skills of experts, but management must set its character by formulating a policy for the establishment. Providing a brief for the designer is the point at which things often go wrong, usually because management has no very clear idea of what it wants. There may be a clearly enough thought out merchandising policy but very little idea how to make the best use of space or how to present the merchandise to best advantage.

Each establishment presents an individual problem, and unless management can convey a reasonably clear idea of what they require, the results may be disappointing. Design is as much part of the merchandising operation as the choice of stock. The establishment must appeal to, and cater for, and stimulate the most profitable potential in its specific location, and before preparing a design brief it is necessary to identify the type of customer in that location, the class of trade, the surroundings, probable developments in the area and the nature and extent of competition. In the great majority of cases careful research is desirable.

Any selling establishment is a package that must be sold to the public just like the package that appears on the shelves, and the final shape of the package is determined by the function of the establishment. Colour and decoration are an integral part of the design but must be appropriate to the type of trade and the merchandise carried. Selection of colour must be governed by the dominant colour of the merchandise.

Any establishment must be an invitation to enter, to see and to buy, and the whole designed to give the merchandise or service offered a strong visual impact which will enable people to identify themselves with the concept. Making a sale is the climax to a series of calculated steps. The sales philosophy that achieves this aim should try to make potential customers feel that they are virtually in the establishment as they pass along the street, but they must also be drawn inside and encouraged to buy or to partake of the service offered. Inside the establishment the space must be so arranged that customers can circulate freely, stand around and make their buying decisions.

The design brief must define the sales policy to be adopted and cover such factors as the degree of self-selection, the siting of fittings, the lines of circulation, the amount of daylighting, the visibility of the interior from the street and other factors of a similar nature. The total design should be flexible so that the arrangements can be altered when necessary to cope with fluctuations in demand, special offers, special promotions and the like.

Individuality is an essential feature of any successful establishment and the whole must reflect the image of the organisation concerned or, in the case of

the individual trader, the image that is desired. Design is an essential contribution to this individuality provided that it is based on sound economic principles at a fundamental level. Design is more than just a face lift and requires expert knowledge of selling to the public.

Design and decoration cannot entirely be governed by personal preferences because the ideas of individuals are not necessarily shared by the mass of customers. Too much creative effort may lead to results which are strange to the majority of people. The ideal would be to provide a common denominator of public taste which does not destroy the individuality of the establishment. This is difficult but not impossible. Successful design rings the bell on the till. If it does not do so, it is not good design.

Summary

Design must:

- reflect merchandising and marketing policy, which must be decided at the outset
- be appropriate to the location of the establishment and the class of customer that it is desired to attract
- be appropriate to the type of merchandise sold or the service offered
- persuade people to identify themselves with the establishment, draw them inside and encourage them to stay
- facilitate circulation within the establishment, create an impact and encourage a buying mood
- create the character of the establishment and give it individuality.

12.3 Attracting attention

The first aim of the management of any selling establishment is to attract the attention of the passer-by so that the latter is impelled to stop, look and ultimately to enter the establishment; in simple terms this means an attractive shopfront and, in appropriate cases, a good window display. It is difficult to generalise about this particular aspect because establishments vary in location, nature and class of trade. Design, decor, colour and lighting all have a part to play, and overall appearance is just as important as detail.

In the first place, every establishment has a civic and moral duty to contribute to the appearance and well-being of the neighbourhood, and the overall design of any establishment should be compatible with its surroundings. In many cases planning regulations will impose some sort of standard, but even without this constriction an establishment that was radically out of line with its surroundings might well lose goodwill. An 'out of the ordinary' decor or exotic colours may attract passing customers because of their novelty effect, but a novelty effect soon wears off; in the long run the decor may frighten away more people than it attracts. Any establishment which depends on the mass market, or on a regular trade, must find a common denominator which will please as many people as possible; a pleasant decor together with well-liked and sensible colours will make people feel at home.

That being said, there is also the commercial aspect; the exterior must make an impact on potential customers with the eventual aim of the total profitability of the enterprise. To achieve this aim the potential customers must be attracted, must respond favourably to what is seen and then must be able to examine the merchandise easily and with confidence, or in appropriate cases appreciate the nature of the service offered.

A main-street establishment will usually seek to attract the attention of the passing customer with a bright exterior display which catches the eye, compels attention and invites the viewer to stop and take another look. Brightness is enhanced by a combination of strong illumination and plenty of colour which helps the display to stand out from the visual attractions surrounding it and which also sets the atmosphere that the establishment wishes to create. Some establishments, and particularly catering outlets, may wish to suggest a discreet environment, and they will tone down the exterior appeal and possibly use more restrained colours.

The modern concept of design often combines the front and interior into a complete display unit, and this needs particularly careful planning of light and colour at ground level. Although this concept applies more to shops than to catering outlets, it is important in both cases. People in a strange town or city can often be seen cupping their hands around their eyes to peer into the interior of a shop or restaurant to see what the inside looks like. First impressions are vital, and the quick, initial reaction will attract or repel trade, depending on the emotions of the individual. Colour can play a large part in creating a good initial impression because it is an emotional thing.

Vision is the dominating influence in creating the right impression. An object, or a surface, cannot be seen until it is lighted and, having been lighted, must then appeal to the emotions, and it is here that colour adds an extra dimension. An establishment in a drab situation where little sunshine penetrates can create a strong impression of the interior by a blaze of brilliant light and colour.

Summary

Design which is aimed to attract attention must ensure:

- that the establishment is compatible with its surroundings
- that the exterior makes an impression on potential customers
- that the impression of the interior from the outside creates a desire to enter.

12.4 Keeping the customer happy

Having attracted the attention of potential customers and persuaded them to come in out of the cold by suitable treatment of the exterior and entrance, the next objective is to ensure that the customers are happy while they are in the establishment; this encourages them to stay a while and to spend money. The physical convenience of the establishment is largely a matter of architectural design and planning and has little relevance to the present subject, although

ease of movement is tied up with the use of light and colour and is described below.

What is relevant in the present context is ensuring that the appearance and the ambience of the establishment are pleasing to customers and make them feel at home or, at least, at ease. What will achieve this objective depends very largely on the class of trade and what customers expect to find. The class of trade is particularly important and falls basically into two categories, the sophisticated market and the mass market, although there are many subtle gradations between the highest and the lowest levels.

The high-grade market, catering for a sophisticated clientele, requires that appearance and ambience be treated with a marked degree of individuality and customers are unlikely to patronise an establishment unless this is done. In mass markets, catering for average people, sophisticated treatment will frighten people away. Average people like what everyone else likes; they are more emotional in their reactions, they are more conservative and, by and large, they do not have gaudy tastes. Human taste is, on the whole, simple, and a subtle decor which appeals to the sophisticates would have an adverse effect on the great majority.

Whatever the class of trade, a well-designed decor and elegance and comfort will all help to create a good selling atmosphere and make a favourable impact on the customers. When prices are similar the establishment with a comfortable image has the highest sales and not the establishment with an exotic image. An exotic style may well jar the nerves and offend the simple tastes of the public; it is contrary to what they understand and expect.

One commentator has complained that most selling outlets represent a compromise between cost, function, appearance and mass production, and the customers are processed rather than served. The desire to attract maximum returns from every cubic foot of space distorts many outlets out of all proportion. There is truth in this complaint, and while there can be little objection to seeking maximum profits, these can be achieved by ensuring that the environment appeals to customers and does not treat them as ciphers.

To ensure an appealing environment the most important element is the total visual image, that is the treatment of the major surfaces such as walls, ceilings, floors and fittings and their brightness relative to each other. It is this brightness which attracts customers and ensures active movement; this does not always mean that a high overall brightness is required. It would be suitable for, say, a staff canteen, but a sophisticated boutique would require a much lower level of overall brightness, but plenty of light in selected areas and plenty of variety – never gloom. Even when there is high overall brightness it must be controlled and glare avoided at all costs; glare frequently arises from the size and positioning of the light source but may also arise from badly planned or too glossy surfaces.

Keeping an area free from glare does not mean making it sterile and uninteresting. In any environment which has a selling job to do, a degree of visual variety and stimulation is essential; while glare is unwanted, scintillation is welcome. The sensible use of colour helps to control glare and provides variety.

Ease of movement within an establishment is vitally important; it should be easy to progress from the doors to the most remote area and to be able to find,

and to recognise, that which is sought, whether it is merchandise or the location of the bar. Ease of movement is partly a matter of design of circulation areas, but the treatment of the ceilings and the colour of the floors will help to direct traffic and increase sales. Lighting also has considerable effect because people tend to congregate in brighter areas and to leave less well lit extremities more or less deserted. Ease of movement is facilitated by good signposting and clear direction; the planning of displays will also help the process.

Most managements wish to create an atmosphere appropriate to the type of establishment and the customers that it is desired to attract. Larger establishments may want to cultivate a house style, but there should always be a degree of individuality. A suitable decorative scheme must be planned for each location by careful use of colour, light and texture. Customers of today are used to being wooed and catered to, however much they may complain about hard selling, but they have to be treated with taste and discrimination; colour is the perfect tool for this purpose and can assist in providing the right atmosphere.

Summary

Design which is aimed at keeping the customer happy must ensure:

- that the establishment is as convenient as possible
- that the appearance and ambience are pleasing and that customers feel at ease
- that there is ease of movement and a sense of location
- that an appropriate atmosphere is created and maintained.

12.5 Ensuring that the customer buys

The ultimate objective of attracting people into any selling establishment is to ensure a sale. In the case of an establishment selling a service, such as hotels or banks, people buy comfort or facilities to carry out some operation, but in most selling establishments the objective is to sell goods. Therefore the fourth aim of design is to ensure that the customer sees the goods under the best possible conditions and is impelled to buy them. This aspect of design is usually called merchandising or display; it includes well-planned use of light and the employment of colour to control the light and enhance the appearance of the goods.

In modern times most goods are sold by effective display; it is vital that management should see merchandise through the eyes of prospective customers and should use common sense. The principles of retail merchandising are beyond the scope of this book, but it is worthwhile to point out that no amount of creative effort will be justified if the customer cannot see the objects clearly displayed or if he or she cannot understand what the display is intended to convey.

Merchandising design is like setting the stage for a production in a theatre, with the added complication that the audience is always on its feet and in constant motion. Furthermore, a typical selling environment may consist of a dozen or more stages, each with a different part to play, although with a connection between all of them. The focal displays that start in the window must be

continued at each point where sales take place, or the urge to buy may die in the entrance area. This point provides particular difficulty in catering establishments where each table or serving point is a stage all of its own.

On the merchandising stage the actors are the goods on display, the principals are the displays themselves and the chorus may be made up of long lines of competitive merchandise, such as bottles. The fixtures are the scenery and are usually standardised, although the merchandise displayed may vary from week to week. The stage must be set in such a way that the displays attract attention, enhance the appearance of the merchandise and invite action, that is purchase.

Around the displays are the walls, floors and ceilings, and the lighting, colour and texture of the whole environment must be designed with the displays in mind. The overall lighting is an essential aid to good display as a whole, but each situation needs its own lighting and colour arrangements to ensure that the goods displayed can be seen to best advantage and in their true colours. The background is equally important because it must not attract attention away from the displays. The nature of the background can often be used to direct traffic and improve flow by identifying specific displays.

Good merchandising and display require creative skills and do not lend themselves to ready-made solutions, nor is it possible to formulate rules that apply to every situation. A display may be built around specific merchandise in a specific environment.

Summary

Design which will ensure that the customer buys must:

- enable the customer to see the merchandise
- ensure that the customer sees under the best possible conditions
- ensure that the customer understands what is seen
- make certain that the environment enhances the display
- make sure that the lighting is adequate
- use colour to enhance the display.

13 Ideal lighting for the selling environment

13.1 The function of lighting

The primary purpose of lighting in the selling environment is visual communication, and the function of light may be summarised as follows:

- It should invite customers to enter the establishment.
- It should help to control circulation within the establishment; people are subconsciously attracted to areas of higher brightness.
- It should create visual comfort and atmosphere.
- It should convey information; making it easier for people to see where they are going, read labels and so on.
- It should help to set off the goods to best advantage.
- It should contribute to an attractive overall effect.

Lighting and colour should be planned in such a way that they attract customers and ensure that the customer buys, thus creating optimum profits. The lighting installation in a productive environment also contributes to profits by way of better productivity, but the task performed by lighting in the selling environment is more complex and includes pleasing the customer as well as ensuring satisfactory conditions for workers and enhancing the appearance of merchandise.

Light is essential in any selling environment because without it the merchandise cannot be seen, but it is more difficult to formulate broad rules because so much depends on the design of the establishment, the nature of the trade and the type of merchandise sold. No lighting can be planned until the interior design has been decided and the sales policy formulated. Lighting is a vital part of the marketing and merchandising function.

The main aim of any selling environment is to sell merchandise or services, and the eye is a vital factor in this process. Consequently there must be enough light for the eye to perform its function adequately, including recognising objects quickly and accurately. However, a lighting installation which reveals objects to maximum advantage does not necessarily produce an emotionally pleasing atmosphere, and some compromise may be necessary; this is particularly the case in catering establishments where the service aspect may be more important than actual products. In addition, of course, lighting must also con-

tribute to safety and perform other useful functions such as conveying information.

Lighting is part of the total image of the establishment and should help to release the selling potential of the outlet, of the merchandise and of the staff. Even where the merchandise is a secondary consideration, as in hotels, lighting helps to create a welcoming and friendly ambience and to reassure the public.

The first function of lighting is to attract attention to the establishment, and this is most easily achieved by increasing light levels, although not at the expense of quality. Brightness designed to attract attention must not become glare, nor must it attract attention away from merchandise. Having attracted attention, the lighting must then persuade people to enter and guide them from department to department. It must also persuade them to approach individual counters or selling points and guide them to the articles or services on sale in such a way that they can examine them under conditions which will facilitate sales.

The lighting must help to create a pleasing atmosphere and make the environment welcoming and cheerful; the light must be reasonably flattering to those using the area, including the staff. A good selling environment should be:

- pleasing in the quality of illumination
- pleasing in the overall character of the environment
- pleasing in the dramatic emphasis of the merchandise at point of sale.

The level of lighting should be sufficiently high to ensure that people can see clearly, read labels easily and appreciate colour and texture, but at the same time people should be able to find pleasure in what they see. This is particularly important in catering establishments which are selling comfort, convenience and a sense of luxury as well as good food; the quality of the light will determine whether customers are impressed, shape the atmosphere and have an effect on staff morale.

The principal difference between lighting in the selling environment and lighting in a productive environment is that in the former case it is necessary to find depth and character in what is seen. Fluorescent lamps will generally be used for overall overhead lighting but will not provide sufficient sparkle without supplementary filament lighting to provide highlights. Above all, the lighting must be economical; there is no point in increasing light within an interior beyond the point necessary to display the merchandise to best advantage.

13.2 Attracting attention

One of the principal functions of lighting is to attract attention to the establishment and thereby induce people to enter. What attracts attention in the first place is the lighting of the exterior, and particularly the lighting of the shop window if there is one, although a brilliant sign may be all that is required to trigger action. Although this function may be no more important than other functions of lighting, it has to be discussed first because unless people notice the establishment they are unlikely to come in and most of the other functions will be unnecessary.

The exterior of any establishment is part of the image of the business, and this must be protected at all costs, therefore exterior lighting generally must be linked with the surroundings. Broad levels of lighting in the district establish a background against which a particular installation can be judged; a general raising of exterior lighting levels may improve the appearance of the area as a whole, but on the other hand, excessive lighting may create a false image; in any case, possible future rivalry should be considered.

As a general rule, brightness attracts the eye and dimness is passed by, but the pattern of brightness must be carefully planned to set the scene to best effect and support marketing policy. Where there is a shop window, brightness in the window will attract attention because it stimulates visual and emotional response and triggers action, but if there is no shop window, there are various alternatives available, ranging from floodlighting of the exterior to moving displays. However, the nature of the establishment may dictate restraint, and it may be sufficient to make the main entrance the focal point of brightness, backed up by a brightly lit reception area. The highest brightness within the field of view should be that to which it is desired to draw attention; in the case of a store, that will normally be the merchandise in the window, but in other cases it may simply be the fascia, the title of the business or a sign.

A sharp distinction has to be drawn between retail environments and catering environments because the means used to attract attention are quite different. In the first case the lighting of the shop window is important because, in addition to attracting attention, the windows encourage examination of the merchandise displayed and promote a desire to buy; the brighter the window, the greater the attraction, within reason, although the window must always remain an integral part of the establishment as a whole. With catering establishments it is unusual to have a shop window in which goods are displayed, and some other means of attracting attention must be found.

Careful thought needs to be given to the difference between daytime and night-time conditions. While good lighting may attract attention at night, it may have less effect in daylight, and colour can be the principal attraction during daylight hours.

Coloured light is sometimes used to illuminate the exteriors of buildings at night, and this often serves to distinguish one establishment from another near by. Various types of lamp can be used for this purpose. For example:

- Low-pressure sodium lamps produce orange
- High-pressure sodium lamps produce pale orange
- Mercury lamps produce blue-white
- Metal halide lamps produce blue-green
- Fluorescent tubes can produce blue, green, red or yellow
- Filament lamps with filters can produce red or yellow, but not blue.

Exterior lighting is worth a great deal of thought and planning. Good lighting is one of the cheapest forms of advertising despite high energy costs; any establishment has to be lit and it is no more expensive to light it to maximum advantage.

Summary

When planning lighting that will attract attention, consider the following points:

- What has to be lit, the exterior as a whole, the shop window or what?
- What is the level of lighting in the surrounding area? Can it be raised? Is it likely to alter in the future?
- Where is the point of maximum brightness? The entrance, the window, the fascia, the sign? Or should the whole exterior be floodlit?
- What effect does the nature of the establishment have?
- What attracts attention during daylight hours and can this be emphasised at night?
- Are coloured floods worthwhile?

13.3 Controlling circulation

Controlling circulation means, in effect, making sure that potential customers who have been attracted by the exterior of an establishment, and persuaded to enter it, do not lose interest once they are inside. The interior lighting should be planned in such a way that they are drawn in either by the physical arrangement of the lighting or by the atmosphere that it creates.

In practical terms, the first step is to ensure that the lighting levels just inside the entrance are reasonably high so that the eyes of customers can easily adapt as they come in from the light outside. If the light level is too low, the eye may take so long to adapt that the customer loses interest. This applies particularly to daylight hours and is less important at night when the eye will already be dark-adapted; it reacts more quickly to brightness than it does to dimness.

The second step is to define the limits of the establishment. People generally like to see the limits of space, and light coloured walls will satisfy this requirement, but where the walls are covered in stock, as in some retail establishments, display lighting will help to delineate the area. Perimeter lighting will also assist customer circulation and can be achieved by washing the walls with softly diffused light.

Once beyond the entrance area patterns of brightness should be planned to channel the progress of customers; these patterns have a definite, if subconscious, effect on customer movement, and their nature will depend on the type. of establishment; the table lighting of restaurants is one example and supplementary display lighting, creating pools of brightness, achieves the objective in a store. In the latter case the pools of brightness persuade customers to investigate, but in very large areas the light must come from above.

The first impression that the customer forms of an area counts for a good deal; the impression created when the area is viewed from near the entrance should surpass the expectations raised by the exterior. The nature of the impression should reflect the image that it is desired to create and which is suggested by the exterior; this image will be brash and cheerful in some cases, luxurious and restrained in other cases. The former is created by bright, diffused lighting planned to provide an exciting effect, while the latter is created

by placing the emphasis on the merchandise in the case of a store or on, for example, the tables in the case of a restaurant. A dark, neutral decor makes the customer unaware of the surroundings and concentrates all the emphasis on certain features, but this has risks; it needs careful planning because an area that is too dimly lit may lose sales – when the eye is dark adapted, all sense of colour is lost.

In a small establishment a bright rear wall will not only improve the appearance from outside but will also act as a magnet which will draw people in to examine the whole. If vertical surfaces are emphasised by light, visual emphasis shifts towards them. This strategy can also be used to direct attention to a specific area and conveys a sense of spaciousness. Vertical brightness patterns can be manipulated to create atmosphere.

Summary

When planning lighting to control circulation, consider:

- higher levels of light within the entrance area
- definition of the limits of the establishment
- the pattern of brightness; use the brightness to channel the progress of customers
- the impression that it is desired to create (e.g. excitement, luxury, etc.)
- where the emphasis is to be placed (e.g. on displays, etc.)
- the brightness of walls, particularly the rear wall.

13.4 Creating atmosphere

Giving an appropriate impression to the customer entering a selling establishment is one thing, but persuading the customer to stay and to come again depends on the atmosphere or feeling within the establishment. It is not enough for customers to be able to see clearly; they must be inspired to find beauty and pleasure in what they see. In other words, the selling environment should not only be attractive in terms of design but it should also be visually comfortable and should awaken a response in the minds of observers. This response is partly influenced by the type of lighting employed and the way that it is used.

First, there should be visual comfort; as a broad rule this depends on the level of lighting – brightness attracts the eye whereas dimness will be passed by. Brightness stimulates visual and emotional response and is therefore very desirable in a selling environment, although the pattern of brightness must be carefully planned. The world seems broad and wide under bright light but seems to crowd in under dim light, and space seems to contract. Under dim light distances cannot easily be judged, forms tend to flatten out, detail is lost and colours undergo radical transformation; colours will only appear in their true values under reasonably high light levels. However, uniform brightness, especially with diffuse lighting, can be very dull; moderate contrasts and applied sparkle are recommended.

Second, the colour appearance of the light (e.g. cool, intermediate or warm) should be carefully chosen. Overall illumination in a selling area should gener-

ally be warm in nature for the benefit of customers, and cool light is only required where colour discrimination is important. Cool light can be stimulating when there is a high level of illumination but creates an uninteresting and depressing atmosphere when light levels are low; in such cases warm light is essential and psychologically desirable. The difference between warm light and cool light is best illustrated by considering candlelight and firelight, which are a warm, orange colour far more friendly and mellow than moonlight, which has a much colder quality. Warm illumination has the additional advantage that it flatters the human complexion and this is particularly important in the selling environment. Warm light with a bias towards red or yellow is generally best for this purpose, except where light levels are very high.

The warmth or otherwise of the light source will also help to convey the image desired by management. A warm impression suggests luxury, comfort, extravagance, while a cooler source has a more clinical effect suggesting cleanliness and efficiency. Obviously the characteristics of the light source should be appropriate to the nature of the establishment and the trade carried on.

Daylight is often ignored when planning a lighting installation for a selling environment, but difficulties do arise when it is present, and brightness differences may be caused by the time of day or the weather. Although daylight has good colour-rendering qualities, it causes some difficulty when there are low levels of interior illumination; the colour quality of the natural light may cause discomfort in such circumstances. It is difficult to suggest a broad rule which would apply in all cases because much depends on the nature of the establishment and its architectural features.

Ideal lighting requires that the installation should provide a controlled means of directing the eye to any objects to be featured, and this involves the facility of the eye to adapt itself to different lighting levels. Whenever there is a change in the luminous energy entering the eye, the visual mechanism begins to adapt itself to the new stimuli, a process which takes times. The importance of this point when entering the establishment has been mentioned above, but the same problem arises when there are different levels of light in different areas of the same establishment. Thus when there is a changing light pattern, visual sensibility and colour discrimination may be the result of past stimuli. To see details with maximum resolution, and colour with maximum discrimination, the retina should have been adapted for a reasonable time to a luminance slightly below that of the final viewing. This requires particularly careful planning when lighting displays.

Summary

In order that lighting will create the right atmosphere, consider:

- visual comfort and the degree of brightness
- the colour appearance of the light source
- the appearance of the customers and staff
- the effect of light on the desired image
- the presence or absence of daylight
- the effect of different levels of lighting.

13.5 Merchandising

The whole object of a selling environment is to make a sale, and to achieve that objective the customer has to be persuaded to enter the establishment, must react favourably to the environment as a whole, and then must be attracted, directed or conducted to the merchandise offered, which may be the goods in the case of a store, or a service in the case of a catering establishment.

The customer must be able to examine the merchandise easily, and this implies vision; modern selling techniques depend on visual impact. No object or surface can have visual impact until it is lighted; more light, used the right way, means more impact. The amount of light may make all the difference between just looking and making a sale. Within reason, sales increase as the level of light rises; light is persuasive in a subconscious way but does not give the customer any sensation of having been tricked into something.

However, before the selling process can be completed, information about the merchandise offered must be conveyed to the potential customer, and lighting is an important part of the chain of communication. It helps to guide the steps of the potential customer as explained in 13.3 but in this part, above all, good lighting makes it easier for the customers to find their way about, read labels, identify signs and, of course, to see the merchandise to best advantage.

Signposting is particularly important, and special care is necessary with directional signs which cannot be seen if they are not well lit. Furthermore, they must be lit in such a way that they do not cause glare and are readable in all circumstances.

The most important element, however, is the way that the merchandise is displayed. Display, and lighting for display purposes, is a subject that requires much careful study and a good deal of experience; it is a subject for the expert. The speed and certainty with which an object can be identified is affected by the way that it is lit, and the nature of the lighting decides how well form, colour, surface properties and other properties are revealed.

It is the properties revealed which influence perception and the buying decision. Displays must be lit with a light which has a directional element; diffuse overall lighting is not generally sufficient. Perception of form depends on shadows, and differences in brightness can only be achieved by supplementary lighting. In supermarkets and certain types of chain store, perception of form and texture is less important, and a high level of overhead lighting may be sufficient.

Summary

Supplementary display lighting is required:

- to attract attention to the individual display
- to reveal detail, character and quality
- to excite interest and create an impulse to purchase.

13.6 The overall environment

It is not practicable to write a lighting specification for a typical selling environment because the lighting required will vary according to the nature of the architecture, the nature of the establishment, the class of trade and the merchandising policy. The services of a competent lighting engineer are essential, but the engineer does need a brief if he is to do the job properly.

The major function of a lighting installation is to ensure that customers see what they are supposed to see, to bring order to the environment and to create a firm identity. It is generally recommended that the lighting necessary for the merchandise should be considered first, and then the further steps desirable to ensure customer circulation, create atmosphere and secure balance; but in the long run the right sequence depends on the circumstances.

As a rough rule of thumb for the selling establishment, 1000 square feet of selling space requires at least 2000 watts of light, about half the total being for general illumination over the selling area and the remainder for emphasis lighting on displays. A catering environment requires rather different treatment because it has to cater for the aesthetic comfort of the individual; the light must contribute to the relief of tension but may also have to provide stimulation for brilliant occasions.

As far as possible light should fall on what people are supposed to see without the source being visible; a bare lamp can be a distraction because of the tendency of the eye to fall on the brightest object in the field of view. For the same reason, well-lit displays and splashes of brightness, especially at the rear of the area, help to draw people in and promote active circulation.

The method of treatment of ceilings has a considerable effect on the overall environment; in some cases they will be left neutral, in others they may have a decorative function, although there is a risk that a decorated ceiling will have a life of its own because the decoration is too dominant and attracts attention away from the merchandise. The false ceiling has created a revolution in interior design, and luminous ceilings have developed into complete systems which incorporate air-conditioning as well as lighting. There is some risk of flatness and sterility with luminous ceilings, but they are particularly useful in basements where a dark ceiling can have a depressing effect; special fittings are available for very low ceilings. When a new ceiling is provided by means of fittings (e.g. a suspended ceiling) all areas above the new line should be painted midnight blue and the fittings white; this helps to hide the cavity above.

Any luminaire which is too obvious will spoil the effect, and so will cheap fittings. Some other points to be noted in relation to ceilings include the following:

- Ceiling treatments should be flexible to allow for alterations.
- Double-skinned ceilings minimise heat losses and gains.
- Modular ceilings have louvres which assist ventilation.
- Metal-bladed ceilings permit a variety of effects.
- Baffles painted in dark grey will help to reduce ceiling brightness.
- Luminous ceilings are so diffuse that any directional quality is lost.

Some points to consider when planning lighting include the following:

- The eye will always concentrate on brightness.
- The customer is impelled by brightness, but dimness is passed by.
- Light levels cannot be considered without also considering the tint of the illumination.
- Normal colour appearance requires a different tint at low levels of intensity and at high levels; in the first case warm tints; in the second case cooler tints.
- General illumination should be warm for customer benefit.
- Cooler light is required when accurate colour matching is necessary.
- Too much cool light will be disliked.
- The type of merchandise will govern the tint of lamp recommended and its colour-rendering qualities.
- Where general illumination is fluorescent, local incandescent light will supply character and depth.
- Human responses are conditioned to an overhead light source; lighting from below creates horror.
- Strong lighting contrasts are recommended; a ratio of 10 : 1 is useful.
- Light the goods rather than the aisles.
- Shadows are helpful in a general lighting plan.
- A lighting condition that alters or reverses the usual direction of light can cause an unpleasant effect.
- Reflection of light from glossy surfaces should be eliminated.
- Increased light renders colours more vividly; planning of lighting should never be at the expense of colour.
- Avoid the risk of customers being able to look at high-level lighting from the wrong side or reflected in counter tops.

Summary

When planning the overall lighting consider:

- the merchandise first and then other functions
- the total amount of light required
- avoiding bare light sources
- treatment of ceilings
- the pattern of brightness
- the colour appearance of the light source
- lighting to provide character and depth
- the direction of lighting
- the colour-rendering qualities necessary.

13.7 Staff welfare

Behind-the-scenes areas require just as much consideration as main selling areas, in the interests of safety and staff welfare. There should be a feeling of continuity between sales areas and administrative areas, but in staff canteens and rest rooms there ought to be a marked change of emphasis, and the overall appearance should be bright and cheerful. In planning lighting for the sales

area pay attention to the needs of the staff because good lighting keeps the staff energetic and cheerful and can do much to promote their health and safety, and there is a legal requirement to instal sufficient and suitable lighting.

In areas where work on goods is carried out the lighting conditions specified for industrial areas would be appropriate, but on the actual sales floor it is important to avoid extremes of brightness at the point of work, which might subject the staff to glare. A high level of lighting may be prescribed for customers, but the staff may suffer considerable discomfort if emphasis lighting is placed too close to them. They may also suffer from reflections of light in counters and showcases.

Normal safety precautions must be observed and care taken that there are no abrupt differences in lighting between one area and another. Loading and unloading areas require plenty of light to avoid accidents. Light finishes for walls will assist in distribution of light. The amount of light required in storage areas depends on the scale of stock, and additional lighting may be required during periods of extensive stock movement.

Car parks can be a source of danger, both to staff and to customers. They have to be lit, and care should be taken that no accidents are caused by abrupt differences of light between the brightly illuminated store and the dimness of the car park. The transition from one to the other should be graduated so that the eye has time to accommodate itself.

The practical housekeeping points also require attention. Food hygiene regulations, for example, specify certain minimum standards of lighting in food handling areas to permit cleaning to be undertaken effectively.

Summary

Planning lighting for staff welfare requires attention to the following points:

- Ensure continuity of lighting between sales and administrative areas.
- Ensure change of emphasis in relaxation areas.
- Ensure staff are not subject to glare or uncomfortable reflections.
- Watch the effect of heat on staff.
- Watch the lighting of exits and car parks.
- Ensure adequate light for cleanliness.

14 Ideal colour for selling environments

14.1 Objectives

In planning a selling environment there are a number of objectives to achieve; the environment must:

- attract the attention of the public
- persuade the customer to come in
- keep the customer happy while in the establishment
- enhance the image of the organisation
- display the merchandise to best advantage
- contribute to staff welfare
- help to create sales
- improve profitability.

The part played by design and lighting in achieving these objectives has been outlined in previous sections, and it is now possible to discuss the place of colour. Each of these factors is interdependent, but it is arguable that colour is the most important of the three. The basic reason why colour is so important is that people like colour, it appeals to their emotions and contributes to a more attractive environment, which assists the selling process. The likes and dislikes of the public play a large part in the success of a selling establishment, and one of the principal functions of colour is to make the customer feel happy and at ease. It helps to turn the establishment into an attractive 'package'.

The objectives can be achieved by making use of the visibility and recognition qualities of colour and by taking into account consumer preferences for colour; it can be used to attract attention and compel the eye of the passer-by, although it must not offend against civic and social good taste.

In addition, colour has a number of attributes and characteristics which can be used to advantage; it helps to provide better seeing conditions, although these are less important in the selling environment than they are in a productive environment; it can make an area look larger; it can flatter the appearance of the customer; it can direct the steps of the shopper; and it can help to achieve a faster turnover. Colour can also provide a number of practical benefits, such as saving energy, identification and so forth.

It is profitable to take trouble with the selection of colour; the right colour

costs no more than the wrong colour and may contribute a great deal more to sales and goodwill. Good colour appeals on sight to the right customer, draws attention away from competition, serves economic ends and helps to create the right image. If an establishment is too drab or too old, or even too sophisticated, the customer may go elsewhere. Colour provides sensory stimulation, breaks up monotony and establishes a change of pace, all of which are psychologically beneficial. Uniformity of stimulus is undesirable, and colour helps to avoid it.

Every selling environment must have an individuality of its own, but colour should be selected with good reason and for practical purposes. Colour for the sake of colour has no particular merit, nor should colour choice reflect the personal preferences of the management or the designer. It should always be possible to justify choice of colour in commercial terms; beautiful colours are those which sell merchandise or attract customers; ugly colours do not.

The effects of colour are largely autonomic in nature and therefore they affect people whether those people are conscious of colour or not; if people are surrounded by colours that they do not like and seldom buy, it can automatically create a barrier which will harm sales. On the other hand, the psychological appeal of colour has a valuable application in the selling field; human reactions to colour influence the behaviour of people. This psychological appeal is particularly marked in the catering field, where the right colour enhances the appearance of food and the wrong colour makes it distasteful.

The part that colour plays in achieving the objectives of the selling environment may be summarised under four headings:

- The total environment The overall appearance of the establishment attracts attention and persuades the potential customer to come in.
- Creating atmosphere The internal decor and use of colour keeps the customer happy and enhances the image of the organisation.
- Merchandising The skilful use of colour sets off the merchandise to best advantage and encourages sales.
- Practical benefits This includes the use of colour to promote staff welfare, for identification, and other purposes.

The whole adds up to increased sales and improved profitability.

14.2 What colour can do

There are many functions that colour can perform in the selling environment but selection of the most appropriate colour depends on the attributes and characteristics of individual hues. A colour specification for any area should prescribe those hues that will best perform the functions appropriate to the area, taking into account the design features and the nature of the lighting. Lighting is particularly important because without light there can be no colour, and without the modifications provided by colour, light is dazzling and uninteresting.

The principal functions of colour in the selling area include the following.

The total environment

- Colour attracts people to the establishment by virtue of the physiological attributes of appropriate hues. Some colours attract, others repel.
- Colour will harmonise with the surroundings and prevent an establishment from standing out like a sore thumb.
- Colour will provide decoration that appeals to customers; this is a creative function and involves harmony.
- Colour will create a favourable impression by utilising its emotional appeal, allied to current trends. This helps to encourage customers to come.
- Colour helps to concentrate visual attention by creating contrasts and points of interest.

Creating atmosphere

- Colour helps to create an atmosphere which appeals to customers by appropriate use of current likes and dislikes, trends of consumer preference, regional preferences, colours preferred in the home and emotional preferences.
- Colour helps to create a mood appropriate to the type of trade envisaged. The psychological and physiological attributes of colour must be related to specific environments in order to produce excitement, relaxation, activity, passivity or whatever is required.
- Colour can relate to type of market (e.g. mass market, teenage market, sophisticated market, etc.).
- Colour will flatter the appearance of customers; an environment that makes then look sickly will do little for sales.
- Colour can remove distractions and provide visual relief; it can introduce sensory stimulation.
- Colour can give pleasure and avoid giving offence. Most people prefer simple colours; colours that are too gaudy may do harm.
- Colour can enhance the image of an organisation.

Merchandising

- Colour can create an impulse to purchase by attracting attention to displays and by complementing the colours of the merchandise, thus displaying them to best advantage.
- Colour can improve the appearance of merchandise; the interaction of light and colour can highlight background and make the merchandise stand out.
- Colour can provide variety; contrasts and harmonising colours will add interest.
- Colour has immediate and emotional impact.
- Colour is perceived more easily than form and this aids perception.
- Colour can enhance the appearance of specific products, especially food; the wrong colour can make it look unappetising.

Practical benefits

- Colour can improve seeing conditions if colours of appropriate reflectance value are prescribed; the optical properties of colour control glare and excessive brightness.
- Colour contributes to planning; it can make an area look larger or smaller, hide or emphasise architectural features, lengthen or shorten perspective, raise or lower a ceiling.
- Colour can direct attention or control traffic by means of correlation of brightness of colour and light.
- Colour can help to use light more effectively by acting as a reflector, thus reducing costs.
- Colour can be used for identification purposes, and for signs.
- Colour strikes a balance between efficient operation and a pleasing environment without losing individuality.
- Colour can contribute to safety.

14.3 The total environment

The first function of colour is to contribute to a total selling environment that will attract attention and create a favourable impression which persuades people to enter it. The skilful use of the psychological and physiological attributes of colour performs this function by helping to create a pleasing and attractive exterior appearance, combined with an equally pleasing and impressive interior. The process of attracting attention has been discussed at some length in previous sections, and this section is concerned with the part that colour plays in the process and formulates broad principles for the selection of the most suitable hues.

Exteriors

It is difficult to formulate precise rules for the selection of colours for the exterior of any selling establishment because so much depends on the architectural features, the nature of the business, the image that it is desired to convey, the house colours of the organisation concerned (if any) and the nature of the surroundings. It is important that the establishment should harmonise with the area in a civic and planning sense. In many cases colour will be limited to the fascia and may be either a house colour or a colour associated with the business of the establishment; in other cases a hard colour having maximum attraction value is indicated. Façades should generally be finished in a cool, retiring or neutral colour which does not offend against local susceptibilities. The colour of window displays, if any, will depend on the merchandise displayed, but the whole object of display is to attract attention.

Interiors

An impression of the interior as a whole is an important factor in attracting the attention of customers, and if first appearances are unsatisfactory, the

customer may turn away. Choice of colour must be governed by the nature and class of trade carried on and the nature of the customer that it is desired to attract. Colours must associate with the merchandise or service offered, reflect a style of decoration which is appropriate to the class of trade, create a mood which appeals to the customers desired, and may also reflect a house style or image.

It would be a mistake to use high-fashion, sophisticated colours in an establishment which is intended to appeal to the mass market, and it would be a mistake to try to attract conservative, older, customers with a decor which appeals to a younger 'with it' generation. Conservative people prefer tradition and sentiment in decoration, and more subdued colours. Outwardly integrated people, including the younger generation, prefer modern, abstract and radical designs with bolder colours and plenty of contrast. There almost always has to be some compromise depending on the weight attached to various classes of customer.

Colour specifications for areas where people foregather should always include warm sequence colours of medium brightness (beige is a good example) that are friendly in quality and that cast flattering reflections. End walls, alcoves and other architectural features can be more brightly coloured to provide variety. The medium tone will prevent the brighter areas from clashing with each other, and the combination of the two will provide a constantly changing scene. A dark environment with low light levels will be most depressing, and a pale environment, also with low light levels, may be too passive. Large areas of blue are cold and depressing; large areas of red may be too overpowering.

There is a degree of latitude in choice of shade, and attention should be paid to trends of consumer preference as reflected in the things that people buy for their homes as well as other factors that may increase attraction. People who use selling establishments, and particularly catering establishments, are the same people who buy paint and furnishings for their homes, and the colours that they buy for the latter are the colours that will attract them on the selling floor.

There is something to be said for creating an integrated colour scheme which contributes to the image or personality of the establishment, especially where there is a chain of similar establishments, but the colour scheme would have to be in tune with the nature of the merchandise. Such a scheme has a favourable influence on the morale of personnel because it stimulates identification with the organisation and makes staff feel that they are joining in an effort to please customers. Where a fully integrated scheme is not practicable, it may be possible to achieve the same object by adopting a standard colour for signs, stationery, overalls and so on.

Summary

Consider:

- the exterior façade – colours suitable for the surroundings
- the fascia – colour of maximum attraction, house colours, colours associated with the business

- the window – colour treatment depends on merchandise
- the interior
 - nature and class of trade
 - association with merchandise
 - mood or image required
 - type of customer
 - warm sequence colours
 - contrasts for architectural features
 - trends of consumer preference
 - house styles.

14.4 Creating atmosphere

The second function of colour is to create an atmosphere which appeals to customers and which keeps them happy while they are in the establishment; the atmosphere will also set the tone of the establishment and enhance the image of the organisation. This function is performed by using the attributes of colour to produce a pleasing ambience. Design dictates that the area should be as convenient as possible; lighting assists ease of movement and provides a sense of location, but there must also be visual comfort and variety, and this is achieved by the use of colour.

Colour is a complex mixture of optical, physiological and psychological characteristics, which have to be related to a particular situation. Colour may be light or dark, and its reflectance value will be largely determined by the architectural design and the lighting plan. Reflectance value is fairly simple to specify, but at any value there are a number of different hues which can be used, and choice of the hue depends on the characteristics and attributes appropriate to the situation.

Any selling environment is a package that must be sold to the public as carefully as any of the packages on the shelves, and the use of colour has a direct bearing on sales. If the sign on the outside identifies the name of the establishment and its speciality, the colour of the interior will contribute to the image of the business and identify the nature of the trade. It follows that choice of colour for interiors is just as important as the colour of the merchandise and may be even more important if the establishment is selling a service rather than goods.

If the appearance is too dark, if the decor is old-fashioned, customers may go elsewhere, and they may also go elsewhere if the interior is too bright or too modern, because in either case they may feel that the merchandise is not to average taste. The appearance, and the colour scheme, must not be out of date, and it should accord with current trends of preference if customers are to feel at ease and eager to buy; then the environment will be in line with average tastes and thereby flatter the ego of the customer. If the colours of the merchandise are wrongly chosen, the customers will not buy; if the colours of the decor are wrongly chosen, the customer will not come at all.

The great majority of people (i.e. the mass market) are motivated by inner compulsions rather than by rational thought, and therefore they react to trends and seek the same as everybody else, but they react to different colours in dif-

ferent ways, and colour can be used to create a mood appropriate to the type of trade carried on. Some colours are exciting, some colours are relaxing, some encourage movement and a fast trade, others induce a more leisurely approach appropriate to a luxury trade.

Because reactions to colour are emotional rather than intellectual, it follows that it is seldom wise to be too 'different', and a riot of colour is unlikely to appeal to the majority; the mass market does not have gaudy tastes. On the other hand, the top end of the market can be treated with more individuality; the sophisticated customer likes to be different from everybody else and welcomes individuality and high fashion. Bright and 'way out' colours may be appropriate in some cases to attract a particular type of customer.

In broad terms, colour will determine the nature of the establishment and must be chosen to suit the locale, the type of business and the class of customer. This means setting aside personal preferences because the individual tastes of management, of architects, of designers, may not appeal to the public at large or to the type of customer that it is desired to attract. It is best to research and study the likes and dislikes of customers; too much creative effort may result in effects which are not well liked, particularly in mass markets. A commercial establishment needs colours which are adjusted to the emotional preferences of the people who use it.

A colourful environment is best produced by normal light reflected from surfaces such as walls and fittings, and not by tinted light, and therefore it is the colour of the surfaces which produce the right atmosphere, provided always that the colours appeal to people at large and that they flatter the appearance of customers. The latter is most important; if the colours make people look wan, they will soon lose the urge to buy. In most selling environments fairly light colours are prescribed, partly to make the most of the available light and partly because people prefer light colours to dark ones. Clear hues, rather than greyed hues, are recommended; simple colours are the preference of the majority irrespective of age, race or cultural background. There are, of course, situations where deeper colours are more appropriate, but they do not need to be considered at this point.

Warm colours are generally preferred to cool ones and are best for most selling conditions because they are welcoming and generally more flattering to the appearance. Cool colours have a place in certain climatic conditions and in situations like food stores where coolness is expected.

Colour has a practical part to play in the selling environment, as described in later sections, and while a colour or combination of colours may be ideal in practical terms, it may be ugly in emotional appeal and therefore fail to create the right atmosphere. The ideal situation exists where colour does its job efficiently in a practical sense and pleasantly in an emotional sense at one and the same time. If the right atmosphere is to be achieved, colours should have maximum emotional appeal, and to achieve this it is necessary to consider trends and to follow them as far as possible. It follows from this that colours must be changed from time to time to reflect changing trends, maintain an up-to-date look and provide variety.

Summary

Consider:

- the tone and image desired
- whether light or dark colours are required and the reflectance values indicated
- the type of trade and its possible effect on colour
- current trends of preference; be up to date
- the mood desired
- the class of customer
- the appearance of customers
- warm colours or cool ones
- the balance between utility and appearance.

14.5 Merchandising

The third function of colour is to create a sale – in other words, merchandising. It is obvious that the colours of the environment should complement the colours of the merchandise, therefore the key to the selection of suitable hues for a selling environment is the dominant colour of the merchandise being sold, where it is possible to determine this. In many cases, of course, this is not practicable, and colour has to be related to individual displays.

To ensure the best results the overall colour scheme should be based on a logical sequence of background and foreground colours set off by the right kind of lighting; where there is a dominant merchandise colour the colour characteristics of the background will accentuate those of the merchandise and can provide useful accents or contrasts. Where the varying colour of merchandise makes individual displays necessary, the overall surround should be of a more neutral character, and more attention should be paid to the immediate background to the display. The overall surround should never be allowed to attract attention away from the merchandise.

In those cases where the selling environment is concerned with services rather than with goods, a different strategy is required and has to be reviewed in individual circumstances; banks, for example, have adopted standard house colours. Where practicable, hues should have an association with the business.

An important function of colour is to create an impulse to purchase by attracting attention to displays, and the background to the display should set off the colour of the merchandise itself to best advantage. Colour is perceived more easily than form, and this aids perception; it also has an immediate and emotional impact.

In all selling environments there should be plenty of variety; if this is not provided by displays, contrasts and harmonies must be created to add interest. Display lighting and colour is a subject that is quite distinct from environmental colour and needs special study.

Summary

Consider:

- the dominant colour of the merchandise
- suitable colours for the overall surround
- attracting attention to displays
- the need for variety.

14.6 Practical functions

The fourth function of colour is to provide practical benefits, and the most important of these is control of light and elimination of glare and excessive brightness. Many interiors have sharp brightness contrasts which are visually and emotionally distressing to both customers and staff, especially where light levels are high.

Much of the trouble can be eliminated by efficient planning of light sources so that the light does not shine directly into the eyes of customers and staff; reflections from counters and other glossy surfaces may be particularly tiring to sales staff, and although direct light may be hidden from the public, it may still be in the line of vision of counter staff.

Heat from lighting fittings, including spotlights, can also cause discomfort. Glare and discomfort can be caused by adjoining areas of high and low reflectance; contrasting areas of black and white would be just as objectionable as exposed bright lights. If the level of light is relatively low, the reflectance values of surfaces within the field of view should be reasonably high, and areas having colours of low reflectance value should be limited. Much of the useful light reaches the environment by reflectance from walls and ceilings, especially where lighting is indirect and higher reflectance values for surfaces will help to make the most of it. On the other hand, reflectance values that are too high may cause glare. If the walls are light, furniture and fittings should also be relatively light in tone to avoid sharp contrasts, but uniform brightness and illumination are not recommended; human beings need stimulus and variety.

Remember the following points:

- The eye tends to concentrate automatically on the brightest object in the field of view. Objects requiring emphasis should be brighter than the surround.
- The eye is quick in adapting to brightness and slow in adapting to dimness, and if not watched this tends to destroy the effect of careful planning.
- Sharp contrasts such as constant changes from dimness to brightness tend to tire the eye.

The attributes of colour make a useful contribution to the planning of the interior as a whole. Cool and neutral colours tend to make an area look larger, warm colours tend to close in. Colour can be used to hide ugly features such as pipes and to smooth out sharp angles; colour used in an appropriate way will raise or lower a ceiling, or appear to do so; it will lengthen or shorten perspec-

tive; cool colours will reduce the apparent temperature of an area; warm colours will make objects look nearer and can be used to bring forward important features.

Another important function of colour is to help control traffic, although this is also a function of lighting; people always tend to gravitate towards any area of high brightness. Plenty of light and bright colours on rear walls will pull people into an establishment and the same technique can be used in a long, narrow area; people can be persuaded to move towards the ends by increasing light and colour. Better traffic flow can be achieved by using brighter colours around the periphery of an area, and brightening up dark corners will move people away from the centre of the area. A reasonably bright coloured floor, perhaps with a directional pattern, will induce people to move in a desired direction, and where appropriate, increasing the light and brightening the colour of the walls of corridors and staircases will encourage people to explore.

Lighter colours, where practicable, will help to use light more efficiently, thus reducing costs; surfaces of high reflectance value reflect more light. Colour can be used for identification purposes (e.g. to distinguish departments) or for signs to direct attention to facilities.

In appropriate cases colour can be used to increase safety, for example by identifying fire appliances and exits. Care is necessary to ensure that colour does not run riot; too many colours will distract attention away from essentials.

Summary

Consider:

- elimination of glare and excessive brightness
- avoidance of excessive contrasts
- the relationship between walls and fittings
- how the attributes of colour can be used in planning
- how colour might be used to control traffic
- making maximum use of light
- how colour might be used for identification
- colour as a safety measure
- avoiding too much colour.

15 Colour planning for the selling environment

15.1 Planning the whole

Previous Sections have defined the ideal selling environment and outlined ways in which light and colour can help to achieve the best possible results, but these basic principles have to be translated into a practical way of selecting suitable colours for an individual establishment. Colour treatment has to be carefully planned and colour specifications prepared for each establishment. Planning requires attention to a number of points, some of which are dictated by the nature of the premises, the nature of the operation and the marketing policy of the operation. Others are related to the atmosphere of the individual establishment and the decor desired. Points dictated by the first category include:

The type of establishment This is the first consideration, whether the establishment is a department store, a supermarket, a cafe, or a hotel, and so forth. The point does not require further elaboration at this stage.

The type of premises Consider the nature of the premises and whether they are old or modern, large or small, and so on. Older premises may need a greater variety of decoration and a brightening up of dark corners. Smaller premises may require lighter colours to create a sense of space. Architectural features may need to be hidden or emphasised, and various characteristics of colour may be useful.

The situation of the premises If the locale of the establishment is a drab one, a bright exterior and interior will liven it up, but the establishment must not look out of place in its surroundings, and the decoration of the façade needs particular care. On an average street brilliant light and imaginative colour treatment will impress potential customers and fix the establishment in their minds, but if the street has, say, historical associations, too much brightness may cause resentment. In the same way, an exterior colour scheme suitable for an urban environment would not necessarily be suitable for a country town or village. Planning regulations may impose conditions, but common sense will suggest restraint where appropriate. Where a restrained exterior is desirable, a dramatic effect can be created when entering by the use of

contrasting colours. The climatic conditions may also be significant; brighter colours are prescribed in the clear air of the seaside, for example. Cool tones should be used for interiors where there is plenty of sunlight, but warmer tones would be ideal in chilly regions and will often provide useful contrast with merchandise.

The type of business The type of merchandise sold or service offered will certainly have an effect on choice of colour for both exterior and interior. The colours of the fascia may be associated with the nature of the business or they may reflect a house style which is common to all establishments within a group. If the merchandise has a dominant colour, the interior decor must complement it. Where practicable the hues used in decoration should have an association with the business or with the products sold. Choice of colour is especially important where food is sold or consumed; colour is always part of food, and cleanliness is also important. Light, bright surfaces are indicated, and cool hues associated with cleanliness.

The type of customer The mass market prefers bright and simple colours; the more sophisticated customer will react best to subtle, high fashion colours. However, the establishment may be designed to attract a specific type of customer, such as teenagers, young marrieds or some other category; the dominant colours of the decor should have an attraction to the type it is desired to attract.

The type of transaction Plenty of light and bright colours are prescribed for a fast trade with a quick turnover and an impulse type of selling. More subtle colours, and a subdued atmosphere, are indicated for a more exclusive type of trade where customers like to take their time. The busier the trade, the brighter the colour. Bright lights and positive colours have a centrifugal effect which promotes a bustling and cheerful atmosphere. Warm colours encourage the body and the mind to direct its attention outwards and promote increased alertness and activation. Softer colours have the reverse effect. A dark environment with low light levels will have a depressing effect, and a pale environment with low light levels can be too passive.

Potential for display The nature of the decorative scheme will depend on whether the main interest is on the perimeter of the area or in the centre of the floor. If the latter, keep the perimeter subdued. Bright colours should be used to attract customers to displays or other points of interest, but the foreground should be light in tone so that displays are thrown into contrast. Special rules will apply to catering establishments where the emphasis will be quite different.

House styles It may be the policy of the operator to ensure that all establishments within a group convey a similar impression, or this may be restricted to a fascia and outward appearance. This is a matter for individual decision.

In all cases colours should be up to date and reflect current trends.

15.2 Planning the interior

When considering the decoration of the interior of an individual establishment, colour selection must be related to the area, and colour can be used in a number of ways to alter its appearance and to create a desired atmosphere. The points listed in the previous section will be relevant so far as they relate to the tone and image desired, the class of customer to be attracted, and so forth, but certain additional points need to be considered in order to ensure a pleasing ambience. For example:

The character of the area This will be largely dictated by the class of trade and may be bright, calm, restful or stimulating, as required. Colour can be chosen to create an appropriate mood.

The aspect of the area This includes the nature of the light. To some extent the colours of interiors should be geared to the prevailing climate; warm, bright colours are ideal for an interior in cloudy regions; cool tones would be better in sunny regions, thus providing a contrast with the world outside. The same principles apply to seaside areas, where the light outside is brighter than in urban or city areas. Warm colours are indicated for a north-facing area; light colours are indicated if the area tends to be dark; a sunny aspect can take any colour but may need cooling down. It is useful to review possible modifications to allow for the interaction of daylight and artificial light.

The features of the area It may be small or large, have a low ceiling or a high ceiling, be long and narrow, be vaulty or confined. The characteristics of colour can be used to correct adverse features.

The function of the area Not all areas of the establishment will be used for purely selling functions, and common sense will dictate modifications where specific work is performed. In a hotel, for example, a lounge would require different treatment to a dining room.

Architectural features Certain features of an area may be incapable of alteration and may dictate some modification of ideas. It may be possible to use colour to hide or enhance such features. This is largely a matter of common sense.

The temperature of the area Warm colours are generally recommended for selling areas, but in some cases the number of people, or the nature of the activity, may suggest cooling the atmosphere down by using cool colours.

Variety Different colours may be used to identify different departments or areas, but the whole should be tied together to promote harmony. A pattern of successive colour treatments can be recommended.

The appearance of customers Certain colours or colour effects should be avoided because they are likely to make customers look or feel sick. The effect of light on appearance has been mentioned in previous sections, but reflected colour can have the same effect, and this needs very careful consideration, particularly in retail establishments selling womens' clothes. A lighting scheme that provides good colour-rendering qualities may be most

unflattering to the customers. All warm colours will cast a pleasing glow, which makes people feel better; reflections from pink walls and surfaces are flattering. However, a human complexion seen against a blue-green background will also take a glow of health because the blue-green is the complement of the human complexion. Lights of mixed spectral quality should be avoided where appearance is important.

Merchandising Consider the nature and location of displays and other points of emphasis and how colour is to be used to set them off to best advantage. The colour of the merchandise itself is obviously an important factor, and surrounding colours must complement it. Impulse colours are those that attract attention; they will bring people to the merchandise and, in appropriate cases, may create sales.

Practical uses Consider the practical ways in which colour can be used to eliminate glare, control traffic, and so on.

15.3 Individual areas

When the basic principles for an area have been decided, the next step in the colour selection process is to decide whether warm or cool colours are required and whether they should be light or dark. Most selling areas benefit from warm colours because they are welcoming and flattering to the customer, but there are instances where cooler colours are indicated, as outlined in the previous sections. As a general rule very light colours are not desirable because they are apt to cause excessive brightness; medium tones are preferable. Some broad principles are suggested below.

The key factor in producing a satisfactory environment is the amount of light which is reflected from the various surfaces in the area, and the amount varies according to the reflectance values of the colours of the surfaces. It follows that by changing the colour it is possible to change the amount of light reflected from given surfaces, and this control of light is an important function of colour in the selling environment. Changing the colour does not necessarily mean changing the hue, but it does mean changing the reflectance value. A light variation of a given hue would have a high reflectance value, but a dark variation of the same hue would have a lower value. The following are some recommended values for surfaces in typical selling areas, but the application of these to an individual area requires creative skill.

Ceilings May be white to ensure maximum light reflection, but for decorative reasons they are often treated in strong colours. Where this is done it is recommended that the walls should be of a different colour but of the same reflectance value, thus providing an interesting contrast. Such an arrangement is best restricted to establishments with an exclusive clientele; it is not recommended for mass markets because many people feel uncomfortable with black or dark ceilings.

Upper walls	Recommended reflectance 50 per cent. Neutrals or almost any pastel that is not too bright can be recommended. Over-colourful walls attract attention away from displays and objects that it is desired to emphasise, whereas a subdued background will allow the displays to stand out. Walls that are not too pale will reduce excessive brightness, which could restrict the pupil of the eye. Contrasts may be provided by brighter and deeper colours on end walls, alcoves and areas at the back of displays. This strategy directs attention to important areas and permits use of accents without clashing.
Lower walls	Recommended reflectance values between 30 to 40 per cent. Lower walls will often be covered by fittings and so on, but in other cases the deeper colours will provide an appropriate background for displays.
Rear walls	Reflectance values up to 70 per cent. Colours of high reflectance value on a rear wall are particularly valuable in long, narrow areas and where the establishment has an 'open' window. It helps to prevent the area from looking murky and intimidating. A bright colour on the rear wall forces the eye directly, and the feet indirectly, to the back of the area.
Circulation areas	Recommended reflectance values up to 70 per cent. Reception areas, entrance halls, areas around escalators and lifts benefit from light colours, which give a sense of space and encourage busy traffic. Good lighting and bright colours are particularly useful in the entrance hall.
Floors	Recommended reflectance values between 20 and 25 per cent. Anything darker would be too sombre and anything lighter would be impractical. Neutral hues are recommended to direct the eyes of customers above floor level. Lighter colours might be used for a food-serving area to encourage cleanliness, and a pattern giving an impression of lightness would be acceptable. Any sharp contrast between the floor and the ceiling should be avoided, and if strong colours are used for the floor, walls and ceilings should be subdued.
Basements	Recommended reflectance value 70 per cent. Lighter colours are recommended in basements to create a more spacious feeling and to make the most of available light.
Storage areas	White or off-white is recommended. Darker colours may be used for the lower half of walls to camouflage soiling.
Staircases	Recommended reflectance value between 60 and 70 per cent. Lighter colours make the most of available light but lower walls can be in deeper colours to hide soiling. A dado strip below eye level will indicate changes in

	floor levels and thus prevent slipping.
Corridors	Recommended reflectance values between 50 and 70 per cent. Avoid too sharp contrasts with the main selling area; delayed eye adjustments can cause accidents if corridors are much darker than the area from which they lead.
Rest rooms	Recommended reflectance values between 50 and 60 per cent. A cheerful rather than coldly clinical atmosphere is prescribed; colours can be decorative and popular but avoid too much bright colour. Colours that are different to those in public and working areas will provide a change of pace and emotional relief. A rest room is intended to provide relaxation, and more subdued colours could be recommended if the establishment is a particularly busy one.
Wash rooms	Recommended reflectance values between 60 and 70 per cent. Light-reflecting and easily cleaned surfaces are desirable. Warm colours such as pink are generally preferred for female toilets and cooler colours, such as blue or blue-green for men.
First aid rooms	Recommended reflectance values between 50 and 70 per cent. Cool colours are generally recommended.
Kitchens	Recommended reflectance values 70 per cent or more. White or cool colours are recommended.
Safety	Use safety colours where appropriate.

15.4 Individual hues

Unlike a productive environment the selling environment does not use colour in a purely functional way, and the process of colour selection is therefore more complicated. The primary use of colour is decorative, with the functional aspects a secondary consideration. It follows that colour in the selling environment requires more creative skills, but there are, nevertheless, certain broad rules which can be followed with advantage to appearance and to sales.

Before making any decisions about choice of colour it is useful to consider the characteristics of the light source in the area under consideration, particularly the colour-rendering qualities of the light. Generally speaking, a light having a warm appearance is desirable in selling environments, but cool light may be required where colour matching is vital.

When the lighting conditions are known it is practicable to decide whether light or dark colours are required and to fix a reflectance value for each of the major surfaces, and it will also be possible to decide whether warm or cool colours are required. Warm colours or neutrals are generally preferred for selling areas, but there are circumstances when cooler tones would be better.

This leads, in turn, to the selection of individual hues, which requires an analysis of the various functions that colour can perform in the environment under consideration. When each of these functions have been isolated, hues

that have the appropriate characteristics can be selected; these will help to create the desired effect.

Example 1 Impulse colours (i.e. those that attract attention) will bring people to the merchandise, or draw attention to appropriate features, and they create a friendly feeling; they may also be used for accent purposes, but must be used with discretion. Too much impulse colour is self-defeating. The meaningless use of strong colour can also cause accidents because it distracts attention.

At this stage trends should be considered and, as far as possible, variations of hue which conform with current trends should be selected.

The way that the various hues are put together is a matter for the designer or stylist, but there are certain broad rules which can be studied with advantage by the designer. Colour harmonies are important, and certain combinations of colour are more effective than others. It is also quite important to consider those phenomena described as colour modifiers; they are significant in two ways in the selling environment.

In the first place they are of interest to designers and display experts because they help to achieve a more pleasing environment or a more attractive display, and an enhanced appearance for merchandise. In the second place a clear understanding of these effects will be helpful in understanding the difficulties of the customer.

Example 2 After-image results from looking at a strong colour for an appreciable period and may have an adverse effect on the colour of merchandise or on the appearance of people; it is particularly significant when combinations of colours are used for decorative purposes. However, the effect can also be used to enhance the appearance of merchandise by ensuring that the background colour of a display is the complement of the colour of the product.

Summary

Consider:

- the characteristics of the light source
- whether light or dark colours are required
- reflectance values appropriate to major surfaces
- whether warm or cool colours are required
- the colour characteristics desirable
- trends
- usage of colour, harmonies and so on.
- colour modifiers.

15.5 Trends

In order to release the maximum emotional appeal of colour it is necessary to consider trends of preference, and these take a number of forms as described in

Section 17 of Part I. It is trends of consumer preference for colour in the home which are of greatest importance in the selling environment, because these reflect the wishes and desires of ordinary people and influence everything that they do. Those colours which reflect current preferences will create the most favourable buying environment, will produce a contemporary look and will also harmonise with the products being sold; they must be used where possible if customer satisfaction is to be created. When a hue is selected for practical or functional reasons, choose a variation which is popular by the standards set by consumer preferences because trends apply to variations of hue just as they do to the hues themselves.

Example Blue may be a popular colour according to a reading of trends of consumer preference, but a clear blue may be more popular than a cloudy blue.

A variation which is popular or fashionable will appeal emotionally to the subconscious and will therefore be more attractive to customers. Choice needs care; a variation chosen at random from a colour chart may be obsolete and may suggest something out of date. Good colour styling needs variety and interest and must be changed from time to time as preferences change.

Trends of fashion in clothing are less important in environmental terms, except, perhaps, in stores or departments devoted to womens' fashions. Trends of interior decoration tend to reflect the ideas of designers and stylists and are often too far ahead of average people. They may be suitable for the sophisticated establishment but not for the mass market. Similar remarks apply to architectural trends, and neither should be allowed to override the need for colours that will appeal to the buying public.

16 Specifying colour for selling environments

16.1 The specification

In discussing selling environments up to this point the main aim has been to formulate certain broad principles for the application of colour based on the reflectance values of colours most appropriate to achieving an ideal environment, and to suggest ways in which colour might be used to optimum advantage. The main emphasis has been on environments in which goods are actually sold; there has been less emphasis on those outlets where service is on sale, as in hotels and restaurants. The reason for this is that selling environments require a great deal of creative skill, and it is not practicable to distinguish between areas in broad terms. Each situation, and indeed each room, needs to be considered individually according to the goods sold in it or the functions of the room.

To apply any principles to the selection of actual hues requires a great deal of careful study and research, both in general terms and in relation to an individual area. It is necessary to study what colour has to do, what it can usefully do, how it can be used to best advantage, and then to apply creative skill. It should be self-evident that before planning the decoration of any area it is necessary to study the total-area environment, the nature of the specific environment, the nature of the goods or services sold, the lighting and the class of trade which it is desired to attract. All these have a relationship with each other.

In most selling situations there are comparatively few colours which will have the right characteristics for the situation as a whole, and these characteristics, and the practical limits permissible, are best discovered before attention is directed to other factors, although the overriding factors should always be the likes and dislikes of people. The whole object of the exercise is to attract the public.

There should be a simple, co-ordinated plan or specification for each situation, partly to avoid the use of too many colours and partly to obviate arguments or second thoughts. Colour can quite easily be overdone, and this is worse than no colour at all. Individual choice cannot be eliminated entirely because of the creative and merchandising skills required, but it should always be guided by the needs and desires of the public. It is far better to plan colour well in advance of actual decoration.

The purpose of the specification is to establish a basis for the application of colour, and as much attention should be paid to broad principles as to choice of actual hue. It is likely that the broad principles will remain relevant over many changes of actual hue, but the whole must be flexible because change is the essence of successful selling. The out-of-date selling environment will very quickly lose sales.

It is not practicable to write a colour specification which will apply to any and every selling environment because each varies with location, architectural features, class of trade and the nature of the goods or service offered. The notes that follow apply to the establishment as a whole, and modification would be required if redecoration of an individual room or department were under review, although it must be pointed out that it is difficult to separate the part from the whole. The total ambience is an important part of the appeal of any establishment.

When preparing a colour specification consider the following points:

- The type of establishment.
- The type of premises and the possible effect of their characteristics on colour choice.
- The situation of the premises and the effect of their immediate surroundings; whether urban or country; the nature of the neighbourhood and its climatic conditions.
- The type of business and the merchandise sold, or the service offered; whether the merchandise has a dominant colour.
- The type of customer that it is desired to attract, for example average, high class, teenager and so on.
- The type of transaction, for example fast trade with a quick turnover, luxury trade with slower pace and so on.
- The potential for display, for example the nature of the window, whether the main interest is on the perimeter or whether it is in the centre of the floor.
- House style, if any, and how this can best be adapted to the premises.

In each case assess the effect on the atmosphere desired and the possible effect on colour choice. The assessment will be partly dictated by the nature of the premises and partly by marketing policy. A change in decoration may be dictated by a change in policy and not necessarily change for the sake of change. Marketing policy must be decided before considering the individual areas.

- The character of the area and the mood desired, for example exciting, restful and so on.
- The aspect of the area, including the effect of natural light.
- The features of the area and the use of colour to correct adverse features.
- The functions of the area and their relationship with the establishment as a whole; any work performed.
- Architectural features; these may require some modification of preconceived ideas.

- The appearance of the area and whether the circumstances suggest that colour should be used to modify it.
- The need for variety; avoid a sterile and uniform appearance.
- The appearance of customers; avoid unflattering reflections and the effect of light.
- The nature and location of displays and other points of emphasis, and how colour can be used to set them off to best advantage.
- The practical use of colour, including elimination of glare, control of traffic, safety and so on.
- What colour has to do, and what it can do; that is, a general review of its functions.
- Review the lighting and the extent to which the nature of the lighting may modify colour; also review the need to control glare and excessive brightness. The following light characteristics are relevant to the selling environment:

Colour appearance of light	This is the colour that a light source appears to be to the observer. Warm sources are recommended for most selling environments because they are inviting, friendly and practical. Consider the colour-rendering qualities – the accuracy with which a light source reveals the colour of objects and surfaces. It is important to balance colour-rendering qualities and the appearance of customers; this is very significant where food is concerned.
Daylight	Varies in quality according to the time of day, the weather and so on, and requires special consideration. Often excluded from selling environments because of its varying quality.
Food	The characteristics of the light have a significant effect on the appearance of food; most foods look their best under warm light. Very significant in food selling and catering environments.
Glare	Too much light, or light in the wrong place causes discomfort and must be eliminated.
Human appearance	Different light sources have different effects on the appearance of people. Warm light is generally the most flattering. Flattering light is recommended for most selling environments but must be balanced with colour-rendering qualities.
Intensity	Colour is seen differently when the eye is adapted to bright light and when it is adapted to dim light. This may be important to the decoration of the selling environment.

Properties of lamps Each type of lamp has different qualities, and the right type must be selected for a specific environment.

- Consider suitable colours for display features when these are semi-permanent.
- Fix reflectance values for each of the major surfaces in the area, including end walls where appropriate. A list of recommended reflectance values will be found in 15.3 in this part.
- Modify reflectance values according to the nature of the merchandise and other factors. In deciding whether to use upper or lower limits of reflectance value, consider the following.

Use higher reflectance values (lighter colours):
 - in areas where there is much movement
 - for circulation areas including corridors and staircases
 - to make an area look larger and to lend distance
 - to eliminate shadows in dark corners
 - for entrance areas
 - in store rooms and basements
 - to make a ceiling seem higher.

Use lower reflectance values (darker colours):
 - in lofty areas which would otherwise look bare
 - to make an area look smaller and more intimate
 - for dados and lower walls
 - to bring down a high ceiling (although people are often uncomfortable in an area having a very dark ceiling).

- Decide whether warm or cool colours are required.

Use warm colours:
 - in lofty areas to reduce visual size
 - in areas having a north or cold aspect
 - to mark hazards
 - for entrance halls, they are welcoming
 - to provide a stimulating and exciting atmosphere
 - when there is little natural light
 - to reduce the size of an area
 - to bring forward distant end walls
 - for long narrow areas
 - to encourage a fast trade
 - in cloudy regions
 - for the features of a display.

Use cool colours:
 - if merchandise is highly coloured
 - to make an area look larger
 - for areas having a south or warm aspect
 - if the environment is warm in nature
 - to create a calming effect (but do not make it too cold)
 - in sunny regions
 - to lend distance, cool colours recede
 - for background to a display

 – for first aid rooms.
 Use neutrals:
 – for upper walls
 – for floors.
* Select suitable hues (see 16.2 following).
* Consider trends (see 15.5, this part).
* Consider colour modifiers (see 16.3, this part).
* Consider colour combinations (see 16.3, this part).
* Consider colour harmony (see 16.3, this part).
* Consider broad rules of colour usage.

Finally, revise, refine and compromise where necessary.

16.2 Selecting the hue

The result of the process up to this point should be that the colour of each surface under consideration has been specified in terms of reflectance values and in terms of warm and cool colours. It is now possible to select individual hues. The first step is to analyse the various functions that colour can perform in the environment under consideration and then to select hues that have the appropriate characteristics. The following is a list of those characteristics that my be useful in a selling environment.

Attributes

Age	Use colours appropriate to the type of customer that it is desired to attract.
Appearance	Reflected colours from walls and major surfaces can have an effect on appearance and need very careful consideration in many selling environments.
Associations	Use colour associations where they are appropriate, especially for fascias.
Fashion	Use colours having a high-fashion connotation where the trade warrants it.
Impulse	Impulse colours are suitable for fascias and displays.
Markets	Use colours appropriate to the type of trade.
Mood	Use according to the mood desired.
Presentation	Significant only in relation to house colours.
Products	Products are often associated with a specific colour; use where appropriate.
Recognition	Use colours having good recognition qualities for signs, to draw attention to hazards, and so on.
Regional	Consider whether there are regional likes and dislikes.
Sex	Use colours appropriate to the class of trade.
Size	This attribute can be used to alter the apparent size of an area.
Visibility	Use colours having maximum visibility for signs and other important objects.

| Warmth | Warm colours are generally recommended for selling areas. |

Functions

Camouflage	Colour can be used to hide unsightly features, to hide soiling and to alter appearance.
Coding	Colour can be used for coding and identification purposes (e.g. for signs) or to identify departments.
Light control	This is the primary function of colour in the selling environment.
Readability	The readability of colour combinations is significant in relation to signs.
Temperature control	Colour can be used to reduce or increase the apparent temperature of an interior.

Applications

Children	This is of limited significance is selling environments, except in some specialised cases.
City or country	Some distinction needs to be drawn between the use of colour in urban environments and in country environments.
Food	There is a definite art of colour in relation to food, and this is significant in catering and food selling.
Merchandising	Some colours are better for display purposes than others, but this only has limited relevance in the environment.
Safety	Recognised safety colours should be used when possible to mark fire appliances, escape routes, first-aid points and to mark hazards.
Signs	Colour has a dynamic effect on the ability of signs to attract attention and trigger action.
Texture	The appearance of any colour is affected by the texture of the surface in which it is used and this may be significant in planning decor.

16.3 Colour usage

Having specified suitable hues, consider colour trends. As explained in 15.5 earlier in Part II, trends are an important factor in decorating the selling environment, and a degree of fashion is an essential part of an agreeable environment. It may be desirable to modify the specified colours in order to ensure that the environment does not look dated.

Even in those cases where hues are selected for practical reasons, it would be advisable to choose variations which conform to current trends. Variations of hue are just as important as the trends themselves, and at any given time there may be a trend towards a particular type of variation; for example, a pink with a

yellow bias may be preferred to a pink with a blue bias. Failure to use an up-to-date variation can also suggest an out-of-date look.

The rest of the colour selection process requires the creative skill of the decorator, but first consider colour modifiers and decide whether they are significant in a particular case and how they can be used to advantage. The most significant in a selling environment are:

Adaptation	The state of adaptation of the eye is significant in both decoration and display.
After image	What the eye has seen beforehand is particularly significant when combinations of colours are used for decorative purposes. The effect can also be used to enhance the appearance of merchandise by ensuring that the background colour of a display complements the colour of the product.
Colour constancy	This is important when a decorative scheme is designed for evening conditions or dim lighting. Dark colours are meaningless without plenty of light and will look drab and hollow. An environment designed with soft lighting (as in catering establishments) should not be decorated in dark colours, because they will appear muddy. No colour with a reflectance value of less than between 15 and 20 per cent should be used because it will be meaningless. When light is dim, space seems to contract, distances cannot be judged, forms tend to flatten out, detail is lost and colour values change. With bright light, space is readily defined, distances can be more easily determined, forms appear to be three dimensional and colour variations can be easily seen.
Contrast	This is significant in both interior decoration and display.
Glare	Colour may be partly obscured by glare, particularly that arising from specular reflections.
Juxtaposition	Colour appearance is affected by light reflected from nearby coloured objects or surfaces. No colour is ever seen alone.
Metamerism	Two-dimensional surfaces never match exactly; this should be known and clearly understood, because it leads to complaints from customers.

Consider also:

Colour combinations	Some colour combinations are more psychologically appealing than others, although they may not necessarily have better visibility or reading qualities.
Harmony	There are natural laws of colour harmony, but they do not reflect the emotions of individuals, and it is better to follow accepted principles rather than strict rules.
General rules	There are a number of broad rules which are not easily

classified but which apply to all aspects of colour usage. Those which apply with special force to selling areas are listed below:

- Aim at variety but do not overdo it.
- Plan for variety, not monotony.
- Avoid overstyling.
- Remember that surface finishes affect colour properties; matt finishes are best in most cases.
- Remember to compare colour samples in the light in which they will be seen.
- Pale colours are difficult to select; they will usually look more intense when seen on a wall.
- One overall colour throughout an environment is sterile.
- An element of texture or pattern is useful, although this may be provided by the merchandise itself.
- Strong, pure, colours are best avoided except at points of emphasis.
- Avoid a 'busy' effect.
- Do not use deep colours except in small areas for accent; they can be used to build up contrasts and sprightly effects.
- Colour contrasts should not be too marked; avoid distractions.
- A white space with a few accents is always safe but is uninteresting.

The overall aim should be to ensure that the public using an area are made happier by it, that their attention is drawn to the goods or services on offer and that they are encouraged to buy. The nature of the decoration will obviously depend on the nature of the area and the image or impression that it is desired to create.

17 About graphical applications

The term 'graphical applications' is used in this book to define the combination of graphic design and colour which is part of the production of promotional material, including:

- press advertising
- printed material generally, such as catalogues, leaflets and so on.
- direct mail shots, circulars and the like
- display material, including showcards, point-of-sale displays and so on.
- packaging
- tags, tickets and labels
- images and image-building material
- vehicle liveries (which are akin to packaging).

The sections dealing with promotional material that follow explain the way that colour can be used to maximum effect, outline the broad principles involved in finding the right hue and provide guidelines for the selection process, but it should be emphasised that this is a complex aspect of colour usage and it is only possible here to provide a guide to the various factors that must be taken into account. The application of these broad principles to specific situations, or to specific categories of promotional material, requires further study and research. The selection of colours for packaging and print, for example, are the subject of separate books.

The main emphasis is on promotional material directed at the ordinary consumer, which may be intended to sell some service, such as banking; to sell products which are bought for the home; to sell products of a more general nature; or promotion designed to convey a corporate image, such as annual reports.

The same principles apply to the promotion of industrial products, although the considerations governing choice of colour may be different. No attempt has been made to provide a treatise on the finer points of graphic design, nor to deal with the technical aspects of reproduction or the technicalities of inks and pigments, but these points have been briefly mentioned where they are relevant to the aim of providing assistance in using colour as part of graphic design to the maximum benefit of promotion. Selection of the most effective colour, and the right combination of colours, is an essential part of marketing, and it

follows that the first step in the selection process is to define the marketing aim quite clearly. It is not intended to pre-empt the creative skill of the artist or designer but to provide a link between design and marketing for the benefit of management generally and all those who are concerned with the initiation and production of promotional material.

In the pages that follow, individual advertisements, catalogues, packages and so on have been described as a 'piece' to distinguish them from the broad categories listed above. If any promotional material is to be effective it has to achieve three primary objectives:

- It must attract attention.
- It must create a desire to read or take notice. There is a great deal of difference between ability to read and desire to read.
- It must communicate a message in the most appealing way and trigger action where necessary.

If any piece of promotional material is to achieve these objectives, it must have visual appeal, and this is a combination of two main elements:

- Graphic design, including shape, form and balance. In the case of packaging, the shape and form of the package itself will also be very significant.
- The colour or combination of colours used as part of the graphic design or as a background to the design. The selection of colours to be used for illustrations is a separate study.

The variables that influence results require careful and thoughtful consideration; just as much thought should be given to effective colour as is given to good layout and typography. The overall objective that must always be kept in sight is that promotional material, as its name indicates, is intended to sell and is more than just a pretty picture. The high standard of living of today depends on the ability to sell and on an ability to induce people to want more and better things.

Industry sets to work to meet the demand and to create new things; in doing so employment is maintained at a high level and overall prosperity improves. However, it takes a great deal of selling to maintain demand at a level comparable with capacity to produce, and it takes even more selling effort to create demand which will provide the incentive to increase productive capacity. Promotional material is an important part of the sales effort.

18 Design for promotional material

18.1 Graphic design

The first of the two principal elements which go to make up visual appeal is graphic design, and although this book is not intended to be a treatise on graphic design, it is desirable to say a few words about it because design and colour are closely allied.

It has been said that good design is the most effective factor in any promotion, whatever the medium, because it goes on working long after the original promotion has been terminated. This is because good design has an effect which is largely subconscious. People do not generally realise that they are influenced by design and they do not analyse each element. Graphic design includes illustration, text, typeface, layout – and colour where appropriate – all combined together to create a total impression which is absorbed subconsciously. Even the environment in which the image is seen may well alter the interpretation created in the mind of the viewer.

This is no place to discuss the merits of various schools of design, nor the advantages or disadvantages of using outside designers or staff designers, but it can be said with certainty that there is a need for the creative skills of the experienced designer, if only to avoid the sameness of much promotional material. There can be a suffocating sameness of layout and typography in all promotional material, and particularly in packaging; this is a serious fault. On the other hand, there is also the risk that the creative designer will express too much of his own personality and produce a result that is way over the heads of the people that it is supposed to attract. If the designer is to earn his keep, the results of his labours might just as well appeal to those who see it and therefore do something to aid sales.

Some designers have the idea that it is their function in life to mould and guide the tastes of the public, and they resent the suggestion that design is concerned with anything so mundane as sales. There is a tendency to complicate what is really a straightforward problem and to forget that artistic designs do not necessarily have marketing appeal. Those who buy, or commission, graphic design are concerned to attract the attention of the public at large and, having done so, to impel that public to take action. All parties concerned are, or should be, interested in ensuring that creative skill is used to make design effective as a selling proposition.

In fairness to designers it must also be said that there often corporate barriers to creativity. Some authorities aver that British manufacturers tend to dictate to designers too much and that the same manufacturers often regard colour as a dirty word. EEC competition has had the beneficial effect of persuading manufacturers to give more attention to good design.

There can be much argument over what constitutes good design, but to create that visual appeal which is so important for promotional material there must be an understanding of the principles of human perception, and they must be put to good use. Evaluation of any promotional message by people goes far beyond the eye, it involves the brain and the human psyche itself; what the brain does with the message that it receives is particularly important. The work of the psychologist has a direct and practical bearing on the subject because it identifies the whys and the wherefores of human action and behaviour.

The following are a few broad principles suggested as helpful in achieving effective design for promotional material:

- The impression should be pleasing from both distance and short view.
- The design must tell the sales story quickly, logically, easily.
- Always reflect fashion trends in design and colour.
- The eye prefers to move horizontally; vertical movements are boring.
- Clear vision requires the eye to be fixed; it is temporarily blinded when in motion.
- Information should be presented logically.
- A well-ordered layout suggests restraint, dignity and self-assured salesmanship.
- A haphazard layout may attract attention but lose a sale because the customer does not bother to read it.
- Certain forms and shapes become distorted in the angles of peripheral vision.
- A distorted shape will do more harm than good.
- An illustration that is too dominant may attract attention away from other important features.
- If motion is implied, move the design off balance (e.g. rotate a square so that it becomes a diamond), this is more dynamic, provided that the shape is regular.
- Convexity is more pleasing than concavity. Convex forms convey an impression of billowing and expanding; concave forms tend to collapse.
- Simple geometric forms have more impact and are more memorable than irregular ones.
- Regularly spaced intervals are stable and satisfactory; haphazard intervals are objectionable.
- A horizontal line based on an imaginary ground conveys tranquillity; a vertical line implies activity.
- Form and shape should be tactile and soft.
- Contrasts of light and shade should not be too sharp.
- To trade up, use a more sophisticated design.

18.2 Perception

Perception can be defined as a study of why human beings see as they do and how they react to shape, form, balance and colour, all of which are important in the graphic design of promotional material whether it be press advertising, direct-mail shots or the label on a can. Perception is not subliminal advertising or any other 'funny' business but is simply the fundamental physiological and psychological principles in which optical considerations, emotion and reasoning all play a part.

A design makes an impression on the mind going far beyond what the camera records, and effective design must take this into account along with all the other factors involved, including functional considerations in the case of a package. Visual appeal requires the application of principles of gestalt psychology; if the piece is to have maximum appeal it must make an instantaneous impression which is simple and direct because exposure to the eye is usually of short duration. Simplicity and regularity are vital.

However, instantaneous impressions are of little value if the design makes no lasting impact, and it is here that colour is so important because it helps to increase impact, increase appeal and provide better recognition quality.

Many of the principles of perception are common sense, and although they have a scientific backing, there is no need to apply them in a scientific way. The aim is to ensure that a design attracts attention without conscious effort on the part of the viewer. Much graphic design is neurotic because it tries too hard and makes a spectacle of itself in an endeavour to attract attention. Simplicity is much more effective.

The first principle of perception is that the eye and the brain demand simplicity and balance in everything that they see; if these two do not exist, the eye and the brain will try to create them. This principle influences the form of a design and the shape of a package and helps to create memorability. Attempts to be too clever will defeat the object of the exercise and are unlikely to achieve a useful result. If an irregular form is seen on short exposure, as it is with most promotional material, the mind of the viewer will tend to smooth out sharp angles and to see the form as regular because the eye and the brain want it that way. Anything that is askew bothers the eye and creates a mental block and this causes impact to be lost. Where there is too much complexity, viewers tend to close their eyes, metaphorically speaking, and to reject something that is too difficult to understand. The majority of people are more favourably influenced by smooth, flowing, lines than by hard, angular ones. No design should ever be so 'hard' that it repels people, nor should it present sharp angles or be 'cut in two' by a brand name or some other feature. Although design trends do change, it is safe to say that simplicity is always best for graphic design of a promotional nature; form, proportion and balance are always important.

Another basic principle of perception is that in any design the eye persists in isolating the principal part, usually the centre, from its surround. The isolated part will be given solidity and detail while the surround tends to be soft and yielding. Vision always tends to concentrate its attention on the principal part, and this is where emphasis should be placed. Undue distraction from the principal part will tend to bother the eye of the viewer and lose the impact of the

design; in the case of packaging it may deter purchase. A simple design will help to concentrate the attention of the viewer and is strongly recommended for packages bought on impulse.

The most satisfactory way of achieving maximum concentration is to use a symbol on which the eye of the viewer can fasten; provided that the symbol is easily recognisable, its use will ensure instant recognition. The symbol can be a name, a trade mark or just an abstract shape; this strategy is particularly useful in packaging design but can be used for other material as well.

Any design which is a jumble of conflicting shapes and forms will be 'lost', and the recommended strategy is to ensure that the attention of the viewer is concentrated on the symbol; then use the natural tendency of the eye to read from left to right to guide subsequent movement. Most people in the West read from left to right, as a matter of habit; therefore, if the symbol is placed slightly to the left of centre of the design, the eye of the viewer will tend to concentrate naturally on it and then move to the secondary item which should be placed slightly to the right.

The secondary item might be price, product description or some other feature. Good colour will help to underline the strategy; both symbol and secondary item should be in stronger colours than the background, which should be kept soft. This will achieve maximum impact.

Note: Some modification of the principles suggested in this chapter is necessary in those cases where it is normal for people to read from right to left (e.g. Arabic), or to read vertically instead of horizontally (e.g. Japanese).

19 Colour for promotional material

19.1 Colour in promotion

Colour is the second of the two main elements which make up visual appeal, and its importance lies in the fact that colour appeals to everyone and it appeals to the emotions rather than to reason. People like colour and react to it at a subconscious level; an innate liking for colour is part of the human psyche. It helps to reduce sales resistance and ensures that graphic design has maximum appeal. Other things being equal, colour is a vital factor in creating that graphic design that sells.

Colour achieves its target by reason of its visual and mental attributes:

Physiological responses Colour catches the eye and invites attention, however colourless the message conveyed. It may create a sale by impulse attraction at point of sale.

Psychological responses Colour can help to express warmth, coolness, quality, moods and other emotions because colour is based on human nature. It can convey an impression of the seasons, such as spring and summer, and other desirable feelings.

The appeal to the senses Colour can add dimension and realism to products whose appearance cannot be conveyed without it.

The appeal to the emotions Colour can be used for the pleasure that it conveys and to improve appearance; however, the user may need to be reassured that this will increase sales.

The basic reason for using colour in any promotional application is to attract attention and thus help to sell the product, service or concept concerned, and the best colours for this purpose are basic, simple, colours which reflect the physiological responses of colour. When the eye looks at the spectrum it does not see an infinity of colours but sorts them out into groups. These elemental groups are hard to surpass in any graphical application. When colour areas of the same brightness are seen side by side, the warm colours (red, yellow, orange) will segregate better than the cool colours (blue, green, violet). The warm colours will be sharp and clear-cut, and for that reason are also called hard colours; the cool colours will tend to merge together, and for that reason

are also called soft colours. Red, orange and yellow are the best attention get-
ters of all the colours and cannot be disregarded in any circumstances, whether
or not a person likes them emotionally or aesthetically. Elements in a design
which are meant to stand out should ideally be in hard colours and preferably
set off against a background of soft colours, but the ideal may be modified for
psychological, emotional or marketing reasons. Colour can do more than just
attract attention, and it is the psychological and emotional responses which
provide the icing on the cake so to speak.

Colour has been described as a unique form of communication which cannot
be compared with any other method. Whether selling, telling a story through
advertisement or communicating in a scientific sense, colour adds dimension to
communication. Among other things, colour:

- activates
- stimulates greater identification
- ensures emotional participation
- adds mood
- creates an internal cohesion in the message
- is perceived before form
- is perceived earlier in the life of an individual.
- is immediate and emotional (words have to stand for something)
- does not have to be translated; it can be understood directly
- adds permanence.

The emotional appeal of colour is particularly useful when the appeal of a
product (or service) to reason and to utility begins to slow down and it is necess-
ary to find some new selling technique. This may include the use of colour as a
means of glamourising the promotion or the subject of the promotion; appeal
to the eye becomes more important than appeal to reason. In such a case appli-
cation of the attributes of colour may extend to the promotion of the product in
order to draw attention to it and underline the message conveyed by the
promotion.

In some cases colour may actually create a sale by catching the eye and impel-
ling purchase. Supermarkets are a riot of colour because colour is considered to
be essential to moving merchandise. At point of sale, colours of display and
background help products to battle it out in the most competitive form of sell-
ing, and this applies equally to packaging; breakfast cereals in a black and white
box just would not sell.

The appeal of colour to the emotions and to the senses, and its importance in
the selling process, is well illustrated by the buying habits of the young marrieds
of today. They will sacrifice quality and convenience for the colour schemes
and decor that they like to live with; in other words, they are colour conscious.
When colour trends dictate change they will do the same thing all over again
and thus create additional demand. It is no longer good enough to make an
efficient device; it must have eye appeal as well and that means colour.

Because the products themselves have increased appeal by reason of colour,
it follows that promotional material which reflects the right colour will have
more impact. Although it is hard to beat the basic colours for attracting atten-
tion, they may be combined with more subtle shades to create a specific

emotional appeal; subtly contrasting or unusual colours can communicate a message in addition to basic attractions. The use of modified colours is not generally recommended in graphical applications, but they may be used when something out of the ordinary is required or, perhaps, in high-fashion markets.

The art of using colour in any promotional application is to find out what will appeal to the public and how colour can be used to best advantage at point of sale, but before pursuing this point it will be useful to summarise what colour can do.

19.2 What colour can do

Colour is one of the most potent tools in the selling process, but it must be the right colour. Sales figures prove that the right colour increases sales, but the wrong colour kills them. The first function of colour is to attract attention, but sales depend on what the brain does with the message, and this depends very largely on the hue selected. There is no point in using colour unless it is used effectively and with good reason. This applies equally to product illustration, to the background of point-of-sale material and to the colour make-up of packages and labels.

In the promotional context, colour creates demand primarily by attracting attention and by exciting desire because it provides pleasure in a way that has an effect on the subconscious.

Example 1 Light, pale colours, especially green and yellow, suggest the spring and will turn peoples' thoughts to new clothes and new furnishings.

Example 2 Certain colours have appetite appeal and will make food promotion more attractive, thus increasing demand for food.

People notice colour much more quickly than they notice shape or form, and this not only helps to attract attention but holds that attention; an instantaneous impression is of little value if it makes no lasting impact. Colour is accepted or disliked intuitively, whereas appreciation of design requires conscious thought; people are attracted by colour irrespective of education or culture, but appreciation of form and shape requires experience.

Some of the things that colour can do include the following:

- Attract attention. The first objective of any promotional design is that it should command the eye; colour achieves this.
- Pre-sell the product, as with appetite colours mentioned above.
- Excite demand, as with spring colours mentioned above.
- Create an image. The psychological appeal of colour helps to ensure maximum visibility and attraction.
- Illustrate the product. Some products cannot be conveyed accurately in black and white.
- Inform about a range of colours. Show people that they have a choice.
- Provide an association of ideas. Important in a fashion context.
- Provide identification. An attractive combination of colours will remain in the mind of the viewer.

- Provide emphasis. The psychological appeal of colour helps to ensure maximum attention value.
- Shriek at the customer, when necessary.
- Identify a brand or company image, especially with packaging.
- Ensure maximum readability. Colour can make print easier to read; few people shopping in a supermarket, or glancing through a journal, have time for mature consideration.
- Ensure recognition. Colour will influence people to look at a design more clearly and to be influenced by it; colour helps the design to sell.
- Ensure maximum visibility, by careful choice of hue.
- Persuade the recipient to read. Pleasing combinations of colour and good contrast make reading easier.
- Impel action. Colour has more impact than neutrality.

19.3 Colour attributes

The objectives outlined in the previous section can be achieved by selecting hues with the appropriate attributes and characteristics, but before they can be used in an individual case it is necessary to identify those attributes or properties which are appropriate to the product, its marketing situation and the objective of the promotion. The following is a list of the principal attributes of colour which need to be considered when selecting colours for graphical applications:

Age	Use colours appropriate to the type of person aimed at.
Associations	Select colours that are associated with the product or with the specific theme that it is desired to communicate.
Fashion	Select colours according to the nature of the image that it is desired to convey; this may be a high-fashion image.
Impulse	Select colours that are compulsive where appropriate.
Markets	Select colours according to the market sector at which the promotion is aimed.
Mood	Select colours to set a mood or convey an image according to the sales theme.
Personality	Select colours only for novelty appeal as part of a well-planned marketing scheme; the idea has been used for personal stationery.
Preferences	General preferences for colour are only significant when other factors are equal.
Presentation	Significant in relation to printed material.
Products	Select colours appropriate to the product and that part of the home in which the product is used.
Recognition	Colours with good recognition qualities are significant in creating an image and in attracting attention; they enhance a brand image.
Reflectance	The reflectance values of colours are important in many graphical applications.
Regional	Regional preferences have limited applications in this context.

Seasons	Seasonal colours are significant in planning seasonal sales.
Sex	Significant in planning promotion directed at one sex.
Shape	People seem to prefer certain colours in relation to certain shapes, and this is useful to designers in creating greater emotional appeal.
Size	Significant in all graphical applications.
Small	Useful in promotional applications where perfume is part of the sales appeal.
Stability	Colour can be used to suggest stability, and this can be useful in establishing a company image.
Taste	Significant where flavour is an important selling point.
Tradition	Traditional colours may be used as a theme for promotion.
Visibility	The visibility of colours is significant in all graphical applications.
Warmth	Warm colours are more appealing than cool colours and are useful in creating an inviting display.

19.4 Colour functions

Colour has a number of practical uses in graphical applications, quite apart from its decorative value. These functions may be summarised as follows:

Coding	Colour is frequently used for coding and identification purposes, and the colours used need to be carefully selected to ensure maximum contrast between each one. Chiefly of significance in packaging.
Heat control	Bright colours will tend to reflect heat away from an object and to keep the interior of a container cooler. Chiefly significant in packaging applications.
Protection from light	Colour can be used to protect the contents of a container from the harmful effects of light. Chiefly of significance in packaging.
Readability	Some combinations of colours have better visibility than others, although they are not necessarily more appealing in emotional terms, and this aspect of colour is important in all graphical applications. The most readable combination is black on yellow, but this is not necessarily the most suitable in graphical terms; the impact on the viewer may be more important. Black on white is highly readable, but colour would have twice as much impact.

19.5 Colour applications

Many of the applications of colour are concerned with the home but there are a number of other applications which require special consideration in the context of graphical applications.

Export	Colours that are suitable for British markets are not always suitable for overseas use, and people of different cultures have different reactions to colour.
Food	There is a definite art of colour in relation to food, and this is significant when selecting colours for packaging or other promotion.
Merchandising	This term refers to point-of-sale displays and the like, and it requires special consideration.
Safety	This is one of the most important applications of colour, although it has limited applications in graphical terms, except in relation to tags and labels.
Television	Colours react in different ways to the television camera, and this is significant when selecting colours for packaging and display.

20 Marketing decisions about promotional material

20.1 The objective

Promotional material is, of course, a marketing tool. Whether to use it, how to use it and what media to employ are essentially part of the whole process of market planning, and it is unnecessary to go into detail here. The pros and cons of, say, press advertising over direct mail or of cans over bottles, depends on what is being sold and how it is being sold.

At some point, however, it becomes necessary to plan the individual piece, and before this can be done a number of marketing decisions are required. The first of these covers the objectives to be achieved and the way that the target is to be reached. The primary objectives of all promotional material have been summarised in Section 17 in this part, but these primary objectives can be expanded further depending on whether the ultimate objective is to sell a product or a service, or to communicate an image or a message. It may be desired to trigger action (e.g. persuade people to make a purchase or, at least, to make further enquiries) or it may be desired simply to provide information or to create a reminder of an organisation or brand. Consider:

- the aim of the promotion
- what the piece is intended to accomplish
- the action sought; purchase, enquiry and so on
- which of the functions performed is the most important.

Some of the more usual objectives are listed below, and the marketing plan should indicate which of them is to be given most weight in design and colour choice. These objectives may be any of the following:

- Attract attention. This is usually the most important function of all, particularly with packaging and display material where it is primarily a function of colour. With press advertising, graphic design may be more important.
- Persuade the customer to read. This requires visual appeal, legibility and the right combination of colour.
- Put over a message. Largely a matter of design and creative copy, but colour can help.

- Trigger sales. The nature of the message is important and should be supported by design and colour. All elements must combine together to make an impact. Packaging and display material may create impulse sales.
- Memorability. The combination of design and colour should be sufficiently distinctive to remember.
- Supply information. Legibility and broad visual appeal are important. Applies to tags and labels.
- Create desire and invite further enquiries. All elements must combine together to make an impact. Travel advertising is a typical example.
- Create a mood, such as excitement or nostalgia, thus leading to further action. Colour is particularly important here.
- Arouse interest in fashion. Both colour and design must reflect current trends.
- Create a desire for change. This is similar to arousing interest in fashion and should trigger further action.
- Provide a reference for future use. Catalogues are a typical example and colour may be used in a practical way for identification purposes. Legibility is important.
- Build prestige, as with annual reports. Colour may convey a company or brand image; legibility is important.
- Provide details of facilities and resources available. Design is important; colour may be used in a practical way.
- Create an image of a company, product, brand or service. This image may be sophisticated or simple and the chief requirement is that colour and design should associate together in a way that will be remembered.

There may be other objectives in individual cases but the objective always to keep in sight is that promotional material, by definition, is intended to sell – and is more than just a pretty picture.

When the appropriate decisions have been made, thought can be given to design and briefing the designer, but before doing so it will be useful to consider the image that it is desired to put over. All promotional material is a promise to the viewer; in the case of a product, the customer is asked to buy on the strength of a promise made by the message, and the point is particularly important because people use appearance to make judgements about reality. Similar remarks apply when communicating a message, but the process is more abstract. Depending on sales policy, the image to be put over may be a hard sell or a soft sell one, or it may be a public relations image. It may take a number of different forms. For example:

- flashy
- dignified
- sophisticated
- technical
- harmonious
- impulse appeal
- fashionable
- new

- up to date
- traditional.

Other ideas will readily present themselves.

20.2 Is colour necessary?

Before going any further it will be useful to decide whether colour is necessary at all. Although colour is an essential part of the marketing process, marketing is also concerned with economics and not necessarily with glamour; there is no point in using colour unless it pays dividends in the form of increased sales and helps to achieve the primary objective of the promotion.

The answer to the question will usually be decided by economic considerations; for example, the additional cost of colour may be justified by the increased sales expected. This may be a matter of commercial judgement or management decision, but it also depends on whether colour can be effective. There may be some cases where good black and white will have just as much impact as colour, and both can fail if the planning concept is wrong. The effectiveness of colour may well depend on the way that it is used and on the actual hues chosen; poor register, garish tones and outdated variations can kill the advantages very quickly. There may even be cases where colour creates an unfavourable climate because the public feels that money is being wasted. Consider:

- the economic justification for colour; the cost is justified if it secures more attention or leads to greater sales
- whether colour can create greater impact; colour may be justified on decorative grounds or to add appeal
- whether the message can be conveyed without colour; promoting some products without colour achieves very little (carpets are a case in point)
- whether colour is essential because of the nature of the product; it may be necessary to convey the reality of the range available.

20.3 How is colour to be achieved?

This question follows on from the previous one and may have an effect on the economics of the situation. If good colour is to be used, the choice of medium may be significant and a factor in the marketing equation. Colour can be achieved in a number of ways depending on the nature of the material. For example:

- coloured cover paper
- tinted paper stock
- coloured inks
- process colour
- product illustration
- decorative illustration
- information illustration (e.g. charts, diagrams, etc.).

The method of reproduction may well be a significant factor in deciding which colours to select; there is no point, for example, in trying to illustrate a product in colours which do not reproduce well in the medium to be used. If the appeal of the promotion is to be made by using subtle colours, then the medium must offer a high quality of reproduction. An illustration of an expensive and sophisticated product would be wasted effort in a poor quality medium.

In certain cases, such as goods sold by mail order, it may be necessary to select colours because they *do* reproduce well. Consider:

- what medium is to be used
- what limitations the medium imposes
- what limitations the process imposes
- whether colour has to be selected for good reproduction.

20.4 How is colour to be used?

Once it has been decided that colour has a part to play and it is known how colour is to be achieved, it then becomes necessary to decide on the right colour or colours and how they are to be used to best advantage. Choice of the right colour is primarily a marketing decision; the marketing plan should specify the colours to be used and the reasons for using them, before the designer is asked to put them together in the most effective way. The reason for choice will not only affect the selection of the actual hues but may also dictate how the designer uses them in the finished design.

In reaching decisions it will be useful to consider what colour can do for the promotion under consideration. The answer will depend, of course, on the nature of the promotion and on the marketing objectives to be achieved. Some of the things that colour can do are listed in Section 19 in this part, and it is recommended that the various attributes and characteristics of colour should be reviewed so that it can be decided how they can be used to best advantage. The aim is to translate marketing and merchandising policy into colour terms in such a way that there is a clear understanding in the minds of all concerned, including the designer, about the objectives of the operation and how colour is to help achieve them. There are a number of special points to bear in mind:

- In any promotion it is desirable to select the special features that are to be emphasised and then to identify those attributes of colour which will underline the emphasis.
- When promoting specific products, select those features of the product that have most appeal to the customer and use the attributes of colour to underline those features.
- There must be co-ordination between various forms of promotional material having the same subject matter, for example, between packaging and press advertising or between press advertising and television. It is not always possible to consider each field in isolation.
- Special care is necessary where illustration is used, particularly illustration of a product. The colour of the product is the important factor and that will be selected because it has most appeal to the *customer* for

that product and not for graphical reasons. Subsidiary colours should be selected to support the product colour.

- Different considerations apply to promotion aimed at industrial markets; the nature of the customer is different, and the appeal of colour may be practical rather than decorative. Trends in architectural decoration and office colour may be more important than consumer trends.

21 Selecting colour for promotional material

21.1 The problem

When all the marketing decisions have been made and the aim and nature of the proposed promotional material has been clarified, it still remains to select suitable colours. Although colour can be used in many different ways, it is only the right colour or colours which will contribute to maximum sales or ensure the optimum benefit from the promotion. Colour can fail just as easily as black and white unless proper attention is given to selection. Colour for the sake of colour is not enough; there must be good reasons for selection, reasons which contribute something to the ultimate objective. For example, in addition to attracting attention, the colour may have to support a specific sales theme and, at the same time, be appropriate to the medium.

Much research into the subject of colour for promotion, and particularly into colour for packaging, is too academic, and researchers tend to credit the spectrum with qualities that it does not possess. The most common fault is to place too much emphasis on more colour and not enough emphasis on the right colour. There is also a tendency to be too clever and to try for effects which are beyond the comprehension of the average person in the street.

The problem for those responsible for colour selection is how to identify the right colours; selection of colour must not be too mechanical, nor should it be made on purely artistic grounds. The colours selected not only have to create visual interest but they must also have lasting appeal, and this depends on many factors which have to be assessed in each case. It is necessary to reconcile optical and physiological facts with emotional pleasure and to strike a balance between visibility, impact and emotional appeal.

There is very little point in employing colour if it is not employed in the most effective way, and although this is partly a matter of good graphic design, choice of suitable colours cannot be left entirely to the designer; the latter should be willing to accept the concept that certain colours have advantages from a marketing point of view, and hues should be selected for marketing reasons. However much care is devoted to the planning, design and preparation of promotional material, the effort will be wasted if the public does not like the colour. The effort will be equally wasteful unless colour strengthens the impact of the promotion and performs a useful function.

Whatever the nature of the promotion, it has to appeal to people, and their likes and dislikes will determine whether the piece is effective or not. The colours have to have sufficient impact to attract attention in the market situation for which they are intended and should have the right association with the product being sold or with the aim of the promotion. Colour should be used with purpose. In addition, the appeal is affected by trends of consumer preference for colour, and the significance of colour cannot be properly appreciated without a clear understanding of the influence of trends. It follows that the facts of each situation have to be analysed and basic data brought to bear on the outcome. Use basic facts first and then good taste and common sense.

Colour selection is a complex process and if carried out properly it involves a great deal of work. It is essentially part of the marketing process and involves analysis of the whole marketing picture and isolation of those functions that colour can, and has to, perform. The purpose is to identify the right colours for a particular situation, and this depends on many factors, including the product, the nature of the market, the marketing plan and the media used. It also involves identifying those attributes and characteristics of colour which will be helpful in the situation under consideration and selecting hues with the appropriate qualities.

The whole may require a combination of market research and colour research techniques, and a study of the physiological, psychological and optical influences of colour, and the end result should be a colour, or a combination of colours, that will attract maximum public acceptance and ensure that sales are not lost because selection has been based on guesswork or the prejudices of the individual.

The first step in the process is to define the marketing aim and to pinpoint the nature of the market concerned and the requirements of that market; on this depends the quality of the hues concerned, but selection also depends on a number of other complex factors such as the type of customer, the nature of the product and the nature of the sales theme. Colour may be selected specifically to support a sales theme.

A second step is to identify those responses that it is desired to trigger off. The basic hue may be selected for physiological reasons (e.g. to attract attention); for psychological reasons (e.g. to convey a mood or impression); or for functional reasons (e.g. to provide identification or readability). Even when a suitable primary colour has been pinpointed, each primary hue has hundreds and thousands of shades, tints and tones.

To hit on the right variation it is necessary to take heed of trends of consumer preference for colour that will be current at the time when the promotion will be seen by the public. The colours that people like change over the years, and preferences vary from time to time, both overall and in relation to specific products. The resulting selection may be subject to limitations imposed by the material used and by the method of reproduction; further limitations and modifications are necessary when the piece includes a product illustration; the colour of the product will then be the dominant factor.

It will be appreciated from these brief remarks that the colour selection process can be complicated, but it is possible to adopt a systematic approach which simplifies the sequence of operations. This is discussed in the next subsection.

The initial problem is to decide what information is necessary and how much research will be required to provide that information. Consider what is required to:

- identify the market
- isolate the attributes and characteristics of colour appropriate to the marketing aim
- establish what is necessary to support a specific sales theme
- identify the responses to be triggered off
- identify trends
- identify other factors affecting selection, including limitations.

21.2 Solving the problem

As indicated in the previous section, the colour selection process is complex but can be simplified by adopting a systematic approach to the whole subject, making maximum use of accumulated knowledge of colour and applying it to situations which have been clearly defined by means of research. In adopting a systematic approach the selector should think about colour and use intelligence and common sense rather than guesswork, hunch or bright ideas. The fatal mistake is to introduce personal preferences; creative people, in particular, are apt to favour clever effects instead of thinking about the purpose behind the use of colour.

The right colour for any promotional material is the right colour for the job that the material is supposed to do, and this has to be established at the outset – it is a marketing decision. No designer can give of his best without a clear idea of what is required, and the same applies to colour selection. The whole should be planned to achieve a specific marketing aim, and the first step is to clarify the nature of the promotion and then to approach colour selection in a systematic way.

It is recommended that a colour specification should be prepared for each situation, setting out all the various factors involved, the market conditions concerned and the attributes and characteristics of colour which are appropriate. This is not a simple task, but the effort is well worthwhile because it obviates the risk of any important factor being overlooked and simplifies the whole approach. For example, it may be taken for granted that the form of promotion is press advertising, packaging or whatever, but forgotten that the same design may be used for more than one medium or, at least, that there must be co-ordination.

Marketing is the key to the whole operation, and the specification must clearly define all the marketing and other considerations which will apply to the situation under review; they will, of course, vary with the object of the material. The basic steps in the preparation of a specification are as follows:

1. What does colour have to do? This requires a complete analysis of the nature of the promotional material and the functions that it is designed to perform, including the marketing aim; the nature of the customer at whom it is aimed; the message that it is desired to communicate;

and the conditions under which the material will be seen. Decide what colour can do to help achieve these objectives and which attributes and characteristics of colour are appropriate to the objectives.

2. Establish the marketing picture. This is a most important step and provides the answer to some basic questions which affect the whole planning process. Some of these questions depend on the characteristics of the promotion and some depend on management decisions. The aim is to define the nature of the market quite clearly so that all concerned know where they are going and how colour is to help in the process. The end result of this stage should be the development of a colour strategy.

3. Consider the nature of the problem. This stage includes consideration of the media to be used and the method of reproduction because this affects all that follows; it is not any use selecting a colour which cannot be reproduced. It also includes deciding what steps have to be taken to provide information about the characteristics of the market and the factors affecting colour choice. It would be advisable to establish machinery to keep track of trends.

4. Identify the market. Define the nature of the market at which the promotion is aimed and the type of customer that it is desired to attract. The make-up of the market may have influence on colour, as may the activities of competitors. The characteristics of the product may be important, and so may selling conditions and the purchasing habits of the customer.

5. The sales theme. Consider the sales theme, or sales message, and how colour can be used to support it. Seasonal factors may be significant and appropriate colours are prescribed.

6. Other considerations. Consider the various functions and applications of colour and how they might be used to best advantage. Readability is particularly important for most promotional material.

When all the required information has been collected and the specification is complete, it is possible to select actual hues whose attributes and characteristics will best fulfil the conditions identified in the specification. The first crude selection will have to be modified to reflect current trends of preference for basic colours and for variations of basic hue. Whatever the reason for selection of hue, use the current popular variation of that hue. When the right hues have been found they have to be used to maximum effect, and this requires attention to colour modifiers, to colour combinations, to the rules of harmony and to the most effective arrangement of colour.

21.3 Specification checklist

Because of the varying nature of promotional material it is not practicable to provide a specimen colour specification, but the following is a list of the points made in this part in Sections 17 to 25 inclusive (which deal with graphical applications) and will provide a useful checklist for the preparation of a colour specification. The list does not claim to be exhaustive, and other points may well occur to the compiler of a specification; nor will all the points be required in every case, but it is recommended that they should, at least, be reviewed.

- What is the nature of the promotion?
 - plan the sales policy to be pursued.
- What media are to be used?
- What is the aim of the promotion?
 - is it designed to sell a product?
 - is it designed to sell a service?
 - is it designed to sell a company?
 - other.
- What is the piece intended to accomplish?
- What action is sought?
 - purchase
 - enquiry
 - other.
- What are the objectives?
 - attract attention
 - persuade the customer to read
 - put over a message
 - trigger sales
 - memorability
 - supply information
 - build prestige
 - create an image of a company
 - create desire
 - invite further enquiries
 - create a mood
 - arouse interest in fashion
 - create a desire for change
 - provide reference
 - provide details of facilities
 - other.
- What image is desirable?
 - Is it hard sell?
 - flashy
 - sophisticated
 - harmonious
 - pleasurable
 - up to date
 - is it soft sell?
 - dignified
 - technical
 - impulse appeal
 - newness
 - traditional
 - other.
- Is colour necessary?
 - economic justification
 - can colour create greater impact?
 - can the message be conveyed without colour?
 - is colour essential to the product?
- How is colour to be achieved?
 - what medium is to be used?
 - what limitations does the medium impose?
 - what limitations does the process impose?
 - does colour have to be selected for good reproduction?
- What can colour do?
 - attract attention
 - excite demand
 - inform about a range of colours
 - provide an association of ideas
 - provide emphasis
 - pre-sell the product
 - create an image
 - illustrate the product
 - provide identification
 - shriek at the customer

- identify a brand, or company, image
- ensure maximum readability – ensure recognition
- ensure maximum visibility – persuade the recipient to read.
- Review attributes and characteristics:
 - how can they be used to best advantage?
- What special features are to be underlined?
 - what attributes will provide emphasis?
- What product features have most appeal to the customer?
 - which attributes will emphasise these features?
- Consider co-ordination between various means of promotion.
- Are illustrations to be used?
- Is an industrial market involved?
- The problem. Information is required to:
 - identify the market
 - isolate the attributes and characteristics of colour appropriate to the market
 - establish what is necessary to support the sales theme
 - identify the responses to be triggered off
 - identify trends
 - identify other factors
 - limitations (including illustrations).

The specification itself

- What does colour have to do?
 - the marketing aim
 - the nature of the customer
 - the message that it is desired to communicate
 - the conditions under which seen
- What can colour do?
 - consider appropriate attributes and characteristics.
- Establish the marketing picture:
 - objectives – image desired
 - whether colour necessary – how colour is to be achieved
 - how colour is to be used – develop a marketing strategy.
- Consider the nature of the problem:
 - media to be used – information required.
 - information about trends
- Identify the market:
 - the product – the market
 - the customer – purchasing habits
 - usage – selling conditions.
 - competition
- The sales theme:
 - define – how can colour support it?
 - seasonal factors
- Other considerations:
 - export – brand image

- Consider attributes:
 - age
 - fashion
 - markets
 - personality
 - presentation
 - recognition
 - regional
 - sex
 - size
 - stability
 - tradition
 - warmth
 - associations
 - impulse
 - mood
 - preferences
 - products
 - reflectance
 - seasons
 - shape
 - smell
 - taste
 - visibility.
- Consider colour functions:
 - coding
 - readability
 - protection
 - temperature control.
- Consider colour applications:
 - export
 - merchandising
 - television
 - food
 - safety.
- Trends:
 - study trends and modify hues selected to reflect trends for hue and variation of hue
 - use an up to date variation in all cases.
- Usage:
 - consider colour usage.

Identification of the market

- The product:
 - colour associations
 - colours which will enhance the product
 - colours which will enhance the attributes of the product
 - specific likes and dislikes
 - preconceived ideas
 - is there any impulse sale?
 - seasonal factors.
- Services:
 - image to be conveyed
 - mood to be conveyed
 - colours associated with the service
 - significance of readability.
- The market:
 - identify the market
 - universal or specific market?
 - trading up
 - snob appeal
 - typical markets:
 - consumer

 business
 technical
 upper class
 mass market
 replacement market
 fashion
 export
 local.

- Consider prejudices.
- Consider special trades:
 - textile
 - clothing
 - furnishing
 - carpets
 - other.
- The customer:
 - who is the customer?
 - whom is the promotion intended to reach?
 - what colours are appropriate to the major customer groups?
 - which sex is the major customer?
 - which age group is significant?
 - consider groups:
 housewives
 businessmen
 purchasing managers
 homeowners
 holidaymakers
 females generally
 males generally.
- Purchasing habits:
 - habits of the customers concerned
 - is colour significant?
 - impulse colours
 - special colour schemes.
- Selling conditions:
 - selling conditions generally
 - the surroundings
 - supermarket selling conditions
 - distribution arrangements
 - coding
 - lighting.
- Usage:
 - usage of the product
 - possible influence on colour
 - after-use of packaging.
- Competition:
 - who is competition?
 - what is competition?

- what colours do competitors use?
- what advantages do competitors have?
- does competition dictate modification?
- Sales theme:
 - the message it is desired to communicate
 - the selling features to be emphasised in promotion
 - the image that it is desired to suggest
 - whether seasonal factors are significant
 - how colour can be used to support the sales theme.
- Export:
 - in which countries will the material be used?
 - which colours are appropriate to each country?
 - the need for different colours in different markets.
- Brand image:
 - consider the whole question.
- Merchandising:
 - consider the implications.
- Food:
 - study the association between colour and food.
- Television:
 - consider the implications of television exposure.
- Coding:
 - whether necessary
 - maximum contrast
 - association of colour with products.
- Protection from light:
 - whether desirable
 - which colour?
- Temperature control:
 - consider.
- Safety:
 - is there a safety element?
 - how can colour improve safety?
 - any recognised safety colours.
- Readability:
 - the importance of legibility
 - how legibility is to be achieved
 - the most appealing combinations.
- Trends:
 - are trends important?
 - what are current trend colours?
 - how are trends to be reflected in the material?
 - whether trends favour bright, pastel or muted colours.
- Variations:
 - which variations to use
 - is change necessary?

Colour usage

- Colour modifiers:
 - adaptation conditions under which seen
 - after-image effect of one colour on another
 - colour blindness if important
 - colour constancy use for brand image
 - contrast how it can be used to advantage
 - illusion how it can be used to advantage
 - juxtaposition possible effects
 - metamerism consider substrate
 - perception consider significance.
- Combinations:
 - is legibility or appeal more important?
 - what combines with the dominant hue?
 - recommended combinations.
- Harmony:
 - rules
 - need for appealing colour
 - broad principles.
- Identification:
 - how is colour to be specified?
- Lighting:
 - will the piece be seen in all types of lighting?
 - type of lighting under which it must make maximum impact
 - is the piece designed for a specific type of lighting?
 - will colours realise their full potential under normal lighting?
 - is testing necessary?
- Lightfastness:
 - is it required?
 - qualities of pigments
 - is modification desirable?
- General rules:
 - hard or soft colours
 - shade, tint and tone
 - simple colours.

22 Identification of the market for promotional material

22.1 The product

Selecting colour for any promotional material is a combination of marketing planning, of consideration of the attributes of each hue, of consideration of colour trends; and of a judicious weighing-up of the advantages of colour, plenty of colour and no colour at all.

Before a specification can be drawn up it is necessary to identify the nature of the market at which the piece of promotional material is aimed, and this will almost certainly require marketing decisions and may require extensive research into the various features of the market; until these have been clearly established it is difficult to select colours because the attributes and characteristics of the individual hues have to be matched to the requirements of the market.

The first point to consider is the influence of the product itself in those cases where the promotional material is concerned with a single product; the nature of the product will obviously have a considerable influence on selection of colours used in promotion, and the choice will depend very largely on whether the product is illustrated. If it is, the product will usually appear in its natural colours or in the colours in which it is sold. These colours will, in turn, govern the hues used for background and for other features.

Selection of colours for products is no part of the present text – it is subject to quite different considerations – but when the selection has been made the result is significant in graphical applications. Where the product is produced in a variety of colours, management will decide which variation they will use in promotion. The criteria of choice that they will use are quite different from those applicable to graphical material; normal practice is to feature the best selling colour. Where colour is the main selling feature of the product, as with carpets, always illustrate the product in colours that the public will want to buy. It may be necessary to illustrate a range of colours.

When the product is not illustrated, or when the product colour is not a vital selling point, the background may be especially important and the colours used should associate well with the product; this is particularly important in the promotion of foodstuffs. Consider the following points:

- Are there any colours associated with the product? Many of these are traditional and have grown up over the years.
- Are there any colours which will enhance the product in the eyes of customers? For example, pink conveys sweetness.
- Are there any specific likes and dislikes in relation to the product? There may be preconceived ideas about the right colour.
- Is there any colour which will enhance the principal attributes of the product? For example, dark green is associated with pine odour.
- How do customers buy the product? If it is bought on impulse, the colour of the packaging, or of the point-of-sale material, is important.
- When do sales take place? Seasonal sales require an appropriate background colour.

22.2 Services

When promotional material is concerned with services or with communicating an image, there is no product colour involved and colours will usually be selected because of their association with the service or because they create an image or a mood. The nature of the market and the type of customer that it is desired to attract are still important. With travel promotion, for example, colour will be used to convey the attraction of a holiday, sunshine, the sea, the outdoors and so on; sunny, bright colours are indicated. Promotion to businessmen, such as financial services, requires a more restrained image, and colour should be influential and quiet in nature.

It is difficult to formulate precise guidelines, and intelligent thought is required. Consider:

- what image it is desired to convey
- what mood is indicated
- any colours associated with the service
- whether readability is particularly important.

22.3 The market

It is necessary to pinpoint the market at which the promotion is aimed; it may be aimed at all markets in which the product is sold or it may be aimed at a specific market segment depending on marketing plans. Promotion might be aimed at a specific market sector as part of a policy of trading up. Promotion of a service may also, of course, be aimed at specific market, and while the same broad rules apply, careful consideration must be given to the target. Brash colours suitable for the mass market would not have the same appeal in the business market.

In broad terms, the mass market likes bright and simple colours but higher-grade or sophisticated markets prefer more subtle tones. Experience has shown that the top 10 per cent of the market likes to be different from anybody else and will tend to be attracted by 'different' promotion.

It would be useful to use more sophisticated variations when trading up; 'supermarket' colours would not be appropriate in such circumstances. If the promotion covers a product or a service sold on snob appeal, it would need quite different treatment compared with a mass-market product and would benefit from more sophisticated colours and a higher degree of fashion. A high-fashion market merits particularly careful treatment; certain colours convey an impression of fashion and should be used where they are appropriate. Consider the following:

- In consumer markets, generally use trend colours.
- In business markets select colours for practical reasons.
- In technical markets select colours for functional reasons.
- In upper-class markets more sophisticated variations are recommended.
- In mass markets bright, simple colours are preferred.
- In replacement markets use restrained colours.
- In fashion markets use up-to-date fashion colours.
- In export markets consider each market individually.
- In local markets consider prejudices which may have to be discovered by market research.
- In all markets consider any prejudices or fixed ideas that there may be.

Special care is necessary with some trades. For example:

- Textiles: pattern, as well as colour, is important.
- Clothing: up-to-date fashion colours are recommended.
- Furnishing: background to illustration is significant.
- Carpets: colour is essential.

22.4 The customer

The nature of the customer at whom any promotion is aimed will have a significant influence on selection of colour. In many cases the average customer is a clearly defined section of the total market, and in other cases promotion will be aimed at a specific type of customer. In all cases colours should be selected to have maximum appeal to the major market. The make-up of the customers in terms of age and sex is important. Promotion aimed primarily at the youth market should be bolder and brighter than material aimed at older and more traditional customers; where products are concerned there is no point in aiming at wild youth if the customers are middle-aged married women. This would be selling in a market which did not exist.

Certain colours have greater appeal to young people than they do to older people, therefore it is important to discover whether the greater proportion of customers are young age groups or whether there is a more universal target. A product or a service may be specifically promoted to young people as a matter of marketing policy. Colour should always be selected to have maximum appeal to the age group concerned.

The sex of customers is also significant. Women, as a general rule, react

more favourably to gentle colours than do men, and certain colours, such as pink, are distinctly feminine in appeal. This is quite different from the use of sex as a basis for advertising; some women are unhappy at the way that women are portrayed in advertisements, and sex may well repel more customers than it attracts.

The overall preferences of ordinary people apply when colour is used for the sake of colour and without other motivation. Red, blue and green are the most popular colours overall among adults, although children prefer yellow. However, in all cases, current trends of consumer preference must be considered; if people like colours to live with, they will also like them in promotional material. It is particularly important to use up-to-date variations whatever basic hue is used.

The type of customer is very important in the case of mailing shots and the like, which are aimed very accurately; a mailing shot aimed at the business market requires quite different colour and design treatment to a piece aimed at the mass market. Consider the following:

- Who is the customer?
- Whom is the promotion intended to reach?
- What colours are appropriate to the major customer group?
- Which sex is the major customer?
- Which age group is the most significant?

Where promotion is directed at:

- housewives, trends and fashions are important
- the business market, dignified colours are prescribed
- purchasing managers, use practical colours
- homeowners, trends are important (what are the Jones's doing?)
- holidaymakers, bright colours create a desire for pleasure
- females generally, use feminine colours
- males generally, use aggressive colours.

22.5 Purchasing habits

The purchasing habits of the average consumer are not a significant factor in the selection of colours for most promotional material, although the point should be considered in each individual case. However, the habits are significant in the case of packaging and display material when sales may be made on impulse; in such cases it is essential that the colours used should have maximum attraction value. They may also be of significance in the case of a considered purchase because purchasers will be favourably impressed by fashion colours or by a specially attractive colour scheme. Consider:

- the purchasing habits of the customer for the product covered by the promotion
- whether colour is significant
- impulse colours where impulse sales are indicated
- special colour schemes in special cases.

22.6 Selling conditions

Selling conditions have little significance so far as most promotional material is concerned, except in the selection of colours for packaging and for point-of-sale material. In the latter case the conditions under which a piece will be seen are very important and should be reviewed in detail. A point-of-sale display, for example, should contrast with its surroundings, and the possible effects of after-image must be considered.

In packaging applications supermarket selling conditions may be very different from those in non-self-service outlets, and this would suggest quite different treatment for a package intended primarily for supermarkets. Display conditions often vary with different systems of distribution, and this may dictate some modification of colour choice. Coding and identification may be more important under some selling conditions, and it may be necessary to distinguish between, say, flavours and textures. The lighting conditions under which a piece is seen may also be very significant. Consider:

- selling conditions generally
- the surroundings in which a particular piece will normally appear
- the significance of supermarket selling conditions
- the significance of distribution arrangements
- the need for coding
- lighting.

22.7 Usage of a product

The usage of a product normally has little influence on colour selection for promotional material about the product, except in those cases where the colour of the product has some special significance. A typical example is where the product is produced in fashion colours to match something that already exists. In such a case the promotion must reflect the fashion theme.

Another case where usage is important is in packaging; the use to which the package is put after sale may have an influence on colour choice. For example, a container of salt which is designed to be used in the kitchen would be appropriate in colours which are acceptable in the kitchen. Consider:

- the usage of the product
- possible influence on colour selection
- after-use of packaging.

22.8 Competition

It is very useful to decide who, or what, is the competition and to study the practice of competition with regard to promotional material. What colours do they use? What theme do they use? Has their material any marked advantages? It may be necessary to change colour to avoid being overshadowed by competition or to avoid plagiarism. Consider:

- who is the competition?
- what is the competition?
- what colours do they use?
- what advantages do they have?
- whether competition dictates modification of colour choice?

22.9 Sales theme

Colour has meaning for people and it can be used for promotional material to express the message that it is desired to communicate. Such expressions as 'garden fresh', 'mountain cool' or 'rugged manliness' can be emphasised by appropriate colours, and in some cases colour can be used to suggest moods or themes without actual use of words. It may suggest the character of a product or the promise of a service. It may be part of the image of a product. For example:

- Black would suggest sophistication or distinction.
- Brown would suggest fashion (at the time of writing).

Even where colours are selected for other reasons, the colours ought to be checked for their possible effect on the image of the product. Although black might be chosen for sophistication, in the wrong context it might convey a negative image, perhaps because of its association with mourning. In the same way, although brown is a fashion colour at one time, it might not be at another time. The marketing plan should take cognisance of the time of year at which the promotion will be used, or the time of year appropriate to the product or service. If the product is essentially a summer one, in the case of a holiday promotion, use colours that are appropriate to the season. If the promotion is aimed at the Christmas trade, use colours that convey the spirit of Christmas. Consider:

- the message that it is desired to communicate
- the selling features to be emphasised in promotion
- the image that it is desired to suggest
- whether seasonal factors are significant
- how colour can be used to support the sales theme.

23 Other considerations affecting promotional material

23.1 Export

If the promotional material is to be used overseas, special care is necessary with the selection of colours. Some colours are unsuitable for overseas markets because of local likes and dislikes. People living in sunny climates generally prefer lighter colours than those who live in temperate climates; promotion and packaging has to compete with a brighter environment. There are also prejudices, such as that against green in Moslem countries. Colour associations and trends may differ from British markets. Consider:

- each country in which the material will be used
- colours which are appropriate to each country
- the need for different colours for different markets.

23.2 Brand image

Colour can be used to create or identify a brand image or corporate identity, and where this has been done the appropriate colours should always be used in promotion. It is important to maintain standards. It is not practicable to say that one colour is better than another for this purpose, and colours should be selected with great care and have the right association with the product or service. Consider:

- the whole question of brand image and corporate image.

23.3 Merchandising

Some colours, by reason of their characteristics or optical properties, are most suitable for background, while others are recommended for attracting attention. This is particularly important in display applications, and there are many practical ways in which colour can enhance display. Any promotional material which is to appear at point of sale, including packaging and point-of-sale dis-

play, should be reviewed in the light of the part that it might play in merchandising. It is difficult to formulate any hard-and-fast rules. Consider:

- the implications of merchandising.

23.4 Food

Promotion of food requires special consideration because some colours associate well with food while others do not. Food packaging needs special care, and so does food illustration. It is recommended that a careful study should be made of the association between colour and food, and especially colour and food packaging.

23.5 Television

Colours react in different ways to the television camera, and special care is necessary in selecting colours for promotion which will appear on television. It is, for example, important that a package which is advertised on television should appear exactly the same on the screen as it does when seen on the shelf. Any piece which appears on the television screen should be easily recognisable when seen away from the screen. Consider:

- the implications of television exposure.

23.6 Coding

Identification and coding is a function of colour and will only be significant in promotional applications when colour is used to distinguish one piece from another. For example, packages of a product may be colour coded to indicate different flavours; leaflets may be colour coded to indicate differences in subject-matter; catalogues may be colour coded to indicate different product headings.

It is usually desirable to use primary colours for coding purposes and to ensure that there is maximum contrast between one colour and another. It is difficult to say that one colour is better than another for this purpose, but strong hues are generally better than pale ones. Colours used should generally associate with the subject-matter. A typical example is the association of green with peppermint. Consider:

- whether coding is necessary
- maximum contrast between colours
- association of colours with product (or service) where practicable.

23.7 Protection from light

Another function of colour is to provide protection from light, and this chiefly

applies to packaging. A typical example is the use of brown bottles to protect beer from the effects of sunlight, but coloured films are also frequently used to protect the contents of a package.

Where protection from light is desirable it would be advisable to study the subject in some detail because the most effective colours from a protection point of view are not always appealing from a marketing point of view. Consider:

- whether protection from light is desirable
- which colour will best achieve the purpose.

23.8 Temperature control

This is a minor function of colour in graphical applications but it may be of some significance in packaging, particularly packaging for export. When the outside of a package is finished in light colours these reflect heat and light and tend to keep the temperature of the contents at a more equable level. This may be useful when a package is displayed in strong lighting conditions and when the contents might easily spoil if subjected to heat. The use of aluminium or other shiny foil serves the same purpose. Consider:

- whether temperature control is useful.

23.9 Safety

There is a recognised code of safety colours to denote fire appliances, first-aid points and the like, but these have little application in promotional material. However, the use of colour for safety purposes may be significant in packaging and label applications. Warnings and the like, whether required by law or not, should certainly appear in bright, visible colours, and there are accepted colours and symbols to denote specific hazards. These should be followed where appropriate. Consider:

- whether there is a safety element
- how colour can improve safety
- whether there is a recognised safety colour.

23.10 Readability

One of the most important functions of colour in all promotional applications is to ensure readability and legibility and to promote a desire to read. Although legibility is mostly a matter of type size and layout, colour also has an important part to play by ensuring good contrast between legend and background, and at the same time providing emotional appeal.

The most legible combination of colours is black on white because this provides maximum contrast, but it lacks emotional appeal. White can provide a good background for almost any colour, but it is not the only possibility, and

other colours can be used provided that they contrast with the type colour. As a general rule the legend should stand out and the background should fade away because this makes the legend easier to read. The reverse is sometimes used in the interest of novelty, but 'clever' effects cannot be read in many cases.

Certain combinations of colours are more readable than others because of the reflectance ratio between the colours. Black on yellow is particularly good from a legibility point of view, but it lacks emotional appeal and is not very attractive in promotional applications. A combination that has good legibility and emotional appeal at one and the same time is far better in most cases, although there may be cases where extreme legibility is the first consideration and the likes of the public have to take second place. Consider:

- the importance of legibility
- how legibility is to be achieved
- the most appealing combination.

24 How trends affect promotional material

24.1 General considerations

Any promotional material can be technically right from the standpoint of vision or colour association but may be ugly in terms of emotional appeal. The ideal situation exists where colour does it job efficiently in a visual sense and pleasantly in an emotional sense at one and the same time. Thus the first essential in the selection of colours for a specific piece is to identify those colours that have the right attributes for the job in hand, but the second essential is to consider trends.

There are a number of different types of trend as pointed out in Section 17 of Part I, but it is trends of consumer preference for colour in the home which are the most important in relation to promotional material because they reflect the wishes and desires of ordinary people. Trends of colour for clothing have little practical application in most promotional situations, but they are, of course, important in promotion directly related to clothing.

In many cases promotional material should reflect current trend colours and should certainly reflect current variations, but this may present some problems. Manufacturers selecting colours for the product have to think ahead and forecast colours that will be current when the product reaches the marketplace. The advertiser is much less concerned with forecasting ahead and must use those trend colours that are current at the time that the promotion appears; it should reflect the current rate of sales by colour.

Trends are, of course, particularly important to product illustration in advertising material because people expect to see the same contemporary colours in promotion that they recognise, and insist on, when purchasing consumer goods. They will expect to see the same trend colours in the products that they buy and in the illustrations of those products, and it should be remembered that fashion is a key element in the sale of many products, ranging from computers to wallcoverings. Even where there is no illustration, and colour is used primarily to attract, people will be better disposed to shades that coincide with current trends. Consider:

- whether trends are important to the product being promoted
- what the current trend colours are

- how trends can be reflected in the promotional material
- whether trends favour bright, pastel or muted variations.

24.2 Variations

The initial stage in the colour selection process is to identify those hues that have the right attributes and characteristics for the assignment in hand (i.e. those hues that will help the piece to achieve its objective), and this includes consideration of trends as mentioned above.

Whether or not trends are important, the next step is to select those variations of hue which will have the maximum effect. A variation chosen at random from a standard colour range may be obsolete and may do more harm than good. A variation which is popular or fashionable will have more emotional appeal than one that is out of date, and will make the piece more attractive, more likely to be noted and more likely to be picked up and studied.

For example, if the selected hue is red, perhaps because of its optimum visibility, use that variation of red which is shown to be popular by current trends of consumer preference. Red is a particularly good example because it has so many useful attributes in graphical applications, and preferences for shades of red change quite frequently. Although people will always be attracted by red because of its physiological attributes, they will be psychologically attracted by the variation that they use in their own homes and which they see around them in the things that they buy. An obsolete variation may suggest that the material is out of date, and would thus lose competitive advantage. Similar remarks apply, of course, to all other hues.

The greater bulk of promotional material is aimed at the consumer, and therefore human emotions and preferences are vital if the promotion is to be effective. There are vogues for colours, and the vogue should be reflected in any promotion aimed at consumers. The same consumers will expect a change from time to time. Although the basic hue may have been chosen for practical reasons, and therefore may not be easy to change, it is usually possible to change the variation and therefore bring it up to date. Consumers can hardly be expected to get excited about a colour which was first used ten years ago.

Whatever the nature of the promotion, the people who have to be attracted are the same, and it is their likes and dislikes which have to be gratified if the aim is to be achieved. Consider:

- which variation of basic hue to use
- whether change is desirable.

25 Usage of colour in promotional material

25.1 Colour modifiers

When colour specifications have been completed and when suitable hues have been selected for a piece of promotional material, the way that the hues are put together is a matter for the designer, but there are a number of phenomena which may affect the end result and which can be used to improve that result. These phenomena are known to most good designers, but they are listed below for convenience. They derive from the fact that in all graphical applications light does not travel directly to the eye but is reflected light; the piece is perceived as having shape, size, texture and colour because of the way that light is reflected from what is seen. This reflected light can be modified in a number of different ways.

Adaptation The interpretation of colour may be affected by the state of adaptation of the eye at the time that an object is seen (adaptation is the ability of the eye to adapt itself to different levels of light). This is primarily of significance in connection with point-of-sale material where visibility depends on the conditions under which the material is seen. A simple example is a tag which has to be seen in a dimly lit basement; in such cases avoid red.

- Consider the conditions under which the piece may be seen.

After-image Colour perception may be affected by what the eye has seen immediately beforehand. The consequence of this may be that an otherwise effective design is spoilt because the after-image of one part of the design alters the visual characteristics of the other part. However, after-image can also be used in a constructive way when perfect opposites are utilised, one against the other; the after-image of the two will enhance each other, provided always that the areas of colour are reasonably large. On the other hand, if two colours are confused, or visually blended, the reverse may apply, and the two colours will cancel each other out. When two colours are not exact complements both may appear to be slightly modified in aspect.

- Consider the effect of one colour on the other when two or more colours are used in conjunction.

Colour blindness Colour may be seen differently if the viewer does not have normal colour vision. This is only of significance where colour is used for identification purposes or, for example, as a safety warning.

 • Consider whether colour blindness is significant.

Colour constancy This concerns the ability of the eye to see colours as normal under widely different conditions of light and to 'remember' colour. Certain colours closely related to the experience of the observer become 'fixed' in the memory. Typical examples are the colour of the human complexion, of foodstuffs, of natural objects such as flowers; they are familiar and the brain 'remembers' them as seen under natural light. A designer using colour to express a brand image or a corporate image should aim at obtaining the same memory, and because of this the colours used for an image should be controlled within very close limits. If distortion creep in, the result can be disturbing and lose the value of the image.

 • Consider use of colour in connection with brand or corporate image.

Contrast The appearance of colours may be affected by other colours within the field of view. Contrasts may be used in graphical design to enhance the appearance of a colour by putting it beside, or on, its exact opposite. Black print on white paper provides maximum contrast and maximum visibility; contrasting two opposites such as red and green will create attention.

 The principal features in any promotional design should have maximum contrast with their surround, and print should always have maximum contrast with its background to ensure maximum readability. In suitable cases the effect of after-image will enhance the contrast and create excitement; this is just what is required to attract attention. Contrast is particularly effective in large areas. There can also be contrast between light and dark; dark colours tend to accentuate the brightness of light areas and a light background will add depth to dark colours.

 • Consider how contrast can be used to best advantage.

Illusion The appearance of a colour may be altered by changing reality to such an extent that people 'see' things that are not there. In the graphic design context this means modifying the appearance of a colour by the way that other colours are placed in relation to it. For example, a line of white type placed against a pure colour will seem to advance, thus adding an illusion of depth which increases impact. Illusion calls for the creative skill of the good designer.

 • Consider how illusion can be used to advantage.

Juxtaposition Colour appearance may be affected by light reflected from other surfaces within the field of view or in close relation to it. In all graphical applications each colour or design loses something to each of the other colours in the field of vision, and it is modified accordingly. The appearance of each colour inclines towards its adjacent (on the colour circle) which is furthest away from the colour with which it is in combination. Thus, if orange and green are seen together, the appearance of the orange would incline to red, and the appearance of the green would incline to blue. This effect is particularly noticeable in colour printing.

In display and packaging applications the colour of the surround or background should be carefully chosen so that there is no undue emphasis on any part of the spectrum. The background should be carefully related to the feature colour.

- Consider possible effects of juxtaposition.

Metamerism The appearance of colour is affected by the chemical composition of the surface on which it appears. The significance of this in graphic design is that a colour specified in, say, artists' colours or printing ink may look quite different on different substrates, such as carton board or plastics film. Even different 'makes' of carton board may have an effect on reproduction, and so will different types and weights of paper.

- Consider the various substrates on which a design may be printed.

Perception An image or a colour may be affected by the interpretation that the observer places on it; it may be a perception with a basis only in the mind. In graphic design this often means that it may not be possible to obtain a required effect within the limitations of the reproduction process. For example, it is possible for the artist to visualise a lustrous red, but it may be much more difficult to reproduce this by commercial processes.

- Consider the significance of perception.

25.2 Combinations

Colour combinations are particularly important in graphical applications because of the need to achieve good readability, as indicated in 23.10 in this part. However, some colour combinations have more psychological appeal than others, and those with maximum visibility and legibility may not be pleasing to the viewer when used in promotional material. Formal rules of harmony do not always reflect the feelings and emotions of ordinary people, and it may be better to sacrifice some legibility in the interest of better appeal. Consider:

- whether legibility or appeal is the more important
- what colour will best combine with the dominant hue
- recommended combinations.

25.3 Harmony

Most designers will be aware of the natural laws of colour harmony, but they may not realise that these do not take into account the feelings and emotions of the average individual, and it is the latter which are important in graphic design for promotional purposes. It follows that formal rules should not be interpreted too literally or too arbitrarily. Reference should be made to Section 13 in Part I.

In most promotional applications it is a good general rule to choose a colour combination in which the current trend colour is dominant, but the dominant colour may be chosen for other sound reasons. Strong, pure hues look best

when they are confined to small areas and when they are seen surrounded by larger areas in shades, tints and tones, but this rule does not always apply in promotional applications, especially when red is used as an impulse colour. The nature of red is such that it ought to command a design and be emphasised through the use of small touches of blue and green. Consider:

- the rules of colour harmony
- the need for colours that appeal
- broad principles.

25.4 Lighting

Colour is, of course, affected by the nature or spectral quality of the light source. The chief significance of this so far as graphic design is concerned is that the piece may be seen under different conditions of illumination, and each of the common sources can produce a different reaction from the same hue. For example:

- Incandescent light makes colours look more yellow.
- The effect of fluorescent light depends on the type of tube.
- Mercury light makes colours look more purplish.

Fluorescent inks are now commonly used in printing display material and packages, and the effect of lighting on these can be even more pronounced; they only achieve their full effect in daylight and look particularly drab under sodium lighting. There is no real answer to this particular problem because most material is likely to be seen under many types of light, but it would be desirable to select those colours that are most effective at the point where they make maximum impact. Thus, in the case of most packages, they have to make maximum impact on the supermarket shelf, and it is recommended that the colours used should be those that show up best under typical supermarket lighting. If the piece is designed specifically for use under one type of light, adjust the colours to that light to secure maximum effect.

In case of doubt, test out the combinations of colours under various types of lighting. Consider:

- whether the piece will be seen under all types of lighting
- the lighting under which the piece has to make maximum impact
- whether the piece is designed for a specific type of lighting
- whether the colours will realise their full value under normal lighting conditions
- the need to test colour appearance.

25.5 Lightfastness

This is a property of pigment rather than of colour, but it is closely allied to lighting. Lightfast qualities are very important when a piece of material is exposed to light, and particularly daylight, for long periods; point-of-sale displays

and posters would be typical examples of material where colours should have good lightfast qualities.

Some pigments and printing inks are particularly prone to fading, and it would be better not to use them for material which will be exposed; others have better qualities, and some are hardly subject to fading at all.

It is usual for paint and printing ink manufacturers to quote the degree of lightfastness of the colours that they offer, and before deciding on a particular hue it would be advisable to check that it would be light fast to a degree suitable for the job that it has to do. Depending on the ink or pigment to be used, it may be necessary to modify a selected hue to ensure adequate lightfast qualities. Consider:

- whether lightfast qualities are required
- the qualities of the pigment that it is proposed to use
- whether modification is desirable.

25.6 General rules

The broad rules of colour usage, which are listed in Section 18 in Part I, apply equally to graphical applications, and they should be consulted. However, the following are a few rules which apply specifically to graphical applications:

- Use detail and texture against filminess.
- Use form against or surrounded by space.
- Consider the relative sizes of colour areas and the right proportions to secure a balanced design.
- Make sure that vision has something on which to concentrate (e.g. a symbol or a design feature).
- A symbol should be in strong colours, on a neutral or soft background.
- Position the symbol slightly to the left of centre; this is the dominant position – less important features to the right (this should be reversed in right-to-left reading countries).
- Make sure everything is readable.
- Concentrate on the intuitive elements of colour. Sophistication may be appropriate in interior decoration, but it is of secondary importance in most promotional applications.

Any graphic design used for promotional purposes involves the use of combinations of colours, contrasting colours, variations of basic hues, trends and other factors which may modify colours selected on marketing, psychological and physiological grounds. It is necessary to strike a balance between visibility, impact and emotional appeal and to reconcile hard facts with emotional pleasure. Consider:

- whether hard or soft colours are required
- shade, tint and tone, not only the primary hue
- whether simple colours can be used; they are almost always best.

26 About consumer applications

Previous Sections in Part II have been concerned with environmental and graphical applications of colour, but so far no mention has been made of the most important application of all, namely the selection of colours for products which are offered for sale in consumer markets, in other words products which are sold to the ordinary man or woman in the street. For the most part these are products used in the home, but similar principles apply to other products bought by the consumer. Typical home products include:

- Bathroom products Sanitary ware, bathroom furniture, accessories.
- Bedroom products Beds, bedwear, bedroom furniture.
- Domestic appliances Cookers, small appliances, space heaters, electronics.
- Housewares Kitchen ware, cook ware, table ware, picnic ware, baby ware.
- Kitchen products Kitchen units, kitchen furniture, fittings.
- Living room products Furniture, upholstery, fabrics.
- Window decoration products Curtains, blinds, awnings.
- Floor coverings Carpets, carpet tiles, rugs, smooth floor coverings.
- Surface coverings Paint, decorative laminates.
- Wall coverings Tiles, wallpapers, other wall coverings.

Other consumer items include products for personal use, leisure products and others which require individual consideration.

The next few chapters do not make colour recommendations for individual products of the nature listed above because each of them must be studied in its own marketing context, but they do provide an introduction to a more detailed study; underline the differences between, say, bathroom products and kitchen products; provide guidelines for the selection process; explain the methods to be adopted, and the principles to be followed. Individual recommendations are far beyond the scope of a book of this size, but the material provided will be a starting point for manufacturers who have to decide what colours they will offer for sale. The material is primarily intended for management, and particularly marketing management, but will also be of interest to all those responsible for

selecting colour for selling and promotional purposes, including advertising agents, designers, retailers and others.

The subject is concerned with the marketing and selling aspects of colour and with the use of colour to achieve optimum sales, and it requires an understanding of trends of consumer preference for colour, of the factors that govern colour choice by the consumer and other factors that have an influence on selection of colour. These points are covered in the sections that follow, and there are also notes on the use of colour in the promotion of consumer products and to support a sales theme, together with instructions for the preparation of a colour specification and advice on how to select hues.

The guidelines provided are concerned with the likes and dislikes of ordinary people and with using colour to sell, and they may be applied to a number of different situations, including the selection of colours for new products and the selection of a range of colours for a new product. In both these cases colours will be selected specifically to meet a marketing and selling target, and no consideration of existing colour is necessary. Other situations to which the notes may be applied include:

- review of any existing colours to ascertain whether change is necessary. This process is the same as for new colours but is applied to existing colours.
- a review or 'audit' of an existing colour range. The same process is used, but some revision of existing colours will almost certainly be necessary. Some existing colours will be retained, perhaps because they are selling well or perhaps because there are stocks that must be cleared.
- addition of new colours to an existing range. This may be because change is necessary; because something new is required; because fashion dictates more colour; to provide a peg on which to hang promotion; or to reach a new market. Some existing colours may have to be dropped.

A first step is to define the object of the exercise and then to consider what colour can do and how it can be used to sell.

27 Using colour to sell consumer products

27.1 What colour can do

There can be no doubt that colour is a potent factor in sales, and the whole point of taking trouble over colour selection is to achieve optimum sales. Colour is essentially part of the marketing mix, and the most effective way of using it is to ensure that every product is offered for sale in those colours with maximum appeal to potential purchasers; this is particularly the case with products for the home. However, colour also has a number of other parts to play in achieving the marketing objective.

The principal ways in which colour aids the marketing of consumer products are as follows:

Attracting attention Colour helps to attract attention to a product at point of sale and, in some cases, may create the sale. Strong and compelling colours which catch the eye may be included in a colour range to attract attention to the product even although the majority of the sales are in other colours. This use is particularly important for products bought on impulse; it is an important part of marketing strategy and requires careful thought and sometimes experiment.

Fulfilling the wants of potential customers Customers are more inclined to purchase a product offered for sale in colours that they like and want; they may refuse to purchase the same product in disliked colours. Attention to trends of consumer preference for colour will maximise sales but bear in mind that trends vary in different parts of the home and that there are always those who dislike the trend colour or who wish to be different to everybody else. A reasonable choice of colour is usually desirable.

Creating an appeal to specific types of purchaser Customers at the top end of the market, for example, have different likes and dislikes from those at the bottom end; young people have different tastes from older people; colours that appeal to women may not appeal to men. Careful attention to selection of colour can sharpen the appeal to specified market segments.

Enhancing design The application of colour and combinations of colour appropriate to the design of the product will enhance its appeal and make it more pleasing to potential customers.

Creating an up-to-date image Purchasers will pass over products offered in old-fashioned or outdated colours; new colours are necessary to sustain an up-to-date image, although replacement demand may prescribe that this process does not go too far.

Demonstrating market leadership Colours that are better than, and different from, those offered by competitors will help to draw attention to the product, and to manufacturers, especially when it can be shown that the colours have been chosen with care and for good reasons.

Providing change The need for change is an inherent human characteristics, and new colours will help to create a desire for change; if purchasers can be persuaded that it is time for a change, they will be more disposed to buy.

Supporting a sales theme Appropriate colours can help to support a promotional theme and make it more compelling. An example is promotion of fashion.

Providing a sales theme A new colour will often be a theme for promotion, and there are various ways of using colour in positive directions.

Enhancing a brand image A manufacturer can acquire a reputation for sound colour choice, for a wide choice of colours, for unusual colours or for good colours. The attributes of colour may be used in appropriate cases for brand identification.

There are, of course, other ways in which colour can be used to assist the sales effort, some of them being peculiar to specific products and therefore needing identification. The ways in which colour is used will depend on the nature of the product and on the marketing plan.

Colour can also be used in a more general way. Colour is always part of decoration and advice on decoration, decorative ideas, specimen colour schemes and help in using colour for decorative purposes is a potent sales aid, in appropriate cases, depending on the nature of the products and the nature of the market. Colour can also be used in a specific way by employing its attributes and characteristics.

27.2 Colour attributes

Each basic hue has a number of individual attributes or properties which have been discovered by research or experience; they are partly emotional in nature and partly derived from the physiological, psychological and optical responses triggered off by colour. Before they can be used in an individual case, it is necessary to identify those attributes or properties that would be appropriate to the product and to the marketing conditions under which it is sold. Research may be necessary to determine which of them will meet the marketing target. The following is a list of the principal attributes of colour which need to be considered when selecting colours for consumer applications.

Age	Certain colours appeal to the young and less so to older people. Those appealing to the young are suitable for promotion to newly weds and teenagers.
Appearance	Flattering colours are often important with bedroom and bathroom products.
Associations	The association of certain colours with cleanliness is particularly important in the home.
Fashion	Some colours have a high-fashion connotation quite apart from trends and are a potent sales aid in appropriate cases. The fashion angle can be promoted to distinguish between high fashion and fashion in a trend sense.
Impulse	Those colours that have high attraction value may be included in a range purely to attract attention at point of sale, thus creating impulse sales.
Markets	The broad principle is that mass markets like bright and simple colours while the top end of the market prefers more sophisticated colours. Specialised markets have specialised needs.
Mood	The use of colour to create a mood or image has promotional possibilities as well as a valuable use in interior decoration.
Personality	The relationship between colour and personality can be used as a theme for promotion.
Preferences	Broad preferences are overridden by fashion and trends.
Products	Certain colours have an association with specific products, and this association should be respected.
Recognition	Some colours have better recognition qualities than others, and this may be useful in certain circumstances.
Regional	Regional preferences are usually associated with climate. Brighter colours are preferred in seaside areas compared with urban areas, and fairly restrained colours are liked in the country.
Seasons	There are colours that are appropriate to each season of the year and can be used with advantage when appropriate.
Sex	Some colours appeal more to women than to men and can be used with advantage in promotion for the female market.
Shape	The abstract association between colour and shape can often be used to create emotional appeal.
Size	Colour can make objects look larger or heavier, smaller or lighter.
Stability	Colour is often used to suggest stability, dignity and restraint as distinct from impulse and excitement.
Tradition	Traditional colours and decorative ideas (e.g. Adam, Regency, etc.) appeal to many people, particularly in higher-grade markets.
Warmth	Warm colours are more appealing than cool colours and may be more suitable in some applications.

27.3 Colour functions

The principal function of colour, apart from its decorative qualities, is to control light, but there are a number of practical functions which may be useful in consumer applications. For example:

Camouflage	In certain cases colour may be used to hide soiling, and this may have promotional possibilities in certain cases. The idea that something 'does not show dirt' appeals to many housewives, especially where children are concerned.
Coding	Colour can be used for coding and identification purposes. This may be useful on occasion (e.g. for controls and the like).
Insect control	A minor use of colour which may be useful in some instances.
Readability	Some combinations of colours have better reading qualities than others; good readability may be necessary for instruction panels and the like.
Visibility of controls	Suitable colours will improve the visibility, and appearance of controls.

27.4 Colour applications

There are a number of applications which require special consideration in the context of consumer applications. For example:

Children	Colour preferences of children are quite different from those of adults, and this is significant in marketing. Special care is necessary when selecting colours for products used by, or bought by, children.
Country	Some distinction needs to be drawn between the use of colour in city and suburban environments, and in country environments, and this distinction applies to products used primarily in the country.
Export	Colours that are suitable for British markets are not always suitable for overseas use, and people of different races have different reactions to colour.
Exteriors	The main weight of these remarks is concerned with interior decoration, and special consideration is required for products used outdoors. The criteria of choice are quite different.
Food	There is a definite art of colour in relation to food, and this is significant when selecting colours for products used in association with food.
Merchandising	Some colours are better for display purposes than others because they have greater impact on the eye and the brain, and this is significant in the case of products bought on impulse.

Pattern	In any pattern it is the overall colour which is important, and this is significant in the selection of colours for products used in interior decoration. There is an association between pattern trends and colour trends, and some colours are not suitable for some types of pattern.
Safety	This is one of the most important applications of colour, but it has limited applications to products used in the home. It should be considered.
Television	Colours react in different ways to the television camera, and this is significant when selecting colours for products likely to be advertised on television.
Texture	The appearance of any colour is affected by the texture of the surface on which it is used; particularly significant with all colours used in interior decoration.
Woods	Each hue harmonises with certain types of wood grain and vice versa. This is primarily of interest in interior decoration but may affect colour selection for products.

27.5 The sales theme

One of the ways in which colour can be used to achieve maximum sales is to use it to support a specific sales theme; obviously the nature of the sales theme will have an effect on the selection of colours. Some typical sales themes are outlined below:

Fashion This is a particularly popular theme for promoting all consumer products. One of the reasons why people choose a particular colour is because they take a quiet pride in their homes and want them to look as good as, or better than, the neighbours. Most housewives are influenced by what the Jones's up the road are doing and by what they see recommended in the press (particularly the womens' press) and on television. At various times more emphasis is placed on one part of the home than on another; at some periods it is the ambition of every housewife to have an up-to-date kitchen, at other times the emphasis is on the bedroom or the bathroom. Anyone installing a new kitchen at such a time would wish to be thought up to date, although sometimes the purchaser has to be satisfied with achieving an up-to-date look by introducing new utensils, carpets, curtains and so on. At times continental ideas and colours have snob appeal and can often be used in promotion. The manufacturer can capitalise on this desire to be 'with it' by emphasising fashion in promotion and by assuring potential customers that great trouble has been taken to offer the right colours. Obviously, extra effort must be made to ensure that the colours offered are, and can be demonstrated to be, the colours that the majority of people want – and ought to have.

Change The fashion theme can also be used in another way by encouraging that liking for change which is inherent in all human beings. Many housewives react favourably to suggestions that it is about time that they changed

the decor of their kitchens, of their bedrooms, of their bathrooms or of any other part of the home; reactions are particularly favourable in the spring, partly because of tradition and partly because the lighter days show up the faults of the older furnishings. Emphasis on change of colour, or on up-to-date colours, will provide a motivation and is a useful promotional theme. Colours must, of course, be up to date and carefully selected to support the theme.

Accents The fashion aspects of colour can be used in yet another way. They can be applied to accessories and furnishings generally by emphasis on accents. New colours, fashion colours and an up-to-date look can be introduced into the home by new accessories, even though no change takes place in the major items of purchase. Specially selected colours are required.

Colours of the future A claim that colours offered are 'shades of the future' will often go down well provided that the claim is backed by sound reasoning. 'Colours of the Future' is a theme that appeals to many purchasers; they react favourably to the suggestion that the colours offered are well ahead of fashion. It appeals to those people who like to think they are ahead of their contemporaries and who think that they are exhibiting a degree of sophistication that gives them status. When using this theme it is more important than usual to ensure that due attention is given to the forecasting of trends and to the direction that they take in the area of the product concerned. It is useful to provide evidence of the trouble taken to get the colours right.

Brightening up Yet another variation of the fashion (new colours) theme. This often applies to the kitchen because housewives become tired of staring at the same old kitchen and react favourably to suggestions that they might brighten it up. Specially selected colours will support the theme.

Matching This is another theme that can often be used with housewares, kitchen utensils and other small items of a similar nature. People will often go to a great deal of trouble to match what they already have and can often be persuaded to buy new items that can be demonstrated to match major items. It would be necessary to study and research the extent to which matching is important with any product and to identify what it is that people want to match. Past trends may be quite significant in this case. The same idea can be adapted to contrasting or 'different' colours to provide decorative effect. The situation alters from time to time.

Personality Colour can be related to personality, and in those cases where a wide choice of colour is offered it may be possible to use this as a promotional theme (e.g. 'choose your colour to match your personality'). This theme has been used with some success for personal writing paper, but its extension to other products needs a good deal of care and planning.

Interior decoration The various attributes of colour can be used in a broad way as a theme for promotion, supplemented by specimen colour schemes and help in choosing the right colours. Yellow, for example, helps to create a sunny atmosphere; red can create an exciting environment, blue helps to cool things down, green is restful; a combination of green and yellow pro-

vides a country look; blue-grey is subduing. Colour can be used to make a room look larger or smaller, longer or shorter, cooler or warmer, and to alter the appearance of the room in various ways. The interior decoration theme can be used in many different ways, but it requires careful planning. Colour may be selected to support an interior decoration theme or, alternatively, when colours are selected first for other reasons, the appropriate qualities of each hue can be underlined in promotion.

Working conditions Colour can be used in a functional way to improve seeing conditions in the home and to relieve eyestrain, especially in the kitchen. The excessive use of bright or light colours combined with poorly designed lighting can often cause eyestrain and tension. The difficulty can usually be overcome by suggesting colours with a lower reflectance value, and variations of hue can be specially developed to obviate glare. Although little use has been made of this aspect of colour, it could be developed into a useful promotional theme.

Food The relationship between colour and food can be used as a promotional theme, particularly with kitchen products and housewares. Some colours associate well with food and enhance its appearance; others do not. Some colours are excellent background for food; some colours encourage appetite. Colours would have to be specially selected to support the theme.

The suggestions made above are, of course, only a few typical examples of the many themes that could be used. The point is, however, that the theme should be decided before colour selection begins, and the colours should be specifically selected to support the theme.

It is desirable to develop a colour strategy for each product by considering the selling implications of colour and choosing a sales theme which relates to market characteristics and trends.

28　Colour problems with consumer products

28.1　The problem

Although colour can be used to sell in many different ways, it is only the right colour or colours which will contribute to maximum sales. The purpose of the colour selection process is to find the right colours, and these depend on the product, the nature of the market and the marketing plan. The end result of the selection process should be a colour or colour range that will attract maximum consumer acceptance and ensure that sales are not lost because selection has been based on guesswork or on the prejudices of the individual.

The problem of those responsible for colour selection is to identify the right colours. Colour for the sake of colour is not enough; there must be good reasons for selection, and the results must contribute something positive to the selling process besides having appeal to the potential purchaser. For example, in addition to attracting attention at point of sale, the colours may have to support a specific sales theme and be appropriate to the media in which the product is promoted.

In simple terms, the colour selection process involves identifying those attributes and characteristics of colour which will be helpful in a specific situation and selecting hues that have the appropriate qualities. The attributes appropriate to a specific situation depend on the nature of the market and on a number of other complex factors such as the type of customer, the method of purchase, the reasons for purchase and the usage of the product. An important step, therefore, in identifying colours that appeal is to define the nature of the market in which the product is sold or at which it is aimed, and to identify the requirements of that market.

In addition to identifying the requirements of the market, it is also necessary to understand the way that the average customer chooses colour (particularly when purchasing products for the home) and the factors that are likely to affect the choice of the consumer. These also vary with the characteristics of the product, the reasons for purchase, the type of customer and the part of the home for which the product is intended.

The colours offered may also be affected by the nature of the sales theme used to promote the product; colour may be specifically selected to support a

sales theme such as 'Colours of the Future'. There are a number of other considerations which may govern the selection of colour, including, for example, production and stockholding limitations and the strength of competition.

However, this is only half the problem. Whatever the product, and whatever the purpose for which it is bought, it is the same people who are buying it, and it is their likes and dislikes which will decide whether the product will sell or not. The appeal to the potential purchaser is affected by trends of consumer preference for colour, and the significance of colour cannot be properly understood, nor its importance to sales appreciated, without a clear understanding of the way that the average man or woman in the street is influenced by trends.

Although the average consumer tends to be conformist and to buy the same colours as everyone else, there are differences in various parts of the home, and likes and dislikes change periodically as trends change. It may be necessary to forecast the requirements of the consumer up to two years ahead, depending on the lead times of the product and the period for which the colour selection has to last.

The process of colour selection is complex, and when carried out properly involves a great deal of work. It is essentially part of the marketing planning operation and involves analysis of the whole marketing picture and isolation of those functions that colour has to perform. This requires a combination of market research and colour research techniques and includes:

- study of, and research into, the way that colour is used in the market under consideration
- identification of the various factors that may influence the colour choice of the purchaser
- collection of data about colour movement and colour trends, including analysis of past data because this must be combined with current information to create a forecast of future demand
- identification of the various factors that ought to be taken into account when making a selection
- applying experience of the use of colour and knowledge of its attributes and characteristics
- application of the whole to a specific product, product range and marketing situation.

The problem really is to decide what steps are necessary to provide the required information and how much research must be undertaken:

- to define the market
- to identify the attributes and characteristics of colours most appropriate to the marketing situation
- to identify trends of consumer preference for colour appropriate to the situation
- to identify the way that the average purchaser chooses colour for use in the home, and how they use it in the home.

In addition to the above it is, of course, necessary to establish:

- what is required to support a specific sales theme
- what other factors should be taken into account.

28.2 Analysis of the product

The first step in the colour selection process is to analyse the nature of the product and the various limitations and practical difficulties that may arise in applying colour. For example:

- What materials are used in the construction of the product, and what limitations, if any, do these impose on colour. Is it possible to use alternative materials?
- What type of finish does the product have, and what effect does this have on colour? Are there alternative finishes? Would another type of finish give more scope?
- What surfaces does the product have, and can these be in different colours? Should they be in different colours? Consider combinations.
- Will surfaces be textured? If so, what effect will this have on the appearance of colours?
- Will surfaces be patterned? If so, what effect does this have? How many patterns and how many colourways are envisaged?
- If there is an existing colour range:
 - which are the best sellers and should they be retained?
 - what recent changes have been made, and why?
 - what are the sales percentages of existing colours?
 - do sales by colour accord with trends?
 - is there any marked demand for colours which are not on offer?
 - are there any specific worries about colour? For example, it may be claimed that they are out of date, retailers do not like them, and so on.
 - are there any problems in changing colours? These may derive from production limitations or from existing stocks.
 - are customers looking for something specific?
- Are there any traditions associated with the product or brand which ought to be maintained? The psychological influences of colour have an effect on the subconscious, and people are not aware that they are influenced by the attributes of colour. For this reason there is a continuing demand for certain colours which have traditionally been considered suitable for home use, and this demand often overrides trends. A good example is blue, which always retains its popularity, particularly for kitchen use; this is because blue is a clean colour, which creates an impression of freshness, coolness and cleanliness. It is ideal for cooling down a hot kitchen and is an excellent background for food. Blue has a perennial appeal to British people because of its association with the sea and the sky. White has a similar effect and represents cleanliness in the minds of most housewives. The same housewives will see red and yellow as bright and cheerful colours which make a kitchen a more pleasing place to work in. There are often associations between colour and a specific product both in a positive and in a negative sense, and these should be given due weight where appropriate.
- Are there any special features that ought to be considered? For example, interchangeable panels.

- What is the object of the design? There may be a need to emphasise special features.
- Where there are control panels, how should they be treated and where should they be placed? Should they be in different colours?

There may also, of course, be other points associated with specific products, and attention is also drawn to production limitations, which are discussed in 32.2 in this part.

28.3 Solving the problem

The most satisfactory way of solving the basic problem is to adopt a systematic approach to the whole colour selection process, using research to establish the marketing picture and making maximum use of accumulated knowledge of colour, which can be applied to clearly defined situations.

It is recommended that a colour specification should be prepared for each situation, pinpointing all the various factors involved, including the attributes and characteristics of colour appropriate to the product and the market conditions under which it is sold. Marketing is the key to the whole process, and the specification must define all the marketing and other considerations that may apply in each case and which will vary with the product. Preparation of a specification is not a simple task, and many factors are, or may be, involved, but the effort is well worthwhile because it simplifies the whole operation. It is only when all the facts are known and the specification is complete that it is possible to attempt the actual selection of hue.

The following is a summary of the steps to be taken in the preparation of a specification. The process is broadly the same whether the objective is to select one colour or a range of colours, and it may also be applied where the objective is to choose new colours for an existing range. In this latter case it may be necessary to identify gaps in an existing range, which can derive from changing market conditions.

1. What does colour have to do? This is the key question. It includes identifying the object of the exercise and considering what colour can do to achieve that objective and how it can be used to increase sales. It will be useful at this stage to consider those attributes and characteristics of colour which will be most useful in achieving the end in view.
2. The nature of the problem. Consider the nature of the problem and what steps have to be taken to produce the required information. This will probably entail the use of market research to pinpoint the characteristics of the market where these are not already known, and the deployment of colour research techniques to identify the factors affecting colour choice and the direction of trends. Machinery to help keep track of trends must be established.
3. Establishing the marketing picture. This is the most important initial step, and it is necessary to provide the answers to some basic questions which affect the whole planning process. Some of these questions depend on the characteristics of the product and some depend on man-

agement decisions. The purpose of these questions is to define the marketing aim quite clearly so that all concerned are quite certain where they are going and how colour is going to achieve the marketing target. In other words, develop a colour strategy; part of this strategy is to identify the nature and usage of the product.

4. Identification of the market. When the nature and usage of the product is quite clear and colour strategy has been established, it is possible to identify the market for the product, and the make-up of the market has a considerable influence on colour selection. The market at which the product is aimed may be specified in the marketing plan, but its nature should be clearly defined; the nature includes the characteristics of customers, the extent of competition and its activities, the nature of distribution and the willingness, or otherwise, of distributors to hold stocks, the purchasing influence and various other factors. Discovery of market characteristics will require study and probably market research if the product is a new one.

5. Factors affecting the colour choice of the consumer. Where the product is purchased primarily for use in the home it becomes necessary to identify the various factors and considerations that are likely to govern the purchasing decisions of consumers. These will depend on the nature of the product, the way that the product is used and the part of the home in which it is used; the way that people normally buy; their reasons for purchase; and other factors including the extent to which they may wish to use the product for accent and decorative purposes. This step determines whether the product is a market leader in colour terms, the type of colours required, the colours that people will want to match, the influence of other products, the way that trends should be interpreted and the differences in various parts of the home. Discovery of these factors will almost certainly require market research in the case of new products, although there may be a fund of knowledge already available for existing products. If the product is not used in the home, the same factors need to be established, but some modification may be necessary according to the usage of the product.

6. Trends. These are a vital part of consumer applications of colour and affect all purchases made by the average consumer whether for the home or not, and there is plenty of evidence that they have a decisive effect on sales. It is particularly important to study the differences in trends in those parts of the home in which the product is mainly used. An interpretation of trends has to be applied to the marketing characteristics of the product because trends may vary to some extent with the type of market, the age make-up of the customers, and other considerations.

7. Sales theme. Consider the selling implications of colour. Although the way that colour is used to achieve maximum sales, and the promotional methods to be employed, may well have been decided at the planning stage, further consideration will almost certainly be required in order to plan promotion to best advantage. The sales theme to be employed must be related to market characteristics and supported by appropriate

colours; modification may be dictated by the media employed.

8. Other considerations. There are many other factors which apply to the selection of colours for individual products and particularly to those products which are not used in the home; they may have to be identified in each case. The method of selling may have some influence on selection; there are often ways in which colour can be used to increase the appeal of a product and make it more useful (e.g. to identify hazards and make identification easier). There may also be technical limitations which restrict the use of certain colours. Broadly speaking, this step is concerned with the subconscious effects of colour rather than with considered choice.

9. Colour selection. When all the required information has been collected and the specification is complete it is possible to select actual hues whose attributes and characteristics will best fulfil the conditions identified in the specification. The crude selection will have to be modified to reflect current trends of preference for basic colours and for variations of basic hues. When the right hues have been found they have to be used to maximum effect; this requires attention to the most appealing variations and to achieving the right combination of colours where product design requires it.

29 Marketing decisions about consumer products

29.1 Is colour important?

The previous Section mentioned a number of basic questions which have to be answered before the colour selection process can begin. These questions are part of marketing planning, and in the majority of cases they require management decisions, and these establish the marketing picture which colour has to support. The first step in establishing the marketing picture is to analyse the nature of the product and to decide whether colour is an important part of sales.

There are very few cases where colour has no part to play in the marketing process, and this should be evident from the summary of what colour can do in Section 17 in this part, but in some cases it is a vital part of sales, and in other cases it is less important. Generally speaking, colour is more important as a selling feature when the product is used in the home, but all the characteristics of the product, and its selling features, need to be carefully analysed to assess the effect that they have on the marketing picture. A product may be promoted for use in the home even though its principal uses are elsewhere.

The colour of carpets, for example, is the single most important factor in sales, and if any carpet is to sell, it is vital that it should be offered in those colours that people want, and will buy. On the other hand, few people are likely to buy a camera because of its colour, but even in this case the right colour will improve the appearance of the product and increase its sales potential; colour might even be used to attract attention at point of sale.

The relative importance of colour will usually be known to marketing management, but in case of doubt it should be investigated and assessed. In all cases it will be useful to discover whether purchasers actively seek colours that will match something else that they already have in their homes and what that something is (e.g. carpets, kitchen units, etc.). It will also be useful to find out whether a colour has had to be withdrawn at any time because of a negative effect on sales.

It is also important to establish whether people insist on the colour of their choice or whether they are prepared to take what is available; in some cases it will be found that people will go elsewhere if they cannot find exactly what they

require. Colour may be less important if price is the main consideration of the purchaser, but in some cases colour may be the only selling point.

The answer to this question will have little effect on the nature of the colours offered, but the more important that colour is to the selling process, the more trouble should be taken with selection. The trouble taken, and the reasons for choice, may be underlined in promotion.

29.2 At whom is the product aimed?

Some products will aim at a universal market; in that case colours must be selected that will appeal to the maximum number of customers. Other products, however, will be aimed more specifically, perhaps at the top end of the market, at children, at males, at females, at those setting up home for the first time, at those buying for replacement purposes, and so on; there are many other specialised market segments that might be mentioned. In other cases a product having universal appeal may be promoted to specific categories of customers either on a continuing basis or as a special promotion.

Identification of the sales objective is a marketing decision; it is important because, if the product is aimed at a specific category, it must be offered in colours which have an appeal to that category. Colours that appeal to teenagers, for example, might not appeal to those buying for replacement purposes.

29.3 What does colour have to do?

It is important to define what colour is supposed to do in the context of the marketing plan. Some of the functions that colour can perform in the selling process are set out in Section 27 in this part. In the case of a product that is bought on impulse, the most important function of colour may be to attract attention at point of sale, but in the case of some products the most important function may be to ensure sales by providing a match for what already exists in the home. Colour may, of course, have to fulfil both these functions, and others as well.

Identification of the job that colour can do is particularly important because it may affect everything else that follows and will certainly affect the number of colours that are offered. It is possible that sufficient colours must be included in a range to fulfil a number of functions to maximum advantage.

29.4 How many colours to offer?

This is essentially a marketing decision which may be influenced by the practices of competition, by production and stockholding considerations or by what distributors will accept.

There are many cases where the customer has learnt to expect a wide choice of colour, and it may be difficult to reduce the range without losing business to

competition; too small a range may be passed over. Some companies make a virtue of a wide choice of colour; others prefer a limited, but well chosen range and make a virtue of that. Too many colours may create serious production and stockholding problems, but too few colours may create sales problems. The ideal of the production manager is one colour only, but this may be quite unacceptable from a sales point of view, and management has to strike a balance between conflicting interests.

The method of distribution may be significant; a company that sells direct can often afford to offer a wider choice of colour than the average retailer is prepared to handle. There is no point in offering more colours than the retailer is prepared to display, and in some cases too many colours can be a definite disadvantage because customers will not be able to make up their minds.

One of the most difficult problems to resolve is colour continuation. Every product should be offered in new colours from time to time in order to keep it fresh and up to date; this applies whether the product is offered in single colours or in a range of colours. The difficulty is to decide whether old colours should be dropped or whether they should be retained for a period. The difficulty is discussed further in the next sub-section.

Where a wide choice of colours is not practicable it may be useful to offer colours 'across the range'. In other words, each model in a product range is offered in different colours, and if the consumers cannot find the colours that they want in one model, they can find it in another. Other difficulties occur where the product is offered in a number of different colour combinations. This problem requires special consideration.

29.5 How long are colours to last?

The answer to this question will depend very largely on the nature of the market and on trade custom. Some products have a strong fashion element and require frequent changes, but in other cases colours have to be maintained for long periods for production reasons or because the customers will want to be able to match replacements.

Trade custom often plays a considerable part in this question; it often dictates the introduction of new colours in, say, spring and autumn, although it has to be decided whether old colours should be dropped entirely or retained for a period and, if so, for how long.

New colours must be introduced periodically as existing ones become dated, and new colours may be dictated by changing markets or by the needs of promotion. A change of colour will often create new interest and be a useful support for promotion, although too frequent changes should be avoided; they upset retailers and may cause stock losses. Except with very high fashion products, frequent change is generally unnecessary.

It is desirable to have a policy about change in order to avoid confusion and indecision, but the policy should be reasonably flexible and should also cover continuity of colour. The latter is a problem that is most marked in the tableware industry; customers expect to be able to obtain replacements for breakages and to make additions to their collections, and manufacturers find that

once a new colour (or pattern) is introduced they have to keep it in their ranges for some years. This is excellent from a production point of view, but makes it difficult and expensive to introduce something new.

Similar problems arise with kitchen units and other products where manufacturers encourage customers to buy basic units and then add additional units when they can afford to do so. In such cases colours must remain available for some years. In the United States it is common practice to change colours at fairly short intervals in order to force obsolescence and persuade customers to buy something new. This strategy has not been noted to any great extent in this country, except in womens' fashions, and it is doubtful whether it would work satisfactorily with products for the home.

29.6　How to achieve optimum sales?

Basically this means offering a product in colours that appeal to the purchaser at whom it is aimed, or which will attract attention at point of sale. However, the question also covers the use of colour to support a specific sales theme or to achieve competitive advantage. Marketing decisions and selling plans are involved and must be finalised before colour selection begins. For example, it may be decided to use 'fashion' as a sales theme, and in that case it is important that the product should be offered in colours that do reflect current fashion in the market in which the product is sold, and that the colours can be demonstrated to be fashionable. Specimen sales themes which can be supported by the positive use of colour are suggested in section 27.5 in this part.

In some cases the process can be reversed; that is, the colours can be selected for other reasons, and then the attributes of these colours can be promoted; this applies particularly where colours are selected for practical reasons, such as safety or cleanliness. Competitive advantage may be achieved by offering better colours than competition, by offering more colours, by offering unusual colours that no one else has, or by offering colours which can be demonstrated to have sound reasons for choice.

29.7　What methods of promotion?

An important influence on the selection of colour is the method of promotion to be used. For example:

Television advertising　If the product is to be advertised on television, it is important that the colours should show up to best advantage on the screen. Certain colours do not reproduce well, and it may be desirable to modify shades; experimentation may be useful. It would be worthwhile to take trouble over this point in any case where the marketing plan for a product calls for extensive television advertising. Bear in mind also that some people do not have colour television and the product should show up equally well in black and white.

Mail order　If the product is designed for sale through a mail-order catalogue,

the colours offered should be suitable for reproduction in the catalogue. Colours may have to be specially selected for this purpose.

Press advertising Colour reproduction is also important but less significant than with television or mail order. Press comment, especially in the womens' press, should not be overlooked; new or unusual colours will often provide a basis for a press feature and help to publicise the product.

Brochures, etc. Presentation of colour can be significant, and it may be desirable to select a well-balanced colour range that looks good on a colour card even though all the colours may not be good sellers. This aspect is particularly important with products like paint and wallcoverings; a brand that does not have a good colour card may be passed over.

Promotion will often include items like specimen colour schemes, advice on colour usage for consumers, or advice to retailers on selling colour. Although items of this nature are unlikely to be very significant in the colour selection process, they are worth consideration. There may be cases where an addition or modification of one of the colours offered will make all the difference to the effectiveness of the promotion.

29.8 How is colour to be offered?

This is basically a question of the design of the product. The design may be such that it requires special colour treatment; a strong, deep colour might not be suitable for a fragile and delicate object. Colour should always enhance the design of a product, and this is relatively more important in higher-grade markets.

The design of the product may affect colour in so far as a 'way out' design would be wasted in traditional colours – the colour selection should appeal to 'way out' people. A modern, futuristic design needs a modern colour. In some cases colour is an integral part of the design; more than one colour may be used, and it is the task of the designer to preserve balance between them. In other cases it may be necessary to decide how colour is to be offered, for example by means of panels or patches of colour in an otherwise neutral surround.

A product may often be designed for a specific type of home (e.g. open-plan houses, modern homes, etc.). Colour for the product should be selected accordingly. It is useful to review the nature of the design and whether a special feature is made of design in promotion. The nature of the design may have some relevance to colour choice, particularly to combinations of colour. Special consideration is desirable when a product is offered in a combination of colours. This is a difficult subject to discuss in general terms, but it can be very important to certain products.

30 Identification of the market for consumer products

30.1 The market

The recommended first step in the colour selection process is to analyse the nature of the product and to decide whether it is bought primarily for use in the home or whether it is promoted for use in the home although it may have other uses as well.

Whatever the nature of the product, a first principle is to establish the nature of the market in which the product is sold, or at which it is aimed, and the types of colour required in that market. In broad terms, the market may be divided into the mass market and the sophisticated market, but these broad divisions may be further subdivided into more precise segments. With some products, for example, differences between big-city demand and suburban demand may be important, and there may be differences of a regional nature between north and south, or between town, country and seaside.

In mass markets simple colours are best and a desire for conformity is most marked; trends applying to products bought for the home tend to move slowly. It is possible to trace the same basic hues in folk art throughout the centuries, and the same elemental colours appear again and again. Good mass-market colours are usually simple and bright.

More sophisticated markets are less conformist, and purchasers often like to be different from everyone else; this applies particularly to the top 10 per cent of the market, which prefers subtle variations of colour and expects them to change fairly often. Although the lower end of the market is more static, as well as having simple tastes, both ends of the market may want the same trend colour at any given time.

Specialised segments of the market may have requirements of their own, and these have to be identified in each case. Identifying the nature of the market and its requirements may be quite difficult, and price is not necessarily a guide. In the UK very expensive products often find their sales in mass markets because of the greater purchasing power of these markets. However, this does not always hold good, and very cheap products usually sell at the lower end of the market. In fact the products may be cheap because the colours are cheap and consequently will only sell at the bottom end of the market. The effect of price on demand for colour needs to be carefully reviewed in each case.

The broad principles outlined in this section apply whether the product is used in the home or outside it. If the market is a rapidly growing one, this would suggest a highly competitive situation and therefore more up-to-date colours are prescribed.

30.2 The customer

Within the various subdivisions of the market there are many different types of customer, and identification of the type that provides the major market for any product is an important factor in the colour selection process. Although customers may be identified in a broad way by market segmentation, and divided into the A, B, C and D classifications known to all marketing managers, these are of limited value where colour is concerned and information is required about the tastes and, more important, the ages of potential customers. The sex and the culture of potential customers may also be significant.

The population as a whole is made up of people with varying tastes. There are those who like traditional things; there are those who like modern things; there are those who like traditional colours; there are those who like up-to-the-minute colours; there are those who like bright and startling colours; and there are those who like conservative colours. Colour selection must allow for varying tastes; if the product is offered in one colour only, it may have to be the lowest common denominator, but where there is a range of colours more scope is possible. The product may also, of course, be aimed at specific types of customers as part of the marketing plan.

A wide colour choice will provide something for everybody, but a product may appeal more strongly to one sector than to another because of its nature or because of its design. It can be made to appeal more strongly to a particular sector by offering appropriate colours. It may be desirable to establish the type of customer to whom the product has most appeal and to pinpoint the likes and the dislikes of that type.

The age of customers is also an important factor in the selection of colours for products used in the home because the younger generation have a decisive influence on colour choice. For practical purposes customers may be divided into the following age groups:

- Children Up to 5 or 6, or sometimes later
- Teenagers 7 or 8 to, say, 16
- The young 16 to 30
- Older people Over 30
- Retired people Over 60

These groupings are purely arbitrary, but they are a convenient subdivision. Children are a special category and require separate attention, although they can be an important influence on the sales of some home products.

The most important group in the context of the home is the 16 to 30 age group because they have the money and the desire to experiment with colour, and they have firm ideas about its use. Young home-makers like colour, they are influenced by colour, they are courageous in its use, and generally speaking

they like brighter colours than older people. Although the young are, by nature, conformist and hate to be different to their contemporaries, they also tend to change their ideas more quickly, and consequently trends that appeal to the young tend to move faster. They often tend to purchase stronger colours, or even unusual colours which have a short-lived trend.

Teenagers have quite an important influence on some sectors of the home market, notably on bedroom products, and it may be good business to select colours with teenage appeal for some products. Young marrieds, who fall within the 16 to 30 age group, account for a substantial share of the market for most products used in the home, and if the product is one that appeals to the young, their likes and dislikes will largely dictate colour choice. There is a tendency for young marrieds to buy for the short term in the expectation of being able to buy something better within a comparatively short period, and this has a twofold significance. Provided that the product is one that has a substantial sale to young marrieds, purchasers are more likely to place emphasis on current colour trends and will expect more frequent changes of colour.

Many young people buy on the principle that they will be able to buy something new in less than ten years, but in practice they seldom do so. It is generally thought that this age group will dominate the household goods market for the rest of this century and that their likes and dislikes should be followed closely when forming product profiles. Some commentators think that a slightly older age group, say 25 to 35, is more important because economic trends are running against teenagers and young marrieds and therefore the spending power of the affluent middle-aged will be of interest to a greater extent. On the other hand, young people are now moving into their own homes at a much earlier age than in previous decades, and there is more consumer freedom and more leisure. However, the growth of one-parent families is a sign of a fundamental change in the pattern of living, and a falling birth rate may also have an effect.

Older people are generally more cautious and have learnt from experience that bright colours fade and get dirty. Older people realise that they have to live with their choice for a long time to come, and they will take more care in their choice and generally choose more restrained colours. They will pay just as much attention to fashion, and to trends, but will be more cautious. Older people are certainly more colour conscious than they used to be but, on balance, are likely to demand the more traditional colours which retain their popularity from year to year. The exception to this broad generalisation is the older couple furnishing a home for retirement; research suggests that they will choose more up-to-date and trendy colours.

It is probable that few people would admit these influences, and some care is necessary if the idea is used in promotion; however, it has become common practice to aim promotion specifically at age groups.

There are some instances where the sex of the purchaser may have some influence on colour choice. Some colours are better liked by women than by men (pink is the best example) and can be recommended when the woman is the decisive purchasing influence. Furnishing a home is increasingly a joint effort, and both sexes are affected by trends in the same way. Experience suggests that the woman will be the decisive purchasing influence in the kitchen and bedroom; men have more say in the living room and with the exterior of the

home. Promotion of certain products is normally aimed directly at women, and in such cases colours with feminine appeal may be indicated. However, care is necessary; it is unlikely that pink will appeal in the kitchen, but the female will certainly be the deciding influence on the purchase of accessories and accents.

The nature of the purchasing influence, and how it is exercised, will be worth investigating in every case; it may have limited influence on colour selection but will certainly affect promotion. The nature of the customer is of most significance in connection with products bought for the home but, with modifications, it also applies to products outside the home.

30.3 Competition

The nature and extent of competition may have an important influence on the selection of colour for any product sold to the consumer whether bought for use in the home or not and irrespective of the reasons for purchase. Competition is important because every manufacturer wants to offer colours that have more appeal than those of competitors and because it may be necessary to take action to counter the effects of competition. Competition does not necessarily mean other companies offering the same product; it may also include similar products which achieve the same purpose. For example, vinyl floor coverings offer competition to carpets; gas stoves are competitive with electric stoves; plastics are competitive with metal, and so on.

The fullest possible information about competition, and what it offers, is most desirable because it may have a significant effect on action taken about colour. No manufacturer wishes to offer the same as everyone else, and every manufacturer should aim at offering a better colour selection and better selling colours than competition. Better selling colours may be an important way of securing competitive advantage and may be the only way.

It is often difficult to avoid offering the same colours as competition in some markets, but it is usually possible to select an improved shade or variation, or to offer a wider choice of colour. When introducing new colours try to avoid copying competition; something different will provide promotional advantage.

The way that competition uses colour in promotion is also important; use a different theme from competition and try to avoid any suggestion of following a lead set by competition. It is useful to keep a continuing check on colours offered by competition because this will often provide a clue to market changes or draw attention to a need for change.

The colours offered by competition may also provide a clue to trends overlooked. Recommended as part of the colour selection process is a detailed analysis of competition and the colours that they offer; this should be updated periodically. It is suggested that a chart should be constructed, covering a reasonable period and showing the colours offered by the principal competing manufacturers; this will also help to bring to light changes in emphasis which are helpful in assessing trends. It may also be found that the majority of manufacturers offer one or more common colours, and in that event particular attention must be paid to variations of hue in order to avoid duplicating competition. Particular care is necessary to avoid being overshadowed by competition when ranges are displayed along side each other on the showroom floor.

30.4 Method of selling

The type of outlet in which the product is normally sold, or which provides its major market, may have an influence on colour selection because of the different methods of selling. It is also important to establish whether the product is a considered purchase or an impulse buy, because in the latter case bright colours which attract attention at point of sale are essential.

If the main outlet is the supermarket type of operation, and this applies whatever the nature of the product, stronger colours are required because of the greater degree of impulse purchase; the product has to sell itself without other aids. Furthermore, a very limited colour range is indicated in this type of operation; the supermarket does not have space for a wide choice of colour, and subtle or less dominant colours will simply be passed over. Similar remarks apply to variety stores and the like and also to non food stores, such as DIY stores and, to some extent, furniture stores.

Many products, whether for the home or not, are sold through the builders' merchant type of operation, where there is scope for more colour choice but where more in the way of selling aids may be required. It is not unknown for manufacturers to try to push poor selling colours through this type of outlet in order to clear stocks, and customers may look for some form of guidance. Specialists, including kitchen, bathroom and bedroom specialists, generally aim at the higher end of the market, and more care is necessary with colour selection for products sold through these outlets. Subtle and sophisticated variations will have more scope.

Mail order and direct selling require special consideration. Colour ranges should be limited, and the colours should be specifically selected to attract attention in a catalogue or press advertisement; it follows that the colours should reproduce well. At one time this type of selling only applied to mass markets, but this is no longer true. A specific catalogue, or a specific promotion, may, however, be aimed at a specific type of customer, and colour should be selected accordingly.

Specialist retail operations, such as boutiques, may also require special attention; they may welcome short-term fashion colours, especially with products appealing to teenagers. The retail trade generally is changing quite radically; department stores and 'normal' retailers are losing their importance; in every case, therefore, it is necessary to study the method of selling in detail and to assess the effect that it may have on the colour choice of the customer.

30.5 Distribution

This section is closely allied with the last one because the way that products reach the retail outlet may be of significance. Wholesalers are often unwilling to hold extensive stocks of different colours, and this may place some limitations on colour choice, particularly on the number of colours offered. Retailers themselves are often unwilling to hold a wide range of colours, just like the wholesalers. This is particularly the case in those circumstances where colours change quite frequently and they may be left holding outdated stocks.

A company that sells direct to the public is usually able to offer a wider colour choice than the company that sells through normal retail channels, although, of course, it may also have the problem of holding extensive stocks.

Most sales ideas using colour as a basis presuppose a choice of colour, and this choice has to be acceptable to all the channels of distribution; they have to be convinced that there are good reasons for holding a range of colours and that, if they do so, sales will thereby be increased. Both wholesalers and retailers tend to play safe, but they can often be convinced by a carefully researched judgement of what the public wants, supported by promotion aimed at the customer.

It should always be remembered that no colour will do anything for sales unless the retailer can be persuaded to stock it; most retailers prefer colours that have sold well in the past and have to be assured that these past colours are not necessarily the best way of increasing sales in the future. This applies particularly to buyers for department stores and the like.

30.6 The purchasing influence

It is desirable to establish the real purchasing influence for any product because this may affect the whole approach to colour selection. In the case of a product bought for the home, and in some other cases, the purchasing influence may be the wife rather than the husband, and colours should be selected to appeal to her, but in the case of larger products, such as suites, the purchasing influence may be the husband and wife jointly. However, in some cases the real purchasing influence may be neither; it could be the children, or teenagers, who influence the decisions of their parents, and the colours offered should appeal to them. Establishment of the purchasing influence permits promotion to be directed more accurately, quite apart from the effect on colour selection.

Another purchasing influence which may be significant is the store buyer, that is the individual responsible for purchase for supermarkets, stores, retail chains and so on. Store buyers tend to be conservative in their outlook and are often unwilling to stock new colours or to stock as large a colour range as the manufacturer might like. The real problem of the manufacturer may not be selecting colours that customers will buy, but to persuade the store buyer that the colours offered are the right colours. There is no ready-made answer to this particular problem; it has to be tackled as it crops up. As a general rule buyers look at past sales and are apt to repeat what sold well last time. On the other side of the coin there are store groups who cherish a reputation for being in advance of fashion and who take a forward-looking attitude; they would be uninterested in a conservative selection. It might be necessary in some cases to have different ranges for different stores.

There may be other purchasing influences in some cases; the architect, for example, may have an influence on the sale of kitchen units, and interior decorators may have an influence on the sale of furnishing fabrics. Many home products are installed by builders and estate developers, more especially kitchen units and bathroom suites, and their special needs have to be considered when selecting a colour range. The actions of estate developers may also have an

effect on the market as a whole because the colours that they instal may govern the colour choice of the homeowner for a period up to ten years. It may well be that consumers have little choice of colour where new houses are concerned.

Some products have a commercial use even though they are primarily intended for the consumer market, and some modification of colour choice may be necessary to allow for this. A typical example is space heaters which may be sold for both home and office use.

31 Colour in the home

31.1 Introduction

When a product is intended for use in the home, or primarily in the home, the colour selection process makes it necessary to establish those factors that govern the colour choice of the consumer when purchasing products for their homes, and these factors vary with the different parts of the home, the reasons for purchase and the way in which the product is purchased.

The broad principles which govern the actions of the consumer are well established and have been discovered by research and experience, but circumstances change, and in any case it is necessary to establish the principles that apply to specific products. Research is very desirable because, unless the manufacturers understand the motivation of the consumer, it will never be possible to offer colours that have maximum appeal.

Colour is particularly important in home decoration because it changes the mood and feel of a room and reflects the personality of the owner; the home is the biggest investment that most people make in their lives, and it expresses their individuality despite the fact that the great majority copy what everyone else is doing. Colour can transform the home more economically than any other device, and even one extra colour can add excitement. The wrong colour makes the occupant feel restless and edgy, while uninspiring colours can make the whole house seem dull.

An important point to remember is that the colour situation is never static; ideas change, trends develop and however well established rules may seem, they change after a period. It has been pointed out in an earlier section that people never buy a product in the same colour twice; they want change, and therefore there is always colour movement, however slight, and a progressive demand for new colours.

In order to establish the position in relation to a specific product, a number of steps are necessary:

1. Establish usage of the product, including the part of the home in which it is primarily used.
2. Decide whether the product is a lead product or a subsidiary product.
3. Establish those influences that may affect colour selection and which may provide a guide to the actions of the consumer.

441

4. Find out how people buy.
5. Identify reasons for purchase.
6. Consider any other factors in the equation.

31.2 Usage of the product

The popular hue of the day is not necessarily used in every part of the home at one and the same time, and there are different trends in the living room, in the kitchen, in the bedroom and in the bathroom. Therefore the pattern of usage of the product, and the part of the home where it is primarily used will be an important factor in colour selection. Strong trend colours will usually reach all parts of the home at some time, but they do not necessarily do so all at once. It follows that timing is all important, and a change of colour for a living room product may be required long before a change for a kitchen product.

It also follows that one of the first points to establish is where the product is used in the home; it may be commonly used in a specific part of the home, or designed for a specific part of the home, and in either case should be offered in colours that are appropriate. Some products may be used in more than one part of the home, and sufficient colours should be offered to reflect this. Kitchen utensils, for example, are normally used only in the kitchen and should follow colour trends set by kitchen units, the lead product in this area; some utensils, however, are also used in the dining room, and a colour range ought to include colours acceptable in that area.

It may not be practicable to offer a wide selection of colours suitable for all parts of the home, and it may be better to have specific ranges. For example, a range of curtain fabrics might include colours suitable for all parts of the home where curtains may be used, but there is a growing tendency to offer limited ranges aimed specifically at kitchens or at bathrooms, and so on. Suitable colours can be extracted from a larger range and used in promotion or for sale through appropriate outlets.

In addition to the different parts of the home, a product may be designed for different types of home (e.g. open plan, traditional, flats, etc.); the effect of this on colour selection will mainly depend on the type of customer concerned.

Each product needs to be analysed individually to establish its pattern of usage, and depending on the pattern, the colours offered may be specific or universal. Investigation should also disclose whether different colours are required for each major usage or whether a few well-chosen colours will meet all requirements. In the United States the popular trend colour of the day will be found in everything from the kitchen sink to the bedroom carpet, and in recent years there has been some tendency for this to happen in Britain; it is a tendency that needs to be watched.

31.3 Lead products

In each part of the home there is usually a lead product which influences everything else bought for that part of the home; this is normally something which

involves the outlay of a considerable sum, such as a carpet, a living room suite or a kitchen unit. When the lead product is bought, either for a new house or for replacement purposes, people are likely to choose the most up-to-date colours and to look to the future. In other words, the lead product sets the colour for the rest of the room.

The clearest example will be found in the kitchen. The colours chosen by consumers for products used in the kitchen tend to be dominated by the colour of the kitchen unit. This will be the lead product in the kitchen; it is a major purchase, it is normally bought first, and because it lasts for a considerable time, the influence that it exercises also lasts for a considerable time. Everything else bought for the kitchen must match or harmonise with the colour of the unit, and this has two major effects. In the first place, when purchasing a kitchen unit people will look at the future and tend to choose colours that they believe to be in advance of fashion and therefore likely to last for a considerable time. In the second place, other products bought for the kitchen will match the forward-looking colours if they are bought at the same time, but if they are bought later they will have to match the recent past; the influence of the kitchen unit colour may last as long as ten years.

It follows that the colours of subsidiary products have to reflect both past and future, and it also follows that sales by colour of lead products will provide a useful guide to the colours required for subsidiary products; this applies both to the future and to the recent past. Thus carpet sales by colour will provide an excellent guide to the colours required for furnishing fabrics.

The lead product in the living room is usually decorative paint because people choose the colour of their walls first and then buy other things to match; therefore sales by colour of decorative paints are a good guide to the colours that people buy for their living rooms. In other rooms the same thing often happens, although perhaps to a lesser extent, and therefore decorative paints tend to be a good guide to the whole home market in colour terms. Trends tend to show up first in decorative paints.

Whether a product is or is not a lead product is a question of fact and depends on current practice in the home. This needs to be investigated as part of the colour selection process and the relative importance of the product assessed.

31.4 Subsidiary products

This is a somewhat misleading term, but it is a convenient way of describing those products that are generally purchased to match or harmonise with the lead products described in the previous section. The appropriate lead product has to be identified in each case and the colour sales of the lead product, both current and in the recent past, will provide a guide to the selection of colours for the subsidiary product.

Thus in the case of kitchen utensils the lead product is the kitchen unit, and a colour range for utensils should include colours that have been popular for kitchen units in the recent past and also colours that are currently popular for kitchen units. People will still want their utensils to harmonise with the kitchen unit colours that they bought a few years ago.

Some subsidiary products will be purchased primarily to provide accent or decorative effect, and therefore the colours offered should contrast with the colours of lead products rather than match them. This depends on the nature of the subsidiary product, but the colour of lead products will still provide a guide to colour selection. Some products such as curtains and blinds, may be purchased primarily to provide change or variety in the overall decor, and the lead product will have less influence, although its sales by colour will provide a useful guide.

Subsidiary products are frequently bought for replacement purposes, and therefore what has happened in the past, both to the colours of the lead product and in the home generally, will be relatively more important because the consumer will seek colours to match what already exists. With some products it may be desirable to give more weight to past trends than to future sales.

When selecting colours for subsidiary products, identify the lead product and decide the extent to which the colours of the subsidiary product should match or contrast with those of the lead product and the weight that should be given to past trends.

31.5 Influences

When selecting colours for any product used in the home it is useful to discover those areas of colour usage which may have an influence on the colour choice of the consumer and which may provide a guide to wanted colours. This is described in Section 17 of Part I. For example, all consumers are likely to be affected by broad trends of interior decoration generally.

At some periods there is a feeling for a minimum of colour in the home; at other times everybody wants plenty of colour, plenty of pattern and the maximum amount of frills and bows. There is a relationship between pattern and colour, and it is worth watching, although it is much more difficult to forecast pattern trends than it is to forecast colour trends.

During the late 1970s and the 1980s the key word in interior decoration has been 'co-ordination'. There has been a tendency to co-ordinate the colours and patterns of carpets, furnishings, wallcoverings and curtains, and this may have considerable influence on colour selection. It is desirable to establish whether a particular product fits into the co-ordination pattern and, if so, what effect it might have on the colour choice of the purchaser.

The influence of overseas design and colour may also be significant. At various times British consumers are influenced by Italian ideas, by French ideas, by Scandinavian ideas, and they may be influenced in some parts of the home but not in others; for example, in the early 1980s there was a strong German influence on the kitchen.

There may also be traditions which have an influence on the colour choice of the consumer. For example, white has long been a traditional colour in the kitchen because of its association with cleanliness, and it might be desirable to continue to include white in a range because of the strength of this tradition. There are other influences on the choice of the consumer which must not be overlooked; they can have a most significant effect on colour choice for lead

products and, through them, will also influence subsidiary products.

Trends in other major products used in the same area of the home may also have some influence, and sales by colour of these products will provide a useful guide to what is happening in the area in question. These influential products have to be discovered and identified in each case, and it is difficult to formulate precise rules. Much depends on the experience of the selector. It has been suggested in an earlier chapter that the following might have an influence on colour selection for living room products:

- trends in interior decoration
- trends in pattern
- overseas influences
- trends in carpet colours
- trends in colour for furnishing fabrics
- trends in colour for upholstered furniture.

31.6 How people buy

The way that people buy is a reflection of the way that they put their homes together and is a most significant factor in the colour selection process, although the colour choice of the consumer is also affected by the reasons for which the product is bought. The way that people buy determines the colours that they look for, and their colour choice will vary according to whether the product is:

- a lead product
- a subsidiary product
- an impulse purchase
- a purchase for the short term or for the long term.

Broadly speaking, the colours that people choose for lead products will be the most up-to-date trend colours, and they will choose for the future. The colours chosen for subsidiary products will match those of lead products, but when bought for replacement purposes people will tend to look to the past.

The kitchen provides a good example of the process in action. The first purchase is almost invariably the kitchen unit; this is the lead product and it is a major purchase. People will look for the most up to date trend colours, and their choice will influence everything else in the kitchen; people will expect to be able to buy other items, such as kitchen utensils to match their units. However, kitchen units have a life of about ten years on average and are unlikely to be changed more frequently than that. Consequently people will expect to be able to purchase matching accessories for a long period of time; colours that were popular ten years ago may still be wanted today. Past trends are not important when selecting colours for kitchen units, but past trends in kitchen units are important when selecting colours for other kitchen products.

There are many products where hues that were popular in the recent past are just as important as current trends; colours of the future may be less important. Each product needs to be investigated with this situation in mind and the exact pattern of purchase established. The pattern needs to be checked from time to

time because practice alters, and the relative importance of lead products needs to be watched.

Some products are bought on impulse, and the attraction of colour lies in the subconscious, although the subconscious is affected by the same trends that apply to considered purchases. If products are bought purely on impulse, colours should be selected to attract attention at point of sale. People sometimes buy on impulse and regret it afterwards, particularly at sales, and this may create a false impression. Shoppers who buy bright puce towels or fierce yellow rugs will be sorry when they get home.

Many items of expenditure, such as furniture, are most unlikely to be bought on impulse; they are a considered purchase, a great deal of thought will be given to choice, and by the time that potential purchasers reach the point of sale they will have a pretty clear idea of what they want. They may flounder a good deal and may look for help and guidance from the retailer or manufacturer – but they will usually expect advice to reinforce their own views.

It is useful to establish whether people buy for the short term or for the long term. In recent years a practice has grown up of buying for the short term – perhaps more cheaply – in the expectation that the product can be changed after a comparatively short period. This practice is particularly prevalent amongst the young, as mentioned in an earlier section, and in such cases purchasers will usually choose a more modern or trendy colour because they anticipate that they will not have to live with it for a long time. Those who buy for the long term tend to be more conservative because it is their intention that the purchase should last. The more expensive products are likely to be bought on a long-term basis because they represent major capital expenditure. Buying for the short term may be a feature of the product.

Economic conditions are often significant. In times of financial stringency people are apt to buy for the long term and to place more emphasis on wear and lasting qualities. They may also prefer neutral shades when choosing colour because they expect that the product will have to last for a longer time and to fit in with future changes in decoration. Some research carried out in the motor industry in the United States found that in good times customers preferred bright and spirited colours but that in times of economic pinch they preferred more sombre hues. Cars were black all through the 1930s, but customers reacted against years of austerity after 1945 and demanded flashy colours. Colours were subdued again during the Korean war, brightened up in the mid-1950s, but in the recession of the late 1950s, black was in demand again. In the early 1960s neutrals and off-whites reflected an uncertain economy.

31.7 Reasons for purchase

The reason why a product is bought is usually a significant factor in the colour choice of the consumer. In broad terms, a product may be bought:

- to furnish a home
- for replacement purposes
- for accent or decorative purposes

- to provide variety
- as a gift.

It is always useful to check reasons for purchase where it is possible to do so, and the position of each product needs to be established and reflected in the colour choice offered. Some products have a substantially higher degree of purchase by those, such as newly weds, who are setting up home for the first time. There may be other reasons for purchase which justify investigation.

When a product is bought to furnish a new home people are likely to start at the beginning, so to speak; they will choose the most up-to-date colours and will think ahead rather than to the past. Trend colours will almost certainly be chosen, and a lead product will be chosen first with other products to match or harmonise with it.

In the living room, for example, people will usually build up the decor by choosing the colours of the walls first and then buying carpets and other furnishings to match. Other people buy the carpet first, paint the walls to match and then choose furnishings to tone. In recent times there has been a tendency to buy the suite first, but the colour will almost always be chosen with a specific wall colour in mind.

In the kitchen the kitchen unit will be bought first, and everything else follows from that. In the bedroom the bed is usually the first purchase. The position varies from time to time, and the significance in relation to any product needs to be investigated, but it is safe to say that in all cases where a product is, or may be, bought for a new home, the most up-to-date colours are required, and in the great majority of cases they should be colours that appeal to the young.

When a product is bought for replacement purposes the situation is more complex and there will be greater emphasis on matching what already exists, but the colours offered will depend very largely on whether the product concerned is a lead product or a subsidiary product. It should be remembered that people seldom buy the same colour twice; when they are buying for replacement purposes they will see an opportunity for change, and the replacement is unlikely to be in the same colours as the original.

If the replacement purchase is a major one, such as a suite or kitchen unit, people will usually take the opportunity to make a complete change and buy up-to-date trend colours, although they may not be too daring because it is seldom possible to change everything in the room at once; there will be some attention to what already exists. However, if the replacement is a subsidiary product, they will take the opportunity to make minor changes, but there will be more emphasis on what already exists in the room, and therefore on past trends. For example, furnishing fabrics will usually be replaced before carpets, and therefore a range of colours for furnishing fabrics should reflect recent best sellers in carpet colours.

Many products are bought primarily for accent or decorative purposes or to provide variety, and the colours offered should contrast with the popular colours of the day, both current and past. Depending on the nature of the product, the popular colours may be either overall trend colours or specific trend colours (e.g. kitchen colours). If the product is bought primarily for decorative

purposes, the colours offered might be adjusted to place more emphasis on what already exists (i.e. on past trends). Curtains and blinds, for example, are often chosen with accent in mind, and as they are relatively cheap and easy to change, they will be replaced at fairly frequent intervals as a means of 'freshening up'.

Many products have a useful sale for gift purposes (e.g. for wedding and birthday presents), and in such cases it may be a good idea to provide some colours which will attract attention at point of sale and create an impulse sale. However, the range must also include trend colours; most people buying wedding presents, for example, will enquire what the recipient wants, and it will probably be a fashion colour that appeals to newly weds.

31.8 Outside the home

Colour selection for products which are not part of the home but which are purchased by the ordinary man or woman in the street for their own use, follow the same broad rules but with modifications according to the product and its usage. Such items include personal products, such as shavers and the like; leisure products, such as garden equipment; and even motor cars. It is difficult to formulate any precise rules which will cover such a wide variety of products because so much depends on how the product is used and the reasons for purchase.

Broad trends of consumer preference for colour will apply as described in 17.3 of Part I. Marketing decisions will be required as set out in Section 29 of Part II, and identification of the market will follow much the same lines as those formulated in Section 30 of Part II, but the nature of the market will obviously vary with each product.

Many of the comments made in this chapter will also apply to products used outside the home but with obvious modifications. There are unlikely to be lead or subsidiary products in this category, but what people want to match will be just as important and will vary with the product. There is likely to be a much greater degree of impulse sale, but short-term or long-term implications are unlikely to be considered by most purchasers.

Reasons for purchase may be important, although they will be quite different from those applying to products for the home and must be identified and assessed in each case. Gift sales may well be more important. Tradition may be quite important; garden products, for example, are almost always green or white because these colours have become traditional.

The other considerations listed in the section that follows will apply equally to the products covered by this section. The most important factor is the usage of the product. The part of the home is only significant to the extent that personal products are often bought for use in the bathroom or bedroom and colours may be chosen to fit in with current colour schemes.

32 Other considerations relating to consumer products

32.1 Brand image

In addition to the marketing and other considerations which have to be taken into account when selecting colour, there are a number of other points which may only have to be taken into account when appropriate but which may affect the selection of colour. The first of these is brand image. The use of colour to establish a company image or brand identity is a complex subject which is a little beyond the scope of this book, although it is a subject which is well worth further study.

Some manufacturers have established a reputation for the excellence of their colours, or for the wide choice of colour that they offer, and this is part of their competitive or corporate image. It is more difficult to establish a brand colour for a consumer product, because of the need to follow trends and change colours from time to time. Brand colours are best limited to packaging or point-of-sale displays, but a feature might be made of an unusual colour, which would help to draw attention to a brand.

The brand leader in any market ought to be particularly careful about colour selection if market leadership is to be maintained. There have been cases where market leadership has been lost because colours have become dated or because insufficient attention has been paid to changing market conditions. The whole subject is closely tied up with marketing planning.

32.2 Production limitations

Problems of production may impose a number of limitations on colour selection. For example:

- The more colours and colour combinations there are in a range, the greater the production problems. There may be limitations of machinery, and of stockholding, or there may be economic limitations on the number of alternatives that can be handled at one time. If it is necessary to limit colours, more care is necessary with selection. It will often be necessary to strike a balance between the ideals of the production manager and the needs of the salesman.

449

- There may be wastage considerations. For example, certain patterns of decorative laminates cause considerable wastage when matching sheets, and in some cases little or no pattern may be preferred. Certain grades of laminate can only be produced in a limited range of colours for technical reasons.
- Some colours are very liable to marking and damage during assembly and are best avoided for that reason.
- Some colours are particularly liable to fading and should be avoided if the end product is exposed to strong light.
- Some colours cannot be produced in some materials, and some colours lead to excessive pigment costs; they may be avoided in order not to raise prices unduly.

32.3 Export sales

The principles that have been formulated in these notes apply primarily to UK markets, and different considerations may apply if the product is to be exported from the UK. However, the differences do depend on the product and need to be studied in each case.

English tableware, for example, has substantial sales in overseas markets because it is 'English', and in this case English colours would be considered a status symbol in the countries concerned. English furnishing fabrics have also had some success in European markets.

With most products, however, the colours offered in overseas markets should be those that are popular in the country concerned, and this means that each market must be investigated individually. Although colour likes and dislikes are broadly the same in Northern European markets, there are differences from country to country, and these differences vary with products. Kitchen units, for example, which would appeal to the German market would not necessarily appeal to the French market, and Southern European markets are different again, if only because of the brighter climate.

Many manufacturers attempt to produce a European colour range, or even a colour range suitable for all overseas markets, but this is seldom very practical because of the differing requirements of each market. If the overseas market is a substantial one, then it is worthwhile selecting a special colour range for that market.

32.4 Display and presentation

Methods of display on the shop floor and the way that alternatives are presented may have some influence on colour selection. There is evidence from the sale of kitchen units and other major home products that the colours actually displayed on the shop floor will sell best of all provided that they lie broadly within current trends of consumer preference for colour. This fact may be used, in some cases, to clear stocks or to direct sales to a particular colour featured in promotion. Use of this strategy makes it unnecessary to hold large stocks of the

alternatives. However, some alternatives are usually desirable in such cases, and the problem arises as to how the alternatives are to be presented. Where carpets are sold from pattern books it has been found that the top pattern in a swatch usually sells best, and this can also be used to control stocks.

In some cases impulse colours may be introduced into a range purely to attract attention to display; such colours may not be good sellers, but they do serve to draw attention to the product and to promote sales of less obtrusive colours. There is a much-quoted aphorism which says that the red refrigerator in the shop window sells the white refrigerator on the shop floor; this strategy is worth bearing in mind.

Yet another aspect of presentation is that situation where a product is sold in a range of colours and where the purchasing influence of the professional is important; paints and furnishing fabrics are typical examples. The professional expects a wide choice and will pass over a limited range, and it may be necessary to include colours in a range simply to provide sufficient choice. The way that the colours are presented, for example in the form of a colour card, swatches and so on, may be significant and so may the way that the colours are grouped; they may be grouped by hue, by usage or to meet some other criterion. This subject needs to be thought through according to the nature of the product.

Special consideration may be necessary where a product is displayed alongside a range of competitive products; extra care may have to be taken with colours selected for display.

32.5 Functional colour

Colour can often be used in a functional way to increase the appeal of a product or to provide a promotional theme. The thoughtful use of colour can often make housework easier by eliminating eyestrain and difficult seeing conditions. A blinding white working surface can cause quite unnecessary eyestrain and so can black sewing machines. Every product ought to be considered from this angle.

Many products used in the home such as thermometers, radios, clocks and others are often difficult to see because of the confusing combination of colours and poor background to figures. A light-coloured door knob is much easier to find in the dark and just as good looking as a dark one. A brightly coloured saucepan handle may prevent accidents on the stove.

Colour can also be used to mark hazards and to make sure that warnings are not overlooked. Instruction plates and the like can be made more visible and easier to read if thought is given to the colour of the legend and its background; if controls or switches have to be found in the dark, good colour will improve their visibility. Power tools and other items with danger points will benefit from colour marking of the hazard.

Colour can often be used for coding purposes, although some care is necessary because a proportion of the public is colour blind, and there are many other ways in which colour can be used in a practical way if sufficient thought is given to the matter. The camouflage effect of colour may sometimes be used and

often has promotional value. People often buy a colour because it will not show dirt, particularly where children are involved.

32.6 Regional variations

Marked regional differences in colour preferences have tended to disappear as mass methods of communication have brought the same influences to bear on all sections of the population, but there are still some differences between north and south which may be relevant if the product has a strong regional sale. By and large the south prefers brighter and more lively colours than the north, and there is a more conservative attitude to colour in the north. Any investigation of colour should bear this point in mind; it is important that a colour range intended for all parts of the country should reflect all attitudes. This aspect is, of course, particularly important in countries, like the United States, where there are vast differences in demand for colour (e.g. in the New England states compared with Florida).

There are also differences in practice in the home in different parts of the country, and these may be relevant to colour selection. It is difficult to formulate any rules because the situation varies with the product.

There will also be differences in colour choice by consumers living in town, country and by the seaside. In the latter case, for example, brighter and stronger colours will not lose their identity in the strong light of the sea and are indicated where appropriate. More restrained or neutral colours are more usual in urban conditions. These differences may or may not have an influence on colour selection; in many cases they are more a matter for the retailer, who will tend to stock what goes down best in the immediate neighbourhood.

It has been noted that the colour choice of consumers varies in those areas where there is a large coloured population, which tend to choose rather brighter colours than the white population. This may be significant in some cases according to product; it may affect the stocking policy of retailers.

32.7 Special ranges

A rather different problem of colour selection arises in those cases where the customer expects a wide choice of colour and pattern; typical examples are furnishing fabrics, upholstered furniture and carpets. It is unlikely that any retailer will be willing to stock and display the whole range, and the economic cost of holding the whole range in stock may throw a severe burden on the manufacturer. A typical solution is for the retailer to display two or three patterns and to have a pattern book showing the remainder which are available on demand from the manufacturer. However, most customers prefer to purchase what they can see and are rather unwilling to wait for a special order, even if the retailer is willing to handle it. If customers do not see what they want on display, they may go elsewhere.

One solution to this problem is a specially selected but limited range of colours taken from the main range and strongly promoted. This has the effect

of concentrating sales on a limited range of colours with advantage to all con-cerned. The success of this strategy depends on the skill with which the limited range is selected; they will usually be trend colours. A lower price might be charged for the limited range, and a premium for other colours. In suitable cases a limited range of this type can be directed at special market segments such as teenagers, young marrieds and others; or at the kitchen, at the bath-room, at the bedroom and so on.

32.8 Appearance of the product

Lighting The effect of lighting on the appearance of the product at point of sale needs to be considered. The type of lighting used in the average show-room is unlikely to be duplicated in the home, and this frequently causes a colour chosen in the showroom to look quite different when the customer gets it home; this can cause some dissatisfaction where colour choice is vital. Colour selections should be viewed under different conditions of lighting to make sure that this situation does not occur.

Metamerism This phenomenon dictates that the colours of surfaces which do not have the same chemical composition will not match, and it sometimes causes trouble when customers try to match, say, a plastic object to a metal one, or perhaps plastics and textiles; the customers are dissatisfied that they are unable to obtain an exact match. This point is not really part of colour selection, but it is worth bearing in mind. Ways may have to be found to solve the problem.

Display items Where a product is displayed under unusual conditions, or where the product is specially prepared for display purposes, some modifi-cation of normal colours may be required. The conditions under which any product is seen are important and may require modification of colour to secure maximum attraction, and extra care is necessary in the instances men-tioned.

Reproduction Certain colours do not reproduce well in print, and when pro-ducts are likely to be sold through printed promotion, or by mail order, special care is necessary in selection. This point has already been mentioned in 30.4 in this part.

33 Selecting colour for consumer products

33.1 Specification checklist

Preparation of a colour specification is aided by a checklist of all the various questions to which answers should be sought and the various points that should be considered. A checklist is required for each product or each situation, and when all the points have been reviewed and all the questions answered, the specification can be completed.

Those responsible for colour selection may prefer to prepare their own checklist, but the following is a summary of all the points made in Sections 26 to 32 in this part, and it may be found helpful. It will not be possible to deal with all the points listed in the exact sequence shown below because the answers to some questions will depend on the answers to other questions that appear later in the list. However, all points should be dealt with or eliminated.

Section II. 26	What is the objective?
	• colour for new product
	• range of colours for a new product
	• review of existing colours
	• review of existing colour range
	• additions to a range.
Subsection II. 27.1	What can colour do in this particular case?
	• attract attention
	• fulfil the wants of customers
	• appeal to specific types of customer
	• enhance design
	• create an up to date image
	• demonstrate market leadership
	• provide change
	• support a sales theme
	• provide a sales theme
	• enhance a brand image
	• provide help and advice.
Subsection II. 27.2	Which attributes of colour are appropriate to the product and its marketing situation?
	• age
	• appearance

• associations	• fashion
• impulse	• markets
• mood	• personality
• preferences	• products
• recognition	• regional preferences
• seasons	• sex
• shape	• size
• stability	• tradition.
• warmth	

Subsection II. 27.3 Which functions of colour can be used with advantage?

• camouflage	• coding
• insect control	• readability.
• visibility of controls	

Subsection II. 27.4 Which applications of colour are appropriate to the product and its marketing situation, and can be used with advantage?

• children	• the country
• export	• exteriors
• food	• merchandising
• pattern	• safety
• television	• texture.
• woods	

Subsection II. 27.5 Can any of the following be used as a sales theme with advantage, or are there other useful themes that might be used with colour as a supporting factor?

• fashion	• change
• accents	• colours of the future
• brightening up	• matching
• personality	• interior decoration
• working conditions	• food.
• snob appeal	

Develop a colour strategy for the product.

Subsection II. 28.1 What are the major problems in selecting colour, and what research is necessary to solve them?
- definition of market
- identification of attributes appropriate to the product
- identification of trends
- identification of the factors affecting the colour choice of the consumer
- support for sales theme
- other factors.

Subsection II. 28.2 Analysis of the product; consider its nature:
- what materials are used, limitations?
- what type of finish?
- what surfaces, and should they be in different colours?
- colour combinations

- will surfaces be textured?
- will surfaces be patterned?
- state of existing colour range
- current best sellers
- recent changes made, and why
- complaints or worries
- difficulty of changing colour
- are customers looking for something special?
- any traditions associated with the product
- special features
- object of the design
- control panels.

Subsection II. 28.3 Solution of the problem; consider the following sequence of operations:

- what does colour have to do?
- the nature of the problem
- establishing the marketing picture
- identify the market
- identify the factors affecting the colour choice of the consumer
- establish the nature of trends
- produce a graded list of colours
- establish a sales theme
- consider any other factors involved
- select hues.

Subsection I. 17.1 Trends. Consider the whole subject.

Subsection I. 17.2 The nature of trends. Consider the usage of the product and decide which trends are appropriate:

- trends in the home
- overall trends
- clothing fashion trends
- trends in interior decoration
- trends in pattern
- trends in the part of the home in which the product is mainly used, including special conditions or prejudices
- regional trends.

Subsection I. 17.3 Outside the home. If the product is used outside the home, consider whether, and which, trends might apply. Also consider whether trends might apply to promotion.

Subsection I. 17.4 Overseas influences. Consider the effect on British choice and decide which influences might be significant.

Subsection I. 17.5 Variations of hue. Remember that trends do not only apply to primary colours. It is also necessary to record bright, pastel and muted variations. Consider the variations that might be relevant in a particular case.

Subsection I. 17.6 Identifying trends. Set up machinery to analyse general colour movement and record:

- movement of demand for primary hues
- movement of demand for types of colour
- movement of demand in different parts of the home
- overseas influences
- the broad direction of trends.

Subsection I. 17.7 Subdivisions of the spectrum. Decide what has to be recorded.

Subsection I. 17.8 Assessing trends. Construct charts, recording in respect of each product:

- trends in those parts of the home in which the product is used
- colour movement in those markets in which the product sells
- sales by colour of related products which influence the purchaser
- colour movement in any other directions which may be relevant
- overseas influences, if significant.

Produce a graded list of colours. Consider whether charts should cover a past period.

Subsection II. 29.1 Is colour important? Analyse the product:

- what is its nature?
- is it used in the home?
- how vital is colour?

Subsection II. 29.2 Aim of product:

- nature of customers
- universal market
- specialised market.

Subsection II. 29.3 What does colour have to do? See I. 27.1 above.

Subsection II. 29.4 How many colours? Consider:

- competition
- tradition
- distribution
- across the range
- production and stock-holding
- trade customs
- colour combinations.

Subsection II. 29.5 How long are colours to last? Define policy based on:

- trade custom
- need for replacement
- promotion.

Subsection II. 29.6 How to achieve optimum sales? Consider how colour can be used to optimum effect:

- sales theme to be used
- what competition offers.

Subsection II. 29.7 Method of promotion. Decide methods of promotion to be used and assess the effect on colour selection:

- television
- press
- display
- mail order
- brochures and so on
- colour advice and so on

Subsection II. 29.8 How is colour to be offered? Consider the design of the product and how colour can be used to enhance it:
- method of applying colour
- number of colour combinations.

Subsection II. 30.1 The market. Identify the market in which the product is sold and consider:
- the importance of market segments
- colour requirements of each sector
- regional differences
- price level
- mass markets
- sophisticated markets
- rapidly growing markets.

Subsection II. 30.2 Identify the type of customer involved and at what sector the product is aimed.

- traditional
- conservative
- children
- the young
- retired people

- modern
- radical
- teenagers
- older people
- sex.

Subsection II. 30.3 Review competition in detail and find out:
- what is the competition
- who is the competition
- what colours do competition offer
- how does competition use colour in promotion.

Construct a comparative chart.

Subsection II. 30.4 Consider general effect of method of selling and effect on colour selection:

- impulse buy
- supermarkets
- boutiques
- wholesalers

- considered purchase
- builders' merchants
- specialists.

Subsection II. 30.5 Consider the method of distribution and the probable attitude of various channels:

- wholesalers
- store buyers

- retailers.

Subsection II. 30.6 Who is the purchasing influence, and what effect does this have on colour selection?

- husband
- children
- store buyers
- builders
- other

- wife
- teenagers
- architects and so on
- estate developers.

Subsection II. 31.1 If the product is bought for the home, consider the implications of the whole subject.

Subsection II. 31.2 Identify the part or parts of the home in which the product is used and the effect on colour selection:
- specific ranges

- universal ranges
- types of home
- overall colour demand.

Subsection II. 31.3 Decide whether the product is a lead product. If so:
- how important is it
- what does it influence.

Subsection II. 31.4 If the product is a subsidiary product:
- identify the lead product
- decide whether purchased for accent or decorative effect
- decide whether purchased to provide change
- decide whether bought for replacement purposes
- weight to be given to trends.

Subsection II. 31.5 Identify the various usages and products which may influence colour selection for the product considered:
- trends in interior decoration
- co-ordination
- trends in pattern
- overseas influences
- traditions
- other influential products.

Subsection II. 31.6 Establish the way that people make their choice and how this differs with:
- lead products
- subsidiary products
- impulse purchases
- short-term purchases
- long-term purchases
- economic conditions.

Subsection II. 31.7 Reasons for purchase. Identify the major reasons:
- furnish a new home
- replacement
- accent or decorative purposes
- provide variety
- gift sales
- commercial use.

Subsection II. 31.8 Consider the usage of the product; if it is not bought as part of the home, decide what modification is necessary:
- usage of the product
- reasons for purchase
- how people buy.

Subsection II. 32.1 Brand image. Consider whether colour is significant and possible effect on colour selection.

Subsection II. 32.2 Production limitations:
- machinery limitations
- stock limitations
- fading
- availability of colour
- wastage
- damage
- price of pigment.

Subsection II. 32.3 Consider the need for separate colour ranges overseas:
- which countries.

Subsection II. 32.4 Consider methods of display and presentation and whether special colour treatment is necessary:
- impulse colours
- sample books
- presentation
- competition.

Subsection II. 32.5 Consider colour functions and how they can be used to advantage (see II. 27.3 above).

Subsection II. 32.6 Are regional variations significant?
- north/south
- town/country
- culture.

Subsection II. 32.7 Decide whether special ranges would be useful and the basis for selection.

Subsection II. 32.8 Appearance of product:
- lighting
- metamerism
- display
- reproduction.

33.2 A typical specification

The purpose of the colour specification is to list all the various factors that should be taken into account when selecting colour and to identify the colour attributes and characteristics which will meet marketing requirements. A typical specification might consider the following points, but it should be appreciated that this is simply an example for illustration purposes and that details have been left sketchy.

Objective
: The objective is to select a range of colours for a new product used in the kitchen, appealing to a specific type of purchaser and with a strong fashion theme. The exact nature of the market has to be identified.

Marketing aim
:
- Because the product is used in the home, in the kitchen, colour must follow kitchen trends with emphasis on the future. Colour is important to sales and therefore care in selection will pay dividends:
- The product is aimed at female young marrieds; brighter colours of an unusual nature are indicated.
- Colour has to attract attention at point of sale; some impulse colours are indicated.
- Colour also has to support a fashion theme; emphasis on up to date trend colours is indicated.
- A choice of six colours is dictated by competition.
- Because of the fashion element, one or more colours should be changed each year; short-term colours are indicated.

	● The product will be promoted on television; colours should show up well on the screen.
The market	● The product is highly priced and appeals to a sophisticated market; subtle colours are indicated:
	● The customer is the young housewife; colours that appeal to her are indicated.
	● Competition offers six colours but is not otherwise strong; colours that are different to competition are indicated.
	● There is a strong element of impulse sale; colours should catch the eye of the passer-by.
	● The purchasing influence is the housewife; colours with a female bias are indicated.
Colour in the home	● The product is essentially for use in the kitchen of the average home and no other usage is perceived.
	● This is a subsidiary product which will be bought to match kitchen units on a short-term basis; colours should follow kitchen trends with emphasis on the future.
	● There is an element of impulse purchase; see above.
	● The product may be bought for accent or decorative purposes; some contrasting colours are required.
	● Gift sales are important; the fashion element will take care of this.
Other considerations	● There are no production limitations but blue may be subject to fading.
	● Display and presentation are important but require no special comment other than impulse colours already indicated.
	● Identification may be a useful selling point; colours should have good contrast with each other.

33.3 The selection process

When all the relevant data has been collected together and analysed and the colour specification is complete, it is possible to commence selection of hues and of variations of hue. Colour selection is more than just picking a basic hue; whatever the circumstances, it is the variation of the basic hue which is important. The basic hue may be picked for marketing, psychological or other good reasons, but the variation should reflect current trends and should be appropriate to the time.

Example The basic hue selected may be red because it has good impulse attraction but the appeal may be that much greater if a warm variation with a yellow bias is selected. The most appealing variation should be obvious from a study of trends.

It follows that in all cases a study of current trends is desirable. Construction of a trend chart (see Section 17 of Part I) for the specimen specification outlined in the previous section would be comparatively simple. Record:

- sales by colour of kitchen units for the past five years
- the general direction of colour trends in the kitchen
- eliminate those colours that have no place in the kitchen
- review the effect of continental colours
- pay special attention to the way that trends are moving in the kitchen.

The result of the above should be a graded list of colours suitable for any product used in the kitchen. This is List A.

The colour specification should answer the vital question 'What does colour have to do?', and it will identify those properties and attributes that will be appropriate to the product, the marketing aim and the conditions under which the product is sold. Again using the specimen specification in the previous section, this would indicate that the following characteristics were appropriate:

Attributes
- Age List colours that appeal particularly to the young.
- Associations List any colours that have an association with the kitchen.
- Impulse List colours that have impulse attraction.
- Markets List colours considered suitable for the market.
- Products List any colours having an association with the product.
- Sex List colours that appeal to females.
- Coding Identification is considered useful. List colours that have good contrast with each other.

Applications
- Food Because the product is used with food, list colours that associate well with food.
- Television The product is to be promoted on television. List colours that will reproduce well on the screen.

The information provided by the specification will make it possible to compile a further list of basic colours having appropriate characteristics and each of which has sound reasoning behind it. This is List B.

The result of these operations will be two lists of colours which include far more hues than are required in practice, and the art of colour selection is to combine the two lists in the most suitable way. The sales theme will provide a useful modifying influence; in this case the sales theme is 'fashion', and therefore from the basic hues in List B select those variations which best reflect current and future trends as indicated in List A.

The colour selection process can never be purely mechanical and its success depends on the skill, experience and 'hunch' of the person making the selec-

tion. Colour selection is an art rather than a science, and when all the various steps selected have been carried out it is still necessary to revise, refine and compromise where desirable to produce a workable range.

The examples quoted above outline a simple, straightforward, selection of colour but a number of modifications may be made:

- Strong trend colours may have to be included in a range, whether or not they have practical use, simply because people expect them.
- A range of colours usually has to meet a number of different criteria but in some cases may be aimed very specifically.
- If a wide range of colours is not practicable, the lowest common denominator will have to be chosen.
- More weight may have to be given to colours of the future, depending on the lead time of the product.
- In some cases more weight must be given to colours of the recent past, as noted in earlier chapters.
- Some modification may be necessary to meet the colours offered by competition.
- Special needs or circumstances may modify choice, perhaps on a temporary basis. An example may be availability of pigments.

33.4 Colour usage

The way that colours are used in relation to a product are primarily a matter for the designer or stylist, and colour should always enhance the design of a product. The relationship between colour and design is not strictly a part of the colour selection process, but if colours having maximum selling value are desired, it is recommended that the appropriate colours be selected first (on the lines of these notes) and then handed over to the designer for further action. However, the design of the product may have some influence on colour selection; for example, strong colours would be appropriate for a product that is designed to be tough but inappropriate for a product that is supposed to be fragile and delicate.

The designer will have to consider the effect of different combinations of colour (in appropriate cases); some colour combinations have greater appeal than others, and combinations may be technically correct but psychologically unpleasing to the consumer. It is often forgotten that any design or combination of colours is primarily intended to please the consumer – not the designer.

The designer might also consider the effect of the phenomena described as colour modifiers; these have little influence on the selection of colour, but they may affect the way that colour is used on the product. Most good designers will be aware of these modifiers, and their effects, but they are listed here for convenience:

- adaptation
- after-image
- colour constancy

- colour blindness
- contrast
- illusion
- juxtaposition of colour
- lighting (see 32.8 in this part)
- metamerism (see 32.8 in this part).

These modifying factors may have considerable significance when plans for interior decoration or display are under consideration; for example, in promotional material which gives advice to customers or retailers, including colour schemes and specimen interiors. The modifiers may also have an effect on colour combinations; a frequent fault is that colours contrast too sharply with each other and 'cut the product in two'.

34 Colour for industrial products

34.1 About industrial products

The term 'industrial products' identifies those products that are sold for use in industry and commerce, as distinct from products which are sold to the ordinary man or woman in the street for personal use, or use in the home, and which are generally known as consumer products. Industrial products are normally purchased by, or specified by, purchasing officers and management generally instead of by the ordinary consumer, and the reasons for purchase are practical ones, decoration being only incidental. Whereas colours for consumer products are selected primarily because they accord with fashion, colours for industrial products are selected for practical reasons which vary with the product concerned.

Typical industrial products include:

- surface-covering materials such as paint, tiles, wall coverings, floor coverings, decorative laminates.
- machine tools, machinery and factory equipment generally
- office equipment and supplies
- semi raw materials such as plastics sheet, paper and board
- contract furniture, which may also include office furniture
- miscellaneous products where colour plays some part in the function of the product.

Display materials such as packaging, print and labels might also fall within the broad definition quoted above, but colour selection for these categories is covered by the chapters dealing with graphical applications. Display material has, therefore, been excluded from this and succeeding sections.

Industrial products may be used in a single, coherent environment, in the case of machine tools, or they may be used in a number of different environments, as in the case of tubular furniture, which may be used in offices, factories, shops, cafes, schools, hospitals and many other different environments. Both colour requirements, and the method of selling, vary according to the end use of the product, and it is end use which is the key to colour selection.

Some products can be classified both as industrial products and as consumer products; a typical example is paint, which is used virtually everywhere, but in

such cases separate industrial and consumer ranges are usual, with specialised ranges for specific uses, such as motor vehicle finishes. Similar remarks apply to both surface coverings and floor coverings, but these often have a decorative function as well, although in a different sense in industrial and consumer use. The patterns of contract floor coverings, for example, have to meet different criteria to floor coverings for the home.

Some products are bought by industrial purchasers but end up as consumer products; typical examples are plastics sheet and paper where the colour may be specified by the purchaser with a specific end use in mind. Such products are commonly sold in a range of colours which must reflect potential end uses.

In the case of surface coverings it is desirable that the two types of use should be considered quite separately and a colour range prepared for each use. In the case of semi raw materials the colour range may have to reflect both industrial and commercial sales. Products such as office equipment and supplies may sell in both commercial and consumer markets, and colour may have to be a compromise between the two, although, if a range of colours is offered, there will be a commercial aspect and a consumer aspect. Other products, such as machinery, are seldom sold in a range of colours, and the colour will be selected for practical reasons, although it should also contribute to sales appeal.

In virtually all the cases mentioned colour has an important part to play in creating sales, either by attracting attention to the product or because the colour contributes something positive to the sales appeal of the product. This applies whether or not the product has a consumer aspect. There are, of course, many products where colour has no part to play at all, as in the case of wire rope, castings or bright steel bars.

The notes in the sections that follow are aimed at manufacturers and suppliers who are responsible for sales of industrial products and who have to make a number of decisions:

- whether to offer their products in colour at all; some products are sold in a priming coat and in other cases colour is only supplied to the specification of the customer
- which colours to use, and how to present them
- how to use colour to the benefit of sales.

These notes are not intended for purchasers of industrial products whose decisions about colour choice will be based on individual circumstances. Nevertheless, the manufacturer is interested in what the majority of customers are likely to do and in the factors that influence the decisions of customers.

34.2 What colour can do

Before trying to answer the questions posed at the end of the previous subsection it will be useful to consider what colour can do for the sale of industrial products. In some cases colour is incidental to the usage of the product, as in the case of beer bottles, which are coloured brown to protect the contents from light, but in other cases colour can play a more positive part in improving the sales of the product, provided that careful thought is given to the selection of

the colour. The desired objective can be achieved in a number of ways, and colour can be used:

- to attract attention at point of sale
- to enhance a corporate image
- as an integral part of design
- to provide benefit to the purchaser or specifier.

Comparatively few manufacturers give much thought to the subject of improving the sale of industrial products by the use of the colour of the product itself, and if they do, it will be mainly about attracting attention at point of sale or at an exhibition. This is a perfectly legitimate way of using product colour, but it is not the only one, and it does need careful consideration because the way that colour is used will vary from product to product.

No plant operator in his right mind would buy a milling machine finished in a delicate shade of pink; he might stop to look at it, but only to wonder why the manufacturer had been so crazy as to choose pink. While this would be a way of attracting attention, it is doubtful whether it would do much for sales.

In other words, the colour of any product must be chosen for sound reasons. Advertising in colour, or coloured literature, is one way of attracting attention, but it is only part of the process. The colour of the product itself should be carefully planned to persuade the potential customer to look – and to buy. In some cases, such as paint, it is not the colour of the product itself which attracts attention, it is the nature and extent of the colour range which persuades the customer to look at one brand rather than another. The old story of the red refrigerator in the shop window selling the white refrigerator on the shop floor applies also to milling machines or any other product. Failure to give adequate thought to the right colour may mean that a useful source of promotion has been neglected.

A second way in which colour can be used to advantage is to enhance a corporate image; this may embrace the use of a corporate house style to cover all products or the use of house colours, or at least a distinctive colour for individual products. Many companies use a corporate house style which includes colour, and while it may enhance the image of the company, it does not necessarily do anything for the sale of individual products. The corporate house styles of the major oil companies are, for example, known to almost everybody and help to sell all the products of those companies, but it would be difficult to say that they contributed to individual product sales.

A corporate house style helps to create prestige and to identify the products of the manufacturer, and it is normally carried through all aspects of a company organisation, including literature, packaging, advertising and transport; the larger companies take immense trouble to ensure that the colours of the style are uniform throughout the operation and that they are used in specified and carefully defined ways. These colours may help to identify the products of the manufacturer and to call attention to them, but they may not be the most appropriate colours for an individual product, and it may be better to identify the product by using the colours of the corporate style in the form of a motif which can be imposed on the main body colour of the product.

A company making a single product rather than a range of products would be

well advised to establish house colours which are appropriate to the product. Where there is no corporate house style, there is often a strong case for adopting distinctive colours for an individual product where it is practicable to do so. A typical case might be a machine tool where distinctive colours would ensure that the machine was readily identifiable in the machine shop or on the exhibition stand. It may be found that a colour which attracts maximum attention on display is not very suitable for use in the factory or office, or on the other hand, product colours that benefit the environment may not have much display value.

Benefit to the environment should always take priority over promotional considerations, and it may be worthwhile having a special colour for display purposes where this is necessary. A distinctive colour scheme for any individual product should be:

- unique to the manufacturer
- pleasing to the eye
- functionally appropriate to the task
- adjusted in tone for practical maintenance
- of such a hue that it will keep its identity under all lighting conditions.

The third use of colour is to improve the appearance of the product; it can be an integral part of design, thus making the product look better and more efficient. With many products, design and appearance have little practical part to play; the product is bought purely on its technical specification or for what it will do, but there is no reason why it should not be good looking, and colour, properly used, can add distinction to design.

There is pressure on manufacturers of industrial products to improve design, and the services of industrial designers are called upon to an increasing extent to improve the efficiency of products and their ergonomics. Experience suggests that improvements in appearance pay dividends as well. Good industrial designers will, of course, be aware of the attributes of colour, but good industrial designers are not always employed, and however good individuals may be at putting together nuts and bolts, they do not always consider appearance. Light reflection qualities and other useful attributes of colour may also be forgotten. Good appearance is desirable for all equipment, but it would be a mistake to sacrifice function for the sake of decoration. Colour should be used in a thoughtful way.

The fourth way of using colour, and the most important of all, is to provide benefit to the purchaser in such a way that the benefit can be demonstrated to the purchaser and thus form part of promotion. While no purchaser would normally buy the pink milling machine mentioned above, they might be persuaded to do so if it could be demonstrated that pink improved productivity or increased safety. In the circumstances described it is very unlikely that pink would do any such thing, but there are colours that would, and these have to be brought to the attention of potential purchasers.

The principal ways in which colour can benefit the purchaser are:

- by ensuring the best possible working conditions for all operatives, thus aiding productivity
- by contributing to a better working environment, eliminating glare and

ensuring the best possible seeing conditions, thus improving employee morale

- by signposting hazards and ensuring correct operation, thus contributing to safety
- by providing a convenient means of identification and coding which saves time and labour, thus improving efficiency
- by encouraging good industrial housekeeping
- by attracting attention in the selling environment, enhancing display and enticing customers
- by providing practical benefits such as control of light and heat and improving the visibility of controls.

The first of these is probably the most important because it means profit and is of interest to almost all purchasers, but all of these benefits can provide a positive selling point. To point out that care and thought have been given to the selection of colour will never do any harm – the very fact that the subject has been given attention is a plus point, and even if the only effect of a 'colour story' is to make sure that the product is considered for purchase, then the effort will be worthwhile.

If a customer is buying an expensive product, it is unlikely that colour will be a decisive factor in the purchasing decision, but it might well tip the balance between two competing products of equal merit.

35 Using colour to sell industrial products

35.1 Selling benefit

Of the four principal uses of colour described in the previous Section, the first three may be described as the abstract use of colour, and colour will be selected to suit marketing policy. The fourth use, however, envisages that colour is used as a positive factor in promotion, and this section is concerned with the way that the characteristics of colour which are of benefit to the purchaser can be used in promotion. The benefits will vary with each product and will also vary according to the type of environment in which the product is used.

None of the characteristics of colour, however, will contribute anything to sales unless colour is selected with care and for good reasons and unless potential customers are made aware of these reasons and told how the colour will benefit their particular circumstances. First identify the potential benefits, then select suitable colours, then promote both.

There are a number of perfectly legitimate ways in which colour can be used to sell, but when basing promotion on the nature of the benefits to the purchaser, the selling message may be based on efficiency and good seeing conditions; on enhancing merchandise and pleasing the public; or on human welfare, depending on the nature of the product and where it is used.

Colour for industrial products is not selected for reasons of fashion or to accord with trends of consumer preference for colour as with consumer products, nor is colour usually selected to promote impulse sales, although the attraction value of colour may be useful, as noted in the previous section. What has to be done is to select colours which have a practical and functional use and which will be valuable to the purchaser, and then to promote those benefits in the most suitable way. The theme of the sales story is the way that colour contributes to the utility of the product in the hands of the customer.

Most customers will appreciate information suggesting how they can make practical use of colour, and the supplier who can provide this information, backed up by practical demonstration, has competitive advantage. Many customers seek assurance that the colours that they have purchased have a sound, practical basis instead of being an arbitrary choice, but many others, of course, have never given much thought to colour and may welcome having its benefits brought to their attention.

The manufacturer who has taken trouble with colour selection can create good-will by helping customers to choose suitable hues, perhaps by specific advice, perhaps by providing advisory material or perhaps by producing standards. Manuals for salesmen are a possibility in some cases.

The average office manager, for example, does not greatly care whether he purchases a blue typewriter or a grey one, but if it can be demonstrated to him that a grey typewriter is more productive than a blue one and produces less worker fatigue, he will be very interested indeed, and the demonstration might well be the deciding factor in clinching a sale. Furthermore, good-will is created because the manager is able to justify the purchase to higher management with the support of sound reasoning.

Those operating in a selling environment, such as store managers, hotel proprietors and the like, will be even more interested in the practical uses of colour and will welcome help and advice. In their case, colours have to last a reasonable time, be practical from a maintenance point of view and be acceptable to *their* customers, who are the general public. If the colours offered can be demonstrated to have these qualities, then the manufacturer not only has competitive advantage but also has a unique means of approach to potential customers, possibly at a higher level than would otherwise be the case.

35.2 The purchasing influence

In those cases where the benefits of colour can be used as a basis for promotion, the form of approach depends very largely on the nature of the purchasing influence, and this varies from product to product. In broad terms, purchasing influence may be classified as follows:

- the direct purchaser, such as the industrialist, office manager, purchasing manager, works manager, shopkeeper, store operator, hotel keeper and so on
- the indirect purchaser, such as architects and designers, who specify colours on behalf of end users
- the processor or converter who purchases semi raw materials, such as plastics sheet, and who has to ensure that the end product for which the materials are used appeals to those who purchase the end products. The ultimate purchaser may, of course, be either industrial users or consumers.

In some cases there are additional complications; distribution may come into the chain of influence as in the case of paint.

The direct purchaser is most unlikely to be an expert on colour and in most cases will welcome assurance that the choice made is the best possible in the circumstances. Even the purchaser who has little interest in colour will be impressed if it can be shown that the colours offered have good reason behind them and will produce practical benefits. In many cases the purchasers will welcome, and may even look for, practical advice about colour.

The indirect purchaser will usually have some knowledge about colour, and a typical architect or designer will consider himself to be an expert on the subject.

However, colours chosen with sound reason do provide an approach, especially to architects who are normally hard to reach, provided that the approach is backed by interesting facts.

Where a product (such as surface coverings) is produced in a range of colours, the main object of promotion is to persuade the specifier, who may be an architect or designer, to specify the products being sold instead of those of a competitor. Such a range must include a sufficiently wide choice to make it attractive to the specifier, and the presentation of the range may be particularly important. The colours included in the range should not only have practical benefits for the end user but should also be backed by facts that justify their inclusion in the range and justify their use by the specifier. This is particularly important in the case of designers who expect 'out of the ordinary' colours, something unusual which will enable them to put their 'mark' on a product or project.

It is often a good idea to pick out suitable colours from a range and to produce promotion directed at a specific application; the promotion should explain why the colours indicated are suitable for that particular application and the circumstances in which they can be used to advantage, and the benefits to be gained from them. This should be backed by adequate research where appropriate. The principles governing the use of colour in hospitals provide a typical example of this strategy in use and might provide a useful approach to architects; the promotion should explain how colour can be used to advantage in hospitals and how specific colours can be used to maximum effect.

Many of the remarks about colour ranges in the paragraphs above apply with equal force to the processor, but in this case there is an additional gambit. The principal objective of promotion to this category of purchaser is to persuade them to use one brand of material instead of something competitive, and colour often provides an opening for a salesman that would not otherwise exist. The processor is obviously interested in ensuring that the end products sell well, and if it can be shown that the colours of the material will help to achieve this objective, there is immediate interest. The colour range offered must cover all the various applications in which the product is likely to be used and must be shown to have advantages for all the end products, preferably backed by research. If this is properly presented, it enables the salesman to make an approach to management at a much higher level than would otherwise be the case.

36 Factors affecting colour choice for industrial products

36.1 The main categories

The factors to be taken into account when selecting colours for industrial products vary according to the nature of the product, and these fit into a number of broad categories, but the key factor in all cases is the usage of the product; this includes where it is used and, in the case of semi raw materials, what it is used for. The suggestions that follow are written from the point of view of the manufacturer who has to select the colours in which a product is offered, but in the great majority of cases it is what the end user does that matters.

The principal categories of product are as follows:

- Original equipment, that is products that may be coloured to meet individual circumstances or to fit into a specific environment.
 - Machine tools may be finished to accord with a works colour scheme but may also be sold in standard colours even if they are repainted by the purchaser.
 - Factory equipment may be finished to accord with the colour of the material being processed.

 In such cases the colour may be specified by the customer, but otherwise the colours should be suitable for the environment in which the product is used.
- Standard equipment, that is products sold in standard colours.
 - Office equipment should be offered in colours which are suitable for use in a productive environment.
 - Shopfitting equipment should be produced in colours suitable for use in a selling environment.

 In such cases the colours should be those that are best for the conditions of use.
- Industrial products, that is those that are produced in colours that have a definite function to perform.
 - Beer bottles are brown because the colour protects the contents.

 Colours should be selected according to function.
- Products sold in a range of colours so that they can be used in a number of different environments:

- surface-covering materials which will be applied directly to the environment, although in some cases there is an element of processing as well. Decorative laminates, for example, may be applied direct but can also form part of other products.

In this case colour selection requires detailed research into potential usage and selection of colours that will meet that usage or rather its colour requirements. The customer will often specify the colour, and it is his requirements that have to be met, although his choice may be influenced by an appropriate sales approach.

- Products sold in a range of colours and used in a number of different end products:
 - plastics sheet
 - coated steel sheet.

Selection of colour depends on what sells typical end products, and research into these end products will be necessary. Note the difference from the preceding category: in the first case the customer specifies the colour, while in the second case it is the ultimate purchaser of the end product who makes the colour decision.

36.2 Original equipment

The first category mentioned in the previous subsection is usually sold on a one-off basis for use in a factory or other specific environment, and the category includes machine tools and the like which are normally finished before they leave the factory. They may be sold:

- in a standard colour (e.g. grey)
- in an optional colour (e.g. grey or blue)
- in a standard livery identified with the manufacturer
- in a state which varies according to circumstances
- in a colour specified by the customer, mostly in the case of custom-built machines
- in a priming coat for finishing by the customer.

Colour selection requires a number of marketing decisions:

- whether to offer in one standard colour or to offer a number of options, and if so, how many
- whether to adopt a distinctive livery which will identify the machine and enhance the image of the producing company (colour should be functionally correct, but it is often possible to adopt a distinctive tone or possibly a two-tone effect made up of colours which are both functionally correct)
- whether to offer in one colour chosen for purely functional reasons based on the usage of the equipment and the conditions under which it is likely to be used
- whether to use different colours for different types of machine, or different types of equipment (e.g. grey for lathes, green for drilling machines, etc.).

Some degree of standardisation avoids arguments, provides a more straight-forward production run and reduces finish inventories. It may be useful to consider what competition does and whether there is any advantage to be gained by offering something different.

The purpose of adopting a distinctive house livery is to enhance the image of the manufacturer and to identify their machines on the shop floor. Some manufacturers believe that there are advantages in this course because it creates a kind of brand image. It would be a mistake to adopt unusual colours for a livery, and it would be better to use a distinctive tone of a functionally correct colour; the fact that the colour had been chosen for functional reasons and would contribute to efficiency and the well-being of workers could be used in promotion. There may be a case for a logo, symbol or manufacturer's label in strong colours to build up brand image, but such a label should not be located within the direct view of the operative, nor should it be located in a position where it might cause distraction in the environment generally.

In all cases colours selected should contribute to efficiency and to improvement of the environment in which they are used by eliminating glare and improving seeing conditions. In addition, safety should be considered in the marking of hazards and highlighting of working planes. Both these provide useful selling points that appeal to specifiers, although obviously performance is the first consideration.

Colour is often used to draw attention to a machine at an exhibition or on a showroom floor, and red is frequently chosen. It would be a mistake to offer a striking colour of this kind in a production machine, and a model should be specially finished for exhibition purposes. On the whole it is better to select colours for purely functional reasons rather than purely for appearance; purchasers will appreciate a practical approach and will not be impressed by bright colours.

In order to select a suitable colour, consider the following points:

- the type of environment in which the product will be used
- the colours must be suitable for that environment
- the type of lighting normally used
- how the product will be used
- in appropriate cases, what materials are worked on; the colour of the material may be significant
- how safety can be achieved
- what features have to be easy to find
- the objectives to be achieved; such as utility, image and so on.
- how the objectives can best be achieved within the limitations imposed by the needs of the environment.

If colours are selected to meet these objectives, the reasons for the choice should be logical and easily understood; the colour should be acceptable to potential purchasers and should contribute to their productivity and profits. Safety may be a particularly good selling point; the correct painting of hazardous machinery will go a long way to reducing accidents, and this will be of interest to most users. Each machine must, of course, be considered individually because the safety application of colour depends on the design of the ma-

chine. Darker colours would be appropriate for equipment which is liable to soiling, and this might also be featured in promotion.

36.3 Standard equipment

The second category covers products which are sold in standard colours, the extent of choice being a marketing decision. Office equipment, for example, is often sold in six different colours. Many of the points made in the previous section apply equally to this category except that the customer is not given the opportunity of finishing for himself, nor is it usual for manufacturers to have a standard livery, although they may offer exclusive colours.

Colours are selected for virtually the same reasons as with original equipment, but with additional reasons according to circumstances. Office equipment is frequently coloured in such a way that the colours can be used for coding and signalling; there may also be a consumer element because office equipment has to appeal to workers and may be purchased for use in the home. Shopfitting equipment has to appeal to the public at large and must also enhance the merchandise. Other products may also have to have consumer appeal.

The type of lighting in which the product will normally be used is quite significant, and so is the function of the product (i.e. what it has to do in its normal working environment). The main function of the colours of a typewriter is to eliminate glare, but a filing system has to lend itself to coding; some products have a decorative function. Hiding soiling may be quite a useful point in promotion; areas that are particularly liable to finger marks or other types of soiling would be better in darker colours, and a two-tone effect may improve appearance. In some instances there are trends to be considered; there are trends of colour preference in the office, and although these trends are sometimes rather impractical, it might be better to follow them. This is a marketing decision.

36.4 Individual products

In this category the colour is the principal selling point of the product because it has a definite function to perform. For example:

- The colour of labels must have maximum visibility.
- Bright colours on the outside help to keep the interior cool.
- Dark-coloured exteriors will absorb heat.
- Choice of colour is quite critical where it is used for coding or signalling purposes.
- Wires and cables are coded according to a standard; it is best not to interfere with the standard.

The functional use of colour for the individual product may be defined as an inherent attribute which helps to sell that product and which helps to provide a selling point (if it is properly explained). In order to select suitable colours, consider the following:

- the function of the product and what it has to do
- where the product is used
- the lighting conditions under which the product will be used
- how the product is used
- what colours would be most suitable for the purpose.

36.5 Surface coverings

The fourth of the main categories covers products sold in a range of colours so that they can be used in a number of different environments, and is almost wholly concerned with surface coverings such as paint, tiles and floor coverings. These products are also sold for use in the home, but selection of colours for consumer ranges requires quite separate treatment and is dealt with in Section 26 in this part, and in sections following. This subsection is concerned with contract ranges which are sold for commercial and industrial use rather than for use in the home, although both pattern and colour should be generally acceptable to the public, especially where the products are used in a selling environment.

The principal factor governing choice of colour for contract ranges is the environment in which the product will be used, and a typical range should include colours which are acceptable in terms of reflectance value and hue for use in the environments described in earlier chapters and including factories, offices, shops, catering establishments, schools and hospitals. If the product is used in any of these environments, or all of them, consider the colours most suitable for each. Adding together the colour specifications for all the relevant environments will produce a crude colour range which can then be refined and modified; it may be necessary to cover the specialist requirements of architects and interior decorators.

Paint also has other uses, such as marking hazards, control of temperature and so forth, and these should be considered separately, although they may be included in a trade range. The sales story varies to some extent with the material. In some cases promotion can be based on the supposition that colours have been selected for specific purposes (e.g. for use in hospitals), and on the reasons for the choice. In other cases the attraction will be the extent and nature of the range as a whole.

36.6 Semi raw materials

The fifth category covers those materials that are processed into manufactured products and includes materials such as plastics sheet and paper and board.

The colours included in a range must be selected to enhance the sales of the products for which the basic materials are used, and both the colour selection process and the sales appeal are different from those applicable to other industrial products. The first step is to identify the uses of the material and the principal products for which they are likely to be used and then to establish the colours that will enhance the sales of these principal products, which may in-

clude both consumer and industrial products. Plastics sheet, for example, may be used for the covers of office ring-binders and for diaries sold to consumers. The range of colours must, therefore, include hues that are suitable for both usages – in the first example, colours that are practical in the office, in the second example, colours that reflect trends of consumer preference.

The end use aspect dictates the nature of the sales approach, the sales story being that the colours will enhance the sales of the end products, the manufacturer of which may not be the purchaser in the first instance. However, all parties in the chain benefit from good sales of the end product, and the material manufacturer is, in effect, doing a selling job for all of them. Both the purchaser of the material and the producer of the end product will benefit from the trouble taken over colour choice by the material manufacturer. The latter may even provide advice to the other parties on how to use colour to the best advantage.

One advantage of this sales approach is that the salesman thereby has an opportunity for contact with the purchaser at a much higher level than would otherwise be the case. The reason for this is that the colours in which the end product is sold will be decided by top management and not by purchasing officers, and if the salesman can put forward convincing arguments, he will gain access to top management. The latter will welcome any assistance available that will increase the sales of the product.

The presentation of the colour range is of much more than usual significance because designers and artists may be employed at more than one stage of the chain and may pass over a limited or ill-presented colour range.

36.7 Other factors

Export Any product that has a substantial export sale requires special consideration. Even in the simplest case, colours that would be perfectly suitable for use in European markets would not necessarily be suitable for use in tropical climates, where the sun and the light are so much stronger. Dark colours are generally unsuitable for tropical climates. Colour sometimes has a religious connotation, and there may be local likes and dislikes; subtle colours have little significance in most African countries. Properly speaking, each country should be considered individually and colours selected for that country, taking into account any local prejudices; in any case, the subject should be considered.

Government Government departments and nationalised industries often have standards for particular applications. For example, the Department of the Environment specifies colours for use in government offices. These should, of course, be taken into account in appropriate circumstances.

Co-ordination Much effort has been devoted by the Design Council and the RIBA to persuading producers of the constructional materials to co-ordinate the colours of their products by using British Standard colours (BS 4800), and the standard provides a convenient means of identifying and specifying colours in terms that are easily understood. The use of BS colours

is, perhaps, most important in architectural applications.

The main drawback is that BS colours provide little scope for competitive advantage. If all products are produced in BS colours only, there is nothing to distinguish one range from another. Where practicable it is recommended that colours should be specified in terms of the British Standard, and a suggested procedure is to select a colour range and then to adjust the hues to coincide with the standard where it is possible to do so.

37 Colour selection for industrial products

In principle colour selection for industrial products is simpler than it is for consumer products, but a great deal more work may be involved, especially if a colour range has to be compiled. The key to colour selection is use; this means either where the product is used or what it is used for. It follows that the first step in the colour selection process is to analyse usage in detail. This may be comparatively simple for a machine tool but is much more complicated and time-consuming for plastics sheet when extensive research may be required.

It is then necessary to identify those colours that will be of most benefit to purchasers in respect of each use. Again, this is comparatively simple with factory equipment where colour can be easily identified in terms of reflectance values, as explained in those sections dealing with productive environments. In the case of plastics sheet, however, each end use has to be investigated individually, and if there are consumer uses involved, trends and other considerations must be taken into account.

The primary objective is to be able to demonstrate to potential customers that the colours offered have some practical benefit, such as helping to create an efficient environment or helping to sell an end product. The secondary objective is a more abstract one of attracting attention at point of sale, enhancing the company image or improving the appearance of the product, and this requires marketing decisions, as explained in earlier sections.

In each situation there are a number of questions that need to be answered either in respect of an individual product or in respect of each end use (in the case of semi raw materials). The questions that need to be answered include the following:

- Where is the product likely to be used?
- What conditions are likely to be met in each usage?
- How is the product to be used? What is its function?
- What objectives can colour be expected to achieve?
- How can colour contribute to an efficient environment?
- How can colour contribute to safety?
- Can colour have a practical part to play, such as visibility?
- How can colour contribute to optimum working conditions?
- What trends are involved (e.g. trends of decoration in the office)?
- Is there a consumer element involved?

- How many colours should be offered?
- What is the primary purpose of colour?
- What is the nature of the purchasing influence?
- How can colour be applied to obtain most benefit to both customers and sales?

For a single product it is recommended that a colour specification should be prepared setting out exactly what colour is supposed to do and how it can best serve the interests of the manufacturer and customers. It is then possible to select hues having an appropriate reflectance value that will best meet the conditions of the specification.

When selection of a colour range is involved it is recommended that a chart should be constructed showing, in one direction, the potential uses of the product as determined by research. In the other direction, list the colours that can be recommended for each use, determined according to the criteria suggested in the appropriate sections of this book. This will usually result in a number of duplications which can be eliminated; if the resulting list is too long, eliminate the less important uses.

The process of colour selection for industrial products is by no means clear-cut because there are so many variations of product and usage. Accordingly, a good deal of careful thought is required and intelligent adaptation of the suggestions made in earlier sections.

The important point to remember when dealing with all industrial products is that it is *use* which is the key. Colour is selected for use rather than for the product itself.

- How many colours should I select?
- What is the primary purpose of colour?
- What is the nature of the purchasing influence?
- How well do graphics or other text need to be in each medium and to scale?

The sample product it is recommended that a colour specification should be prepared setting out exactly what colour is required to the limit that their every appearance prior to manufacture and customer. It is then possible to select new forms of supply that relate to a specification that will best meet the conditions of the specification.

When selecting a colour range it may well be recognised that that colour should be constituted to show not one colour but a range that are of the most appeal or pinned to research, applied or otherwise. Broadly, for the eye is comprised of the field at a different hue or chroma as criteria is rejected. If later any great accuracy of detail is lost, this will usually result in a number of observations which are not channelled in the resulting field of a range, although the less important ones.

The nature of colour research in industrial products is obvious an obligation to the requirements. Research may often need against the need to correctly interpret measured and influential adaptation of the subject of measurements in detail.

It is important both to remember the changes which are underlined and felt by that it is one which is the very Colour is selected for use in branding and to the product itself.

Part III
COLOUR CATALOGUE

1 Introduction to Part III

A dictionary describes a catalogue as a 'complete list of items with notes giving details', and this description fits the third part of this book admirably. It is thought that this part may, perhaps, be the most useful to those who have to select colour. It analyses the various attributes, applications, characteristics, properties and uses of colour which have been described in earlier sections and adds information about uses taken from other sources. It summarises this information and groups it in two different ways: first, under the type of colour such as hard colours, soft colours and so on; second, under hue headings such as violet, blue and so on, using the subdivisions of the spectrum suggested in Section 17 of Part I. It is felt that this subdivision will meet most practical requirements.

The catalogue can be used in two different ways. Supposing that it is desired to find colours which will appeal to younger age groups, a glance through the attribute headings of each hue will indicate those colours that have the necessary appeal, and the same principle can be applied to any other characteristic or property. The second way is for comparison of the advantages or disadvantages of one or more hues. For example, the search for colours appealing to the young will show that both yellow and red fit the bill. Which to use? This will depend on the other characteristics of the hue, and these are readily available from the catalogue.

Each hue has been subdivided under the following headings:

- The subdivisions of the hue, suggested as suitable for the recording of trends. See Section 17 of Part I.
- The character of the hue:
 - general description
 - whether hard, soft and so on
 - notes on other hues with which it harmonises
 - notes on specific variations
 - effect on vision
 - practical points.
- Lighting. This heading indicates the effect of different forms of lighting on the appearance of the hue and also indicates whether the hue can be recommended as an illuminant or for lampshades.
- Attributes. This Section rearranges the colour analysis in Section 10 of

Part I under hue headings and under types of colour.
- Functions. Colour analysis from Section 9 of Part I.
- Applications. Colour analysis from Section 11 of Part I.
- Domestic interiors. Colour analysis from Section 15 of Part I.
- Commercial interiors. Information about commercial interiors will be found under the use heading (see below).
- Combinations. This heading lists typical harmonies and colour combinations which have been found by experience to work well in practice. It includes the views of various experts and is intended to be helpful rather than a statement of formal rules. The combinations suggested may not always be the best to use in specific circumstances and design must always be taken into consideration.
- Uses. This heading suggests suitable uses for the hue in the following applications:

– Consumer applications	Bathroom products
	Bedroom products
	Domestic appliances including major appliances, small appliances and space heaters
	Housewares including kitchen utensils, tableware and food containers
	Kitchen products including kitchen units
	Living room products
	Window decoration products
– Graphical applications	Packaging
	Print
	Images
	Vehicle liveries
– Environmental applications	Catering
	Factories
	Offices, including office screens
	Retail
	School
	Hospital
– Commercial applications	Office supplies
	Paper and board

In most commercial and industrial applications the selection of colour depends on the end use of the product and requires individual investigation in each case. The two categories listed above, dealing with the office and paper, are exceptions where it is possible to formulate some rules of a more general nature.

– Surface covering applications	Decorative laminates
	Floor coverings
	Paint
	Wall tiles
	Wall coverings

The most suitable colours for surface coverings intended for domestic use depends on where the product is to be used. A range may be designed specifically for use in, say, the bedroom, and in that case the colours to be included would be those that are suitable for bedroom use. On the other hand, the range may be designed for universal use in the home, and in that event the colours to be included should embrace hues suitable for all areas of the home.

In the same way, ranges designed for commercial and industrial use should include colours suitable for a specific environment, such as factories, or colours which would be suitable for all the environments listed above. There are various possibilities between the two extremes of the one-environment range and the universal range. A common example is a carpet range intended for both bathroom and bedroom use.

- Interesting points about the hue derived from legend, symbolism and folk lore. These points have little commercial significance and they have been jotted down, more or less at random, because they are interesting and may provide useful talking points. The choice is arbitrary, and no attempt has been made to provide a complete record of colour symbolism or lore.
- Notes:
 - References to likes and dislikes are based on general usage and not on fashion. In any process of colour selection due weight must be given to any trends which may be applicable; these often override general preferences.
 - NSC. This indication against an entry in the catalogue indicates that no special comment is necessary either because the item is not significant in that particular context or because there are no special connotations worth recording.

2 Types of colour

2.1 Introduction

Colours are commonly classified into broad categories such as hard colours, soft colours, pure colours, neutrals and so forth. These categories are often imperfectly understood, and although some of them have been described in earlier sections, they have been defined in the pages that follow. Each category performs certain broad functions which derive from the characteristics which causes them to be categorised. For example, hard colours are so called because they form a sharp image on the retina and are therefore particularly suitable for attracting attention, but in any situation it is still necessary to select an *individual* hard colour, perhaps because it is psychologically suitable or because it accords with current trends of consumer preference.

Each type of colour has certain broad characteristics, and these are also listed; they are linked with the characteristics of individual hues which will be found in later sections. It should be noted that although hard colours, for example, are listed as red, orange and yellow, the description does not only cover the central portion of each waveband but also includes all variations provided that they are not mixed with any other colour. However, variants such as deep colours or pastels will be modified in their effect by the considerations listed under the appropriate headings.

It has not been thought necessary to analyse types of colour under consumer application headings because in most domestic interiors it is hue that is important rather than types of colour. The analysis under the heading of domestic interiors will apply to all domestic interiors.

2.2 Hard colours (warm colours)

Description

The hard colours are red, orange and yellow and are so called because they form a sharp, clear image on the retina of the eye and thus tend to suggest angularity. They are also known as warm colours because psychologically they tend to have a warming effect.

Hard colours are focused easily by the eye and they can be seen more clearly.

They are only slightly refracted by the lens of the eye and their point of focus is behind the retina; to see them more clearly the lens of the eye tends to grow more convex, thus pulling the image forward and making it appear nearer, larger and more visible. Hard colours have maximum brightness and thus tend to spread out on the retina of the eye like water on blotting paper, thus making the image larger and attracting attention to a greater extent and giving the image more impact. Because hard colours are brighter, they have better visibility and they tend to increase autonomic response and tension. They have a psychologically warming effect and create a mood that is energetic, vital, cheerful and conducive to sociability. Hard colours will always dominate soft colours in any visual application. They attract attention, provide accent and come forward to enhance an image.

Lighting

Hard colours look dull under fluorescent light. Objects seem bigger and better under warm light.

Features

Hard colours:

- have maximum brightness in pure form
- focus at a point behind the retina of the eye
- always dominate soft colours because of their effect on the retina; red letters on a blue background are better than the reverse
- make objects look nearer because they focus at a point behind the retina
- are easier to focus; red is only slightly refracted by the eye
- are more visible because they are brighter; visibility is dependent on brightness differences between the colours
- are impulse colours, inviting to the viewer
- tend to make objects look larger
- associate with warmth
- signify contact with the environment
- create excitation
- cause people to overestimate time
- tend to make objects look heavier
- hold most attention in the early years of life
- tend to cancel out soft colours.

Attributes

Age	Generally appeal to the young rather than to older people and are useful in environments used by the young because their brightness tends to absorb surplus energy.
Appearance	Generally flattering.
Associations	NSC.
Fashion	NSC.
Impulse	Recommended in all cases where it is desired to attract attention. They are more visible than, and dominate,

soft colours and command attention whether or not a person likes them, because they create a psychological stimulus. Hard colours against a soft background will have maximum impact, although some combinations may not be emotionally acceptable.

Markets	NSC.
Mood	Exciting, express vitality, energetic, cheerful, sociable.
Personality	Generally preferred by people with an extrovert personality and younger, less conservative people. Appeal to dynamic people who are outwardly integrated; such people often prefer modern abstracts and radical designs.
Preferences	Generally preferred by children and younger people and those living in sunny climates.
Presentation	Recommended where maximum impact is required.
Products	NSC.
Recognition	Good recognition qualities because they have good impact. Better recognition qualities than soft colours.
Reflectance	NSC.
Regional	Better liked in seaside areas than in city environments.
Seasons	Essentially for autumn and winter because of their warmth.
Sex	Appeal to males more than to females but this is not an invariable rule; some appeal to dark-haired females.
Shape	Form a sharp and clear image on the retina and suggest angularity.
Size	Make objects look larger and nearer to the eye. Surfaces appear nearer to the eye.
Smell	NSC.
Stability	Generally suggest excitement.
Taste	NSC.
Tradition	NSC.
Visibility	Pull the image forward and make it larger; hard colours are also brighter and attract the eye to a greater extent. Sharp, clear image.
Warmth	Warm by definition; inviting to the viewer.

Functions

Camouflage	Not generally recommended where camouflage is concerned.
Coding	Recommended because they have greater impact.
Heat control	NSC.
Insect control	Warm colours generally are not attractive to insects.
Light control	NSC.
Pipeline identification	NSC.
Protection from light	NSC.

Readability	Always dominate soft colours and are best on a soft background.
Signalling	NSC.
Visibility of controls	Recommended for marking controls and providing maximum visibility.
Other	NSC.

Applications

Biological	Psychological effects: individuals dominated by warm colours are receptive and open to outside influences and strong effects, have warm feelings, and are suggestible. Mental functions are rapid and highly integrated; with warm colours go the primitive responses of children and the extrovert.
	Medical effects: pleasing to depressed patients; cause an increase in blood pressure, pulse rate, respiration rate and muscular tension; speed up digestive processes and more marked cortical activation; muscular reactions are more marked.
Children	For children and young people generally.
The country	Of little significance except as accent.
Export	Generally preferred in warmer climates because their brightness is not overshadowed by the strong sunshine. Used for interiors in cool countries.
Exteriors	Appropriate for prominent forms and details seen at short distance. Warm colours for north-facing houses.
Food	Generally preferred for most foodstuffs because they stimulate the appetite.
Food packaging	Preferred to soft colours.
Food in the home	Stimulate the appetite.
Food processing	Not generally recommended, although pale yellows are acceptable.
Food service	Stimulate the appetite and are recommended for the overall surround, fascias and signs; provide welcome decorative effect; may be used with care in the immediate surround.
Food stores	As for food service.
Industrial plant and equipment	Only for marking hazards, control boxes and the like.
Merchandising	Excellent for display purposes because they attract attention and encourage impulse sales. Can make objects on display appear larger; good impact.
Pattern	NSC.
Safety	Generally recommended for safety purposes because they have more impact and because they make objects look nearer thus preventing misjudgement.

Signs	Generally best for signs of all kinds because they have better recognition and more impact.
Television	Most variations reproduce satisfactorily, but intermixtures are often present. Yellow is difficult.
Texture	Generally look best on rich materials with a marked texture; can be overwhelming on shiny surfaces.
VDUs	Not recommended.
Woods	NSC.

Domestic interiors

Usage	Warm colours go well with cool colours in a complementary scheme, and while they warm up a cool room, the effect can be cooled down by using warm pastels with plenty of white. They create a centrifugal effect and are best used in a room with plenty of natural light.
Room character	Warm colours create a mood that is energetic, vital and cheerful, and they suggest sociability.
Room aspect	Warm colours will cheer up a north-facing room and create an exciting look; they add a flattering glow to a chilly room.
Room size	Warm colours and a wallpaper with a fussy pattern make a room seem smaller. Warm, dark colours can improve a small room; they reduce room size and appear to be nearer than they actually are.
Room features	Warm colours on an end wall will bring it forward, and dark versions on a short end wall will make a room seem better proportioned.
Room users	Very suitable for rooms used by children because the warm colours help to absorb surplus energy.

Working interiors

In a productive environment, use warm colours:

- if the room is cool
- if the noise element is low
- if the room is too large
- where texture is smooth
- where physical effort does not generate heat
- where the time exposure is short
- where a stimulating atmosphere is desirable
- where lighting sources are cool
- in a lofty room to reduce visual size
- in areas having north light
- when the overall appearance is greyish
- to mark hazards for safety reasons
- where manual tasks are carried out
- for entrance halls; they are welcoming

- for recreation areas and reception areas
- where natural light is deficient
- where women are employed
- for end walls in some cases, especially long narrow rooms
- for large spaces where the worker is not close to the walls
- for offices in an industrial environment
- for lively general offices
- for a stimulating environment and to direct attention outwards.

In a selling environment, use warm colours:

- to provide a stimulating and exciting atmosphere
- to reduce the size of an area
- to bring forward distant end walls
- for long, narrow areas
- to encourage a fast trade
- in cloudy regions
- in areas having a north or cool aspect
- to mark hazards
- where there is little natural light
- for the features of a display.

Uses in consumer applications

No special comments seem to be necessary except that it is advisable to avoid aggressive colours in bedrooms.

Uses in graphical applications

Packaging	Recommended for feature colours for most packages because they create greater attraction and impact. Where package design features a symbol or logo, the symbol and secondary features are best in strong, hard colours which dominate soft colours.
Print	As for packaging. Tags: generally favoured because of their superior impulse value, but readability may be a limiting factor.
Images	As for packaging; they are recommended for house colours where practicable and strongly recommended for symbols and trade-marks. Create a modern, friendly, efficient image.
Vehicle liveries	Those colours that are effective in package design are equally effective in livery design, and there is no disputing the effect of hard colours; they are the key to successful liveries and strike an essential chord in human perception.

Uses in environmental applications

No special comments seem to be necessary; attention is drawn to the remarks under working environments above.

Uses in commercial applications

Office supplies NSC.

Paper and board Red, orange and yellow are the action colours but they should not generally be used as background because they tend to 'come forward' and overwhelm the print.

Attention is also drawn to the notes in Section 1 of this part.

Uses in surface covering applications

Attention is drawn to the explanation of colour selection for surface coverings in Section 1 of this part.

2.3 Soft colours (cool colours)

Description

The soft colours are violet, blue and green, and they are so called because they are less sharply focused by the eye and tend to form a blurred image and retire into the background. They are also called cool colours because of their retiring quality and because they are psychologically cooling; they appear warmer if they are very vivid. Soft colours have the reverse effect to hard colours and are dominated by hard colours in most instances.

Soft colours are less easily focused by the eye and tend to suggest roundness and softness. They are sharply refracted by the lens of the eye, and their point of focus is in front of the retina; to see the image clearly, the lens tends to flatten out and the image is pushed back and decreases in size. In other words, it tends to retire. Soft colours are normally less bright than hard colours and therefore less visible; they are not inviting to the viewer, although green tends to be neutral in this respect. Soft colours tend to decrease autonomic response and to reduce tension; they are subduing and create a quiet mood.

Lighting

Lampshades in cool colours are not generally recommended, but green may be used in some instances.

Features

Soft colours:

- are more retiring than hard colours
- are dominated by hard colours
- recede into the background
- are less visible than hard colours
- make objects look further away
- are retarding, not inviting to the viewer
- are difficult to focus and often appear blurred
- tend to make objects look smaller
- are associated with coolness

- signify withdrawal from the environment
- have a calming effect on the organism
- cause people to underestimate time
- increase mental concentration
- are preferred by those of mature age
- are best as background because they are passive.

Attributes

Age	Often preferred by older people.
Appearance	NSC.
Associations	NSC.
Fashion	NSC.
Impulse	Little impulse attraction, best for background.
Markets	Generally have more appeal in higher grade markets, but this is not an invariable rule.
Mood	Subduing, create a quiet mood, relaxing and restful but can be rather cold if not relieved; suggest sea and water; conducive to mental effort.
Personality	Tend to appeal to conservative people who have a natural predilection for tradition and sentiment; they are generally inwardly integrated and normally older. For introverts and blond types.
Preferences	Preferred by older people and those living in temperate climates.
Presentation	Use where a subduing image is required or as background.
Products	No special associations but light, delicate, colours are preferred for flowers.
Recognition	Poor recognition qualities, except lighter greens.
Reflectance	NSC.
Regional	NSC.
Seasons	Essentially for spring and summer because they are cool and associated with the outdoors.
Sex	Generally, but not always, appeal to females, especially fair-haired.
Shape	Tend to appear blurred and suggest roundness and softness.
Size	Make an object look further away and smaller; surfaces appear to recede.
Smell	NSC.
Stability	Recommended where dignity and restraint are required.
Taste	NSC.
Tradition	NSC.
Visibility	The image tends to be pushed back and decreases in size. Soft colours also tend to be less bright than hard colours, and when seen in combination with them the soft colours will tend to look blurred and less visible.
Warmth	Cool by definition; not inviting to the viewer.

Functions

Camouflage	Tend to hide soiling, especially darker tones.
Coding	May be used because they provide contrast with hard colours or because it is essential that legend should be visible, as in signs or filing systems.
Heat control	NSC.
Insect control	Insects are generally attracted by cool colours.
Light control	NSC.
Pipeline identification	NSC.
Protection from light	NSC.
Readability	Always dominated by hard colours and best as background.
Signalling	NSC.
Visibility of controls	Can be used as background to dials and controls.
Other	NSC.

Applications

Biological	Psychological effects: cool colour dominated subjects tend to have a detached attitude, find it difficult to adapt and express themselves freely; they are cold and reserved; the introverted type.
	Medical effects: pleasing to people with hysterical reactions; decrease blood pressure and, in general, have the reverse effect to warm colours; recommended for manic depressives.
Children	Preferred by older people.
The country	Preferred for interiors concerned with food processing.
Export	Generally preferred in temperate climates but used for interiors in hot climates, including wall coverings.
Exteriors	Soft colours need careful application; they lend themselves to large areas and simple mass. Soft pastels best match the colours of the landscape.
Food	Soft colours tend to retard the appetite and are generally best for background.
Food packaging	Pastels suggest sweetness, and soft colours may be used to suggest sophistication.
Food in the home	Soft colours retard the appetite.
Food processing	Generally preferred in most food-processing applications.
Food service	Recommended for immediate background to food and in the immediate surround. Most food is warm in colour and cooler shades provide a good contrast.
Food stores	Generally recommended for the immediate background to food display and in the immediate surround.

Industrial plant and equipment	Recommended for most surfaces.
Merchandising	Used mainly for background. Can make objects look smaller.
Pattern	Soft colours are not generally suitable for modernistic or geometric designs but are preferred by professional specifiers.
Safety	Soft colours have some safety applications (e.g. for information), but because they are difficult to focus they tend to lead to misjudgements. Best used for background.
Signs	Generally best for ground use, particularly for advertising signs, because they tend to recede, and this emphasises the legend.
Television	Greyish and muted variations are best for background. Blue and green reproduce well, but violet is difficult to fix.
Texture	Look best on shiny surfaces or on a material with a completely smooth texture. Out of place on a brick wall.
VDUs	Recommended for most surfaces in VDU applications.
Woods	NSC.

Domestic interiors

Usage	Cool colours tend to make objects recede and fade into the background; they should be used in a room that gets plenty of sun at the time that the room is most used. They make interiors seem cooler and because they are retiring they cause less distraction and are conducive to mental effort. They have a centripetal effect and direct attention inwards.
Room character	Cool colours have a quieting and relaxing effect, although they can be cold if not relieved in some way.
Room aspect	Cool colours help to cool down a south-facing room and should be avoided in a room with a north or north-east aspect. They can be used in a room which receives a lot of light.
Room size	Cool colours increase room size and make the room look more airy.
Room features	Cool colours tend to make walls recede.
Room function	Cool colours are recommended for much-used rooms because they are soothing and relaxing; they can be recommended for a room in which study takes place and where mental tasks are performed.

Working interiors

In productive areas cool colours should be used:

- if the noise element is high

- if the room is too small; they will make it look larger
- where texture is rough
- where physical exertion generates heat
- where materials being worked are highly coloured
- where conditions are overcrowded
- in areas facing south
- where mental concentration is necessary
- where the environment is warm in nature
- for end walls in some cases; for example, where seeing tasks are critical
- where time exposure is long
- where a restful atmosphere is desirable
- when light sources are warm
- for libraries and drawing offices.

In selling areas, cool colours should be used:

- if merchandise is highly coloured
- to make an area look larger
- for areas having a south or warm aspect
- if the environment is warm in nature
- to create a calming effect, but do not make it too cold
- in sunny regions
- to lend distance; cool colours recede
- for background to a display
- for first-aid rooms.

Uses in consumer applications

No special comments seem to be necessary except that cool colours are often recommended for bedrooms.

Uses in graphical applications

Packaging	Soft colours should generally be used as a background to hard colours; on their own they tend to be a little subduing if not relieved in some way. A soft feature should not be used on a hard background.
Print	Preferred for background in most print applications. Tags: superior as a base colour for tags which contain much information and which must therefore be legible.
Images	Generally used as a background colour in house styles and for symbols. Soft colours tend to fade and look shabby but are suitable in some cases for a conservative, dignified or specialised image.
Vehicle liveries	As for images.

Uses in environmental applications

No special comments seem to be necessary except that cool colours are recommended for offices in a city environment.

Uses in commercial applications

| Office supplies | NSC. |
| Paper and board | Cool colours are sedative and generally best for background. |

Attention is also drawn to the notes in Section 1 of this part.

Uses in surface-covering applications

Attention is drawn to the explanation of colour selection for surface coverings in Section 1 in this part.

2.4 Bright colours

Description

Brightness is a function of light, and the brightest colours are those that reflect the most light. In the present context bright colours are defined as those that reflect more than 50 per cent of light falling on them, but this is purely a rule of thumb; brightness is a relative term. Bright colours may be either hard or soft, warm or cool, and choice of colour for a specific purpose will depend on hue as well as brightness; a strong, clear blue may be brighter than a dusty red, but the red may be preferable in some cases. In many applications brightness differences are more important than hue differences.

Brighter colours have better visibility than dark ones, irrespective of hue, because visibility is dependent on brightness and not on hue. Brightness tends to command attention whether or not the viewer likes the hue, because the eye tends to focus on the brightest object in the field of view or in any combination of hues. For the same reason, great differences of brightness within the field of view can be very trying.

When brightness strikes the retina of the eye it tends to spread out like water on blotting paper, and thus something bright will have a larger image than something dark. In addition, a bright, hard colour will have a larger image than a bright, soft colour because of the effect of hue on the focusing mechanism of the eye. Apparent size is only partly a function of brightness. Apparent weight is also a function of brightness: the brighter the colour, the lighter it seems to be. Brightness tends to accentuate darkness and vice versa; there is good contrast between bright and dark.

Bright colours suggest excitement and awareness for the same reason that people feel more alive and cheerful in sunlight. Brightness tends to accentuate muscular tension and autonomic responses, although the effect is less marked with soft colours than with hard colours. Bright, hard colours tend to stimulate to a greater extent.

Features

Bright colours:

- make objects look larger; brightness spreads out on the retina like water

on blotting paper
- are preferred to deep colours because they afford greater stimulation to the retina of the eye
- are more visible against a neutral background than the reverse
- make an image look nearer to the eye but avoid one dominant colour
- will accentuate dark colours because there is good contrast.

Attributes

Age	Bright colours are preferred by the young.
Appearance	NSC.
Association	Excitement; associated with high musical notes.
Fashion	NSC.
Impulse	Recommended for impulse attraction, other things being equal.
Markets	Generally preferred in mass markets.
Mood	Pale greens and yellows suggest the spring and turn thoughts to new clothes and furnishings.
Personality	Outwardly integrated people prefer sharp contrasts.
Preferences	Bright colours are preferred to dark colours because they afford greater stimulation to the retina of the eye.
Products	For products where brightness is a virtue.
Recognition	Generally have good recognition qualities, but this depends on the hue.
Reflectance	High, by definition.
Regional	NSC.
Seasons	Suggest sunshine and are particularly welcome in spring, but bright, warm colours are warming in winter.
Sex	Appeal to both sexes, but women are more likely to prefer brighter colours than are men of the same age.
Shape	NSC.
Size	Make an object look larger and lighter; surfaces seem nearer.
Smell	NSC.
Stability	Suggest brightness and awareness.
Taste	NSC.
Tradition	Associated with the Georgian period and earlier.
Visibility	Bright colours are more visible against a neutral background than the reverse; they are also more visible than dark colours because the eye tends to focus on brightness.
Warmth	Depends on hue.

Functions

No special comments are necessary except in the following cases:

Coding	Bright colours are generally preferred, but the important factor is contrast between hues.
Heat control	Bright colours reflect away heat.

| Visibility of controls | Recommended for controls and dials. |

Applications

Biological	Psychological effects: stimulate the nervous system and direct attention outwards. Medical effects: generally stimulating effect.
Children	Preferred by children and the young generally.
The country	Only required for accent purposes.
Export	Bright colours are generally preferred in countries with sunny climates because any hue lacking brightness is overwhelmed by the sunlight. For unsophisticated markets and for decoration and accent in temperate climates. Usually preferred for kitchens in sunny climates. Bright colours are generally preferred by races with very dark skins. For exteriors in sunny regions; for interiors in temperate zones.
Exteriors	Strong colours look best in sunnier regions. Vivid colours are demanding and have more attraction than dark colours. Especially recommended for the seaside. Very suitable for awnings and for doors with a dark porch.
Food	Tend to suggest artificiality unless they are the natural colours of food.
Food packaging	Preferred for most food packaging applications because of the display element; they have more emotional appeal.
Food in the home	Bright colours have decorative value but otherwise no special comments are necessary.
Food processing	Colours of high reflectance value are recommended to promote cleanliness.
Food service	Recommended for display and for areas with a fast trade. Plenty of light and colour is welcoming and promotes traffic.
Food stores	Recommended for most food stores; plenty of light and bright colour promotes cleanliness and is welcoming.
Industrial plant and equipment	Not recommended except for highlighting; medium tones are preferred.
Merchandising	Bright colours are best for display, but not for background.
Pattern	Not suitable for 'pretty' patterns but recommended for large flowing patterns. Go with regimented design.
Safety	Bright colours are generally desirable for safety applications, but use depends on hue. Avoid mixtures of primaries.
Signs	Pure hues having a good reflectance value are recommended for most signs and should be strong enough to provide good contrast with legend.

Television	Very pale tints are often indistinct but may be emphasised by surrounding them with stronger colours.
Texture	Happiest with less-textured surfaces.
VDUs	Colour of medium tone is preferred.
Woods	Clear, strong, colours go with beech.

Domestic interiors

Usage	Brightness stimulates darkness but the meaningless use of bright colours may cause accidents because they are distracting. They tend to reflect heat and may keep an interior cool where appropriate, but they may also create an impression of warmth depending on the hue selected. Although one wall in small rooms may be painted in bright colours, they should normally be used in small doses or they may become overpowering. Bright colours look a good deal more intense on a wall than they do in a sample, and on a highly reflective wall they may bounce back and forth in a most disturbing way.
Room character	Bright colours set against a neutral background create a cheerful setting; they produce a stimulating effect and will brighten up a large dark room. Bright colours on the wall are good for morale.
Room aspect	Bright colours are recommended for a north-facing room and will look even brighter in a south-facing room. They cheer up the north-facing room and those with little natural light.
Room size	Make a room larger or the ceiling higher.
Room features	Bright colours on a feature wall will attract the eye. A wall painted in bright colours will seem to advance.
Room function	Bright primaries are recommended for a family dining room, and they are suggested in a room where there is consistent television viewing.

Working interiors

No special comments seem to be necessary.

Uses in consumer applications

No special comments seem to be necessary except that bright colours are recommended for the bedrooms of newly weds.

Uses in graphical applications

| Packaging | Bright colours make a package look larger and nearer to the eye. Young people like large areas of bright colours such as red, yellow and strong blue. Bright colours are preferred in most packaging applications because they have greater impact on the eye, but too much bright |

	colour can be overpowering. As a general rule use brightness against darkness.
Print	Bright colours are preferred for accent purposes and re-commended where it is desired to attract attention, but too much may be overpowering.
	Tags: bright colours are recommended.
Images	Generally preferred for image purposes, at least for the features of a design, because they attract attention. Convey a modern or efficient image.
Vehicle liveries	As for images.

Uses in environmental applications

No special comments seem to be necessary except that clear colours are gener-ally preferred in selling environments.

Uses in commercial applications

Office supplies	NSC.
Paper and board	NSC.

Attention is also drawn to the notes in Section 1 of this part.

Uses in surface-covering applications

Attention is drawn to the explanation of colour selection for surface coverings in Section 1 of this part.

2.5 Muted colours

Description

Muted colours include shades which are hues mixed with black, and tones which are hues mixed with grey, but the term is usually used to describe greyed variations of basic colours. They may be light, medium or dark in character, depending on the amount of admixture, but because they are subdued in nature they are the antithesis of bright colours.

Muted colours reflect less light than pastels or pure colours and, therefore, tend to decrease the size of an object and make it look heavier in weight, irres-pective of basic hue. Muted colours tend to be subduing, and darker variations can be depressing and should be avoided when it is desired to attract attention. They tend to be preferred by older people, are restrained and, in some cases, convey a high-class image. A large proportion of grey in the mixture makes for the most passive and subdued of all colours.

Features

Muted colours make objects look smaller.

Attributes

Age	Tend to be preferred by older people.
Appearance	NSC.
Associations	NSC.
Fashion	Muted colours have more appeal in high-fashion markets.
Impulse	Little impact; not recommended.
Markets	Generally preferred in sophisticated markets.
Mood	Can create a mood of luxury but are generally passive and subduing.
Personality	For inwardly integrated people and conservatives.
Preferences	No special preferences.
Presentation	May be used where dignity and restraint are required.
Products	NSC.
Recognition	Poor recognition qualities.
Reflectance	Usually have a low reflectance value.
Regional	NSC.
Seasons	Tend to be subduing and cooling; spring and summer.
Sex	NSC.
Shape	Tend to appear blurred and suggest roundness and softness.
Size	Decrease the size of objects and make them look heavier in weight; surfaces recede.
Smell	NSC.
Stability	Restrained in nature; suggest dignity.
Taste	NSC.
Tradition	Associated with later Georgian and early Victorian eras.
Visibility	As for soft colours.
Warmth	NSC.

Functions

Camouflage	Can be recommended to hide soiling.
Coding	Not recommended.
Heat control	Use depends on reflectance value.
Visibility of controls	Not recommended.

No special comment is necessary under the other subheadings.

Applications

No special comment is necessary under any sub heading except:

Television	Greyish tints and muted hues generally should be used for background; background colours are unlikely to appear visually vivid.

Domestic interiors

Greyed colours will bring down the ceiling of a lofty room but otherwise no special comments are called for.

Working interiors

No comments are called for.

Uses in consumer applications

No special comments are called for.

Use in graphical applications

Packaging	May be used to convey fashion or subtlety but they do not have maximum impact.
Print	As for packaging; muted hues are liked by people of higher education and older people.
Images	As for packaging; can be recommended for conservative images.
Vehicle liveries	As for packaging.

Uses in environmental applications

Muted hues may be used for decorative purposes in selling environments, but in other cases usage depends on the hue.

Uses in commercial applications

Office supplies	Use depends on hue.
Paper and board	NSC.

Uses in surface-covering applications

Attention is drawn to the explanation of colour selection for surface coverings in Section 1 of this part.

2.6 Light colours

Description

Light colours, in the present context, are defined as those colours having a reflectance value of more than 50 per cent and in practice may be either pure hues or tints, which are an admixture of pure hue and white (see also Pastels, 2.13 below). The definition also covers pale colours, a term which is used broadly but which most often means tints. Light colours are similar, in many ways, to bright colours, but bright colours will generally have a greater strength of hue. Light colours are psychologically more pleasing than dark colours, and their high reflectance value improves the lighting in any area. They stimulate to a greater degree than dark colours because of their greater brightness.

Lighting

Pale colours at low light levels are passive.

Attributes

Age	Preferred by the young so long as they are bright; the young are less interested in pastels.
Appearance	NSC.
Associations	Cheerful associations.
Fashion	NSC.
Impulse	Good impulse attraction, but depends on hue.
Markets	Preferred in mass markets.
Mood	Help to direct attention outwards.
Personality	Generally for outwardly integrated people.
Preferences	Preferred to dark colours because of their greater brightness.
Presentation	Recommended where impact is required.
Products	NSC.
Reflectance	Qualities depend on hue.
Regional	NSC.
Seasons	Essentially for the spring.
Sex	Pale shades are considered feminine.
Shape	NSC.
Size	Make an area more spacious; make an object look lighter in weight and increase its size. Effect on surfaces depends on contrast.
Smell	NSC.
Stability	Associated with excitement rather than restraint.
Taste	Generally suggest a milder and more delicate taste.
Tradition	NSC.
Visibility	As for bright colours.
Warmth	NSC.

Functions

Coding	May be used if there is adequate contrast.
Heat control	Reflect heat; recommended.
Visibility of controls and dials	Recommended.

No special comments are necessary under the other subheadings.

Applications

Children	Preferred by children and the young generally so long as they are bright.
The country	Best for most applications in this category.
Exteriors	Best suited to upper reaches of high buildings. Recommended for doors with a dark porch.

| Merchandising | Can make objects look lighter in weight. |
| Television | Colour differences will be fairly well maintained, although tints are likely to appear filmy in quality. Very pale tints are likely to appear indistinct. Pale colours may be emphasised by surrounding them with medium or deep colours. |

No comments are necessary under the other subheadings.

Domestic interiors

Usage	A light colour placed next to a dark colour seems lighter, and light colours may look insipid without accents. Pale colours help to avoid an overcrowded feeling in a dual-purpose room. Light colours reflect a good deal of light and reduced levels of illumination may be desirable; they need special care when chosen from a paint chip. Pale colours show soiling more easily, especially on floors.
Room character	NSC.
Room aspect	Light colours are recommended for dark rooms; yellow is especially recommended for rooms which have little natural light.
Room size	Light, cool colours on the walls and ceiling of a small room will make it appear larger. Light colours tend to recede and to diffuse light; they increase room size and lend distance.
Room features	Light colours reflect more light from ceilings and make them seem higher; used below the dado they will reduce emphasis on the upper part of the wall. Light tones on longer walls will make a room better proportioned. Used for overall decoration they will make angles less noticeable and create a more unified appearance. Light colours on end walls will make them recede. Pale colours on the floor show soiling more easily.
Room function	Pale colours are not recommended for halls and staircases unless plenty of light is required, but light colours can be recommended for bedrooms.
Room users	Very pale colours are not suitable for children.

Working interiors

No special comments are necessary; use depends on reflectance value.

Uses in consumer applications

No special comments are necessary. See Domestic interiors above.

Uses in graphical applications

| Packaging | Light variations may be used for features where circum- |

stances dictate. Pale colours look light in weight. They suggest sugar confectionery.

Print	Light colours suggest brightness, airiness, nimbleness, but in most print applications are best used as a base (background) colour.
Images	As for print; indicate friendly, efficient, feminine images.
Vehicle liveries	As for packaging and print; they associate well with flowers and can be recommended for:

- liveries associated with food
- vehicles operating in warm territories
- upper bodies of large vehicles
- heat control of refrigerated vehicles and tankers.

Uses in environmental applications

Catering	Light colours are generally used for walls.
Factories	Light colours are generally used for walls.
Offices	Light colours on an office floor make the area look larger, but light colours are generally used for walls.
Retail	Best for walls.
Schools	Best for walls.
Hospitals	Best for walls.

Uses in commercial applications

Office supplies	Not generally used.
Paper and board	NSC.

Attention is also drawn to the notes in Section 1 of this part.

Uses in surface covering applications

Attention is drawn to the explanation of colour selection for surface coverings in Section 1.

2.7 Medium colours

Description

Medium colours, for the present purposes, are those having a reflectance value of between 25 and 50 per cent, and this covers the great majority of the practical uses of colour. Medium colours are the work horses of the spectrum and do not have the advantages of light colours, nor the disadvantages of dark colours.

Attributes

No special comments are necessary under this heading because in most cases the effect depends on the hue rather than on the fact that the colour is a medium one.

Functions

No special comments are necessary. Effect depends on hue.

Applications

No special comment is necessary, except in the following cases:

The country	Medium colours may be used for walls instead of light colours.
Food	Medium colours are generally best for most foodstuffs.
Television	Medium tones reproduce satisfactorily, whether pure or muted, and they show up best of all after pure hues. Medium and grey tones are, perhaps, the safest of all for use on television and are preferred in most circumstances because they help to avoid glare.
VDUs	Medium colours are preferred for VDU applications.

Domestic interiors

No special comments are called for.

Uses in consumer applications

No special comments are called for.

Uses in graphical applications

Packaging	Feature colours should generally be of medium tone and be accentuated by a background having a higher reflectance value.
Print	As for packaging.
Images	Best used for the features of a design with lighter tones as a background. For modern, conservative, friendly, efficient, sophisticated, masculine or feminine images.
Vehicle liveries	As for images.

Uses in environmental applications

In all cases medium colours may be used for walls, end walls, floors, furniture and equipment.

Uses in commercial applications

Office supplies	Most suitable for office use.
Paper and board	NSC.

Attention is also drawn to the notes in section 1 of this part.

Uses in surface-covering applications

Attention is drawn to the explanation of colour selection for surface coverings in section 1 of this part.

2.8 Dark colours

Description

In the present context dark colours are defined as those having a reflectance value of less than 25 per cent, and this accounts for a very large proportion of all colours used in practice. They may be hard or soft, warm or cool, and they have the reverse effect to bright, or light, colours and tend to lose some of their identity in dim light and to merge into greyness.

Dark colours have less visibility than light colours and they do not spread out on the retina in the way that brighter colours do, consequently objects in dark colours tend to look smaller and heavier. Dark colours, by reason of their low reflectance value, tend to absorb light and heat. Thus a dark-coloured object would keep its contents warmer than a light object. A room full of dark objects requires a much higher level of illumination to ensure comfortable seeing.

Dark colours have least visibility in dim lighting when the eye is dark-adapted, and in those circumstances they tend to melt together and resemble each other; they tend to have uniform brightness. They tend to be subduing because the human body reacts to brightness and does not react when brightness is absent. Dark colours can be used to impart a sense of weight and stability, both in interior decoration and in the colouring of objects. They require plenty of light to be seen clearly.

Features

Dark colours:

- tend to resemble each other at low light levels
- are stimulated by light colours
- look heavy
- are accentuated by brightness; the reverse also holds true.

Attributes

Age	Generally preferred by older people, but they are sometimes in fashion and influence the young.
Appearance	NSC.
Associations	Subduing; associated with deep musical notes.
Fashion	NSC.
Impulse	Little impulse value and little attraction.
Markets	Mainly for higher-grade markets.
Mood	Tend to create a sombre, serious mood.
Personality	NSC.
Preferences	Are less liked than bright colours.
Presentation	Can be used where dignity is required.
Products	May infer heaviness or strong flavour.
Recognition	Not easy to recognise or to remember.
Reflectance	Low reflectance value by definition.
Regional	NSC.

Seasons	Associated with summer and autumn but too dark colours may be too sombre.
Sex	Generally appeal to men rather than to women.
Shape	NSC.
Size	Make an object look smaller and heavier; effect on surfaces depends on hue.
Smell	NSC.
Stability	Suggest stability and weight.
Taste	Suggest a strong or even harsh taste.
Tradition	Associated with the Victorian era.
Visibility	Least visibility; tend to merge into greyness in dim light.
Warmth	Depends on hue.

Functions

No special comments are called for except in the following cases:

Camouflage	Can be recommended to hide soiling but not where safety is concerned.
Coding	Will provide contrast in appropriate cases.
Heat control	Absorb heat.
Visibility of controls	Not recommended for controls but may be used as contrast for dials and gauges.

Applications

Biological	Little significance.
Children	Sometimes a fashion influence on the young but generally preferred by older people.
The country	NSC.
Export	For exteriors in cool climates, interiors in hot climates. If used for packaging they will not be seen in a dark shop in a bazaar. No racial significance.
Exteriors	Dark tones are preferable in metropolitan areas and show less dirt in town conditions. A dark colour with white wood can be recommended where traffic fumes are bad. Weather better than lighter colours. Dark walls with white plasterwork are dignified. Especially recommended for doors of red-brick houses and with weatherboarding or shingles.
Food	For any foodstuff having a naturally dark colour and may also be used to suggest strong flavour.
Food packaging	Not recommended except to suggest strong flavour or stability and weight.
Food in the home	Best avoided.
Food processing	Few applications.
Food service	NSC.
Food stores	Few applications except for small areas for accent purposes.

Industrial plant and equipment	For bases and plinths only; also for safety purposes where appropriate.
Merchandising	Mainly to provide contrast; can make objects look heavier; may be used as background in some cases.
Pattern	Goes well with regimented design.
Safety	Best avoided in safety applications.
Signs	Not generally recommended except for legend against a light ground; dark colours used for ground tend to merge into black or grey.
Television	Highly saturated colours tend to look black and small colour differences in dark shades may be lost. All very dark surfaces look the same and should have a dull finish. Dark colours can be made darker by surrounding them with medium deep colours. Deep shades such as maroon, dark brown, olive and navy blue are difficult to use satisfactorily, and objects in these colours may not appear structural; it is difficult to register subtle differences.
Texture	Dark colours go well with strong texture.
VDUs	Small areas for accent only.
Woods	NSC.

Domestic interiors (see also deep colours)

Usage	Dark ceilings with pale walls can make a room look intimate; can be used in an open-plan room with large windows but are not recommended for very small rooms, although a sunny room can take any colours. Useful as a means of providing contrast.
Usage	Darker colours placed next to light colours appear deeper. Dark colours in a matt finish tend to absorb light and heat.
Room character	Dark colours make a room look more intimate; they bring the walls forward.
Room aspect	Dark, warm colours can look exciting in a north-facing room or in a cold room.
Room size	Dark colours on floors and ceiling, with neutral walls, make a room seem longer and wider, and dark colours on the walls and ceiling, down to dado height, will make a lofty room seem cosier. Dark colours tend to make a room seem smaller and absorb light, but warm, dark colours can improve a small room.
Room features	Dark wall colours will have little significance. Dark ceilings make some people feel uncomfortable, and a really dark ceiling will 'disappear' optically. Dark colours on a short end wall will make a room seem better proportioned. Dark side walls will make a room seem narrower, dark floors will increase visual height, and

| | dark colours on the ceiling will lower it. Dark walls are a good background for pictures or for framing light-coloured or pine furniture. |
| Room function | Dark, rich colours are inviting in a dining room. |

Working interiors

Avoid dark colours, they absorb too much light and are depressing; they show dirt as readily as any other colour. Dark-coloured selling areas are depressing.

Uses in consumer applications

No special comments are necessary; see Domestic interiors above.

Uses in graphical applications

Packaging	Not usually recommended except in small areas, perhaps to give stability or for contrast or foil. Look heavier in weight.
Print	Use dark colours for print, as distinct from background, especially where maximum contrast is required. May be used in small areas for contrast purposes or as foil. Tags: use only for print.
Images	Best not used as a background to a design but may be used in house colour combinations where maximum contrast is desired. Suggest stability and weight and might be used to convey a dignified image, although dark colours lack impact. Might also be used to suggest a masculine image.
Vehicle liveries	As for images and also recommended:

- where soiling is a problem
- for wheels and lower portions of large vehicles; this creates an appearance of stability for the vehicle and is practical because the lower part is subject to more soiling.

Uses in environmental applications

In most environmental applications use dark colours only for floors and for accent purposes. Dark-coloured selling areas are depressing.

Uses in commercial applications

No special comment is necessary; attention is drawn to the notes in section 1 of this part.

Uses in surface-covering applications

Attention is drawn to the explanation of colour selection for surface coverings in section 1 of this part.

2.9 Pure colours

Description

Strictly speaking pure colours are the central portion of each waveband of the primary colours, which are violet, blue, green, yellow, orange and red, but in practice the term also covers mixtures of primary colours, such as purple, blue-green, yellow-green and so on. The distinguishing feature of pure colours is that they do not have any admixture of black, white or grey and consequently they have maximum strength or saturation.

In general terms, pure colours stimulate the eye to a greater extent than colours with an admixture of grey or black but not necessarily those with an admixture of white. It is also true to say that pure primary colours have more impact than mixtures of primary colours. Pure colours should be vivid and intense to secure maximum acceptance and should not be indefinite. Pure colours with a touch of black or white are not liked; it would be better to turn them into precise tints or shades.

Features

Pure colours:

- have more appeal than muted hues; they stimulate the retina to a greater extent
- look light in weight
- harmonise with tints and white
- harmonise with tones and greys
- harmonise with black and white
- harmonise with the tint of their complement
- harmonise with tones on a grey background
- harmonise with tints on a white background.

Attributes

No special comments are necessary except in the following cases:

Impulse	Attract more attention than modified colours.
Preferences	Most people prefer pure colours to greyish ones because the brain responds more readily to simple colours.
Presentation	Pure colours are preferred, except where a specialised image is required.

Functions

No special comments are required.

Applications

Comments are only required in the following cases:

Export	Pure colours are preferred in sunny climates.
Merchandising	Pure colours are best used when it is desired to attract

attention; they have maximum impact against a grey background.

Safety	Pure colours are best for safety purposes; avoid modified hues.
Signs	Pure hues having good reflectance values are recommended.
Television	Pure colours show up better than modified colours, with the exception of yellow. Variations of red, blue and green, which are the television phosphers, reproduce very well, although reds tend to have an orange cast and greens tend to go yellowish, although some greens take on a turquoise tinge. Sharp distinctions of tone or shade may be difficult to obtain. Combinations of red and green, or blue and green, are likely to be difficult to obtain.

Domestic interiors

Usage	Primaries should be used boldly and are best used as accents; mixed together they create a dramatic effect.
Room character	Primary colours, angular shapes and abstract designs combine to make the most practical situation cheerful.
Room aspect	NSC.
Room size	Best used in large rooms, but small areas of pure colours can be used in smaller rooms.
Room users	Primaries are recommended for children; they find them most attractive and are most responsive to them.

Working interiors

No special comments are necessary.

Uses in consumer applications

No special comments are necessary.

Uses in graphical applications

Packaging	Pure colours are best when direct impact is desired and medium tones are recommended for features.
Print	As for packaging; preferred by the young.
Images	Recommended where it is desired to establish a strong image; pure hues of medium tone are recommended because they have maximum impact.
Vehicle liveries	As for images; the simplest forms of colour are usually best.

Uses in environmental applications

No special comments are necessary except that pure colours are preferred in most selling environments.

Uses in commercial applications

No special comments necessary, and attention is drawn to the notes in section 1 of this part.

Uses in surface-covering applications

Attention is drawn to the notes in section 1 of this part.

2.10 Modified colours

Description

Modified colours are those that are mixtures of primary colours which do not lie next to each other on the colour circle and, more specifically, mixtures of hard and soft colours or those that have an element of grey. Typical examples are mustard, Wedgwood blue, chartreuse. A distinction should be drawn between modified colours and intermediates, the latter being mixtures of pure colours which are next to each other on the colour circles, such as blue-green and red-orange. These do not suffer from the same disadvantages as modified colours.

Modified colours are not clearly perceived by the eye and therefore they are not easily noticed, nor are they so easily remembered; they do not have the impact of pure hues, particularly in strong sunlight. Many of the remarks made above about muted colours apply equally to modified hues; they are not as well liked as pure colours and may be depressing. They can have a high-fashion implication and in certain cases can add sophistication. Modified colours acquire the attributes of the dominant primary hue, but they generally lack brightness and recognition value. It is difficult to generalise because there are so many alternatives; beige, for example, is not a standard colour, and although it has reasonably good visibility, it lacks the punch of primary hues and can easily be 'lost'.

Attributes

No special comments are necessary except in the following cases:

Impulse	Little impact; not recommended.
Markets	For sophisticated and fashion markets.
Mood	Often have a strong emotional appeal.
Preferences	Not generally well liked.
Presentation	Not recommended.
Visibility	Effect depends on hues.

Functions

No special comments are necessary.

Applications

No special comments are necessary.

Domestic interiors

No special comments are called for; some designers favour muddy colours because they are supposed to be easier to work with.

Working interiors

No special comments are called for.

Uses in consumer applications

No special comments are called for.

Uses in graphical applications

Packaging	May be used where something subtle is required, but they do not have maximum impact.
Print	As for packaging.
Images	As for packaging.
Vehicle liveries	As for packaging.

Uses in environmental applications

No special comment is called for.

Uses in commercial applications

Office supplies	Modified colours have few applications in the office and most are best avoided.
Paper and board	NSC.

Attention is also drawn to the notes in section 1 in this part.

Uses in surface-covering applications

Attention is drawn to the notes in section 1 in this part.

2.11 Neutrals

Description

Neutrals are difficult to define exactly, but the term generally means paler shades such as grey, off-white and beige, which will harmonise with all other colours and which will not modify stronger colours when associated with them, except by contrast. They are particularly significant in interior decoration. A grey tint with a reflectance value of about 30 per cent is an ideal neutral, it is non-distracting and holds the balance between black and white; fawn is also good. By definition, neutrals are usually fairly bright and take on some of the attributes of bright colours. Pink adds impact to neutrals.

Features

Neutrals:

- create a spacious effect, especially in a small room
- do not tire the eye, but they need lighting
- provide a useful background where high visibility is required
- cause a surface to look larger or more distant
- create a mood of dignity and safety
- are easy to use and always look smart
- are often described as enigmatic
- are best used as background.

Attributes

No special comment is necessary except in the following cases:

Impulse	Some neutrals have impulse attraction.
Mood	Create a mood of dignity and safety; often described as enigmatic.
Presentation	Lack impact in this context.
Recognition	Poor recognition qualities.
Sex	More feminine than male in appeal.
Size	Create a spacious effect; cause surfaces to look larger or more distant; make an object look larger and lighter in weight. Grey is a far element.
Visibility	Effect depends on hue.

Functions

Comment is only required in the following cases:

Coding	Only to be used if there is adequate contrast.
Visibility of controls	Not recommended.

Applications

Comment is only required in the following cases:

Exteriors	Neutrals are recommended for a narrow house and for a well-proportioned house. Use if the house next door is brightly coloured.
Texture	Neutrals go well with texture; they are specifically recommended.
Woods	Neutrals generally go with teak, dark oak, tola, afrormosia.

Domestic interiors

Usage	Neutrals without sharp contrast but with texture and pattern will make a room less claustrophobic; they can

be accentuated by one contrasting colour and can be used with brilliant accents. They will offset a more definite colour so long as it is bright. Neutrals can be used as background to colours of high intensity, and when used as a basis for a room they permit more frequent changes of decor. A neutral colour is always obliging; a grey can be made to look either green or blue and will often take colour from its immediate neighbour, especially if the neutral surface is shiny. A neutral room can seem so diffused with light that the walls lose their solidity, but they can also be heavy and confining. Gradations of one neutral can be interesting but can also be boring if not relieved; playing one neutral against another can have interesting effects. In any room decorated with neutrals, texture is of vital importance; neutrals go well with texture. Neutrals will simplify a colour scheme and are recommended for a narrow house.

Room character
Neutrals are enigmatic, and together with rounded shapes they create a quiet, gentle decor and a relaxed atmosphere that is easy to live with.

Room aspect
Neutrals can be used, with brilliant accents, in a room which has little natural light.

Room size
Neutrals create a spacious effect, especially in a small room.

Room features
Neutrals can be used to disguise a badly shaped room and will act as a foil to a bright feature wall. Neutral carpets and floor coverings tend to reflect the darker colours in a room. Recommended for long side walls when combined with deeper colours on end walls. Neutrals form an excellent setting for pictures and possessions.

Working interiors

No special comments are necessary except that neutrals may be used for upper walls and for floors.

Uses in consumer applications

No special comments are necessary except:

Bedroom products The restfulness of neutrals can be a major point in their favour in bedrooms.

Uses in graphical applications

No comments necessary.

Uses in environmental applications

No comments are necessary except the following:

Factories	Neutrals are recommended for lockers, storage cabinets and so on in drawing offices.
Retail	Neutrals may be used for upper walls and for floors.

Uses in commercial applications

No comments necessary; see notes in section 1 of this part.

Uses in surface covering applications

See notes in section 1 of this part.

2.12 Strong colours

Description

An imprecise term which generally means colours of good chroma and value which have good impact; the opposite of neutrals. No special comments are called except in relation to domestic interiors.

Domestic interiors

Usage	Strong colours should generally be confined to small areas and look best when surrounded by large areas of shades, tints or tones.
Room size	Strong colours are suitable for large rooms and if used on the ceiling will raise it. Strong colours on end walls are recommended in long, narrow rooms.

2.13 Pastels

Description

Pastels are hues mixed with a large proportion of white and are therefore bright and possessed of many of the attributes of bright colours. Strictly speaking they are tints but normally have a larger admixture of white than a conventional tint, and some pastels are akin to off whites or tinted whites. Pastels are frequently described as 'candy colours', and the term is used for mixed pastels. Because pastels are bright they make an object look lighter in weight and larger than tones or shades of the same basic hue; they reflect back heat and light and lend distance. Pastels are soft, romantic and easy to live with, and they are generally preferred to shades because of their brightness. Pastel tints of cool colours are warmer than a pure version of the same hue, while pastel tints of warm colours are restful without being cold. They need to be seen in a large area to be appreciated and are particularly deceptive when seen on a colour card.

Attributes

Age	Young people are less interested than older people.

Appearance	NSC.
Associations	Suggest sugar confectionery, cosmetics.
Fashion	NSC.
Impulse	Have little impact.
Markets	NSC.
Mood	Soft, romantic, easy to live with, but too many pastels may cause people to become silent and withdrawn.
Personality	NSC.
Preferences	Preferred to darker colours.
Presentation	NSC.
Products	Particularly associated with flowers and cosmetics.
Recognition	Poor recognition qualities.
Reflectance	Have a high reflectance value, by definition.
Regional	NSC.
Seasons	Spring and summer.
Sex	Essentially feminine in appeal.
Shape	NSC.
Size	Make objects look lighter in weight and larger than tones or shades of the same hue, which are deeper.
Smell	Associated with the smell of flowers.
Stability	NSC.
Taste	Suggest a milder and more delicate flavour.
Tradition	NSC.
Visibility	NSC.
Warmth	Pastel tints of warm colours are restful without being cold; pastel tints of cool colours are warmer than a pure version of the same basic hue.

Functions

No special comments are necessary except that pastels reflect back both heat and light.

Applications

Comments are only required in the following cases:

Children	Not interested in pastels.
The country	Pastels are particularly recommended.
Export	Not suitable for sunny climates; they are 'lost' in strong sunlight. Pastels are acceptable to Europeans and North Americans but not generally elsewhere.
Exterior	Can fade into uncertainty on a town house. Soft pastels best match the colours of the landscape.
Food	Suggest sweetness, and 'candy colours' are commonly used for sugar confectionery.
Television	Often indistinct on television but can be emphasised by surrounding them with medium or dark colours.
Texture	Happiest on smooth or less-textured surfaces.

Domestic interiors

Usage	Pastels need to be seen in a large area to be fully appreci-ated; they lend distance. Pastel walls with a dark ceiling make a room look intimate; they are out of place in a brick-walled room and with some other natural mat-erials. Pastels tend to intensify over a large area; select tints that are half as bright as the effect wanted. Pastels can create distinctive modern settings which are easy to live with; think of them as blocks of colour that can be blended with each other or mixed with small amounts of primaries. They look well with neutral shades such as grey or cream. Pastels show soiling easily.
Room character	Pastels and rounded shapes create a quiet, gentle decor and a relaxed atmosphere that is easy to live with, but too many pastels should be avoided. They can look in-sipid or be stimulating.
Room aspect	Pastels can be used in any room, but warm pastels are best in a north-facing room.
Room size	Pastels are recommended in a small room; they increase room size and are warmer than cool colours; they in-crease ceiling height.
Room features	Pastels on the floor show soiling easily.
Room functions	Pastels should generally be avoided in places where people work and concentrate because they are apt to lead to emotional monotony. Candy colours are recom-mended for bedrooms and pastels provide soothing charm in dining rooms. Not recommended for halls or staircases unless plenty of light is required.

Working interiors

No comment is required.

Uses in consumer applications

No comment is required.

Uses in graphical applications

Packaging	Pastels appeal to young people less than to older people. They suggest sweetness and are suitable for confection-ery.
Print	Pastels can be recommended as a base for cosmetic or toiletry applications.
	Tags: subtle pastels are recommended for tags associ-ated with cosmetics or for high-fashion applications.
Images	Best as background rather than as features of a design.
Vehicle liveries	As for light colours.

Uses in environmental applications

No special comment is necessary except that they can be recommended for upper walls in selling environments.

Uses in commercial applications

No special comment necessary; see also notes in section 1 of this part.

Uses in surface-covering applications

See notes in Section 1 of this part.

2.14 Deep colours

Description

Deep colours are those having maximum saturation, and in many ways they are similar to dark colours; they include shades like maroon, the darker browns and similar.

Attributes

No comment is necessary except in the following cases:

Mood	Create a stimulating effect.
Warmth	Deep colours make a room seem warmer.

Functions

No comment is necessary.

Applications

No comment is necessary except in the following cases:

Food service	May be used for accent purposes and for the overall surround in more intimate establishments.
Television	Deep shades such as maroon, brown or olive may be difficult to see.

Domestic interiors

Usage	Deep colours can be stimulating but should be used in small areas; too much may be overpowering and they absorb a great deal of light. May be used as accents.
Room character	Deep colours make a room look more intimate, they bring the walls forward and give an illusion of warmth.
Room aspect	Deep colours create a warming and exciting look in a north facing room.
Room size	Deep colours will bring down a high ceiling.

Working interiors

Deep colours may be used for accent purposes, but if so, they should be restricted to walls not faced by workers. They may cause details to become a source of glare. They should be restricted to small areas.

Uses

No special comments are necessary in any application.

2.15 Natural colours

These are the colours of natural materials such as brick, stone, parchment, straw and so forth. They have many uses in interior decoration and are easy to live with because they are natural. At times there are trends in favour of natural materials, and their colours are copied onto fabrics and other objects.

No special colour analysis is required except to comment that natural colours create a calm background, especially when used on the floor.

3 Violet group

Light	Blue type	Lilac
	Red type	Heather
Medium	Blue type	Mauve
	Red type	–
Dark	Blue type	Purple
	Red type	–

3.1 Character

Violets are high-fashion colours, but as trend colours they usually have a short-lived reign. They are cool, soft colours, not inviting to the viewer; restful. Modify other colours and mix best with blue, but violets are difficult for the eye to focus and may be blurred when seen in combinations with other hues. A violet tone is more distant and atmospheric than any other colour; it is soft, filmy and never angular and tends to 'cling to the earth'. Violets are not abundant in nature and cause conflicting emotions because they are a mixture (of red and blue) and are usually either positively liked or disliked. Strong violet looks dull under incandescent light but not in daylight; African violet looks beautiful in daylight. Should not be used as an illuminant or for lampshades.

3.2 Attributes

Age	Appeals to the young only in a fashion sense; they will go for strong purples when these are in vogue but usually for short periods only. Older people will seldom be attracted by purple but are attracted by lilacs and mauves.
Appearance	All shades are generally unflattering to human appearance and to be avoided in all circumstances where colour may be reflected on to humans, especially the darker variations.
Associations	High fashion, excellence, chocolates, florists, cosmetics;

purple with royalty, lilac with fashion. Purple signifies high rank when used in Eastern carpets.

Fashion	A high-fashion colour. Purple often has short-lived popularity.
Impulse	Little value from an attraction standpoint.
Markets	No special virtue for any markets except high-fashion markets.
Mood	Evokes conflicting emotions; indicates a depth of feeling, sensuality, richness. Purple is enigmatic and dramatic; royal purple creates an influential atmosphere.
Personality	People who like purple are artistic, temperamental, aloof, introspective, creative by nature; those who dislike it are critical, lacking in self-confidence. People who like lavender are quick-witted, individualistic, vain, refined.
Preferences	Choice 8 for children, 6 for adults.
Presentation	Not generally recommended except for high-fashion presentations.
Products	Cosmetics, fashion, florists; mauve is particularly good for the latter. Avoid purple for coffee and kitchen products.
Recognition	Poor recognition qualities.
Reflectance	Depends on variation; a typical purple is 20 per cent.
Regional	NSC.
Seasons	Summer; paler versions such as lilac may be used in the spring.
Sex	Most variations have feminine appeal.
Shape	Suggests the form of an oval.
Size	Makes an image smaller and surfaces look further away.
Smell	Typical colours with an associated distinctive smell are lilac, violet, lavender; the latter has pleasant associations, and purple conjures up rich, exotic odours.
Stability	Restrained colour; purple suggests influence.
Taste	Associated with confectionery and other sweet things but not with sugar confectionery.
Tradition	Particularly associated with the Victorian era; also, of course, with royalty.
Visibility	Difficult for the eye to focus and to recognise; makes objects smaller than they actually are. Best used for background.
Warmth	Soft colour, cool, not inviting to the viewer.

3.3 Functions

Camouflage	NSC.
Coding	Not generally recommended, only to be used where a large range of colours is required. Difficult to distinguish from blue.

Heat control	NSC.
Insect control	Peach moths are responsive to violet, and silkworms are active in violet light. It has been found that 14 per cent of beetles react to violet, and bees are sensitive to it.
Pipeline identification	To mark acids and alkalis.
Protection from light	Does not exclude harmful effects of light and promotes rancidity in food.
Readability	White on purple, purple on white, purple on yellow have good qualities.
Signalling	Not suitable for signalling because it is not easily recognised and focused.
Visibility of controls	Use is not recommended in this context because the colour is difficult to focus and has poor recognition qualities.
Other	NSC.

3.4 Applications

Biological	Very little significance in either psychological or medical effects.
Children	Appeals to teenagers and the young only in a fashion sense.
The country	NSC.
Export	Pale colours like lilac may be used for interiors in a sunny climate. Never use in Japan; it is a royal colour.
Exteriors	General For the charmer. Weathers very quickly.
	Doors Purple may be used in some instances.
	Windows Not generally recommended, but lilac might be used on a period house.
	Walls Not generally recommended.
Food	The natural colour of grapes and grape juice; retards digestion. Should generally be avoided in association with food, although mauve and lilac may be used for some sweet things because they are traditional; consider crystallised violets. Choose warmer variations. Purple might be used for grape juice but not for mashed potatoes.
Food packaging	Not generally recommended, but paler shades might be used for some bakery products and confectionery. Do not use for coffee. Cadbury's purple is an exception to most rules.
Food in the home	Avoid in association with food, particularly darker variations. Might have a decorative function for food containers but is not recommended for tableware.
Food processing	All variations should be avoided.
Food service	Not recommended; not well liked and does not associate well with food. Avoid in display.
Food stores	Not generally recommended but might be used for the interior of confectionery shops of the higher class.

Industrial plant and equipment	Colours in this group are not suitable and are not recommended. Purple is sometimes used to indicate radiation hazards, but this practice is not universally accepted.
Merchandising	Seldom used for display purposes because it has little impact, poor recognition qualities and is difficult for the eye to focus, but purple is sometimes used as a background for high-quality products because of its associations. Essentially a background colour with a fashion note, to be used when it has an appropriate association with the product or sales theme.
Pattern	NSC.
Safety	Purple is used in some countries to indicate radiation hazards on doors, door frames leading to hazardous areas, controls, charts, labels and so on.
Signs	Purple is sometimes used as a background to signs where variety is required or because of its associations, but it lacks impact and has poor recognition qualities. Purple on yellow has good visibility and good legibility, but it is not widely liked. Used in hospitals to signpost mortuaries and chapels.
Television	Purple and violet are difficult to fix.
Texture	Looks best on comparatively untextured material. Mauve is not recommended for velvets, but deeper shades are suitable.
VDUs	NSC.
Woods	Medium violet goes with teak, dark oak, afrormosia, tola; mauve goes with light oak and pine. Pale mauve and purple go well with antique furniture, and purple goes well with polished brown.

3.5 Interiors

Domestic interiors

Light variations	Pale mauve is elegant and goes well with painted furniture and polished dark wood. Pale variations will create a fragile effect and added accent is desirable; they are light and etheral.
Medium variations	Purplish pinks and lilacs will create a pretty room suitable for traditional floral fabrics and dark woods. Can be used as an accent at the back of an alcove when the walls are pale.
Dark variations	Deep mauve can be exciting; deeper mauves and purples create luxurious interiors but make a small room even smaller; they go with pine, polished brass, polished brown and velvet upholstery which make up the Victorian look. Deeper shades have a calming and atmospheric effect; purple is powerful and dramatic and

can provide some unusual colour combinations.

Usage in interiors	Creates a restful background, although deeper shades can be exciting; better used as a background colour than as an accent, although purple and lilac can be used for cushions. Gives a rich effect but can be difficult to use; it is apt to be distorted by fluorescent light. Violet can be soft and subtle when used with blues or greys, or strong and vibrant when used with greens and crimson; it is a colour for a unique decor.
Room character	Indicates a depth of feeling, sensuality and richness. Mishandled it can cause confusion and be unsettling.
Room aspect	Generally for south- and west-facing rooms.
Room size	Makes room look larger, although deeper shades tend to be claustrophobic.
Room functions	Not recommended for dining rooms.

Commercial interiors

Commercial interiors do not lend themselves to analysis on the same lines as the above, and attention is drawn to their use in specific environments listed in 3.7 below.

3.6 Combinations

Good harmonies	Most variants with blue, peach. Lilac with deep pink; mauve with beige, tan, coffee, pale green, pale blue-green, most blues, olive, emerald green, silver grey; pale mauve with grey (sophisticated effect), pink; purple with silver grey, pink, pale beige, deeper blue-greens; violet with orange, peach, ivory; deep violet with orange buff.
Avoid	Lavender with maroon; pale tints of violet with brown, orange, dark green.
Good contrasts	Violet with yellow.
Accentuated by	Proximity to green.
Diminished by	Proximity to blue, red, blue-black.
Accentuates	Green, blue-green.
Diminishes	Blue.
Suggestions	Mauve mixes well with many colours; mauve and blue go well together and mix with strong green; to prevent purple becoming too aggressive, add a touch of brilliant white, shocking pink, blue-green or orange; with pale lilacs use deep pink or beige to prevent the scheme becoming too insipid, and for more drama add purple, turquoise, sea green; where violet is used with grey, the violet becomes more intense, grey appears yellowish; purples and mauves look best when used with plenty of white and create an individual, special look; cream is a

soothing counterbalance to purple; purple and mauve look well with pale green against an oatmeal background.

3.7 Uses

Consumer applications

Bathroom products Colours in this group are not generally recommended for bathroom use because they have an unflattering effect on the human complexion. At various times the paler variations such as lilac have been tried for sanitary ware, but the demand has usually been short-lived.

Bedroom products People who like a purple bedroom are said to suffer from a feeling of emotional disappointment, but the group is unflattering to the human complexion and best used with other colours; it does create a restful background but is difficult to live with. Lilac and similar variations are often a vogue and are less difficult than more positive violets. Purple often has a short-lived popularity and may appeal to younger people who are fashion conscious, but it is best used in small doses, not in large patches. Blue variations tend to be rather cold; red variations are better. Dark variations create a Victorian bedroom.

Domestic appliances The group is not really suitable for domestic appliances, although lilac and other pale variations may occasionally be used for personal products such as hairdryers. Nor is the group suitable for space heaters, because it is essentially 'fashion' and would soon clash with most decors; the colour is too cool for space heaters.

Housewares Not generally recommended, although there may be a decorative function for sophisticated products; the group is not recommended in association with food and has little impact on display. Not suitable for tableware except when a popular trend; it may then have limited uses. Not suitable for food containers except in a purely decorative sense; there might be a limited demand in higher-grade markets.

Kitchen products Occasionally introduced into kitchen ranges but seldom with a great deal of success; not suitable for food nor pleasing in the kitchen.

Living room products Best used as a background colour, rather than as an accent, although lilac and purple can be used for cushions. Otherwise as for Domestic interiors (see 3.5 in this part).

Window decoration products Not very suitable because it is not flattering to human appearance and tends to create a rather depressing atmosphere. Its short-term nature makes it only suitable for accent purposes or for special circumstances.

Graphical applications

Packaging Colours in this group are not generally recommended for packag-

ing because they are weak in motivation and do not inspire any favourable impulse. There is often a short-lived fashion trend in favour of this group, and when this exists the colours might be used for products having a fashion connotation. Essentially a background colour with a fashion note, and can be used where it has an association with a product or service. Restful, modifies other colours and mixes well with blue; best used for features.

- Light Orchid is suitable for the packaging of cosmetics and also for their caps and closures. Group generally can be used for some bakery products and for confectionery.
- Medium May be used for confectionery; recommended for florists.
- Dark For high fashion products, when in vogue.
- Avoid Use for products used in the kitchen and for coffee.

Print Remarks as for packaging and not generally recommended for print applications. Poor for display purposes; best used as background if at all. Purple is essentially background and strikes an enigmatic and dramatic note but is not very friendly. Lighter variations may be suitable for tags for fashion products but lack impact.

Images Similar remarks as for packaging and print.

Vehicle liveries Similar remarks as for packaging and print; may be used for businesses where there is an association with the products or service. Lilac and mauve are recommended for florists; avoid for passenger-vehicle liveries.

Environmental applications

Catering Colours in this group are not recommended for catering except, perhaps, in small areas for decorative purposes. Violets are particularly bad in relation to food and do not flatter the complexion. Light and medium variations are for decoration only; dark variations should be avoided in restaurants and bars.

Factories Not generally recommended for industrial use except in some decorative applications but watch effect on appearance.
- Light Not recommended.
- Medium May be used for accent purposes (e.g. in reception areas); also for pipeline identification.
- Dark Not recommended; sometimes used to identify radiation hazards.

Offices Not recommended for office use except for minor decorative purposes or for use in executive offices where individuality is permissible. Violet shades are not psychologically pleasing to most people and are unflattering. Not recommended for office screens. Light and dark variations are not recommended; medium variations may be used for accent purposes in upholstery and carpets.

Retail Few uses in the store except in high-fashion applications. Light variations are sometimes used in florists shops and in association with cosmetics;

medium tones are for accent only, generally in high-fashion applications. Avoid dark tones.

Schools No applications in schools except that light variations might be used for occasional decorative purposes.

Hospitals Not recommended because they are unfavourably associated with health and do not flatter the complexion. The darker shades have a yellow-green after-image which can be disturbing to sick patients; used for signs indicating chapels. Light variations might be used for decorative purposes in staff quarters.

Commercial applications

Office supplies No substantial demand is likely except at certain times for semi consumer items. The group has little impulse attraction, is not pleasing to most people and would only be required for identification purposes if a particularly wide range of colours were required.

Paper and board Little significance except to convey fashion and an association with certain trades. The association with royalty and with top quality may sometimes be used with advantage.

Attention is also drawn to the notes in Section 1 of this part.

Surface-covering applications

Attention is drawn to the explanation of colour selection for surface coverings in Section 1 of this part.

3.8 Legend

Purple has been concerned with power and wisdom since at least Roman times and has consequently become associated with royalty; purple was the ceremonial dress of the Roman emperors mainly because purple dyes were so expensive only emperors could afford them. From this derives the red hat of the cardinal. Queen Victoria is reported to have had lilac bedroom walls and to have claimed that purple gave a flattering glow to early morning pale faces.

Purple symbolised the east to the ancient Irish; water to the Jews; the earth to the Egyptians; and the wanderings of Ulysses to the Greeks. Purple is frequently used to indicate overall winners, probably because of its association with royalty. It signifies high rank when used in Eastern carpets. You can have a 'purple time', probably another association with royalty.

4 Blue group

Clear blue subgroup
- Light Pastel, kingfisher
- Medium Mallard, summer
- Dark Midnight, navy

Muted blue subgroup
- Light Steel
- Medium Wedgwood, saxe
- Dark Slate

4.1 Character

Blue is the colour of heaven, a happy colour, that suggests air and space. The most tranquil of colours, the colour of many flowers, which has the power to relax and soothe. Cold, wet, transparent, atmospheric, always popular with the British public. It has great structural beauty, many applications and mass appeal. Cool, soft colour, not inviting to the viewer but is well liked. It lends emphasis to other colours, particularly vivid ones, mixes well with violet and green but not with bluish reds.

Clear blues are generally best for promotion applications; muted blues often indicate high fashion. Deep blue is the 'mother' colour and conveys love, harmony and tranquillity. Dresden blue is recommended for high-temperature areas; it suggests sky and water but is retiring, soft and restful. Ideal background, especially for food service.

Blue is difficult for the eye to focus and to recognise; it creates a blurred image and does not lend itself to sharpness of detail. Large areas of blue, particularly intense blue, can make the eye near-sighted and cause headaches; it is a difficult colour to contemplate. It is not a good functional colour because it tends to distract the focus of the eye. Sharply refracted by the eye and often makes objects appear to be surrounded by haloes, especially when seen in combination with other colours. Tends to merge into a grey background.

Easy to use, but it is sometimes described as a wayward colour. It can be melancholy but has warm tones, especially when it inclines towards purple. Conveys cleanliness and freshness but can be cold. Some blues have a tendency

to fade in use. Man-made blues, as in textiles, generally harmonise with nature. Essentially a background colour; it tends to recede.

Most blues are brilliant in daylight but may turn grey or blue-black in any artificial light; darker blues tend to look dead in electric light and should be used in small doses only. Blue can be seen more clearly at low light levels, but a dark blue requires plenty of light to be seen clearly. The true colour shows up best in artificial light if relieved with white and in a very white, cool light. Blue is enhanced by daylight fluorescent light, but some fluorescent lights impart a violet tinge. A rich blue tends to deepen at night. Blue-tinted light reduces acuity; the sensitivity of the retina to blue is low. It does not flatter humans complexions. Blue-coloured light causes objects to become blurred and is not recommended as an illuminant or for lampshades.

4.2 Attributes

Age	Mainly preferred by older people but strong blue often appeals to the young, especially for packages.
Appearance	Not very flattering when reflected on to the human face, but the medium blues provide good contrast. Too large areas of blue are likely to be unsatisfactory. A little cool for working environments but very suitable for bathrooms and washrooms.
Associations	The law, coolness, the sky, the navy, the sea, summer, engineering, airlines, antiseptics, steel, dairy products, electricity, baby products, male cosmetics; also with depression, pornography and cold; associated with male babies, 'blue for a boy'. Traditionally the symbol of first prize, and only purple ranks above it as a symbol of excellence. People tend to think of peace as blue, partly because of its tendency to reduce blood pressure and tension but also because of its association with the sea and the sky.
Fashion	Always popular with the British public. Clear blues are generally mass market and muted blues are high fashion, but this does not always hold true.
Impulse	Essentially a background colour, passive, little shelf impact.
Markets	Good for almost any market; sky blue appeals to business markets.
Mood	Denotes quietness because it retards autonomic response. Also denotes softness, coolness, freshness, cleanliness, the outdoors generally. Blue is fresh and translucent but may also be subduing and depressing if not used with care. Smoky blue is particularly depressing and creates a restrained mood, although it may also infer influence. Blue is a pleasant colour to live with and can be light-hearted and restful, sunny and mysterious, or

just plain chilly; it has the power to relax and soothe, a tranquil quality. The perfect colour to release highly strung, overworked people because it calms their emotions; the peace-maker, calming.

Personality
Blue people have thoughtful, reflective minds and are likely to be conscientious workers; they are deliberate, thoughtful, introspective, cautious and conservative. People who dislike blue are irritable, neurotic, resentful. For introverts.

Preferences
Choice 6 in children, 1 in adults. Comes first in any poll. Particularly popular with the British.

Presentation
Medium clear blues have dignity, and although they do not have a great deal of impact, they convey a feeling of efficiency. Muted shades of blue would be suitable where it is desired to convey restraint.

Products
Business, travel, food, fish, steel, engineering, electricity, baby products, dairy products, including milk. Recommended for masculine-type cosmetics. Sky blue and grey-blue are recommended for business. Sapphire blue is recommended for caps and closures. Blue is particularly associated with kitchen products because of its cleanliness.

Recognition
Poor recognition qualities.

Reflectance
Light blue 36 per cent, dark blue 9 per cent.

Regional
NSC.

Seasons
Recommended for all seasons because it is the colour of the sky but particularly associated with summer.

Sex
Essentially a male colour but some women do buy blue for themselves. Blue for a boy is well established. Women like blue in the kitchen.

Shape
Suggests the form of a circle or sphere.

Size
Makes the image smaller and surfaces look further away.

Smell
There are no typical associations with scent, but blue is associated with antiseptics and cleaning products having an antiseptic smell.

Stability
Restrained colour, fresh but not particularly dignified.

Taste
May suggest that a product is weak or watery.

Tradition
Widely used in Georgian times; Wedgwood blue belongs to the later Georgian period. Traditionally the symbol of first prize, of the sea and of the law. Blue-black traditionally means trouble.

Visibility
A retiring colour, difficult to recognise and to focus. Sharply refracted by the eye and often makes objects appear blurred or surrounded by haloes; tends to merge into a grey background. Makes objects look smaller than they actually are and also further away; this can lead to mistakes in judgement in some applications. Can be

seen over a wide range of vision at night because the rods of the retina do not see red; it is most visible to the dark-adapted eye. Best used as a background, but take care when using as a background to red – the two may merge. May have bulk but does not lend itself to sharpness of detail.

Warmth Soft colour, cool, not inviting to the viewer.

4.3 Functions

Camouflage Dark variations and muted blues will hide soiling.

Coding A strong, medium blue would be included in most ranges, although it does not have good visibility or recognition qualities but would provide good contrast with other colours. Clear blues and muted blues could be used in the same range without difficulty.

Heat control NSC.

Insect control Repels some insects, but dark blue attracts mosquitoes. Peach moths are responsive to blue, 11 per cent of beetles react to blue and bees are sensitive to it. Blue light is often used to attract insects to destruction.

Pipeline
 identification Light blue identifies air; dark blue identifies fresh drinking water, with red, central heating; with white, cold water.

Protection
 from light Does not exclude harmful effects; promotes rancidity.

Readability Blue on white, white on blue, orange on navy blue, navy blue on yellow, yellow on navy blue have good qualities. Navy blue is recommended.

Signalling Difficult to see and distinguish but can be seen over a wide range of vision when the eye is dark-adapted. When used for flashing lights a slower rate of flashing is prescribed.

Visibility of
 controls Not recommended except for kitchen appliances.

4.4 Applications

Biological Psychological effects: some people judge blue as cool, but not all. Calms anxious subjects and is allied with a conscious control of emotions; the colour of circumspection; people who like blue try to run away when under stress; introverts prefer blue. Reduces crying and activity in infants. Blond people generally prefer blue because they are descended from Nordic stock and blue skies have caused pigmentation of the retina.

Medical effects: associated with schizophrenia; causes urticaria solare; relieves headaches and high blood pressure; may retard muscular activity of nervous origin; tranquillises in cases of tension and anxiety; alleviates muscle spasms; helps in cases of irritation of the eye; contributes to the subjective relief of pain; reduces activity in torticollis; dim blue light is conducive to sleep in insomnia; visible blue and blue-violet light helps to counteract jaundice in newly born babies.

Children Mainly preferred by older people, but a strong, light blue often appeals to the young.

The country Blue is frequently used because it is cool and clean, but in fact it has little virtue compared with white except to provide change. Colder blues should be avoided; they tend to appear bleak. Blue is good background for food and is sometimes used for creameries. Deeper blues might be used as accents.

Export Essentially for temperate climates; the bright blue of the sky overpowers it in warm climates, but it can be used to cool down interiors.
China: blue and white mean money.
Sweden: do not use blue and white for packages.
Switzerland: conveys textiles.
Other countries: conveys detergents.
Holland: liked for bathrooms.
France: liked for bathrooms.
Ireland: preferred by the young.
Arab countries: do not use blue and white.

Exteriors Cool, calm, collected; tends to make a building look smaller and is forbidding in bulk.
Doors: navy blue for doors of red-brick houses and for yellowish brick; smoky blue is also recommended.
Windows: smoky blue for outer frames of white windows.
Walls: navy blue looks good, set off by white; dark blue for walls in towns; hyacinth blue for walls in a garden setting; all blues are good in town, especially with a black-and-white surround to the doors; Trafalgar blue for terrace houses; pale blue for a cottage in the country; dark blue is not right for the country but is quite suitable for the seaside. Bright blue is recommended for colour washed walls; recommended for bungalows; alpine blue for an Edwardian house; pigeon blue for a semi detached cottage.
Industrial: generally for accent only; good association with food and food packaging.
Farm buildings: dark muted blue for roofs.

Food Not a colour of any natural foodstuff but an excellent foil

| | for most foods; clean, cool, well liked, retards digestion. Not suitable for any food but excellent background, especially to meat and dairy products. Avoid violet type blues; not recommended in association with bread. |

Food packaging Essentially a background or foil colour which denotes coolness and cleanliness. Tends to suggest a mild taste and very pale blues may suggest a product is watery. Suitable for seafoods, milk, dairy products, baby products (but not pale blue), tomatoes, white vegetables, frozen chicken. Not for bread or bakery products.

Food in the home Excellent background, well recommended for food containers, especially those for use in freezers; clear blues are indicated. Can be recommended for tableware applications and either clear or muted blues may be used; Wedgwood blue is well established for tableware. Light and medium versions are best but strong blue can be used for ovenware.

Food processing Particularly suitable for food plants. Has a flattering effect on appearance but tends to accentuate coldness. Recommended for dairies but may be a little cool; light blue is suggested for meat-processing plants.

Food service Well liked in association with food, although not a food colour; popular, non-distracting, cool. Best used as a background for food, especially meat and seafood. One of the safest colours for display and presentation of food and can be used adjacent to salads and also for the immediate surround to food, although it is too cool for walls in large areas.

- Light Plates, serving dishes, table tops.
- Medium Immediate surround, background to servery.
- Dark Accent only; small areas in luxury establishments.

Food stores As for food service above. Use for walls, fixtures, trim for shelves, immediate surround but a bit cool for large areas. Particularly suitable in association with meat, milk and seafood.

- Light Walls for grocery.
- Medium Food shop exteriors.
- Dark Said to make the tissue and fat of meat look more tender.

Industrial plant and equipment Blue is perfectly suitable for most industrial equipment; it is cool and relaxing in character, and although less neutral than grey, may be more attractive to operatives. It is a little too cool for large machines but could be recommended to cool down a warm environment. Muted blue is preferred to clear blues. A light blue is recommended for food-processing machinery but not for most

workshops; medium tones are recommended for machine bodies; very dark blues might be used for bases and plinths. Safety blue is used to indicate mandatory action and impart information; contrast with white. Often used for control boxes.

Merchandising Ideal background because it does not attract attention away from the merchandise; especially good where it is desired to place maximum emphasis on the product because it is not easily focused by the eye. Good in graphical applications, for food and for impulse-sold merchandise but should not be used in large areas. Navy blue is particularly recommended as background to light-coloured merchandise and for fashion merchandise.

Pattern NSC.

Safety Safety blue (BS 18E35) is recommended for signs with white contrast to indicate mandatory action and to give information. It is used in some countries to indicate electrical hazards or to mark equipment that is out of order and control boxes that might otherwise be difficult to find. It is also used to mark cars or equipment that are being unloaded. Painted on electrical control panels, switchboxes, welding generator boxes, electrical control cabinets and wherever caution is necessary.

Signs Has some disadvantages as a colour for signs because it tends to recede and is difficult for the eye to focus. Best used as a ground colour for large signs; it is used as a ground for direction signs on motorways. Very apt to fade. Not easy to recognise or to find, especially against an outdoor background, but it is good for advertising signs because it emphasises the legend. Tends to merge into a grey background but has better visibility at night than other colours, or in dim lighting conditions. Does not lend itself to sharpness of detail. Red on blue needs care because the two tend to merge.

Television Most variations reproduce acceptably, but navy is difficult to use and dark blues generally tend to look black. Ultramarine tends to look turquoise, and combinations of blue and green present some difficulty.

Texture Dark blues look best on pile fabrics or soft velvet. Paler blues reflect more light on a sheer finish.

VDUs Screen: blue on grey can be used.
Equipment: medium blue is acceptable.
Surround: Acceptable where intense mental effort is required.

Woods Light blue with mahogany and rosewood, also greyish blue. Medium blue with teak, dark oak, afrormosia, tola, light oak, pine, beech.

4.5 Interiors

Domestic interiors

Light variations Pale blue greys will make a room seem larger and raise a low
ceiling, but they are cold to the eye and best left for sunny rooms; brighten
up with accents.

Medium variations Powder blue can create an etheral background.

Dark variations Deeper blues will create a less chilly effect and may remind
people of holidays. Very deep blues can make a room seem smaller,
although most blues have the opposite effect; the darker blues tend to be
claustrophobic and people are afraid of them. Navy, royal and peacock
blues provide a cheerful background and are a good foil for white or chrome.

Use Blue will flatter the home and create tranquillity, elegance and spacious-
ness; a refined colour. Can be used almost anywhere if it is clean, but avoid
purplish blues in most cases. Blue is difficult to contemplate in large areas
and it looks grey in a cold room; it is sometimes described as a melancholy
colour, but it does have rich, warm tones and can add sophistication and
luxury. Flexible in use, particularly in the dining room. Avoid large areas of
blue, they can make the eye near-sighted and cause headaches. Quieting
effect if not relieved with accents and lends emphasis to more vivid colours.
Most blues look warmer in electric light and are apt to be distorted by fluor-
escent light.

Room character The colour of the sky, creating a cool, fresh, restful look
which can make a room appear larger; tranquil.

Room aspect Blue is recommended for sunny rooms with a south or south-
west aspect but not for rooms having a north or north-east aspect nor for
rooms having little natural light. However, deep, rich blues can be used in a
north-facing room. Blue looks grey in a cold room and tends to look dirty in
setting sunlight.

Room size Blue increases the size of a room.

Room function Blue is good background for dining areas and is recommen-
ded for narrow halls and small, cramped rooms. Blue is recommended for a
library or a study; it provides stimulation as well as relaxation but use
accents. Refreshing in a kitchen, and blue fabrics make for a peaceful bed-
room.

Room users Blue is attractive to children but can be intimidating. It is the
ideal colour to relax highly strung people and is a peace-maker.

Commercial interiors

Attention is drawn to specific environments listed in 4.7 below.

4.6 Combinations

Good harmonies Most variants with green, violet, mauve (especially good), white (the best mixture), red (brilliant effect), brown, olive, coral, emerald green, peach, orange (especially navy blue), flame red. Dark blue with pink; deep blue with pale green, off-white. Midnight blue with scarlet is a strong combination and so is royal blue with scarlet. Pale blue with peach, ivory.

Avoid Avoid mixing blue with bluish reds such as magenta, shocking pink. Dark blue with black traditionally means trouble. Deep blue with pale yellow is disturbing. Avoid pale blue with deep green, maroon, brown, olive and dark green.

Good contrasts Blue with white.

Accentuated by Proximity to yellow, white, apricot.

Diminished by Proximity to violet, black.

Accentuates Red, orange, yellow.

Diminishes Blue-black diminishes violet shades.

Suggestions
- If blue and yellow are seen together, the blue becomes redder and inclines to purple, the yellow inclines to orange.
- If blue and red are seen together, the blue will incline to green and the red will incline to orange.
- A blue background will cause red to advance (but green is better)
- Blue in proximity to blue-green causes the latter to appear greener.
- When blue is mixed with grey it becomes more intense and often greener, while the grey inclines to orange.
- Adjacent combinations based on blue are well liked.
- Blue looks good when used tone on tone or offset with green or yellow.
- Blue and white is a little cold in large areas.
- Three shades of blue are recommended for vehicles; bright blue for the top controls heat.
- Blue and coral for food is bold and dramatic; the blue provides a foil and denotes cleanliness.
- Two shades of blue with yellow accents create a favourable image, and the combination is well liked.
- Accent blue with white, soft green, greys.
- Blue can complement pale yellow, pink, coral, peach.
- Ice blues are best teamed with yellow, orange, light brown, old rose, burgundy.
- Blue goes particularly well with gold.

- Sky blue sets off purple, mauve.
- Blue and pink in equal quantities is the perfect compromise between masculine and feminine in shared double bedrooms.
- Electric blue combined with pink is dramatic.
- Blue with yellow is summer all the year round.

4.7 Uses

Consumer applications

Bathroom products One of the best of all colours for bathrooms and pale blues have long been a favourite bathroom colour. Denotes coolness and cleanliness and is flattering to the human face because it is the direct complement of the colour of the skin and contrast enhances appearance. Clear blues are recommended in light or medium variations. Darker blues have been introduced into sanitary ware in recent years and probably appeal to more sophisticated users.

Bedroom products Blue has long been a popular bedroom colour, especially for beds and at the lower end of the market, but the type of blue that is popular at any given time can vary quite considerably. One in three people are said to like blue for beds, partly for traditional reasons. Although blue can be the most claustrophobic of colours in its deeper variations, pastel blue can be the gentlest and most feminine of colours, and this accounts for its popularity in the bedroom. Blue can be used to highnote a bedroom, but too much blue might make it cold. Smoky blues are rather subduing and need livening up; strong, dark blues have more life but are best avoided in large areas. White is the ideal colour to go with blue in bedrooms, but red will create a more vibrant atmosphere; yellow is a possibility in country bedrooms. Blue has an association with night and with sleep. Blue is unlikely to appeal to young people but is recommended for a male bedroom. If a person likes a blue bedroom, that person has a need for tranquillity. Said to be suitable for the artistically sexy.
 - Light Pastel blue is cool, calculating, precise. Light blue is recommended for children.
 - Medium Flanders blue is dashing and vital, but reserved.
 - Dark Navy blue is nautical and masculine; midnight blue is sometimes used but if darker blues are used, fabrics should have plenty of white in them.

Domestic appliances Blue is one of the best of all colours because it denotes coolness and cleanliness and is a good background. It always retains its popularity for kitchen use and is ideal for cooling down a hot kitchen and an excellent background for foods. Well recommended for small appliances because of its association with cleanliness. Not recommended for space heaters because of its coolness; space heaters should give an impression of warmth; the supply boards consider it to be a colour which does not sell. Light blue

can be used for refrigerator trim and interiors; medium and dark variations can be used for virtually any appliance used in the kitchen.

Housewares Blue is recommended for kitchen utensils because it is always a popular kitchen colour and is clean and cool looking. Muted blues have a decorative function but clear blues are best for kitchen utensils. An excellent background for food; limited impulse attraction but provides a good background for display. It is the most popular of all colours in relation to tableware and always a good standby because it provides a clean, cool background for most foods and liquids. Paler blues are recommended for the interiors of vessels, but deeper blues may be used for the outside. Muted blues are acceptable but in the current trend variation. It would be hard to exclude blue from any tableware range. A 'must' in every food container range, particularly for freezer use; clear blues are indicated.

Kitchen products Most kitchen product ranges include a blue because it is ideal for cooling down a hot kitchen and in association with food; there are probably more blue kitchens in existence than any other colour. In the past clear blues have generally been preferred, but in more recent times trends have moved in favour of muted variations. Blue can be used for virtually any kitchen product but use a current popular variation.

Living room products Will flatter the home and create a tranquil room; can be used almost anywhere if it is clean and pure but avoid purplish blues. Otherwise see Domestic interiors in 4.5 in this part.

Window decoration products Blues have a cooling effect and may be a little trying in large areas; suitable for rooms that receive plenty of sun; suggest the sea and the sky. Particularly suitable for bathrooms and kitchens but a little cooling for living rooms and bedrooms; can be recommended for areas where visual tasks are carried out. Clear blue is recommended; sky blue is a natural daylight colour which cancels out yellow sunlight; summer blue is clean, pure, cooling.

Graphical applications

Packaging Good feature colour for packaging, but it has comparatively little shelf impact and is best used for background, especially in graphical applications. Fresh and translucent but may be subduing and depressing if not used with care. Retiring, dignified, difficult for the eye to focus; while it may have bulk it does not lend itself to angularity and detail. Blue tends to fade quickly and needs care for that reason; it may need testing in use.
- Light Generally for background. Pastel blue for cosmetics and caps and closures for same.
- Medium A strong, clear blue is best used for features. Sapphire blue has impulse attraction when used for caps and closures. Recommended for cosmetics, including aftershave.
- Dark Midnight blue is a good foil.
- Avoid Large areas of intense blue.

Print Remarks as for packaging; best used as background in display appli-

cations. Blues are appropriate for business markets because they create a dignified atmosphere. Clear blues are generally best except in some fashion applications. Universal favourite, appeals to men, good for most seasons but more especially summer. Blue and white tend to look insipid under supermarket lighting. Lacks impact when used for tags, but stronger blues may be used for tags for products aimed at men and children.

Images Similar remarks as for packaging and print. Good background for print and lends emphasis to warmer and more vivid colours.

Vehicle liveries Remarks as for packaging and print. Clear blues are generally best for vehicle applications; a bright blue is better than a pale blue and does not show mud to the same extent. Blue provides a good background that sets off legend well and lends emphasis to other colours. Blue and white are good for refrigerated vehicles, and blue can be recommended for fishmongers. The safety implications of blue are important to vehicle livery applications; it is a retiring colour which is difficult to recognise and to focus and it tends to cause objects to look blurred; it also tends to merge into a grey background, although it can be seen over a wide range of vision at night. Blue tends to make objects look smaller and further away than they actually are, and this may lead to mistakes in the judgement of distances. Reports suggest that cars with blue wings are likely to have more dented wings than cars of other colours because the receding quality of blue makes the apparent width of a parking space seem greater than it actually is.

Environmental applications

Catering A very useful colour in all catering palettes because it has universal appeal to all age groups and backgrounds. Non-distracting, cool and excellent as a background or foil to food. Suitable for all food service areas but tends to be forbidding and cold in large areas, deeper blues are subduing. May be used as accent on walls, for signs, for display and in alcoves. Clear variations are best; muted variations should be limited to hotel bedrooms and lounges and some exteriors.
- Light Restaurants, kitchens, food stores, hotel bedrooms, washrooms.
- Medium Exterior trim of motels, exteriors in cloudy climates, serveries, display; restaurants and coffee bars, although mainly for accent; lower half of walls in corridors and service areas, muted variations could be used; canteen furniture.
- Dark Luxury restaurants but avoid navy and marine blue in hotel rooms.

Factories Generally speaking, muted blues are preferred for industrial use. Blue tends to be cold in large areas but is useful where the working temperature is high. The deeper blues are subduing and can be used for this purpose where appropriate but very strong blues should be avoided.
- Light For walls in areas where critical seeing tasks are performed; for first-aid rooms, mens' washrooms; for areas behind

counters in canteens; for food-processing plants.
- Medium For end walls in inspection and assembly areas but may be a little cool if combined with grey side walls; could be combined with green for fine assembly work; for exterior structures; for lower walls of storage areas; for corridors, but combine with warmer colours on upper wall.
- Dark For exterior structures.

Offices A cool colour well suited to office use, although a little cold in large areas; particularly suitable where a restrained atmosphere is desired; conducive to quietness and concentration. A blue-green is often more attractive than a plain blue.
- Light For walls in general offices; muted blues for those areas where intensive mental effort is required and preferred for screens; conference and board rooms; canteens; washrooms for men.
- Medium Muted blues are suitable for end wall treatments; for food serveries.
- Dark Deeper shades are useful for accents; recommended for signs conveying information.

Retail Recommended for trim, fixtures and shelving; appeals to men and is excellent for mens' clothing; good background for glassware; ideal background for display, especially if used for dramatic emphasis. May be used for accent on walls, signs, displays and in alcoves; also for exterior applications although it tends to fade.
- Light Clear blues for first-aid facilities, restrooms, washrooms, walls of car showrooms.
- Medium Clear blues for lower half of walls in corridors, staircases, storage areas; muted blues could also be used in this application. Clear blues can be used for trim of shelves, to set off shelf goods; for womens' fashions; for accent in mens' departments.
- Dark May be used as a background for merchandise.

Schools A good colour for encouraging concentration and study but tends to be a little cold and bleak. Most blues used in schools should be slightly greyed, especially when used for end wall treatments.
- Light Muted shades might be used for elementary grades, especially if combined with peach.
- Medium Muted shades for secondary-grade classrooms, particularly for end walls; could also be used for elementary grades. Recommended for desks.
- Dark Not recommended.

Hospitals Pure blue should generally be avoided because it tends to have a bleak and cold look; it is especially unsuitable for long-stay patients and is trying to the vision, especially in large areas; it tends to cause nearsightedness and blurred images and disturbs some people. Brilliant blues tend to become monotonous. Blue is quite widely used in mental hospitals but some other colour might be better.

- Light Muted blue for some wards, preferably smaller rooms; for treatment rooms, reception areas, corridors, kitchen and food preparation.
- Medium Muted blues for end walls in conference rooms and wards.
- Dark Clear tones for signs indicating stores, supplies, etc.

Commercial applications

Office supplies A blue should be included in most office ranges, but it should be positive – a pastel blue is not generally satisfactory. It is well liked by men, and darker shades are preferred for executive use. Darker blues are traditional in many stationery applications but are only required for consumer applications when trends so dictate; it has little impact at point of sale. Muted blues have been traditional in the office field but have little to recommend them; they are 'ordinary'. A strong medium blue should be included in most ranges because it provides good contrast with other colours, although it does not have good recognition or visibility qualities. Clear blues and muted blues could be used in the same range.

Paper and board An excellent colour for paper because it is good background and sets off print well. It also lends emphasis to warmer and more vivid colours. A cool, sedative colour; clear blues are recommended. Suitable for letterheadings, stationery generally, airmail, mailings about finance. Conveys an image of many trades and products. Pale blue paper with blue-black ink conveys a lively image. Azure blue paper is recommended for display material. Grey-blue paper is traditional for many business applications but has little to recommend it.

Attention is also drawn to the notes in Section 1 of this part.

Surface-covering applications

Attention is drawn to the explanation of colour selection for surface coverings in Section 1 of this part.

4.8 Legend

Blue is one of the most commonly liked colours (the other being red); it signifies escape to the quietness of inner self and is one of the most relaxing of all hues. It is always popular with the British, perhaps because it goes with our climate and temperament, and it is always a good seller in womens' clothing, and a bride always carries blue for luck. It also appeals to older people, possibly because the fluids in the eye become yellowish with age and therefore blue, being the complement of yellow, looks more intense. Blue has a calming effect and releases tension and this aspect is reflected in the term 'to feel blue', which can be traced back to at least 1550. The word 'blue' itself probably derives from the colour caused by a blow, that is a bruise.

Blue has always been a celestial colour, and in the Old Testament it was the

Lord's colour. In the *Arabian Nights* Christians were catalogued as blue, and in ancient mythology it signifies the heavens. It was also the colour of Mercury, the messenger of the gods. The Tibetans considered light blue to be a celestial colour and to them it signified the soul, but in general there is little reference to blue in the east. Aristotle mentioned various colours but no blue, but it was important in early Christianity. Navajo Indians use blue to signify the south, but Hopi Indians use it to signify the west.

The Gauls clothed their servants in blue and eventually it became a livery for many types of servant. The guardians of the Roman Senate were clothed in blue, and from this derives our police uniform. In Greek symbolism blue was for earth and also for truth, it signified air to Leonardo Da Vinci, and the god Isis to the Egyptians. It also meant truth to the Druids.

There are many colloquial expressions which include blue, some of which are difficult to explain. For example:

- blue laws supposedly from the colour of the cover
- true blue the integrity of the sky
- once in a blue moon invented in 1869
- wild blue yonder the sky
- blue in the face the effect of running
- blue noses descriptive of a physical condition
- yell blue murder
- blue blood superior to red blood
- blue music is mournful compare 'feeling blue' above
- blue funk the colour of the skin when very frightened.

The calming effect of blue is of very ancient origin. An Arab healer in the Dark Ages said that blue light soothed the movement of the blood, while red stimulated it; this has been proved in more modern times. Primitive man associated blue with the dark.

In Syria and other countries, blue things or cloths tied to animals were supposed to protect them from death, but the use of blue in Eastern carpets signifies trouble, but also the eternal. Greek traders called the people of Britain 'Bretani' because of their habit of painting themselves with blue woad; hence Britain. In Ireland a blue ribbon was supposed to cure croup.

The sky is blue because blue has the shortest wavelength of the visible spectrum and therefore when sunlight passes through the atmosphere, the blue rays are the first to be reflected by the particles of dust and water. Most of the associations of blue are concerned with the sky and with fine weather and the association with depression and infirmity probably derives from the colour of a bruise.

The use of blue as a sign of excellence, such as a blue riband, is well established, but its origin is less certain; it may be because it is the colour of the ribbon of the Order of the Garter, the highest British decoration.

5 Blue-green group

- Light Aqua
- Medium Turquoise
- Dark Ming blue, petrol

5.1 Character

This group is a mixture of blue and green which has rather more blue than green in its composition. The group has many of the attributes of blue but has rather more impact and is more inviting than plain blue. Both aqua and turquoise are high-fashion colours. Blue-green is a cool, soft colour which is very flattering to human appearance by contrast and which is complemented by tan and fawn.

Sea green is a variation that can be specified for a cool atmosphere; it has beauty in large areas but is neutral in quality and will enhance other hues; it dramatises furnishings and textiles and is perfect for bathrooms, washrooms and working areas generally; it aids vision and mental concentration.

Blue-green photographs well and is excellent for a brand image, but otherwise it has the same qualities as blue. It has normal appearance under most types of lighting, including sodium lighting, but reflects more light than blue and looks brighter in dim light. It is not recommended as an illuminant or for lampshades.

5.2 Attributes

Age	Appeals to all age groups, has more appeal to the young than blue.
Appearance	The complement of the human complexion and flatters by contrast; it is highly recommended from an appearance point of view. It is less cooling than pure blue and creates a flattering effect for women when a cool colour is prescribed.
Associations	Cleanliness, freshness.
Fashion	Turquoise is a high-fashion colour; so is aqua when trends so indicate.

Impulse	Has more impact than pure blue, particularly turquoise which has good impulse value.
Markets	Appeals to most markets. Turquoise is recommended for fashion, higher-grade markets and for business markets.
Mood	Less subduing than blue; infers coolness, freshness, cleanliness.
Personality	People who like blue-green are discriminating, exacting, sensitive. Those who dislike it are disappointed, confused and weary. It is more outgoing than blue.
Preferences	As for blue.
Presentation	Turquoise has more impact than blue and has dignity and fashion associations.
Products	Business, travel, food, cosmetics. Aqua is recommended for cosmetics, and turquoise appeals to business markets and is especially good for meat and meat products.
Recognition	Easier to recognise than blue.
Reflectance	A typical variation, 42 per cent.
Regional	NSC.
Seasons	As for blue.
Sex	Appeals to women more than to men, especially aqua.
Shape	As for blue.
Size	Makes an image smaller but not as much as blue.
Smell	As for blue.
Stability	Suggests a higher-grade image than blue.
Taste	Turquoise has pleasant associations.
Tradition	NSC.
Visibility	As for blue but has rather more impact; turquoise has some of the properties of green.
Warmth	Soft colour, cool, more inviting than blue; counteracts heat. Two tones of turquoise will compensate for a warm temperature.

5.3 Functions

| Coding | Turquoise would have better qualities than blue, and in suitable circumstances a clear turquoise could be contrasted with a muted blue. |
| Visibility of controls | Recommended for controls or dials which have to be seen by a dark-adapted eye. |

Under all other function headings comments are the same as for blue.

5.4 Applications

| Biological | In psychological terms blue-green tends to increase nar- |

cissism, fastidiousness, sensitivity and discrimination; such persons need to be loved. Otherwise as for blue.

Children More appeal to children and the young than pure blue.

The country Generally better than pure blue where a change from white is required; it is more lively and less sterile. Particularly recommended for meat-processing plants because it is the complement of the red of meat and thus prevents unsavoury after images and enhances the appearance of the meat. Also recommended for dairies but tends to accentuate coldness.

Export As for blue.

Exteriors As for blue, although it has more impact than pure blue. It harmonises well with other colours and is acceptable in a civic colour scheme.

Food Not a colour of any natural foodstuff but is a good foil to food.

Food packaging An especially good foil for meat because it helps to make the meat look more appetising, otherwise as for blue. Tends to suggest a mild taste. Not for use with bread.

Food in the home As for blue. Perfectly suitable for food containers, and medium variations have good attraction value. Aqua is recommended for tableware; stronger blue-greens are suitable for table linen.

Food processing As for blue but is rather more decorative; turquoise is useful where an attractive appearance is required, and it has an excellent effect on human appearance. Recommended for meat processing because it is the complement of red.

Food service Well liked in association with food and is more lively than pure blue. Best used as an immediate background for food, especially meat; for walls, immediate surround, background to food presentation and is especially good allied with white.
- Light Plates, serving dishes, table tops, etc.
- Medium Immediate surround, overall surroundings.
- Dark Accent and decorative purposes.

Food stores Excellent for many food applications, including walls, immediate surrounds and display generally; especially allied with white. Particularly good in association with meat.
- Light For walls and the immediate surround of the provision section of grocers and for display generally.
- Medium Immediate surround to meat services.
- Dark Accent only.

Industrial plant and equipment Well recommended for most industrial uses because it has more character than blue and has restful qualities; it

is passive and does not impose itself unduly. Medium tones will conceal marks and stains and withstand much wear without showing worn areas. Can be recommended where appearance is important and is normal under most types of lighting. Recommended for instrument housings where the instruments have to be viewed under dark conditions, but it is also restful and non-distracting under normal lighting conditions. Particularly suitable in difficult lighting conditions and where a distinctive colour is required.

Merchandising Has more impact than pure blue and better recognition and visibility qualities; turquoise has good impulse attraction and is recommended as a background to womens' fashions but can also be used as a feature colour. Blue-greens are generally background colours and have a high-fashion association.

Pattern NSC.

Safety As for blue.

Signs Generally as for blue but has rather more impact and some of the qualities of green; it also has a higher fashion image than blue.

Television Most blue-greens tend to look too blue.

Texture Best on hard-glazed surfaces, especially turquoise.

VDUs Screen: no application.
Equipment: medium shades are acceptable.
Surround: acceptable, more flattering than blue.

Woods Medium blue-green goes well with mahogany, rosewood, light oak, pine.

5.5 Interiors

Domestic interiors

Light variations Aqua has many of the properties of pale blue but has a higher fashion connotation.

Medium variations Have a calming effect and are relaxing but a little cold if not relieved. Turquoise will provide accent against a neutral background and has a fashion connotation.

Dark variations Deep blue-greens are for the adventurous; they create jewel-like effect.

Usage Very similar to blue but is less chilly and more flattering to the human complexion; any chilly tendencies can be offset by using accents. Blue-greens reflect a good deal of light and create elegance and spaciousness; they are generally best for background and tend to recede, but not as much as blue.

Room character Blue-green is elegant and brings a touch of fashion.

Room aspect	Blue-greens are recommended for sunny rooms with a south or south-west aspect.
Room size	Blue-green has the effect of making a room look larger but also lowers the height of a ceiling.
Room function	A good background for food and very suitable for dining rooms.

Commercial interiors

Attention is drawn to the specific environments listed in 5.7 below.

5.6 Combinations

Good harmonies	Most variations with pink, rose, especially aqua; light variations with grey; medium variations with cream, caramel, deep pink, mauve; darker variations with white (sensational), purple (dramatic), dark brown, beige.
Avoid	No special combinations.
Good contrasts	Turquoise with dark grey.
Accentuated by	Proximity to golden yellow, red, white, violet.
Diminished by	Proximity to green, black.
Suggestions	Use paler blue greens with grey but add some variety such as pink or orange. Combine medium blue-greens with pink or mauve for a mad colour scheme. Blue-green inclines to blue when seen in proximity to green and inclines to green when seen in proximity to blue. Turquoise with beige is conservative, exclusive, original and attracts favourable attention.

5.7 Uses

Consumer applications

Bathroom products Similar remarks as for blue but slightly more sophisticated. Tends to be a trend colour to a greater extent than blue. Variations such as aqua or turquoise are well recommended.

Bedroom products More exciting than blue and well recommended for bedrooms because it flatters the complexion. Very similar to blue but is less chilly and reflects a good deal of light. Any chilly tendencies can be offset by using accents.

Domestic appliances Excellent for most appliances; similar remarks as for blue but has more impact. Well recommended for refrigerator interiors because it forms a good background to food. Recommended for personal products because it flatters the human complexion. A little cool for most space heaters, but it is the complement of red and could form a background to radiant fires.

- Light Refrigerator interiors, personal products.
- Medium Personal products.
- Dark A little dark for most appliances.

Housewares Aqua and turquoise rank with blue as a popular kitchen colour and are particularly suitable for use with food; they set off meat to best advantage. Better impulse attraction than blue. Well recommended for tableware when trends so dictate; aqua is pale enough to be acceptable for the interior of vessels. Perfectly suitable for food containers.

Kitchen products Similar remarks as for blue but appeals to a higher-grade market and has a higher fashion image. Although blue-greens appeal to women, and to the young, they have not been widely used in the kitchen.
- Light Recommended for use when pale colours are popular.
- Medium Turquoise has more impact than pure blue and is more inviting.
- Dark An alternative to dark blue when trends so dictate.

Living room products See Domestic interiors, 5.5 of this part.

Window decoration products Rather more suitable for window decoration than pure blue, it has more impact and provides better accent; also better for human appearance.

Graphical applications

Packaging Similar remarks as for blue but tends to appeal to a higher-grade market and has a higher fashion image. Appeals to women and to the young and has more impact than blue. Well recommended for packaging, especially for food, and is a good foil colour.
- Light For cosmetics, particularly those with a clinical theme.
- Medium For cosmetics used in the bathroom or bedroom. Turquoise appeals to business markets; recommended for meat products.

Print Remarks as for packaging. Turquoise is recommended for promotion with a business or travel theme. More impact than blue for tags and often suitable for fashion products.

Images As for packaging and print.

Vehicle liveries As for packaging and print; good foil colour and recommended for identification purposes.

Environmental applications

Catering The most useful colour in the catering palette; excellent as a background for food and in many food applications. Cool, soft, restful, excellent for background, flattering to the customers. Appears bright to the dark-adapted eye and recommended for use in a dim light. Contrasts well with red and yellow and has more impact than pure blue.
- Light Bedrooms, motel bedrooms, exteriors of motels, restau-

rants, coffee bars, walls generally, background to food, restrooms, kitchens, serving areas, counters, table tops.
- Medium Restaurants, coffee bars, interiors in sunny climates, lounges, hotel and motel rooms generally, serving areas, counters, table tops, especially in canteens.
- Dark Accent only.

Factories Similar in many ways to blue but has more interest and is less monotonous. Cool in nature and has a bluish cast in daylight but a yellowish cast in artificial light. Provides an ideal brightness for average lighting conditions and relieves glare. Provides a neat sequence between white ceilings and average or medium tones for equipment and floors. Flattering to workers.
- Light Similar to blue. Particularly suitable for walls in areas where critical seeing tasks are carried out, where a cool atmosphere is desired, or as a background to food in canteens.
- Medium For warm working areas; two tones are good for average areas in machine shops and may be used for end walls in machine shops. For kitchens, canteens, mens' washrooms. Highly recommended as a background to meat processing.
- Dark Generally only for lower walls.

Offices The lighter blue-greens are cool and very suitable for office use; they are psychologically pleasing and flattering to the workers. While they are more attractive than blue, they are still a little cold and best not used for north-facing environments or where conditions are cool. Have a calming influence; suitable for screens.
- Light For walls in those areas where mentally intense tasks are performed, as a background to food in canteens, conference rooms, washrooms.
- Medium Useful for floors where the outside environment is exciting; they have a calming influence. Background for food in canteens.
- Dark Accent purposes only.

Retail Blue-greens are particularly useful in a shop because of their flattering qualities. They have more impact than pure blue and are hard to surpass in many applications.
- Light Walls generally, background, first-aid facilities, restrooms, mens' washrooms, some walls and background to products.
- Medium Background to products, provides equal visibility for light and dark garments in a clothing department. Good background for fashions.
- Dark Accent purposes only.

Schools Well recommended in all areas devoted to concentration and study and less bleak than blue. Ideal for study rooms and libraries and allows the surroundings to recede. May be useful to calm down a room with a south or west aspect that receives a good deal of sun.
- Light Blue-green having a reflectance of between 50 and 60 per cent is suitable for classrooms, especially those in use for

long periods at a time. Suitable for the walls of labora-
tories, libraries, art departments, offices, teachers' rooms,
cafeterias, dining rooms (especially for areas behind food
counters). For washrooms and assembly halls.
- Medium End wall treatments in secondary-grade classrooms, often
associated with grey; also as an end wall treatment in kind-
ergartens where a cooler effect is desired; also in elemen-
tary grades and study rooms generally. For floors, table
tops and furniture in cafeterias and dining rooms; also
behind food counters.
- Dark Not recommended.

Hospitals Well recommended for hospitals because it is the complement of
human blood and tissue and flatters the human complexion. Less melan-
choly than pure blue and one of the most useful colours in the hospital pal-
ette; it has a pinkish after-image. Blue-green is cool and flattering and helps
to relieve tension; especially suitable as an accent colour with pinks, peaches
and beiges. Tones should be slightly greyish, avoid very light shades. Will
remove glare from the field of view and lesson visual fatigue.
- Light Chronic wards, treatment, physiotherapy, private wards,
surgeries and adjacent facilities, recovery rooms, treat-
ment rooms generally, service areas, kitchens and food fa-
cilities.
- Medium Chronic wards; wards generally, combined with pearl grey,
beige or yellow; operating theatres and also for sheets,
towels and so on; recovery rooms, treatment rooms, kit-
chens, food facilities, laundries; staffrooms, if relieved with
other colours. May be combined with dark green and used
for end walls.
- Dark Accent only.

Commercial applications

Office supplies Turquoise is well liked for many applications and provides
more emphasis than blue; it can be recommended for identification pur-
poses. Particularly suitable for consumer items because it appeals to women;
also for presentation items because it has more impact than pure blue. Ex-
cellent for sedentary occupations requiring concentration but a little cool in
character.

Paper and board Blue-green provides more emphasis than blue and is a high-
fashion colour which appeals to women and also attracts men. Associated
with vogues and colour trends and very suitable for the promotion of con-
sumer goods of all kinds. Recommended for identification purposes, and a
clear turquoise can be contrasted with a muted blue.

Attention is also drawn to the notes in Section 1 of this part.

Surface-covering applications

Attention is drawn to the explanation of colour selection for surface coverings
in Section 1 of this part.

6 Green group

6.1 Character

One of the most complex of the groups and includes a wide variety of colours ranging from greens with a blue bias to the more widely used greens with a yellow bias and including greyish greens and greens with a touch of black. Green is the colour of nature and has all the manifold variations of nature. Most shades are named by association with nature (e.g. pea green, grass green) and are linked with the ancient belief that growing crops suggest safety. Green signifies plant rebirth and represents stability and security. Greens are easy to use, easy to live with, restful, neutral in appeal. It is cool, soft colour, neither inviting nor unfriendly.

Green is a modifying colour but is also described as a no-nonsense colour; it mixes well with yellow and blue but tends to modify other colours; contrasts with pink and goes particularly well with brown, both colours of nature. Man-made shades of green, as in textiles, seldom harmonise with nature. Brownish and greyish greens are often considered to be the easiest to use because we are used to seeing them around. Yellow-greens have a bilious look, and their after-image is purple, which can be disturbing.

Spring green or apple green are nature's neutrals; they refresh the eye, re-new the spirit and go with anything. Ocular green is a functional colour for critical seeing tasks and where cool, low brightness is required. Light greens have universal utility for any operation involving many employees. Green is not sharply focused by the eye and does not lend itself to angularity. It is a 'big' colour which can dominate the eye without disturbing it. There are often pre-

judices against green, particularly religious prejudices, but these prejudices seldom extend to its use as a furnishing colour. Many people set great store by green; one of England's oldest and best-known tunes is *Greensleeves*, but on the other hand, some people will not have it in the house.

Green is associated with movement in the same way that red is associated with prohibition of movement. It is enhanced by daylight fluorescent lamps but any green-coloured light shining on the human complexion should be avoided at all costs. Best not used as an illuminant except in certain industrial applications but may be used for lampshades; dark green is a mellow colour for well-shaded electric light or lamplight.

6.2 Attributes

Age	Mainly appeals to older people, but there is often a strong demand from the young, especially for brighter greens but usually for short periods; white/green combinations appeal to the young.
Appearance	Suitable as a contrast, but too much green reflected on to the human complexion can create a sickly effect and green light should be avoided at all costs. Avocado tends to appear bleak and may give people a sallow look. Sickly yellow-greens are best avoided because their after-image can be disturbing.
Associations	The country, open air, apples, fields, emeralds, pine trees, spring, summer, freshness, trees generally, agriculture, British racing cars, farm products, cosmetics, jewels such as jade, jealousy, inexperience. Strong associations with religion, especially in Ireland and in Moslem countries, and there are prejudices against it for that reason. Associated with safety because growing crops suggest safety. Means joy in Eastern carpets but is not seen in Persian carpets for religious reasons.
Fashion	Neutral, but strong yellow-greens, such as lime green, are high fashion. Darker greens appeal to men.
Impulse	Luminous shades of green have good attraction value, especially those shades having a good proportion of yellow. Other variations are mainly suitable as background.
Markets	Appeals to most markets but watch prejudices. Lime and similar types of yellow-green can be recommended for high-grade markets; pastel green is well liked by businessmen.
Mood	Denotes freshness, restfulness, the outdoors; soothing, refreshing, abates excitement, non-aggressive and tranquil. Creates a feeling of spring and of the country. Fresh and translucent but pastel green can be a little subduing; dark greens tend to be rather depressing; a greyish green creates an influential image.

Personality	Green people have a balanced personality and are good workers, they are good citizens, loyal friends, frank, moral. For escapists and country lovers who live in towns. People who dislike green are frustrated and individualistic.
Preferences	Choice 7 in children, 3 in adults.
Presentation	Clear greens on the yellow side are suitable for many applications; medium shades have good attraction qualities and good visibility. Good recall value.
Products	Business, farm products, florists, trees, cosmetics, lime juice. Pastel greens appeal to businessmen, clear greens are best for farm produce but not recommended for products sold to farmers; lime green is for cosmetics; strong greens are for masculine toiletry; recommended for domestic appliances and kitchen units but not for housewares; for confectionery containing peppermint. Avoid green for childrens' wear and for anything put in the mouth such as food or toothpaste, although the food prohibition applies mainly to the sickly yellow-greens.
Recognition	Excellent recognition qualities.
Reflectance	Sage green 36 per cent, typical dark green 9 per cent.
Regional	Needs care in Ireland and Scotland and in any region with an Irish element.
Seasons	The colour of the country, particularly associated with spring and to a lesser extent summer. In appropriate circumstances use green for St Patrick's Day in March; dark green has an association with Christmas.
Sex	Appeals to both sexes, but dark greens appeal particularly to men; olive is masculine. Recommended for a man's room.
Shape	Suggests the form of a hexagon.
Size	More or less neutral; the lighter shades of green will make an image larger, but darker shades may make it seem smaller, and there will be an equivalent effect on surfaces.
Smell	Typical colours having an associated smell are pine, wintergreen, sage, olive, apple, lime. Green is also associated with many odours including trees, shrubs and herbs generally. It has been used successfully for scents having a country atmosphere and has pleasant associations.
Stability	The safety associations of green suggest stability and security and greyish green creates an influential atmosphere. Restrained colour; darker shades may be a little depressing.
Taste	Suggests a lime flavour to beverages and coolness in cigarettes. The shade of green may be significant with some vegetable products. Light greens convey a pleasing taste.

Tradition	Light and medium greens distinguish the Adam and Regency periods, and moss green belongs to Georgian times. It was common to use a rich, dark green for wainscots in the Queen Anne period, and green has been used throughout the ages in interior decoration. Traditionally, dark green has been used for executive office furniture, and British racing green is for cars. Green is also associated with Ireland and with Catholicism, and this is one reason for prejudices against it.
	Adam was a greater user of delicate pastel greens and recommended them for ceilings to take the glare off; pale green was favoured by William Morris; greyish green was very popular in the eighteenth and nineteenth centuries, and Georgian green is considered to be a natural background to antique furniture.
Visibility	Green has many of the properties of blue; it is a restful colour and kind to the eye, but it does not always provide good contrast and tends to retire; it is particularly difficult to distinguish in country conditions. Yellow-greens have excellent visibility and have many of the properties of yellow, although they may not be well liked.
Warmth	Soft colour, neutral, neither inviting nor unfriendly.

6.3 Functions

Camouflage	Darker greens may be used to hide soiling.
Coding	Excellent recognition qualities, and yellow-greens have good visibility; can be recommended for identification purposes, and strong variations are better than pale greens.
Insect control	Mosquitoes are neutral to green; 13 per cent of beetles react to yellow-green, and bees are sensitive to greens.
Pipeline identification	Green for water; with red for condensate; with white for chilled water; with brown for town gas; with dark brown for lubricating oil.
Protection from light	A yellowish green has the best protection qualities and minimises rancidity, but green will only exclude light up to a wavelength of 350 nanometres.
Readability	White on green, green on white, red on green, green on red have good qualities.
Signalling	Recommended for signalling; good recognition qualities.
Visibility of controls	Can be recommended for controls because it has good recognition qualities but not for domestic appliances.

6.4 Applications

Biological
: Psychological effects: a predilection for green sym-
bolises the escape mechanism; it is the colour of people
who are superficially intelligent; suggests an escape from
anxiety, a sanctuary in nature; green people will crave
company when under stress. Likely to be preferred by
the mentally ill and is a great favourite of psycho-
neurotics and psychotics.
Medical effects: decreases restlessness in torticollis;
causes the least increase in autonomic arousal; anxiety
states are improved by tablets coloured green. Green
glasses which screen out red rays help mental patients.
Green protects against red and yellow in Parkinson's dis-
ease.

Children
: There is often a strong demand from teenagers and the
young for lighter greens, which also appeal to young
children. Spring green teamed with pink or peach is
particularly good for children and chartreuse is recom-
mended for the bedroom of a small girl. Green is not
recommended for childrens' clothing.

The country
: Cool and restful but tends to cause unpleasant re-
flections on food. In any case, there is always plenty of
green in the country and some change from it may be
desirable. A light green might be used in meat-
processing plants.

Export
: Recommended for interiors in sunny areas and for exter-
iors in temperate zones, but some shades can be used for
sunny exteriors where natural green is lacking. Has a
general cooling effect and is widely liked; vivid greens
are often used in sunny areas for both interiors and ex-
teriors. Has religious connotations and needs to be used
with care in Moslem countries and where there is an Irish
element; there are often local prejudices against green.
France: associated with cosmetics.
United States: associated with confectionery.
China: green hats are considered to be a joke.
Czechoslovakia: green means poison.
Turkey: a green triangle indicates a free sample.
Ireland: use needs care.
Arab countries: use needs care.
Europe: as a whole, Europeans tend to favour green.

Exteriors
: For those who are self-confident, assured and always
content.
Doors: grey-green is good, but dark green is better for
doors of brick houses; all shades of green are suitable for
doors in the country, especially if sparked off with white.
Thames green doors look good with pink walls; sage is

sophisticated for doors in towns; dark olive is also suit-able.

Windows: grey-green for outer frames of white windows.

Walls: green goes well with neighbouring pink; pastel green for an elegant house; dark green with white windows and doors. Green looks best linked with white or cream in towns; sage green and olive green look best when set off by white woodwork. Dark green is best for walls in towns but does not look right in the country, although it can be used at the seaside; willow green helps a house to blend into its setting. Apple green is good for a period house.

Industrial: spruce green is recommended for factory in-teriors and may also be used for structures and for accent.

Farms: a medium muted green is recommended for walls.

Food The natural colours of vegetables, fruit and other good things to eat; for country products generally. Soft colour, but neutral in digestion terms. Light, clear greens are best for food but avoid greenish yellow, yellow-green and greenish orange. Greens should be selected carefully to match the natural colour of the product. Green suggests spoilage in association with meat and mould in association with bread, while some yellow-greens tend to suggest sickness, and olive greens are also best avoided, except where they are the natural colour of the product. Lime is the natural colour of many products and it also suggests a lime flavour.

Food packaging For vegetables and country products generally but select the shade with care to convey the right association with the product; clear and bright shades are best. Avoid in association with bread, meat, iced cakes and avoid yellow-greens because they are the colours of sickness. Green is good for Easter packaging. Lime green and similar shades have good attraction value, but otherwise greens tend to be neutral. Use for vegetables, country products, peas, baby foods.

Food in the home Light and medium greens are better than dark greens for most uses; olive shades are not well liked in association with food, although avocado has been a strong seller in kitchen units. Clear greens are suitable for food containers, and muted greens might be introduced in an up-market range. Pastel and pale greens can be recom-mended for tableware in either clear or muted vari-ations; deep green is best not used. Light or medium greens provide a cheerful table covering.

Food processing	Recommended for food plants, especially where a cool atmosphere is desired; lighter greens are flattering. Recommended for meat processing and vegetable processing, but darker greens should be avoided lest they cause an unpleasant reflection on the food. Yellowish greens may cause nausea. Use greens with care in the country, they can be overdone; green is provided by nature and something warmer may be better.
Food service	Excellent in association with most foods but not as a background to meat or bakery products; clear greens are best. Use for overall surroundings, immediate surround, presentation of salads and green foods.

- Light Plates, serving dishes, table tops and so on; interiors generally (combines well with peach); presentation of salads; food display fixtures.
- Medium Immediate surround, overall surroundings, immediate surround to display.
- Dark Accent or decorative purposes in small areas only.

Food stores	Excellent for many foods but not for meat or bakery products. Clear greens are best and may be used for walls and immediate surrounds. Association with fresh vegetables and cool drinks. Avoid use for exteriors of grocery stores.

- Light For interiors generally and especially for vegetables; combines well with peach. For cooking areas.
- Medium Immediate surround to display, particularly of vegetables; may be used for accent.
- Dark Not recommended.

Industrial plant and equipment	Green is restful in nature and not as cooling as blue; it has more character than grey and is suitable for machinery and all industrial equipment. Light greens may be used for highlighting working areas, while medium greens are suitable for machine bodies, preferably in greyish tones. Dark greens have few uses. Safety green is used to indicate first-aid points and safety exits.
Merchandising	Basically neutral, but luminous shades have good impact; excellent recognition and visibility qualities, well liked. Best used for background purposes and to create a pleasing immediate surround. Darker greens should generally be used for accent purposes, but forest green can be recommended to provide dramatic emphasis. Darker greens can be used as a background for light coloured merchandise, as a background for fashion merchandise and especially in alcoves. Stronger yellow-greens have good attraction value.

Safety	NSC.
Green	Green (BS 14E53) is recommended with white contrasts for exits, escape points, first-aid points and safety equipment. Overseas uses are similar; large green crosses are painted on walls or columns to aid location.
Signs	Excellent qualities for signs; a luminous medium green is recommended because dark green may be indistinguishable from black, especially in dim light. Excellent recognition qualities but difficult to identify against a green background. A little retiring and may not provide good contrast. Not sharply focused by the eye and best as ground. Associated with movement generally.
Television	Most variations reproduce acceptably, but some will pick up a yellowish or lime green cast in one direction and blue cast in the other direction. Dark green tends to look black, and olive is best avoided. Forest green will fail to register small differences. Combinations of green with red or with blue tend to be difficult.
Texture	Suitable for most textures.
VDUs	Screen: yellow-green on dark green is recommended; orange on dark green is acceptable; green characters can be used on a neutral dark grey or black background. Equipment: medium green is acceptable. Surround: green is acceptable and pleasing but avoid yellowish or harsh greens.
Woods	Medium clear green with mahogany, rosewood, light oak, pine, beech, antique furniture. Light clear greens such as lime with beech. All greens go best with pine and paler woods. Green emphasies old furniture.

6.5 Interiors

Domestic interiors

Light variations	Pale grey-greens are restful but rather limpid; the lighter greens are restful and refreshing without being too cool and are lively without being aggressive.
Medium variations	Lime green is a high-fashion colour and can be used as an accent against a neutral background; it looks good in the tin but less good on the wall. Avocado tends to appear bilious and may give people a sallow look; the same applies to chartreuse.
Dark variations	Olive green can be just plain gloomy; it is a masculine colour.
Usage	Green transforms the gloomiest room and brings a breath of fresh air into the city. Greens are best used as background, but luminous tones can be used for accents such as cushions and lampshades. Bright green is not

easy to introduce into a family home, and no other colour should be allowed to intrude; it is probably most easily used in the dining room. Green can be the most pallid and doleful of foreground colours or the most deep and enriching of background colours, but use out of place can depress the temperature of a room; it has considerable furnishing appeal and emphasises old furniture. Sickly yellow-greens are best avoided. Green is refreshment pure and simple, it is wonderful with white and friendly to the whole spectrum; apple green is nature's own colour and creates spaciousness and elegance.

Room character
Greens have a quieting effect but some variations may be rather cool, well used they can make a room look sunny. Green is the most restful colour to the eye, being cool, fresh, elegant and dignified.

Room aspect
Green should be avoided in a north-facing room but light green is good in sunny rooms – it has a cool quality and reduces glare.

Room size
Green helps to make a room look larger and airier; pale greens make a room look larger but are cold.

Room features
Green will go with pine or paler woods.

Room function
Green is excellent for a study or any area where concentration may be required; dark greens are an ideal background for books. Lighter greens are good for a dining room. Green is restful and a good choice for a bedroom; pale greens are relaxing. Pale greens can be recommended for a television room and are very refreshing in the kitchen.

Commercial interiors

Attention is drawn to the uses in specific environments listed in 6.7 below.

6.6 Combinations

Good harmonies
Most variations with blue, yellow, orange, brown (the colours of nature), magenta, shocking pink, candy pink; bright variations go with cream, yellow, lemon (daring), brown. Pale green with deep blue, darker bronze greens (create a delicate effect), grey-green, mauve, jade green. Emerald green with mauve, blue, vermilion (a strong combination). Grey-green with pink, beige, peach. Khaki with orange, tan, auburn; lime green with yellow, brown, fern green (unusual, high intensity). Olive green with yellow, gold (traditional, restful), mauve, blue. Coffee goes well with most kinds of green.

Avoid	Olive green with pale tints of red, blue or violet and, in fact, any dark green.
Good contrasts	Green with red (causes red to advance), soft gold, tan, pink.
Accentuated by	Proximity to violet, black, grey.
Diminished by	Proximity to orange, brown.
Accentuates	Red, violet.
Diminishes	Blue-green.
Caution	Green tends to modify most colours except yellow and blue.
Suggestions	• If green is seen in proximity to blue-green, the latter inclines to blue.
	• If green is used with grey, it becomes more intense and usually yellower; the grey inclines to red.
	• Crystal green with white and woodland green provides a fresh country effect in urban areas.
	• Metallic green, metallic bronze and white will attract attention; it is distinctive and strikingly different.
	• Grass green and pillar-box red are an ideal combination for kitchens and bathrooms; they are bright and cheerful.
	• Sea green is complemented by tan or fawn, producing a warm, muted variation which is flattering to any furnishings.
	• Green goes well with dawn yellow, producing a reminder of daffodils and primroses.
	• Soft greens are accentuated by alice blue; pastel green with grey and pink is restful; pale green with purple and mauve looks well against an oatmeal background; green and cream are relaxing partners.
	• Three shades of green for food service is restrained and suggests the country.

6.7 Uses

Consumer applications

Bathroom products Green is the colour of nature, it is restful and relaxing and has universal appeal in the bathroom, it never seems to become monotonous and is suitable for those who desire a relaxing bathroom. However, there are some prejudices against green and some people will not have it in the home at any price. Pastel greens and medium clear greens with a yellow cast are best; deeper shades have been introduced but have limited appeal. Muted greens such as avocado or olive green have been very successful, but deeper greens with a blue cast are best avoided because they tend to be harsh and unfriendly. Bright, clear greens are popular in Europe but have not caught on with the British public.

Bedroom products Green is a restful colour and is frequently used for bed-rooms, especially in the country, although there are some prejudices against green for beds; it is surrounded by superstitions; whether people will buy it largely depends on trends. It appeals to older people but is probably best mixed with yellow to create a 'country' look; this latter appeals to the young and helps to brighten up a dull bedroom. It is said that if you like a green bedroom you need to impress people. Green is best used as background, but luminous shades can be used as accents; well used it can make a room look sunny and goes well with pine and paler woods. Sickly yellow-greens should be avoided; their after-image is disturbing. Spring green is a soft tint for a study or a bedroom and is recommended generally for bedrooms teamed with yellow. Chartreuse is recommended for the bedroom of a small girl.
- Light Pale greens are irresistible to the owners of cottages; brighter shades have good impulse attraction.
- Medium Moss green is for lovers of nature.
- Dark Richer dark greens are ideally suited to town bedrooms.

Domestic appliances Recommended for appliances but should be used with care because of the prejudices against it; variations are important. Avocado has had a long run of popularity for kitchen units but hard greens have been less acceptable. Can be recommended for space heaters, but greyed greens would be better than bright greens. Excellent where an unobtrusive effect is desired; restful.
- Light Can be used for almost any appliance, but lighter greens are probably best for small appliances.
- Medium Can be used for almost any appliance. More impact.
- Dark Best avoided except for large appliances.

Kitchen products Green is a very suitable colour for kitchens because it is cool and restful but has had a somewhat chequered career. Avocado has been well liked in the kitchen for many years, but bright greens have been less successful; they were popular on the Continent but did not find favour with the British housewife when introduced into this country. Great care is necessary in the selection of green for any kitchen product; green cools down a kitchen. If green is used, it is best used for textiles and items that are inten-ded for accent purposes, although avocado has been widely used for kitchen units. The green and yellow 'country' look is popular as a means of brighten-ing up the kitchen. Light and medium variations are best for most kitchen products and avoid sickly yellow-greens.

Housewares Pale, clear shades are clean and cool looking and, in theory, are excellent for kitchen utensils, but there are many prejudices against green. Excellent in association with food but has little impulse attraction; follow trends closely. Pale variations are suitable for the interiors of vessels and for tableware generally; muted greens are not suitable for interiors but can be used elsewhere – the same applies to deeper greens. Shades such as avocado would be wanted for decorative purposes. Strong, clear greens with a yellow bias are recommended for most tableware applications – excellent as a back-ground to salads. Clear greens are suitable for food containers, and muted greens might be included in more expensive ranges as a fashion element.

Living room products Attention is drawn to the remarks under Domestic interiors in 6.5 of this part.

Window decoration products Very suitable for window decoration, but paler shades are recommended; deeper greens would be overpowering except for accent purposes. Creates a country look and combines well with yellow; this combination is very suitable for kitchens and for rooms with a limited outlook. Strong greens are recommended for awnings. Pastel greens suggest a cool interior and are very suitable for hot climates; spring green is very cooling.

Graphical applications

Packaging One of the more difficult colours because of the prejudices against it and because it has little shelf impact, but it can be recommended for many packaging applications and to create associations. Bright and clear variations are generally recommended; a bright apple green is excellent. Restful and kind to the eye but does not provide good contrast and tends to retire; not sharply focused and does not lend itself to angularity.

- Light Few packaging applications.
- Medium Lime green is recommended for cosmetics and for better-class markets. Emerald green has a neutral effect and can be used for caps and closures; emerald, lime and spring greens have a high proportion of yellow and therefore good impulse attraction. Medium clear greens may be used for farm products but not for products sold to farmers.
- Dark Excellent foil and recommended for mens' toiletries.
- Avoid Sickly yellow-greens for products put in the mouth; although they have good visibility, they are not well liked. Cotton-tipped swabs packed in pink and white sold well, but not in chartreuse because they reminded people of dirty nappies.

Print As for packaging. Green is primarily a background colour, although some yellow-greens have good attraction value. Particularly suitable for any application that has to do with the country, travel, camping and so on. Greyish greens create an influential image. Green is a poor colour to use for direct mailings to farmers because they are in a green atmosphere all day long, but it can be used with advantage for mailing to other categories, especially in winter, when it has psychological appeal. Green envelopes have been found successful for mailings, and green paper is recommended for ledgers and inventory sheets. Not recommended for tags as a general rule, but some greens may be suitable for products aimed at men.

Images As for packaging and print.

Vehicle liveries As for packaging and print; can be recommended where the association is right. Green is very suitable for greengrocers because it brings the farm into the city, and also for florists; clear greens are best. Bright green may be used for agricultural vehicles. Dark green is not recommended for

passenger vehicle exteriors; it tends to be depressing and lacks visibility. Greens are best avoided for cab interiors because there are superstitions connected with it. Green is a standard safety colour for first-aid points and the like, and this may have vehicle livery applications (e.g. for chemists). In general terms, many of the remarks made about blue also apply to green; it does not provide good contrast and tends to retire. It is particularly difficult to distinguish in country conditions; the Post Office abandoned the use of green for its service vehicles and painted them yellow to ensure better visibility.

Environmental applications

Catering Green can be used for almost all food applications and is good for almost any area and can be used for walls, signs and displays. Clear greens are generally best in catering applications, but muted greens can be used for decorative purposes.

- Light Restaurants, kitchens, hotel rooms, display; muted versions can be used for exteriors in cloudy climates.
- Medium Hotel rooms, coffee bars, restaurants, display, interiors in a sunny climate; muted versions in restaurants, lounges and hotel rooms.
- Dark Accent only, and in small areas.
- Avoid Yellow-greens in most applications, olive in food applications and dark greens in kitchens, hotel rooms and lounges.

Factories Greyish greens are generally best for industrial use; green is one of the best of all hues, fresh in appearance but slightly passive in quality, it cools a warm area but is not as cold as blue. Excellent in fine assembly or where materials are coloured. Appeals to both men and women. Brighter greens are appropriate to physical tasks, monotonous assembly and where close attention to the task is not required. Softer greens are recommended for mental tasks, fine assembly and inspection, relaxation areas.

- Light For walls where materials are highly coloured and for critical seeing tasks; for small areas, canteens, drawing offices, offices generally; for power stations, chemical plants, meat-processing plants; recommended for machine shops (upper walls) and where manual tasks are carried out.
- Medium For end walls in areas where inspection and assembly is performed; in drawing offices; for machine bodies; for first-aid rooms. Muted greens are recommended for dressmaking shops. When used for end walls, they may be combined with light green side walls.
- Dark Suitable for exteriors, otherwise only for accent purposes.

Offices Light and medium greens are very suitable for office use and are well recommended; green is very suitable where a restful environment is desirable and where intense mental tasks are performed. Appeals to both men

and women, but too much green may have a sickly effect on appearance. Safety applications are important; green is used to mark escape points, first aid and so on. Well recommended for screens; muted greens are preferred, and very bright greens are best used for decorative purposes only. Jade is particularly recommended where concentration is important.

- ● Light Walls generally, including general offices, executive offices, conference rooms, drawing offices.
- ● Medium Recommended for end walls where it acts as a visual cushion.
- ● Dark Accent purposes only.

Retail Green has universal appeal and is good for almost all merchandise and merchandise areas, it can be used for walls, signs and display. Combinations of green and blue are not recommended, it would be better to use blue-green, but green is a good background colour when used with blue or grey fittings. Clear greens are generally best in the retail environment, but muted greens can be used in more sophisticated applications.

- ● Light Dignified for walls; for kitchen areas, general stores, walls of car salerooms.
- ● Medium For rear walls, emerald signifies high fashion; for first-aid facilities, restaurants, walls of china departments. Chartreuse is good for exteriors and in flower shops but not for food; use in small areas in sophisticated shops or speciality shops, also with expensive products.
- ● Dark For small areas on rear walls; with care as a background for china; forest green is good for dramatic emphasis and as a background to displays, but use in small areas.

Schools Conducive to study and allows walls to recede; may be used instead of blue-green, but muted variations are recommended. Some yellow-greens may give pupils a bilious look. Greens have a calming effect.

- ● Light Upper walls of corridors; walls in secondary grades where the light is strong; laboratories, art rooms, teachers' rooms.
- ● Medium For lower part of corridor walls.
- ● Dark Not recommended.

Hospitals Cool and flattering and recommended for use in hospitals where it has a calming effect. Yellow-greens should be avoided because they are unfavourably associated with health and tend to give people a bilious look. Tones should be slightly greyed; grey-green is an alternative to blue-green. Green is widely used in eye hospitals for its restful qualities.

- ● Light Chronic wards, wards generally, surgeries, laboratories, treatment rooms, recovery rooms, utility rooms, kitchens, food service areas, offices, reception, waiting rooms.
- ● Medium End walls in conference rooms and wards generally; small wards, with red accents; surgeries, as an alternative to blue-green; laboratories, treatment rooms, recovery rooms, kitchens, reception areas.
- ● Dark For signs indicating wards, admission, clinics, laboratories.

Commercial applications

Office supplies Suitable for many purposes and appeals to both sexes; medium clear greens are especially suitable for the office market and particularly the higher-grade end, darker greens are recommended for executive use. Stronger greens have reasonable impact without being too impulsive and are suitable for presentation use. Green for consumer items needs care. Without being an impulse colour, green has good attention-getting qualities in the lighter and medium shades and has good recognition qualities; it is suitable where a restful environment is desired and where intense mental tasks are performed. Darker greens are traditional for certain office uses and are suitable for desk furniture. Muted greens have slightly more dignity than clear greens but lack sufficient impact for presentation purposes except where it is desired to convey stability. Greens may be used for consumer items when trends so dictate. Excellent recognition qualities and good for identification, but use stronger greens.

Paper and board Green is an excellent colour for paper, particularly the paler variations. It is cool, suitable for almost any purpose, appeals to both sexes and all income groups; suggests spring, summer and the outdoors and is associated with many trades and services such as florists. Good background for print and can be recommended for maps, charts and other outdoor applications because it creates less glare than white. Emerald green has most impact and commands attention without being too impulsive; it has fulness of hue but is non-aggressive and has qualities similar to those found in nature. Lime green is a warmer tint with high visibility and good attention value, it caters for advanced tastes but gives a message a dramatic quality; particularly appropriate for higher-grade markets and upper-income groups and has a fashion aspect; can be used for products and services where a fashion note is desirable and also for spring and summer promotions. Green paper with green-blue ink is lively; green ink with canary yellow paper has an action image.

Attention is also drawn to the notes in Section 1 of this part.

Surface-covering applications

Attention is drawn to the explanation of colour selection for surface coverings in Section 1 of this part.

6.8 Legend

Green is a colour which is surrounded by a great deal of lore and legend mainly because it is associated with growing crops and with life itself; the annual renewal of vegetation in the spring was a source of great interest to our ancestors. The 'Green Man' pub is a survival of spring festivals. It has been considered unlucky to bring green into the house since Roman times, when green was the colour of inferior gods, which were not brought into the innermost household.

Green was the colour of Venus, and Chaucer considered it to be a symbol of lust; brides wore green in the Middle Ages, and Mary, Queen of Scots, was said to be one of the earliest brides to wear a white wedding dress; in later times a girl with a 'green gown' was pregnant illicitly and green for wedding dresses was frowned upon in Victorian times.

The Puritans considered green (and all colours) to be heathen and Catholic, and it became especially associated with Irish Catholics. This prejudice still exists; the Protestants adopted orange as their colour from William of Orange. There are many religious associations. In the New Testament green is called the colour of God, and the Holy Grail is said to have been green; The Holy Grail is closely associated with the King Arthur stories, and the search for the vessel represented the eternal quest for truth. Green is particularly associated with the Moslem faith; those who perform the journey to Mecca are entitled to wear a green turban, and the flags of most Moslem countries are dominated by green.

The ancient Egyptians produced a green pigment from elder leaves and the bark of the larch tree, while true Irish green is said to be produced by boiling vegetable roots in bogwater. In Greek symbolism green was for water, and it meant water to Da Vinci; it stands for wood in Chinese symbolism and also represented the east, although to Hopi Indians it meant the west. It was the colour of the god Osiris in Egypt.

Green is the demon of jealousy but quite why it is difficult to determine. Here are some other points:

- Greenhorn derives from green vegetation, meaning immaturity.
- The Celtic 'glas' meant green and stood for water, hence 'glass', which has the appearance of solid water.
- Green pebbles were found in early burials, and in China green jade is placed in the mouths of the dead.
- Sir Walter Scott associated green with the elves and with vengeance; he reported it as a colour fatal to several families in Scotland.
- Green was the colour of the banshee, a supernatural woman who heralded death in Celtic households.
- Fairies were said to be dispossessed druids, the lower orders of which dressed in green.
- There is a longstanding superstition in northern Britain that green is unlucky, and this derives from a one-time dye that was poisonous and tended to kill children who chewed garments dyed green.
- The Japanese attach more importance to green in their gardens than to a blaze of other colours. The Chinese are also appreciative of green.
- Pale greens have long been popular for womens' clothing in this country because it is supposed to enhance fair skins; it is less popular in Italy and France. Superstition is limited to yellow-greens.
- Green signifies joy in the colours of Eastern carpets but is not seen in Persian carpets.
- Greenbacks are so called from the colour of dollar notes.
- Green with greed comes from the physical colour of those who overeat.

7 Yellow group

7.1 Character

This group includes pure yellows and muted variations which have many uses in decoration. At the green end of the spectrum, yellow-greens tend to be dominated by green, and in the other direction yellows are dominated by red, but yellow itself eliminates soft colours. Generally a mass-market colour except, in some subtle variations; British people tend to be cautious of yellow, and there are some prejudices against it. It is outgoing and conveys stability rather than dignity. In its purest form it radiates warmth, provides inspiration and prompts a sunny disposition.

Yellow is a warm, hard colour, inviting to the viewer and incandescent. It blends well with orange, brown and green to create a look of the country; it blends particularly well with tan. Yellow-greens are not liked for anything put in the mouth; lemon yellow in large areas tends to cause a form of jaundice which makes people look ill. Harsh, acid yellows are best avoided. It is easily focused by the eye without aberration and is only slightly refracted by the lens of the eye. Sharp, angular and crisp in quality but without solidity; reflects more light than any other colour. It is excellent for accent but very deceptive when seen on a colour chip. Yellow loses much of its radiance on textiles such as felt or wool. It is said to stimulate the intellect and for that reason is often used in libraries.

Yellow eye glasses are said to make for clearer vision. Some research has suggested that yellow rooms are more often vandalised, and one researcher claims that yellow incites the educated middle classes to violence! Yellow is

appropriate for physical tasks, monotonous assembly and where close visual attention to the task is not required. It is almost always a safe colour when taking or sending flowers as a present, because it goes with almost any colour scheme.

Yellow may appear overpowering at first sight in daylight, but the eye soon tires of it and it may become greyish. It tends to lose its identity in artificial light and often has a strong greenish tinge in fluorescent light; this causes trouble in some graphical applications, particularly in association with food. Yellow and yellow-green are brightest in strong light; yellow is enhanced by warm light but tends to look quite different in daylight. Incandescent light and warm white fluorescent light add richness.

Acuity is best in a light which has a yellow quality, because the sensitivity of the eye is at its maximum, but it may have poor colour-rendering qualities. Yellow-tinted light is pleasing and best at low levels of illumination. Yellow is at the top of the list of desirable illuminants, followed by orange-yellow. Yellow-greens provide good acuity but are not flattering to human appearance. Light that is artificially tinted yellow is difficult to handle because it tends to make people look ill. Acceptable for lampshades.

7.2 Attributes

Age	Appeals to the young, especially the very young, and teenagers.
Appearance	A flattering colour which provides a warm sunny effect, but too much yellow reflected on the human skin may make it look sickly; this applies particularly to the harsher yellows.
Associations	Energy, spring, summer, sunlight, newness, caution, quarantine, cowardice, defeat. Kodak yellow is associated with photography world-wide; favoured for female babies; signifies honour when used in Eastern carpets.
Fashion	Generally mass market, except for some subtle shades; golden rod and canary yellow are high fashion.
Impulse	Excellent attention getter, but avoid pale yellows.
Markets	A mass-market colour; gold and similar variations are suitable for higher-grade markets and golden rod is recommended for business markets, especially where it is desired to create impact.
Mood	Energising and conducive to vitality; most cheerful of colours, but pale yellows produce a quieter note; incandescent, suggests the spring, sunshine and holidays. Friendly, provides inspiration and a sunny disposition; the happiest of colours and 'brings you in out of the cold'.
Personality	People who like yellow are idealistic, intellectual, aloof, have imagination and nervous drive and like novelty. People who dislike yellow are seeking reality, critical. For peace lovers.

Preferences	Choice 1 in children, 8 in adults. Yellow is bottom of the list of preferences for adults because the eye yellows with age, but it is, nevertheless, the most recognisable and visible of all colours and has many practical uses whether people like it or not. Yellow particularly appeals to babies and very young children.
Presentation	High visibility and excellent attraction value but may be a little overpowering for many applications. Muted shades, such as gold, are dignified and convey an impression of luxury.
Products	Travel, food, photography, cosmetics; associated with lemon drinks; recommended for childrens' wear.
Recognition	Good qualities, but although highly visible, it is not as easy to recognise as red.
Reflectance	Average yellow is about 50 per cent.
Regional	NSC.
Seasons	The colour of sunshine, especially associated with summer but equally good for spring (daffodils). Deeper yellows are for autumn.
Sex	Essentially feminine but stronger shades appeal to men; commonly used for baby girls.
Shape	Suggests the form of a pyramid or triangle with its apex or point down.
Size	The largest of all colours and surfaces seem nearer; also the colour giving the sense of lightest weight.
Smell	Typical colours having an associated smell include vanilla, lemon, honeysuckle, saffron.
Stability	Suggests vitality, but muted shades such as gold create dignity and stability.
Taste	In some cases may suggest a weak product, but a dark yellow could suggest a strong-tasting butter or cheese. Suggests a lemon flavour for beverages; soft yellow is pleasing.
Tradition	Gold was used extensively in Georgian times and has always typified richness; traditionally associated with children.
Visibility	The most visible of all colours when the eye is fully adapted to light and stands out sharply in the dark. It makes objects look larger, tends to advance and is the brightest colour; however, it reflects a good deal of light and may be tiring to the eyes. Variation is important; a pastel yellow would look little different to white. A strong yellow, approaching yellow-orange or red-orange would have maximum visibility and recognition value. Canary yellow has particularly high visibility but does not have maximum impact.
Warmth	Hard colour, warm, inviting to the viewer.

7.3 Functions

Camouflage	No functions.
Coding	Excellent visibility but only third in recognition qualities; strong yellow should be included in most ranges, but pale yellow may be difficult to distinguish from white.
Heat control	Reflects heat well and tend to protect the contents of a package.
Insect control	Attracts houseflies but repels mosquitoes. About a third of all beetles like yellow, including Japanese beetles.
Pipeline identification	Yellow with a black stripe warns of dangerous contents; with a black trefoil symbol warns of radiation hazards.
Protection from light	Excludes more harmful effects than blue or violet. Amber has excellent qualities for protecting products from the effects of light; a greenish yellow protects from rancidity.
Readability	Black on yellow, yellow on black, blue on yellow, scarlet on yellow, yellow on blue, purple on yellow all have good readability.
Signalling	The most visible of all colours but lower in recognition value than red.
Visibility of controls	The best of all colours for controls and dials which have to be seen in normal lighting conditions. Yellow or yellow green would be excellent for illuminating panels.

7.4 Applications

Biological	Psychological effects: colour of the morbid and feeble-minded and also of great intelligence. Intellectual reformers may like yellow. Medical effects: preferred by schizophrenics; dangerous in Parkinson's disease; tablets coloured yellow improve depression.
Children	Highly recommended for children and appeals to the young generally, but it has been claimed that it can incite children to vandalism. Light yellow is recommended for a child's bedroom; darker yellows are suggested for a playroom.
The country	Pale yellow is suitable for dairies and dairy plants.
Export	For exteriors in sunny areas and interiors in temperate zones but may be overshadowed by natural sunlight. The high-visibility qualities of yellow make it suitable for exteriors in any climate. Yellow conveys food in most countries except Switzerland. Israel: avoid yellow. Eastern countries: yellow means plenty but can also mean pornography.

Switzerland: conveys cosmetics.

Sweden: gold is not recommended for packages.

Pakistan: saffron and black are the colours of hell.

Buddhist countries: saffron is the colour of priests.

Exteriors For light-hearted, cheerful and friendly people. Pale yellow lacks impact in urban conditions and very deep yellow can be unpleasing, so can strong harsh yellows.

Doors: mustard can be used for a door of a pinkish brick house. A yellow-green door is suggested with blue walls.

Walls: mustard walls create a sunny effect; golden yellow looks fresh on the greyest day, team with white; yellow is too dazzling for a south-facing house.

Walls: pale yellow can be used for a town house with woodwork in white, pale grey or off-white, a strong yellow can also be used; lemon is a possibility for a cottage in the country and deep mustard could also be used in the country; pale yellow for colour-washed walls and jonquil for plaster walls; lemon and white for a terrace cottage.

Industrial: right association with food.

Farms: medium or dark muted yellows are recommended for roofs.

Food The natural colour of butter, cheese and other foods, stimulates digestion and is excellent for food, especially the paler variations. Butter yellow is a good food variation, and gold has a high-class image; yellow-green, greenish yellow, mustard tones, orange-yellow and cold or harsh variations should not be used. Appeals to children and has good attraction value, conveys a lemon flavour and may also convey a mild taste.

Food packaging Highly visible and recommended to attract attention but use butter yellow and not harsh variations; gold denotes quality and richness. Associated with Easter packs and excellent for children, but avoid variations listed above. Use for butter, cheese, baby foods, split peas, corn.

Food in the home Excellent in association with most foods; muted variations can be used to suggest richness. An essential for any food container range; deeper and muted yellows can be used and have decorative value; excellent attraction value. Light and medium yellows are preferred for tableware, muted versions may be used, and gold adds refinement. A butter yellow would be particularly good for tableware, but antique gold and similar greenish shades are best avoided.

Food processing Soft yellow and primrose can be recommended as an alternative to white and are warmer than white; can be used with white as an accent to provide variety. Recommended for refrigerated areas, it warms them up; for

	dairies, it is the natural colour of butter.
Food service	Associates well with all foods; paler yellows are preferred, although not lemon yellow – butter yellow is best. Can be used for walls generally, for immediate surround and for presentation; warm yellows are a good general accent colour.

- Light Plates, serving dishes, table tops and so on. Walls in general run of restaurants; immediate surround.
- Medium Walls generally, and for accent.
- Dark Accent and decorative purposes only.
- Avoid Variations mentioned above.

Food stores Excellent in association with food but use paler yellows. Use for walls generally, immediate surround, accents; warm yellow is a good general accent colour; for rear walls in a long, narrow shop. Good for butter and cheese.

- Light Good immediate surround for vegetables; for walls in grocer's shops and wherever lighting is less than brilliant; for refrigerated areas and end walls.
- Medium Display accents.
- Dark Accent only
- Avoid Variations listed above.

Industrial plant and equipment Yellow has few uses in industrial applications because it reflects too much light. Safety yellow is used to mark hazards, including the edge of shears, guards, exposed gears and the like.

Merchandising Strongly recommended for point-of-sale and display applications and appeals to the young; excellent impact value, good recognition qualities and most visible of all colours. Paler yellows are suitable for background and immediate surround. Deeper yellows are best where impact is required; especially suitable to suggest sunshine and the spring, but avoid harsh yellows.

Pattern NSC.

Safety Yellow is recommended with black contrasts to mark hazards which may cause accidents. It is most vivid and high in attention value and useful to mark any hazard which is likely to cut, burn or shock. Overseas it is recommended that yellow should be painted on or near gear wheels, pulleys, along cutting edges, rollers, presses and the hazardous parts of saws; it is also used inside guarding plates and lids and applied to guard rails, platform edges and so on. Yellow and black stripes can be used on the steps of buses to help prevent accidents and one company in the United States reported a reduction of 90 per cent in boarding accidents after paint-

	ing their buses in this way.
Signs	Yellow, or preferably yellow-orange, is suitable for signs and is particularly associated with caution and hazards; it is less likely to cause glare than white, but it can be confused with green, and a pale yellow would look too much like white. Good recognition qualities; black on yellow can be highly recommended where maximum attention is required but is best restricted to cautionary notices. Yellow reflects in the high-visibility region of the spectrum where visual acuity is keen and where images are most easily focused, but although highly visible, it may not be easy to find and identify; it stands out sharply in the dark and provides a sharp, crisp image.
Television	It is not easy to create a satisfactory yellow on the screen because to 'see' yellow the eye must 'confuse' dots of red and green. At the slightest excuse pure yellow becomes tan, orange, mustard, buff or green. The balance between red and green is very critical.
Texture	A light yellow is best on comparatively untextured material, it looks good on shining silks and loses much of its radiance on felt or wool; not recommended for velvets.
VDUs	Screen: yellow-green is the most visible of colours and recommended with green background. Equipment: not recommended. Surround: not recommended.
Woods	Medium yellow with mahogany, rosewood and beech.

7.5 Interiors

Domestic interiors

Light variations	Pale yellows are generally unsuitable for carpets, and lemon yellow, used in excess, is liable to cause a kind of psychological jaundice; it can look sickly but can be recommended to offset neutrals in north-facing rooms and in dining rooms.
Medium variations	Sunny yellow will cheer up a bleak room; it is a very cheerful colour to greet you in the morning and suitable for a breakfast room, dining room or kitchen. Golds create richness and warmth.
Dark variations	Deep yellow is very suitable for a playroom and will provide the most cheerless room with light.
Usage	Yellow is particularly suitable where there is little natural light; it is for peace lovers, but it can be cheap and cheerful. The British tend to be cautious with yellow, and some people find it too invigorating. Yellow is recommended for decoration because so many other colours can be used with it; in fact it is best used with

other colours. Yellows are wonderful to live with but can be tricky and should not be overdone; the warmer the yellow, the more it seems to need a little light relief or bright contrast. Yellows are excellent for accents such as cushions or lampshades and other accessories in a dark room, and because it has high-reflectance qualities, it can be used to lighten a room; it looks twice as bright on the wall as it does in the tin.

Room character | Yellow is the colour of flowers and sunshine and evokes a feeling of warmth and inspiration; when used for furnishings it can be soft and vibrant and is versatile and mixes with almost any other colour to create a bright and uplifting environment. In its purest form it radiates warmth, provides inspiration and prompts a sunny disposition. The happiest of colours and 'brings you in out of the cold'.

Room aspect | Yellow for a north-facing room should be golden, although light versions can also be used; it cheers up dark rooms and brings light and colour to dark corners; it is particularly useful in a room which has little natural light.

Room size | Yellow is the largest of all colours, but because it advances, it tends to make a room look smaller.

Room features | Yellow is not recommended for floors except in the darker variations.

Room functions | Yellow is ideal for basements because it brings light. Yellow, but not yellow-green, can be used for dark dining rooms.

Room users | Yellow is particularly suitable for rooms used by children; sunshine yellow is their first preference as young children but it can also be intimidating.

Commercial interiors

Attention is drawn to the uses in specific environments listed in 7.7 below.

7.6 Combinations

Good harmonies | Yellow with orange, brown, green, ginger, cork, pink, lime green, white, deep blue (although this may be disturbing). Darker variations with orange, ginger, flame (flamboyant), black (dramatic), brown. Strong yellow with red is brilliant. Gold with olive green (traditional, restful). Lemon with gold, mustard, brilliant green (daring). Marigold with brown.

Good contrasts | Yellow with violet; gold with green.

Accentuated by | Proximity to black, dull blue, grey.

Diminished by | Proximity to brown.

Accentuates Blue-green, blue.
Diminishes Red, orange.
Suggestions • Yellow blends well with orange, brown, green to
 create a country look.
 • If yellow and red are seen together, the yellow
 inclines to green and the red inclines to violet. If
 yellow and blue are seen together, the yellow in-
 clines to orange and the blue becomes redder and
 inclines to purple.
 • If yellow is used with grey, it becomes more in-
 tense and usually less green; the grey inclines to
 violet.
 • Yellow with blue-green, white and black is
 conservative and refined but highly visible and
 protects against soiling.
 • Yellow with red is striking and modern; with blue
 is a summery colour for all the year round; with
 green suggests daffodils and primroses; with pink
 is pretty and imaginative; with white is crisp,
 fresh and clean; with black is dramatic and sty-
 lish; with grey is low key and very modern.
 • Orange and lemon go well together.
 • A fried-egg colour scheme would be excellent.
 • Brilliant yellow with apple green is recommen-
 ded.
 • Yellow goes well with turquoise and green, and
 also with grey.
 • Yellow provides a good accent colour with
 cream, beige, brown.

7.7 Uses

Consumer applications

Bathroom products Yellow is a cheerful and sunny colour which is well
 recommended for bathrooms because it helps to brighten up a small room,
 particularly those with little natural light. Pale yellows have long been popu-
 lar for bathrooms and can be recommended, and so can medium clear vari-
 ations. Very deep yellows may be a little overpowering except as accents.
 Muted yellows, such as gold, in medium or light shades can also be recom-
 mended. The country look, a mixture of yellow and green, has been very
 popular in recent years. Yellow has excellent visibility and good impact at
 point of sale.

Bedroom products Yellow is a difficult colour for the bedroom because of its
 tendency to lose its strength in artificial light and therefore it should be really
 deep, but it is best used with other colours such as pink, lime green or white.

However, it is a cheerful colour with good impulse attraction and brightens a dull bedroom; it appeals to the young but is best not used in large areas, particularly lemon yellow. Gold and similar variations have long been popular for bedrooms and convey a feeling of richness; they are warm and cosy. Yellow is particularly suitable where there is little natural light, but the warmer the yellow, the more it seems to need a little light relief or bright contrast; goes well with blue in country bedrooms. If you like a yellow bedroom, you are probably an optimist looking for new and pleasing experiences, and for love; it is recommended for bachelors; gold is recommended for early risers and is cheerful and happy. Yellow with a grey floor is high style for bedrooms and is recommended with green to create a country look.

Domestic appliances Yellow is suitable for most appliances and particularly for kitchen appliances; it is pleasing in the kitchen and is cheerful and has good attraction qualities. Warmer yellows are best for personal products; gold and antique gold convey richness and are very suitable for trim. Warmer yellows are very suitable for space heaters but need care in application; an all-yellow heater would be a little overpowering. Muted variations can be recommended.

- Light For kitchen appliances, when in fashion.
- Medium Best for small appliances, particularly gold.
- Dark Can be used for all appliances, but with care.

Housewares Long a popular kitchen colour and well recommended for kitchen utensils. For many years lemon yellow was one of the popular kitchen colours, but in more recent times muted yellows, such as gold, have been strong favourites. Excellent in association with food, and good display value. Second only to blue as a favourite for tableware, and always a good standby because it is cheerful and goes well with anything else. Pale yellow is suitable for the interiors of vessels; darker yellows elsewhere. Muted variations provide richness; pure gold decoration of china is always well liked. An essential for any range of food containers and either clear or muted variations are acceptable. A good 'universal' colour.

Kitchen products Yellow is one of the classic kitchen colours because it is bright and cheerful as well as being clean and going well with food. Paler yellows have been very popular in the past, and muted yellows, such as gold, in more recent times. Yellow adds a touch of sunshine to any kitchen; a mixture of yellow and green is often recommended for kitchens, particularly those in towns, because it suggests the country. Yellow can be recommended for most kitchen products, but the shade selected should be chosen in the light of current trends; avoid harsh variations and greenish yellows.

Living room products Attention is drawn to the comments under Domestic interiors in 7.5 of this part.

Window decoration products Well recommended for window decoration, but deeper yellows and golds are best; they create a rich look. Paler yellows are a little strong but excellent for rooms with little natural light because they create a 'sunshine' effect. Gold harmonises well with metal furniture, and sunshine yellow is particularly suitable for a dark room.

Graphical applications

Packaging Yellow is well recommended as a feature colour for packaging; it is luminous and has high visibility but often has a greenish tinge under artificial light, and this can cause difficulties, especially with food; harsh variations should be avoided. Strongly recommended for point-of-sale and display material because of its high visibility; sharp, angular and crisp in quality but without substance. Use sparingly for print read at short range. The eye sees it clearly, and it stands out well in the dark; makes objects look larger and tends to advance. Light yellows are recommended for caps and closures because they have impulse attraction. It is best to avoid sickly greenish yellows for anything put into the mouth, and some versions of yellow-orange lack impact; avoid also modified versions such as mustard and large areas of pale yellow like lemon.

Print See remarks under packaging above; the possible greenish tinge under fluorescent light may cause difficulties in display applications, but otherwise yellow can be strongly recommended for display and point-of-sale applications, but avoid large areas of pale yellow. A strong yellow, approaching red-orange, is best from a visibility and recognition point of view, but all yellows may be difficult against a lighted background, and some versions of yellow-orange lack impact. Yellow can be seen further away than any other colour on painted and printed surfaces and can be recommended where long-range visibility is important, although its background is also important. Yellow should be used sparingly for print read at short range, because of its high visibility; it has a tendency to pull the eye away from the text and may cause difficulty in reading unless toned down. The contrast between yellow and white makes headings difficult to read. Black on yellow is a combination of the highest visibility but is not particularly pleasing. Yellow can be recommended for direct-mail applications, and yellow envelopes are good. Canary yellow is suggested for news bulletins and golden rod for general stationery. Yellow has good visibility and attraction value for tags, but black print on yellow is not very appealing; suitable for products sold to or for children.

Images As for packaging and print. A warm yellow with a sunny quality is recommended for industry and commerce, and canary yellow has a fashion emphasis; golden yellow with orange-brown ink is very suitable for a corporate image and can create an influential feel; it has also been recommended for new enterprises.

Vehicle liveries As for packaging, print and images. A strong yellow, approaching red-orange, is best from a visibility point of view, but the difficulty of seeing yellow against a lighted background may be of some significance in vehicle applications. On a painted surface yellow can be seen further away than any other colour and can be recommended for features where long-range visibility is important, but its background is also important. Brilliant yellow is recommended for breakdown vehicles, earth-moving vehicles and agricultural vehicles, but yellows are best not used for passenger vehicle interiors because they may cause sickness.

 As a standard safety colour yellow is used to mark hazards (contrasted

with black) and this has many applications to vehicle liveries, both overall and to mark hazards that project. Yellow is one of the best of all colours from a safety point of view. It is the most visible of all colours, it stands out sharply in the dark, the eye can focus it clearly, it makes objects larger, it tends to advance and it is the brightest colour. On the other hand, the very brightness of colour reflects sunlight and may tire the eye, and it may also be difficult to see a yellow vehicle against a background of shop lighting at night in urban conditions; also, because of its brightness, yellow may cause irritation to, and adverse reactions from, other drivers. The variation of yellow used would be very important; a pastel yellow would look little different from white under most conditions, and a strong yellow would be far better.

Environmental applications

Catering Yellow is the colour of many foods and is excellent in association with food; it has high visibility, is good when the eye has to be stimulated but tends to be dominating. Good for most walls because it creates warmth; can be recommended for hotel rooms, corridors, signs and display. Clear yellows are generally best, but some light yellows have an unduly high reflectance value and need to be used with care; a very pale yellow lacks impact and a very deep yellow may be overpowering. Muted yellows are good for decorative purposes and can be used in hotel rooms; gold is particularly good.

- Light End walls, corridors, circulation areas; restaurants, medium and fast trade; coffee bars, kitchens, bedrooms, canteens, service areas lacking light.
- Medium Exteriors in sunny climates; excellent for the inner walls of a room that needs to be lightened up; display, canteen furniture, end walls in narrow rooms; a warm butter-type yellow is best.
- Dark Mainly for decorative purposes.

Factories The lighter yellows are warm in nature and suitable for warming up a cool space or in windowless areas or large spaces. Recommended where manual tasks are carried out. Yellow is a luminous colour and should be used sparingly in restricted areas because it may cause glare. Muted yellows are best in industrial applications, most stronger yellows tend to be too glaring.

- Light For areas where manual tasks are carried out; for storerooms and corridors, especially if light is not good, combined with medium blue or green for lower walls; for upper walls in large areas, combined with grey for lower walls; recommended for machine shops; for canteens, but avoid yellow-greens; for female washrooms; for power plants, chemical plants, dairies, refrigerated areas.
- Medium For end walls in large areas, combined with cream, peach or ivory side walls; for exteriors.
- Dark Limited uses, sometimes for lower walls.

Offices The lighter yellows are warm in nature and suitable for warming up a

cool room or for one where there is very little sun. Yellows having a very high reflectance value need to be used with care lest they cause glare; greenish yellows are psychologically unpleasing.

- Light Light, clear yellows need to be used with care; sand is a warm and cheerful version of yellow which could be recommended for office use. The softer yellows are very suitable for walls opposite windows and make maximum use of reflected light. Use warm versions for canteens and avoid greenish yellows. Good for reception areas.
- Medium For end wall treatments.
- Dark Accent and decorative purposes.
- Screens Warm yellow can be used for screens; muted variations are best but should not be used where intense mental effort is required. Strong yellows and very light yellows are best avoided because they may cause glare but could be used for decorative purposes.

Retail Yellow is excellent for any situation where the eye has to be stimulated – it has high visibility but tends to be dominating. A very pale yellow lacks impact; a very deep yellow is too compelling. Yellow is good for all walls because it has maximum visibility and creates warmth; for signs and special display features.

- Light Hardware stores; staircases, corridors, basements, areas lacking natural light.
- Medium End walls in long, narrow stores; for refrigerated areas; for accent in drugs, hardware and impulse merchandise; as background for mens' wear. Pale gold is recommended for female washrooms.
- Dark Accent only.

Schools Yellow is a good colour for young children and for relaxation areas but is a little overpowering in large areas, while paler yellows are a little bleak.

- Light May be used with care for primary grades but not in secondary grades. For manual training areas, gymnasia, upper walls of corridors.
- Medium End walls in kindergartens; walls in libraries and assembly halls; light variations should be used if the area is large.
- Dark Decorative purposes only.

Hospitals Recommended variations are warm yellow and pale gold; brilliant yellows should not be used because they are unduly impulsive for ill patients and may grow monotonous to those confined. Yellow is not generally suitable for wards; harsh and greenish yellows should be avoided.

- Light Convalescent and maternity wards with turquoise for accents; corridors, nursing stations, reception areas, lavatories, washrooms.
- Medium End walls in dark, vaulty, spaces.
- Dark Accent only.

Commercial applications

Office supplies Medium yellows are suitable for office use but avoid any suggestion of green; can be recommended for presentation purposes. Strong yellows have powerful visual impact and are excellent for attracting attention at point of sale. Not suitable for desk furniture. Excellent for consumer items and appeals to all groups, especially the young. Yellow needs to be used with care in the office because of its high reflectance value; muted variations have rather more dignity and restraint than clear yellows and are suitable for higher-grade markets and where it is desired to convey stability. Sand is a warm and cheerful yellow, very suitable for office use, while gold and antique gold can be used for accent and decorative purposes. Recommended for point of sale and display. Excellent visibility for identification purposes but only third in recognition qualities; strong yellow should be included in most ranges, but pale yellows may be difficult to distinguish from white.

Paper and board One of the best of all colours for paper because of its high visibility, but it should not be used with white because of the lack of contrast between the two. It is warm and good for creating action, and its high visibility makes it good for tags and for identification purposes generally. Because of its warmth, it is good for spring and summer promotions. A rich, warm yellow, like golden rod, has powerful impact and is particularly recommended for an advertising message that needs intensity; it is associated with heat, sunshine and high brightness and has a sunny quality which appeals to men and is suitable for products related to industry and commerce. Canary yellow is a softer, luminous colour with a fashion emphasis and has good legibility if combined with deep colours; it is suitable for an advertising message which should appear modern; with green ink it impels notice. Golden yellow with orange-brown ink is very suitable for creating a corporate image and could be used for a new enterprise; it can also be used to create an influential image. Black on yellow is highly visible but not very pleasing.

Attention is also drawn to the notes in Section 1 of this part.

Surface-covering applications

Attention is drawn to the explanation of colour selection for surface coverings in Section 1 of this part.

7.8 Legend

No other colour has so many pleasing associations and so many unpleasant ones. On the one hand, yellow is the colour of the first crocus, the stars of forsythia, the tang of lemon and grapefruit, the gleam of amber and topaz, the pleasure of spring, the uppermost tips of the flame in a fire. It has the tang of mustard or the sweetness of honey. On the other hand, it represents the old,

curly edged and creepy, boxes of forgotten snapshots, specimens, the centre of a pimple, the skins of old actresses; yellow peril, Buddhist monks, the devastation of the Yellow river, old braid on a retired admiral, the Star of David, yellow fever, perfidy and cowardice, leaves swept by the wind, margarine, bad cake, bad teeth and many others.

The religious associations of yellow are primarily negative. Judas was said to have dressed in yellow when he betrayed Jesus Christ, and from this derives the association of yellow with Jews, notably in Austria and Germany, although Jews were also yellow in the *Arabian Nights*. On the positive side, yellow is associated with Buddha, and Buddhist priests wear yellow robes.

Yellow symbolised Asiatic people to the ancient Egyptians, it symbolised air to the Greeks and to the Jews; it was the sun in ancient mythology and to the Tibetans north was yellow; it was west to the ancient Irish and Navajo Indians but north to Hopi Indians. To the Chinese it symbolised the earth.

Most of the negative associations of yellow derive from the fact that it is the colour of old age and of sickness, particularly jaundice, and of course, people are supposed to turn yellow when they are afraid, hence yellow for cowardice. Yellow marked the heathen, hence scoundrel; in early France the doors of traitors were marked with yellow paint, hence the 'yellow streak'. On the positive side, yellow is supposed to cure jaundice; yellow turnips were used in Germany and yellow spiders were rolled in butter in England.

Some commentators believe that yellow incites violence and have suggested that yellow rooms are particularly prone to vandalism; one writer goes so far as to suggest that yellow incites the middle classes to violence. Pliny omitted yellow as a principal colour because it was 'reserved for the nuptial veils of females'; yellow journalism derives from an experimental printing of *The New York World* in yellow in 1896; and yet yellow is associated with honour in heraldry, and with purity, while yellow and gold are symbols of God and creation.

Yellow or gold is third prize at a cattle show but first prize in athletics; it signifies honour when used in Eastern carpets, and the energetic connotation derives from primitive man, who associated yellow with the dawn.

8 Orange group

- Light Orange
- Medium Tangerine
- Dark Burnt orange

8.1 Character

Orange is almost always used in pure form, although the darker variations merge into brown. Compels interest but is not a fashion colour and should be used with care. An earthy colour representing nature such as autumn leaves. Warm, dry, compelling, exciting, stimulating, energising; warm, hard colour, inviting to the viewer; it blends well with brown and yellow and looks as if it contains both red and yellow but neither of these two latter colours look anything like orange. A blackish cast to orange looks dirty; a brownish cast is better.

Orange produces a sharp image and therefore lends itself to angles. It is incandescent, has very high intensity, excellent for accent but rather trying in large areas. Because it is aggressive and advancing it makes a good feature hue and is almost always good in a selling and packaging context; particularly suitable for children and teenagers and excellent for accents. Orange is enhanced by warm illumination, incandescent light and warm white fluorescent light add richness. Acuity is good in orange-tinted light, and it is best at low levels of illumination. Orange-yellow is a very desirable illuminant and is recommended for lampshades; it is especially good with food.

8.2 Attributes

Age	Appeals to the young, less so to older people.
Appearance	Not a very flattering colour because it is too strong and may cause the complexion to look unnatural, but it will seldom be used in an application where it is likely to affect appearance.
Associations	Autumn, winter; political associations in Ireland and Scotland.

Fashion	Compels interest and sells in all markets when popular.
Impulse	Red-orange has by far the strongest impulse value; it is a colour of great vividness and impact and impossible to disregard. Red-orange is preferred to brilliant orange.
Markets	A mass-market colour but secures attention in almost any market, although it is a little brash for businessmen.
Mood	Compels interest and indicates warmth and excitement; gives a feeling of solidity, warmth, serenity and assurance; cheerful and stimulating but can also be tiring and irritating in large areas. It makes a 'loud sound' and, although incandescent, tends to be hard, dry, opaque.
Personality	People who like orange tend to be social by nature, gregarious and good natured; people who dislike it are often serious and cold.
Preferences	Choice 5 for children, 7 for adults. Low in both categories but has many practical uses.
Presentation	Maximum visibility and impulse attraction but a little too brash for many business applications.
Products	Food.
Recognition	Excellent recognition qualities, especially red-orange.
Reflectance	According to variation.
Regional	Needs care in Ireland and Scotland.
Seasons	A warm colour but bright and suitable for early winter; think of leaves in early autumn.
Sex	Probably appeals to women more than to men.
Shape	Suggests the form of a rectangle.
Size	Makes the image larger and surfaces seem nearer.
Smell	Typical colours having an associated smell are apricot, orange, tangerine.
Stability	Brash colour, not suitable where stability is required.
Taste	Appropriate to any product having an orange flavour and also to cereal products.
Tradition	Associated with the Protestant faith.
Visibility	The most visible of all colours and the best attention getter. Excellent recognition qualities, partakes of many of the attributes of yellow and has the recognition qualities of red but can cause irritation and tension if used to excess. Provides a sharp image and lends itself to angles.
Warmth	Hard colour, warm, inviting to the viewer.

8.3 Functions

Camouflage	NSC.
Coding	Excellent visibility and recognition qualities and high impact. Better than yellow, but red-orange could be used in the same range as yellow.
Insect control	Orange light will help to keep insects away.

Pipeline identification	Electrical services.
Protection from light	Excludes more harmful effects than violet or blue.
Readability	Black on orange, orange on navy blue, orange on black are good.
Signalling	Has some of the qualities of both yellow and red.
Visibility of controls	Red-orange is excellent for controls which have to be seen easily in an emergency.

8.4 Applications

Biological	Few connotations, but psychologically it is attractive to convivial persons; very friendly people like orange.
Children	Well recommended for children; appeals to teenagers and the young generally. Suggested for carpets in a child's room.
The country	NSC.
Export	Not likely to be used for interiors in sunny regions but suitable for exteriors anywhere because of its impulsive qualities; use with care in markets with an Irish element.
Exteriors	Should generally be avoided for exteriors, especially in towns, because it is too compelling, but it could be used in limited quantities where the light is strong.
Food	The colour of fresh bread, oranges and other good things to eat; hard colour, stimulates digestion and one of the best of all colours for food. Red-orange has high impulse value and associates well with many products, including bakery products, meat and so on; it has good attraction value. Orange is almost as good, but yellow-orange has less appeal.
Food packaging	Red-orange is well recommended for many foodstuffs, particularly those with an orange flavour; paler versions are equally suitable but less powerful. May be a little overpowering in large areas. Use for bakery products, bread, flour, cereal products, meat, baby foods.
Food in the home	Orange should be included in most food container ranges and is excellent for display. A little strong for tableware, although it could be used for some forms of pottery; pale or medium variations are preferred, especially for table linen.
Food processing	Although excellent with food, orange is too strong to be used in food-processing plants.
Food service	Orange should be used mainly for accent purposes, it is too strong for walls or large areas, although it has good associations with bakery products. Peach is a better colour (see Pink, Section 11 below).

Food stores	As for food service above. Melon is a good general accent colour.
Industrial plant and equipment	NSC.
Merchandising	Best of all colours for display purposes; it has maximum impact, excellent recognition qualities and good visibility. Red-orange, in particular, provides dramatic emphasis and cannot be overlooked in any circumstances; it puts over a striking point but is a little strong if used in large areas and for most background purposes. Good with food.
Pattern	NSC.
Safety	An alternative to yellow in most safety applications but has rather more impact; red-orange has better visibility than pure yellow and is strongly recommended for use at sea (e.g. for life rafts). It has been suggested that orange would be very suitable for small cars and sports cars because it makes them more visible.
Signs	An alternative to yellow where maximum impact is required but a little brash for most uses except hazard warnings. Excellent recognition qualities and good visibility. Red-orange has the recognition qualities of red and the visibility qualities of yellow.
Television	Reproduces well.
Texture	Suitable for most textures but rather overpowering on shiny surfaces.
VDUs	Screen: orange characters on dark green are recommended; orange on amber is acceptable. Equipment: not recommended. Surround: not recommended.
Woods	Light orange (apricot) with teak, dark oak, afrormosia, tola; medium orange also with these woods. Creates a feeling of sophistication and warmth with wood.

8.5 Interiors

Domestic interiors

Light variations	Pale orange is easy to live with and warms up a cold room. Apricot is clean, fresh, warm and brings a touch of sunshine; it is a warm shade for a cosy atmosphere and is complemented by blue.
Medium variations	Brighter shades are useful in a darkish small room or hall.
Dark variations	Burnt orange is easy to live with and warming.
Usage	Orange is trying in large areas but creates a feeling of sophisticated warmth with wood; it is an earthy colour which represents nature like golden autumn leaves, and

	it gives a feeling of solidity, serenity and assurance; it can be cheerful and stimulating like red but can also be rather trying and slightly irritating if overdone. It looks better in the tin than it does on the wall and should be used sparingly.
Room character	Orange may be useful in a warm, friendly, living room.
Room aspect	Orange is good for a north-facing room; apricot can be recommended for a cool room.
Room size	Orange reduces the size of a room.
Room features	Recommended for receding end walls; used for walls at the end of a long room, it will make the room seem wider.
Room functions	Apricot is suitable for a relaxing bedroom and can also be used for a television room; orange can be recommended for halls.
Room users	Orange is particularly suitable for rooms used by children and teenagers.

Commercial interiors

Attention is drawn to the use of orange in specific environments listed in 8.7 below.

8.6 Combinations

Good harmonies	Orange with yellow, brown (including tan), white (for food service), pink (vibrates and creates warmth), magenta, shocking pink, deep violet, navy blue, coffee, khaki. Strong orange with grey, green. Pumpkin with brown is exclusive.
Accentuated by	Proximity to black, dull blue.
Diminished by	Proximity to red, yellow, brown.
Accentuates	Grey.
Diminishes	Green.
Suggestions	If orange is used with grey, it becomes purer and more yellow, and the grey appears blue. Orange and strong turquoise give a room a good kick. Apricot is complemented by blue.

8.7 Uses

Consumer applications

Bathroom products Orange is unlikely to appeal to any great extent for sanitary ware, although it has been on the market, but it is excellent for accent purposes. Paler shades such as tangerine can be recommended for accessories and textiles, and deep variations might be used in moderation.

Darker oranges, such as burnt orange, have been a strong trend colour in the home but are probably best avoided in the bathroom except in small doses for accent; will warm up a bathroom.

Bedroom products Warm and cheerful in the bedroom, excellent for children and well liked by teenagers, but it is trying to live with in large areas and is better blended with yellow and brown; recommended for early risers. Orange and apricot counteract lack of sunshine in a cold room, and darker versions are easier to live with than paler versions. People who like orange bedrooms are said to have a quiet forcefulness.

Domestic appliances Well liked in the kitchen and good with food; may be rather strong for large appliances, although it has been well liked for kitchen units. Excellent for small appliances, it compels interest in a selling situation. Can be recommended for space heaters, although probably best limited to smaller models, especially small portable heaters. All versions can be used for appliances where appropriate.

Housewares Orange is good for kitchen utensils; it has been a strong trend colour in the kitchen for many years and is excellent in association with food; it has good display value. It has long been popular for tableware and has excellent decorative qualities, but strong variations are not suitable for the interior of vessels. Included in almost all ranges of food containers; red-orange is particularly well recommended, and browner variations like burnt orange are also well liked.

Kitchen products Orange came to the fore as a kitchen colour at the end of the 1960s, at a time when it was a strong trend colour in the rest of the home; it is well recommended for most kitchen products because it is bright and cheerful and goes well with food. It is essentially a trend colour. Light and medium variations are suitable for most kitchen products, but dark variations are best used for accent and for utensils.

Living room products Attention is drawn to the remarks under Domestic interiors in 8.3 of this part.

Window decoration products A little overpowering for most window decoration purposes except in small areas or as an accent; it creates a lively effect and would be suitable for children. Darker versions would be better than than paler versions and burnt orange is warming. Particularly recommended for awnings.

Graphical applications

Packaging Red-orange is the best of all colours for packaging; it is dynamic, pleasing and has high impulse attraction, but too much may make a container look too heavy. Pure orange lacks the impact of red-orange but is good for food containers. Orange is the best of all colours from a visibility and attention-getting point of view, and it is good for almost any selling application because it has dramatic emphasis; but use with care.

Print As for packaging; orange cannot be overlooked in any circumstances, it draws attention and puts over a striking point but is a little brash for business use. Can be recommended for tags where maximum visibility and impact are required; black on orange is highly visible and suitable for mass markets.

Images As for packaging and print. Orange is a little strong when used in large areas and needs deep, rich, colours to balance it.

Vehicle liveries As for packaging and print; best for features and can be used instead of red for fire appliances. Orange and white are excellent in association with bakery products or fruit. Generally speaking, red-orange and yellow-orange are the best of all colours from a visibility point of view and are ideal for their recognition qualities; however, too much orange may cause irritation and tension. Red-orange would be very suitable for small vans because it makes them more visible to other drivers trying to overtake in adverse conditions.

Environmental applications

Catering Excellent for food service but is a bit overpowering in large areas and best used for accent; can be used in fast-food applications and for display. Good impulse colour, creates warmth, use in small quantities to attract attention. Light variations may be used for decoration and display, medium and dark variations for accent only.

Factories Distracting and should not generally be used in industrial plants; it carries a message of attention and danger. Light variations are suitable for the walls of canteens if not overdone; it is cheerful and enhances food. Medium and dark variations have limited uses.

Offices Best avoided in offices because it is distracting but might be used for limited accent purposes.
- Light May be used in canteens as in factories above.
- Medium For furniture and accessories provided that it does not distract workers.
- Dark Accent purposes only.
- Screens Only recommended for screens that are not in the direct line of sight of workers; best used for decoration or for rest areas.

Note that peach is one of the most useful tints for office use and is sometimes classified as orange, but in this book it has been classified under pink (section 11 below).

Retail One of the most striking of colours and is well recommended in association with food but is best used in small quantities to attract attention; it is a good impulse colour which creates warmth. Light variations may be used in small patches on rear walls but medium and dark variations are for accent only. Peach is a most useful tint in the store (see Section 11 in this part).

Schools Although children react well to orange and like it, it is too overpowering for large areas in the school. It may be used with advantage in

kindergarten and primary grades as an accent and for decorative purposes. Light variations are best.

Hospitals Orange has few uses in the hospital because it is too impulsive but might be used in small areas for accent purposes, especially in corridors, where it would help to pick up spirits during a long day.

Commercial applications

Office supplies Orange tends to be distracting but is good for identification purposes and has excellent attraction value and is therefore suitable for presentation purposes, although it may be a little brash. Compels interest and provides decorative emphasis. Not recommended for desk furniture. Excellent for point of sale use but has limited consumer applications. Better than yellow for identification purposes, but red-orange could be used in the same range as yellow.

Paper and board Red-orange is a little strong for paper but could be used for tags and covers in appropriate cases; it is a warm colour that impels action, has high attention value, is universally liked and can be used for dramatic emphasis. It needs deep, rich colour to balance it and can be used for autumn and winter promotions. It is well suited to any message that puts over a striking point.

Attention is also drawn to the notes in Section 1 of this part.

Surface-covering applications

Attention is drawn to the explanation of colour selection for surface coverings in Section 1 of this part.

9 Brown group

- Light Beige, fawn, buff
- Medium Copper, tan
- Dark Coffee, chocolate, saddle

9.1 Character

The browns comprise a very wide range of hues and the whole group has many different uses, particularly in interior decoration. Brown is a country colour which is soothing and restful, it is warm, hard and inviting to the viewer. Brown is easily harmonised, flexible and will go with anything, particularly variations like fawn and tan; it blends well with orange and yellow and looks well with green and has the invaluable decorative facility of changing its character in proximity to other colours.

Fawn and beige have a fashion note and appeal to upper-income groups; putty is a golden variation of beige. Tan is a good trim colour, especially when associated with ivory, yellow or cream, and it is useful by itself when low brightness is required; it will stand high light intensities without being disturbing. Buff is a bright, luminous, colour with high light-reflectance qualities and at the high-visibility end of the spectrum; it is an aid to good seeing and suited to large interiors and spaces deprived of natural light, but it has too high brightness for critical seeing tasks. It is good where illumination is poor. Brown does not look its best under incandescent light, but otherwise no special comments are required; acceptable for lampshades.

9.2 Attributes

Age Mainly for older people, except when a fashion trend.
Appearance The lighter shades of brown are generally flattering but not dark browns, although the latter may provide an acceptable contrast; any complexion seen against a background of dark oak, for example, is generally flattered.
Associations Autumn, winter, warmth, firelight, refinement, quality,

the earth; most associations refer to fawn, beige and tan rather than to darker browns. Some undesirable associations.

Fashion
Fawn, beige and tan have a high-fashion note and appeal to upper-income groups.

Impulse
Not recommended; fawn does have some attraction value but is not as good as orange.

Markets
Not usually for mass markets; lighter shades appeal to higher-grade markets and buff and yellow browns are suitable for business; woodgrains appeal to all classes.

Mood
Evokes deep restful feelings, peace, tranquillity, warmth, mellowness. Yellow browns create an intense mood, but tan is soft and warm; peaty browns are intimate. Tan and sandtone are influential, while fawn and beiges are sophisticated.

Personality
People who like brown are conscientious, shrewd, obstinate, conservative; solid and dependable types. People who dislike it are generous, gregarious, impatient.

Preferences
Not well liked except when fashionable.

Presentation
Lighter variations have a high-quality image and reasonable visibility; darker variations are a little too retiring, although they convey solidity.

Products
Business, especially lighter variations and tan; cola drinks; avoid brown for cigarettes and use with care for soap.

Recognition
Poor recognition qualities.

Reflectance
Buff about 50 per cent, medium brown about 25 per cent.

Regional
NSC.

Seasons
Essentially the colour of autumn and winter; warm and the colour of leaves, trees and so on. Light shades are best for early winter.

Sex
Appeals to women, especially lighter variations. Yellow browns, including tan, tobacco and saddle brown, appeal to men because of their association with outdoor pursuits.

Shape
NSC.

Size
Effect depends on the variation used; lighter shades will make the image look larger; darker shades will make it look smaller, with an equivalent effect on surfaces.

Smell
Typical colours having an associated smell include coffee, balsam, cedar, chestnut, cinnamon, ginger, nutmeg, chocolate; also associated with carbolic soap and laundry soap.

Stability
Denotes refinement and quality; tan is recommended for good taste and refinement; it has an influential quality.

Taste
Appropriate to any product having a coffee or chocolate

flavour, but shade is important; a dark brown might suggest a very strong coffee.

Tradition	Darker browns belong to the Regency and Victorian periods; buff belongs to the latter.
Visibility	Most browns are mixtures of primary hues and will acquire the characteristics of the dominant hue, but they generally lack brightness and recognition value. Beige has reasonably good visibility but lacks punch.
Warmth	Hard colour, warm, inviting to the viewer.

9.3 Functions

Camouflage	Medium and dark variations will hide soiling.
Coding	Brown is a neutral colour and has few qualities to recommend it for identification purposes, but lighter variations could be used and will contrast well with darker hues. Buff is commonly used in office systems.
Insect control	Browns tend to attract mosquitoes.
Pipeline identification	Dark brown, oils; light brown, natural gas.
Protection from light	Brown or amber glass will protect against light up to a wavelength of 450 nanometres and is recommended for beer bottles, medicinal containers and most packaging applications. It is more pleasing than yellow-green and is recommended for windows where it is necessary to exclude the harmful effects of light.
Readability	Not recommended.
Visibility of controls	Not recommended.

9.4 Applications

Biological	NSC.
Children	Mainly for older people, except when a fashion colour.
The country	There are few applications for brown in this context, but tan might be used as a background for meat processing and for vegetable processing; it could also be used for farm shops.
Export	Generally a colour for temperate regions; in most sunny zones there will be enough brown already, and it is a little warm for interior use, although lighter shades can be used to simulate wood. Tan could be used for interiors in sunny regions.
Exteriors	Doors: beige is suitable and tan or pale chocolate are sophisticated in towns. Windows: beige for outer frames of white windows.

Walls: brown/pink decreases height and narrowness. Dark brown is suggested for walls in towns and is also practicable in the country; rich ochres are successful where light is strong.

Industrial: tan is useful for exteriors, particularly those of food manufacturers.

Farms: dark brown is recommended for walls and roofs.

Food
The natural colour of many foods such as coffee, chocolate, cocoa, many bakery products, nuts. Stimulates digestion, and warmer shades, including tan, are recommended for many foods, although earthy variations should be avoided because they suggest dirt. Good for bakery products, baked beans, nuts, coffee and so on; brown bread is acceptable and brown shelled eggs are liked in the UK; warmer variations are acceptable for baby foods.

Food packaging
The variation used should be related to the actual colour of the product. Suitable for baked beans, nuts, coffee, bakery products, chocolate, corn, but tan or warmer shades are recommended. Conveys a taste of cola, strong beer and coffee; brown ice cream is considered to be chocolate flavoured.

Food in the home
Light and medium shades are best in most applications, although warmer variations of dark brown can be used; recommended in association with food. Care is necessary in using brown for food containers, it would not be suitable for freezer use but excellent for coffee or for containers which appear on a shelf. Brown lids for clear-bodied containers are acceptable. Not recommended for tableware except for casseroles and the like; pale variations would be acceptable for table coverings, and beige might be used for plates and plastics ware. Brown mugs can be used for coffee, but not for tea. Use warmer variations such as beige or tan, but avoid earthy shades in all applications.

Food processing
Light variations such as buff or beige can be used to create a warmer atmosphere, but dark browns should not be used. Lighter variations are reasonably flattering. Recommended for dairies; refrigerated areas; vegetable processing (tan is a good background); bakeries (but use paler variations).

Food service
Good in association with food, but lighter shades are preferred and may be used for overall surroundings and immediate surround with darker variations for accent.
- Light A good general sequence colour in all catering environments.
- Medium For fixtures, fittings and furniture; for accent.

	• Dark Not recommended except in small areas.
Food stores	Lighter shades are suitable for food stores and can be used for some walls, fittings and accent. Good background for tea, coffee and bakery products.

 • Light Suggests warmth in refrigerated areas.

 • Medium For fixtures, fittings and accent.

 • Dark Not recommended.

Industrial plant and equipment Browns are perfectly suitable for industrial equipment but have not been widely used; warmer than blue or green and may not be suitable for a warm environment. Could be recommended for machines used by female labour (e.g. clothing factories) and would be conducive to good morale in semi-automatic assembly plants. Light browns are excellent for highlighting purposes and can be applied to prominent parts of a machine, such as heads, background to working planes and so on, but should not be used for the main body of a machine. A tone having a reflectance of about 60 per cent is particularly suitable where the material being worked is copper, brass, aluminium or wood; medium browns may be used for a main body whether or not brown is used to highlight; darker browns are only suitable for bases.

Merchandising Recommended where good taste and refinement are required; basically a background colour, has little impact and poor recognition qualities, but lighter variations, such as beige, have some attraction and reasonable visibility. Warm wood tones are good background for clothing. Associated with autumn.

Pattern NSC.

Safety Few safety applications. Orange brown is used to indicate the presence of hazardous chemicals and explosives (HAZCHEM).

Signs Not usually used for signs and has little impact. Lighter browns such as beige have reasonable visibility but lack punch; they might be used for ground but not for legend. Brown is a mixture of hues and acquires the characteristics of the dominant hue, but it lacks brightness and has poor recognition qualities.

Television Darker browns are difficult to use, and the screen fails to register small differences; tan often looks like pale orange because the slight grey influence in the original shade is lost.

Texture Darker browns are best on shiny surfaces; a matt brown is very dreary. A matt untextured surface in light brown or beige is neutral. Brown makes its warmest impression as thick-pile rugs.

VDUs	Screen: not recommended.
	Equipment: lighter browns, including beige, are highly recommended.
	Surround: lighter variations are recommended, especially where tasks are routine and a warm effect is desired. Flattering to workers.
Woods	Browns and beiges create a feeling of sophisticated warmth with wood and are the complement of good furniture. Browns are at home with pine, and dark brown goes with beech; fawn goes well with wood tones.

9.5　Interiors

Domestic interiors

Light variations	Beige creates an impression of spacious calm; with a matt surface it is neutral, but it is not a true neutral and often has a deadening effect on other colours; beiges are warm without being overbearing; they look smart, are easy to use and will blend with any colour scheme. Fawn and beige have a high-fashion connotation and are suited to upper-income groups; they are warm and flattering to any furnishings and fawn goes well with wood tones. Pale variations are restful without being cold.
Medium variations	Tan and copper make a beautiful background for living rooms and are warm and flattering to furnishings; khaki shades provide a long-lasting background for lighter colours. Berber shades look well in almost any setting, and caramel is recommended for a luxury home.
Dark variations	A matt chocolate surface would be very dreary; gloss livens it up.
Usage	Browns are easily harmonised and blend with any colour; they have the invaluable decorative facility of changing their character in proximity to other colours. Brown is a complement to good furniture, a perfect background for pictures, ceramics or works of art; it has a tonal kinship with many natural materials but needs to be lit with the sparkle of white or the sheen of black. Browns are easy to live with and warm up a cold room; they add a flattering glow to a chilly room.
Room character	Brown is a country colour which is soothing and restful; it creates a feeling of sophisticated warmth.
Room aspect	Browns are recommended for north-facing rooms.
Room size	Lighter browns make a room larger, but darker shades tend to reduce the size of a room. Beige reflects light well and is particularly suitable for a small room, but is too dazzling for a south-facing room or a large area.

Room features	Brown walls have a relaxing effect.
Room function	Brown is particularly good for the 'public areas' of the home. Beige is frequently used for formal interiors which are traditional in style.
Room users	Brown is not recommended for children or teenagers.

Commercial interiors

Attention is drawn to the uses in specific environments listed in 9.7 below.

9.6 Combinations

Good harmonies	Brown with orange, yellow, green, magenta, shocking pink, chrome yellow, marigold, scarlet, lime green, blue, pumpkin (exclusive), light green; light brown with peach; dark brown with blue-green; beige with pink, darker greys, mauve, grey-green, aqua, mushroom, silver grey; coffee with green, orange, mauve, peach; caramel with grey, black; ginger with pink, yellow; orange buff with deep violet; tan with green, orange, mauve, khaki; pale beige with hot pink, mauve, purple, turquoise; auburn with khaki.
Avoid	Brown with pale tints of red, pale tints of blue, and pale tints of violet or lavender.
Good contrasts	Tan with green.
Diminishes	Green, yellow, orange, red.
Suggestions	• Wood colours go well with an intense colour contrast.
	• Beige with turquoise is conservative, exclusive and attracts attention; two shades of beige make a room look larger.
	• Beige and mushroom have good resistance to soiling and are useful for heat control.
	• Brown, beige and cream make a good team for a long room.
	• Brown, beige and pink are ideal combinations for a safe, friendly scheme.
	• Tan and fawn complement sage green.
	• Brown harmonises with most colours and goes well with dawn yellow.

9.7 Uses

Consumer applications

Bathroom products Brown, in all its variations, has been one of the strongest trend colours in the 1970s, and most sanitary ware manufacturers have a

brown in their ranges. Although the deep browns, such as sienna, have been very popular in the bathroom, it is unlikely that they will be a lasting trend, and paler variations would be better. In psychological terms brown is unsuitable for bathrooms because of its associations with the earth, but it has been in demand because it was a trend colour in the home generally. Pale and medium variations would be very suitable for wallcoverings and accessories. Warmer (or reddish) browns are recommended rather than cooler variations, like bitter chocolate. Browns and beige go well with coral sanitary ware.

Bedroom products Mainly appeals to older people, except when in fashion, but it is successful for bedrooms and can create a feeling of grandeur; it is the complement of good furniture and has a tonal kinship with many natural materials; it is at home with pine and at ease with chrome, but it needs to be lit with the sparkle of white and the sheen of black. Most browns are easy to live with and warm up a cold room; it is a country colour. If you like a brown bedroom it is said that you have a love of home and family and a need for security. Most light variations are suitable for bedrooms and for display purposes, and biscuit is gentle, warm and neutral. Darker shades, such as bitter chocolate, may be a bit subduing but are often fashionable, particularly at the upper end of the market; they are not recommended for bed tickings because they show through sheets.

Domestic appliances Browns have been much used for appliances since the 1970s and have been a strong trend colour, particularly for kitchen appliances; lighter variations reflect the colour of many foods and fit in with woodgrain kitchens. Well recommended for space heaters because brown is warm in nature and fits into most furnishing schemes. Brown is particularly suitable for larger heaters which may be considered part of the furniture; almost all variations can be used. Burnished copper is popular in the kitchen and might be used for appliance trim and space heaters; tan and yellow brown could be recommended for small appliances, particularly those used in the kitchen. Bitter chocolate might be used for appliances but needs care because it is an up-market colour.

Housewares Browns are not recommended for kitchen utensils despite the popularity of woodgrain kitchen units, although lighter variations including tan might be used; associates well with many foods but lacks impulse attraction. Brown can be used for tableware and is, of course, the traditional colour of cooking pots, casseroles and the like; lighter and warmer variations should be used for the inside of vessels. Brown, including darker browns, are popular for ovenware, and a coppertone finish on plastics can be recommended. The 'natural' look of brown can be sold. Brown would not be suitable for food containers for freezer use, but would be acceptable for coffee tins and canisters kept on a shelf; brown lids on clear containers are also acceptable. With all housewares the fashion element may be important, especially in relation to woodgrain kitchen units.

Kitchen products Browns were the strong trend colour in the kitchen during the 1970s and early 1980s and were a natural progression from orange; the

trend largely took the form of woodgrains, although shades such as bitter chocolate also had a vogue at the top end of the market. The popularity of wood was largely a reaction against the starkness of conventional decorative laminates and partly a return to a 'natural' look. Light and medium variations can be used for most kitchen products, but dark variations should be limited to the top end of the market.

Living room products Attention is drawn to the remarks under the heading of Domestic interiors in 9.5 in this part.

Window decoration products Deeper browns may be a little sombre when used for window decoration, but medium and pale shades are excellent, and particularly in living rooms. Beige and other light variations are good for bedrooms; fawn goes well with wood tones. Light variations provide a good distribution of light.

Graphical applications

Packaging Light browns, and medium tones, like tan, have many packaging uses and have reasonable shelf impact. Many browns are the natural colour of foodstuffs and should be used with those foods; brown is also essential for fashion applications. It is a 'country' colour, soothing, restful and easily harmonised. Light versions are good for most business applications, and tan can be recommended where good taste and refinement are required. Use for cigarettes should be avoided and also use of earthy shades.

Print As for packaging above. Lighter shades will usually be used for background, especially in fashion applications, but fawn, buff and tan can be used in many ways; tan is especially good where refinement is required. Fawn and beige can be used for fashion applications for tags, but browns generally are not recommended.

Images As for packaging and print above. Fawn and beige are suitable for upper-class markets and buff is acceptable for business. Dark browns are best not used except for contrast.

Vehicle liveries As for packaging and print above. Beige and tan can be recommended for vehicle cabs, but if used overall, the vehicle may be 'lost' in dust; beige has reasonable visibility but tends to merge into a dusty background.

Environmental applications

Catering Good food colour for food service; warm and friendly and easy to harmonise with other colours; tends to reduce the size of a room and make it cosy. Most browns are suitable for fittings and fixtures.
- Light Good sequence colour for general use in restaurants, lounges, hotel rooms, motel rooms, coffee bars and so on.
- Medium As for light variations but also for corridors and for display.
- Dark Restaurants, display but a bit heavy in large areas.

Factories Considered to be suitable where women are employed, and the lighter shades will compensate for cool temperatures; friendly and well liked, and useful where the environment is an active one.

- Light For working areas generally, especially those that are cool, and for large areas without daylight, buff being especially good. For power stations, refrigerated areas, dairies; for headstocks of machines. For upper walls of machine shops where exacting tasks are performed. Buff is recommended for the working plane of machines; sandtone and beige are warm and suitable for areas where there is a degree of manual activity, also for recreation areas; fawn is suitable where a neutral is required.
- Medium Side walls in fine assembly areas; food processing, especially where vegetables are processed.
- Dark Limited uses.

Offices The lighter browns are highly recommended for office use, particularly where the environment is an active one; they are friendly and well liked and flattering to the appearance; fawn is recommended where a neutral is required.

- Light For walls generally but especially general offices and machine rooms; executive offices, conference rooms. Very suitable for north-facing rooms.
- Medium For floors, especially where the outside environment is grey and uninteresting. Browns with a reflectance of about 30 per cent are very suitable for desk tops. For bookshelves in libraries.
- Dark For accent only.
- Screens Medium browns are highly recommended for screens, especially where there is much activity; tones at the higher end of the reflectance range would be best.

Retail Woodgrains are widely used in shops and are best in medium tone; deep browns should generally be avoided except as accents. Most browns are suitable for fixtures and associate well with medium green walls.

- Light Warm wood tones are useful as a background to male and female fashions and for footwear; recommended for upper walls and for fixtures, counters and table. Beige is recommended for speciality shops but is not a colour for a man's market.
- Medium Sandalwood with green can be recommended for general stores.
- Dark Walnut is a possible background for light-coloured or fashion merchandise, but use in small areas only or in alcoves. Cedarwood is a good accent colour.

Schools Lighter variations are excellent for school use, especially for younger children. Buff can be used but is a little 'ordinary'; beige can be recommended and is a warm neutral shade with many uses.

- Light Kindergarten and primary-grade classrooms, assembly halls, manual training areas, gymnasia.
- Medium Furniture, otherwise decorative purposes only.
- Dark Not recommended.

Hospitals A warm beige is recommended for many purposes in a hospital and is highly favoured for patient accommodation; blue-green and coral can be used alternately with beige to provide variety.

- Light Maternity wards, convalescent wards, private rooms, recovery rooms, utility rooms, sluice rooms, laboratories, pharmacies, corridors, anaesthetic rooms, dining areas, offices, reception areas; well recommended for floors.
- Medium Primarily for accent and decorative purposes.
- Dark For signs indicating appointments, enquiries, visitors.

Commercial applications

Office supplies Light and medium browns are well recommended for office use and harmonise with desks and so on. Warm browns are better than colder versions such as chocolate; browns with a reflectance of about 35 per cent are well recommended for desk tops. Not really suitable for presentation purposes, except to convey fashion or where dignity is required; lighter browns command attention and, with refinement, are excellent for higher-grade markets. A brown simulating leather would be excellent for desk furniture. Recommended for consumer items when it is a trend colour; brighter variations have quite reasonable impulse attraction and will appeal to women and to higher-grade markets. Harmonises well with other colours and therefore good for personal products. There are few qualities to recommend browns for identification purposes but lighter variations, including buff, would contrast well with darker colours; buff is commonly used for office systems and is generally acceptable for business.

Paper and board Brown will usually be used in the lighter variations for promotional purposes, especially where fashion is involved. Fawn and beige are suitable for upper-class markets; yellow-browns and buff are acceptable to business; dark browns should not be used. Fawn is a warm, mellow colour which suggests firelight and the autumn, and is appropriate for women and for fashion use; it is quite luminous but does not have as much compulsion as yellow, although it does command attention with refinement. It is ideal for promotions to higher-class markets and upper-income groups. Tan has similar qualities and harmonises easily with other hues. Buff is recommended for commercial applications such as memos, conference reports and similar; buff paper with blue and tan ink creates an up-to-date image. Attention is also drawn to the notes in section 1 of this part.

Surface-covering applications

Attention is drawn to the explanation of colour selection for surface coverings in section 1 of this part.

9.8 Legend

Browns seems to be singularly free of lore and legends; the only point that seems to be worth mentioning is that the term 'to be done brown' was first used by Dickens in the *Pickwick Papers* in 1832.

10 Red group

10.1 Character

Warm reds have a yellowish cast and have more impact than cool reds, which have a bluish cast; the latter may be preferred by higher-income groups. There are also muted reds like maroon which also appeal to higher-grade markets. Lighter reds are classified as pink and are described in a separate section. Red is universally liked as a colour for all seasons and for all temperaments; it is the easiest colour to identify and creates most attention; it is fiery, dramatic, eye-catching and exciting and will consistently assert itself against all other colours, but it is inclined to be aggressive and demanding.

Red mixes well with pink and blue, but avoid magenta and blue. A red which is less than pure may appear faded; reds with a touch of white or black in them are not liked – it is better to be definite. Always be careful of variation; preferences change, so make sure that the shade used is not out of date. Vermilion has particularly strong impact and is well liked world-wide. Red is sharply focused by the eye and lends itself to structural planes and sharp angles; it is slightly refracted by the lens of the eye and therefore tends to advance and make objects look larger. Hard, dry and opaque in quality and conveys a feeling of durability; it is solid and substantial.

The nature of red is such that it ought to command a design and be emphasised by small touches of blue or green; because it is aggressive and advancing it makes a good feature hue in promotional applications, but it tends to cause restlessness if used in large areas, and its green after-image can be trying; this is especially the case with brilliant reds under strong illumination. Red surfaces

tend to look black or 'disappear' under dim light, but red is enhanced by incandescent or warm white fluorescent light. Most reds appear brown under sodium lighting, and magenta requires a cool light to be properly appreciated. The dark-adapted eye has best acuity under red light, and red-tinted light creates a flattering environment; red-coloured light may distort the appearance of food. Red is a good illuminant and suitable for lampshades, although very deep reds should be avoided.

10.2 Attributes

Age
: Appeals to all age groups; children particularly like red and it is good for packaging aimed at the young.

Appearance
: Generally flattering but too much red may look unnatural. Red walls or red light help to create a flattering environment but too much would be overpowering in the home. Full-blooded reds such as ruby and crimson make a flattering background for grey-haired women and blonds.

Associations
: Urgency, warmth, excitement, winter, passion, fashion, fertility, fire, the Post Office (in the UK), the army. The colour of war because it is stimulating and tends to raise blood pressure and increase tension; indicates anger; means 'stop' world-wide. Red has political associations and religious associations (e.g. the cardinal's hat) and is traditionally associated with fire, although orange is frequently used for fire appliances because it has better visibility in street lighting.

Fashion
: Universally liked and a mass-market colour; blue-type reds have a high-fashion note.

Impulse
: Excellent attention getter but use reds on the yellow side. Vermilion is particularly recommended and appeals universally. Flame red can also be recommended but avoid blue-type reds. Do not use red for background except in special circumstances.

Markets
: Suitable for all markets, but bluish reds generally have more appeal in higher-grade markets; scarlet is particularly good for business.

Mood
: Makes for passion, warmth and excitement because it increases autonomic response, mentally stimulating; it signifies richness and is fiery, dramatic and exciting. Creates a 'hard sound' and is dry and opaque. Many people only quarrel when they are in a bright red room, and people react more quickly to red than to any other colour. While it can be an irritant, it can also be welcoming and cosy.

Personality
: People who like red are aggressive, vivacious, passionate, optimistic, dramatic, and they may be abrupt in

	manner. It is for extroverts, but people who like maroon are passionate but disciplined. People who dislike red are fearful, apprehensive and unsettled.
Preferences	Choice 4 for children, 2 for adults. Universally popular irrespective of nationality.
Presentation	Excellent recognition and impulse qualities, and one of the best of all colours for presentation. Yellow variations are preferred, but darker reds and blue-type reds often have fashion connotations and convey restraint.
Products	Business, travel, food, meat products, machinery, soap; scarlet appeals to business markets. Use red for masculine toiletries but with care for cigarettes; it is suitable for most kitchen products.
Recognition	The easiest of all colours to identify and recognise.
Reflectance	Varies with shade; a dark red is about 14 per cent.
Regional	NSC.
Seasons	The warmth and cosiness of red makes it especially suitable for winter and it is associated with Christmas.
Sex	Appeals to both sexes equally.
Shape	Suggests the form of a square or cube.
Size	Makes an image larger and surfaces look nearer.
Smell	Typical colours having an associated smell are rose, plum, geranium.
Stability	Cool reds are dignified, but bright reds are exciting and not recommended where it is desired to suggest stability.
Taste	May suggest richness or even harshness in some cases.
Tradition	Deep reds belong to the Victorian era; they are traditionally used for fire appliances, for the Post Office (in the UK) and for executive office furniture.
Visibility	The most easily recognised and identified colour and the easiest to see in daylight conditions. A bright red attracts attention to itself and will take a lot of dirt without losing its appearance. Yellowish reds have better visibility than bluish reds. Reds tend to 'disappear' in a dim light (e.g. a dark cellar), because the cones of the eye which detect red do not operate when the eye is dark-adapted; red can be difficult to see in the twilight period and loses its value under some lighting conditions. Red illumination is particularly suitable for night flying instruments because the light has no effect on the dark-adapted eye. It loses its value under sodium lighting.
Warmth	Hard colour, warm, inviting to the viewer.

10.3 Functions

Camouflage	NSC.
Coding	Easiest of all colours to identify and has excellent visi-

bility; however, it tends to disappear in dim lighting conditions and may be difficult to identify.

Insect control	Red light will keep insects away and it inhibits the growth of cockroaches; silkworms are inactive under red light and bees are confused by red; ants like visible red light.
Pipeline identification	Firefighting, fire extinguishing; with white for boiler feed; with emerald green for condensate; with dark blue for central heating; with white for hot water; with dark brown for transformer oil.
Protection from light	Excludes more harmful effects of light than blue or violet; infrared light does not cause rancidity, but it may cause heat build-up.
Readability	Red on white, white on red, red on green, green on red, red on yellow – all have good visibility; scarlet is recommended.
Signalling	The best of all colours for signalling; it is aggressive, has good visibility and good recognition qualities, although it is less visible when the eye is dark-adapted.
Visibility of controls	Recommended for controls associated with 'stop'; red illumination is excellent for controls which have to be seen by the dark-adapted eye.

10.4 Applications

Biological	Psychological effects: associated with outwardly integrated personalities, highly prized by people of vital temperament; such people are often ruled by impulse rather than by deliberation, and desire to be well adjusted in the world. Most people judge red to be warm, but there are people who do not; it is debilitating to more anxious subjects and the colour of choice of manics and hypomanics. Brunettes prefer red and Latin types descended from tropic stock have retinas which are red-sighted due to infrared light. Red causes the greatest increase in autonomic arousal.
	Medical effects: red flashing lights will excite epilepsy; it is dangerous in Parkinson's disease; it helps to relieve skin diseases, scarlet fever and measles; it may cause distress in cerebellar disease and accentuates nervous diseases such as tic and torticollis; red light may increase restlessness in the latter. Red is disturbing to anxious patients and is related to excitation in general, it may help to increase blood pressure in muscular tonus. Red has a stimulating effect on sexual activity and induces a decrease in blood sugar. Red inert tablets help to reduce pain in arthritis and red light helps active eczema. Red

may help to arouse people with reactive depression and neurasthenia, and mentally disturbed patients are excited by it.

Children
The country
Export

Children love bright red, but it appeals to all age groups.

NSC.

Essentially for sunny areas, especially for exteriors but can also be used in temperate zones; it is unlikely to be used for interiors in sunny regions except to create a feeling of richness. Red is universally popular, and vermilion appeals to both men and women in all parts of the world. Red conveys the Post Office in the UK but not in other countries; it conveys caution in most countries.

Brazil: not allowed for cars.

Ecuador: not allowed for cars.

Zambia: use with care, particularly for illustration.

China: a happy, propitious, colour.

Taiwan: as for China.

Czechoslovakia: a red triangle conveys poison.

Exteriors

Explosive, dramatic, fiery, but also generous, kind and helpful, it gives a cheerful welcome. Bright red is recommended for doors of yellowish-brick houses, but avoid maroon and blue reds. Red is recommended with a cameo façade.

Windows: brownish reds for outer frames of white windows; terracotta goes well with white walls.

Walls: true reds are a possibility in the country with black and white woodwork, and terracotta is also practicable in the country. Brownish reds with blue or yellow doors are a possibility for the seaside. Russet for a Victorian house.

Industry: for factory exteriors and structures, particularly as accent.

Farms: dark warm red for farm walls.

Food

The natural colour of raw meat and many fruits; one of the best of all colours for food; a hard colour which stimulates digestion. Variations like flame, coral, scarlet and vermilion can be recommended. The best forms of red are warm (i.e. with a yellow bias), and purplish reds should generally be avoided. Conveys a rich taste in some cases but can convey a harsh taste. Claret red is well liked for wine; conveys strawberry flavour.

Food packaging

A friendly colour, although some versions can be repelling; warm variations are preferred and have high attraction value. Red-orange is best of all, but variations like flame, scarlet and coral can be recommended, although red is a little overpowering in large areas. Recommended for meat, meat products, cherries, beetroot, bread, baby foods.

Food in the home	Warm variations can be recommended and are well recommended for food containers, but avoid cool variations – and especially purplish reds, which suggest bad meat. Most reds are a little strong for tableware applications, although warm reds are suitable for table linen. Bright reds are acceptable for plastics ware, but too much strong red may be overpowering. Cool reds or muted reds such as maroon are best avoided in tableware applications.
Food processing	No applications in the food-processing plant, except as a safety colour, because it is too strong.
Food service	The best of all colours with food and the most useful colour in the whole catering environment; use for overall surroundings, immediate surround and presentation.

- Light See Pink (Section 11 below).
- Medium Immediate surround to cooked meats, and display; for accent purposes, fixtures and so on.
- Dark Mainly for decorative purposes.

Food stores	The best of all colours with food, red-orange is excellent for accents and display; use for walls, immediate surround, display, and accents.

- Light See Pink (Section 11 below).
- Medium Immediate surround to cooked meats but generally for accent purposes, fixtures and so on. A strong coral might be used for exteriors.
- Dark Mainly for accent purposes.

Vermillion and flamingo are good accent colours but avoid purplish reds.

Industrial plant and equipment	Red is not a suitable colour for workshop use, although machines are often finished in red for exhibition purposes. Safety red is used to indicate stop or prohibition and for firefighting appliances.
Merchandising	Red has excellent impact value, good recognition qualities and good visibility, and it is well liked. One of the best colours for display purposes, but use bright reds and not blue-type reds; yellowish reds are generally preferred and have better visibility. Red should not normally be used as background because its strength tends to hide a message; strong reds are best used as attention getters or for accent, but red does lose its value under some lighting conditions and is at its best in daylight.
Pattern	The nature of red is such that it ought to command a design.
Safety	Red with white contrast is recommended to locate firefighting equipment and alarms; also for prohibitions and instructions to stop. Overseas, red is used, in addition,

for stop buttons and for positive prohibitions, and in certain countries it is recommended that red should not be used for anything flammable. The use of red as a danger signal requires care because so many males are colour blind.

Signs
Red is excellent for signs because of its recognition and visibility qualities; it has good impulse attraction, but it suffers from the disadvantage that many people are colour blind to red and therefore the form of the sign may be most important. Red is used world-wide to indicate prohibition, and its use is best limited to this application; red tends to 'disappear' in dim lighting conditions, but it will take a lot of dirt without losing appearance. It is an easy colour to see in daylight conditions; it is the easiest of all colour to identify and recognise, but it can be difficult to see in twilight conditions and under some forms of lighting; it is sharply focused by the eye. Yellow-type reds have better visibility than bluish ones.

Television
Most variations reproduce acceptably, although they often have an orange cast; small variations do not show up, and a vermilion with an orange cast or a scarlet with a purplish cast simply show up as red. Maroon is difficult to reproduce and combinations of red with green may also be difficult.

Texture
Strong reds demand rich materials. A surface lacquered in red is impressive and looks better than a rough wood painted in the same colour.

VDUs
No applications.

Woods
Medium warm red goes well with teak, dark oak, afrormosia, tola and antique furniture; a bright red goes with light oak or pine and a deep variation goes best with old furniture. Red is an excellent background for all furniture.

10.5 Interiors

Domestic interiors

Light variations
See Pink (Section 11 below).

Medium variations
Vermilion is recommended for a dining room; rust is good for receding end walls and makes a room warm, welcoming and smart; it will warm up a north-facing room. Terracotta adds an atmosphere of warmth and cosiness and enhances the rich colour of mahogany furniture; flame is recommended for halls and corridors.

Dark variations
Dark reds are recommended for a dingy dining room; pillar-box red makes floor space contract.

Usage	Reds with a touch of white or black in them will not be liked: be definite. Reds with blue in them can be comforting and purposeful, but the deeper tones can be sombre. Reds will give a warm and friendly look to a large room and can be used in rooms that seem cold; they are a splendid background for antique furniture. Red will consistently assert itself against all other colours and is inclined to be aggressive and demanding; Venetian reds are particularly demanding because of their high yellow content; brownish reds are much easier to live with, but too much red of any kind can be overwhelming. Full-bodied reds such as ruby or crimson are appealing and make a flattering background to blond or grey-haired people, but deep reds are apt to be distorted by artificial light. Red can cause restlessness if used in large areas, and its green after-image can be disturbing in some conditions; it is said that many people only quarrel when they are in a red room.
Room character	Reds can create an extremely restful background and a cosy quality, but red can also be an irritant because its physical effects prompt the release of adrenalin; people react more quickly to red than to any other colour; it is fiery, dramatic and eye-catching.
Room aspect	Reds are ideal for rooms that seem cold, including north-facing rooms; they are not recommended for south-facing rooms.
Room size	Reds tend to make a room seem smaller, drawing walls closer together and reducing the size of an already small room, but they give a warm and friendly effect to a large room.
Room features	Red walls at the end of a living room will make the room seem wider, but bright reds make floor space contract.
Room functions	Red is very comforting for a study or writing room but is not very conducive to concentration; it is suitable for some dining areas, and red floors in a hall create a welcoming effect.
Room users	Red is a warming colour for the escapist or a dramatic colour for the extrovert; it leaps on the beholder and refuses to be taken for granted, it never recedes or takes second place. Reds are the preferences of children from about 2 until 5 years old and are therefore recommended for rooms for very young children; strong reds are good for all children.

Commercial interiors

Attention is drawn to the environmental uses listed in 10.7 below.

10.6 Combinations

Good harmonies	Red with white (partners and natural foils), pink, blue (vibrant effect), red (all reds go together), brilliant yellow, shocking pink. Bright red with cream; deep red with flesh, peach, ivory; coral with white; flame with darker yellows, white, blue; magenta with orange, brown, green, other reds including pillar-box red; scarlet with royal blue (strong), midnight blue, brown; vermilion with emerald green.
Avoid	All bluish reds (including magenta) with blue; pale reds with brown, olive, dark green; maroon with lavender, pale blue.
Good contrasts	Scarlet with darker greys; red with green.
Accentuated by	Proximity to dull green, dull blue, grey.
Diminished by	Proximity to yellow, brown.
Accentuates	Blue-green.
Diminishes	Violet, orange.

Suggestions

- Pure reds with a touch of white look faded; it is better to add enough white to turn red into pink. Pure reds with a touch of black look dingy; it is better to add enough black to turn red into maroon.
- If red and yellow are seen together, the red will incline towards violet and the yellow to green; if red and blue are seen together, the red will incline towards orange and the blue to green; if red and grey are used together, the red will be purer and the grey will be greenish.
- If red is put near blue, the red seems yellower; near yellow the red seems brownish; near green the red seems purer and brighter; near black the red seems duller; near white the red seems lighter; near grey the red seems brighter.
- Team reds with peaches, apricots and tans with touches of lime and shocking pink.
- Adjacent combinations based on reds are well liked.
- Flame red with white and blue has high attraction value because it combines the most liked colours; red and artic white is sophisticated and functionally sound – it provides heat control. Apache red with white and black is sophisticated and has good style and memory value; it is recommended for urban areas.
- Pillar-box red and grass green are an ideal combination for a kitchen and also for a bedroom; they are bright and cheerful.

- Red, white, black and grey is stylish and a classical colour scheme which always makes an impact.
- Red with yellow is striking and modern.

10.7 Uses

Consumer applications

Bathroom products There is unlikely to be a demand for pure reds in the bathroom except for accent purposes; some sanitary ware manufacturers have strong reds in their ranges, and autumn red, which is a compromise between red and brown, has been well promoted, but these deeper shades probably have most appeal at the top end of the market. Clear reds on the yellow side are recommended and will warm up a bathroom.

Bedroom products An all red bedroom would be overpowering and pink is the best bedroom colour but red can be used for bed covers, curtains, and other accents. Red is very suitable for bedrooms because it conveys cuddling and passion to most people, it is warm but it is also an excitable colour. It appeals to the young and to all age groups and it will help to create a sexy bedroom; it is recommended for a bachelor pad. Used properly, red can provide a restful background in the bedroom, its sense of warmth promotes a feeling of comfortable enclosure; it is a warming shade for the escapist and a dramatic colour for the extrovert.

 Red sparks neutrals into life while red with blue will create a vibrant atmosphere which can be comforting although deeper tones may be sombre. Use red in a bedroom that seems cold, it will give a friendly effect to a large room; brownish reds are easier to live with than those with a high yellow content. Red is said to be for sexual athletes and people who like a red bedroom are aggressive, extrovert and sensual.

- Medium Pale brick red is recommended for bedroom carpets.
- Dark Create a rich look but tend to dominate a room; deep reds go well with dark ivy green; mulberry is a sober, forceful hue. A Pompeiian red carpet is well recommended for a bedroom.

Domestic appliances Red is best suited to smaller appliances; it is rather strong for large appliances but is a cheerful colour that makes a kitchen a pleasing place to work in; it is an excellent colour to attract attention. Red is a warm colour, symptomatic of fire, and can be used for space heaters, although it is not recommended for radiant fires, because it would detract from the 'flame', but it is an excellent attention getter on the showroom floor. Flame and similar variations are recommended for small personal appliances but could also be used for larger space heaters. Restrained variations, such as maroon, might be used for space heaters and for cookers.

Housewares Clear reds on the yellow side are well recommended for kitchen utensils; cool reds are less well recommended but have a place at the top of the market; excellent in association with food and fine for attracting atten-

tion in the showroom. Clear reds may be used for tableware but are not recommended for the interior of vessels; cool reds are much used in the decoration of ceramic ware but are not recommended for plastics ware. Deep, cool reds such as aubergine might be used in higher-grade markets. Red is well liked as a means of providing accent or decoration on the table; reds like scarlet are preferred for tableware, and variations near to red-orange could be used, but trends are important. Clear reds are well recommended for food containers; scarlet or vermilion would be good, but not cooler reds.

Kitchen products The brighter reds have long been popular for all kitchen products and are likely to remain so; red is one of the classic kitchen colours and should be included in most ranges. Housewives see red as a cheerful colour which makes the kitchen a pleasing place. Blue-type reds have been tried from time to time in higher-grade markets but seldom take off. Warm reds are suitable for most kitchen products including units and utensils. Dark variations are also suitable for most kitchen products and cool types might be tried for units at the top end of the market, but not for utensils.

Living room products Attention is drawn to the remarks under the heading of Domestic interiors in 10.5 in this part.

Window decoration products One of the best of all colours for window decoration; warming and cosy. Deeper reds create a rich look but tend to dominate a room.

Graphical applications

Packaging Warm reds are preferred because they have better visibility than cool reds and are an excellent feature colour for packaging, probably the best of all colours, pure and with high impulse value. Red appeals particularly to the young in packaging applications. Vermilion has high visibility, strong emotional and visual impact and appeals to both sexes world-wide; no other colour has so much appeal. Be careful of variations; preferences change. A red which is less than pure may appear faded. Red tends to disappear when the eye is dark-adapted, and this may cause difficulty with some packages. Red should not normally be used as background to a message; it is sharply focused by the eye and lends itself to sharp angles. It conveys a feeling of durability; it is the most easily recognised and identified colour and the easiest to see in daylight conditions. Medium variations are strongly recommended for food, with flame and vermilion having maximum attraction; may also be used with advantage for caps and closures. Maroon is a good foil colour, and scarlet is recommended for business markets. Magenta and purplish shades generally should be avoided, especially for food because they may suggest bad meat.

Print As for packaging. Essential for point-of-sale and display applications because of its high visibility and impulse attraction, but use on a neutral background; red letters on a grey background are more visible than the reverse. Scarlet and other clear reds are recommended for business applications. Red is excellent for tags for many products, especially those appealing to men and children, but it may be difficult to read in dim lighting.

Images As for packaging and print.

Vehicle liveries As for packaging and print. Red should not be used for background except in special circumstances and, if it is, take care to ensure that legend and features are legible. Red is recommended for fire engines and is suitable for agricultural vehicles, but it is not now generally used for the exteriors of passenger vehicles, except for London Transport. Generally red is the most easily recognised and identified colour and the easiest to see in daylight conditions; it tends to advance, it attracts attention, it makes objects look larger and will take a great deal of dirt without losing appearance, but it is difficult to see in dim light and may be particularly difficult in the dangerous twilight period and in city conditions, at night, against a background of neon lights, traffic lights and so on; it may also be almost invisible, or look brown, under some forms of street lighting.

Environmental applications

Catering The most useful colour in catering, good with food, warm, welcoming and flattering; it is inescapable as an accent colour and ideal for any situation where the eye has to be stimulated; it has universal appeal and is highly suitable for signs. Excellent for accents and for displays intended to catch the eye; cool reds are best not used as an immediate surround to food but may be used in the overall surroundings. Lighter reds are discussed under Pink (Section 11 below).

- Medium Exteriors in sunny climates, hotel rooms, coffee bars, restaurants, canteens, kitchens, corridors, display, lounges, canteen furniture.
- Dark Restaurants, bars, display, fast-food outlets, but keep dark, cool reds away from meat.
- Avoid Strong reds in canteens, it is said to make workers aggressive; dark reds in kitchens; maroon in hotel rooms and lounges.

Factories Red is the most insistent of colours and can be used to draw attention and create warmth. Medium reds may be used for end wall treatments, but darker reds should only be used for safety purposes. Most reds may be used for exterior structures. Medium variations may be used for end walls in cool areas, combined with grey side walls, and this is very suitable for fine assembly work. Coral is suitable for an area in which mental tasks, fine assembly or inspection are performed, also for areas where there is manual activity and in recreation areas. Dark variations should be used for safety purposes only.

Offices Cool reds and those with a bluish tinge should be avoided except in small areas. Red is used to mark fire points, prohibitions, and for 'stop'. Medium variations may be used for end wall treatments (cool reds may be used for this purpose) and for accents on furniture and equipment. Coral provides a friendly atmosphere in reception areas or lobbies and for recreation areas, and a pale coral can be used for general offices. Medium tones can be used for floors especially where the outside environment is drab.

Dark variations should only be used for accent purposes. Medium reds would not be very suitable for screens which are in close proximity to workers, but they can be used for decorative screens and for rest areas and the like.

Retail Red is inescapable as an attraction colour and ideal for any situation where the eye has to be stimulated, it creates warmth; it has universal appeal and is highly suitable for signs; it is excellent for accents and displays designed to catch the eye. Red is a safety colour recommended for fire appliances; medium variations may be used for hardware stores. Maroon is good for dramatic emphasis in a fashion store but its use needs care; it may be used as background for light-coloured merchandise. Pink has most uses in the store (see Section 11 below).

Schools There are comparatively limited applications for reds, although pink is well recommended (see Section 11 below), terracotta is warm and friendly.
- Medium Deeper corals may be suitable for end wall treatments in corridors; terracotta is recommended for kindergartens, is good in the assembly hall and can be used for end wall treatments. Rose can be used in classrooms as an end wall treatment and can also be used in auditoria.
- Dark May be used for accent purposes, especially in kindergartens and primary grades, but use in small areas; large areas of strong red are too overpowering.

Hospitals Brilliant reds are to be avoided; they are unduly impulsive for ill patients and will grow monotonous to those confined. Terracotta may be used for identification purposes, and dark reds may be used for signs indicating ambulance, accidents, casualties and so on.

Commercial applications

Office supplies Warm reds are the most important colour in the office equipment sector and will be wanted in all applications; excellent for identification and have maximum attention value. Darker reds are traditional for desk furniture, but medium versions have more impact and good contrast with other colours; best of all colours for recognition purposes. Medium reds are well recommended for presentation and have excellent qualities. Reds are also essential for consumer items whether trends so indicate or not. Medium reds will have most impact at point of sale but choose variations that accord with current trends. Reds should not be used for furniture or machines except for accent purposes such as for drawer fronts.

Cool reds have comparatively little impact in the office and have few uses; they can be used for presentation purposes when it is desired to convey a rich and dignified impression; darker shades are suitable for desk furniture. Medium and dark variations on the blue side lose impact at point of sale, but magenta might be suitable for personal use in higher-grade markets; darker shades are also useful for book covers. Scarlet is particularly good for business use. The Post Office refuses to handle red envelopes because they cause strain to the eye.

Paper and board Red is a bit strong for most paper applications except where immediate action is required or for identification purposes. Clear reds are sometimes used for business stationery and letter headings and have applications for file covers and the like, where identification is important.

Attention is also drawn to the notes in Section 1 of this part.

Surface-covering applications

Attention is drawn to the explanation of colour selection for surface coverings in Section 1 of this part.

10.8 Legend

Red has always been attractive to human beings, and the people of North Africa and Asia Minor, including the Egyptians, considered themselves to be a red race and were proud of it; they dyed their flesh red. Red-bearded youths were sacrificed in Egypt to ensure an abundant harvest. The Arabs recognised two races, one red and the other black; in the *Arabian Nights* Magians were red. In African mythology those who drank the blood of the first ox slaughtered for food began the red race and those who ate the liver began the black race.

Red was the colour of Mars, the god of war, and in ancient lore it was the habitable earth. To Tibetans the west was red, but to the Chinese and to Hopi Indians the south was red. Red was the colour of fire in Greek symbolism and in Hindu, Jewish and Chinese lore. To American Indians red symbolised the day and it was considered a masculine colour; it also signified success and triumph. To early Christians it signified love and sacrifice.

The physician of Edward II directed that everything in a room should be red to thwart smallpox, and English physicians wore red cloaks as a mark of their profession. Francis I of France was treated with a red blanket, and in Ireland and Russia red flannel was a cure for scarlet fever. Red wool cured sprains in Scotland, sore throats in Ireland and prevented fever in Greece. Red thread was thought necessary to the teething of English children, and in China a child wore a red ribbon to promote long life. In Scotland and many other countries a bit of red string or cloth was tied to animals to protect them from death. In Egypt, the Orient, Russia and the Balkans, red is the colour of marriage, and in China a bride always dressed in red.

The word 'red' is found in virtually every language, including Anglo-Saxon and Sanskrit, and the colloquial terms which include red are almost all based on the emotions that it arouses, such as passion and excitement. As a girl grows up she tends to splash out with reds and pinks to tell the world of her independence, but red also stimulates men. In Roman times the posting stations along the Imperial highways were painted red, and this is possibly the derivation of the 'red light' area – a red lamp marks a brothel and a scarlet woman is a prostitute.

Red was reserved for saints and martyrs in the Christian calendar, hence 'red-letter days'. 'Red tape' refers to the tape of that colour used for documents in government offices and has come to mean bureaucracy. A man who is in debt

is 'in the red', and this derives from the practice of bookkeepers who wrote losses in red, but even when the man has not 'a red cent to his name', he still looks at the world through 'rose-tinted spectacles'.

Red is a symbol of courage, bloodshed, cruelty, martyrdom, justice, danger and health; the red flag has always been the symbol for battle, hence its adoption by the Communists, who are now called 'Reds'. 'Red-hot news' speaks for itself, but 'painting the town red' is less easy to explain; it is certainly an American term and may have something to do with blood-letting in the Wild West. Nor is it very clear why politicians are apt to put forward 'red herrings'.

Red is almost universally popular, irrespective of race, culture and nationality, and it is featured in almost all countries. In heraldry red betokens courage and zeal; a red ribbon is usually second prize at a cattle show. All the terms mentioned, including 'seeing red', convey excitement; red-letter days, for example, were exciting. Red signifies high rank in Eastern carpets and is associated with fast music.

11 Pink group

Orange-pink subgroup
- Light Pastel pink, peach
- Medium Coral pink
- Dark Flame pink

Mauve-pink subgroup
- Light –
- Medium Orchid
- Dark –

11.1 Character

This group consists of reds with white and is separated from the main red group because pink is such a versatile colour that experience has shown that a separate heading is useful. Pink is one of the most imaginative of colours, it can be subtle and sophisticated, bright and chic, vibrant and stylish, and can give a glow to a room, it is cosy and flattering.

It is a warm, hard, colour which is inviting to the viewer. All pinks go well together, and pink mixes well with red. Coral is a warm, flesh-coloured variation which is very suitable for cool conditions and areas with a low temperature; it appeals to almost all women. Subtle pinks are exclusive and essentially feminine and pink conveys an impression of sweetness. Visual conditions are the same as for red. Pink light is very flattering to humans, and pink light in a dining room will enhance a meal, although artificially coloured lamps may distort the appearance of food; it is best at low levels of illumination. Pink is a good illuminant and excellent for lampshades.

11.2 Attributes

Age	Appeals to all age groups but usually only to women.
Appearance	The most flattering of all colours, particularly to females, and well recommended in any situation where females dominate: the reflection of pink on to the hu-

	man face creates a flattering glow, and warm coral pink is particularly good.
Associations	Fashion, women, flowers, sweetness, confectionery, babies, although the old association 'pink for a girl' is now falling out of use. Peach is associated with happiness.
Fashion	Subtle pinks are exclusive and high fashion and very feminine.
Impulse	Luminous tones of pink have good attraction value; coral pink is recommended but avoid very pale pinks.
Markets	Suitable for most markets but essentially for fashion applications or for women.
Mood	Creates a gentler mood than red and is essentially feminine.
Personality	People who like pink are gentle, loving and affectionate; people who dislike it are resentful and peevish.
Preferences	Choice 3 in children, 5 for adults. Appeals to women more than to men and does not generally appeal to teenagers.
Presentation	Good visibility and particularly suited to presentations to women; rose pink has a fashion application.
Products	Cosmetics, business, food, confectionery, fish; flesh, peach, rose, are good for feminine cosmetics; traditionally for baby products; use for shellfish. Peach is particularly good with food and it, and soft rose, appeal to businessmen. Use for feminine cigarettes.
Recognition	Poor recognition qualities.
Reflectance	Light pink about 65 per cent, flesh about 50 per cent.
Seasons	The pale, delicate colouring of pinks is suitable for spring; stronger variations with summer.
Sex	Appeals to women but not to men as a general rule; rose pink is particularly feminine. Pink was, at one time, especially associated with female babies, but yellow is now taking its place.
Shape	NSC.
Size	As for red; strong pinks will make an image seem larger than will dark reds.
Smell	Typical colours having an associated smell include rose, carnation, peach. Pink has an association with flowers in general and with crushed flowers in particular.
Stability	Creates a gentler mood than red and a feminine atmosphere but does not suggest stability.
Taste	Associated with sweet things, including bakery products and sugar confectionery. A 'candy' colour.
Tradition	Widely used in most decorative periods; Adam recommended pink for ceilings. Traditionally associated with girl babies.
Visibility	Stronger pinks, such as coral, have excellent visibility

and reasonable recognition qualities.

Warmth As for red but may be less inviting.

11.3 Functions

Camouflage NSC.
Coding Not generally recommended except as a contrast to
 darker colours; a strong pink is indicated if used at all.
Insect control Repels mosquitoes.
Pipeline
 identification Hydraulic oils.
Readability Not recommended.
Signalling Not suitable.
Visibility of
 controls Not recommended.

11.4 Applications

Biological Psychological effect. Aggressive people may be drawn
 to pink; a symbol of an unconscious wish for gentility.
Children Particularly suitable for girls; appeals to all age groups
 but to older people rather than teenagers.
The country Pink may be used in cases where a warmer tone is re-
 quired; peach is well recommended in association with
 any food; coral may be used in a food factory to compen-
 sate for very low temperatures, also for vegetable
 processing and in farm shops.
Export Essentially a colour for temperate regions, it is lost in
 strong sunlight, but rose or peach might be used for ex-
 teriors in sunny regions. Arabs like pink bathrooms, and
 pink may convey pornography in some Eastern coun-
 tries.
Exterior Some forms of pink weather very quickly, and too strong
 pinks are best avoided in towns; apricot can be recom-
 mended.
 Walls: Suffolk pink is recommended for suitable houses;
 soft pink is good for a semi-detached bungalow and suits
 a garden setting; dawn pink is good for a cottage in the
 country; pink is good for colour-washed walls, and
 strong pinks are successful if the light is strong; coral and
 slate go well together; pink/brown decreases height and
 narrowness; peach for a cottage or damask pink for a
 semi-detached cottage.
Food Peach is the colour of many fruits, including the peach
 itself, and is well recommended for many foodstuffs; all
 pinks can be well recommended for confectionery and
 other sweet things, especially sugar confectionery and

	iced cakes. Peach is an especially good appetite colour, and pink is the colour of cooked meats.
Food packaging	Peach is good for many foodstuffs but lacks impact at point of sale. Suitable for fruit, confectionery, sweet things generally, seafoods.
Food in the home	Peach is particularly recommended in association with food and promotes appetite; other pinks can be used but not dusty pinks or cool pinks; peach could be used for food containers, but other pinks lack impact. Acceptable for tableware and has refinement.
Food processing	Some variations are a little too warm for food plants, but peach is a good background to food and an alternative to white. All pinks are flattering to the human complexion. Peach or coral can be recommended for refrigerated areas and coral for cool areas generally and for vegetable processing.
Food service	Pink is one of the most useful colours in the catering environment and may be used for walls in many catering applications, including walls adjacent to displays. May be used for plates, serving dishes, table tops and so on, and for immediate surround, particularly with fish. Peach may be used as accent in fast-trade outlets.
Food stores	Peach and coral are very useful in the food store and may be used for walls in groceries, immediate surround to vegetables, walls for bakers (peach with blue accents is recommended), refrigerated areas, walls in delicatessens, immediate surround to shellfish, immediate surround to confectionery, accent for fixtures (especially coral), walls in car showrooms. Peach is good in supermarkets because it suggests activity and promotes appetite; coral is an alternative to peach and is one of the most edible of colours.
Industrial plant and equipment	NSC.
Merchandising	Luminous shades of pink are good attention getters, but paler shades are best used as background; less dominating than red, essentially feminine and best used for fashion and cosmetic applications.
Pattern	NSC.
Safety	NSC.
Signs	Pink is quite suitable for signs, but its use should be limited to ground, it is not suitable for legend; it has less impact than red but may be used where it is desired to convey something a little unusual. Poor recognition qualities, although stronger pinks, such as coral, have reasonable qualities; stronger pinks have reasonable visibility. Recommended for powder rooms and other feminine facilities.

Television	The pink of the human complexion shows up well, but a dusty pink against a dark field will look washed out; aim for a brightness ratio of about 5 : 1.
Texture	Pink is not suitable for heavily textured surfaces.
VDUs	NSC.
Woods	Deep pink goes well with beech, but peach is neutral with woodtones.

11.5 Interiors

Domestic interiors

Light variations	Pale pink is delicate, unobtrusive and flattering, it is restful without being cold; pastel pinks with primaries create a demure and lively look.
Medium variations	Peach is recommended for a sophisticated living room or bedroom but requires the addition of accents; it is neutral with woodtones and has a sunny aspect in winter. It is an appetising colour which is very suitable for use in eating areas and in the kitchen.
Dark variations	Flame pinks can be quite dominating and aggressive.
Usage	Pinks make a room seem warmer but not overbearing; as background they warm even the cool light of northern exposure and the cool light of certain fluorescent lamps; they are the most flattering colour to the complexion. Bold pinks can be bright and striking; contrasting pinks add impact to neutrals; pure pinks create a fashionable look and soft pinks are warm and subtle. Pink is adaptable to a variety of styles; think of it as a neutral with an extra block of colour; different tones of pink create a positive look. Warm coral pink is particularly flattering to the appearance.
Room character	Pink is one of the most versatile and imaginative of colours; it can be subtle, sophisticated, bright, vibrant and stylish. Fuschia pinks have a more lively effect than candy pinks.
Room aspect	Pink is recommended for north-facing rooms and rooms without direct sunlight, or for east-facing rooms that may only get sun in the morning. It is ideal for rooms that seem cold and adds a flattering glow.
Room size	Pink has little effect on room size.
Room features	Pink ceilings give a glow to a room.
Room function	Pink is excellent for bedrooms; peach and coral are good for dining areas; darker pinks may be used for halls.

Commercial interiors

Attention is drawn to the uses in environmental applications in 11.7 below.

11.6 Combinations

Good harmonies	Pink with mauve, grey-green, aqua, pink (all pinks go together), red, beige, orange (vibrates and creates accents), dark blue, purple, yellow; deep pink with lilac, pale grey, pale blue-greens; hot pink with grey (sophisticated), pale beige; shocking pink with orange, green, brown, red; coral with blue (recommended for food service); peach with deep red, flesh, blue, violet, light browns, copper, dark ginger; rose with blue-green.
Avoid	Shocking pink with blue.

Suggestions

- Pink mixes well with reds and blues, and adds impact to neutrals.
- Peach can be combined with coffee cream, caramel, copper or dark ginger and is improved by a touch of aqua.
- Use hot pink with greys for a sophisticated scheme, add green or turquoise as accents, or purple for drama.
- Coral with blue is bold and dramatic for food service, the blue provides a foil and denotes cleanliness; pink, rose, coral, peach are all complemented by Alice blue. Avoid shocking pink with blue.
- Peach harmonises with almost anything; it combines well with pale blue and with warm grey-green.
- Shocking pink with white creates a clean, vibrant look.
- Pink combined with electric blue or black is dramatic; combined with grey and pastel green it is restful.
- Peach and white in a dining room will create space; pink with yellow is pretty and imaginative.
- Pink and blue in equal quantities is the perfect compromise between masculine and feminine in the shared double bedroom.
- The natural contrast to pink is green.

11.7 Uses

Consumer applications

Bathroom products Pink is one of the most popular of all colours for the bathroom because it creates a flattering glow on the human complexion; it is considered particularly appealing to women for this reason and is enhanced by artificial light. It is a warming colour which makes a cold bathroom more comfortable. Pink is always likely to be a popular colour, but the types of pink wanted may vary from time to time. Suitable for towels, wallcoverings and all accessories.

Bedroom products Pink is probably the most popular colour of all for bedrooms because it is feminine, flatters the complexion and is warm. Yellowish pinks are generally better than bluish pinks; candy pinks are livelier than fuschia pinks. Pink appeals to mass markets but to other markets as well; it is popular for beds at the lower end of the market and is traditional. Pink makes a room seem warmer but is not overbearing, and it is recommended for early risers; it counteracts lack of sunshine in a cold bedroom. Pastel pink is soft, pale and romantic, while peach is feminine and tempting and is recommended for a sophisticated bedroom.

Domestic appliances Pink is not very suitable for most appliances except for personal products; it is essentially a feminine colour and is suitable for products used by women, but not in the kitchen. Although variations such as peach are excellent with food, they are a little warm for kitchen use and have been found to be unsuitable for refrigerator interiors. Not very suitable for space heaters, except, perhaps, those designed for use in the bedroom. Peach is warm in nature and might be used in some cases for accent purposes; it might be used to tone down a red unit. Light variations are recommended for personal products, and medium and dark variations can be used for the same purpose and also for space heaters in some cases.

Housewares Pink has never been considered to be a kitchen colour, and pink utensils are virtually unknown, although there is no practical reason why it should not be used. Pink is not normally considered to be a tableware colour, perhaps because it was widely used at one time for cheap bodyware, but it is frequently used in the decoration of fine china and for table linen; it can be used for the interiors of vessels. Not well liked for food containers.

Kitchen products Many of the remarks made about red apply equally to pink, although it has never been very popular for kitchen use; even peach, which is particularly suitable, has been neglected. If pink is used at all, orange-type pinks are recommended.

Living room products Attention is drawn to the remarks made under the heating of Domestic interiors, 11.5 in this part.

Window decoration products Excellent for windows in all parts of the home, but especially for bedrooms; gives a glow to a room.

Graphical applications

Packaging Similar to red, although pink lacks the impact of pure red; it is particularly recommended for cosmetics and fashion products. Light variations such as flesh, peach and rose are recommended for feminine cosmetics and are traditional for baby products; can also be used for shellfish. Peach is particularly good with food, and rose appeals to business markets. Medium variations can be used for caps and closures for cosmetics and can also be used for cigarettes intended for women.

Print As for packaging. Strong pinks may be used for mailings, especially about fashion; rose and peach are suitable for business use. Well recommen-

ded for tags for feminine products and for cosmetics; black on pink has good visibility.

Images As for packaging and print.

Vehicle liveries As for packaging and print, otherwise no special connotations.

Environmental applications

Catering Pinks are excellent for food and for display (see also Red, Section 10 of this part). Pinks generally can be used for fast-food restaurants, bedrooms, motel rooms, kitchens (although in small areas), restrooms, washrooms. Peach is excellent for all food applications; for exteriors in sunny climates; for restaurants, both fast and medium trade; for coffee bars; for bedrooms, corridors, washrooms, restrooms; and is particularly useful in canteens. Coral is good for all eating places, especially those with an active trade; restaurants with both a fast and a medium trade; for bars and coffee bars; and is recommended for canteens. Coral is also good for interiors in cloudy climates and for hotel lounges and bedrooms, display, bathrooms, corridors. Rose pink may be used for exteriors in sunny climates, interiors in cloudy areas, exterior surfaces of motels, hotel rooms, motel rooms, washrooms, restrooms, fast-trade restaurants, coffee bars and is good in most bars.

Factories Pink and its variations may be used for walls, particularly where women are employed. It may be used for large wall areas without daylight or where temperatures are low; where materials are highly coloured; for female washrooms; for canteens; for refrigerated areas; for processing of vegetables; for chemical plants, provided that conditions are cool; for machine shops where temperatures are low.

Offices Warm pinks are particularly suitable for offices with a large proportion of female workers because women like pink and it flatters their complexions. Peach is particularly useful in the office and in relation to food; a deep peach having an appropriate reflectance value could be used for screens. Pinks can be used for walls of general offices, peach is recommended for walls opposite windows and for rooms having little sun; it is also recommended for typing pools and in canteens where it is conducive to the consumption of food. Rose pink is well recommended for female restrooms.

Retail General remarks are the same as for red (see Section 10 of this part). Pink and rose are recommended for female fashions because they appeal to women and outsell most other colours in consumer goods, but the exact shade needs care in choice; for chemist's shops and food stores; rose pink is recommended for walls in a fashion department, it is warm and makes an area look larger; it is also an excellent background for home furnishings. Peach is good for baby products and for car salesrooms. Blossom pink or flamingo is a suitable background for childrens' wear and for womens' wear.

Schools Peach is particularly good for rooms occupied for long periods at a

time and for rooms with north or east exposure or where natural light is weak; warm pinks have much the same attributes. Peach is excellent for kindergarten and primary grades and for areas of relaxation, dining halls, cafeterias; a deep peach is a good end wall colour. Warm pink is recommended for manual training areas, for locker rooms and for changing rooms because it matches the complexion; coral pink is very suitable. Pink is a possibility for the ceilings of auditoria; rose, peach or coral could be used for walls of assembly halls, for upper walls of manual training areas and for gymnasia. Coral is a possibility for desks, and most pinks can be used for dining areas and cafeterias.

Hospitals Peach is similar to the colour of the human complexion, tends to increase room dimensions and is useful in areas without much natural light and can be one of the most useful shades in the hospital. Coral is highly pleasing to the appearance and has a slightly stimulating visual and emotional effect, especially if accented with blue-green. Pinks may be used for convalescent wards and maternity wards; peach is ideal for small wards, short-stay wards; coral is good for most patient accommodation; rose may be used for wards in conjunction with grey or a neutral, and for nurses' bedrooms and sitting rooms; peach is recommended for all dining areas and is preferred for corridors. Pinks generally may be used for toilet areas, small dressing rooms, lavatories, nursing stations, reception areas.

Commercial applications

Office supplies Pink has comparatively few uses for office supplies; salmon pink is sometimes used for coding and identification, and rose pink might be suitable for some consumer applications. It may be useful as a contrast to stronger colours.

Paper and board Pink is better than red for most paper applications; black ink on pink paper gives excellent legibility. Pink is particularly suitable for anything to do with women, such as mailings about fashion. Rose is a warm tone of pink which can be recommended for this purpose, but stronger pinks, such as coral, could also be used. Salmon pink has business applications and is recommended for ledgers, inventory sheets and purchase requisitions. Pink paper with purple and green inks will create a mood of excitement and is very suitable for fashion mailings; pink envelopes are also good for mailings.

Attention is also drawn to the notes in Section 1 of this part.

Surface-covering applications

Attention is drawn to the explanation of colour selection for surface coverings in Section 1 of this part.

12 White

12.1 Character

White is the universal alternative, something unaltered; it provides good background but has little interest because of its lack of chromaticity but it can have an effect on a room that no other colour has. It is a neutral colour and is not particularly inviting. When used it should be unquestionably white, and if this is not possible, use some other colour; it can look like cream in a sunny room or grey-green in a cold room. An all-white environment can cause glare and may even cause illness; too much white can cause headaches if not broken up and it is not recommended for floors, off-whites are better. It may be used for walls where critical seeing tasks are not performed, such as for corridors and so on. White looks whiter against a black background than it does against a grey background.

A white surface will appear under all light conditions so long as it is visible; it is recommended for ceilings to reflect maximum light and is essential with an indirect lighting system but is not recommended for walls in a working environment; a preponderance of white is emotionally sterile and white light should be avoided. It can be recommended for lampshades.

12.2 Attributes

Age	No special age group, but young people like large areas of white; a white/green combination is associated with the young.
Appearance	Neutral in character, and while not unflattering, tends to be sterile and uninteresting.
Associations	Associated with cleanliness in the minds of most housewives; also with purity and weddings; although with mourning in some countries. Signifies joy in Eastern carpets.
Fashion	Generally for traditional use, such as weddings.
Impulse	Background only.
Markets	Acceptable in all markets.

Mood	Neutral in character; creates a stark atmosphere but is also associated with weddings and other joyous occasions.
Personality	No effect.
Preferences	Choice 2 for children, 4 for adults.
Presentation	No special virtues.
Products	Right for most products but lacks impact. Suitable for pharmaceuticals and associated with kitchen appliances.
Recognition	Has little visual interest because of its lack of chromaticity; it has good visibility but is difficult to find and identify.
Reflectance	84 per cent.
Regional	NSC.
Seasons	Late winter and early spring; think of snow and crocuses.
Sex	Neutral.
Shape	NSC.
Size	Tends to make an image larger but has little effect on the distance of surfaces.
Smell	No associations.
Stability	Dignified but a little stark and sterile.
Taste	No special associations, but white lemonade is expected in some quarters.
Tradition	One of the most popular colours for interior decoration; traditionally for weddings and domestic appliances.
Visibility	Can be seen at a considerable distance, but it is difficult to remember and to find, the eye has difficulty in seizing upon it. It stands out sharply in the dark but tends to reflect sunshine and can be trying to the eyes. It is difficult to pick up quickly when it is dirty.
Warmth	Neutral, but may be a little cool.

12.3 Functions

Camouflage	NSC.
Coding	Only to be used if contrast is necessary; it has little visual interest and is not generally recommended.
Heat control	Ideal for reflecting heat.
Insect control	NSC.
Pipeline identification	Cooling water; with red for boiler feed; with green for chilled water; with dark blue for cold water from storage tanks; with red for hot water supply; with blue for vacuum; with brown for diesel fuel.
Readability	Black on white, white on black, blue on white, white on blue, white on green, green on white, red on white, white on red, white on purple, purple on white.
Signalling	Good visibility but does not have good recognition.

| Visibility of controls | Good visibility but poor recognition qualities; best used as background to dials and the like. |

12.4 Applications

Biological	Preferred by schizophrenics, otherwise no special comments.
Children	Appeals to all age groups but is not very practical for furnishings for the very young, and it is too clinical for a child's bedroom.
The country	Widely used but tends to be cold and sterile and accentuates the natural coldness of food-handling installations and is only recommended for food plants where cleanliness is imperative and where cost is a major consideration. May be used for dairies, cow-houses and slaughter-houses.
Export	Suitable for any country or climate, and it is often used for its heat-reflecting qualities, but it is not a very practical colour for underdeveloped countries because it gets too dirty. White is restricted to ambulances in some countries. China: the colour of mourning; use with care for illustration. White and blue together mean money. Hong Kong: not recommended for packaging. Colombia: not allowed for cars. Arab countries: avoid use of blue and white, the colours of Israel. Sweden: avoid blue and white for packages, the national colours.
Exteriors	White means purity in most Western countries. Always light, pure, clean, simple; excellent in sunny regions and for town houses, although it tends to look dirty after a while and lacks impact. It may be best to pick out details in white. Doors: a white frame to a black door is good; white is very suitable for the doors of town houses. Windows: white window frames reflect light and are welcoming; use white if the paintwork next door is bright. White woodwork goes well with sage green, olive green, navy blue, battleship grey and looks well with a house painted golden yellow. Walls: white plasterwork with dark panels is dignified; it may be used for details of brick houses, it cools down the brick. Use for colour-washed and roughcast walls; balconies should usually be white; white walls go well with terracotta woodwork; black and white is good for plain houses; recommended for mouldings in town houses and

	can be used with green or pale yellow for town houses; brilliant white for a Victorian house. White walls provide an attractive background for foliage in the country; looks good linked with green; goes well with natural woods. Industrial: recommended for industrial interiors. Useful for heat control purposes.
Food	The natural colour of salt and sugar and always correct in relation to food; goes with any other colour; no particular effect on digestion. Good foil and is best used as a background to food except for iced confectionery. Salt and sugar should always be pure white, although coloured sugar crystals are acceptable. White ice-cream is considered to be vanilla flavoured. White is the universal alternative; it conveys cleanliness and purity and something unaltered; because of its cleanliness connotations it is particularly suitable for trays and other background.
Food packaging	Always correct but lacks impact and is best as background. Conveys purity and has been used for health-foods to emphasise the health aspect.
Food in the home	Excellent as a background to food and for trays and the like. Recommended for the interior of food containers and can also be used for exteriors but lacks interest. Right in all tableware applications.
Food processing	The ideal colour for food plants because it is cool, clean and promotes hygiene; widely used but tends to be cold and sterile unless relieved. Very large areas tend to be trying and to create glare; they also accentuate coolness. Reasonably flattering to human appearance. Recommended for dairies.
Food service	Ideal background for presentation; use for fittings, fixtures and refrigerated displays and for accent in immediate surround. May be used for plates, serving dishes, meat trays and so on, and for table tops; also for back of shelves and racks. White is not recommended for walls in catering establishments because it is sterile; avoid too much white.
Food stores	Clean and effective for food applications, it denotes cleanliness, and research carried out in the United States found that white is pleasing to the housewife because it gives her the feeling that the shop is an extension of her own home and that the store has a feel for cleanliness. May be used for walls, although too much white may be sterile and cause glare; a neutral might be better in some cases. Ideal background for the display of foodstuffs, particularly meat and provisions, and for the interiors and backs of shelves. Use for fittings in grocer's shops,

	refrigerated fittings, walls in off-licences and dairies.
Industrial plant and equipment	Not recommended in the industrial context because it tends to cause glare and distraction. Can be used for the body of food-processing machinery because it promotes cleanliness.
Merchandising	Lacks impact, difficult to find and to remember but has good visibility; stands out sharply in the dark. Best used as background, especially for food and in connection with weddings. White has maximum contrast with black but can be used with any colour.
Pattern	Often used as a base colour for design because it will go with anything; in such cases the secondary colour has more significance.
Safety	In standard safety applications it is used as a contrast to other colours. Overseas it is used for aisle markings, waste receptacles and storage-area bins.
Signs	Good ground colour for signs, but although it has good visibility, it is difficult to recognise and to find; it is best used for regulatory signs, and in the UK is used for minor road signs. It is subject to glare and can cause blurring; it may cause a blind spot in bright sunlight but is good in darkness because it is always white and does not lose its identity. Poor recognition qualities, it has little visual interest, particularly against a background of sky; can be seen at considerable distances but is difficult to find and is particularly difficult to pick up quickly when dirty. Stands out sharply in the dark.
Television	Large areas of white may cause 'flare'; it is often indistinct on the screen and may be emphasised by surrounding it with medium or deep colours.
Texture	Suitable for most textures.
VDUs	Screen: white characters on a grey or black background can be used. Equipment: no application. Surround: ceilings only.
Woods	Goes reasonably well with pine, less so with rosewood and mahogany.

12.5 Interiors

Domestic interiors

Use	White is a good background colour but may cause headaches if not broken up; it cannot add warmth or depth. It should be unquestionably white; if this is impossible, use some other colour. It can have more effect in a room than most other colours since it is the greatest reflector of light and can often be used to lighten a colour. It can be used as a foil to enhance or add impact to other

colours. Touches of white enhance a room and soften other colours; white is the space-maker and bringer of light. Large areas of white are generally best avoided if they fall within the normal field of view; the eye cannot help focusing on the brightest object within the field of view, and because this constricts the pupil of the eye, it tends to blur vision. Texture adds interest to the white surface.

Room aspect
White is suitable for dark rooms, but not north-facing rooms, because it looks grey. Care is necessary in a room which receives a lot of light; white looks creamy during sunny periods but goes grey when the sun goes in.

Room size
White tends to make a room look smaller.

Room features
White ceilings make a room seem higher but it is not recommended for floors; off-white is better. White walls may be used when in doubt; all fabrics look good against white. White tops the poll of preference for ceilings; tinted whites can add a touch of colour to ceilings without affecting light. A preponderance of white walls is emotionally sterile and visually dangerous, especially where people work and concentrate, because of glare and eye abuse.

Room users
White is not recommended for rooms used by children.

Commercial interiors

Attention is drawn to the use in specific environments listed in 12.7 below.

12.6 Combinations

Good harmonies
White with black (mediator), blue, red (partners and natural foils), orange (food service), coral, flame red, yellow, deeper blue-greens, tints of all kinds, shades and tones.

Accentuates
Blue (white is the best colour to go with blue), blue-green.

Suggestions
● White looks whiter on black than it does on grey; it harmonises with shades and tones and tints of all kinds.
● Artic white and red is striking and functionally sound and provides useful heat control; white combines well with Alice blue; white and peach in a dining room create space; white with yellow is crisp, fresh and clean.
● White, black, grey and red is a stylish and classical colour scheme which always makes an impact; attention is also drawn to the black/white combinations mentioned in 15.5 in this part.

12.7 Uses

Consumer applications

Bathroom products The most popular colour of all in the bathroom; it is the ideal colour for sanitary ware because it goes with everythhing else and is also a 'clean' colour, which appeals to the housewife. There are more white bathrooms in existence than of any other colour, and it is essential in most ranges. People will always ask for cleaner, or whiter, whites and will usually buy the brightest shade available.

Bedroom products Essentially a background colour and goes well with most other colours; areas of white can help to brighten up a bedroom, but it is not for a child's bedroom. White and blue is an ideal bedroom combination, but white can also be used with yellow; the white does not add any warmth or depth. Black and white are often linked in the bedroom (see 15.7 in this part).

Domestic appliances The universal colour for domestic appliances because it is clean and cool and goes with anything; however, it lacks interest and in large areas tends to cause eyestrain, but it is an excellent background for food and represents cleanliness in the minds of most housewives. It is not really suitable for space heaters because it is too sterile and clinical; off-white would be better, but otherwise suitable for all appliances.

Housewares White is always popular for kitchen utensils, but it is rather uninteresting and has little impact; however, it is good in association with food and goes with any other colour. It is the traditional tableware colour and one of the primary attractions of fine china; the latter holds its place as a status symbol, but white is not very well liked for cheaper earthenware or for plastics ware because of the difficulty of achieving a satisfactory white. For general table use it tends to be 'ordinary' although the attraction of white table linen still holds good. No special comment is necessary about food containers.

Kitchen products White is favoured by many housewives because of its cleanliness, and all-white kitchens come to the fore from time to time, but they tend to be rather cold and sterile and it is recommended that white should be combined with something else; it should, however, be included in most ranges. White is suitable for kitchen units, appliances and housewares generally, but is not recommended for worktops of kitchen units, nor for textiles, wall or floor coverings.

Living room products No special comments are necessary; see under Domestic interiors in 12.5 in this part.

Window decoration products Too much white can cause headaches if not broken up; it is not very practical for curtains but creates plenty of light when used for blinds. It is rather uninteresting from a decorative point of view but provides maximum distribution of daylight; it is particularly recommended for exterior use.

Graphical applications

Packaging Excellent foil colour, essentially background, it has maximum contrast with black but can be used with any colour; it has little visual interest and is difficult to remember and to find; while it can be seen at a considerable distance, the eye has difficulty in seizing upon it. Blue/white combinations look insipid under supermarket conditions, and if white is used for caps and closures it has a neutral effect. Recommended for pharmaceuticals.

Print As for packaging above. White stands out sharply in the dark but can easily merge into the background, especially when dirty. Black on white for print has become a convention; white is just another colour and in abstract choice is not liked as well as blue, it is only average in liking and is the exception in nature. A truly neutral white will not be liked as much as a cool white or a warm white. White lacks visual interest for tags but provides maximum contrast with black print.

Images By its very nature white only has a place as part of an image where it is the background to some other hue. It has little visual interest, is difficult to remember and to find; while it can be seen at a considerable distance, the eye has difficulty in seizing upon it. This is the antithesis of what is required for a successful image. White may be used as part of a house style or symbol in order to convey cleanliness or purity, but it should only be used as background to other hues.

Vehicle liveries White only has a place as part of a livery as a background to some other hue, but it does have a place in vehicle liveries because of its association with cleanliness. Blue and white are good for refrigerated vehicles; white and orange are excellent for bakery products and for fruit; white with blue or pink is recommended for fishmongers. Although white stands out sharply in the dark, it tends to reflect sunshine and glare, and this may be tiring to the eyes; it is difficult to pick up quickly when dirty, and in wet conditions it can merge into the background; it picks up mud badly.

Environmental applications

Catering White is an excellent background to food and conveys cleanliness, but if used in large areas it may appear sterile and cause glare. White is luminous and clean and is a good foil for pastels and light colours. May be used for ceilings, the exteriors of motels, immediate background to most foods, table tops, washrooms, service areas, kitchens, serving areas, counters.

Factories All-white interiors should generally be avoided because they are sterile and tend to cause glare; they should only be used where hygiene is essential, and then with some other colour to provide variety; white is particularly harmful where it is in stark contrast with black machinery. Recommended for ceilings and window frames only, except in food-processing plants, and for undersides of staircases.

Offices The use of white is not recommended except for ceilings and window frames; an all-white surface would tend to cause glare and impair visual acuity. Not recommended for screens.

Retail Use requires care because white may cause glare and large areas may appear sterile, but it is luminous and clean and does not clash with any other colour. Recommended for shelves because it does not clash with packages and reflects light into shady corners. It has high reflectance value when used for ceilings and is good as a background for most merchandise, including fashion products. Contrasts well with red and yellow and can be used for male washrooms, toilet areas and storage areas.

Schools The use of white is best limited to ceilings; it is unsuitable for walls because of glare and is not very practical in corridors and other spaces because of soiling.

Hospitals All white is to be avoided in patient accommodation and in most working areas because it tends to cause glare and restrict the pupil of the eye, although it does afford maximum reflectance and distribution of light. It is undesirable in most areas where medical examination takes place, or any form of treatment, because it tends to handicap the clear vision of the doctor or surgeon; it fogs vision and introduces tiring glare. It may be used for linen storage rooms, sterilising rooms, diet kitchens, ceilings in working areas, any area where occupancy is not constant, including service areas; it could be used for small treatment rooms where adequate light is important.

Commercial applications

Office supplies Commonly used for file covers and contrasts well with other colours, although rather subject to soiling; it is not recommended for furniture or machines, because it causes glare; only used for identification purposes if contrast is necessary.

Paper and board White is the normal colour of paper and requires little comment except to point out that sustained reading of print on white paper may cause eyestrain. Snow blindness is caused when a person remains in white atmospheres for long periods, the eye becomes fatigues and sees the complementary colour (i.e. black); a similar situation can arise through too much exposure to white paper. Road maps and other items used outdoors are better on coloured paper from an acuity point of view. Combinations of white and yellow should be avoided because there is insufficient contrast between the two. Recommended for most commercial stationery applications.

12.8 Legend

The Aryan race is white, and from this derives many items implying 'white supremacy'. However, in the *Arabian Nights* Moslems were white, and the term 'white-haired boy' is an Irish term meaning the pride of the family.

White is the colour of the moon, to the Hindus it meant water but the earth to the Jews; the east was white to Tibetans but west to the Chinese, south to the ancient Irish and east to Navajo and Hopi Indians. It stood for metal in Chinese symbolism and meant light to Da Vinci. The Egyptian Pharoah wore a white crown in token of his dominion over Upper Egypt, and it symbolised the child-god Horus. A white flag, or a white feather, derives from white as a symbol of peace, and the white wedding dress is a symbol of purity which dates from Tudor times. White is the colour of mourning in China and other Eastern countries.

White animals have always been considered with special favour, perhaps because they are unusual. A white elephant is treated with special respect in Thailand, but as it is otherwise useless it has come to be associated with the 'white elephant' stall at a jumble sale. In Eastern carpets white signifies joy. The term 'white all through' is part of the 'white supremacy' aspect mentioned above.

13 Off-white group

- Cool off-whites Ivory, parchment
- Warm off-whites Magnolia
- Cream type Regency cream

13.1 Character

There are many variations of off-white; some are white with a hint of other colours, the so-called tinted whites, but all are, strictly speaking, very pale tints or pastels. Off-whites have similar characteristics to white but have a luxury image and are less stark than white. Some off-whites are high fashion. In general they are neutral and more inviting than white. Cream is a good background to many different colours; it is restful without being cold; cream and ivory associate well with tan. Ivory can be used where plenty of light is required, surface texture will add interest. No special comment is required about lighting, but off-whites can be recommended for lampshades.

13.2 Attributes

Age	Generally for older people.
Appearance	As for white, but the warmer off-whites have more interest
Associations	As for white
Fashion	Usually high fashion but depends on product.
Impulse	Not generally recommended for impulse applications.
Markets	For higher-grade markets; create a subtle difference from white and may be used for this purpose in business markets.
Mood	Off-whites give a distinctive tone to an otherwise white world; they create a mood of dignity and safety.
Personality	No effect.
Preferences	None recorded.
Presentation	NSC.

Products	Business.
Recognition	Not significant.
Reflectance	Cream 68 per cent, ivory 66 per cent.
Regional	NSC.
Seasons	As for white.
Sex	Cooler off-whites appeal to men; women like the warmer versions.
Shape	NSC.
Size	As for white.
Smell	Typical colours having an associated smell include almond and lily-of-the-valley.
Stability	Off-whites create a more dignified atmosphere than white and give a distinctive tone.
Taste	No associations.
Tradition	Cream belongs to the Victorian era but has been widely used in other periods.
Visibility	As for white.
Warmth	Neutral, less cool than white.

13.3 Functions

No special comments are necessary under this heading except to note that off-whites are not recommended for coding purposes.

13.4 Applications

Biological	NSC.
Children	Not for children, but off-whites appeal to older age groups.
The country	Cream or ivory are better than white for dairies, farm buildings generally, food plants, piggeries; cream is less cold than white when used for large wall areas.
Export	As for white but more often used in temperate climates; tends to look dirty in sunny climates.
Exteriors	Similar remarks as for white.
	Doors: cream for doors of town houses and for pinkish-brick houses.
	Walls: cream looks good linked to dark green, particularly in towns; a cameo façade goes well with doors in red. For town houses try off-white with pale yellow, mid stone; magnolia is recommended for terrace houses; buttermilk for a country cottage; cream goes well with natural woods and is recommended for a cottage.

Food	Cream is a natural food colour and acceptable in any circumstances, but otherwise off-whites are best avoided in association with food – they may suggest dirt. Warmer variations can be used instead of white.
Food packaging	As for food; warmer off-whites might be used as background to suggest softness and quality.
Food in the home	Cream is the colour of many foodstuffs and can be used in association with food in almost any circumstances; other off-whites need care, they may suggest something not quite clean. Cream and warmer off-whites would be acceptable for food containers and also for tableware applications.
Food processing	Off-whites are a warmer alternative to white and suitable for large wall areas where pure white would be bleak. Cream, ivory, shell white are acceptable, but all off-whites should be used with care; can be recommended for refrigerated areas, vegetable processing.
Food service	Off-whites may be used for overall surroundings in catering applications provided that the variation is carefully chosen; they are best not used as an immediate background to food.
Food stores	Much the same as for white, off-whites are less glaring but need care in use because they may suggest that something is less than clean; magnolia is very suitable for food stores where something a little warmer is required. Cream can be used for walls where lighting is dim and for refrigerated areas.
Industrial plant and equipment	Off-whites are not recommended, although they are sometimes used for the housings of VDUs.
Merchandising	Not generally recommended for display purposes but may be used for immediate surround, although not as a background to merchandise.
Pattern	Often used as a base colour for designs because off-whites will go with anything; in such cases the secondary colour has an added importance.
Safety	As for white.
Signs	Not recommended.
Television	As for white.
Texture	Suitable for most surfaces; cream goes well with texture.
VDUs	Screen: no application. Equipment: deeper off-whites may be used as part of a two-tone arrangement, but should not create glare. Surround: not recommended.
Woods	Cream goes well with teak, dark oak, afrormosia and tola.

13.5 Interiors

Domestic interiors

Variations	Cream is a good background to many different colours and is easier on the eye and easier to live with than white; it will make everybody healthy looking and is recommended for a narrow house.
Usage	Off-whites are a good background to other colours and texture goes well with them. Cream is restful without being cold.
Room aspect	Warm white or pale cream is better than white in a north-facing room, otherwise as for white.
Room size	Off-whites have little effect on room size.
Room features	Off-white floors have a luxury image and are better than white.
Room users	Off-whites are not recommended for children.

Commercial interiors

Attention is drawn to the specific uses listed in 13.7 below.

13.6 Combinations

Good harmonies	Off-whites with deep blue (accents); black (mediator); cream with light red (dainty), bright green, pale blue, green; ivory with deep reds, blue, violet.
Suggestions	• Creamy colours will set off furniture to advantage.
	• Cream is a soothing counterbalance to purple.
	• Cream and green are sympathetic partners.

13.7 Uses

Consumer applications

Bathroom products Off-whites are an alternative to white, but most people seem to prefer the cleaner, purer whites; a warm off-white such as magnolia can be recommended. Slightly brown off-whites, such as pale beige, can also be recommended when trends so dictate.

Bedroom products Cream is easier on the eye and easier to live with than white; off-whites are essentially background colours but less clinical than white. Oyster reduces glare and harmonises with most decors; dusk white is the tint of sunset (slightly pink) and is particularly flattering for bedroom use. Brown off-whites are always smart.

Domestic appliances An acceptable alternative to white for all appliances when consumers are ready to accept off-whites; cream was, at one time, the

standard colour for appliances and may return to favour. Off-whites are re-commended for space heaters because they will blend with anything; they are particularly useful for convectors and the like, which have to be unob-trusive; they are a little cool in nature and best used, perhaps, in conjunction with radiants or in conjunction with other colours. Warm off-whites may be used in place of white for all appliances but cooler variants are best not used for larger appliances; cream is recommended for space heaters and for larger appliances.

Housewares Off-whites are not generally recommended for kitchen utensils, although cream might be used in some cases. Warmer variations can be re-commended for tableware, but some of the cooler off-whites tend to look grey; otherwise as for white. A warm off-white or cream is an acceptable alternative to white for food containers.

Kitchen products Off-whites are not recommended for kitchen products un-less combined with something else; off-white fronts or worktops are popular for kitchen units where the main colour is stronger. Cream was, at one time, the universal kitchen colour and may return to that place. Off-whites gener-ally indicate a somewhat higher-grade market. Cool off-whites may be used for work tops or panels of kitchen units if combined with other colours but are not recommended for appliances or housewares, and similar remarks apply to warm variations. Cream is suitable for most kitchen products and may be used as an alternative to white; it is also suitable for textiles, wall and floor coverings.

Living room products Attention is drawn to the remarks under the heading of Domestic interiors in 13.5 in this part.

Window decoration products Off-whites are better than pure white for most window decoration purposes and have the advantage that they go with all other colours. Oyster reduces glare, ivory is slightly warmer than white, dusk white is very flattering.

Graphical applications

Packaging Not generally recommended for packaging except in special cir-cumstances but can be used instead of white to secure subtle variety.

Print As for packaging, but off-white paper as background can convey soph-istication and is good for business use; off-whites have good contrast with dark colours. Off-whites lack visual impact when used for tags but may create a subtle tone for high-fashion merchandise.

Images Similar remarks as for white; off-whites have little part to play in the image context except as a background to design, and they can be used in-stead of white for variety and a greater degree of sophistication, particularly for business use.

Vehicle liveries As for images; there are no other special connotations.

Environmental applications

Catering As a general rule off-whites should not be used as an immediate background to food because they may suggest dirt, but they can be used in the immediate surround. Cool off-whites can be recommended for restaurants and service areas; warm off-whites for hotel lobbies, rooms and reception, and they are a good general colour for bedrooms. Cream may be used with food instead of white; ivory is recommended for fast-trade outlets.

Factories Similar remarks as for white. Cool off-whites may be used for corridors, upper walls of staircases, storerooms and drawing offices; warm off-whites may be used for the same and for upper walls of canteens, for large spaces where temperature is low and there are few workers; for windowless areas and where manual training and tasks are performed; for power stations, chemical plants, refrigerated areas, dairies, processing of vegetables.

Offices Cream and warm off-whites have many uses in the office, and ivory is a general utility colour of high reflectance value suitable for many areas; parchment also has many uses. Off-whites might be used for screens in some instances provided that they are not too glaring. Cool off-whites may be used for corridors, upper walls of staircases, storerooms, executive offices, drawing offices, libraries; warm off-whites may be used for the same and also for upper walls of canteens, with a dark dado.

Retail Similar remarks as for white; ivory may be used for storage areas, parchment is recommended for hardware and hairdressing, oyster is a sequence colour for most department stores; shell white is an alternative to cream; magnolia is suitable for many applications where a warmer shade is desired, and cream can be used for food generally and for walls in a handicraft store.

Schools Off-whites have limited uses in schools, although they are better than pure whites; some might be used for trim and for areas where maximum light is desired. Ivory is recommended for manual training areas, gymnasia and auditoria, it suggests sunshine in corridors; parchment might be used as an alternative to light grey.

Hospitals Some surgeons prefer cream or ivory in operating theatres because they believe that it helps to judge the condition of patients; a pale ivory is sometimes recommended for wards, but it should be relieved with accents; parchment is an all-purpose colour which has a luminous quality. Cool off-whites may be used for short-stay wards, laboratories, preparation rooms, lavatories, washrooms, utility rooms, some operating suites (particularly for the ceilings), corridors, reception areas, conference rooms. Warm variations may be used for service areas generally, preparation rooms, washrooms, dressing rooms, reception areas. Cream can be used for some operating suites, corridors, lavatories, washrooms.

Commercial applications

Office supplies May be better than white in many applications and especially in higher-grade markets; cream or warm off-whites may be used for presentation items and will convey more dignity than pure white. A warm off-white is useful for desk furniture, especially as there has been a trend in recent years to white offices. Magnolia or cream would be acceptable for consumer items depending on the direction of trends; it creates a subtle difference from white.

Paper and board Off-white provides an acceptable alternative to white, particularly where substantial reading is required and may be used in business markets to create a subtle difference. India is a creamy off-white which provides more emotional interest than white; it has excellent legibility but is 'different' and under normal reading conditions provides easier reading; it can also be used to create a historical or aged effect. Ivory is a more subtle off-white with excellent visibility and legibility, and it provides effective contrast with dark colours; the small difference between ivory and pure white is just sufficient to provide extra interest.

Attention is also drawn to the notes in Section 1 of this part.

Surface-covering applications

Attention is drawn to the explanation of colour selection for surface coverings in Section 1 of this part.

14 Grey group

- Light Pearl, dawn, oyster
- Medium Silver
- Dark Charcoal

14.1 Character

All greys are a mixture of black and white, and those with a touch of colour are discussed in Section 16 below. Grey is a conservative colour which reduces emotional response and is non-committal; it has a high-fashion image and is suited to people of good taste and upper-income groups. It is neutral and not inviting to the viewer.

Grey blends well with other colours, it is refined and pleasing to the eye but should be unmistakably grey. Light grey is practicable where good visibility is required, it is free of glaring brightness and will not distract attention from critical seeing tasks. Oyster is recommended where concentration is required, and pearl grey is particularly suitable for commercial use, for hospitals and so on; it is bright and lustrous, resists soiling and has a shiny quality. Granite grey is ideally suited to desk and bench tops, instrument panels and similar applications because it is neutral in hue and not distracting. It is also an ideal background; black and white both look well on it, and as a local background colour it will 'cushion' visual shock and help to maintain a steady and uniform adjustment of the eye. Grey tends to look dirty in some circumstances.

Grey with a reflectance value of about 30 per cent is neutral and non-distracting and strikes a balance between black and white. Pale grey is suitable for small areas having a strong light and sunny aspect, especially if a quiet effect is wanted and occupancy is not high; it is good for concentration. In industrial areas it is suitable where seeing tasks are performed and helps to control glare. Glossy surfaces are best for corridors and so on, but matt tones should be used where glare has to be overcome. Grey is non distracting, pleasing, cool and dignified and it helps to camouflage dirt.

Under normal light a grey scale will be seen in all its gradations, but in dim light the scale shortens from the bottom up, and the eye can only see white and deep grey. As illumination grows dimmer, white will always be seen, but

middle and deep values tend to blend together, particularly the middle greys. Grey is not suitable for lampshades or as an illuminant.

14.2 Attributes

Age	Not recommended for either young or old; they find it depressing. But it is sometimes a fashion colour.
Appearance	Provides a good background but is a little depressing.
Associations	Dignity, common sense, good taste, high fashion, conservative, but also depression, old age and dirt.
Fashion	High fashion, appeals to upper-income groups.
Impulse	Background only, little impulse attraction.
Markets	Not recommended for products for the home as a general rule. Charcoal has an appeal in higher-grade markets but is not suitable for mass markets, because it tends to suggest futility, particularly at the lower end of the market. It is dignified, and for this reason it is often used for business applications. Do not use for promotions directed at the very young or the very old.
Mood	Creates a mood of dignity and safety and denotes common sense and influence, but in the wrong context it can be depressing – this is particularly so in the kitchen. Grey is a conservative colour which reduces emotional response and is non-committal. Remember 'grey skies'.
Personality	People who like grey are calm, self-centred, sober, dedicated; people who dislike it are unemotional and mediocre.
Preferences	Not liked by either young or old; if used it should be unmistakable.
Presentation	Not recommended in this context except where it is desired to convey a particularly restrained image.
Products	Business; avoid using for home products.
Recognition	Difficult to identify.
Reflectance	Light grey 45 per cent, aluminium grey 41 per cent.
Regional	NSC.
Seasons	Only suitable for winter, but use with care because it may be a little depressing. Lighter shades would be suitable for spring.
Sex	Appeals to both sexes but essentially a fashion shade for women; a status symbol for men.
Shape	NSC.
Size	Makes the image smaller and surfaces look further away.
Smell	NSC.
Stability	Puts over a refined and dignified image and creates a distinctive tone; charcoal is particularly dignified.
Taste	NSC.

Tradition	Associated with the Victorian era, and with dignity.
Visibility	Has little brightness and in full daylight tends to look further away than it actually is; tends to merge into shadows, particularly at twilight, and is virtually invisible in the dark.
Warmth	Cool colour, not inviting to the viewer.

14.3 Functions

Camouflage	Useful as a means of hiding soiling.
Coding	Little to recommend it in this context, although sometimes used for office systems.
Pipeline identification	Steam.
Protection from light	Darker greys may exclude light altogether, but otherwise grey is not significant in this context.
Readability	Not recommended.
Signalling	Not recommended.
Visibility of controls	Silver or charcoal may be used as a background to controls of domestic appliances.

14.4 Applications

Biological	NSC.
Children	Grey does not appeal to children.
The country	Pearl grey can be used for corridors and so on in food plants; it hides smudges and the like, but generally speaking grey should not be used where the appearance of food is important.
Export	Not suitable for sunny climates except for its cooling qualities; can be used for exteriors in cloudy regions. Colombia: not allowed for private cars.
Exteriors	Middle of the road, looks forlorn in bright sunlight; austere, cold, does not lend itself to a cheerful mood. Doors: for front doors of brick houses and sparked off by white in the country. Windows: fine for outer frames of white windows. Walls: battleship grey can be recommended if set off by white woodwork; pale grey for pebble-dashed walls; medium greys for concrete walls. Grey walls are best in the country but are practical in towns; pale grey looks well with pale yellow for town houses. Slate and coral go well together; pale grey goes well with natural wood. Industrial: for factory exteriors. Farms: medium and dark greys for farm walls and roofs.

Food	Grey should be avoided in relation to food; grey bread or grey meat would be rejected, and food on a grey plate looks revolting.
Food packaging	Not recommended for packaging, especially in association with iced confectionery.
Food in the home	Grey tends to suggest dirt and is not recommended for food containers nor for tableware.
Food processing	Should not be used in relation to food but can be used for corridors and staircases to conceal soiling; useful in bottling plants for this purpose.
Food service	Not recommended in direct association with food but can be used in restaurants for decorative purposes.
Food stores	Not recommended, it suggests dirt and poor housekeeping.
Industrial plant and equipment	Grey is a neutral colour ideally suited to most industrial equipment, including machine tools; non-distracting and strikes a balance between black and white, each of which have equal visibility against it. A good background for most visual tasks because it acts as a cushion to visual shock, and even if there are lighter and darker colours in the environment, it promotes a steady and uniform adjustment of the eye. Medium tones are recommended for the body of most machines, including VDUs. Grey is not recommended for working surfaces because it does not provide sufficient contrast with the task, nor reflect light where it is required.
Merchandising	Grey has little impact, poor visibility and is difficult to identify, but it conveys dignity and may be used as a background to metal articles in hardware stores.
Pattern	NSC.
Safety	No safety connotations but has camouflage implications; grey objects may be difficult to see and will merge into the background.
Signs	Not recommended, it is difficult to identify and tends to merge into the shadows.
Television	Will usually be undistorted; darker greys look black.
VDUs	Screen: background only, with blue or green characters. Equipment: acceptable. Surround: acceptable but may be a little depressing.
Woods	Silver grey and lilac grey are elegant and well suited to darker woods; darker greys look well with antique furniture.

14.5 Interiors

Domestic interiors

Light variations	Silver grey and lilac grey are elegant and well suited to

	polished, darker woods and to the display of silver. Light greys create a spacious effect in a small area.
Medium variations	Pewter is for a modern home.
Dark variations	Darker greys are dramatic and look well with silver-coloured metals, including chromium; good background for antique furniture. Charcoal has a sophisticated image.
Usage	Greys are useful for toning-down purposes; schemes based on grey have a long-lasting quality because they do not date. They create a spacious and sophisticated setting; greys blend well and are refined and pleasing to the eye. Grey is the most versatile of colours; an unusual scheme uses nine shades of grey from charcoal on the floor to light grey on the ceiling.
Room aspect	Grey is not recommended for a dark room.
Room size	Greys make a room look larger.
Room features	Grey for walls and floors can be offset by yellow.
Room function	No special comment.
Room users	Grey is not for children or old people, they tend to find it depressing.

Commercial interiors

Attention is drawn to uses in specific environments listed in 14.7 below.

14.6 Combinations

Good harmonies	Grey with tones of all kinds, caramel, strong orange, pale blue-green; darker greys with beige; pale grey with pink; silver grey with mauve, purple, pinky beige.
Good contrasts	Darker greys with scarlet, turquoise (formal).
Accentuated by	Proximity to orange.
Accentuates	Red, yellow, green.
Suggestions	Use pale greys in the same way as white with soft or deep hues. Grey and violet together make the grey yellower and the violet more intense; with grey and blue together the grey inclines to orange and the blues are more intense and greener; with grey and green together, the grey inclines to red and the green is more intense and usually yellower.
Suggestions	• When grey and yellow are seen together the grey inclines to violet and the yellow becomes more intense and less green; with grey and orange together, the grey appears blue and the orange purer and more yellow; with grey and red together, the grey appears greenish and the red purer; tones of all kinds harmonise with grey.

- Soft greys are accented by Alice blue.
- Greys blend well with bright greens, reds and yellows.
- Grey combined with pink and pastel green is restful.
- Grey, black, white, red is a stylish and classical colour scheme which always makes an impact.
- Grey with yellow is low key and very modern.

14.7 Uses

Consumer applications

Bathroom products Grey is not recommended for bathrooms because of its association with dirt and because it tends to be depressing. Grey sanitary ware has been tried but without great success.

Bedroom products Not generally recommended for bedroom use, but it may be used to tone down other colours; schemes based on grey have a long-lasting appeal because they do not date, but grey tends to be depressing; not for those with sexual inclinations. A grey floor goes well with deep yellow in a bedroom. Light variations have a neutral quality which is useful when light is intense; charcoal has a sophisticated image.

Domestic appliances Grey is not very suitable for most appliances because it may suggest dust or dirt, although silver grey has its uses. Darker greys have been used for cookers and for trim; use with care. Grey is often used for space heaters when unobtrusive qualities are required; it blends well with other colours and is refined and pleasing to the eye. Light grey is not recommended, but medium variations may be used for appliances when acceptable to the consumer and may also be used for space heaters. Charcoal is used for cookers and is well liked as trim or as a background to controls.

Housewares Grey is not recommended for kitchen utensils, because it creates an impression of grubbiness, nor is it recommended for tableware; deeper greys such as charcoal might be used for decorative purposes but not for vessels or for food; not recommended for food containers.

Kitchen products Grey is not generally recommended for kitchen use; woods such as grey oak have been tried but have not been too successful. Although grey harmonises well, it is best limited to small areas. Light greys might be used for panels of kitchen units if combined with other colours; medium and dark variations might be used for control panels of appliances and for doors but are not otherwise recommended.

Living room products Attention is drawn to the remarks under the heading of Domestic interiors in 14.5 in this part.

Window decoration products Not generally recommended for window decoration purposes because it is a little depressing and tends to look dirty. Light grey might be tried when light is intense, and silver (natural aluminium) harmonises well.

Graphical applications

Packaging Grey is not recommended for packaging, although it may be used in promotional applications where it is desired to put over a refined and dignified image; it blends well with other colours and is refined and pleasing to the eye; charcoal is sophisticated.

Print Grey may be used for promotional applications when it is desired to put over a dignified image, but normally it should be used for background only and is sometimes used to create a historical effect. Charcoal grey is sophisticated and suitable for business markets where dignity is required. Grey has comparatively few print applications and is best not used for any products concerned with the home.

Images As for packaging and print. Grey is a colour of good taste but too much tends to be depressing, although it is pleasing to the eye.

Vehicle liveries As for packaging and print; may be used to put over a refined image but for background purposes only. Grey is best not used on its own; a grey van would be most uninteresting. Dark greys such as charcoal might be used for contrast. Admiralty grey is widely used for vehicle finishes but sacrifices safety for utility; it was designed as a camouflage colour. Grey is the worst of all colours from a safety point of view and tends to merge into the shadows, particularly at twilight and in the dark; it also tends to look further away than it actually is, thus leading to mistakes in judgement.

Environmental applications

Catering Not recommended as a background to food but may be used in overall surroundings; a rather subduing colour that needs care in use, but it blends well and is pleasing to the eye.
- Light Exteriors in cloudy climates, exteriors of motels, bedrooms in hotels and motels. A general wall colour for lounges and service areas.
- Medium As for light grey and also for lower walls of corridors and service areas.
- Dark Accent only.

Factories Grey is very useful in industrial environments because it is neutral in emotional quality and non-distracting. It is suitable for areas where a high degree of visual concentration is required because it is subduing and provides freedom from distraction; it may be used where material worked is highly coloured, but not for food processing or for canteens. It is best used in small areas and may also be used for exteriors. Light grey can be used for main walls in inspection and assembly areas with blue end walls; for walls of machine shops, also with blue end walls or rose end walls if the atmosphere is cool; for power plants, chemical plants, dressmaking shops, first-aid rooms, drawing offices. Grey is particularly suitable for equipment such as lockers where stronger colours would be inappropriate. Medium tones are recommended for machines because they do not show finger marks, but avoid dark greys, which are depressing.

Offices Grey is an ideal average for the office but lacks variety if used exclusively, it serves as a visual cushion, helps to keep the adjustment of the eye steady and lessens the visual shock of glancing from light to dark and back again. Light, warm variations are well recommended for walls, particularly where concentration is necessary, and are better than dark grey, but do not use too light a shade, particularly for equipment. Pearl grey is excellent for walls generally, small rooms with strong light, dados in corridors and staircases, shelves in libraries, executive offices, drawing offices. Greys at the higher end of the reflectance range are acceptable for screens and serve as a useful visual cushion, but they tend to be a little depressing; very light greys are not recommended.

Retail A rather subduing colour for retail use and needs care in use; it may suggest dirt if used in association with food. It is appropriate as background, particularly for hard goods and furniture. Grey blends well and is refined and pleasing to the eye.

- Light For fixtures, counters, tables, first-aid facilities and for walls in hairdressers. Pearl grey is a good general wall colour and sets off deeper colours, but it lacks emotional appeal; it is particularly good as background in supermarkets and for furniture.
- Medium Use in alcoves, especially in chemist's shops, and for lower walls of staircases and corridors.
- Dark Avoid use of dark greys in most cases.

Schools One of the most useful colours for use in schools and can be used in all areas, although preferably not in kindergartens or primary grades, where more excitement is prescribed.

- Light Recommended for classrooms where concentrated study takes place; for laboratories, art departments and study rooms; for doors, door frames, baseboards and all trim; useful for dados in corridors; for manual training areas, gymnasia. If grey is used for side walls in classrooms, it is best offset by brighter colours for end walls; rose or turquoise is suitable for the latter. Pearl grey can be recommended.
- Medium May be used in association with light grey for trim, for lower walls in gymnasia and also for lower walls in classrooms when light grey is used for the upper walls. For lower walls in libraries, laboratories and art rooms.
- Dark No applications.

Hospitals Grey as a colour is unfavourably associated with health and can be depressing, especially for old people, but it can be used for patient accommodation if relieved by accents and furnishings. It is a perfect foil for other colours and goes well with rose. Off-white is generally better than grey for most hospital uses; it should not be used in childrens' wards.

- Light Laboratories, dispensaries, preparation rooms, waiting rooms, reception areas, utility rooms, sluice rooms, nursing stations, corridors; it may also be used for ward walls but see above.

- Medium Floors, equipment and for harmonising purposes.
- Dark Signs indicating administration.

Commercial applications

Office supplies Grey is a colour of good taste and is pleasing to the eye but it lacks impact; it is conservative and has dignity and may be useful where mature consideration rather than impulse is required. Grey is frequently used for office items and a light grey would be an alternative to white. Medium grey is recommended for desks and for furniture and is suitable for presentation where dignity is required. A dark grey, such as charcoal, would be a pleasing alternative to black for desk furniture and would be dignified. Grey items are unlikely to appeal to consumer markets. It has little to recommend it for identification purposes but is sometimes used in office systems.

Paper and board The use of grey for paper needs care because it tends to be depressing, but it is often used to achieve an aged or historical effect. Grey is a colour of good taste, and a suitable variation might be used to indicate high fashion for higher-class trade. It has the advantage that it is pleasing to the eye, and its neutral tint blends well with other hues.

Attention is also drawn to the notes in Section 1 of this part.

Surface-covering applications

Attention is drawn to the explanation of colour selection for surface coverings in section 1 of this part.

15 Black

15.1 Character

There are many types of black, ranging from jet black to blue-black and green-black, and there is nothing negative about any of them. There are blacks that reflect, blacks that absorb and blacks that act as a stimulant to other colours; they are often used in high fashion. Black should always be unquestionably black. It is a colour that is not inviting to the viewer. No black surfaces absorb all light; the more light that shines upon it, the blacker it appears to be.

Black can create serenity and has maximum contrast with white; it signifies solidity, represents style and conveys sophistication, sadness and mystery. Darkness is a positive factor in human perception and not a negative one; total darkness is grey in visual experience. A black surface looks blacker as the light level increases; in other words, it needs plenty of light to appear black. It is not suitable as an illuminant or for lampshades.

15.2 Attributes

Age	Fashion colour only.
Appearance	Provides maximum contrast with human skin, and for this reason some men like women in black underwear; black sheets and bedwear are supposed to make the skin look more attractive.
Associations	Mourning (although not in all countries), high fashion. Signifies trouble when used in Eastern carpets.
Fashion	Usually high fashion, seldom a mass-market trend.
Impulse	May be useful in special circumstances.
Markets	Often useful in fashion markets.
Mood	Creates a 'deep tone'; it can be dramatic but may also suggest mourning, and in the wrong context may be depressing.
Personality	People who like black are regal, dignified, passive, sophisticated; people who dislike it are fatalistic and naïve.
Preferences	No particular preferences.

657

Presentation	Not recommended in this context except in special cases.
Products	Pharmaceuticals, particularly ethicals.
Recognition	Not easy to identify.
Reflectance	About 5 per cent.
Regional	NSC.
Seasons	No seasonal applications.
Sex	Sometimes bought by men for women because of its contast with pink skin.
Shape	NSC.
Size	Smallest of all colours, but gives a good sense of weight.
Smell	NSC.
Stability	Suggests weight and stability but is a little sombre for most applications.
Taste	NSC.
Tradition	Used for centuries, chiefly as a foil to other colours and is traditionally associated with funerals and mourning in Western countries. Blue/black is said to mean trouble.
Visibility	The least visible of all colours and makes objects look smaller than they actually are; it is particularly difficult to see at night because it merges into shadows, but it stands out well against greyness.
Warmth	Cool colour, not inviting to the viewer.

15.3 Functions

Camouflage	Black will hide much soiling but it also tends to show up dust and light dirt.
Coding	Black provides maximum contrast with other colours but is not otherwise recommended.
Heat control	Black absorbs heat.
Pipeline identification	Drainage and other fluids.
Protection from light	Excludes light altogether.
Readability	Black on yellow, black on white, yellow on black, white on black, black on orange, orange on black are the most readable combinations.
Signalling	NSC.
Visibility of controls	Best for contrast or as background to controls.

15.4 Applications

Biological	NSC.
Children	Not for children, but may be a fashion colour at times.
The country	NSC.

Export	To be avoided in sunny regions because it absorbs heat; it is the colour of mourning in many countries.
	Pakistan: saffron and black are the colours of hell.
	Egypt: associated with evil.
Exteriors	Black is traditional for drainpipes and is always right, particularly for town houses.
	Doors: sophisticated, up to the minute, creates an aura of mystery; black doors look well with white woodwork and are good for doors of red-brick houses.
	Windows: can be used for outer frames of white windows and recommended for windows in town.
	Walls: black and white for plain houses; black and brownish red walls with blue/yellow doors are very suitable for the seaside. Goes well with natural woods.
Food	No association with food except for black puddings, black sausages and black bread, most of which are not really black. Best avoided in relation to food.
Food packaging	Few uses except to create contrast; black tops may be used to make a package stand out; not recommended for cake mixes but acceptable for tea.
Food in the home	Not recommended in association with food except for small areas for contrast purposes; black kitchen units have attained some popularity at the top end of the market but are not really recommended. Black is not recommended for tableware, nor for food containers, although a black lid for a clear body is acceptable.
Food processing	No applications.
Food service	No applications.
Food stores	No applications.
Industrial plant and equipment	No applications.
Merchandising	Little impact, poor recognition qualities and poor visibility, but sometimes used for display in special circumstances, perhaps to create contrast with lighter colours; it has maximum contrast with white. May be used as a background for hardware and can be recommended as a background to china and glass.
Pattern	NSC.
Safety	In standard safety applications it is used as a contrast to yellow.
Signs	Used mainly for contrast with other colours but is a poor target. Black is almost wholly passive in the process of seeing and affords no stimulation to the nerves of the retina of the eye; it is also emotionally negative and holds little visual interest. It is difficult to focus and to judge as to distance and is the least visible of all colours. It is difficult to see at night but stands out well against greyness.

Television	May look like darkness seen in space and not be definite. The theory of television supposes that black is the absence of light, but in fact it is a psychological effect. There is a vast difference between a piece of coal and an empty tomb and, in practice, black surfaces look more black as increasing light is thrown on them. Dark shades containing black are difficult to fix satisfactorily.
Texture	Looks best on shiny surfaces. Matt black can look very dreary.
VDUs	Background to screen only.
Woods	No special comment.

15.5 Interiors

Domestic interiors

Usage	Black is normally used in small doses, it creates a stark appearance and is frequently used in high-fashion applications. Black should be definitely black and needs more cleaning than white.
Room character	Black represents style and sophistication.
Room aspect	No special virtues.
Room size	Black can change shape, size and so on, but can be deceptive; the smallest of all colours.
Room features	Black ceilings make some people feel uncomfortable. Black is frequently used for rugs in high-fashion applications.
Room users	Black is not recommended for children.

Commercial interiors

Attention is drawn to uses in specific environments listed in 15.7 below.

15.6 Combinations

Good harmonies	Black with white (mediator), tints and tones, shades of all kinds, off-white, caramel.
Avoid	Black with dark blue (means trouble), pale colours.
Accentuates	Green, yellow, orange.
Diminishes	Violet, blue, blue-green.
Suggestions	• Black harmonises well with yellow but takes the heart out of paler colours.
	• Black is versatile with white, grey, red; sophisticated with green, yellow; dramatic and luxurious with pink, cream.
	• Black and white are classics that never date and which create a dramatic impact on their own or com-

bined with primaries or pastels; black and white can
be pleasing in its simplicity.

- Black, white, grey, red is a stylish combination
 which always makes an impact.
- Black with yellow is dramatic and stylish.

15.7 Uses

Consumer applications

Bathroom products Black sanitary ware and baths have an exotic touch which
sometimes appeals to the luxury end of the market, but in general black is
not recommended for the bathroom.

Bedroom products Black is sometimes used in high-fashion applications but
is normally used in the bedroom in small doses as a contrast. It is a masculine
colour and is supposed to create a sexy bedroom; black sheets are sometimes
bought for this purpose, and it is sometimes used to create a stark appear-
ance; it is recommended to those who like to be sad to be amorous. From
time to time a fashion for black and white spreads to the bedroom, and black
bedwear sells briskly for a period, usually to the younger generation. Black
has the advantage that it keeps fresh-looking longer than pastel colours, but
the real attraction is usually part of a switch to stark contrast in decor, or
demand from those who see it as a sex symbol. The market for black and
white has been researched from time to time, and it has usually been found
that there is little demand outside London and even there it is not seen as a
threat to normal colours. People are said to like it but they still buy colours.
Most textile manufacturers are asked to supply black on occasions, and do
so, but they do not promote it. Most sources of information feel that black or
black and white is an artificial demand created for promotional purposes
rather than by public demand.

Domestic appliances Black is not recommended for domestic appliances,
although there is sometimes a short-lived demand, sparked off by fashion.
Black is often used for trim, particularly in association with silver, and it
provides a high-grade background. Black has been used for cookers at the
top end of the market; cooker tops in black are practical rather than decorat-
ive. Black is not recommended for space heaters except in small areas for
contrast purposes.

Housewares Although black kitchen units have a sale in some segments of the
market, black is not suitable for kitchen utensils. It is sometimes used to
create an unusual effect for tableware, especially for coffee cups and the
like, but is not generally recommended for tableware. It is sometimes used
for ovenware and sometimes combined with gold. It is not recommended for
food containers, although black tops to clear-bodied containers are accept-
able.

Kitchen products Although black is not really a practical colour for kitchens,

it does look well when combined with white. Black kitchens are popular in continental markets and have been introduced into the British market, but they only appeal in higher-grade sectors. Black can be recommended for accent purposes and is sometimes used where contrast is required, but it is not recommended for kitchen products generally.

Living room products Frequently used in high-fashion applications and needs more cleaning than white, but otherwise see Domestic interiors in 15.5 in this part.

Window decoration products Not generally recommended for window decoration unless it is necessary to darken a room.

Graphical applications

Packaging Black is sometimes used in packaging applications to suggest sophistication and high fashion, but its use needs care. It is a good foil and provides maximum contrast with white, but it is difficult to see at night. Black can be recommended for pharmaceuticals and for caps and closures; it is always safe for lingerie because men like it.

Print As for packaging; in display applications it stands out well against greyness but merges into shadow. Uses are generally limited to print, but it can also be used for dramatic emphasis and for occasional fashion applications. Similar remarks apply to its use for tags; it is often used for products sold to men as well as in fashion applications, but generally it is used only for print.

Images As for packaging and print.

Vehicle liveries As for packaging and print. It is an easy colour to match but the worst possible colour for showing dirt. In safety applications it is contrasted with yellow or orange to mark hazards; it is the least visible of colours and makes objects look smaller than any other colour; it is particularly difficult to see at night because it merges with shadows and therefore both pedestrians and other drivers will have difficulty in seeing it. To the credit of black it should be pointed out that it stands out well against greyness and also against the environment in city conditions.

Environmental applications

Catering	Not recommended.
Factories	Not recommended.
Offices	Black has little place in the office except for contrast purposes.
Retail	Black provides good contrast and is appropriate for background, especially for metal hardware; it highlights displays of glass and china but large black areas should be relieved by or surrounded by blue.
Schools	Not recommended.
Hospitals	Not recommended.

Commercial applications

Office supplies Essential in most office ranges and has many applications, mainly for contrast purposes; it provides excellent contrast with brighter colours.

Paper and board Not normally used in paper applications except for specialised materials such as mounts and background. It is suggested for the covers of company reports and conference reports, but in such cases the colour will usually be provided by print.

Attention is also drawn to the notes in Section 1 of this part.

Surface-covering applications

Attention is drawn to the explanation of colour selection for surface coverings in Section 1 of this part.

15.8 Legend

Black is the colour of Saturn and in ancient mythology it represented the Underworld. All negroes were black to the ancient Egyptians, while the Arabs divided the world into two races, one of which was black; African mythology has it that the black race was begat by the person who ate the liver of the first ox slaughtered for food. In Hindu symbolism black was the colour of earth; to the Chinese, the Irish and the Navajo Indians it represented the north; it also stood for water in Chinese symbolism and represented total darkness to Da Vinci.

In India a twin saved the crops by standing in the direction of the wind with one buttock painted black, the other in some other colour. In Ireland burning the pelt of a black dog quelled a storm, the ashes being scattered down wind. In India the sacrifice of black animals drew water from the sky. A solution of black plants poured over the head by a black doctor will grow black hair on a bald head. An old saying has it that 'a black man is a pearl in woman's eyes'. Chimney sweeps and black cats are considered lucky because they are the same colour as the devil and keep him at bay.

Blackguard comes from the black garb worn by camp followers in medieval times; 'black list' was used by Milton. Black is the colour of despair, hence 'black look' and 'black conscience'; 'black ball' derives from the practice of voting by means of black and white balls placed in a receptacle; 'blackmail' also derives from despair.

Black cats are by no means all lucky, in some cultures they are considered to be unlucky, but in many cultures the black of jet was supposed to keep away magic and spells. In Eastern carpets the use of black signifies trouble.

16 Grey tints

- Brown type Mushroom, stone
- Yellow type Champagne
- Green type Mistletoe
- Blue type Dove

16.1 Character

Grey tints are very pale colours with a hint of grey; they might be classified with the muted versions of the basic hues, but experience has shown that a separate heading is useful. These tints are fashionable and neutral and make the most of limited natural light; grey is a colour that varies dramatically according to the colour on which it is based.

A typical example is nocturne, which is a soft lichen grey that is almost next door to beige and which is especially suitable for rooms whose aspect is a little too cold for comfort. No special comment is necessary about lighting; some grey tints may be used for lampshades; see the basic hues concerned.

16.2 Features

Attributes

No special comment is necessary; the attributes of the basic hues will apply.

Functions

No special comment is necessary.

Applications

Comment is only necessary in the following cases:

The country	Mushroom can be used for large wall areas, it is less cold than white.
Exteriors	Mushroom is sophisticated for the doors of town houses;

664

	sandtone is recommended for farm walls.
Food in the home	Grey tints may be used in association with food when the basic hue is suitable, but they require care; they are not recommended for food containers, clear colours are better; they could be used, with care, for tableware.
Food processing	Mushroom can be recommended for large wall areas where white would be bleak.
Industrial plant and equipment	Light stone is recommended as a highlight colour, similar remarks apply as for brown.

Domestic interiors

The following special features are worth recording in connection with domestic interiors.

- Brown types Stone is recommended for modern living rooms; it is always smart and has a spacious effect.
- Green types Pale grey-green is recommended for really small areas.
- Blue types Grey-blue is suitable for sunny rooms.

16.3 Uses

Consumer applications

Domestic appliances Grey tints are not, in general, recommended for domestic appliances except for the more decorative type of appliance, and then for panels rather than for overall colour; in other words, they are best used as accents. They are not really suitable for small appliances, particularly those used in association with food, but they could be used for space heaters in more decorative applications.

Housewares Grey tints are not recommended for housewares, but they could be used for textiles; not to be used in direct association with food.

Kitchen products Not recommended for kitchen units except for door panels or as accents in combination with stronger hues; nor are they recommended for fittings except as accents.

Living room products See remarks under the heading of Domestic interiors in 16.2 in this part.

Graphical applications

Packaging As a general rule grey tints are best not used for packaging because they lack impact, but they might be used in special cases where a sophisticated effect is required.

Environmental applications

Catering Grey tints may be used in place of pure grey where appropriate and

can be used for decorative applications; they can produce a subtle touch but do not use in association with food; stone is a good wall colour for hotels.

Offices Can be used in place of pure grey where suitable, and this includes use for screens.

Retail In general, greyed colours are not recommended for use in stores, but there may be occasions when they would produce a subtle touch. Mushroom, for example, can be recommended for first-aid facilities and restrooms, and also for walls in hairdressers. Stone may sometimes be used in place of beige.

Schools Mushroom is an acceptable alternative to light grey in any school application.

Hospitals Mushroom may be used for laboratories, receptions, utility rooms and as a general alternative to beige.

Further information

So far as I am aware there is no complete bibliography of colour. There is a vast literature on the subject, dating back to the very earliest times, although much of it is concerned with the artistic and technical aspects of the subject rather than with commercial aspects.

The most extensive collection of material known to me is the Faber Birren Collection of Books on Colour in the Art and Architecture Library of Yale University. This includes some 700 books, as well as much other material, from the seventeenth century onwards. A bibliography of this collection is available from the Yale University Library, New Haven, Connecticut, USA. The Royal College of Art in London also has a renowned collection.

The earlier books from both these collections are available in microfilm form from Research Publications Ltd, PO Box 45, Reading RG1 8HF.

Colour systems

There are many colour systems or standards in current use, including the Munsell, Ostwald and Plochere systems from the United States. The Pantone system will be known to most designers, and the Colorizer Paint system is useful to those concerned with interior decoration. There are also the extensive systems of the Japanese Colour Research Institute and the Swedish Colour Centre.

However, systems tend to 'date' and are not very helpful in dealing with colours for consumer products which must reflect current trends. When dealing with the practical problems of everyday the writer has found that the colour collections of the major paint companies, such as the Dulux Matchmaker system and the Crown Colour Plan, are a convenient means of specifying colours and have the advantage of being readily available.

Most colours for environmental use can be specified from British Standards which are specifically designed for building purposes, but in most other cases it is desirable to specify colours by means of suitable samples rather than to depend on colour systems.

British Standards

There are numerous British Standards dealing with various aspects of colour, including pipeline identification, covers for wires and cables, safety and others, but as these standards are revised from time to time it is not proposed to quote them here. A list of current British Standards will be found in most commercial reference libraries, and further information can be obtained from the British Standards Institution, 2 Park Street, London W1.

The most important standards in the present context are those dealing with colours for building purposes, mentioned above, and they are certainly necessary in dealing with environmental colour:

- BS 4800 Paint Colours for Building Purposes was last revised in 1981.
- BS 5252:1976 Framework for Colour Co-ordination for Building Purposes provides a basis for many derived standards, including BS 4800.

Technical aspects

It is difficult to suggest sources of information about the technical aspects of colour because there are so many of them, but there is a useful bibliography dealing with the psychology of seeing in *Eye and Brain* by R.L. Gregory (Weidenfeld and Nicolson 1966). Some valuable references to various aspects of vision and seeing will be found in *The Rays are Not Coloured* by Professor W.D. Wright (Adam Hilger 1967).

Current information

For more than twenty-five years I have scanned a wide selection of journals and publications and noted, abstracted and analysed information about colour, colour trends and changing market conditions; since 1970 I have recorded salient points in my files. This record would be much too extensive to repeat in this book, but the following is a list of those journals in which useful information has been found. It will be appreciated, of course, that these are not the only journals that might have been used.

Advertisers Weekly	*Campaign*
Architect and Building News	*Caterer and Hotel Keeper*
Barclaycard Magazine	*Commercial Vehicles*
Birmingham Post	*Confectionery Manufacture*
Biscuit Maker and Plant Baker	*Confectionery Production*
British Ink Maker	*Daily Express*
The Builder	*Daily Telegraph*
Building Industry News	*The Decorator*
Building Trade News	*Design Magazine*
Business Equipment Digest	*The Director*
Business Information Technology	*Drive Magazine*
Business Systems and Equipment	*The Economist*

The Energy Manager
European Plastics News
Europlastics
Evening Standard
Financial Times
Finishing
Food Manufacture
Food Marketing
Frozen Food News
Frozen Foods
Fortune Magazine
Furnishing World
Good Housekeeping
The Grocer
The Group Grocer
Hardware Trade Journal
Health and Safety at Work
Heating and Ventilating Review
Homes and Gardens
Hosiery Trade Review
The Hospital
Hospital Year Book
House and Garden
House and Garden (USA)
Ideal Home
Industrial Advertising and Marketing
Industrial Design
Industrial Engineering (USA)
Institutional Management
Instore
International Lighting
International Lighting Review
Institute of Packaging Journal
International Paper Board Industry
International Perfumer
Investors Chronicle
Ironmonger
Journal of Commercial Art (USA)
Life Magazine (USA)
Lighting Equipment News
London Portrait
London Pride
The Manager
Management Today
Marketfact
Market Research

Marketing
Marketing Week
Media Week
Metals
Modern Purchasing
North West Industrial Review
Office Equipment News
Office Magazine
Office Methods and Machines
Packaging
Packaging Digest
Packaging News
Packaging Review
Paint Journal
Paint Technology
Plastics News
Plastics and Rubber Weekly
Pottery and Glass
The Print Buyer
Printing Magazine (USA)
Product Finishing
Purchasing Journal
RIBA Journal
Rubber and Plastics Age
Sales Director
Satellite News
Self Service
Signs
Stores and Shops
Sunday Express
Sunday Mirror
Sunday Times
Surface Coatings
Tack Magazine
Technology Ireland
Time Magazine
The Times
Tin and Its Uses
Ulster Builder
Vending
Vogue
Wireless Trader
Woman
Worlds Paper Trade Review
Worlds Press News

Books

The following is a list of titles noted over the years as being authoritative sources of information either because the author has read them himself or because they have been quoted by other experts. This list is not a formal bibliography and any reader attempting to use it will need to check the references; in many cases there will be later editions of the books noted, and in many cases books published in the United States will have been republished in Britain, or vice versa.

Abbott, Arthur G. *The Color of Life*, McGraw-Hill, New York, 1947.
Albers, Josef, *Interaction of Colour*, Yale University Press, New Haven, Conn., 1971.
Aldis, Guy, *Hospital Planning Requirements*, Pitman, London, 1954.
Allen, D. Elliston, *British Tastes*, Hutchinson, London, 1968.
Allport, F. *Theories of Conception and the Concept of Structure*, Wiley, New York, 1955.
Alschuler, Rose H. and others *Painting and Personality*, University of Chicago Press, Chicago, 1947.
Arnheim, R. *Art and Visual Perception*, Faber & Faber, London, 1967.
Babbitt, Edwin D. *The Principles of Light and Colour*, E. Babbitt, East Orange, NJ, 1896; ed. Faber Birren, 1967, Citadel Press, Secaucus, New Jersey, USA.
Baker, S. *Visual Persuasion*, McGraw-Hill, New York, 1961.
Bartley, S.H. *Principles of Perception*, Harper, New York, 1958.
Bayes, Kenneth *The Therapeutic Effect of Environment on Emotionally Disturbed and Mentally Subnormal Children*, Unwin, London, 1967.
Byaliss, L.F. *General Principles of Physiology*, Longmans, London, 1961.
Beck, Jacob *Surface Color Perception*, Cornell University Press, Ithaca, 1972.
Berlin, B. and Kay, P. *Basic Color Terms. Their Universality and Evolution*, University of California Press, Berkeley, 1969.
Birch-Lindgren, G. *Modern Hospital Planning*, Constable, London, 1952.
Birren, F. *The American Colorist*, Prang, Sandusky, Ohio, 1962.
 The Application of Color to Shore Establishments, US Navy Dept, Washington DC, 1953.
 Character Analysis Through Color, Crimson Press, New York, 1940.
 Color Dimensions, Crimson Press, New York, 1934.
 Color, Form and Space, Reinhold, New York, 1961.
 Color and Human Response, Van Nostrand Reinhold, New York, 1978.
 Color for Interiors, Whitney Library of Design, New York, 1963.
 Color in Modern Packaging, Crimson Press, Chicago, 1935.
 Color Perception in Art, Van Nostrand Reinhold, New York, 1976.
 Color for Naval Shore Facilities, US Navy Dept, Washington DC, 1971.
 Color Psychology and Color Therapy, University Books, New York, 1977 (earlier editions in 1950, 1972 published by McGraw-Hill, New York).
 Color: A Survey in Words and Pictures, University Books, New York, 1963 (reprinted by Citadel Press, Secaucus, NJ, 1980).
 Color Systems and Standards, F. Birren, Stamford, Conn. 1980.

Color in Vision, C.V. Ritter, Chicago, 1928.
Color Vision in Art, Reinhold, New York, 1964.
Color in Your World, Collier Books, New York, 1962.
Creative Color, Van Nostrand Reinhold, New York, 1978.
Functional Color, Crimson Press, New York, 1937.
History of Color in Painting, Van Nostrand Reinhold, New York, 1980.
Light Color and Environment, Van Nostrand Reinhold, New York, 1969.
Monument to Color, McFarlane, Ware, McFarlane, New York, 1938.
New Horizons in Color, Reinhold, New York, 1955.
Paint and Color Manual, US Coast Guard, Washington DC, 1952.
Principles of Colour, Van Nostrand Reinhold, New York. 1978.
The Printer's Art of Color, Crimson Press, Chicago, 1935.
Selling Color to People, University Books, New York, 1956.
Selling with Colour, McGraw Hill, New York, 1945.
The Story of Color, Crimson Press, Westport, Conn., 1941.
The Textile Colorist, Van Nostrand Reinhold, New York, 1980.
The Wonderful Wonders of Red-Yellow-Blue; McFarlane, Ware, McFarlane, New York, 1937.
Your Colour and Yourself, Prang, Sandusky, Ohio, 1952.
Blum, Harold F. *Photodynamic Action and Diseases Caused by Light*, Reinhold, New York, 1941.
Boring, Edwin G. *Sensation and Perception in the History of Experimental Psychology*, Appleton-Century-Crofts, New York, 1942.
Bouma, P.J. *The Physical Aspects of Colour*, Philips Electrical, Eindhoven, 1947.
Bragg, Sir William *The Universe of Light*, Macmillan, New York, 1934.
Briston, John H. and Neill, Terence J. *Packaging Management*, Gower Press, Aldershot, 1969.
Brown, Barbara B. *New Mind, New Body*, Harper & Row, New York, 1974.
Bruner, J. *Expectation and Perception of Color*, McGraw-Hill, New York, 1951.
Buckner, Hugh *How British Industry Buys*, Hutchinson, London, 1967.
Burnham, R.W. and others *Colour: A Guide to Basic Facts and Concepts*, Wiley, London, 1963.
Burris-Meyer, Elizabeth *Color and Design in the Decorative Arts*, Prentice-Hall, New York, 1935.
Decorating Livable Homes, Prenctice-Hall, New York, 1947.
Historical Color Guide, William Helburn, New York, 1938.
Bustanoby, J.H. *Principles of Colour and Colour Mixing*, McGraw-Hill, New York, 1947.
Cheskin, Louis *Colors: What They Can Do for You*, Blandford, London, 1950.
Chevreul, M.E. *The Principles of Harmony and Contrast of Colours* (first published 1938), ed. F. Birren, Reinhold, New York, 1967.
Coleman, Howard W. *Colour Television: Techniques, Business, Impact*, Focal Press, London, 1968.
Cott, H.B. *Adaptive Colouration of Animals*, Methuen, London, 1940.
Dakin, Tony (ed.) *Sales Promotion Handbook*, Gower, Aldershot, 1974 (contribution by E.P. Danger).

Danger, Eric P. *Using Colour to Sell*, Gower, Aldershot, 1968.
Selecting Colour for Print, Gower, Aldershot, 1987.
Selecting Colour for Packaging, Gower, Aldershot, 1987.
Day, R.H. *Human Perception*, Wiley, Sydney, Australia, 1969.
Dichter, Ernest *Handbook of Consumer Motivation*, McGraw-Hill, New York, 1964.
The Strategy of Desire, Doubleday, New York, 1960.
Duffy, Frank *Office Landscaping*, Anbar, London, 1966.
Eddington, A.S. *The Nature of the Physical World*, Macmillan, New York, 1948.
Evans, Ralph M. *An Introduction to Color*, Wiley, New York, 1948.
The Perception of Colour, Wiley, New York, 1974.
Fisher, Lawrence *Industrial Marketing*, Business Books, London, 1969.
Fromm, Erika O. and Brosin, H.W. *Rorschach and Colour Blindness*, Rorschach Research Exchange, 1940.
Gerritsen, Frans *Theory and Practice of Color*, Van Nostrand Reinhold, New York, 1975.
Gesell, Arnold and others *Vision: Its Development in Infant and Child*, Paul B. Hoeber, New York, 1949.
Gibson, J.J. *Perception of the Visual World*, Houghton Mifflin, Boston, 1950.
The Senses Considered as Perceptual Systems, Allen & Unwin, London, 1968.
Goethe, J.W. Von *Theory of Colours*, MIT Press, Cambridge, Mass., 1970.
Goldstein, Kurt *The Organism*, American Book Co., New York, 1939.
Gombrich, E.H. *Art and Illusion*, Pantheon Books, New York, 1960.
Graham, Clarence *Vision and Visual Perception*, Wiley, New York, 1965.
Gregory, R.L. *Eye and Brain: The Psychology of Seeing*, Weidenfeld & Nicolson, London, 1964.
The Intelligent Eye, McGraw-Hill, New York, 1970.
Grundy, J.W. and Rosenthal, S.G. *Vision and VDUs*, Association of Optical Practitioners, London, 1980.
Guss, Leonard M. *Packaging is Marketing*, American Management Association, New York, 1967.
Hard, A. *The NCS Colour Order and Scaling System*, Swedish Colour Centre, Stockholm, 1969.
Hardy, Leonard *Marketing for Profit*, Longmans Green, London, 1962.
Harris, Moses *The Natural System of Colours* (first published 1766), ed. and ann. F. Birren, Whitney Library of Design, New York, 1963.
Harris, Ralph and Seldon, Arthur *Advertising in Action*, Hutchinson, London, 1962.
Advertising and the Public, Hutchinson, London, 1962.
Hartmann, E. *Lighting Problems in Highway Traffic*, Pergamon Press, New York, 1963.
Hartridge, H.H. *Colours and How We See Them*, Bell, London, 1949.
Hayek, F.A. *The Sensory Order*, University of Chicago Press, Chicago, 1952.
Hering, Ewald, *Outlines of a Theory of Light Sense*, Harvard University Press, Cambridge, Mass., 1964.
Hesselgren, S. *Colour Manual*, T. Palmer, Stockholm, 1953.

Hiler, Hilaire, *Color Harmony and Pigments*, Favor, Ruhl & Co., Chicago, 1942.

The Technique of Painting, Oxford, London 1948.

Why Abstract?, James Lauglin, New York, 1945.

Hogg, J.H. *The Experience of Colour*, New Society, London, 1979.

Hopkinson, R.G. *Hospital Lighting*, Heinemann, London, 1965.

Hunt, R.W.G. *The Reproduction of Colour*, Fountain Press, London, 1959.

Huxley, Aldous *The Doors of Perception*, Harper & Row, New York, 1963.

Isihara, Shinobou *Tests for Colour Blindness*, H.K. Lewin, London, 1951.

Itten, Johannes, *The Elements of Colour*, Van Nostrand Reinhold, New York, 1970.

The Art of Colour, Reinhold, New York, 1961.

Jones, K. *Colour Story Reading*, Nelson, London, 1967.

Jones, Tom Douglas *The Art of Light and Colour*, Van Nostrand Reinhold, New York, 1972.

Judd, Deane B. *Color in Business, Science and Industry*, Wiley, London 1963.

Kandinsky, Wassily *The Art of Spiritual Harmony*, Houghton Mifflin, Boston, 1940.

Katz, David *Gestalt Psychology*, Ronald Press, New York, 1950.

Animals and Men, Penguin, London, 1953.

The World of Colour, Kegan Paul, London, 1935.

Kepes, Gyorgy *The Language of Vision*, Paul Theobald, Chicago, 1959.

Ketcham, Howard *How to Use Color and Decorating Designs in the Home*, Greystone Press, New York, 1949.

Ketchum, Morris *Shops and Stores*, Reinhold, New York, 1957.

Klee, Paul *The Thinking Eye*, George Wittenborn, New York, 1961.

Klein, Bernat *Eye for Colour*, Collins, London, 1965.

Klopfer, Bruno and Kelley, D.M. *The Rorschach Technique*, World Book Co., Yonkers, NY, 1946.

Knighton, P.H. *The Use of Colour in Hospitals*, Newcastle Regional Hospital Board, Newcastle upon Tyne, 1955.

Koffka, Kurt *Principles of Gestalt Psychology*, Harcourt, Brace, New York, 1935.

Kohler, Wolfgang *Gestalt Psychology*, Liverwright Publishing, New York, 1947.

Kornerup, A. and Wanscher, J.H. *The Methuen Book of Colour*, Methuen, London, 1967.

Kouwer, B.J. *Colours and Their Character*, Martinus Nÿhoff, The Hague, 1949.

Kuhn, Hedwig S. *Industrial Ophthalmology*, C.V. Mosby, St Louis, Miss., 1944.

Eyes and Industry, C.V. Mosby, St Louis, Miss., 1950.

Kuppers, H. *Color: Origins, Systems, Uses*, Van Nostrand Reinhold, New York, 1973.

Le Blon, J.C. *L'Art d'Imprimer Les Tableaux Coloritto* (first published in 1756), ed. and ann. F. Birren, Van Nostrand Reinhold, New York, 1980.

Le Grand, Yves *Form and Space Vision*, Indiana University Press, London, 1967.

Light, Colour and Vision, Chapman & Hall, London, 1957.

Letouzey, V. *Colour and Colour Measurement in the Graphic Industries*, Pitman, London, 1958.

Levitt, Theodore *Innovation in Marketing*, McGraw-Hill, New York, 1962.

Linsz, A. *An Essay on Colour Vision*, Grune & Stratton, New York, 1964.

Lock, Dennis (ed.) *Engineer's Handbook of Management Techniques*, Gower, Aldershot, 1973 (contribution by E.P. Danger).

Logan, Henry L. *Amenity Lighting*, Holphane, New York, 1965.
Lighting Research: Its Impact Now and the Future, Holophane, New York, 1968.

Luckiesh, M. *Light, Vision and Seeing*, D. Van Nostrand, New York, 1944.
Colour and Its Applications, D. Van Nostrand, New York, 1921.
Visual Illusions; D. Van Nostrand, New York, 1922.
The Science of Seeing, D. Van Nostrand, New York, 1937.

Luscher, Dr Max *Luscher Colour Tests*, Jonathan Cape, London, 1970.

Lynes, Russell *The Taste Maker*, Harper, New York, 1955.

McClelland, W.G. *Studies in Retailing*, Basil Blackwell, Oxford, 1963.

McKay, H. *Tricks of Light and Colour*, Oxford University Press, London, 1955.

Manning, Peter *Office Design: A Study of Environment*, Liverpool University, Department of Building Science, Liverpool, 1965.

Moholy-Nagy, L. *Vision in Motion*, Paul Theobald, Chicago, 1947.

Munsell, Albert H. *A Grammar of Colour* (first published in 1921), ed. and ann. F. Birren, Van Nostrand Reinhold, New York, 1969.
A Color Notation, Munsell Color, Baltimore, Maryland, 1926.
The Munsell Book of Color, Munsell Colour, first published 1929.

Murch, Gerald M. *Visual and Auditory Perception*, Bobbs-Merill, New York, 1973.

Murray, H.D. *Colour in Theory and Practice*, Chapman & Hall, London, 1952.

Newcastle Regional Hospital Board *The Use of Colour in Hospitals*, The Board, Newcastle upon Tyne, 1955.
Finishes and Fittings in Operating Suites, The Board, Newcastle upon Tyne, 1965.

Nuffield Foundation, *The Design of Research Laboratories*, Oxford University Press, London 1961.

Nuffield Provincial Hospitals Trust, *Studies in the Function and Design of Hospitals*, The Trust, London, 1955.

Optical Society of America *The Science of Color*, Thomas Y. Crowell, New York, 1953, and by the Society, Washington, DC, 1953.

Ostwald, Wilhelm *The Colour Primer* (first published in 1916), ed. and ann. F. Birren, Van Nostrand Reinhold, New York, 1969.
Colour Science, Winsor & Newton, London, 1931.

Paine, F.A. *Fundamentals of Packaging*, Blackie, London, 1962.

Patterson, D. *Pigments*, Elsevier, London, 1967.

Pilditch, James *The Silent Salesman*, Business Publications, London, 1961.

Polyak, S.L. *The Retina*, University of Chicago Press, Chicago, 1941.

Porter, Tom and Mikellides, Byron *Colour and Architecture*, Studio Vista, London, 1976.

Prizeman, John *Kitchens*, The Design Centre, London, 1966.

Renner, Paul *Colour Order and Harmony*, Studio Vista, London, 1964.

Rood, Ogden N. *Modern Chromatics* (first published 1879), ed. F. Birren, Van Nostrand Reinhold, New York, 1973.

Rowe, David and Alexander, Ivan *Selling Industrial Products*, Hutchinson, London, 1968.

Sacharo, Stanley and Griffin, Roger C. *Food Packaging*, AVI Publishing, 1969.

Sheppard, Joseph J. *Human Color Perception*, Elsevier, New York, 1968.

Sloan, Alfred P. *My Years with General Motors*, Pan Books, London, 1967.

Sloan, Raymond P. *Hospital Colour and Decoration*, Physicians Record Co., Chicago, 1944.

Stevens, S.S. *Handbook of Experimental Psychology*, Chapman & Hall, London, 1951.

Stokes, A. *Colour, Light and Form*, Faber, London, 1950.

Sully, Thomas *Hints to Young Painters* (first published 1873), ed. and ann. F. Birren, Reinhold, New York, 1965.

Taylor, F.A. *Colour Technology*, Oxford University Press, London, 1962.

Taylor, J. Scott *A Simple Explanation of the Ostwald Colour System*, Windor & Newton, London, 1935.

Teevan, R.C. and Birney, R.C. *Colour Vision, Selected Readings*, D. Van Nostrand, New York, 1961.

Thomson, J. Arthur *The Outline of Science*, G.P. Putnam's Sons, New York, 1937.

Tolansky, S. *Optical Illusions*, Macmillan, New York, 1964.

Van Der Veen, R. and Meijer, G. *Light and Plant Growth*, Philips Technical Library, Eindhoven, 1959.

Vavilov, S.I. *The Human Eye and the Sun*, Pergamon Press, London, 1965.

Vernon, M.D. *A Further Study of Visual Perception*, Cambridge University Press, Cambridge, 1952.

The Psychology of Perception, Penguin, London, 1966.

Vines, H.W. *Background to Hospital Planning*, Faber & Faber, London, 1952.

Williams, L.A. *Industrial Marketing Management and Controls*, Longmans Green, London, 1967.

Williams, R.G. *Lighting for Colour and Form*, Pitman, London, 1954.

Wills, Gordon and others *Fashion Marketing*, Allen & Unwin, London, 1973 (contribution by E.P. Danger).

Wilma, C.W. *Seeing and Perceiving*, Pergamon Press, London, 1966.

Wilson, Aubrey *The Marketing of Industrial Products*, Hutchinson, London, 1965.

The Assessment of Industrial Markets, Hutchinson, London, 1964.

and Stacey, N.A.H. *Industrial Market Research*, Hutchinson, London, 1963.

Wilson, Robert F. *Colour and Light at Work*, Seven Oaks Press, London, 1953.

Colour in Industry Today, Allen & Unwin, London, 1960.

Wright, Frank Lloyd *An Autobiography*, Longmans Green, New York, 1938.

Wright, W.D. *The Rays are Not Coloured*, Adam Hilger, London, 1967.

The Perception of Light, Chemical Publishing, New York, 1939.

The Measurement of Colour, Hilger and Watts, London, 1964.

Researches on Normal and Defective Colour Vision, C.V. Mosby, St Louis, Miss., 1947.

Wyburn, G.M. and others *Human Senses and Perception*, Oliver & Boyd, Edinburgh, 1964.

Wyszecki, G. and Stiles, W.S. *Colour Science*, Wiley, London, 1967.

Articles

The following is a selective list of articles and papers recorded as being useful sources of information. The record that I maintained lists many hundreds of references, but it is felt that this would be too long to reproduce in full and therefore those that I consider to be most useful have been selected for inclusion. I do not claim to have read them all and in many cases the titles have been quoted by other experts (whom I have consulted) to support their opinions.

Beare, A.C. Colour names and a response criteria, *Ergonomics*, no. 11, 1968.

Birren, F. Better safety and accident prevention with colour, *Industrial Welfare*, Nov. 1960.

Blueprint for cost reduction, *Factory Management and Maintenance*, USA, Feb. 1954.

British colour trends in home products, *Paint Journal*, May 1964.

Choosing the right colour, *Machine Design*, USA, Aug. 1959.

Color, *Modern Hospital*, USA, May 1969.

Color and the cash value of accidents, *Mass Transportation*, USA, Dec. 1948.

Color in advertising, *Advertising requirements*, USA, Nov. 1954.

Color's cash value, *Railway Age*, USA, April 1949.

Color coding system for marking hazards, *Architectural Forum*, USA, Dec. 1948.

Color it color, *Progressive Architecture*, USA, Sept. 1967.

Color conditioning: aid to getting work done, *Dun's Review*, USA, Jan. 1949.

Color conditioning in modern industry, *Dun's Review*, USA, July 1942.

Colour: the constant reminder, *Safety*, USA, July 1942.

Color dynamics, a potent tool, *Dun's Review*, USA, July 1952.

Colour in the factory, *The Builder*, 1961.

The color guard: a report on safety colour code in accident reduction, *Du Pont Magazine*, USA, Aug. 1953.

Colour in hospitals, *Medical World*, May 1962.

Color and human appetite, *Food Technology*, USA, Vol XVII(5), 1963.

Color and human response, *Color Research and Applications*, USA, vol. 8, 1983.

Color in industry, *Steel*, USA, Jan. 1949.

Color and man made environments, *The American Institute of Architects Journal*, Aug. 1972.

Colour is more than beauty, *Modern Hospital*, USA, Jan. 1952.

Color must be functional, *The Nation's Schools*, USA, Dec. 1942.

Colour: a new tool for industry, *Mill and Factory*, USA, Oct. 1953.

Color: a new tool of management, *Forbes Magazine*, Aug. 1943.

Color in the office, *Contract*, USA, Sept. 1962.

Color: paint plants scientifically, *Iron Age*, USA, May 1953.

Colour in package design, *Sales Appeal and Packaging Technology*, March 1961.

Color in the plant, *Factory Management and Maintenance*, USA, Feb. 1945.

Colour in plastics, *Plastics*, June 1962.

Color preferences as a clue to personality, *Art Psychotherapy*, USA, vol. 1, 1973.

Color for production, *Architectural Forum*, USA, July 1942.

Color and psychotherapy, *Modern Hospital*, USA, Aug. 1946.

Colour research: a tool for modern business, *Plastics*, June 1962.

Colour in schools, *School and College*, 1961.

Colors that sell: how to find them, *Sales Management*, USA, June 1958.

Color, sound and psychic response, *Color Engineering*, USA, May 1969.

Color and the sense of space, *American Institute of Architects Journal*, Mar. 1966.

Color and transportation, *American Paint Journal*, April 1945.

Color and the visual environment, *Color Engineering*, USA, July 1971.

A colorful environment for the mentally disturbed, *Art Psychotherapy*, USA, Vol I, 1973.

The dollar value of colour, *Banking*, USA, Dec. 1950.

The effects of color on the human organism, *American Journal of Occupational Therapy*, May/June 1959.

The emotional significance of color preferences, *American Journal of Occupational Therapy*, Mar. 1952.

Engineered plant color, *Food Engineering*, USA, 1953.

Form, proportion and balance in package design, *Sales Appeal and Packaging Technology*, London, May 1961.

Functional color for better work production and safety. Talk delivered for the US State Department at the First World Congress on the Prevention of Accidents, Rome, April 1955.

Functional colour in the factory, *The Builder*, London, Dec. 1960.

Functional color in the schoolroom, *Magazine of Art*, USA, April 1949.

Functional color and the architect, *Journal of the American Institute of Architects*, June 1949.

Functional color in hospitals, *Architectural Record*, USA, May 1949.

Functionalism with color, *The Nation's Schools*, USA, May 1947.

A guide to the use of color in painting the plant, *Factory Management and Maintenance*, USA, June 1949.

How color can aid seeing, *Factory Management and Maintenance*, Jan. 1943.

How to get the most out of color in your plant, *Factory Management and Maintenance*, Feb. 1954.

Human response to colour and light, *Hospitals*, USA, July 1979.

Light: what might be good for the body is not necessarily good for the eye, *Lighting Design and Applications*, USA, July 1974.

Light control versus light intensity, *Transactions, American Academy of Opthalmology and Otolarynology*, May 1960.

Local color, *National Safety News*, USA, Sept. 1944.

Lunchroom colors affect appetite, *School Executive*, USA, May 1953.

Meet your colour mate, *Woman*, London, 1961.

The modern techniques of color in retail merchandising, *Today's Business*, USA, 1963.

On understanding color, *Illuminating Engineering*, USA, July 1948.

The ophthalmic aspects of illumination, brightness and color, *Transactions, American Academy of Ophthalmology*, USA, May 1948.

An organic approach to illumination and color, *Transactions, American Academy of Opthalmology*, USA, Jan. 1952.

The problem of color in schools, *School and College*, USA, Nov. 1960.

The proper use of color in the schoolroom, *School and College*, USA, April 1956.

The psychology of color in the schoolroom, *School and College*, USA, April 1956.

Psychological implications of color and illumination, *Illuminating Engineering*, USA, May 1969.

The psychologic value of color, *The Modern Hospital*, USA, Dec. 1928.

Put colour to work, *American School and University*, vol. 24, 1952/3.

The rational approach to colour in hospitals, *The Hospital*, London, Sept. 1961.

Renovate with color, *Home Furnishings*, USA, May 1946.

Safety and color, *Industrial Welfare*, USA, 1961.

Safety on the highway: a problem of vision, visibility and color, *American Journal of Ophthalmology*, Feb. 1957.

A sense of illumination, *Color Research and Application*, USA, Summer 1977.

The specification of illumination and color in industry, *Transactions, American Academy of Ophthalmology*, Jan. 1947.

What color can do for you, *Pathfinder*, USA, May 1950.

What color shall we choose for the schoolroom? *The Nation's Schools*, USA, Jan. 1928.

War paints for plants, *Modern Industry*, USA, April 1943.

Why not use color? *National Safety News*, USA, June 1943.

Birren, F. and Logan, H.L. The agreeable environment, *Progressive Architecture*, USA, Aug. 1960.

Blackenmore, C. Development of the brain depends on the visual environment, *Nature*, London, no. 228, 1970.

Carter, E.V. Colour in the workshop, *Industrial Architecture*, Mar 1963.

Cartin, J.D. Animal senses and reactions, *Journal of the Royal Society of Arts*, no. 108, 1960.

Casson, Sir H. Colour for caravans, *Drive Magazine*, Summer 1970.

Chadwick, H. Colour in modern life, *Journal of the Royal Society of Arts*, Feb. 1964.

Charlesworth, C. How to screen your VDU, *Technology Ireland*, Dublin, May 1981.

Culshaw, P.T. Refinishing of commercial vehicles, *Surface Coatings*, May 1966.

Danger, Eric P. The best use of light and colour, *Stores and Shops*, June 1961.

Choosing the best colour, *Wireless and Electrical Trader*, June 1961.

Choosing colour for new upholstery ranges, *Furniture and Bedding Production*, Dec. 1964.

Colour and the brand image, *World's Press News*, Jan. 1965.

Colour can help to sell your products, *Industrial Advertising and Marketing*, July 1965.

Colour can sell pottery, *Pottery Gazette*, Dec. 1961.

Colour can whet your customers' appetites, *Self Service*, Oct. 1961.

Colour in advertising, *The Sales Director*, 1961; also in *World's Press News*, 1962.

Colour in advertising material, *Marketing*, Dec. 1961.

Colour and appetite, *Self Service*, 1961.

Colour and the builder, *Ulster Builder*, Dec. 1964.

Colour and catering, *The Caterer*, 1961.

Colour and the domestic appliance market, *Diecasting*, Mar. 1965.

Colour and floors, *Building Materials*, Aug. 1961.

Colour and furnishing, *Furnishing World*, 1961.

Colour in the hosiery factory, *The Hosiery Trade Journal*, Jan. 1965.

Colour in industry, *Purchasing Journal*, Dec. 1964.

Colour in large scale establishments, *Institutional Management*, May 1965.

Colour for the motor industry, *Paint Journal*, Feb. 1963.

Colour in the office, *Business Equipment Digest*, Jan. 1965.

Colour and office equipment: a case history, *Paint Journal*, May 1963.

Colour for office machinery, *Business Equipment Digest*, Mar. 1965.

Colour and packaging. Similar articles under this title appeared in *Confectionery Manufacture, Food Manufacture and Frozen Foods* in 1961.

Colour in the packaging of cosmetics, *International Perfumer*, 1962.

Colour and paper, *World's Paper Trade Review*, 1961.

Colour at point of sale, *World's Press News*, Aug. 1962.

Colour in pottery, *Pottery and Glass*, 1961.

Colour and printing inks, *British Ink Maker*, Feb. 1962.

Colour psychology in food packaging, *Biscuit Maker and Plant Baker*, Sept. 1967.

Colour for radios, *Wireless Trader*, 1961.

Colour in shops, *Stores and Shops*, 1961.

Colour as a tool of marketing, *Marketing*, May 1965.

Colour and the toy trader, *The Toy Trader*, Jan. 1965.

Colour trends for domestic appliances, *Product Finishing*, Oct. 1966.

Colour trends, *Surface Coatings*, July 1965.

Colour in vending, *Vending*, Dec. 1961.

Development of a new line of papers in colour: a case history, *World's Paper Trade Review*, Jan. 1961.

Documentation of overseas orders; *Tack Magazine*, Nov. 1961.

Do not be frightened by market research, *Industrial Advertising and Marketing*, Aug. 1965.

Easter packaging: an appraisal, *Confectionery Manufacture*, Feb. 1963.

Effect of colour on output, *Birmingham Post Business Efficiency Supplement*, May 1965.

Evaluating the package, *Institute of Packaging Journal*, Jan. 1963.

Evaluating packaging, *Packaging Digest*, June 1964.

The expert's advice on colour, *Ironmonger*, Mar. 1964.

Fern green and blue for kitchenware, *Hardware Trade Journal*, Mar. 1967.

Finishing as a sales factor, *Product Finishing*, Mar. 1963.

Functional colour, *Commercial Decor*, May 1965.

Functional use of colour, *Caterer and Hotelkeeper*, Oct. 1965.

The importance of the right colour for coated metals, *Light Metals*, Aug. 1965.

Increasing demand for lighter colours, *Hardware Trade Journal*, Aug. 1966.

Is colour important in selling? *World's Press News*, Oct. 1964.

Is the use of metal declining? *Metals*, Nov. 1966.

Let shoppers run your stores, *Self Service and Supermarkets*, Oct. 1960.

Making the package sell, *Confectionery Manufacture*, Jan./June 1962 (a series of six articles).

Market research for the paint industry, *Paint Technology*, April 1963.

Market research and colour, *Colour* (Journal of the British Colour Council), April 1967.

Market research: the service you need, *Building Industry News*, Aug. 1964.

Metals and the packaging industry, *Metals*, Oct. 1966.

Market research and polymer applications, *Rubber and Plastics Age*, Dec. 1962.

The need to fully understand marketing, *Metals*, Sept. 1966.

The paint manufacturer and colour, *Paint Technology*, Jan. 1963.

Packaging evaluation, *Confectionery Manufacture*, 1962 (a series of six articles).

Produce prepackaging, *International Paper Board*, 1961.

Prospects for marketing consumer products, *World's Press News*, May 1963.

Put colour into marketing, *Tack Magazine*, Aug. 1964.

The right colour to sell your product, *Product Finishing*, Jan. 1963.

Sales appeal in packaging, *Food Marketing*, 1962.

Specialised consumer research in colour selection, *Paint Journal*, Feb. 1963.

Steps in achieving good packaging, *International Paper Board Industry*, May 1964.

Technical market research, *Engineering Industries Journal*, Nov. 1963.

These colours will sell this year, *Furnishing World*, April 1962.

Using colour to sell, *Marketing*, April 1962.

Using colour to sell furniture, *Furnishing World*, Sept. 1961.

Using colour to bring in more guests, *Caterer and Hotelkeeper*, Oct. 1961.

Using product colour as a consumer sales weapon, *World's Press News*, May 1962.

What does the user want? *Metals*, Dec. 1966.

What market research can, and cannot, do, *Food Marketing*, Jan. 1963.

What colour can do for your store, *Group Grocer*, 1962.

Why doesn't industry do more about prefinishing? *Metals*, Jan. 1967.

Which colours sell best, *Industrial Finishing*, May 1962.

Why the correct colour scheme is so important, *Confectionery Manufacture*, Sept. 1961.

Why worry about colour? *Industrial Design*, Ireland, 1962.

Dashiel, J. Childrens' sense of colour harmony, *Journal of Experimental Psychology*, 1917.

Diamond, Ivan L. Photodynamic therapy of malignant tumours, *American Society of Photobiology*, Annual Proceedings 1973.

Garrett, A. Colour, vision and motion, *The Ophthalmic Optician*, April 1963.
 Colour in motion, *Automobile Engineer*, Dec. 1962, Jan. 1963.

Githens, Norman S. Color and the expanding economy, *Dyestuffs*, USA, Dec. 1960.

Gloag, H.L. Hue, greyness and weight, *Building Materials*, July 1969.

Gloag H.L. and Keyte, M.J. Colour co-ordinating a range, *Design*, Sept. 1959.
 Colour co-ordination for manufacturer and user, *Design*, Mar. 1959.
 Rational aspects of colouring in building interiors, *Architects Journal*, vol. 125, 1957.

Gloag, H.L. and Medd, D.L. Colour in buildings, *RIBA Journal*, vol. 63, 1956.

Goldstein, K. Some experimental observations concerning the influence of colour on the function of the organism, *Occupational Therapy and Rehabilitation*, USA, June 1942.

Hall, Arnold L. Colour in hospitals, *The Hospital*, June 1951.

Hardy, A.C. Colours for floor finishes, *Building Materials*, Vol. 26, 1966.
 An architect looks at colour, *Colour Environmental*, 1966.

Harmon, D.B. Lighting and the eye, *Illuminating Engineering*, USA, Sept. 1944.
 Lighting and child development, *Illuminating Engineering*, USA, April 1945.

Harrison, W. and Luckiesh, M. Comfortable lighting, *Illuminating Engineering*, USA, Dec. 1941.

Holmes, J.C. A lighting engineer looks at colour, *Colour Environmental* 1966.

Holt, E. Colour preferences of children. Dissertation at Birmingham University, 1958.

Hopkinson, R.G. The selection of suitable chalkboard colours, *RIBA Journal*, Vol. 59(10), 1952.
 The lighting of hospitals, *The Hospital*, Vol. 59, 1963.

Hopkinson, R.G. and Collins, J.B. The prediction and avoidance of glare in interior lighting, *Ergonomics*, Oct. 1963.

Hubble, L. Colour and productivity in the motor car industry, *Product Finishing*, Oct. 1966.
 Colour and national productivity, *Colour Environmental*, 1966.

Hurst, A.E. Colour and environment as an aid to industrial safety, *Painting and Decorating*, Jan. 1967.

Judd, Deane B. Colour vision, *Medical Physics*, USA, 1944.
 Facts of color blindness, *Journal of the Optical Society of America*, June 1943.
 A flattery index of artificial illuminants, *Illuminating Engineering*, USA, Oct. 1967.

Kelner, A. Revival by light, *Scientific American*, no. 184, 1951.

Keyte, M.J. The BS colour range for building and decorative paints, *Architects Journal*, no. 123, 1956.

Knighton, P.H. The right use of colour in hospitals, *The Hospital*, Mar. 1956.

Kravkov, S.A. Color vision and the autonomic nervous system, *Journal of the Optical Society of America*, June 1942.

Logan, Henry L. Outdoor light for the indoor environment, *The Designer*, USA, Nov. 1970.

Color in seeing, *Illuminating Engineering*, USA, Aug. 1963.

The anatomy of visual efficiency, *Illuminating Engineering*, Dec. 1941.

Light for living, *Illuminating Engineering*, March 1947.

Luckeish, M. Brightness engineering, *Illuminating Engineering*, USA, Feb. 1944.

Luke, V.N. Colour as an economic factor in thermoplastics, *Plastics*, June 1962.

Lythgoe, R.J. Visual perceptions under modern conditions, *Illuminating Engineering*, USA, Jan. 1936.

Manor, J. Stressless use of VDUs, *Health and Safety at Work*, Aug. 1980.

Mayall, W.H. Colour in engineering, *Engineering Materials and Design*, Feb. 1963.

Medd, D.L. Architecture in an affluent society, *The Listener*, Aug. 1961.

Colour in schools, *Architectural Review*, no. 106, 1949.

Moon, P. Colors of furniture, *Journal of the Optical Society of America*, May 1942.

Reflection factors of floor materials, *Journal of the Optical Society of America*, April 1942.

Wall materials and lighting, *Journal of the Optical Society of America*, Dec. 1941.

Newhall, S.M. Warmth and coolness of colours, *Bulletin of American Physical Society*, Feb. 1940.

Page, J.K. The role of lighting in the search for better interiors, *Transactions of the Illuminating Engineering Society*, London, 1962.

Payne, C. Color as an independent variable in perceptual research, *Psychology Bulletin*, No. 3, USA, 1964.

Apparent weight as a function of color, *American Journal of Psychology*, Vol. 71, 1958.

Poole, D. Colour in buildings, *Building Materials*, no. 26, 1966.

Porter, T. An investigation into colour preferences, *The Designer*, Sept. 1973.

Rhodes, H. Colour in a woollen mill (Oldham), *Architects Journal*, no. 111, 1950.

Rosenfeld, A. Seeing colour with the fingers, *Life Magazine*, USA.

Sherwood, F.W. Colour matching of industrial finishes, *Product Finishing*, April 1964.

Smith, Kendrick C. The science of photobiology, *Bio Science*, USA, Jan. 1974.

Thomson, W.A.R. Colour can help in healing, *Daily Telegraph*, Nov. 1974.

Troland, L.T. Analysis of the literature concerning the dependence of visual functions on illumination intensity, *Illuminating Engineering*, USA, Feb. 1931.

Trower, B.E. The lighting of hospitals, *Lighting Equipment News*, Feb. 1972.

Warr, A. and Colover, J. VDUs: a suitable case for treatment, *Occupational Health*, July 1979.

Wright, Professor W.D. Colours under scrutiny, *New Scientist*, July 1969.

Yogo, E. The effect of visible light on the vegetative nervous system, *Japanese Journal of Obstetrics*, June 1940.

Official bodies

The material issued by government departments and semi-official bodies is required reading in many colour applications, particularly where regulations or official guidelines are concerned, but this material changes so frequently that it would be misleading to list it here. In the UK most government publications are obtainable from HM Stationery Office (HMSO), and the sectional lists issued by them will be helpful in tracking down the latest information. The following selective list of official bodies is mainly concerned with the UK.

British Colour Council. This body is not now in existence but some of the publications that they issued are still very useful if access can be obtained to them, notably:
> *Dictionary of Colour for Interior Decoration*, 1949
> *Dictionary of Colour Standards*, 1955
> *Horticulture Colour Chart*, 1950 with the Royal Horticultural Society
> *Colour and Lighting in Factories and Offices*, 1953

Building Research Establishment. The BRE produces a vast amount of material, particularly on lighting, and the author has a long list of references, but the material is frequently updated and new material is issued. Some material is obtainable direct from the BRE and some is available through HMSO. Information can be obtained direct from the BRE.

Design Council. The Council produces a number of publications concerned with colour and interior decoration, and details can be obtained direct from the council. They also act as booksellers and produce useful lists of books concerned with design subjects.

Institute of Directors. The Institute has produced at least two books which the author has found useful:
> *Better Offices*, 1976
> *Better Factories*, 1963.

Department of Education and Science. The publications of the department are essential reading for anyone concerned with environmental colour in schools; they are supplied through HMSO, and the latter can advise on material currently available.

Electricity Council. Their publications on lighting are invaluable and essential reading for anyone concerned with environmental colour and lighting. The following are some typical examples but later editions of some of these are available:

Lighting for Shops, Stores and Showrooms, 1969
Lighting for Hotels and Restaurants, 1964
Interior Lighting Design, 1974
Better Office Lighting, 1976.

Food Manufacturers Federation. This is the best known source for information about the labelling of food.

Department of Health and Social Security. Publications are essential reading in connection with the decoration of hospitals; obtainable through HMSO.

Health and Safety Executive. This body has taken over many functions from other government departments, and their functions are primarily concerned with environmental health and safety; some publications are obtainable direct and some through HMSO. This department is concerned with the health aspect of VDUs and a useful publication is:
Visual Display Units, 1984.

Illuminating Engineering Society. This is a most valuable source of information on all matters concerned with lighting. Particularly useful:
The IES Code for Interior Lighting, 1973.
There is a similar organisation in the United States which performs the same function.

Medical Research Council. A number of their publications deal with lighting and visual subjects; available from HMSO.

Property Services Administration (Department of the Environment). Publications dealing primarily with offices, and especially government offices, obtainable through HMSO.

Road Research Laboratory. Publications dealing with road safety, signs and vehicle colours; mostly obtainable through HMSO.

Department of Transport. Similar remarks as for Road Research Laboratory.

US Department of Commerce, National Bureau of Standards. A most valuable publication is:
The ISCC-NBS Method of Designating Colour and Dictionary of Colour Names, 1955.
This is obtainable from the US Government Printing Office.

Commercial information

The material issued by business firms often provides valuable information, and the following is a list of typical publications known to the author.

Allied Chemical Corporation, USA. *The Age of Reason for Colour* by F. Birren (promotional booklet).
Color, People and Paper by F. Birren.

American Seating Company. *How Colour Can Create an Environment of Excellence in the Classroom* by F. Birren, 1969.
Color in today's schools text by F. Birren, 1961.

Appleton Coated Paper Co., USA. *The Use of Tinted Paper*, 1956 (also a number of other publications concerned with paper and colour).

Birds Eye Foods Ltd. *Annual Review*, 1976.
Bolands Ltd., Dublin, Ireland. Brian Boru in modern dress, *Development* (Ireland), Sept. 1968 (dealing with the recolouring of their packages).
Cambridge Tile Manufacturing Co., USA. *The Changing Market for Color* by F. Birren (promotional booklet).
 Color Engineered Facing Tiles by F. Birren.
Champion Paper Co. Inc., USA. Various leaflets dealing with colour and paper.
Colorizer Associates, USA. *Making Color Work for You* by F. Birren (a promotional booklet containing advice on the application of colour to motels, restaurants, retail shops, schools, hospitals and industrial plants).
Coloroll. Promotional material issued by this company contains useful hints on interior decoration.
Container Corporation of America. *Colour Harmony Manual* (Ostwald system), 1948.
Dorma. Promotional material from this company contains useful hints on interior decoration, particularly in relation to bedrooms.
Du Pont Co., USA. *Colour Conditioning* by F. Birren (promotional booklet).
 Colour Designed for Sales by F. Birren (promotional booklet for Delrin).
 Functional Colour Styling for fleets by F. Birren (promotional booklet for vehicle finishes).
J.R. Geigy, S.A. Basle, Switzerland. *Colour in Painting*, 1965.
General Color Card Co., Fort Wayne, USA. *Color Systems and Colour Standards* by F. Birren (booklet).
General Electric Company, USA. *Preliminary Report on a New Approach to Color Acceptance* by W.G. Pracejus.
Goodlass Wall & Co. Ltd. *Sight, Source and Surface* (booklet published by the company in association with Philips Electrical Ltd.).
 Hospital decoration (booklet by the company with Philips).
Hytone Paper Co., USA. *Color and Personality* (promotional material).
ICI Paints Division. *A Guide to Office Decoration*, 1972.
 Thinking in Colour, 1976 (the company produces a number of other useful publications on various aspects of colour).
Jenson & Nicholson Ltd. (now part of Berger Group). *Historical Colours* (a series of colour selections based on decorative periods).
Monsanto Chemical Company, USA. *Color and How It Can Help You Sell* by F. Birren (promotional booklet).
Pilkingtons Tiles Ltd. Various leaflets, by F. Birren, on the use of coloured tiles in hospitals, shops and other environments.
Richard Tiles Ltd. *Colour in Hospitals* 1966 (booklet).
Rohm & Haas Co. *Signs in Oroglas* (promotional booklet).
Rothchild Printing Co., USA. A series of promotional leaflets, by F. Birren, dealing with the use of colour for tags.
Royal Typewriter Co., USA. *Color for Typewriters* by F. Birren (promotional material).
Shell Chemical Co. A series of promotional booklets, by F. Birren and E.P. Danger, dealing with the use of coloured plastics for furniture, travel

goods, bottles, blow-moulded containers, packaging and kitchenware.
Spicers Ltd. *House Styles* (promotional booklet).
St. Regis Paper Co. USA. *Visometrics* (promotional booklet).
Sun Chemical Co. USA. *The Motivational Approach to Package Design* by F.
Birren (promotional material; also various other booklets).
West Virginia Pulp & Paper Co., USA (now Westvaco). Promotional material,
by F. Birren, dealing with colour and paper.

Note: A number of American paper companies issue promotional material
dealing with the use of coloured papers and with the use of colour in pro-
motion. Many of these are very valuable as a source of ideas, but they are too
numerous to list here.

The author's own publications

Books, books to which the author has contributed and articles are listed under
the appropriate headings above.

Colour Research Reports

These major reports are unpublished but can be made available to individual
firms on demand. Cost varies with size.

Colour in the Bedroom, 1981
Choosing Colour for Bathroom Products, 1979
Colour for Catering Establishments, 1984
Colour Selection for Decorative Laminates: Consumer Aspects, 1982
Colour Selection for Domestic Appliances, 1987
Colour for Factory Environments, 1983
Colour Selection for Floor Coverings: Consumer Aspects, 1982
Colour for Hospital Environments, 1983
Selecting Colour for Images: Corporate Images and Brand Images, 1986
Colour Selection for Kitchen Products, 1984
Colour in the Living Room, 1979
Colour for Office Environments, 1983
Colour Selection for Office Screens, 1983
Colour Selection for Office Supplies, 1979
Colour Selection for Paints: Consumer Aspects, 1982
Choosing Colour for Paper and Board, 1985
Selecting a Range of Colours for Plastics Sheet, 1978
Colour for Retail Environments, 1984
Colour for School Environments, 1983
Selecting Colour for Vehicle Liveries, 1986
Colour Selection for Wallcoverings: Consumer Aspects, 1982
Colour Selection for Wall Tiles: Consumer Aspects, 1982
Colour for Window Decoration, 1980

Note: All reports are updated annually where necessary.

Colour Research Notes

These are shorter reports on specific aspects of colour application. They are unpublished but can be made available to individual firms on demand. Cost depends on length.

Biological Aspects of Light and Colour
Colour and Building Exteriors
Colour and Children
Corporate Colour Standards
Colour in the Country
Colours for Export
Colour for Food
Food Colours in the Home
Colour for Food Packaging
Colour for Food Processing Plants
Colours for Selling Food
Colour for Food Service
Colour for Industrial Plant and Equipment
Colour for Merchandising
Colour and Pattern
Colour and Safety
Colour and Signs
Colour and Television
Colour and Texture
Colour and Visual Display Units
Colour and Woodgrains

Muirhead Library
Michigan Christian College
Rochester, Michigan